D1576485

Walker Art Gallery Liverpool

MERSEYSIDE

PAINTERS, PEOPLE & PLACES

Catalogue of Oil Paintings — Text

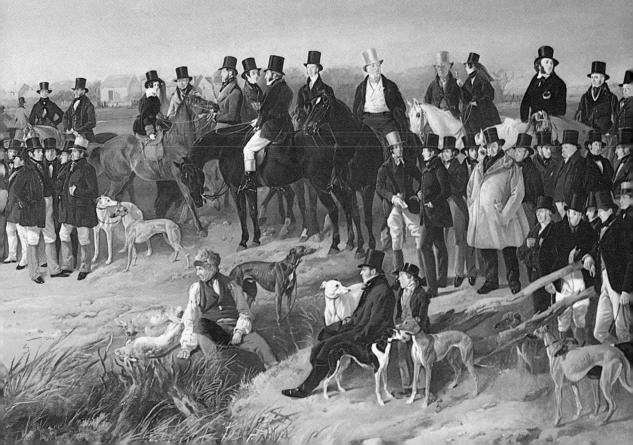

Walker Art Gallery Liverpool

MERSEYSIDE

PAINTERS, PEOPLE & PLACES

Catalogue of Oil Paintings — Text

WITHDRAWN

B
DEPARTMENT
OF PRINTS AND
DRAWINGS 1979

MERSEYSIDE COUNTY COUNCIL 1978

193513- 1091

SBN For Complete set of 2 Volumes 901534 62
SBN For this Volume 901534 60
Printed in England by J. H. Leeman Ltd., Neston, South Wirral, L64 3S
Type: Perpetua (Series 239) 12 pt Imprint (Series 101 and 310) 8 pt and 10
Times (Series 327) 18 pt and 24
Cover: Type Imprint and Imprint Shado
Text: Huntsman Super White Cartridge 100 gs
Cover: Novacote Board 260 gs
Cover: Subject R. Ansdell, " The Waterloo Cup " (deta
Origination by Gilchrist Bros., Lee

Preface

THIS catalogue of part of the Gallery's collection, together with its forthcoming companion volume on sculpture, watercolours and miniatures, sets out to record the activities of artists working in Liverpool and on Merseyside from the 18th century to the present day, together with the works of other artists in so far as they relate to local scenes or local sitters. It is by no means a total picture, for the Collection is far from representative and several artists are missing and some important works find their homes elsewhere. It does not pretend to be consistent, for while later works of the minor artists who left Merseyside are occasionally included for the sake of the record, the later pictures in the collection by George Stubbs, in particular, are not, as his fame an as animal painter post-dates his final departure from Liverpool in the 1750's. Every endeavour has been made to give as full a biography as possible on local artists but living artists and those based elsewhere are not included.

Our decision to bring together these works, with their local links, highlights the developing artistic pretensions of Liverpool as it grew from a small and secondary port needing only the services of itinerant artists, to a major city capable of supporting its own school of painters. Local circumstances, from time to time, produced works which, though they might be different from the main stream of British painting, were of high quality and valid within their own terms. The reasons for the successes and failures of local artists have a relevance for today, with the desire to decentralise within the arts wherever possible and the growth of local arts associations.

The catalogue has been prepared by Mary Bennett, Keeper of British Art, and much of the material included is dependent on two main sources: firstly the files on artists built up from the early years of the Gallery; and more particularly to Liverpool Record Office in Liverpool City Library. Indeed without the mass of published and manuscript material in the latter this catalogue would not have been possible. To the staff of the Liverpool Record Office in particular, for their unstinting assistance, to the many other Record Offices, and to the many individuals who have provided information we should like to extend our sincerest thanks.

TIMOTHY STEVENS,
Director.

Introduction

IT is possible to follow the gradual growth of Liverpool from a small port, through its great expansion in the 19th century, to the metropolitan complex of today, in the parallel growth in volume and importance of local artists and local patronage, reaching its peak in the mid years of Victoria's reign, and affected in quality and productivity by trade expansion or recession, by war or the like, and by the drain of talent to the south-east.

The pattern before the 1900's shows, on the one hand, the essentially local school of artists risen initially from the journeyman level, with their provincial standards and very varied stylistic forms (for only in the 1850's did a small group consistently follow one style, that of the then controversial Pre-Raphaelites), who found just sufficient livelihood, often necessarily eked out by teaching or sometimes a secondary trade. On the other were the visiting artists mopping up a few chance commissions, and the London artists, occasionally with local or northern affiliations, who were commissioned by the wealthier merchants and local gentry, by the city fathers or by public subscription to paint the major citizens or execute the important monuments.

In the present context history painting barely finds a place. With the exception of Winstanley's copies of Old Masters for the Earl of Derby in the early 18th century, pictures in this category were usually sought for elsewhere. Outsiders like Fuseli (1803), Hilton (1821), B. R. Hayden (1837), and Furse (1898), gained the few public commissions, in the same way that the major monuments went to London artists. The aspirations of the young Mosses and Huggins very quickly evaporated.

Inevitably portraiture is in the forefront. The first Liverpool street directory of 1766 records only one artist, William Caddick, a portrait painter. With his sons Richard and William, he managed to find a lifetime of employment here, unless there are travels about the country which are unknown to us. His career spans the half century in which Liverpool's cultural life was first expanding in the midst of its prosperity, years when the major families sat to Reynolds or Cotes or their competitors, when in 1769 a local Society of Artists was formed in imitation of the new Royal Academy in London by the versatile P. P. Burdett, engraver and cartographer from Derby, and his friend Joseph Wright of Derby came at the same time to wrest the better commissions from the merchant class. Wright of Derby is still missing as a portraitist in the Collection; the highlights of this period are the early portraits of a complaisant local nobody by George Stubbs, who left Liverpool very young for fame in London, and Gainsborough's *Viscountess Molyneux, later Countess of Sefton*. Later, in the earlier 19th century, come the portrait of Canning, M.P. for Liverpool (the source of which remains a mystery) from Sir Thomas Lawrence's studio, and the Corporation commissions

to Sir Thomas Phillips in the 1820's for the newly completed interior of the Town Hall. On a more domestic level around the 1800's the popular rival to minor local talent was Joseph Allen, based in Wrexham and Manchester, but closely tied up with the flamboyant George Bullock, sculptor, cabinet maker and first President of the new Liverpool Academy of Arts of 1810. Following him was the outstanding Liverpool painter Alexander Mosses, whose provincial rendering of the neo-classical ideal in his large portraiture, and fluid and atmospheric handling of paint in his small-scale portraits and genre, places him head and shoulders above his local competitors.

During the same period the work of the innumerable visiting miniaturists is now hard to identify, but the town was well able to support several of its own, and most particularly the family of Hargreaves over two generations, albeit bolstered up by a drawing academy and framemaker's business.

In the 30's and 40's whilst romanticism is giving way to realism, the hard gloss of William Daniels contrasts with the more perceptive realism of Huggins and Ansdell, whose portraits get entangled with their animal painting. While amongst the morass of magisterial municipal portraits of the later years of the 19th century, which record more than anything the increasing social consciousness and public service of the town at the height of its prosperity, the Pre-Raphaelite brilliance of J. E. Robertson's portraits are notably able to withstand the damaging influence of photography. Two important visitors after this were James McNeill Whistler to the Leylands at Speke Hall in the 70's and Augustus John to the University around 1900. Whistler's portraits of the great ship owner, Frederick Leyland, and his family, are in America, while Augustus John's portraits are at the University and the Gallery can, alas, only present their etching done while here.

Liverpool as a port was adequately represented in the world of topography. The finest early views are undoubtably the pair of watercolours by Michael Angelo Rooker, exhibited at the Royal Academy of 1769 and bought by the Earl and Countess of Sefton. The engravings were published locally and were probably closely related to local map making. They are revealing as an indication of the pride in the mounting importance of Liverpool in the mercantile world. Following on came the marine painters, John Thomas Serres, Nicholas Pocock, Robert Salomon and the locals, Samuel Austin, Samuel Williamson and Samuel Walters, and many lesser and unidentified figures. While ship portraits of the mushrooming shipping lines must have been the staple trade of many of them, the life of the port and the changing face of the Mersey waterfront at Liverpool, Bootle, Wallasey and Birkenhead, viewed sometimes topographically, sometimes atmospherically, is their real contribution.

From a basically topographical approach the landscape painters towards the mid-19th century concerned themselves with finding in the countryside near at hand, towards Speke or Southport or on the Wirral, and further and further afield, their motif for atmospheric landscape painting as a nostalgic release from the growing industrialism of the town. Charles Towne's development owed much to his London contemporaries and to Dutch art. The

Dutch flavour of early Samuel Williamsons changed to a hotter palette and more fluid technique derived from J. M. W. Turner (visible at least to him through Liverpool Academy exhibitions and widely collected on Merseyside). In the 1850's William Davis, native of Dublin and initially a portrait painter, evolved a more delicate and tentative version of the brilliant Pre-Raphaelite palette; notable for his refusal to paint a 'view' he preferred the simplest of motifs and worked best on a small scale. Even he followed the general trend towards Wales for subjects and there many of his later contemporaries were to settle.

Surprising in view of the increasing industrial aspect of Liverpool was the long survival of sporting art. George Stubbs began painting animals as well as portraits here, but made his great reputation after he had left Liverpool for good (though he kept up his local connections through William Caddick at least). Following in his footsteps, Charles Towne, from Wigan, after a roving youth which included some time here, settled in Liverpool finally around 1810 and appears to have had a prolific practice in the whole of the North West. The shimmering and often lyrical backgrounds to his horse and cattle subjects must have provided a panacea for the reluctant town dweller. On the other hand his successor, Richard Ansdell, in his various group portraits of sporting events, also well represented in the Collection, shows us the richer merchant aspiring to mix with the aristocracy and gentry in the events taking place in the country around. Their aspirations are underlined by the number of families, who having made their fortunes, moved out into the adjacent counties and further afield as country gentlemen and took their collections of pictures, family portraits, old masters and sprinkling of local art, along with them. The Claytons in the mid-18th century were among the first, the Robinsons of Sudley and the Naylors are 19th century examples; Leyland set up his magnificent London town house in the 1870's. Ansdell, with enhanced reputation, quickly moved to London and membership of the Royal Academy, although always proud of his simple beginnings at Liverpool's Blue Coat School. His near contemporary William Huggins was in contrast entirely satisfied with a provincial reputation. Beginning as a portrait painter with aspirations to history he found his niche as an animal painter with leanings to genre and no doubt benefited by Ansdell's removal, though in a somewhat different category. His change of style from the rich romanticism of the 30's and 40's to the light almost Pre-Raphaelite palette of later years spans almost half a century. He, too, moved from Liverpool to Chester where his brother worked, and spent some time in Wales.

The mature flowering of Liverpool art came in the 1850's with the small group of followers of the Pre-Raphaelites. Encouraged by their patron, John Miller, a prolific collector, W. L. Windus, William Davis, J. J. Lee, James Campbell in particular, turned to the brilliant palette, delicate detail and careful imitation of nature of the then controversial London artists. Windus developed more serious subject matter; Davis evolved exclusively as a landscape painter. Though linking up with Madox Brown and Rossetti and Hunt in London exhibitions in the late 1850's, they were still very much dependent on a few local patrons. In following in the footsteps of the Pre-Raphaelites and in supporting the prize of the Academy

to Hunt and Millais and Madox Brown, they were self-destructive. Such paintings were too advanced or more particularly too controversial for Liverpool. The old guard, led by the topographer W. G. Herdman, broke off relations with the Academy and set up a rival exhibition society. The Academy exhibitions, held almost annually since 1822 and which were undoubtedly a useful source for sales and advertisement, came to an end in 1867. Their demise coincided with a general exodus from Liverpool of the brighter talent. Oakes had already gone in the early 50's to achieve an A.R.A.; A. W. Hunt went in 1861 to success as a watercolour painter. In turn Windus, Campbell, Lee and Davis left, their inspiration almost evaporated and not to achieve any success. In Liverpool artistic vitality became dormant at the same time as the town itself was expanding enormously.

For patronage up to this time the local artists had various resources. The local aristocrats, the Earl of Derby and the Earl of Sefton, provided some small measure: Winstanley of Warrington was much employed at Knowsley in the early 18th century; Charles Towne, John Boultbee and Dalby of York painted horses for the sporting Earls of Sefton and most particularly Richard Ansdell found favour in this field. The landed gentry such as Henry Blundell of Ince patronised Towne and Bullock. The multiplying printsellers and dealers around 1800, like Thomas Vernon who brought in J. C. Ibbetson and auctioned J. T. Serres' views, were more concerned with the new London prints or with Old Masters than local talent. With the proliferation of provincial academies in the 1820's came the possibility of exhibition and sale in other towns, while the exceptional artist found his market through London exhibitions. But the staple dependence over all was on the local merchant class. Amongst the most outstanding of these, William Roscoe, solicitor and writer, most noted for his collection of Old Masters, turned to John Williamson and the Haughtons for family portraits and assisted many artists, in particular John Gibson and George Bullock, in their early careers. Much later, in the 50's, John Miller, a tobacco merchant, made his house the centre for the whole group favouring Pre-Raphaelite ideals; to his fine examples of Turner, Linnell and the like he added innumerable local purchases, and broadcast the merit of his chosen men to their peers in London, where he encouraged Windus and Davis and Campbell to visit and exhibit. George Rae of Birkenhead, a great Rossetti fan, was a little later a major supporter of Davis, and others followed on. In the many large later 19th century Merseyside collections of British Academic paintings with their sprinkling of fine Turners were usually to be found some few of the local school.

These collectors tended more and more to represent the previous generation as a historical consciousness came into play. In spite of the many artists working on Merseyside the tight local ethos of former years had evaporated. The only artists of stature to span both worlds were the prolific W. J. C. Bond and John Finnie, whose local success it is perhaps just again possible to appreciate in context. With the opening of the Walker Art Gallery in 1877 a very gradual attempt was made to acquire work by earlier Liverpool artists but contemporaries were annoyed at receiving no concessions at the new Autumn Exhibitions, designed

now to mirror the Royal Academy in London.

At the turn of the century the depressing local scene was brightened by the advent for a period of a lively group of artists in the Applied Art Department of the School of Architecture at University College until its amalgamation with the Liverpool School of Art in 1905. The arts and crafts of R. Anning Bell from London, the art nouveau of Herbert McNair from Glasgow, the panache of Augustus John, the general more cultivated and informed circle must have been the basis for the awakening of a modern school of thought amongst the younger set, J. Hamilton Hay, Mary McCrossan, Herbert Tyson Smith, J. Carter Preston, etc., some of whom stormed and modernised the moribund Liverpool Academy for a short time and brought modern art exhibitions to Liverpool and founded the bright rival Sandon Studios Society. Again came the exodus to London at the first opportunity. The following decades also saw the break-up of the many merchant collections around Liverpool, leaving only the Holt collection at Sudley virtually intact until today.

The tight group of the Sandon Studios, embracing music and drama as well as painting, the 20th century repetition of the Pre-Raphaelite group of the 1850's in its corporate identity, survived both wars, as did the reliable craftsmanship of H. Tyson Smith's sculpture studio. The public galleries in Liverpool, Birkenhead and Southport acquired local historical paintings and supported contemporaries by occasional purchase and opportunities for exhibition.

The 1950's saw the re-emergence of the Liverpool Academy from the reactionary position of the previous 50 years to take the lead in a modern movement. Its exhibitions, held at the Walker Art Gallery and its own gallery show the newest work produced on Merseyside.

Through the whole period of two hundred years and more we are presented with a surprisingly large body of interesting and worthwhile development, with the highlights provided by some few artists of stature or at least talent, who, having spent some small part of their active life here, have instilled something of their own forcefulness into the provincial scene.

MARY BENNETT.

Chronology

1682 Earliest known view of Liverpool, for Richard Windle, Mayor, showing the Castle, Tower and waterfront with many ships in the Mersey (Merseyside Museums).

1690's The Viscounts Molyneux of Sefton and Croxteth patronised (?) Irish portrait painters.

1700 Population of Liverpool: about 5,714.

1715 Hamlet Winstanley of Warrington, portrait painter, patronised by country families; employed by James, 10th Earl of Derby at Knowsley for portraits, copies of Old Masters and engravings.

1724 George Stubbs, portrait and pioneer animal painter, born Liverpool. Near contemporaries were William Caddick, portrait painter and Richard Wright, ship painter.

1725 Chadwick's Map of Liverpool. 1728, Buck's engraved panoramic view.

1740 Stubbs at Knowsley under Winstanley for short time. 1744, left for Wigan and York.

1746 William Caddick visited London: saw studios of Hudson, Ramsay, Rysbrack, Van Aken, etc. Limner, painter and portrait painter in Old Hall Street until death, 1794; joined by sons Richard (born 1748) and William (born 1756). Richard Wright, limner and painter in Old Hall Street until about 1758: thence to London as marine painter.

1750's James Cranke of Urswick and Henry Pickering, portrait painters in area.

1753 Birth of William Roscoe, son of Liverpool publican and market gardener, to become centre figure in patronage of the arts, as well as many other interests.

1755–6 Stubbs revisited Liverpool: thence to Lincolnshire and London, where settled.

1756 Population 18,500. First important Liverpool newspaper. Subsequently advertised artists' visits, art societies, drawing masters, auctions, exhibitions, panoramas etc.

1759 John Deare, sculptor, born: trained at Royal Academy and settled at Rome.

1766 First Street Directory, listed one artist only: William Caddick.

 P. P. Burdett advertised his survey of Lancashire locally; settled in Liverpool and centre figure in art circles. His friend Joseph Wright of Derby in Liverpool during 1768–71 painting local sitters, and William Tate of Liverpool became his pupil.

1767 Nathaniel Tucker, portrait painter, held exhibition at Golden Lion. Henry Fuseli visited the town with Joseph Johnson, bookseller and publisher, native of Liverpool, the first of several visits.

1769 Society of Artists formed, emulating Royal Academy in London (1768); headquarters at 30 John Street (Liverpool Library) with P. P. Burdett, engraver, as President, and 22 gentlemen and artist members including Richard Caddick, Peter Romney (in Liverpool *c.* 1769), Thomas Chubbard, etc. Burdett left the town and the society soon lapsed.

Two panoramic views of Liverpool from watercolours by Michael Angelo Rooker published by George Perry in same year as his map of the town; originals bought by Lady Sefton whose portrait by Gainsborough at the same Royal Academy exhibition, 1769.

1773–4 Society for the Encouragement of Designing, Drawing and Painting founded, with William Caddick as President and 59 members including William Roscoe. Programme of lectures and classes for students. August, 1774: exhibition of this society held at 30 John Street, the first in the provinces, with 85 items by artists and amateurs, including P. P. Burdett, Thomas Chubbard, John Rathbone, Mr. Stringer, Mr. Sharples, Daniel Daulby (important local collector), Matthew Gregson (upholsterer and antiquarian) and the Tate family.

1781± A Print Club active, to circulate and discuss Old Master prints; chief figures, Daniel Daulby, Matthew Gregson, and Samuel Stringer of Knutsford.

1783–7 Society for Promoting the Arts in Liverpool founded. President Henry Blundell of Ince (important collector of classical marbles and old masters); Vice President and Treasurer William Roscoe; Thomas Taylor, Secretary. Headquarters in Leigh Street. 1784 Exhibition in Rodney Street (now No. 35), called Society for Promoting Painting and Design in Liverpool. 206 items with contributions from Reynolds (P.R.A.), Fuseli, Sandby, Wright of Derby, and locally from R. Caddick, Chubbard, W. Tate etc. and amateurs. 1784–5 evening classes in Leigh Street for students with Caddick, Chubbard, McMorland, Holland, W. Tate and J. Williamson as Visitors. 1787 2nd Exhibition at Liverpool Library, Lord Street. 140 items. Classes continued. The Society faded out by mid-1790's.

1780's Charles Towne, animal painter, in Liverpool on and off for a time; finally settled here permanently 1810. John Williamson, portrait painter, of Ripon and Birmingham, here by 1784 and founded family of artists. Miss Knipe, miniature painter and teacher, here by 1784. Thomas Hazelhurst, miniaturist settled here.

Newspapers advertised annual visits of portrait and miniature painters: 1783 Mr. Sheridan, Mr. Hamlyn; 1788 Mr. Lightfoot; 1792 onwards Mr. Barry; 1793 Mr. Pack; 1797 W. H. Watts; 1799 T. J. Hunter, Mrs. Henderson and son, Mr. Lewis; 1801 Mr. Batty, Mr. Thompson; 1802 onwards J. Fernel, E. Goodwin; 1805 Mr. Steele; 1806 Mr. Burnell; 1807 Mr. Burns, etc. etc.
Fuseli here again in 1785; assisted to sell work by William Roscoe.

1791 William Martin, History Painter to George III, presented 4 of his large history paintings and a group of allegorical chiaroscuro subjects for the Exchange (Town Hall); burnt in the fire, 1795; engravings by Bartolozzi published London, 1804.

1795 Thomas Hargreaves, trained under Lawrence, returned to settle as important miniature painter, later joined by his sons with drawing school, carvers and gilders shop, etc.

1796 John Turmeau, from London, miniaturist, settled here and became important in art circles; also did business as stationer and tradesman. J. T. Serres, marine painter, here for two years; exhibited naval pictures 1796 and published four views on the Mersey 1798 through R. Preston, stationer and printseller of Liverpool.
Daniel Daulby, the collector, published catalogue of his Rembrandt prints; his collection sold in Liverpool 1788–9 and London, 1800.
Charles Towne copied Wilson landscapes at Ince for Henry Blundell.

1798–9 J. C. Ibbetson working in Liverpool for Thomas Vernon the dealer and auctioneer, who was in business here 1794–1802 and exhibited a Transparency by Ibbetson, 1798.

Views on the Mersey by Nicholas Pocock published 1798 and 1800.

Travelling Panoramas began to appear at Liverpool.

1801 Population: 77,708.

1800's William Roscoe collecting Old Master paintings to add to his prints and drawings. Instrumental patron in Liverpool of Henry Fuseli, (who presented his *Allegory of the Union* to the Union News Rooms, 1803), and assisted early careers of John Gibson, George Bullock, Matthew and Moses Haughton (from Birmingham), etc.

Various drawing academies advertised: 1801 Mrs. Thompson, J. Batty; 1802 Peter Holland, Matthew Haughton and John Turmeau, Mr. James (whose Drawing school flourished for many years).

1802 Messrs. S. & T. Franceys, marble masons, began advertising; employed F. Legé as sculptor and later John Gibson and William Spence as apprentices.

1804 George Bullock, sculptor and cabinet maker, native of Birmingham, set up on own account in Lord Street; became first President of Liverpool Academy, 1810; moved to London, 1814.

Thomas Winstanley, auctioneer, began business; closely associated with Liverpool Royal Institution.

1806 Robert Salomon, travelling marine (? and scene) painter, first visit to Liverpool, 1806–1811; here again 1822–25 and in 1828 before embarking for Boston. J. and R. Jenkinson local marine and portrait painters until 1820's.

1810 11 August: Liverpool Academy founded. Patron: Henry Blundell of Ince; Treasurer: William Roscoe; Lecturer in Anatomy: Thomas Stewart Traill; Chemist: William Strachan. 17 Academicians and 4 Associates. 1 August: First Exhibition opened at Gothic Rooms, Marble Street. 343 items with contributions from Benjamin West (P.R.A.) and London artists and locally from John Gibson, Thomas Hargreaves, Charles Towne, Samuel and Daniel Williamson, Henry Hole, etc. Annual exhibitions until 1814 with Presidents: John Turmeau, 1812–13; Jeremiah Steele, 1814.

Henry Hole, pupil of Bewick, William Clements, and Edward Smith important local engravers. T. Troughton's *History of Liverpool* published with wood engravings of local views. Joseph Allen, native of Birmingham, at Wrexham, Manchester etc., painted local sitters; member L.A. 1810. Mather Brown, American, in Liverpool painting portraits 1810–13 and exhibited at L.A.

Henry Blundell of Ince died; left bequest of £1,600 to L.R.I. and L.A.; monument by John Gibson at Sefton.

1812 John Boultbee, artist, died at Edge Hill; painted horses for Lords Derby and Sefton, 1801–3.

1813 Nelson monument, Exchange Flags, by M. Cotes Wyatt with work by Westmacott (subscription began 1805), the first public monument in Liverpool.

1814 Liverpool Royal Institution founded and Colquitt Street Rooms opened 1817 with accommodation for Liverpool Academy.

1815–16 William Roscoe's portrait commissioned by Coke of Norfolk from Sir Martin Archer Shee, P.R.A. 1816, Roscoe's collection of old masters sold and some passed to L.R.I.

1816± Charles Barber of a Birmingham family of artists settled here as landscape artist and drawing master to L.R.I. Schools etc.; later President of L.A.

1817 John Gibson, sculptor, left for Rome with help of local patrons, and stayed there permanently continuing to receive local patronage throughout career. His contemporary William Spence a partner with Messrs. Franceys by 1821 and eventually took over. Many monuments by both in the area.

Matthew Gregson published *Portfolio of Fragments. . . of Lancashire,* with woodcuts, lithographs, by several local artists. He continued to encourage understanding of decorative arts.

1819 J. A. Minasi, pupil of Bartolozzi, advertised locally as portrait painter and engraver.

1821 Corporation of Liverpool commissioned Sir Thomas Lawrence for portrait of George III for newly completed interior of Town Hall; also Sir Thomas Phillips for portraits of Duke of York (1823) and subsequently George Case (1830) and W. W. Currie (1837), and Sir Francis Chantrey for statue of Canning (1832).

Liverpool Academy reconstituted at the L.R.I., with intention of holding drawing classes from the antique (Aegina and Elgin casts presented by J. Foster and George III). An exhibition was planned for August but came to nothing.

1822 First Exhibition of Academy of the Liverpool Royal Institution opened 1st August at Colquitt Street. 248 items with many London contributions. President: John Foster, corporation architect until 1840; with chief local artists as members: Alexander Mosses (portrait and some history), Thomas Griffith, John Turmeau and Thomas and George Hargreaves (miniature), Charles Towne (animal), Daniel and Samuel Williamson, John Pennington, Charles Barber, Gustavus Sintzenick, Samuel Austin, N. G. Philips (landscape and marine and some genre), Edward Smith (engraver), Solomon Gibson and William Spence (sculptors), T. Rickman (architect). 8 exhibitions held 1821–30, with improving sales and increased review space in local newspapers. Then annually (except 1833) until 1862, then 1864, 1865 and 1867 (last and 41st of series).

George III equestrian statue by Westmacott erected London Road (public subscription began 1809 for the King's Jubilee).

1823 Old Master Exhibition at L.R.I. from many local collections.

1826 J. J. Audubon (1780–1851) the American naturalist, in Liverpool; exhibition at L.R.I. August.

c. 1826: Records of students attending Liverpool Academy Life Classes begin, with Alexander Mosses, Drawing Master. Early students: W. G. Herdman, F. Hargreaves, W. J. Bishop, W. Daniels, Edwin and Joseph Lyon, F. & R. Hargreaves, etc. Mid–1830's: W. Huggins, B. E. Spence, R. Ansdell etc.

1827 Daguerre and Boulton's Diorama of the Ruins of Holyrood House on show in Liverpool.

1828 The Town Council gave prizes for local artists at Liverpool Academy Exhibitions and from 1830 a £50 prize to encourage non-local artists; after 1837 this from Academy's own funds.

1820's–
1830's Visiting and London portrait painters of local sitters included: T. Arrowsmith, W. R. Bigg, W. Bradley, S. Gambardella, J. Lonsdale, G. S. Newton, G. Patten, Thomas Phillips, A. Rippingille, T. C. Thompson, H. Wyatt.

1831 Mosses portrait of the Mayor praised 'so long as the town could produce such an artist they had no need to go about to seek strangers. . .'
L.R.I. rooms proving unsatisfactory the L.A. held exhibitions at New Rooms, Old Post Office Place until late 1850's.

1831–32 Huskisson statue by Gibson: marble in St. James's Cemetary; 2nd version cast in bronze for Custom House, 1847 (now Prince's Park Avenue).

1832–37 Edward Lear (1812–1888) at Knowsley drawing Lord Derby's menagerie.

1833 David Dalby of York painting horses for Earl of Sefton.

1837 B. R. Hayden commissioned to paint *Suffer little Children* (c. 10×12 ft.) for the Blind School as companion to Hilton's *Christ healing the Blindman* of 1821. Lectured at Liverpool on Northern tours and commissioned by subscribers to paint *Duke of Wellington musing on Field of Waterloo*, 1838–9.

1840's Liverpool Academy President, 1841–2 and 1847–53: Charles Barber; followed by Samuel Eglington, 1842–44, and Richard Ansdell, 1845–46. New members included: Samuel Walters (marine), Philip Westcott (portrait), J. T. Eglington, T. F. Marshall, Andrew Hunt, Thomas Crane. Academy students: W. L. Windus, Robert Tonge, James Campbell, John Robertson, J. W. Oakes.
Local sitters painted by T. H. Illidge, Sir Francis Grant.
Ansdell patronised by Earl of Sefton, John Naylor (banker and collector), and Joseph Mayer (goldsmith and antiquarian collector), who also commissioned W. Daniels.

1840, 1842 and 1844 Liverpool Mechanics Institute held *Exhibitions Illustrative of the Fine Arts, Natural History and Philosophy,* including local artists, sitters and views.

1843 W. G. Herdman published first of his local views in *Pictorial Relics of Ancient Liverpool,* and subsequently in 1857 and 1878.

1844–49 Henry Dawson, marine painter, working in Liverpool.

1847 Richard Ansdell, first Liverpool artist to gain considerable success at Royal Academy exhibitions, moved to London: R.A. 1870.

1851 Population: 376,065 (census).
Liverpool merchants increasingly forming collections of, usually, English painters.
John Miller, tobacco merchant, large collector of British paintings in 1840's including Turners, now patronised Pre-Raphaelites; his home centre for local artists favouring their style: W. Davis, (from Ireland), J. Campbell, W. L. Windus, etc.; entertained Ford Madox Brown and W. Holman Hunt on visit 1857 and later.
Liverpool Academy gave £50 prize for first time to a Pre-Raphaelite: W. Holman Hunt, *Valentine rescuing Sylvia.*

1853 Liverpool Museum opened as part of Free Public Library in Duke Street. New buildings donated by William Brown, banker, opened 1860 with provision for pictures and exhibitions. Corporation commissioned Brown's portrait by Sir J. Watson Gordon to commemorate gift.

1854–5 Liverpool Academy President, 1854–87: W. J. Bishop. 1854–5 Philip Westcott moved to London and thence settled Manchester *c.* 1862. J. W. Oakes moved to London: A.R.A. John Finnie appointed Master of Art School of Mechanics Institute which became the Liverpool School of Art, and exerted important local influence, retired 1896.

1856 St. George's Hall completed, sculptured pediment by Cockerell; series of statues of local public men in Great Hall, from Chantrey's *Roscoe* (transferred from L.R.I.) and Gibson's *George Stephenson*, 1851 to A. Bruce Joy's E. *Whitley*, 1895.

1857 Last of Academy prizes to a Pre-Raphaelite (Millais' *Blind Girl),* led to split headed by W. G. Herdman, topographer. Rival Society of Fine Arts held 5 exhibitions, 1858–62 and contributed to downfall of Academy. W. J. J. C. Bond and J. Finnie joined Academy. Ford Madox Brown and W. Holman Hunt visited Liverpool and met artists when seeing Art Treasures Exhibition at Manchester.

1860's 1861, W. Huggins moved to Chester and North Wales; A. W. Hunt to Durham and, 1865, to London. 1862, J. Campbell moved to London, but returned mid-70's. Mid-60's, W. L. Windus left for North Lancashire and *c.* 1875, London. 1870, W. Davis moved to London.

1860 Philip Wilson Steer born Birkenhead, son of a portrait painter of same name. Family soon moved. Trained and lived in London.

1866 Equestrian statue of Albert, Prince Consort by Thornycroft, erected outside St. George's Hall; companion of Queen Victoria erected 1870. Joseph Mayer established a Free Library near his residence at Bebington and donated works of art.

1867 Last Academy exhibition for many years. Joseph Mayer gave his collection of historical art treasures to Liverpool Museum.

1869–77 Frederick Leyland, ship owner and great art patron, rented Speke Hall where James McNeill Whistler visited and painted family portraits and etched.

1870's Several art societies founded: 1871, Liverpool Society of Watercolour Painters; 1872, Liver Sketching Club; 1873, Liverpool Art Club, for general art exhibitions; 1877, Artists' Club. 1876, Exhibition of Past and Present Members of Liverpool Academy at Liverpool Art Club.

1871 First Autumn Exhibition organised by Corporation at Liverpool Museum, on lines of Royal Academy in London.

1873–77 Walker Art Gallery erected at expense of Sir Andrew Barclay Walker. Opened September 1877 with major celebrations and large crowds. Autumn Exhibitions held until 1938; local artists represented on hanging committee but no special consideration. Gradual acquisition of local artists for permanent collection by gift and purchase.

1878 Atkinson Art Gallery, Southport, opened.

1880 Liverpool became a city.

1885–97 Statues and monuments erected St. John's Garden's and St. George's Plateau to public figures and local benefactors: Disraeli, Gladstone, Rathbone, etc. and King's Liverpool Regiment; sculptors included Thomas Brock, George Frampton, A. Bruce Joy, F. W. Pomeroy; some plaques on St. George's Hall by local sculptor, C. J. Allen.

1887 Bootle Public Library and Museum opened.

1892 Liverpool Royal Institute transferred Old Master Collection on deposit to Walker Art Gallery, included Liverpool Academy Diploma pictures; made Deed of Gift 1948.

1894 University College, Liverpool: a School of Applied Art set up in Architecture Department. Artists teaching there were: C. J. Allen, Liverpool sculptor; Herbert Jackson; R. Anning Bell (1895–99); R. L. B. Rathbone; R. W. Warrington; Herbert McNair (1898–1905); Augustus John (1901–1902); David Muirhead. Students at day and evening classes included Phoebe Stabler (née McLeish), Herbert Tyson Smith, W. Alison Martin, George P. Harris, E. Carter Preston.

1895 City area extended.
 Della Robbia Pottery, Birkenhead, founded by Harold Rathbone, son of Liverpool merchant and City Councillor. Conrad Dressler worked there, 1894–95. Closed 1906.

1896 Gamble Institute, St. Helens, opened, with central library, museum and art gallery, succeeding earlier libraries from 1854.
 Liverpool University Club founded: R. Anning Bell designed for it.

1897 Liverpool Academy recommenced exhibitions.

1901 Population 684,947 (census).
 Christopher Wood born at Knowsley; trained in Paris and worked in Cornwall, Brittany etc.

1902 Mural painting: 1898–1902, C. J. Furse, pendentives in dome of Liverpool Town Hall; 1902, Gerald Moira at Ullet Road Unitarian Church; 1902, W. Alison Martin at Toxteth Public Library, Windsor Street.

 Augustus John painted portraits of members of the University Club: Professor J. M. Mackay (1902), Sir John Brunner (1906), Dr. E. K. Muspratt (1906), Sir John Sherrington (1924), Professor O. Elton. Painted Lord Mayor H. Challoner Dowdall, 1909 and Kuno Mayer, 1911.

1905 The Liverpool Institute Art School and the University School of Applied Arts amalgamated under Liverpool Corporation in Mount Street. C. J. Allen transferred there. H. McNair and Gerard Chowne taught breakaway group at Sandon Terrace, which became the Sandon Studios Society from 1907 at Bluecoat Chambers, with lively membership of professionals and amateurs of the arts, and an exhibition programme.
 Liverpool Academy exhibitions temporarily revitalised by McNair, J. Hamilton Hay, Mary McCrossan, David Muirhead, Herbert Royle, Alison Martin etc., including members of Sandon and New English Art Club.
 Bernard Meninsky, student at the Art School, left for London 1912. Albrecht Lipczinsky in the Sandon Studio circle, returned to Poland after Great War.

1907 Liverpool 700th Anniversary Exhibition.

1908 Historical Exhibition of Liverpool Art.

| 1911–14 | Sandon Studios Exhibitions included besides members shows: Augustus John, (1911), mixed shows with Post-Impressionist section (1911 and 1912), Gordon Craig (1913), Omega Workshops (1914), Contemporary Art Society Collection (1914). |

1911–14 Sandon Studios Exhibitions included besides members shows: Augustus John, (1911), mixed shows with Post-Impressionist section (1911 and 1912), Gordon Craig (1913), Omega Workshops (1914), Contemporary Art Society Collection (1914).

Members decorated newly opened Playhouse Theatre. George Harris started designing stage sets, and mural for Sandon (removed 1951); later worked in London for Rean Dean Company.

1917 John Elliot bequest of Liverpool School pictures to Walker Art Gallery.

1922 Lady Lever Art Gallery, Port Sunlight, opened, the gift of 1st Viscount Leverhulme with his collection of English paintings and furniture, Wedgwood, Chinese ceramics, etc.

1922–27 James Smith of Blundellsands, bequest to Walker Art Gallery including Liverpool artists (others from his collection at Williamson Art Gallery, Birkenhead).

1925 Geoffrey Wedgwood won Rome Prize for engraving and studied in Italy.

1926 Bluecoat Chambers saved; became Arts Centre.

1928 Williamson Art Gallery, Birkenhead, opened.

1930 Cenotaph, St. George's Plateau; competition won by L. B. Budden of Liverpool University with sculpture by H. Tyson Smith. Both designed other war memorials in the area.

1931–33 Walker Art Gallery closed for enlargement and remodelling. Re-opened with updated Autumn Exhibitions including modern movements (Surrealist Art, 1938), purchase grant from the rates and (1934) Wavertree Bequest Picture Purchase Fund.

1931–50 Liverpool Academy Exhibitions at Bluecoat Chambers.

1933+ Sculpture for Liverpool Cathedral by E. Carter Preston.

1938 Last Autumn Exhibition.

1940's Walker Art Gallery closed. Programme of exhibitions at Bluecoat Gallery including *Recording Merseyside* and various Liverpool artists in mixed and one-man exhibitions; including, 1948, Albert Richards.

1944 Emma Holt bequest of Sudley at Mossley Hill and collection of paintings formed by her father, George Holt.

1945 Stone Bequest of Sporting pictures including group by Charles Towne.

1951 Population 789,532 (census).

1951–52 Reopening of Walker Art Gallery: exhibition *George Stubbs*. Sandon Studios, Festival of Britain Exhibition *50 Years of Merseyside Art*. Liverpool Academy exhibition held at gallery, with open section from 1955. Arts Council 1952, *Sandon Studios Society* exhibition.

1956 Sculpture by Epstein commissioned by Lewis's for façade of new building.

1958 First John Moores Liverpool Exhibition (biennial). First prizes: 1957 Jack Smith; 1959 William Scott; 1961 Henry Mundy; 1963 Roger Hilton; 1965 Michael Tysack; 1967 David Hockney; 1969 Richard Hamilton and Mary Martin (joint); 1972 Euan Uglow; 1974 Myles Murphy; 1976 John Walker.

1960's Liverpool Academy 150th Anniversary Exhibition with historical section at the Walker Art Gallery, 1960.

 The Gallery's exhibition programme included work of local artists: 1958, George Harris; 1961, George Mayer-Marton; 1964, Stuart Sutcliffe; 1967, John Edkins; 1970, William Huggins; 1971, Charles Towne; 1972, Geoffrey Wedgwood; 1972, Maxwell Gordon Lightfoot; 1973, J. Hamilton Hay.

 Three Pre-Raphaelite exhibitions mounted: Ford Madox Brown, 1964; John Everett Millais, 1967; William Holman Hunt, 1969.

1965 Victorian Society Liverpool Branch formed: for preservation of regional architecture and with programme based on local architecture and art heritage.

1972 Liverpool Academy opened gallery in Renshaw Street, and 1977–8 Pilgrim Street.

1974–5 Merseyside County Council formed as part of Local Government re-organisation.

 Population 1,588,400.

1973–77 Liverpool Academy Exhibitions at the Gallery and some touring the Districts on special themes: 1973, Communications; 1976, Face of Merseyside; 1977, Liverpool Academy Celebrates the Walker Art Gallery's 100th Anniversary.

1977 Peter Moores Liverpool Project *Real Life* included Mark Boyle's Liverpool Dock Series and 4 Liverpool artists: Adrian Henri, John Baum, Maurice Cockrill and Sam Walsh. Walker Art Gallery Centenary Exhibition of *Treasures from The Lady Lever Art Gallery*, opened by H.R.H. the Duke of Gloucester.

ALLEN, Joseph 1770 - 1839

Portrait and genre painter. Born Birmingham. After designing for japanned trays went to London and entered as student at Royal Academy Schools, 23 November 1787, and gained Silver Medal, 1789; exhibited at Royal Academy, 1792–1822. Settled for a period at Wrexham, 1798–9 and built up successful connexion with Manchester, Preston and other northern towns as a portrait painter. Exhibited from a London address 1800–9, 1816–17 and 1822. He was a founder member of the Liverpool Academy, 1810 and exhibited there until 1812 from Manchester and from George Bullock's headquarters in Bold Street. His local sitters included William Rathbone (1757–1809), and George Bullock. His later attempt to establish himself in London was unsuccessful and he retired to Erdington, near Birmingham, in comfortable circumstances and died there 19 November, 1839.

8532 A Sculptor with a bust of Mr. Blundell
Oil on canvas, 127 × 100·5 cm. (50 × 39½ in.)
A portrait of George Bullock (d.1818) the Liverpool sculptor, with his bust of Henry Blundell of Ince (1724–1810). The bust in marble, formerly at Ince, is now in the Collection (6531).

Bullock was probably the young Birmingham artist who left there for London in 1798 at twenty years of age, 'the statue business not answering his expectations.'[1] At Liverpool it seems he was a protégé of William Roscoe,[2] and advanced rapidly in his career. He first appears in the street directories in 1804 as modeller and sculptor in Lord Street and may until then have been connected with William Bullock, a silversmith, jeweller, toyman and statue figure manufacturer with a Museum in Lord Street from 1801, for he advertises his removal from the 'Museum' to Mr. Stoakes in Church Street in June 1804.[3] He was in partnership with (William) Stoakes[4] as cabinet-makers, general furniture and marble workers until early in 1806, when he advertised his intended transference of his Grecian Rooms in Bold Street and a large sale of stock.[5] In 1810 he was, in partnership with Joseph Gandy (1771–1843) the architect, as architect, modellers, sculptors, marble masons, cabinet-makers and upholsterers. He exhibited sculpture at the Royal Academy from 1804–1816, and was elected first President of the new Liverpool Academy 1810–1812, Henry Blundell being patron.

In 1814[6] he moved to London where he was a successful cabinet-maker and marble worker in the neo-classical style, favouring simplicity of form. He became noted for his revival of the use of native woods, as an exponent of brass inlay, and for his introduction of 'Mona marble' from Anglesey for chimney-pieces. He was criticised for the somewhat ponderous quality of his furniture. His clients included Roscoe, Thomas Johnes of Hafod, the Earl of Atholl and Sir Walter Scott. He died at London, 1 May 1818.[7] Scott commented on his sudden death: 'in the full career of honourable condition – distinguished by his uncommon taste and talent, – esteemed by all who transacted business with him, – and loved by those who had the pleasure of his more intimate acquaintance, – I can scarcely conceive a more melancholy summons. . . I liked George Bullock because he had no trumpery selfishness about his heart, taste, or feelings.'[8]

He is shown holding a modelling tool rather than a chisel, and the slight differences in the form of the cravat in the bust of Blundell in the Collection, suggests that he is most probably shown with the model: this seems to be confirmed by an identical plaster bust which belongs to the Tempest family, descendants of the sitter's son-in-law, and bought from Bullock April 1807.[9] Presumably the marble bust was that exhibited at the Royal Academy, 1804: it was subsequently engraved for Blundell's catalogue of his marbles, 1809, a copy of which he presented to Bullock.[10] A marble bust, presumably the same, appeared at the Liverpool Academy, 1810, and a bust was also at the Royal Academy, 1813.

The bravura quality of the portrait under-

lines the evident versatility and ambitious character of the sitter. The early history and ownership of the portrait is unknown.

PROV: John Lane, sold Sotheby's 1.7.1925 (1).[11] Burgess Standley, U.S.A. from whom purchased 1973.

EXH: Royal Academy, 1808 (29).

REF: 1 J. A. Langford, *A Century of Birmingham Life*, 1868, II p. 118, quoted in Trevor Fawcett, *The Rise of Provincial Art*, 1974, p. 62. 2 On the evidence of a letter from Thomas Johnes (1748–1816) from Croft Castle to Roscoe 15 March 1808 (2223, Roscoe Papers, Liverpool Record Office). A pair of ebonised cabinets made by Bullock for Roscoe is in the Collection. 3 *Liverpool Chronicle*, 27 June 1804. 4 Stoakes is listed as looking glass manufacturer, and later bronze figure manufacturer, 1803–post 1816. 5 *Liverpool Chronicle*, 12 February 1806, 22 October 1806: he stressed that he had no connection with William Bullock except in name (the latter's Egyptian Rooms and Museum remained in Church Street). 6 *Liverpool Mercury*, 11 November 1814: notice of auction of remaining stock and premises in Bold Street. 7 For his furniture see Brian Reade, *Regency Antiques*, 1953, pp. 63–71; Clifford Musgrave, *Regency Furniture*, 1961, pp. 80–82; Anthony Coleridge, *The Work of George Bullock, cabinet-maker, in Scotland*, I and II in *The Connoisseur*, April and May 1965; Ralph Edwards, *George Bullock as Sculptor and Modeller*, in *The Connoisseur*, July 1969. 8 J. G. Lockhart, *Life of Sir Walter Scott* (1900 edition, III pp. 176–7). 9 Information from Henry Tempest, 1975. 10 *Engravings and Etchings of the Principal Statues, Busts, Bass-reliefs, Sculptural Monuments, Cinerary Urns, Vases, etc. in the Collection of Henry Blundell Esq at Ince*, Vol. I, 1809, inset after frontispiece; Bullock's inscribed copy is in Liverpool Record Office. 11 Another label inscribed 490 is on the back.

9055 Peter Whitfield Brancker

Oil on canvas, 125 × 99·6 cm. (49¼ × 39¼ in.)

Peter Whitfield Brancker (1750–1836),[1] merchant of Liverpool connected with the West Indian market. His family settled in Liverpool in the late 17th Century and he and his descendants were prominent figures. He is said to have been a man of 'strong individuality and resource.' He was elected to the Common Council, 1793, Bailiff 1795, and Mayor 1801.

Active in the Council's endeavours to uphold the slave trade, he was presented by them with a piece of plate in 1798. In 1804 he was Major Commandant of the Artillery in the Liverpool Volunteers raised to defend Liverpool against Napoleon. He married a daughter of John Aspinall.[2]

See Mosses 7032 for a portrait of one of his sons and British School 9194.

The contemporary gilt frame has reeded convex sides and egg and dart border with high relief acanthus swags at the four corners (the frame of 3059 below is identical).

PROV: By descent in the family of the sitter's son John Brancker to Mrs. Cubitt of Yarmouth; presented by her Trustees, 1975.

EXH: Royal Academy, 1808 (43).

REF: 1 A fragmentary MS label identifies the sitter and artist. 2 J. A. Picton, *Memorials of Liverpool*, 1873, I, p. 302; Gomer Williams, *History of the Liverpool Privateers*, 1897, pp. 613–614, 683; *Liverpool Courier*, 3 June 1903, *The Branckers of Liverpool* (by W. A. Stibbard) in obituary notice on the sitter's grandson James Barnes Brancker (Press cuttings, Liverpool Record Office).

3059 John Bolton

Oil on canvas, 127·7 × 102 cm. (50¼ × 40⅛ in.)

Colonel John Bolton (1756–1837), Liverpool merchant. Born Ulverston 22 March, 1756, son of an apothecary. He was apprenticed to Messrs. Rawson and Chorley, merchants of Liverpool, and spent some years in the West Indies, c. 1773–1790. On his return to Liverpool he set up as a merchant on his own account with great success, being connected with the slave trade; was later a president of the West India Association.

He took a leading part in the local defence movement and in 1797 contributed £500 to the Government defence scheme against the French, and in 1803 raised and equipped 800 men for the First Battalion of the Liverpool Volunteers, 'Bolton's Invincibles'; this was disbanded in 1806 upon the creation of a local militia. In 1805 he fought a duel with Major Brooks, the last in Liverpool.

In 1804 he was elected to the Common Council but declined to sit; from about 1807 he played an important part in local politics as an ardent supporter of Canning and the Tories, for which his house in Duke Street formed an headquarters.

He bought Storrs Hall on Windermere, in 1808, which was remodelled for him by Gandy; there became an important local figure; his guests included Canning, Walter Scott and Wordsworth.

Married in 1797 Elizabeth (1768–1848), daughter of Henry Littledale of Whitehaven and a distant relative of the Fletchers of Allerton Hall, Liverpool. They had no children. He died at Liverpool 24 February, 1837 and was buried at Bowness after an immense funeral procession through Liverpool.[1]

A portrait of the same size, of Mrs. Bolton, by Joseph Allen was in the same sale as this portrait, which was there ascribed to Opie which is unacceptable. The style makes the present ascription reasonable. The date is presumably in the first decade of the 1800's. The frame is identical to 9055 above. An equestrian portrait by Charles Towne (34×46 in.) was also in the same sale (Danson Collection).

A portrait in militia uniform belonged to Lady Boughley of Aqualate.[2] A drawing by Hargreaves, presumably for a miniature, is in Liverpool City Library.[3] A bust by George Bullock was exhibited at the first Liverpool Academy of 1810. Two portrait prints are recorded.[4]

PROV: T. Alfred Fletcher, Allerton Hall, Liverpool, sale Christie's (469 DN), 23.6.1922 (150) as *Opie*, bt. Carpenter 5 gns. Entered collection at unknown date, prior to 1955.

REF: **1** G. W. Mathews, *John Bolton, A Liverpool Merchant*, in *Transactions of the Historic Society of Lancashire and Cheshire*, Vol. 93, 1941, pp. 98 ff, and citing other references; J. G. Lockhart, *Life of Sir Walter Scott*, 1900 edit., IV p. 310, entry for 25 May 1816. **2** *Liverpool 700th Anniversary Exhibition*, 1907 (27). **3** J. Picton, *Memorials of Liverpool*, extra illustrated, III fp. 394 (Liverpool Record Office). **4** *Ibid*, repr. fp. 98, and *Transactions*, Vol. 80, repr. fp. 42.

7393 Thomas Lance
Oil on canvas, 127×101·6 cm. (50×40 in.)

7392 Mrs. Thomas Lance
Oil on canvas, 127×101·6 cm. (50×40 in.)

7391 Thomas, Eleanor and Anne Lance
Oil on canvas, 142·2×175·3 cm. (56×69 in.)
Thomas Lance (1769–1829) of Wavertree,

Insurance Broker and merchant. He holds a paper inscribed *Liverpool*. In 1805 he was living at 5 Great George Street, and between 1807–10 had moved to Wavertree.[1] He married Eleanor (1755–1843) 5th daughter of Robert Maddock of Flookersbrook, Cheshire. Their children were Thomas (1794–1879), Elinor (or Eleanor) (1793–1876), who married John Philipps Philipps, Commander R.N., and Anne (1796–1864), who married, as his second wife, H. R. Hughes of Bache Hall,[2] into whose family these portraits passed. The age of the children suggests a date around 1809–10.

The attribution in the Hughes family inventory was to Sir William Allen, but John Steegman first suggested Joseph Allen.[3] Other portraits of them including miniatures by Hargreaves are listed by Steegman.

PROV: Mrs. H. R. Hughes (née Lance) of Bache Hall; thence to her son H. R. Hughes (1827–1911) of Kinmel Park; by descent to David Fetherstonhaugh of Kinmel Manor; purchased Kinmel Manor Sale, Abergele 15.10.1970 (651, 652, 653).

REF: **1** Liverpool Street Directories. **2** Information from David Fetherstonhaugh of Plas Kinmel, letters 29 October 1970, 16 March 1971. **3** John Steegman, *A Survey of Portraits in Welsh Houses*, 1957, I, pp. 107–8.

ANSDELL, Richard 1815 - 1885

Animal painter. Born Liverpool 11 May 1815, son of Thomas Griffith Ansdell, blockmaker. Educated at the Blue Coat School July 1824–November 1828, and from thence sent to 'W. C. Smith profile and portrait painter, Chatham, Kent' (Bluecoat School Admission Book, Liverpool Record Office). Nothing has been discovered about this artist in the Kent area, nor is such an artist recorded in Chatham Street, Liverpool: a W. C. Smith is listed once in Liverpool Street Directories, in 1835, at the Hubard Gallery, 28 Lord Street, with no indication of occupation.

Ansdell is said to have visited Holland and to have worked for a period with a travelling Show whose signs he repainted. He was back in Liverpool by 1835 and entered Liverpool Academy Schools in October, exhibited there from that year, and also gained a £10 prize; elected Associate, 1837; Member, 1838; President, 1845–6; and then non-resident member until he resigned in 1852, apparently over the award of the £50 prize to W. Holman Hunt. Exhibited at Manchester Royal Institution from 1837 and won the Heywood Gold Medal, 1844, 1847 and 1848. Exhibited at the Royal Academy from 1840 and elected A.R.A. 1861 and R.A. 1870. Gained a third class Gold Medal at Paris 1855.

Little is known about the first steps in his career. He produced some profile portraits, while his first exhibited pictures were animals and still life; Charles Towne's death in 1840 left the sporting field open to him. From around 1840 he quickly began to receive commissions for large family sporting groups from the aristocracy and gentry of the area, and group portraits of agricultural and sporting society Meetings. Patrons at this period included the Earls of Sefton and Derby, Joseph Mayer and John Naylor of Liverpool, and the Earl Spencer. He must have travelled fairly widely particularly in the North and in Scotland for some of his backgrounds. His pictures give a vivid insight into social events, public and private, of the period.

He also made occasional essays into historical themes involving animals, in particular the *Death of Sir William Lambton at the Battle of Marston Moor* (Preston Art Gallery), R.A. 1842, which added to his increasing reputation. His success induced him to settle in London in 1847, where his career rivalled that of Landseer. Many of his paintings were popularised through engraving and he produced a few etchings for the Etching Club. He collaborated occasionally with other artists such as Thomas Creswick, W. P. Frith and John Phillip, and in 1856 visited Spain with John Phillip, and went again in 1857 alone. He subsequently produced many Spanish subjects in a richer vein of colour. While his provincial work had been in the robust sporting tradition to which he contributed a personal atmospheric realism, his mature painting achieved a highly professional finish at the expense of individuality.

His brother-in-law William Romer, also an animal painter, may have been an assistant.

Lytham St. Annes proved an early and favourite background and in 1861 he built a summer residence there which he sold, 1864 and afterwards built a house at Loch Laggan, Argyllshire.

This he gave up for health reasons in 1873. He moved from his London home to Farnborough in 1884.

In 1841 he married Marie Romer of Liverpool and had eleven children; he died at Farnborough, 20 April 1885.

2119 Shooting Party in the Highlands

Oil on canvas, 97×161·2 cm. (38½×63½ in.)

SIGNED AND DATED: *Richd Ansdell / 1840*

According to an old note[1] this picture was presented by the artist to a Mr. Green, who was represented amongst the sitters.

It was favourably reviewed at the 1840 Liverpool Academy along with the artist's *A Galloway Farm, the property of the Marquis of Bute:* 'Mr. Ansdell, a young artist who is treading on the heels of the most eminent painters in the country, has two pictures in the present exhibition, both of which do him infinite credit.' The critic continued: 'This painting realizes a scene which makes us long for a few weeks "amang the heather." A bevy of sportsmen have chosen a sheltered spot, beneath a "windy summit", and by the side of a rushing burn, for a place of rendezvous and refreshment. The bulk of the party have already arrived, the panniers carried by the sumpter ponies are already more than half unpacked, and some of the fowlers, with such appetites as are already communicated by the keen air of the hills, have already commenced operations. Couched among the heath, with abundance of bread and ham, full flasks of mountain dew, and water from the mountain stream, they are as well provided as mortal sportsmen need wish to be. They have had good sport, too, for the foreground is strewed with the victims of their skill. Some twenty or thirty brace of grouse and black cocks show, that they have ranged through a well plenished track, and that there are those among them who know well how to handle their Marston's with effect. A wild duck, which has been thrown into the heap by one of the party indicates that some keen sportsman has not been over fastidious where a tempting shot was fairly within range. The landscape exhibits, on the left, an extensive range of sterile moorland, while the view to the right is shut out by the intervening heights. A broad-shouldered Gillie, on the wrong side of the burn, is endeavouring to curb the impetuosity of "twa dogs" which he holds in leash, and which, scenting the odour of the repast, would fain drag him through the stream. A laggard sportsman, who has taken a wider range than his companions, is coming in with his attendant down the pass of the high ground. As he strides over the heather, we may imagine him to be carrolling the fragment of some sporting ditty:

"Twas up by Glenbarchin's braes I gaed,
An' owre the bent o' Killibrade,
An' mony a weary cast I made
　　To kittle the muir fowl's tail.

"If up a bonnie black cock should spring
To whistle him down wi' a slug in his wing,
An' strap him on my lunzle string
　　Right seldom wad I fail."

The dogs, both spaniels and pointers, are very finely painted, and their various actions help to give life and character to the picture. One of them is paddling "i' the burn", another is evidently begging from his master, while the rest are reposing, sitting, or wistfully gazing on the pleasant employment of their superiors. This picture will be a great favourite with sportsmen. It is painted with great freedom and truth. The two ponies are, if we may use such an expression, full of character. If we were to point out a fault, or, rather, suggest an improvement, we should say, that the introduction of some warmly-tinted object in the foreground would relieve the eye and add greatly to the effect of the picture.'[2]

PROV: Presented by Oliver Ormerod Walker of Bury (1833–1914) and his cousin Captain Edgar J. Garston, R.A., 1887.

EXH: Royal Academy, 1840 (485) as *Grouse Shooting – Luncheon on the moors,* and Liverpool Academy, 1840 (179); Walker Art Gallery, 1908, *Historical Exhibition of Liverpool Art* (515); and, 1960, *Liverpool Academy 150th Anniversary (46);* Arts Council, 1974–75, *British Sporting Paintings, 1650–1850* (199) repr.

REF: 1 Walker Art Gallery 'Stock Book I', p. 49. The information came from a Mr. Bradbury of Princes Park, who housed the picture prior to its presentation. 2 *Liverpool Albion,* 19 October, 1840.

9021 The Waterloo Coursing Meeting

Oil on canvas,[1] 143·5 × 238·7 cm. (56½ × 94 in.)
SIGNED AND DATED: *Richd. Ansdell./L.1840.*
Representing the meeting at Altcar, near Liverpool, on Wednesday and Friday, 4 and 6 March 1840. This was and is the great coursing fixture of the season in which the skill of the greyhound is pitted against the hare. On this occasion the Waterloo Cup (a sweepstake of 25 sovereigns each, 300 sovereigns the winner) was won by Mr. Richard Easterby's *Earwig,* beating his own *Emperor.*[2] The two greyhounds appear at the left held in a leash by William Warner, the slipper. The owner is in the crowd behind them (No. 46 on the key plate); the judge, Mr. Nightingale, in pink, rides the chestnut horse, centre background, while the 3rd Earl and Countess of Sefton and their party are on horseback at the right where also appears the large figure of James Aspinall, an important Liverpool public figure. Many of the notables were present for the National Steeple Chase which was held on the Thursday. The column in the left background is the pumping station at Altcar.

The Waterloo Cup was founded in 1836 under the auspices of Mr. Lyon, and run on the Altcar course on the Sefton property where the Altcar Coursing Club had been founded in 1825 by Lord Molyneux, later the 3rd Earl. Coursing was first given its rules in Queen Elizabeth's day.[3]

This type of group portraiture of great sporting and agricultural events was becoming increasingly popular in the 1830's and 1840's. This was Ansdell's first work of the kind and must just post-date his *Grouse Shooting Luncheon on the Moors,* 1840, 2119 above. The picture may have been a commission from Thomas Agnew[4] the art dealer of Manchester who published an engraving which was advertised and reviewed in the *Art Union* early in 1843:[5]

'This publication reflects the highest credit upon the enterprising publisher, who has been bold enough to issue so large and costly a work in a provincial town. We have never inspected a more satisfactory specimen of the class of "Sporting Prints." The grouping is admirable, and in excellent taste, although it has been necessary, as usual in such cases, to give prominence to a few prominent personages who have not formed the most advantageous "sitters" for the artist. The portraits *appear* to

be all good likenesses – and there are no less than seventy-three of them, with eighteen horses [sic]; the gentlemen and their steeds being greatly distinguished on the 'turf'. The Waterloo Coursing meeting is an event of vast magnitude in the north of England. A memorial of it is here worthily preserved. The artist has shown excellent judgment and matured skill; he has contrived to render his picture interesting, even to the indifferent spectator, and has produced a work of Art of very considerable merit.'

An identical equestrian portrait of the 4th Lord Talbot (20 × 24 in.), who appears in the light-coloured hat at the right, in a different composition with greyhounds, is in a private collection.[6]

ENGR: S. W. Reynolds (24 × 42 in.); published by Thomas Agnew, Manchester and Ackermann & Co., London, 24 November 1842, with key.
PROV: By descent to the 7th Earl of Sefton; his Executors' sale Croxteth (Christie's), 19.9.1973 (1012) repr. colour, bt. Roy Miles; purchased by the Gallery, with the aid of contributions from the Victoria and Albert Museum Grant-in-aid, The National Art-Collections Fund, the Pilgrim Trust and an anonymous donor, 1975.
EXH: Arts Council, 1974–5, *British Sporting Painting, 1650–1850* (200), colour repr. p. 24 of cat.
REF: 1 Relined. 2 Reviewed in the *Liverpool Mercury* 6 and 13 March 1840. 3 See Harding Cox, *Coursing and Falconry* (1899 edition) pp. 8, 181–2. 4 *The Art Union,* 1 February 1843, p. 29: an *advertisement* states 'painted to order.' 5 *The Art Union,* 1843, p. 49. 6 Photograph Gallery files.

8189 Dead Hare

Oil on canvas, 76·3 × 63·6 cm. (30 × 25 in.)
Dating from about 1840.
PROV: The Earls of Sefton, Croxteth; presented by the Countess of Sefton, 1972.

8779 The Earl of Sefton and Party returning from grouse shooting with a view of Glen Lyon, Perthshire[1]

Oil on canvas, 111 × 199·5 cm. (43¾ × 78½ in.)
SIGNED AND DATED: *Richd. Ansdell 1841*
The view is above Meggernie Castle at the head of Glen Lyon, north of Loch Tay,

Perthshire, an estate hired by the Seftons for shooting.

The equestrians have been identified[2] as the 3rd Earl (Charles William) leading, on a bay horse, the Countess on a smoke-grey horse, followed by Colonel the Hon. H. R. Molyneux wearing a round-topped hat, on a black horse, and Colonel the Hon. G. B. Molyneux on a dappled grey horse; with the Hon. F. K. Craven on a bay horse at the extreme left.

Three small studies exist[3] with figures of the same scale as this painting: 1 The brother in the round hat with a boy on a grey horse in place of the Countess, with the pointers in a leash from right front of picture; signed and dated 1840; 2 The two brothers and the two dogs, as in the picture; 3 The second brother on a brown horse with a retriever.

Evidently the outcome of a commission of 1840 which perhaps resulted from the success of *The Waterloo Cup*, dated 1840, in which the Earl and Countess also appear (see above).

A Liverpool Academy reviewer[4] noted that 'The likenesses of the Earl, the Countess, and the late Colonel Molyneux are excellent.' A later review[5] commented that the picture 'has been much and justly admired. The artist's powers have been considerably restricted by the nature of his subject, which necessarily admitted of little variety in the way of position or arrangement. He has, however, contrived to render it a very capital picture. Every figure, both of persons and animals, is perfectly distinct, without any appearance of straggling. The main body of the party is brought well up together, and one, who has got some distance in advance, halts, and brings his horse round till the rest come up. The cavalcade is thus agreeably broken, and more picturesqueness of arrangement secured. The dogs are well placed, and equally well drawn. The horses have been carefully painted, and are very favourable specimens of Mr. Ansdell's abilities in that line. They are, we presume, portraits, as well as the human figures. The latter are strikingly correct. Lord Sefton, who is more particularly known in this neighbourhood, will not fail to be immediately recognised by any one who has ever seen him. The gillies, who carry home, with business-like *nonchalance*, the fruits of the day's exploits, are true examples of their kin and craft. They would be known for Highlanders half a mile off. The landscape, a range of blue Scotch hills, offers nothing to compensate for the dryness and intractable quality of the main subject. It has been treated, however, by Mr. Ansdell, in a style suited to its wild and simple character. To give effect to a series of portraits, it is perhaps better adapted than a more ostentatious view.'

See also Westcott/Ansdell 8655 for another portrait of the Earl.

ENGR: W. H. Simmons (19 × 34 in.), published H. Graves, December 1856.

PROV: Charles William, 3rd Earl of Sefton and thence by descent to the 7th Earl; accepted by H.M. Government in lieu of Death Duties, 1973, and presented to the Gallery, 1975.

EXH: Royal Academy, 1841 (1192); Liverpool Academy, 1841 (180); Arts Council, 1974–5, *British Sporting Painting, 1650–1850* (201).

REF: 1 Title at Liverpool Academy, 1841. 2 Inscription on integral frame in panelling at Croxteth (placed there in comparatively recent years). 3 Coll: Countess of Sefton. 4 *Liverpool Courier*, 15 November 1841. 5 *Ibid*, 20 October 1841.

1432 A Mastiff

Oil on canvas, 110·5 × 159 cm. (43½ × 62⅝ in.)

SIGNED AND DATED: *Richd. Ansdell/1841*

Portrait of a mastiff belonging to the father of the last owner,[1] John Leigh Clare, member of a long-standing cotton brokerage firm in Liverpool.

PROV: Purchased from J. Leigh Clare, 1884.

EXH: Walker Art Gallery, 1908, *Historical Exhibition of Liverpool Art* (492); and 1970, *The Taste of Yesterday* (18) repr.

REF: 1 Letter of 21 February, 1884 from Alderman Samuelson to the Mayor (Gallery files).

7777 Two Spaniels with their Pups

Oil on canvas, 91 × 121·7 cm. (35¾ × 47⅞ in.)

Joseph Mayer's MS list refers to this painting as 'An oil painting of my dogs, Tummis and Meary, and their pups. (this was the fourth picture he [or re-] painted) by Ansdell.'[1] A bill from Ansdell dated 9 July 1842 for '*Portrait of Dog*', £20, in the Mayer Papers,[2] may refer to this or yet another picture.

The Spaniel at the top also appears in Daniel's portrait of Mayer (7355).

PROV: Painted for Joseph Mayer; Mayer Trust, Bebington; presented to the Gallery by Bebington Corporation, 1971.

EXH: Possibly Mechanics Institute, 1842 (335), as *Household Favourites*.
REF: 1 MS inscribed: *List of articles bequeathed to the Bebington Museum by the Late Joseph Mayer* (Liverpool Record Office). 2 Liverpool Record Office.

9266 Tiny, a Manchester Terrier

Oil on panel, 36·8 × 26·5 cm. (14½ × 10⅞ in.)
SIGNED AND DATED: *Richd. Ansdell 1844*
INSCRIBED, on frame back: *Tiny, Dog belonging to the Countess of Sefton 1844*

An almost illegible verse on a label on the back of the picture includes the lines, 'We hope our little gift you'll fancy', and is signed by various members of the Molyneux, Towneley and Grenfell families, children, nephew and nieces of Mary Augusta, wife of the 3rd Earl, to whom the picture was evidently their present.

PROV: Mary Augusta, Countess of Sefton; by descent to the 7th Earl of Sefton; his Executors' sale Croxteth (Christie's), 19.9.1973 (1034) bt. Warren; anon. sale Bonham's, 5.5.1977 (88); anon. sales Christie's (South Kensington), 20.7.1977 (79), 31.8.1977 (134) and 26.10.1977 (34), bt. Agnew for the Gallery.

8633 A Brace of Pheasants hanging from a Nail

Oil on canvas, 86·5 × 56 cm. (34⅛ × 22⅛ in.)
SIGNED AND DATED: *Richd. Ansdell/1845*

A sprig of holly is attached to the birds and a label inscribed 'To the/Earl of Sefton'. The painting records a present from the Earl to the artist,[1] and was presumably sent in acknowledgement of the gift.

PROV: The Earls of Sefton, Croxteth;[2] purchased from the Executors of the Estate of the 7th Earl of Sefton, 1974.
REF: 1 Information from the Countess of Sefton, 1974. 2 1946 MS Inventory, No. 33.

7255 The Death of the Stag

Oil on canvas,[1] 79·1 × 272· cm. (70½ × 107 in.)
SIGNED AND DATED: *Richd. Ansdell/1846*

By family tradition the hounds are stated to be those of Richard Christopher Naylor, the brother of John Naylor (1813–1889), the Liverpool merchant banker and collector who commissioned the picture from the artist.[2] It was also supposed to be his first large 'gallery' work. In fact the artist's first exhibited picture of the type was *The Death,* Royal Academy and Liverpool 1843,[3] whose composition appears on the strength of the *Art Union* and *Albion* descriptions[4] to have been not dissimilar to 7255. John Naylor also commissioned two other paintings from Ansdell: *The Combat* (Royal Academy, 1847), and a double portrait of himself with his bride, witnessing the gralloching of a stag on their honeymoon in 1846 (Coll. H. P. McIlhenny, Philadelphia). On his visit in 1850 Waagen described the two stag pictures as 'displaying great animation of motives, knowledge of nature and excellent execution.'[5]

ENGR: H. T. Ryal, published by E. Gambart, 19 April 1847 (with *The Combat*).
PROV: Commissioned by John Naylor of Liscard and Leighton Hall Welshpool, 1846, £130;[6] J. M. Naylor, sold Harrods, 17.3.1931 (457), bt. in.; Miss Georgina Naylor sold (Norman R. Lloyd), Leighton Hall, Welshpool, 21.9.1959 (234), withdrawn; by descent to Mrs. Claud Cleaver who presented it, 1970.
REF: 1 Canvas stamp of Charles Roberson, 51 Long Acre, London. Large tears, lower right, were repaired and the picture restored, 1970. 2 See portrait by Grant (6582). 3 65 × 107 in.: anon (Col. Kennard) sale Christie's 24.2.1906 (132) bt. Compton. 4 *The Art Union,* Vol. 5, 1843, p. 171; *Liverpool Albion,* 25 September 1843. 5 Dr. Waagen, *Treasures of Art in Great Britain,* III, p. 242. 6 MS Inventory of the Pictures belonging to John Naylor, begun 1856, family ownership; and see Edward Morris, *Catalogue of paintings, watercolours and sculpture owned by John Naylor,* in Walker Art Gallery, *Annual Report and Bulletin,* V, 1974–5, pp. 80–81.

III Stag at Bay

Oil on canvas,[1] 213·6 × 367·3 cm. (84⅛ × 144⅝ in.)

Exhibited at the Royal Academy of 1846[2] on the same occasion as Landseer's *Stag at Bay,* it received a favourable criticism in the *Art Union:* 'The dogs are accurately drawn and display extraordinary vivacity and spirit, while the stag is painted with great power and truth. On the whole few works of its class have ever surpassed it.'[3]

PROV: Presented by the artist to Liverpool Academy as his Diploma work, 30 March 1847;[4] passed to Liverpool Royal Institution

before 1859;[5] deposited at the Walker Art Gallery, 1893 and presented, 1948.

EXH: Royal Academy, 1846 (488); Liverpool Academy, 1846 (116); Walker Art Gallery, 1908, *Historical Exhibition of Liverpool Art* (4).

REF: 1 Canvas stamp of Charles Roberson, 51 Long Acre, London. 2 An MS label on the back confirms this; it reads '48 Seel St. Liverpool. No. 1. Stag at Bay. Vide Scrope on Deer Stalking. Price including frame £200. 1st April 184[6?].' (William Scrope, *The Art of Deer-Stalking, Illustrated by a narrative of a few days' sport in the Forest of Atholl. . . ,* 1838). 3 *The Art Union,* 1846, p. 182; see also *The Art Journal,* 1860, p. 234. 4 Liverpool Academy *Minutes* (Liverpool Record Office). 5 L.R.I. Catalogue, 1859, No. 168, and Liverpool Academy *Minutes,* 23 December 1853.

6158 Jonathan Blundell, with his greyhounds

Oil on canvas[1], 71·1×91·5 cm. (28×36 in.)

The low horizon is characteristic of the artist's mature work. The detailed, almost photographic style of the portrait suggests a date in the 1850's. Jonathan Blundell (1832–1870), was a great-uncle of the last owner.

PROV: Mrs. J. A. Pollen, daughter of Major Cuthbert Blundell-Hollinshead-Blundell, of Halsall, Ormskirk; presented by the Trustees of her Estate, 1962.

EXH: Arts Council, 1974–75, *British Sporting Paintings, 1650–1850* (203).

REF: 1 Canvas stamp of Charles Roberson, 51 Long Acre, London.

3070 The Hunted Slaves

Oil on canvas, 184×308 cm. (72½×121¼ in.)
SIGNED AND DATED: *Richd. Ansdell/1861*

Exhibited at the 1861 Royal Academy with the following quotation in the catalogue, from Longfellow's poem, *The Slave in the Dismal Swamp,* (first published, 1842):

'In dark fens of the dismal swamp
 The hunted negro lay;
He saw the fire of the midnight camp,
And heard at times a horse's tramp,
 And a bloodhound's distant bay.

Where hardly a human foot could pass,
 Or a human heart would dare,
On the quaking turf of the green morass
He crouched in the rank and tangled grass,
 Like a wild beast in his lair.'

It received an enthusiastic review in the *Art Journal* ' . . . just now the mere representation of an American slave hunt cannot fail to be doubly interesting . . . A slave chased through the silent gloom of nature's night, has, with his wife, been tracked to one of those reeking marshes which exhale contagious vapours. . . But virtue evidently waits on justice. The slave has already laid one pursuer, and a dog painted as Ansdell has never before painted the texture of a mastiff, is sprawling in its gore. . . The energy of character, and broad vigorous painting of the man's head, is a great step in advance for Ansdell, and the entire male figure is drawn with a largeness of style and a decision of form for which this artist's works have hitherto furnished little preparation to the public mind. Had the colour and the painting of the flesh been equal to those displayed on the head of this slave, the picture would have been a still greater triumph in this higher walk of Art.' The female figure the critic considered small in drawing and 'feeble and mean' by contrast with the male, and the other dogs without the same 'felicity or power' of the dying animal, 'but' he continued, 'as a whole it is a picture where the general simplicity and form of treatment are so in unison with the nature of the thought as to leave their joint impress on the memory for ever. . . '.[1]

The *Saturday Review* critic[2] thought it a picture 'to haunt one's dreams. . . Though powerful the picture is displeasing. We presume the local colouring is true; but the tint of the negro's skin is more bronze-like than we fancy to be common; and the fallen trunk, round which a snake is coiling in the foreground, is certainly ill-painted. So, again, the white patches of light on the man's forehead and left shoulder are clearly exaggerated.' The *Athenaeum*[3] enlarged on the fierce drama of the subject and considered that 'the execution. . . is almost as coarse as floor-cloth, but even this is redeemed in some measure by the vigour of the design. For the subject the work is excellent.'

It was the first picture by Ansdell to be acquired by Liverpool Corporation.

A version signed and dated 1862 (35½× 59½ in.) was in a U.S. private collection (1969).[4]

PROV: Presented by the artist to the Lancashire Relief Committee, Manchester for disposal; its lottery raised about £700 in guinea shares; won 18 May 1863 (ticket 707) by

27

Gilbert Winter Moss, Liverpool, who then presented it to Liverpool.[5]

EXH: Royal Academy, 1861 (59); *International*, 1862 (655); Wrexham, 1876 (481); Walker Art Gallery, 1908, *Historical Exhibition of Liverpool Art* (1).

REF: **1** *The Art Journal*, 1861, p. 166. **2** *The Saturday Review*, 18 May 1861, p. 503. **3** *The Athenaeum*, 18 May 1861, p. 666. **4** Photograph Gallery files. **5** *The Times*, 19 May 1863, and *The Liverpool Mercury*, 23 May 1863.

1433 Sheep and Lambs
Oil on canvas, 137·7×193·7 cm. (54¼×76¼ in.)
SIGNED AND DATED: *Rd. Ansdell/1874*
PROV: Presented by Mrs. William Leech, daughter of the artist, 1920.

1431 The Interrupted Meal
Oil on canvas, 76·2×125·7 cm. (30×49½ in.)
SIGNED: *R. Ansdell.* (initials in monogram)
PROV: Possibly W. Lawson Peacock (dealer) sale, Christie's 11–14.11.1921 (6) as *Scenting Danger*, 29½×49 in., bt. Lister, £16:5:6. Presented by George Audley, 1925.

ANSDELL, Richard 1815 – 1885 and
CRESWICK, Thomas 1811 – 1869

366 The King of the Forest; a Forest Glade with Deer
Oil on canvas,[1] 71×91·6 cm. (28×36 1/16 in.)
The landscape is by Creswick with animals by Ansdell. Their first collaboration was in 1850.

PROV: William Sharp, Birmingham, sold Christie's (106N), 9.7.1881 (65), as *The King of the Forest*, bt. Agnew for George Holt (bill Xmas for 22 July 1881), £693; thence to Emma Holt, who bequeathed it with her collection at Sudley, 1945.[2]

EXH: Walker Art Gallery, 1886 *Grand Loan Exhibition* (1189).

REF: **1** Canvas stamp of Charles Roberson of 51 Long Acre, London, and in a box *CR* 488; framemaker's label of Haywood and Son, 88 Newgate Street. **2** See Catalogue, *The Emma Holt Bequest*, Sudley, 1971, passim.

ANSDELL, Richard 1815 – 1885 and
PHILLIP, John 1817 – 1867

2715 Students of Salamanca Serenading
Oil on canvas, 153×120 cm. (60¼×47¼ in.)
The mule is by Ansdell.
PROV: Possibly Phillip's Executors' Sale, Christie's, 31.5.1867 (369) as *Students from Salamanca* bt. Earl, £157.10.0. Presented by Benson Rathbone, 1880.

EXH: Whitechapel, 1905 (67); and 1920 (24).

ANSDELL, Richard and
WESTCOTT, Philip

2577 3rd Earl of Sefton
See under Westcott

ARROWSMITH, Thomas, about 1772 - after 1829

Portrait and miniature painter. Deaf and dumb. Entered Royal Academy Schools at 17 years on 25 December 1789, and exhibited at R.A. 1792–1800 and 1829, from London addresses. In 1823 was in Liverpool and later said to be in Manchester.

8705 William Durning
Oil on canvas, framed as oval, 67·3×55·2 cm. (26½×21¾ in.)
8703 Jane, wife of William Durning
Oil on canvas, framed as oval, 67·3×55·2 cm. (26½×21¾ in.)

William Durning (1751–1830) and his wife Jane (c.1760–1830), daughter of Captain Samuel Lang, whom he married about 1798. Cousin of John and Anne Durning (see Williamson 8706–8); Unitarians. Their elder daughter Emma married George Holt (see Westcott

8707, 8710), and with her sister Jemima succeeded to the estate of Anne Durning at Edge Hill.

He was a wine and spirit merchant and bookkeeper, who, after apprenticeship with Harveys and working for a Mr. France, set up on his own account about 1800.[1]

Dateable on the costume about 1810–20.

PROV: With Anne Holt by 1885;[2] thence by descent to Miss Anne Holt, grand-daughter of Robert Durning Holt, who presented them, 1974.

REF: 1 Anne Holt, *Memoir of the Durnings,* MS (1885), copy in Liverpool Record Office; J. Hughes, *Liverpool Banks and Banking,* 1906, p. 207 n.1. 2 Anne Holt, *loc. cit.,* mentioning Jane Durning's portrait.

ARROWSMITH, Thomas, Ascribed to

8704 Oliver Holt

Oil on canvas, 73·6 × 61 cm. (29 × 24 in.)

Oliver Holt (1752–1830) of Rochdale. Woollen manufacturer and dyer; a dissenter. Father of George Holt, senior (see Westcott 8710). Traditionally by Arrowsmith, but the technique differs from 8703 and 5 above. Probably dating from very early in the 19th Century.

PROV: Presented by Miss Anne Holt, 1974.

8701 Young man of the Holt Family

Oil on canvas, 54 × 46·4 cm. (21¼ × 18¼ in.)

Probably by the same hand as 8704, and around the same date. From the likeness the sitter might be George Holt, senior (1790–1861), as a young man (see Westcott 8710).

PROV: Presented by Miss Anne Holt, 1974.

AUSTIN, Samuel 1796 - 1834

Landscape and marine painter, chiefly in watercolour. Born 23 October 1796, said to be son of William Austin, a joiner, who may have died in London, 1806. In that year his mother, Mary Austin, entered him at the Blue Coat School, Liverpool, so he was probably born in Liverpool. In 1809 became clerk to William Barber, a Liverpool Merchant, but gave this up to become an artist and is said to have had lessons from Peter de Wint. He made a living by teaching and taking private pupils. Exhibited at the Liverpool Academy, 1822–32; elected Member, 1824; Secretary, 1824–30. He may have been in London from time to time after 1824 and in 1833 gives both London and Liverpool addresses. Exhibited at the Royal Academy in 1820 only; founder member of the Society of British Artists, 1824; in 1827 Associate of the Society of Painters in Watercolour; Member, 1834 and exhibited with them until that year. Besides English and local views, his subjects included scenes in Holland, France and the Rhine. Turned to oil painting only late in life. Watercolours are also in the collection. Died at Cefn-y-Gribin in Montgomeryshire, 15 July 1834.

837 Bootle Landmarks

Oil on canvas, 45·5 × 61·2 cm. (17¹⁵⁄₁₆ × 24⅛ in.)

The North and South Bootle landmarks, 100 feet high, were erected 1 September 1829 in Bootle Bay to enable mariners entering the Mersey to take their bearings. They stood on the site of what is now Alexander Dock and must have been removed before its opening in 1881. The Fort and Black Rock lighthouse at New Brighton are visible in the background.

PROV: Purchased from Messrs. Bowker (£5), 1876.[1]

REPR: H. S. and H. E. Young, *Bygone Liverpool,* 1913, pl. LXXXI.

EXH: Walker Art Gallery, 1908, *Historical Exhibition of Liverpool Art* (539); Bluecoat Chambers, 1945, *Pictures of Old Liverpool* (11).

REF: 1 Library, Museum and Art Gallery Committee, Minutes, 30 March 1876.

AUSTIN, Samuel, After

417 The Black Rock Fort and Lighthouse, Liverpool

Oil on panel,[1] 53×88 cm. (20⅞×34⅝ in.)
Inscribed with title.
On the back is a fragmentary painting.

The lighthouse superseded the earlier Perch Rock beacon. It was designed by Foster and the foundation stone was laid 8 June 1827. It was completed 1829 with the adjacent battery of the Ordnance. It was in line with Bootle landmarks.[2] *Gore's General Advertiser* of 11 February 1830 announced that 'the light will be exhibited on the night of Monday the 1st of March next.'

417 is almost identical with the engraving.

after Austin, in *Lancashire Illustrated. . . in a series of views after original drawings by S. Austin, Harwood Pyne etc., engraved on steel by Rt. Wallis,* published 1829–1831. In the engraving a white horse is being transported in the boat, centre.

PROV: Unknown; in the collection before 1956.
REF: **1** Inscribed on back: JENNENS & ETTRIDGE; and framemaker's label of William J. Bartran, Euston Square. **2** E. C. Woods, *Some History of the Coastwise lights of Lancashire and Cheshire* in *Transactions of the Historic Society of Lancashire and Cheshire,* 98, 1945, pp. 107–112; John S. Rees, *The First and subsequent Cheshire Lighthouses* in *Transactions of the Nautical Research Society,* V, 1949–50, pp. 19–21.

BACON, John Henry Frederick 1865 - 1914

3008 T. P. O'Connor, M.P.

Oil on canvas, 143·5×111·8 cm. (56½×44 in.)
SIGNED AND DATED: *John H. Bacon* /03
The Rt. Hon. Thomas Power O'Connor, M.P. (1848–1929), journalist, politician and Irish patriot. M.P. for Galway 1880–1885, and for the Scotland division of Liverpool, 1885–1929. First President of the Board of Film Censors, 1917; Privy Councillor, 1924. Published a *Life of Lord Beaconsfield,* 1879, and *The Parnell Movement,* 1886; founded two London

evening papers. A portrait by Lavery is in the National Gallery, Dublin.[1]

PROV: Bequeathed by the sitter, 1929.
EXH: Royal Academy, 1904 (496); Walker Art Gallery, 1904, *Liverpool Autumn Exhibition* (113).
REF: **1** T. P. O'Connor, *Memories of an Old Parliamentarian,* 1929, passim; H. H. Fyfe, *T. P. O'Connor,* 1934, passim; D.N.B.

BALLARD, Arthur, living artist

1102 Children Playing

Oil on canvas, 77·1×63·5 cm. (30⅜×25 in.)
PROV: Purchased from the artist, 1954.
EXH: Arts Council, 1952, *Merseyside Artists from the Sandon Studios Society* (1); Walker Art Gallery, 1954, *Liverpool Academy* (97).

3147 Farm

Oil on canvas, 71·7×92 cm. (28¼×36¼ in.)
PROV: Purchased from the artist, 1955.
EXH: Walker Art Gallery, 1955, *Liverpool Academy* (80).

1812 Non-Figurative Painting No. 2

Oil on board, 101·5×76·3 cm. (40×30 in.)
SIGNED: *B*
PROV: Purchased from the artist and presented by John Moores, 1958.
EXH: Walker Art Gallery, 1958, *Liverpool Academy* (117).

BARBER, Charles 1784 - 1854

Landscape painter and drawing master. Born Birmingham, eldest son of Joseph Barber, the artist and drawing master, and a fellow student under him with David Cox. May have followed Cox to London in 1804, and his companion on a sketching trip to North Wales, 1805. A founder member of the first Society of Birmingham Artists, 1809. Exhibited watercolours at the Associated Artists in London, 1810, and as a member 1811–12; Associate of the Old Watercolour Society, 1812, and exhibited eight works there 1813–20.

Moved to Liverpool about 1816 and joined the Literary and Philosophical Society that year; first listed in the street directories 1818 as drawing master and artist. Was drawing master at the Liverpool Royal Institution School from its beginning, about 1819 to his death. Member and Treasurer of the Liverpool Academy, 1822; Secretary, 1828–9; resigned 1830; rejoined 1835 and President, 1841; again resigned 1842 and rejoined 1846; President, 1847–53. His various periods of non-membership evidently had to do with factions within the Academy. Exhibited at the Royal Academy 1829 and 1849. Associated with the Gothic Revival in Liverpool, he had offered to tint the plates of Thomas Rickman's *Attempt to Discriminate the Styles of English Architecture* of 1817; brother-in-law of John Lightfoot who read papers on the Gothic to the Literary and Philosophical Society. Barber contributed a paper called *Of the Characteristics of the English School of Painting* to the Society, 1848. A Vice-President of the Liverpool Architectural and Archaeological Society. He died at Liverpool 4 January 1854.

An enthusiastic obituary, in the Liverpool *Courier* (quoted by the *Art Journal*) noted: 'As a teacher he ranked very high, not contenting himself with the routine commonplace so often indulged in, but labouring to infuse into his pupils a portion of his own enthusiasm and love of the beautiful for its own sake . . . As an artist Mr. Barber was an enthusiastic lover of nature; he never wearied in his attentive devotion to catch her changeful expressions, whether in the gorgeous effects of sunrise, the mysterious mantle of mist, or the sparkling brilliancy of sunlight on the waters. During his moments of leisure his pencil was ever in his hand, striving to embody and make patent the sense of the beautiful as present to his mental vision . . . Relieved during his latter years from the necessity of toil, by the possession of ample private means, his enthusiasm for art continued to the last. Above a year ago he suffered severely from an attack of paralysis, from which he partly recovered but which left its effects upon his utterance. His mind and right hand, however, were still healthy and sound . . . As president of the Liverpool Academy he won the respect and esteem of his brother artists, soothing when necessary the *genus irritabile vatum*, and encouraging the younger members in their aspirations after distinction and success . . .'.

1757 Dovedale, Derbyshire.
Oil on canvas, 86·5 × 122·5 cm. (34⅛ × 48¼ in.)
SIGNED AND DATED: *Charles Barber/1829*
A party with fishermen are on the river bank at the left, one plays a flute.

Liverpool papers commented on its picturesque effect but deficiency in the depth and tone of nature. One noted: 'There is a beautiful effect of light and shadow in the middle and background of this choice subject, but the foreground is dry, weak and appears unfinished. The tints of the trees on the left do not harmonise with the landscape, nor is it easy (either as to form or colour), to distinguish the sheep from the stones that rest beneath them'.[1]

A picture with the same title was exhibited at the Society of British Artists in 1831.
ENGR: Robert Barnard in *The Winter's Wreath,* Liverpool Annual, 1831, fp. 361.
PROV: Presented by Walbanke Barber, 1867.
EXH: Royal Academy, 1829 (457); Liverpool Academy, 1829 (216); Walker Art Gallery, 1908, *Historical Exhibition of Liverpool Art* (560); and 1960, *Liverpool Academy 150th Anniversary* (32).
REF: **1** Press cuttings with 1829 catalogue (Liverpool Record Office).

1756 Landscape
Oil on canvas,[1] 89·5 × 122·5 cm. (35¼ × 48¼ in.)
SIGNED AND DATED: *Charles Barber/1837*
PROV: Presumably the picture presented by the artist to the Liverpool Academy as his Diploma work, 1848;[2] they presented ten works by living artists to the town, 1853[3], and thence to the Liverpool Royal Institution before 1859[4]; thence presented to the Gallery, 1948.
REF: **1** Canvas stamp of Charles Roberson, Long Acre, London **2** Liverpool Academy *Minutes,* 22 April 1848, (Liverpool Record Office). **3** *Op. cit.,* 3 December 1853. **4** L.R.I. Catalogue, 1859, (177).

BARRETT, Jerry, about 1824 - 1906

1132 John Hughes, Mayor of Liverpool
Oil on canvas, 243·5 × 149·2 cm. (95¾ × 58¾ in.)
SIGNED AND DATED: *Jerry Barrett 1883*
John Hughes, J.P. (1825/6–1895), Mayor of Liverpool, 1881–2, in court dress and robes of office, and wearing the mayoral chain.[1] A Liverpool solicitor; Town Councillor from 1869, Alderman 1886, retired 1893.
PROV: Presented by subscribers to the sitter, who presented it to the Gallery, 1884.
EXH: Walker Art Gallery, 1883, *Liverpool Autumn Exhibition,* (1598).
REF: **1** The chain was presented by members of the council in 1872 and first worn by John Pearson, Esq.

BAUM, John, living artist

9202 Windermere House
Acrylic on canvas, 193 × 180 cm. (76 × 71 in.)
SIGNED, verso: *John Baum '72*
PROV: Purchased from the artist, with the aid of the Calouste Gulbenkian Foundation's Regional Purchase Scheme, 1977.
EXH: Bluecoat Gallery, Liverpool, Sept.– Oct. 1971, *Maurice Cockrill, John Baum, Peter Mousdale* (1); Walker Art Gallery, 1972, *John Moores Liverpool Exhibition 8* (76); Welsh Arts Council, 1972, *Every Picture Tells . . .* (3); Walker Art Gallery, 1977, Peter Moores Liverpool Project 4: *Real Life.*

BEACH, Thomas 1738 - 1806

L136 John George Audley

Oil on canvas, 126 × 102 cm. (49⅝ × 40 in.)

SIGNED AND DATED: *T Beach p/1793* (initials in monogram)

Supposedly a John George Audley, merchant of Liverpool,[1] but the sitter cannot be identified in the Liverpool section of Reade.[2] The family of George Audley (see Berrie 3001) starts with his great-grandfather, William Audley (about 1776–1833), a bookmaker and victualler, followed by John Audley (1806–

1885) a noted shipbuilder of Liverpool.[3]

PROV: John Audley in 1843.[4] George Audley, sold Christie's 12.5.1932 bt. Fane 15 gns.; Anon. sale Christie's, 25.4.1958 (106), bt. Sherborn 24 gns.; Anon. sale Sotheby's, 15.7.1959 (162), bt. Sawyer £50; thence to Liverpool City Library; lent to the Gallery, 1973.

REF: **1** MS label on verso. **2** A. L. Reade, *Audley of Liverpool,* (1929–1936). **3** *Loc. cit.,* **4** MS label, verso.

BEATTIE, Robert 1810 - 1874

Portrait and landscape painter. Born Preston 6 October 1810, son of John Beattie. First worked in solicitor's office but left to study art. May have taken lessons from Robert Carlisle of Preston and later from Mr. Faulkner of Manchester and is said to have studied at Sass's School in London. Founder member of Preston Society of Artists, 1835. Hargreaves is said to have persuaded him to come to Liverpool, where he lived 1841–52, when he moved to Southport. There he also taught drawing and ran, probably with his son, a photographic business. He returned to Preston 1873 and died there March 1874. Two of his sons were artists.

1133 James Lawrence, Mayor of Liverpool

Oil on canvas, 199·3 × 133·4 cm. (78½ × 52½ in.)

James Lawrence (1790/1–1856), a Liverpool brewer and Tory Councillor, in his robes of office as Mayor, 1844–5.

PROV: Entered collection at early date.

EXH: Liverpool Academy, 1845 (193).

BEAUMONT, Frederick S. 1861 - after 1952

3009 Sir Alfred Lewis Jones

Oil on canvas, 142·2 × 113 cm. (56 × 44½ in.)

SIGNED AND DATED: *Frederick Beaumont 1906.*

Sir Alfred Lewis Jones (1845–1909), prominent Liverpool shipowner and philanthropist. Born Carmarthen, and came to Liverpool at early age. Embarked on shipping career in West African trade and rose to managing director of the

Elder Dempster Line. Gained the sobriquet of the 'Banana King'. Founded the Liverpool School of Tropical Medicine, 1899 and established Liverpool University Institute of Commercial Research in the Tropics, 1905. President of the Liverpool Chamber of Commerce, 1900–1909, and President of the British Cotton Growing Association. Created K.C.M.G., 1901; Hon. Fellow Jesus College, Oxford 1905.

A monument with medallion portrait by G. J. Frampton was erected at the Pierhead, 1913.

PROV: Presented by subscribers through Sir Thomas Jones, 1908.

EXH: Walker Art Gallery, 1907, *Liverpool Autumn Exhibition* (144).
REF: 1 Press cuttings (Liverpool Record Office); A. H. Milne, *Sir Alfred Lewis Jones K.C.M.G.*, 1914, passim.

BELL, Robert Anning 1863 - 1933

Decorative designer and painter. A leading member of the Arts and Crafts movement. He taught painting and drawing in the department of Applied Art in the School of Architecture at University College, Liverpool, 1895–99. Afterwards lived in London. A founder member of University Club in Sandon Terrace, 1896 and an Honorary Member of the Sandon Studios Society. A member of various London societies and A.R.A., 1914. Other oils, drawings and plaques are in the Collection.

2432 Study of a woman's head in a mediaeval headdress

Oil on panel, 22·1 × 23·8 cm. ($8\frac{11}{16} \times 9\frac{3}{8}$ in.)
Identified as Fanny Dove Hamel Lister (1864–1954), a pupil of Anning Bell (see below), from a similar study certainly of her, signed by the artist, and still in family ownership.[1] She is in a similar headdress and appears to be the same model as the right hand figure in the left panel (8511) of the King and Queen of Hearts series below.

PROV: Presented by Miss A. Porter,[2] Liverpool, 1954.

REF: 1 Exhibited Bluecoat Gallery, 1977, *Bluecoat Cavalcade* (8). 2 Her brother (*sic*) was R. Warrington (*q.v.*) who taught at Liverpool University department of Applied Art from about 1900.

8520 Clock with decorative panels

Painted wood with oil and gesso decoration, 58·6 × 31·5 × 19 cm. (23 × 12$\frac{1}{2}$ × 7$\frac{1}{2}$ in.)
A clock in the Art Nouveau style of the 1890's period painted cream and with three panels of decoration: on the front two young girls in white kneeling in front of a green bushy bank and on each side a shield hanging from a tree above similar bushy banks.

PROV: As 8510–12.

EXH: Possibly Walker Art Gallery, 1898, *Spring Exhibition* (144) as *Clock*.

BELL, Robert Anning, and students of Liverpool University School of Art

Enid Jackson and Fanny Dove Hamel Lister (later Mrs. Calder) were amongst Bell's students at Liverpool. The former, an excellent draughtsman, exhibited at Liverpool Autumn Exhibition; she was lost sight of after her family left Liverpool in 1914. The latter was subsequently Hon. Secretary and Treasurer of the Sandon Studios Society. As students they gained first and second prizes for decorative design in 1898.

8510– The King and Queen of Hearts, 8512 three panels of a frieze

Oil and gilt gesso on canvas, mounted on panel, 71 × 240 cm.: 68·5 × 148 cm.: 70 × 148 cm. (28 × 94$\frac{1}{2}$ in.: 27 × 58$\frac{1}{4}$ in.: 27$\frac{1}{2}$ × 58$\frac{1}{4}$ in.)
The centre panel of the *King and Queen Enthroned* by R. Anning Bell and Students;[1] the left hand panel of courtiers presenting plates of tarts to a lady by Miss Hamel Lister, and the right hand panel of a lady carrying a plate of tarts to kneeling courtiers by Enid Jackson.[2]

In March 1895 Anning Bell produced a musical on this theme for the Athletic Fund Entertainment at University College.[3] It is possible that these panels (and possibly 2432 above) were either connected with this or were a development of the idea, and were carried out for the University Club, founded in 1896.

The centre panel, on exhibition in 1896, was considered by *The Studio* reviewer:[4] 'full of beautiful work; yet the "swags", both in scale and colour, seem to mar its perfection. The figures are excellently placed, and full of that curious distinction which Mr. Anning Bell imparts to his most graceful creations. The detail of the costumes and of the accessories is certainly delightful, the flowers are as charming and as new as anything he has done; but yet one cannot help feeling that the "swags" are unduly prominent in the section shown. It is quite possible that in the completed frieze this detail would not merely fall into its proper place, but prove to be the connecting link which brought the whole procession into unity. . .'

The purpose of the frieze is mentioned in a later *Studio* review[5] on the exhibition of students' work at the close of the 1898 session of the School of Architecture and Applied Art at University College, Liverpool: 'In the last Arts and Crafts Exhibition in London was shown a centre panel of a frieze, the *Queen of Hearts* designed by R. Anning Bell for the University Club. The right and left panels (reproduced), have been designed in continuation of the same subject by two students, Miss Enid Jackson and Miss Hamel Lister, and executed by them in oil on canvas enriched with gesso and gilding, the whole colour scheme is strong, rich and glowing.'

Anning Bell as a founder member of University Club, 1896, advised on its decoration and that of the subsequent premises in Mount Pleasant. In both a private dining room was named after him.[6] A drawing in the Collection (6808)[7] is a design for a frieze of the Queen of Hearts and is presumably connected with the same scheme, perhaps a first idea. About half-size to these panels, it shows the queen centrally placed in one section with two attendants holding up the curving folds of her train, and a smaller section with a shield and helmet cartouche; they are joined by columns. A group of pastels of Hearts and Clubs figures, (Nos. 8517-19 in the Collection), and the painted clock above, which were also from the University Club, were probably part of the same series. No descriptions have so far been traced of the actual interiors of the original club.

PROV: University Club by 1898; purchased from them at the winding up of the Club, 1973.

EXH: (8510), *Arts and Crafts Exhibition Society*, 1896 (217); (8511-12), School of Architecture and Applied Art, Liverpool, 1898; ?Walker Art Gallery, 1898, *Spring Exhibition* (118) as *Queen of Hearts, frieze in relief and colour*, £35.

REF: 1 In Arts and Crafts Catalogue, *loc. cit.*; repr. *The Studio*, IX, 1896, p. 120. 2 *The Studio*, XIV, 1898, p. 200 (repr. of both side panels). 3 *Sphinx*, II, No. 18, 1895, pp. 110 ff. 4 *The Studio*, IX, 1896, p. 120. 5 *The Studio*, XIV, 1898, p. 200. 6 Stanley Conway, *The University Club Liverpool, its history from 1896–1956 (c. 1967)*, pp. 23–4. 7 70·5 × 176 cm.; 7 signed and inscribed with title; presented by Miss A. Porter to Liverpool Museum, 1953, and transferred 1968.

BELL, Norman Martin 1907 - 1970

Born Great Meols, Cheshire, 16 April 1907; his uncle was W. Alison Martin (*q.v.*). Trained at Liverpool College of Art, 1925–30, and the Royal College of Art, 1931–33. Taught part time at King's School, Chester, 1933–44, Prescot Grammar School, 1936–39, and at Liverpool College of Art from 1939, where full time from 1944 and Head of Department of Fine Art, 1965. Member of Liverpool Academy and President, 1957–60. Exhibited with the London Group, at Liverpool, Manchester and other provincial exhibitions. After the war took part in Recording Merseyside. Died 11 March 1970.

2363 Bombed Houses
Oil on canvas, 40·7×51 cm. (16×20⅛ in.)
SIGNED AND DATED: *N. MARTIN BELL '43*
PROV: Purchased from the artist, 1944.

1813 Seaside Fair Ground
Oil on canvas, 63·5×76·5 cm. (25×30⅛ in.)
SIGNED AND DATED: *MARTIN BELL.'58.*
PROV: Purchased from the artist and presented by John Moores, 1958.
EXH: Walker Art Gallery, 1958, *Liverpool Academy* (83); and 1970, *Liverpool Academy, Memorial section* (40).

2362 Arles
Oil on canvas, 60·5×76 cm. (23⅞×29⅞ in.)
SIGNED AND DATED: *MARTIN BELL '54*
PROV: Purchased from the artist, 1954.
EXH: Walker Art Gallery, 1954, *Liverpool Academy* (17).

7259 Figures bathing
Oil on board, 29·2×39·4 cm. (11½×15½ in.)
SIGNED: *N. MARTIN BELL*
PROV: Purchased from the Sandon Studios Society, 1970.

BENSON, Edward 1808 - 1863

2274 John Bramley-Moore
Oil on canvas,[1] 142×111·8 cm. (56×44 in.)
SIGNED AND DATED (signature damaged by bitumen): *Novre 1845/E. Benson*
John Bramley-Moore (1800–1886), born at Pontefract, Yorkshire, and after a period in Brazil settled as a merchant in Liverpool, 1835. He entered local politics as a Conservative and was elected Alderman 1841. He added Bramley to his name in 1840. He became a member of the Dock Committee in 1842 and was Chairman 1843–1848, when he resigned on his election as Mayor of Liverpool. His great *coup* was a personal negotiation with Lord Derby for the free gift of two and a half miles of shore-land for new docks at the North End of Liverpool in exchange for newly constructed land behind. In 1848 the first part of his great project was opened with the Salisbury, Nelson, Collingwood, Stanley and Bramley-Moore Docks.[2] The plan for the extension, dated *Vic VII* and *VIII* (1844 and 45) is unrolled at the left of the picture and Bramley-Moore holds a copy of the Dock Acts. He was Conservative M.P.

for Maldon, 1854–59 and later sat for Lincoln 1862–65. Some contemporary opinion in the press was not complimentary of his quick rise to power on a basis of 'push and pretentiousness'.[3]

A bust is in the Collection (8241).

PROV: W. Bramley-Moore, son of the sitter, who presented it to Liverpool, 1887; transferred from the Town Hall, 1955.
EXH: Presumably Liverpool Academy, 1846 (357) as *A Portrait;*[4] Walker Art Gallery, 1970, *The Taste of Yesterday* (53) repr.
REF: **1** Relined. **2** J. A. Picton, *Memorials of Liverpool*, 1873, I p. 669, II pp. 462–3; obituary notices (Liverpool Record Office). **3** *Pen and Ink Sketches of Liverpool Town Councillors, 1857*, 1866, pp. 78 ff. **4** Identified in the *Liverpool Courier*, 30 September 1846, together with a portrait of his wife (No. 378), and considered a good likeness; see also the *Liverpool Times*, 15 September 1846, where his portrait was considered amongst the best portraits.

BERRIE, John Archibald Alexander 1887 - 1962

Portrait and landscape painter, resident in Liverpool until 1935–6. Born Manchester 28 December 1887; trained at Bootle Art School, Liverpool, London and Paris. Exhibited at Liverpool Autumn Exhibition from 1908 and Royal Academy from 1924, and elsewhere.

Associate Royal Cambrian Academy, 1912; Member, 1923; F.R.S.A., 1950. Moved to London and was later living at Harrogate and finally at Johannesburg. An exhibition at Walkers Gallery, Bond Street, 1936. Died Johannesburg 3 February 1962.

7131 Thomas Dowd, Lord Mayor of Liverpool

Oil on canvas, 132×96·5 cm. (52×38 in.)
SIGNED: *John A. A. Berrie*

7132 Mrs. Dowd, Lady Mayoress of Liverpool

Oil on canvas, 111×86·5 cm. (43¾×34 in.)
SIGNED: *John A. A. Berrie*

Alderman Thomas Dowd, J.P. (born 1866), Lord Mayor of Liverpool 1924–5, and the Lady Mayoress, wearing chains of office. He was born in Liverpool and rose from an errand boy to head of a large firm of fruiterers and florists. Councillor, 1908; Alderman, 1923; J.P., 1924.[1]

PROV: Presented to the sitters, 1925. Transferred from the City Estates Committee, 1968.

EXH: Walker Art Gallery, 1925, *Liverpool Autumn Exhibition* (958).

REF: 1 Press cuttings (Liverpool Record Office).

3001 George Audley

Oil on canvas, 137·8×96·5 cm. (54¼×38 in.)
SIGNED: *John A. A. Berrie*

George Audley, J.P. (died 1932), merchant and public benefactor and art patron. Born Liverpool; career in export bottling business. A shy and retiring man particularly interested in work with children. His gifts to the City included replicas of Frampton's *Peter Pan* and Gilbert's *Eros* for Sefton Park. He gave a collection of paintings, chiefly Victorian, to the Gallery, and a large donation towards the Gallery Extension. Member of the Arts Sub-Committee from 1926; J.P. 1929.[1] His collection of paintings was sold at Christie's 12 May 1932.
See Thomas Beach (L137) for a portrait of John George Audley.

PROV: Bequeathed by the sitter, 1932.

EXH: Walker Art Gallery 1927, *Liverpool Autumn Exhibition* (80) repr.; Harrogate 1930.

REF: 1 Press cuttings, (Liverpool Record Office).

7014 Miss Margaret Beavan, Mayor of Liverpool

Oil on canvas, 198×127 cm. (78×50 in.)
SIGNED: *John A. A. Berrie*

Miss Margaret Beavan, J.P. (1877–1931), first woman Lord Mayor of Liverpool, 1927–8, wearing robes and chain of office. Born Liverpool. An eminent social worker and pioneer in child-welfare; founder of the Child Welfare Association and many medical convalescent institutions. The open-air hospital for children, Leasowe, was renamed after her. Co-opted on to Education Committee, 1900; J.P., 1920; Councillor, 1921–29 (Liberal and subsequently Conservative). Her portrait was also painted by W. C. Penn, 1926.[1]

PROV: Presented to the sitter, 1928. Transferred from City Estates Committee, 1968; hung in the Town Hall.

EXH: Walker Art Gallery, 1928, *Liverpool Autumn Exhibition* (983) repr.; Royal Academy, 1929 (527).

REF: 1 Press cuttings (Liverpool Record Office); Ivy A. Ireland, *Margaret Beavan: her Character and Work*, 1938, *passim*.

7135 Stuart Deacon

Oil on canvas, 129·5×96·7 cm. (51×38 in.)
SIGNED: *John A. A. Berrie*.

Stuart Deacon, J.P. (1868–1947). Born Widnes. Called to the Bar (Inner Temple) 1892; Northern Circuit; J.P., Liverpool, 1903, and County of Cheshire, 1910; Stipendiary Magistrate for Liverpool, 1910–1946.

PROV: Painted at the request of the Justices of the City, and presented to the sitter, 1931. Transferred from City Estates Committee (Magistrates Court), 1969.

EXH: Walker Art Gallery, 1932, *Lancashire and Cheshire Artists* (373).

REF: 1 Press cuttings, (Liverpool Record Office).

BIFFIN, Sarah 1784 - 1850

Miniature painter who spent her final years in Liverpool. Born Great Quantox-heath, near Bridgewater, Somerset, 25 October 1784. Born without arms or hands, she painted 'with her shoulder assisted by her mouth.' Taught first by a Mr. Dukes, who exhibited her at fairs and with whom she stayed contracted for about sixteen years, and, as a result of the Earl of Morton's patronage, by William Marshall Craig; through the Earl she received royal patronage and made a successful career. Married a Mr. Wright, 1824. Her eventual move to Liverpool about 1842 appears to have succeeded a period of retirement and a revived need again to earn money. She worked from various addresses in Bold Street, Slater Street, and finally 8 Duke Street. She exhibited works at the Collegiate Institution and Mechanics Institution; she received help from Joseph Mayer, and in 1847 a subscription was opened by Richard Rathbone to save her from penury. She died in Duke Street, 2 October 1850. Her friends erected an epitaph over her grave in St. James's Cemetery and an obituary notice commented that 'the products of her pencil have rarely been surpassed, especially as a copyist.' Several Liverpool works are recorded; a self-portrait was in Merseyside Museums and two self-portraits were published.

2559 Fanny Maria Pearson

Oil on canvas,[1] 91·4×75·2 cm. (36×29⅝ in.)
Fanny Maria Pearson (born 1813), daughter of John Cox (1785–1843) tanner and maltster of Rugeley, Staffordshire. She married Edward Pearson (1794–1867), apothecary of Liverpool, in 1833. They had fourteen children. The costume suggests a date around the period of her marriage.[2] The sitter and artist are identified on an MS label on the back and a further label reads: *Miss Biffin/Emma went with Mother & saw Miss Biffin when she was painting Mother's portrait.* The style is much coarser than the artist's miniatures and differs considerably from a smaller oil portrait by Biffin of Edward Pearson belonging to a descendant.[3]

PROV: Presented by Miss A. Cox, granddaughter of the sitter, 1933.

REF: 1 Relined and new stretcher, 1933. 2 Information from John Cox Pearson, in letter 19 February, 1977. 3 75×62 cm.: coll. John Cox Pearson.

BIGLAND, Percy 1858 - 1926

Portrait and subject painter. Born Birkenhead, son of Edwin Bigland, a merchant in Liverpool. Trained at Munich, where stayed seven years. Exhibited at the Liverpool Autumn Exhibition from his home and family firm's address, 1878–84. Afterwards practised in London. A member of the Society of Friends. Died Jordans, Bucks, 7 April 1926.

1746 Man with a Beard

Oil on canvas, 58·5×32·5 cm. (23×16¾ in.)
SIGNED AND DATED: *Percy Bigland/1880*
PROV: Presented by Alderman E. A. Cookson, 1953.

1747 An Old Lady

Oil on panel, 46×38 cm. (18⅛×14⅞ in.)
PROV: Presented by Alderman E. A. Cookson, 1953.

8700 Emma Holt

Oil on canvas, 83×66·3 cm. (32⅝×26⅛ in.)

SIGNED AND DATED: *Percy Bigland 1889*

Emma Georgina Holt (1862–1944), daughter of George Holt (1825–1896) (see Morrison 275). Philanthropist and local benefactress, particularly to the University of Liverpool, where she founded University Hall for Women, endowed the Holt travelling scholarship in architecture, etc. etc.; life member of University Court, and life governor of University College; Hon. LL.D. She presented extensive parkland at Mossley Hill to Liverpool, 1926, and bequeathed her house and grounds, Sudley, Mossley Hill and her father's collection of paintings to the City 1944.[1] She was described as 'modest, simple, invariably kind and friendly, yet with a shrewd judgement of men and things. . .'[2]

She appears seated in the Garden hall at Sudley with the columns of the staircase hall visible in the background.

Two portraits of her, by David Muirhead, 1909, and René de l'Hôpital, 1928, belong to Liverpool University (University Hall).

PROV: By descent to Miss Anne Holt, who presented it, 1974.

REF: **1** Press cuttings, (Liverpool Record Office); Catalogue of *The Emma Holt Bequest, Sudley*, 1971. **2** Eleanor Rathbone, in *Liverpool Post*, 21 Dec. 1944.

2584 Robert Durning Holt

Oil on canvas, 101·6×64·8 cm. (40×25½ in.)

SIGNED: *Percy Bigland*

Robert Durning Holt, D.L., J.P. (1832–1908) eminent Liverpool merchant, politician and public benefactor. Son of George Holt (1790–1861), cotton broker who founded the family fortunes (see Westcott 8710), and brother of George (see Morrison 275). Succeeded to his father's firm. Entered local politics in the Liberal interest and became leader of the party; Councillor from 1877; last Mayor and first Lord Mayor 1892–3 in the first Liberal dominated Council for fifty years. Deputy Chairman, Libraries, Museums and Art Gallery Committee, 1899–1903, and 1905–1908. Declined both Aldermanship and baronetcy. J.P.; Deputy Lieutenant for Lancashire. Honorary Freeman, 1904. Married Laurencina, daughter of Richard Potter of Manchester, 1867. Their son Richard was M.P. for Liverpool.[1]

Another portrait by Bigland was exhibited at the Liverpool Autumn Exhibition 1893 (898), repr.

Bigland is listed three times in the sitter's account book[2]: 5 Dec. 1889, £132.15.0; 24 Jan. 1891, £157.10.0; and 16 Aug. 1893, £75.

PROV: Transferred from the Town Hall, 1956.

REF: **1** *Liverpool Legion of Honour*, 1893; *Lancashire Leaders, Social and Political*, 1897; etc; press cuttings (Liverpool Record Office). **2** Family ownership.

8712 Robert Durning Holt

Oil on canvas, 64×54 cm. (25¼×21¼ in.)

A head and shoulders version of 2584.

PROV: By descent to Miss Anne Holt, granddaughter of the sitter, who presented it, 1974.

7000 Rt. Hon. W. E. Gladstone

Oil on canvas, 95·6×127 cm. (37⅝×50 in.)

SIGNED AND DATED: *Percy Bigland/1890.*

The Rt. Hon. William Ewart Gladstone (1809–1898), Statesman, and four times Prime Minister. Born 62 Rodney Street, Liverpool, 29 December 1809, the fourth son of John Gladstone (see Bradley 1134); named after William Ewart (see Mosses 3006) a Scottish friend of his father's in Liverpool. Married Catherine Glynne of Hawarden, 1839. Died at Hawarden 1898 and buried in Westminster Abbey. His portrait was painted by William Bradley, John Everett Millais, G. F. Watts, W. B. Richmond, S. P. Hall, etc., A bust by H. C. Fehr is in the Collection (8237).

This or another portrait was exhibited at the Society of Portrait Painters, 1896.[1] A mezzotint after Bigland was published by the Fine Art Society, 1892.[2]

PROV: Presented to the City by Alderman William Denton and friends, 1940.

EXH: New Gallery, 1891 (179);[3] Walker Art Gallery, 1891, *Liverpool Autumn Exhibition* (449).

REF: **1** *The Athenaeum*, 1896, p. 721. **2** *The Athenaeum*, 1892, p. 122. **3** Repr. *Pall Mall Gazette*, 4 May 1891, *The Pictures of 1891*, p. 101.

BISHOP, John 1810/11 - 1858

Portrait and genre painter, possibly younger brother of William James Bishop (*q.v.*), who may have taught him. Admitted probationer in the Liverpool Academy Schools, 12 November 1827; exhibited at Liverpool Academy, 1830–44; Associate, 1837; Member, 1842; resigned September 1845. Moved to Birmingham, where died.

3002 Michael James Whitty
Oil on canvas, 127×101·5 cm. (50×40 in.)
Michael James Whitty (1795–1873), journalist. Born at Wexford, he commenced a literary career in London in 1821 and was editor of the *London and Dublin Magazine,* and the friend of George Cruikshank. On 1 January 1830 he was appointed first editor of the *Liverpool Journal.* In 1832 he was appointed Chief of the Night Watch by Liverpool Corporation, and in 1836 Head Constable, and was responsible for the organization of the new police and fire brigade. On his resignation in 1848 he received £1,000 as a public testimonial. He then resumed the running of the *Liverpool Journal,* of which he became sole proprietor, and in 1855 founded the *Liverpool Daily Post,* the first penny daily newspaper, which he owned and directed until 1872, when he retired. He died 10 June 1873.[1]
A bust by Fontana belonged to Liverpool Daily Post.[2]
PROV: Presented 1883 by Thomas R. Russell, who married a daughter of the sitter.
EXH: Liverpool Academy, 1840 (6); Walker Art Gallery, 1908, *Historical Exhibition of Liverpool Art* (523).
REF: 1 *Porcupine,* 14 June 1873; D.N.B. 2 Photo Liverpool Record Office.

6661 John Hastings
Oil on canvas,[1] 92×72 cm. (36¼×28⅜ in.)
John Hastings (1800–1881), designer of island refuges for the safety of pedestrians in Liverpool streets. Born Thornhill, Dumfries, 9 September 1800. Came to Liverpool in 1822 and became a leading saddler, setting up on his own account about 1829 in Dale Street and subsequently Lord Street. The dangerous street crossing near his shop led him to advocate the construction of an island with gas lighting, 1860, and the Watch Committee finally put his idea into motion the following year. He retired from business in 1869 and died 24 March 1881.[2]
The sitter appears here to be in his thirties: J. Haill, the framemaker, is listed at 29 Tarleton Street only in 1837 (in 1839 the number is changed to 10). Said to be by Bishop; the style appears a little harder than 3002.
PROV: Miss Catherine Smitton, granddaughter of the sitter, who bequeathed it to Liverpool City Library, 1953; thence transferred to the Gallery, 1968.
REF: 1 Framemaker's label of J. Haill, 29 Tarleton Street, Liverpool. 2 Obituary Notices, and *Liverpool Daily Post* off-print, 4 July 1933 (repr. detail) (Liverpool Record Office.)

BISHOP, William James 1805 - 1888

Genre and landscape painter. Born Manchester 13 April 1805. After a period in a glass factory and a roving early life settled in Liverpool about 1825, and was one of the painters of Hilton's *The Crucifixion* on glass for St. George's Church. Admitted student at Liverpool Academy Schools, 17 October 1825; and gained first prize for design, 1829. Exhibited Liverpool Academy 1827–65; Associate, 1831; Member, 1838; President, 1854–87, during

the most distinguished and controversial years of the Academy; he was not personally sympathetic to the Pre-Raphaelite adherents in its midst. Exhibited Liverpool Autumn Exhibition, 1871–87. Chiefly employed as an art teacher: at the Mechanics Institute, 1838–43; at the Liverpool Collegiate Institution, 1843–85; and as Head of the Liverpool North District School of Art from 1885. He taught several Liverpool artists, notably J. W. Oakes. Died Liverpool, 3 July 1888. See Boadle 2586 for portrait.

1722 Crazy Kate

Oil on panel, 53·4×42·5 cm. (21×16¾ in.)
SIGNED AND DATED: *W. J. Bishop*
Illustrating the lines from Cowper's *Task:*

'A tatter'd apron hides,
Worn as a cloak and hardly hides, a gown
More tatter'd still, and both but ill conceal
A bosom heav'd with never-ceasing sighs;
She begs an idle pin from all she meets,
And hoards them in her sleeve; but
 needful food,
Though pressed with hunger oft, or
 comlier clothes,
Though pinched with cold, asks never
Kate is crazed'

An oil sketch of the subject (7×8½ in.), signed and dated *W. J. Bishop* 1837, belonged (1970) to Major E. G. Roberts, Dawlish.
PROV: R. E. Harvey, by 1840; bequeathed by Mrs. Margaret Harvey, 1878.
EXH: Liverpool Academy, 1837 (112); Liverpool Mechanics Institute, 1840 (145); Walker Art Gallery, 1908, *Historical Exhibition of Liverpool Art* (1534); Harrogate, 1924, *Liverpool School of Artists* (2).

BOADLE, William Barnes 1840 - 1916

Portrait painter. Born Belfast, of Quaker stock; most of his life spent in Liverpool. After starting in commerce turned to art and trained in 1871 at the Slade School under Poynter. Exhibited at the Liverpool Autumn Exhibition from 1872, beginning with genre subjects; and at the Royal Academy from 1874–1901. Member Liverpool Academy and Liverpool Artists Club. Became leading portrait painter in Liverpool for a time. Visited Buenos Aires 1888–90. Died Birkenhead 7 June 1916.

7136 Thomas Stamford Raffles

Oil on canvas, 143×113 cm. (56¼×44½ in.)
SIGNED AND DATED: *W. B. Boadle/1881*
Thomas Stamford Raffles (1818–1891), eldest son of Dr. Raffles (see Rippingille 1139), and a cousin of Sir Thomas Stamford Raffles, Governor of Java. Educated at Glasgow University; called to the bar, 1841 and joined the Northern Circuit. Appointed Stipendiary Magistrate for Liverpool, 1860. Like his father had a fine library and collected autographs.

Wrote for the local press and published a life of his father, 1863.[1]
PROV: Painted at the request of the City Justices and presented to the sitter, September 1881. Hung in the Magistrates Court.[2] Transferred from the City Estates Committee, 1969.
EXH: Walker Art Gallery, 1881, *Liverpool Autumn Exhibition* (1411).
REF: 1 Press cuttings, (Liverpool Record Office). 2 *Ibid.*

2586 William James Bishop

Oil on canvas, $51 \times 41 \cdot 2$ cm. ($20\frac{1}{8} \times 16\frac{1}{4}$ in.)

The Liverpool artist (1805–1888), *q.v.*

PROV: Presented by the Executors of the sitter, 1897.

EXH: Walker Art Gallery, 1882, *Liverpool Autumn Exhibition* (235).

3010 William Bennett

Oil on canvas, 136×108 cm. ($53\frac{1}{2} \times 42\frac{1}{2}$ in.)

William Bennett (1811–1885). Born Chester; successful ironfounder and ironmonger in Liverpool. Elected to the Council, 1846; Alderman, 1850; resigning finally in 1880; magistrate; Member of the Library, Museum and Art Gallery Committee. Died Heysham Tower, near Lancaster.[1]

He presented two paintings by Edward Armitage to the Collection, and a painting by Rosa da Tivoli (No. 134) belonged to him.

PROV: Presented to Liverpool by subscribers, 1882.

REF: 1 Press cuttings, (Liverpool Record Office).

2558 E. Rimbault Dibdin

Oil on canvas, $107 \cdot 8 \times 87$ cm. ($42\frac{1}{2} \times 34\frac{1}{4}$ in.)

SIGNED AND DATED: *W. B. Boadle/1886*

Edward Rimbault Dibdin (1853–1941), second Curator of the Walker Art Gallery. Born Edinburgh. Entered lawyer's office and in Liverpool from 1877 in insurance office. Closely associated with art circles in Edinburgh and Liverpool; a president of the Liverpool Artists' Club and the Dickens Fellowship; Art Critic for the *Liverpool Courier,* 1887–1904. Curator, 1904–1918; President of Museums Association, 1914–1918. Principally concerned with promoting Liverpool artists. His publications included a *Biographical Account of the Works of Charles Dibdin,* 1909, *Liverpool Art and Artists in the Eighteenth Century, Walpole Society Journal,* 1918 and many articles on local artists. See also his portrait by Copnall.

PROV: Presented by Mrs. S. B. Dibdin, 1942.

REF: 1 Press cuttings (Liverpool Record Office); *Museums Journal,* Vol. 40, 1940–41, p. 231.

3056 Sir James Allanson Picton

Oil on canvas, $128 \cdot 2 \times 102 \cdot 5$ cm. ($50\frac{1}{2} \times 40\frac{3}{8}$ in.)

SIGNED AND DATED: *W. B. Boadle/1887*

Sir James Allanson Picton, J.P., F.S.A., (1805–1889), educationalist, antiquary, and local historian. Born Liverpool, son of a timber merchant from Warrington. At first followed father's calling but later in spite of educational drawbacks and family responsibilities became architect and surveyor. Councillor from 1849. Promoted the provision of a free public library and gained financial backing of William Brown (see Gordon 1138); first Chairman of Library, Museum and Art Gallery Committee, 1851–1889. The Picton Reading Room, opened 1876, named after him. Knighted 1881. Member and president of various local societies including the Architectural Society and the Literary and Philosophical Society. His chief publications were the *Memorials of Liverpool,* 1873 and *Liverpool Municipal Records,* 1883 and 1886.[1]

See also his portrait by Morrison (3005); his portrait by J. E. Robertson was destroyed in the 1939–45 war. A bust by J. McBride is in the Picton Library, Liverpool City Libraries.

PROV: Presented by subscribers, 1887.

REF: 1 J. Allanson Picton, *Sir James A. Picton,* by his son, 1891; press cuttings (Liverpool Record Office).

3093 Philip Rathbone

Presented by subscribers, 1893; destroyed 1939–45 war.

BOND, William J. J. C. 1833 - 1926

Marine and landscape painter. Born Knotty Ash, near Liverpool 1833, the son of a school-master. Educated at Stonyhurst College. He wrote (1883: see 3107 below) that he was 'apprenticed to Mr. Griffiths St. Anne St. [Thomas Griffiths, miniature painter, restorer etc.,] to learn the whole trade and business of a picture restorer and cleaner after that I began to sketch a little out of doors and Mr. John Miller happening to see some of my work advised me to follow it up entirely and I have done so ever since . . .'. Exhibited at the Liverpool Academy, 1853–67; Associate, 1856; Member, 1859. Exhibited British Institution, 1859; Suffolk Street 1860–70; Royal Academy, 1871 and 1874; Liverpool Autumn Exhibition from 1871–1901. Member of Liverpool Society of Watercolour Painters. Married 1861 and settled for a time at Caernarvon but had returned to Liverpool by 1865. Assimilated the styles of several of his con-temporaries, in particular Davis, Tonge, Oakes and Huggins, and sometimes produced works in imitation of them. He was also influenced for a period by the minute vision of the Pre-Raphaelites, but in particular he came under the sway of Turner's work which formed the basis for his own mature style and which he is said to have sometimes imitated closely. His work is generally characterised by a light bright palette over a white ground, and he intended, as did Huggins, that his works should mature with keeping. Whilst producing many pictures in a more sketchy style, at his best his mature paintings have a steady even quality and show little further development after the 1870's through a long and prolific career. Watercolours by him are also in the collection. He did restoration work for the Corporation and Liverpool Royal Institution. See G. Hall Neale for his portrait. Died Freshfield, Liverpool, 1 March 1926.

7463 House at Oxton
Oil on board,[1] 26·3 × 21·2 cm. (10⅜ × 8⅜ in.)
SIGNED IN MONOGRAM: (?) CJB and signed and dated, verso: W. J. Bond 21/ AD 1854 Septr(?)
PROV: Purchased from the Boydell Galleries, Liverpool, 1970.
EXH: Boydell Galleries, 1970, Paintings. . . from the 19th Century Liverpool School (10).
REF: 1 Framemaker's label of William MacGull, Edinburgh.

1750 Raven's Fall, near Hurst Green
Oil on panel, 42 × 32 cm. (16½ × 12⅝ in.)
SIGNED: W J C BOND and in monogram CJB (in a circle).
The waterfall is between Longridge and Clitheroe, north-east of Preston, Lancashire. The monogram in this form does not appear elsewhere in the artist's works in the collection.

The detailed finish suggests an early date and James Elliot dated it to 1856.[1]
PROV: Bequeathed by James Elliot, 1917.
REF: 1 List of his donation (Gallery files).

1776 Stranded
Oil on canvas, 98 × 137 cm. (38½ × 54 in.)
SIGNED AND DATED: WJJC Bond 1866 (initials in monogram)
PROV: Presented by Col. W. Hall Walker (Lord Wavertree), 1910.
EXH: Harrogate, 1924, Liverpool School of Painters (16); Walker Art Gallery, 1960, Liverpool Academy 150th Anniversary Exhibition (80).

1357 Stranded
Oil on canvas, 91·2 × 71·7 cm. (35⅞ × 28¼ in.)
SIGNED: W J J C Bond (initials in monogram)
PROV: Bequeathed by John Elliot, 1917.

696 Making the Harbour

Oil on board,[1] 55·9×45·4 cm. (22×17⅞ in.)

SIGNED: *W J J C Bond* (initials in monogram)

PROV: John Elliot before 1909, and bequeathed by him 1917.

EXH: Bristol, 1909.

REF: **1** Label of Charles Roberson, artists' colourman, 99 Long Acre.

2746 The Parting Gleam: Old St. Benet's Abbey, Norfolk

Oil on canvas, 95·9×152·4 cm. (37¾×60 in.)

PROV: Entered Collection at unknown date.

EXH: Royal Academy, 1874 (366) with this title, and/or Royal Scottish Academy, 1874 (516) as *The Old Abbey of St. Benedict, Norfolk*.[1]

REF: **1** An almost indecipherable label gives the first and last words: Old. . . Norfolk. A picture with the second title was also exhibited at St. Helen's, 1892, *Summer Exhibition* (43), price £75.

1775 Old Mill Near Rossett

Oil on canvas, 128·3×102·3 cm. (50½×40⅜ in.)

SIGNED AND DATED: *WJJCBond 77* (initials in monogram)

PROV: John Elliot before 1908, and bequeathed by him, 1917.

EXH: (?) Walker Art Gallery, 1878, *Liverpool Autumn Exhibition* (1021), as *The Mill on the Welsh Borders;* and 1908, *Historical Exhibition of Liverpool Art* (110).

3107 The Beach at Scheveningen: arrival of the fishing fleet

Oil on canvas, 92×152·7 cm. (36¼×60⅛ in.)

SIGNED AND DATED: *WJJCBond 1878* (initials in monogram)

The artist exhibited views in Holland between 1874 and 1876. In answer to an enquiry about the title of the picture he wrote: 'The title of the picture I think must remain the arrival I think as the last boat is just coming in. They always leave in the evening or night.'[1]

PROV: Presented by William Radcliffe, 1883.

EXH: Walker Art Gallery, 1908, *Historical Exhibition of Liverpool Art* (547).

REF: **1** Letter from Beaumaris Road, Menai Bridge 24 July 1883 to unnamed correspondent, probably William Radcliffe; also containing short biography (Gallery files).

1749 On a lee shore in a gale

Oil on panel, 41×54·6 cm. (16⅛×21½ in.)

SIGNED: *W J J C Bond* (initials in monogram)

PROV: James Pelham (Blundellsands); Mrs. Pelham, from whom purchased, 1908.

EXH: Walker Art Gallery, 1908, *Historical Exhibition of Liverpool Art* (565).

561 Conway Castle

Oil on panel, 19·2×17 cm. (7 1/16×6 11/16 in.)

SIGNED AND DATED: *WJJCBond 81* (initials in monogram)

PROV: John Elliot before 1908, and bequeathed by him, 1917.

EXH: Walker Art Gallery, 1908, *Historical Exhibition of Liverpool Art* (717).

563 Ships at Anchor

Oil on panel, 20·1×17·1 cm. (7 15/16×6¾ in.)

SIGNED AND DATED: *WJJCBond 81* (initials in monogram)

PROV: John Elliot before 1908, and bequeathed by him 1917.

EXH: Walker Art Gallery, 1908, *Historical Exhibition of Liverpool Art* (727).

1364 Hoylake Fishing Boat

Oil on panel, 12×17·1 cm. (4¾×6¾ in.)

SIGNED AND DATED: *WJJCBond 84*

PROV: John Elliot before 1908, and bequeathed by him, 1917.

EXH: Walker Art Gallery, *Historical Exhibition of Liverpool Art* (132).

1365 Leasowe Shore

Oil on panel, 12·7×17·1 cm. (5×6¾ in.)

SIGNED AND DATED: *WJJCBond 84*(?)

PROV: John Elliot before 1908, and bequeathed by him, 1917.

EXH: Walker Art Gallery, 1908, *Historical Exhibition of Liverpool Art* (17).

562 On the Ogwen

Oil on board, 30·4×48·2 cm. (12×19 in.)

SIGNED AND DATED: *W J J C Bond 87*

PROV: Purchased from James King (dealer), Liverpool, 1912.

6257 Rhoscolyn
Oil on board, 30·5×48·3 cm. (12×19 in.)
SIGNED:: *W J J C Bond*
INSCRIBED, on the back: *Rhoscolyn/WJJC Bond*
PROV: Edward Rae, 1908; G. V. B. Rae;[1] Miss Sonia Rae, from whom purchased, 1964.
EXH: Walker Art Gallery, 1908, *Historical Exhibition of Liverpool Art* (668).
REF: 1 Label on the back.

1362 Fisherman and spinney
Oil on board, 30·4×47·5 cm. (12×18¾ in.)
SIGNED: *W J J C Bond*
PROV: Bequeathed by Mrs. E. Littler, 1943.

6256 Near Twizell Bridge, Northumberland
Oil on board, 30·5×49 cm. (12×19¼ in.)
SIGNED: *W J J C Bond*
INSCRIBED, on the back: *Near Twisel Bridge/ Northumberland/W J J C Bond*
PROV: Miss Sonia Rae, from whom purchased, 1964.

1363 The Path to the Church
Oil on board, 30·4×47·5 cm. (12×18¾ in.)
SIGNED: *W J J C Bond*
PROV: Bequeathed by Mrs. E. Littler, 1943.

BOND, William J. J. C.
See also HUGGINS, William
1621 Donkey and Foal

BOXALL, Sir William 1800 - 1879

3161 Mrs. William Stanley Roscoe
Oil on panel,[1] 51·7×45·3 cm. (20⅜×17⅞ in.)
Hannah Eliza (1786–1854), eldest daughter of James Caldwell of Linley Wood, Staffs., married William Stanley, eldest son of William Roscoe, in 1818. Seen here as an old lady.

A miniature by Hargreaves is also in the Collection (2188).
PROV: Bequeathed by Mrs. A. M. Roscoe, 1956.
REF: 1 Panel stamp of Brown, 163 High Holborn.

BRADLEY, William 1801 - 1857

Portrait painter, a native of Manchester. Pupil of Mather Brown and Sir Thomas Lawrence.

Made successful career in London, 1822–47. Died Manchester.

1134 John Gladstone
Oil on canvas, 241·3×148·5 cm. (95×58½ in.)
Sir John Gladstone, Bart. (1764–1851), merchant and shipowner of Liverpool, and father of W. E. Gladstone, Prime Minister (see Bigland 7000). He stands with his left hand resting on a pile of books, one inscribed *EDUCATION*, and documents lie at hand inscribed *Liverpool Docks/Dec. 1842* and *WEST INDIA ASS[OCIATION]*; a view of shipping appears at the right.

Born Leith, the eldest of seven sons of Thomas Gladstones *(sic)*, shopkeeper and corn merchant, he came to Liverpool in 1786 when 22. He joined a leading merchant house (Corrie & Company, corn merchants), of which he became sole proprietor and brought in his brothers. He was Chairman of the West India Association, founded 1809; his work for the Docks Estate resulted in the 1811 Act for extension and reconstruction. His ship was the first to open up trade with India after the

abolition of the East India Company's monopoly, 1814. He traded also with Russia and China, and later with the West Indies in sugar, and was a slaveowner with plantations in Demerara, etc. His interests also included the Liverpool Manchester railway, 1826. He promoted the foundation of the Liverpool Royal Institution, 1813, was a vice-president of the Liverpool Collegiate School, opened 1843, and made many public benefactions in Liverpool and Leith. In politics he was first a liberal and a supporter of William Roscoe, but became a Tory and Canningite. M.P. for Lancaster, 1818, Woodstock 1820, and Berwick, 1826–7. He opposed the abolition of the slave trade, and was against the repeal of the corn laws until ultimately convinced by Peel. In 1829 he purchased the Fasque estate in Kincardineshire where he settled until his death. Created baronet, 1846.[1]

He mentions sitting for his portrait in a letter to his son Robertson Gladstone, 3 February 1843, when he asked him to send copies of the last reports of the Liverpool Dock Revenue, the West India Association and the Shipowners' Association so that these could be placed on a table beneath his right hand.[2] The three-quarter length seated portrait (63 × 59 in.) at Hawarden shows him thus[3] (inscribed similarly to 1134), as does the whole length seated version of it in the Liverpool Collegiate School (inscribed similarly with the date *June 1842*), presented by Robertson Gladstone.[4] 1134 would appear to be a variant of the former with the pose slightly altered to accommodate a standing position. See also L280 below.

He was also painted by J. Graham (Liverpool Academy, 1828), and Thomas Hargreaves. A portrait by his nephew Thomas Gladstone, formerly in the Royal Society of Arts, is now in the National Portrait Gallery.

ENGR: S. W. Reynolds, 1844, 24 × 15¼ in. (published Colnaghi, 26 Feb. 1844).

PROV: Arthur S. Gladstone, who presented it, 1919.

REF: **1** D.N.B.; J. Morley, *Life of W. E. Gladstone*, 1903, I pp. 16–25, and passim. **2** S. G. Checkland, *The Gladstones, A Family Biography, 1764–1851*, 1971, p. 337: W. E. Gladstone sat to Bradley in 1838 (portrait at Hawarden). **3** Repr. J. Morley, *op. cit.*, I frontispiece. **4** D. Wainwright, *Liverpool Gentlemen*, 1960, p. 63.

L280 John Gladstone

Oil on canvas, 157·8 × 121·7 cm. (62⅛ × 47⅞ in.) Three-quarter length seated portrait, a version of the Hawarden portrait. The documents on the label are not inscribed. See 1134 above.

St. Thomas' Church, Seaforth near Liverpool was built at the expense of the sitter, 1811, near his own residence, Seaforth Hall (since demolished).

PROV: St. Thomas' Church, Seaforth (hung in the Vestry); lent to the Gallery by the Church-wardens, 1976.

BRITISH SCHOOL, 17th Century

1608 The Child of Hale

Oil on canvas, 310 × 154·9 cm. (122 × 61 in.) John Middleton (1578–1623), the Child of Hale, a giant said to be 9 feet 3 inches in height.[1] Born and lived at Hale, between Liverpool and Warrington, and buried there 23 August 1623. His cottage is still to be seen at Hale.

Matthew Gregson relates what must have been a traditional story[2] that, 'Sir Gilbert Ireland Knt. about 1617 took him to the court of James I, where he wrestled with the King's wrestler, and put out his thumb, by which awkwardness he disobliged the courtiers, and was sent back, the King giving him, as it is said £20. He returned by Brazenose College, Oxford, which was full of Lancashire students, and where his picture was taken and now exists. A likeness of this English giant is also preserved at High Leigh [*sic*] and one at Hale.'

The present picture is that formerly at

High Legh House, and is thought[3] to have been obtained by Thomas Legh who was brother-in-law to Sir Gilbert Ireland of Hale Hall, who had the probably contemporary portrait (since given to Brazenose College, Oxford: 117×65½ in.). It is less starkly 'primitive' in technique than the Hale Hall picture and could well be later in date. In both the Child appears in the costume traditionally stated to have been worn on his visit to court: a red striped doublet with lace ruffles (the stripes are much wider and more pronounced in the Hale Hall portrait); white plush breeches embroidered with blue *fleurs de lys* (which occur in the arms of the Irelands of Hale); a blue sash embroidered with gold, from which hangs a small-sword; green stockings tied at the knee with red bows. His left hand in our portrait measures from the wrist to the tip of the middle finger 15½ in.

Samuel Pepys is apparently the first to make any reference to the Child in print. On 9 June 1668 on a visit to Oxford he went to Brazenose College 'to the butteries, and in the cellar find the hand of the Child of Hales ... long' (the measurement is omitted). An outline of the hand was apparently at one time on a door-post of a cellar there but has since disappeared. Confused references to a life-size portrait at the College must in fact refer to this as the Hale Hall portrait was only presented to the College in 1924 by Colonel Ireland-Blackburne. Also at Brazenose are: two paintings of the hand, one showing a measurement of 16 in. and the other, and probably earlier representation, 11½ in.; a small oil copy of the Hale Hall portrait (26½×19½ in.) by T. B. Banner, 1842; and a watercolour (8¼×4¼ in.), probably 18th century in date.

R. Stewart-Brown quotes the first certain reference to a full-scale portrait, in the diary of a visitor to Liverpool in September 1705, who saw it at an inn which may, according to a note by Gregson, have been the *Folly* (demolished about 1785), where it was apparently nailed to the ceiling.[5] Gregson also noted another copy at the *Red Lion* at Warrington (of which the Ireland-Blackburne's were the ground landlords). The signpost of the inn at Hale is also of him.

Besides these works, all listed by Stewart-Brown, there is also a further reference to a portrait in the MS Catalogue of paintings at Knowsley, 1772,[6] where is listed: 'Child of Hale [?Winstanley] hung on the Great Stairs.' It was still there when Pennant saw it around 1801 and described it as a 'Gigantic figure.'[7] It is no longer traceable at Knowsley, and the two noted by Gregson are unidentified.

PROV: Recorded at High Legh House, Knutsford, Cheshire, from the early 19th Century;[8] presented by C. L. S. Cornwall-Legh, 1955. Hung at Speke Hall.

REF: **1** The gravestone at Hale gives the measurements, but the inscription, which avoids the crack across the centre of the stone, probably post-dates the disinterment of about 1768. **2** Matthew Gregson, *Portfolio of Fragments relating to Lancashire*, 1817, p. 212, quoted with other references, in R. Stewart-Brown, *The 'Child of Hale' (John Middleton); Some Portraits* in *Transactions of the Historic Society of Lancashire and Cheshire for 1934*, Vol. 86, 1935, pp. 73 ff. This entry is briefly based on his article. **3** High Legh Picture Catalogue, 1884, quoted in a letter from C. L. S. Cornwall-Legh, 8.8.1955. **4** R. Lane Poole, *Catalogue of Portraits at Oxford*, III p. 317; Stewart-Brown, *loc. cit.*, where all are reproduced; letter from Robin Peedell, Assistant Librarian, Brazenose College, Oxford, 10.7.1972. **5** Joseph Taylor, *A Journey to Edenborough in Scotland* (*sic*), publ. 1903 (visit to Liverpool: 14 September 1705), quoted in Stewart-Brown with MS notes by Gregson in John Rylands Library copy of his *Fragments*. **6** Archives at Knowsley. **7** Thomas Pennant, *A Tour from Downing to Alston Moor*, 1801, p. 41: 'On the staircase is a gigantic figure of John Middleton commonly called the Child of Hale. . . A picture is preserved at *Hale*, in this neighbourhood; another in the *Museum* at *Oxford*; but we know no more of him than that his height was eight feet.' **8** C. L. S. Legh, *loc. cit.*

47

BRITISH SCHOOL, late 17th Century

8627 Hon. Richard Molyneux

Oil on canvas, 127·8 × 102·2 cm. (50¼ × 40 3/16 in.)
The identity of the Sefton family portraits is traditional.

The sitter,[1] eldest son of Caryll, 3rd Viscount Molyneux (1622–1699/1700, who married about 1650), married Mary, daughter of the 1st Marquess of Powys (see Huysmans 8640 note 2); he pre-deceased his father. In half armour and holding a baton: as a noted catholic family this and 8631 might commemorate the accession of James II in 1685. A portrait of his father of about this time is ascribed to Garrett Morphey (flourished 1680–1716).[2]

PROV: Purchased from the Executors of the Estate of the 7th Earl of Sefton, 1973.

REF: **1** Croxteth Inventory, 1946, No. 3. **2** Anne Crookshank and the Knight of Glin, Exhibition Catalogue, *Irish Portraits 1660–1860*, National Gallery of Ireland etc., 1969–70, (9) in armour, 29½ × 24 in., repr.; Coll: Lord Talbot de Malahide, Malahide Castle Sale, 10–12.5.1976 (462) and now National Gallery of Ireland, at Malahide.

8631 William, later 4th Viscount Molyneux

Oil on canvas, 128·2 × 102·7 cm. (50½ × 40 7/16 in.)
The sitter (*c.* 1655–1717/18), was 3rd and youngest son of the 3rd Viscount Molyneux, whom he succeeded in 1700. In armour holding a baton.[1] See, however, 8641 below for another supposed portrait.

Married, first, Bridget, daughter and heiress of Robert Lucy of Charlcote (who must have brought the smaller version of the *Lucy Family* portrait);[2] she died 1713 and he married secondly, 1716, Mary, daughter of Lt. General Bevil Skelton; she died 1765, having married again.

He was appointed Collector of Customs at Chester, 1688, but was dismissed at the Revolution as a Papist and later, 1694, charged with receiving a Colonel's commission from King James. The appointment of Constable of Liverpool Castle was considered hereditary in the family (though Caryll, the 3rd Viscount, was stripped of this with all his offices under the Crown after the Revolution); according to family tradition, the Castle appears in the background.

William added the main west front to Croxteth Hall, 1702–14, when the former residence at Sefton was abandoned. The family had also built a town house in Lord Street, Liverpool, when the Castle became untenable in the later 17th Century.

PROV: Purchased from the Executors of the Estate of the 7th Earl of Sefton, 1974.

REF: **1** Croxteth Inventory, 1946, No. 5. **2** Christie's sale, Croxteth Hall, 17–20.9.1973 (1011), pl. 62.

8628 William, 4th Viscount Molyneux

Oil on canvas, feigned oval,[1] 76·8 × 62·9 cm. (30¼ × 24¾ in.)

The face appears identical with 8631. This may be the portrait identified in the 1946 Inventory[2] as Caryll, 3rd Viscount Molyneux (1622–1699/1700), but it does not resemble the portrait of the latter in the Malahide Collection.[3]

PROV: Purchased from the Executors of the Estate of the 7th Earl of Sefton, 1973.

REF: **1** Relined. **2** Croxteth Inventory, 1946, No. 70. **3** See 8627, note 2.

BRITISH SCHOOL, early 18th Century

8629 Richard, 5th Viscount Molyneux

Oil on canvas, 76·4×61·8 cm. (30$\frac{1}{16}$×24$\frac{3}{8}$ in.)
A shield at top left with the arms of Molyneux and Brudenell, the coronet of a Viscount above and with lion supporters, is inscribed beneath: *Richard: Vyc: Molyneux:*
Richard (1679–1738), son and heir of the 4th Viscount Molyneux.[1] Married, 15 February 1704/5, Mary, daughter of Francis Brudenell, styled Lord Brudenell (heir of 2nd Earl of Cardigan). Succeeded his father 1717/18.

Closely following a portrait ascribed to Garrett Morphey (flourished 1680–1716) in the Malahide Collection,[2] and there identified as William, 4th Viscount Molyneux. Here the wig has been reduced to a shorter more rounded form revealing the left shoulder of the sitter, and the knot of the stock differs slightly. 8629 might be a variant of what was perhaps a (?) marriage portrait, made or altered after Richard succeeded to the title.

PROV: Purchased from the Executors of the Estate of the 7th Earl of Sefton, 1973.

REF: **1** Croxteth Inventory, 1946, (?) No. 103. **2** Malahide Castle Sale (Christie's), 10–12.5.1976 (457), 29$\frac{1}{2}$×24 in. repr.

8641 (?) Richard, 5th Viscount Molyneux

Oil on canvas, 75×62·2 cm. (29$\frac{1}{2}$×24$\frac{1}{2}$ in.)
An old label (? 19th Century) identifies this as William, 4th Viscount (c. 1655–1717/18),[1] but the sitter appears different to, and younger than 8631 above, and similar though older in appearance to the portrait of Richard, 5th Viscount, 8629 above, and more particularly to its prototype in the Malahide Collection (there identified as William).[2]

PROV: Purchased from the Executors of the Estate of the 7th Earl of Sefton, 1973.

REF: **1** Croxteth Inventory, 1946, (?) No. 96. **2** See 8629, note 2.

8630 Mrs. Mary Molyneux

Oil on canvas,[1] feigned oval, 76×63 cm. (29$\frac{15}{16}$×24$\frac{13}{16}$ in.)
There are three candidates for this sitter. If the prefix *Mrs.*[2] is accurate then she should be Mary, daughter of Lord Brudenell, who married Richard, 5th Viscount Molyneux in 1704/5. She certainly resembles, though as an older woman, the portrait inscribed 'Lady Molyneux',[3] a companion in the Malahide Collection to the supposed portrait of the 4th Viscount which is perhaps the 5th Viscount mis-identified (see 8629 above).

Alternatively she appears to be identified with Lady Mary Molyneux, daughter of the Marquess of Powys and wife of Hon. Richard Molyneux, in the 1946 Inventory;[4] but does not resemble the portrait of that sitter at Coughton Court (see Huysmans 8640, note 2); and a further possibility is Mary, daughter of Lt. General Skelton, who married the 4th Viscount as his second wife in 1716.

PROV: Purchased from the Executors of the Estate of the 7th Earl of Sefton, 1973.

REF: **1** Relined. **2** A painted inscription on the back of the relining canvas reads thus. **3** Malahide Castle Sale, 10–12.5.1976 (458), repr. **4** Croxteth Inventory, 1946, No. 98.

8638 Little Girl holding a Bouquet of Flowers

Oil on canvas, 75·7×62·9 cm. (29$\frac{13}{16}$×24$\frac{3}{4}$ in.)
Possibly a child of the Molyneux family.

PROV: Purchased from the Executors of the Estate of the 7th Earl of Sefton, 1974.

REF: **1** Relined.

BRITISH SCHOOL, 18th Century

8637 Charles William, 1st Earl of Sefton

Oil on canvas, 75·7 × 62·3 cm. (29 13/16 × 24 9/16 in.)
Identified as Charles William (1748–1795)[1], son of the Hon. Thomas Joseph Molyneux (1689–1756), succeeded his uncle as 8th Viscount Molyneux, 1759. Conformed to the Established Church, 1768 and advanced as Earl of Sefton (in Ireland), 30 November 1771. Married, 27 November 1768, Isabella (1748–1819), second daughter of the 2nd Earl of Harrington (see her portrait by Gainsborough); they had one son who succeeded as 2nd Earl. Unsubstantiated accounts also suggest that Thomas Creevey, M.P., later a close friend of the 2nd Earl, was his natural son.[2]

He is dressed in a blue velvet coat with silver braided buttons, a white and silver waistcoat, and black stock. These colours are echoed in Gainsborough's portrait of Isabella. The sitter appears rather old for twenty or twenty-one.

The costume however suggests an earlier date, possibly in the later 1740's or early '50's, or a little later.[3] The sitter would then be mis-identified.

PROV: Purchased from the Executors of the Estate of the 7th Earl of Sefton, 1973.
REF: 1 Croxteth Inventory, 1946, No. 6. 2 John Gore, Creevey, 1948, pp. xxvi, 393 ff, and repr. fp. xxvi. 3 Sir Ellis Waterhouse, in a letter; Miss Anne Buck, in a letter.

3115 Liverpool from Tranmere Pool

Oil on canvas,[1] 67 × 102·5 cm. (26⅜ × 40⅜ in.)
An early view of Liverpool across the Mersey from Holt Hill overlooking Tranmere Pool. Birkenhead Priory is visible at the left and the domes of St. Paul's Church and the third Town Hall are seen in the distance.

It was presented as dating from 1769.[2] In this year P. P. Burdett announced his intended survey of Lancashire and around this period several new maps of Liverpool were being produced: Williamson, 1766; Eyes, 1768, 1785; Yates and Perry, 1768; Perry, 1769 (2). George Perry also published engravings after Michael Angelo Rooker's views of Liverpool in 1770 and 1772.[3] The present painting may have been intended for such a purpose and been connected with an increasing interest in the layout and appearance of the growing town.

Dibdin[4] attributed it to Charles Eyes (? 1754–1803), member of the Liverpool family of surveyors and map-makers (who was a founder of the Society of Artists in Liverpool in 1769). George Perry himself made various drawings of Liverpool and collected materials for a History of Liverpool (including Rooker's views), later published by Dr. Enfield. Thomas Chubbard (q.v.), exhibited a View on the River Mersey at the Free Society's Exhibition in 1771, and a W. Jackson, a portrait, landscape and marine artist, exhibited at Liverpool in 1774, 1784 and in 1787 showed a View from the River Mersey on the Cheshire side with a distant prospect of Liverpool (rather too late for this picture).

PROV: Presented by (Sir) J. A. Picton, 1873.
EXH: Wembley, 1924, Liverpool Civic Week; Birkenhead, 1927; Bluecoat Chambers, 1945, Pictures of Old Liverpool (1); Walker Art Gallery, 1970, The Taste of Yesterday (5) repr.
REF: 1 Relined. 2 At some period (see e.g. Stewart-Brown below) it was dated 1800/10, which is too late on grounds of costume and style. 3 The two watercolour views by Rooker belonged to the Earl of Sefton and are now in the Collection (8653 and 8654). 4 E. R. Dibdin, Liverpool Art and Artists in the 18th Century, in The Walpole Society Journal, 1917–18, p. 72; and see R. Stewart-Brown, Maps and Plans of Liverpool and District by the Eyes Family of Surveyors in Transactions of the Historic Society of Lancashire and Cheshire, Vol. 62, 1910, pp. 143 ff, and p. 159.

2506 Richard Gildart

Oil on canvas, 82 × 61 cm. (32¼ × 24 in.)
INSCRIBED: R. Gildart M.P./aet 95
Richard Gildart (c. 1673/4–1770), Liverpool merchant in the Virginia trade and sugar refiner, son of James Gildart or Geldart and his wife Elizabeth Sweeting, of Middleham, Yorkshire. Sworn a Freeman 2 November 1698; Common Councillor 4 August 1708 and Bailiff 1712; Mayor 1714–15, 1731–2 and 1736–7; M.P. for Liverpool 1735–1754; Alderman by 1766. Married about 1707 Ann (1690–

1742) daughter of Sir Thomas Johnson Kt., Mayor and M.P.; a daughter Ann married Spencer Steers; a son Francis was Town Clerk 1742–1780, a son James was Mayor in 1750. The sitter died 25 January 1770, aged 96 (Peet, *loc. cit.*, says 99). He was buried with his wife in the Johnson vault in St. Nicholas' Church.[1]

Family tradition states that Gildart was painted at 95 by Joseph Wright of Derby (i.e. in 1768/9, when the artist would have been in Liverpool; Peet (*loc. cit*), gives 1766, following a birth date of *c.* 1691). Peet reproduces a portrait similar in quality and in pose, but of longer format, from 2506 and showing that the sitter was gripping a long cane; this had descended through a grand-daughter to the Worsley family of Little Ponton, Lincs. Gildart *(loc. cit.)* refers to this or another copy in family ownership. 2506 must be yet another copy.[2] The original may have been by a local or a visiting artist: Gildart's name does not appear in Wright's Account Book.

PROV: Unknown, perhaps acquired about 1920.
REF: 1 *Liverpool General Advertiser*, 2 February 1770, obituary; J. Picton, *Memorials of Liverpool*, 1873, I pp. 202–3, and author's interleaved copy (Liverpool Record Office); H. Peet, *Thomas Steers, the Engineer of Liverpool's First Dock: Appendix, The Gildarts* in *Transactions of the Historic Society of Lancashire and Cheshire*, Vol. 82, 1930, pp. 221 ff and repr. p. 223; C. R. Gildart *The Gildart-Geldart Families*, 1932, pp. 13–18. 2 A portrait 60 × 40 in., artist unspecified, was offered to the Gallery in 1933 by James Geldart Riadore but declined.

3019 Robert Williamson

Oil on canvas,[1] 124·5 × 101·5 cm. (49 × 40 in.)
Robert Williamson, bookseller, printer and publisher, etc. in Liverpool. His first listed publication was the *Liverpool Memorandum Book*, which he printed and published 1752 for 1753. On 28 May 1756 he issued the first number of *Williamson's Weekly Advertiser*, which continued to appear under his name until 31 March 1769 (except in 1764 when he may have been in financial difficulties) and was subsequently taken over by A. Williamson (seemingly his sister Alice). He may have left Liverpool for Madras later.[2]

In Liverpool his address was in Castle Street and his other activities included that of stationer, editor, agent for the State Lottery Office, general broker and auctioneer, and house agent.[3]

In 1767 he printed *A Catalogue of Paintings performed by Nathaniel Tucker to be seen (at the Exhibition at the Golden Lion Inn Dale Street) Liverpool, as likewise the rules of painting*.[4] Tucker was only in Liverpool in 1766–7,[5] and nothing seems to be known about him beyond the engravings after some portraits of a much earlier date,[6] very different in style to 3019. Thus an attribution of 3019 to him though attractive cannot be substantiated; it probably dates from the late 1760's, however, and is a provincial rendering of the solid bourgeois character promulgated by Joseph Wright of Derby (who was in Liverpool during 1768–71).

PROV: Presented prior to 1873, possibly 1860.[7]
REF: 1 Relined. 2 A. H. Arkle, *Some Notes on Robert Williamson, printer and stationer*, in *Transactions of the Historic Society of Lancashire and Cheshire for 1928*, Vol. 80, 1929, pp. 147–9 (repr.). 3 J. A. Picton, *Memorials of Liverpool*, 1873, II p. 21. 4 A. J. Hawkes, *Lancashire Printed Books: a Bibliography*, 1925, p. 41; the copy at Liverpool was destroyed in the 1939–45 war. 5 *Notes and Queries*, 5 August 1933, p. 81, *Tucker and Caddick, Portrait Painters at Liverpool*, 1767. 6 B. M. Print Room and N.P.G. 7 Picton, *loc. cit.*; Charles Dyall, *First Decade of the Walker Art Gallery, A Report*, 1888, p. 7 list; listed for restoration by W. J. J. C. Bond, Committee Minutes, 2 July 1874 (Liverpool Record Office).

2548 Thomas Bentley

Oil on canvas,[1] feigned oval of simulated stonework, 105·6 × 85 cm. (41⅝ × 33½ in.)
Thomas Bentley (1730–1780), Liverpool merchant, scholar and antiquarian, and partner of Josiah Wedgwood the potter.[2] He reads from Book I of the *Life of Socrates* (by John Gilbert Cooper), page 15 *(sic)* and his finger points to phrases which can be made out: . . . *his celebrated Graces. . .|. . . were his Performances*. The book rests on a volume inscribed CHARACTERISTICKS *(Characteristics of men, manners, opinions, times*, etc., by Anthony Ashley Cooper, 3rd Earl of Shaftsbury). A pair of stone-coloured plaques, with rims, representing the Three Graces and a bust of Socrates, rest against a stack of books, one of which is

inscribed: (X)ENOPH(ON) MEMOR-(ABILIA) (of Socrates). The sitter wears a green coat and waistcoat.

A native of Derbyshire, born 1 January 1730 (o.s.) of farming stock, he was educated in a Presbyterian Academy and afterwards apprenticed to a Manchester merchant in the wool and cotton trade. He visited France and Italy, 1753, and afterwards set up in King Street, Liverpool as a woollen warehouseman and cotton agent, with a house in Paradise Street. He later became a general agent with Samuel Boardman as partner.

As a cultivated and sociable man of wide interests, he was a prominent member of the literary and philosphical circles in Liverpool. He helped to found the dissenting Academy at Warrington, 1757; was a founder of Liverpool Library, 1758, and the Octagon Chapel in Temple Street (built 1762); was connected with the Town Council; wrote for *The Gentleman's Magazine* and *The Monthly Review;* was instrumental in plans for a new canal scheme to link up the potteries with Liverpool, 1766–77; drained part of Chat Moss for farming; and was an early and keen opponent of the slave trade. He was a member of the Liverpool Regiment of Volunteers.

In 1762 he met Josiah Wedgwood (1730–1795) and became an intimate friend. Acted as his agent in Liverpool as a major exporter of his earthenwares, which became the chief part of his business. Wedgwood suggested a partnership and move to Staffordshire in 1767: 'You have taste', he wrote, 'the best foundation for our intended concern', but added, 'the leaving your friends, and the giving up of a thousand agreeable connections and pleasures at Liverpool . . . this staggers my hopes . . .'[3] Bentley finally agreed to a partnership which took effect in November 1768 and after a visit to Wedgwood at Burslem moved to new headquarters at London in August 1769. His cultivation and charm were an important factor in the advancement of the firm's business; he introduced Flaxman as a designer in 1774. Twice married, he had no children, and died at Turnham Green, London, 26 November 1780. A monument to him by Scheemakers was erected by Wedgwood in Chiswick Church. His likeness appears also in Wedgwood portrait medallions.[4]

Several painted portraits of him are recorded but the artists are uncertain: a portrait by 'Caddick' belonged to his early biographer Joseph Boardman, son of his Liverpool partner;[5] a confused list, published 1927, adds a further portrait 'in military dress,' by Caddick probably when a Volunteer;[6] a 'Copy of Mr. Bentley Kit cat, £21' is listed by Joseph Wright of Derby after 1780,[7] which might be this sitter. Three certain portraits are now known of which the present picture and another at the Wedgwood Museum are identical compositions. The third picture (in Liverpool Museum, destroyed 1939–45 war), perhaps by Caddick, was in Joseph Mayer's collection, may have been Boardman's portrait, and was engraved in Meteyard's life of Wedgwood as by Chubbard.[8] It was a straightforward likeness, half-length, full face in high buttoned coat, with no attributes of learning.

The present portrait has a definite programme content. The books and plaques indicate the source of Bentley's philosophic and artistic inheritance through his immediate 18th century predecessors to its ultimate foundation in Socrates. He would have known the engraving after Shaftesbury's own portrait by Closterman which prominently displays volumes of Xenophon and Plato. The author from whom he reads, John Gilbert Cooper (1723–1769), was himself an enthusiastic disciple of Shaftesbury and in his *Life of Socrates* collected from the Memorabilia of Xenophon and the dialogues of Plato (first published 1749; 4th edition 1771), in Book I page 14 (here transposed to the right hand side on page 15), he wrote of Socrates' youth: '. . .as several Authors affirm, the celebrated *Graces,* carv'd on the walls of the Citadel at *Athens* behind the statue of *Minerva,* were his Performances. An early Indication of the Propensity of his Mind to Beauty! From this, compar'd with his Life and Doctrines, we may perceive what invariable Anology there is between a Taste for moral and for natural Comeliness. . .' in a footnote he refers the reader to the third book of Xenophon, the *Characteristics,* and to Hutcheson's *Enquiry into the Origin of our Ideas of Good and Beauty.*

This evident compliment to Bentley must have a more specific significance by the repetition of the Three Graces motif in the plaque of Socrates' early type of the Three Graces draped, and of his bust. The former, signifying generosity and the giving, accepting and returning of favours, may on the one hand refer to the sitter's own contribution as philosopher, writer and connoisseur, as well as

indicating the source of his inspiration in antiquity in the latter.

On the other hand they may also refer tangibly to his association with Wedgwood and his introduction of this type of subject into the firm's production. While Wedgwood plaques of this apparent size are known,[9] these particular subjects exist only on a smaller scale, the former at least in a slightly different pose of the figures. The portrait or its prototype, may therefore be a memorial to him post-dating his move from Liverpool and perhaps after his death, rather than a commemoration of his departure which may have been commissioned perhaps by his Liverpool 'philosophical friends.'

The authorship is bound up with the version now at Burslem. The latter, of similar size (38×28 in.), varies in several minor details: the feigned oval is cut off on all four sides; the sitter appears fatter; he is seated in a brass-buttoned chair; his waistcoat is more open and the cuff of his jacket cut open at the side; the book he holds is more stylised and the writing cannot be read in such detail; one plaque is without a rim and the other books vary slightly. It belonged to Mrs. Marsh Caldwell of Linley Wood when exhibited and photographed at the National Portrait Exhibition 1867 and was then ascribed to Wright of Derby.[10] Nicholson does not consider it by Wright.[11]

2548 comes from the Roscoe family but it is not certain whether William Roscoe had it; his daughter-in-law, Mrs. William Stanley Roscoe was a Caldwell, whose mother Mrs. Elizabeth Caldwell was a niece of the second Mrs. Bentley.[12] It could therefore be drawn from the same source as the Burslem picture.

2548 itself appears to be by a provincial hand; Caddick seems accounted for; the portrait style of the sitter's other Liverpool friend, Chubbard, (q.v.) is hardly known. While it would appear to be the more significant of these two versions, a primary source for both must be considered. It might just be noted that (?John) Williamson certainly copied another Wright portrait after 1800,[13] and Roscoe was his friend and patron.

PROV: Bequeathed by Mrs. A. M. Roscoe, 1950.

REF: **1** Relined. **2** For biography, besides D.N.B.: Joseph Boardman, *Bentleyana, a Memoir of Thomas Bentley*, 1851; E. Meteyard, *The Life of Josiah Wedgwood*, 1885, I, p. xvii

and passim; 'R. Bentley', *Thomas Bentley of Liverpool, Etruria and London*, 1927; Lady Farrer, *Letters of Josiah Wedgwood, 1762–1770*, 1903. **3** Farrer, *op. cit.*, pp. 183–186, Wedgwood to Bentley, 8 November, 1767. **4** Robin Reilly and George Savage, *Wedgwood, the Portrait Medallions*, 1973, p. 60. **5** J. Boardman, *op. cit.*, p. 12. **6** R. Bentley, *op. cit.*, p. 79 (list). **7** B. Nicholson, *Joseph Wright of Derby*, 1968, I, p. 180. **8** Meteyard, *op. cit.*, II, frontispiece and p. xiv. **9** See W. Mankowitz, *Wedgwood*, 1953, pp. 230, 238; a 15 in., medallion was in a London sale 8.1.1974. *The Three Graces* is not identical with e.g. that repr. in C. Macht, *Classical Wedgwood Designs*, 1957, pp. 72–3, fig. 44, but does not appear to be directly after the antique (letter from Denys Haynes, British Museum, 10.12.1974). **10** Thence to Captain C. H. Caldwell, sold Sotheby's 2.11.1949 (84), bt. Knoedler for Sir Ralph Wedgwood. Leigh Hill Place (information from Bruce Tattersall, Wedgwood Museum); repr.: Ann Finer and George Savage, *The Selected Letters of Josiah Wedgwood*, 1965, fp. xiv (the shirt ruff has been altered since 1867). **11** Nicholson, *loc. cit.* **12** Llewellyn Jewitt, *The Wedgwoods*, 1865, pp. 166, 213. **13** Nicholson, *op. cit.*, I, p. 179, No. 10, a copy of Master John Ashton and Dog (of Woolton Hall, near Liverpool).

BRITISH SCHOOL, late 18th Century

6252 The Leicester Family

Oil on canvas, 100·6 × 121·3 cm. (39⅝ × 47¾ in.)

Identified as portraits of the grandparents of Miss Mary Leicester.[1] These would be Ellen and Peter Leicester (timber merchant) of Liverpool, with possibly their two fathers, and their child who was a brother of Miss Leicester's father the Rev. Robert Leicester, Vicar of Much Woolton (died 1875). Ellen Leicester died in 1830, aged 62. This portrait group probably dates from the 1790's. Miss Leicester was in 1859 a co-heir of the Pickmere property of an earlier Cheshire branch of the Leicester family of Hale Lowe and Pickmere.[2]

PROV: Miss Mary Leicester, Gateacre, Liverpool, who bequeathed it, 1919, to the brother of the last owner; thence to Miss M. G. Findlay, god-daughter of Miss Leicester, who bequeathed it 1964.

REF: **1** Note by Miss Findlay, 13 January 1954. **2** R. Stewart-Brown, genealogy in *Cheshire Sheaf*, 1920.

1740 The Burning of Liverpool Exchange

Oil on canvas, 92 × 122·5 cm. (36¼ × 48¼ in.)

The third Exchange at Liverpool, now the Town Hall (by John Wood, 1749–54) was gutted by fire early on Sunday 18 January 1795 when the upper floors and their contents were destroyed. Watercarts and pumping engine are shown drawn up outside the blazing building watched by an orderly crowd controlled by militia with rifles: the heart of the fire is in the first floor room to the left of the entrance.

The Exchange Keeper, Elias Jones, was awakened by smoke between 4 and 5 a.m. on 18 January and after trying to reach the source of the fire, a faulty chimney in the Council room, gave the alarm. The fire was at first confined to the one area when the first fire engines came up, but an adequate supply of water was the main problem and the whole building was eventually ablaze. Many private watercarts were brought to the scene to assist the town engines and the Corporation expressed their thanks in advertisements in the newspapers:[1]

The Mayor of Liverpool takes the earliest opportunity to express the most grateful Thanks of the CORPORATION to MAJOR CLARKSON, and the OFFICERS of the SOUTHERN FENCIBLES, for the very great Order which they were the Means of preserving at the unfortunate FIRE which took place this day in the Exchange, and also to the GENTLEMEN and other INHABITANTS of the Town, who so actively, strenuously and spiritedly assisted on this unhappy Event: And he has, at the same time, great satisfaction, in informing the Public, that the RECORDS, DEEDS, and other Municipal PAPERS belonging to the Corporation are in a perfect state of Preservation The Mayor, on behalf of the CORPORATION wishes to give their best thanks to Mr. KIRKMAN, one of the Proprietors of the Union Cotton Mill, for the very effective assistance rendered, by means of his *ENGINE* and *MEN* at the late Unfortunate *FIRE* in the *EXCHANGE;* and also to the other *GENTLEMEN* who so kindly contributed their assistance of WATER CARTS and MEN, on the same occasion.[2]

The town was itself well supplied with engines[3] and the Corporation was insured with the Sun Office. The latter, through its local agent, William Pole, haggled over the expenses incurred in the fire, at first declining to pay and subsequently offering two-thirds of the £123 involved.[4]

This picture appears to be a near contemporary record of the scene (at time of donation attributed to Joseph Wright of Derby). Two vigorous coloured sketches by (?) John Foster, the Corporation Surveyor, show the same view from Castle Street and the South West aspect.[5] They suggest that the occasion was considerably more confused than appears in this orderly picture.

PROV: Presented by E. S. S. Samuell, 1865.[6]

REF: **1** Reports to Special Council Meeting, 20 January 1795 *et seq* (Liverpool Record Office). **2** *Gore's Liverpool Advertiser*, Thursday 22 January 1795; repeated in *Billinge's Liverpool Advertiser*, 26 January. **3** See P. C. Brown, *Fire Insurance in Liverpool*, in *Transactions of the Historic Society of Lancashire and Cheshire*, Vol. 78, 1927. **4** Exchange Committee, 26 January and 14 March 1795, *loc. cit.*

5 Foster-Tinne Papers, 9 and 10, (Liverpool Record Office): reproduced as chromolithographs in W. G. Herdman, *Pictorial* *Records of Ancient Liverpool*, 1856. 6 Library, Museum and Art Gallery Committee, Minutes, 1 June 1865.

BRITISH SCHOOL, early 19th Century

7026 John Bridge Aspinall, Mayor of Liverpool

Oil on canvas,[1] 237 × 148 cm. (93¼ × 58¼ in.)

Alderman John Bridge Aspinall (d. 1830), in his robes as Mayor of Liverpool, 1803; the Town Hall appears in the right background. He and his family were West Indian merchants and he was a plumber and glazier with works in Park Lane and a house in the fashionable Duke Street; he retired from business in 1808.[2] He was a man much esteemed in his day, active in party politics in the Tory interest and a supporter of General Gascoigne at the various elections.[3] His children and grandchildren were also important Liverpool figures. He died at Bath, where he had property and was buried in the Abbey Church.[4]

See also his portrait by Mather Brown (7041).

PROV: Presented to Liverpool by Clarke Aspinall, grandson of the sitter 1851;[5] transferred from City Estates Committee, 1968 (hung in the Town Hall).

REF: 1 Relined; an unidentified wax seal is on the back. 2 J. A. Picton, *Memorials of Liverpool*, 1873, II p. 312 and 1903, I p. 283; Gore's *Directories*; *Liverpool Courier*, 3 August 1808, advert. 3 [Aspinall], *Liverpool a few years since*, 1885, p. 33; W. Lewin, *Clarke Aspinall: a biography*, 1893, pp. 42, 47, 50. 4 *Liverpool's Legion of Honour*, 1893, p. 139. 5 Lewin, *loc. cit*; Committee Minutes, 12 Nov. 1851.

2587 John Bridge Aspinall

Oil on canvas,[1] 72·5 × 49 cm. (28½ × 19¼ in.)

The composition is that of 7026 but with freer treatment of the head, slight differences in the pose of the sitter's right hand, a more carefully constructed carpet pattern, and trees and clouds in place of the view of the Town Hall. Possibly a first design on which 7026 was based rather than a reduced version.

PROV: R. A. Aspinall, who presented it to Liverpool, 1858.[2]

REF: 1 Relined. 2 Label on frame (no size is given in Aspinall's letter offering a portrait in the Committee Minutes of 27 May 1858).

949 Everton Village

Oil on canvas, 94 × 128·3 cm. (37 × 50½ in.)

The village street, seen from the north and looking back towards the centre of Liverpool. The second house on the right is supposed to have been Molly Bushall's, the inventor of Everton Toffee. At the left is the market cross in the form of a sundial with a balustered base, which does not agree with other descriptions (in particular Herdman, who illustrates it as a straightsided column). The 'cross' was taken down 1820 and preserved in the Round House on Everton Brow.

949 was formerly attributed to Charles Towne and gives some indication of his influence. Compositionally it comes close to John Pennington.

PROV: Purchased through Grindley and Palmer, Liverpool, May 1883.

EXH: Walker Art Gallery, 1908, *Historical Exhibition of Liverpool Art* (568a).

2400 Brickfield, (?) Denison Street, Liverpool

Oil on canvas, 69·8 × 89 cm. (27½ × 35 in.)

In the foreground a workman at his table makes bricks in the open air; a boy stands ready at his side while another at the right is perhaps starting a new line alongside the three hacks of drying bricks; the woman has probably brought fresh water. In the background beyond excavations and piles of clay are the kilns. The windmills in the distance may represent the line of the Mersey with the skyline of the Wallasey to Hoylake coast beyond. Central Liverpool would be hidden behind the hillock at the left.

Mr. Brook's Brick Yard is marked on Parry's map of Liverpool for 1769 on a site below Old

Hall Street and north of Queen Street, slightly in-town from what was to become in 1785 Denison Street. A blank appears on the same position in later maps until 1803, but on the map of 1807 the area is marked as a coal yard and canal basin. The location of 2400, which appears well post–1800 in date, may therefore be elsewhere and indeed another part of the North-West. The type of the workman's moulding table appears of simpler form than either the Nottingham or Staffordshire examples reproduced by Dobson.[1]

From the same source as 137 but evidently by a different hand.

PROV: D. D. Burrell, Oxton, in 1907. Purchased from R. Langley, dealer, Chester, 1948.

EXH: Walker Art Gallery, 1907, *700th Anniversary Exhibition of the Foundation of Liverpool* (116) as *View from Denison St;*[2] Manchester, 1968, *Art and the Industrial Revolution* (6); Walker Art Gallery, 1970, *The Taste of Yesterday* (12) repr.

REF: **1** E. Dobson, *A Rudimentary Treatise on the Manufacture of Bricks and Tiles*, 1899 edit. p. 68 fig. 6 and p. 103 fig. 4. **2** MS Label.

137 The North Shore

Oil on canvas, $59 \cdot 5 \times 90 \cdot 8$ cm. ($23\frac{1}{2} \times 35\frac{3}{4}$ in.)

View of the foreshore at the entrance of the Mersey. *James Lowes Rotunda Hotel*, formed from an old windmill, is at the right. The site was near the present Formby Street off Great Howard Street, now occupied by Waterloo Docks (opened 1834), and was a favourite resort at the edge of the town until overtaken by the docks. The *Rotunda* is also visible in the left background of Samuel Williamson's *Liverpool from Bootle Sands* (2285), and was still there in Picton's time.[1]

Views on the North Shore are recorded in the Liverpool Academy Exhibitions, by R. Jenkinson (1811 and 1812), A. Ralson (1811), and J. Pennington (1825).

PROV: Robert Dean (Salt Merchant, Irwell Place) in 1848; Donald Dean Burrell, Oxton, in 1907.[2] Purchased from R. Langley, dealer, Chester, 1948.

EXH: Walker Art Gallery, 1907, *700th Anniversary Exhibition of the Foundation of Liverpool* (115) as *The North Shore, site of Stanley Dock.*

REF: **1** J. A. Picton, *Memorials of Liverpool*, 1873, II p. 52. **2** MS. label, post–1907.

7001 Thomas Golightly

Oil on canvas, $89 \times 69 \cdot 2$ cm. ($35 \times 27\frac{1}{4}$ in.)

Thomas Golightly (1732–1821), Liverpool merchant, as an old man. Elected to Liverpool Council 1769; Bailiff 1770; Mayor 1772–3; J.P. 1779; from 1789–1820 a Senior Member of the Council and Treasurer. Married Ann, daughter of Spencer Steers, son of the Dock engineer. A monument to them both by Spence was formerly in St. Nicholas' Church.

In 1791 during his term of office as Treasurer the Burgesses pressed the Council to publish its accounts and on Golightly's refusal took out a writ. In spite of two court judgements in their favour they were finally forced to abandon the prosecution before the Council's superior financial forces, and the abuse continued until the Municipal Reform Act of 1835.[1]

PROV: Presented to Liverpool by the widow and sister of Richard Golightly Boydell of Rossett, great-grandson of the sitter, October 1923;[2] transferred from City Estates Committee, 1967.

REF: **1** H. Peet, *Thomas Steers, the Engineer of Liverpool's first Dock*, in *Transactions of the Historic Society of Lancashire and Cheshire*, Vol. 82, 1930, p. 199; J. A. Picton, *Memorials of Liverpool*, 1873, I, pp. 264–5, and *Municipal Archives and Records*, 1886, pp. 207–8. **2** Label, verso, with a coat of arms.

7481 Portrait of a Liverpool sitter

Oil on canvas, $101 \cdot 6 \times 127$ cm. (40×50 in.)

He holds a pamphlet inscribed *REPORT*.

PROV: Transferred from Liverpool City Library, 1971.

L250 Joseph Brackley

Oil on canvas, feigned oval, $62 \cdot 5 \times 50$ cm. ($20\frac{5}{8} \times 19\frac{5}{8}$ in.)

Joseph Brackley (about 1780–post 1864) son of a labourer. He was educated at the Blue Coat Hospital which he entered 30 June 1788;[1] he left in December 1794 to go to sea and became an eminent ship owner. In 1864 he visited the school and gave sixty guineas for the years since he left and requested that a portrait of him might be placed somewhere in the school after his death, his 'only wish being that it might have a place in the building he had loved so long and so well.'[2] In the portrait he appears to be in his forties or fifties.

A Trustee of the School 1838–9 and a benefactor.

PROV: Bequeathed to the Blue Coat Hospital by the sitter; lent by the Blue Coat School, 1975.

REF: **1** MS Minutes of Governors' Meeting, 30 June 1788, 30 December 1794 (Liverpool Record Office). **2** J. P. Hughes, *Sketch of the History of the Liverpool Blue Coat Hospital,* in *Transactions of the Historic Society of Lancashire and Cheshire,* 1861, Vol. 13, p. 96.

9263 Rev. J. B. Monk

Oil on canvas, 56·2 × 47·2 cm. (22⅛ × 18⅝ in.)

Rev. John Bouchey Monk (1791–1861), first Head Master of the Royal Institution School, Liverpool. Born Liverpool, 22 April 1791, son of the Rev. George Monk; educated at Trinity College, Cambridge; B.A. 1812, Fellow 1813, M.A. 1815. In 1818 appointed curate of St. John's Haymarket, Liverpool and February 1819 – December 1828 Head Master of the new Royal Institution Schools. Afterwards minister of St. Martin's in the Fields, Vauxhall Road and Chaplain of St. George's Church; Vice-President of the Royal Institution, 1835–37.[1]

PROV: Liverpool Royal Institution; presented by Liverpool University from the L.R.I., 1977.

REF: **1** A. T. Brown, *Some Account of the Royal Institution School,* 2nd edition, 1927, I pp. 14, 53, 107; repr. fp. 134.

7480 Joseph Williamson

Oil on canvas, 124·5 × 99·1 cm. (49 × 39 in.)

Joseph Williamson (1769–1840), the 'King of Edge Hill'. His obituary notice described him as 'a person of very eccentric habits, and well known in his own neighbourhood by a peculiar and to all persons but himself seemingly ridiculous propensity of making extensive excavations under the earth.'[1]

Born at Warrington 10 March 1769, he came to Liverpool, according to his own account[2] as a poor boy, was apprenticed to Thomas Moss Tate, tobacco merchant and probably to his father, Richard Tate, (see Tate 9062), married his master's daughter Elizabeth in 1802, (sister of Thomas), and succeeded to the business, from which he retired 1818, having made his fortune. He built various curiously constructed houses on his land in Mason Street, Edge Hill, and constructed extensive and apparently useless tunnels in the rock beneath, which provided employment for the poor of the neighbourhood (since largely filled in). He patronised Cornelius Henderson, the artist *(q.v.),* for whom he built a house and left a legacy. Henderson threatened Joseph Stonehouse with litigation if he attempted to read in public his account of Williamson's excavations.[3]

According to Stonehouse[4] Williamson's costume was remarkable, 'His hat was what might have been called "a shocking bad one". He generally wore an old and very much patched brown coat, corderoy breeches, and thick, slovenly shoes; but his underclothing was always of the finest description, and faultless in cleanliness and colour. His manners were ordinarily rough and uncouth, speaking gruffly, and even rudely when he did not take to anyone. Yet, strange to say, at a private dinner or evening party, [he] exhibited a gentleness of manner, when he chose, which made him a welcome guest. His fine, well-shaped, head and face made him, when well-dressed, present a really distinguished appearance. He seemed to be possessed of two opposite natures – the rough and the smooth.'

A former (damaged) label attached to this portrait, apparently in the sitter's hand, stated:[5] 'This half-painted Portrait must not be sold at a price less than [–] 5 guineas on account [of being a good like]ness of me when I was half-seas over 10th March 18[– –]' The sitter was fifty in 1819, which makes the portrait too early to be likely to be by Henderson. J. Jenkinson of Liverpool is a possible candidate. A portrait by Henderson of August 1828 (30 × 25 in.), belonged to Frederick G. Yates in 1927,[6] and one dated 15 December 1838 (27½ × 24¼ in.), and possibly also by Henderson, belonged to G. Turner of Liverpool in 1916.[7] A photograph of the sitter is also recorded.[8]

Williamson died 1 May 1840 and a sale of his effects was held 5 June 1841.[9] This included a series of portraits of public figures: the Duke of Wellington, Lord Nelson, Napoleon Buonaparte, William Roscoe and a three-quarter length of General Gascoigne (see Lonsdale 2284). Were these perhaps by Henderson? Also in the sale were portraits of her own family by his wife who must have been an amateur artist like other members of her family.

PROV: Given by the sitter to Joseph Williamson Sedgwick, his godson (b. 1824); thence to his daughter Miss Lucy Sedgwick, who presented

57

it to Liverpool City Library, through C. R. Hand, 1926; transferred to the Gallery, 1971.

REF: 1 Obituary, *Liverpool Mercury*, 8 May 1840, quoted in Charles R. Hand, *Joseph Williamson, the King of Edge Hill*, in *Transactions of the Historic Society of Lancashire and Cheshire*, Vol. 79, 1927, pp. 100–101. 2 Hand quoting Stonehouse's MS Account of *Excavations at Edgehill* (intended for delivery in 1844), in *Transactions*, Vol. 68, 1916, pp. 1 ff. (MS.: Liverpool Record Office 942.721.1. EDG) and Joseph Stonehouse, *Recollections of Old Liverpool*, 1863, pp. 168 ff. and *The Streets of Liverpool*, 1870, pp. 130 ff. 3 *Transactions*, 1916, *loc. cit.* 4 Joseph Stonehouse, *Recollections of Old Liverpool*, 1863, p. 171 and with variations in his *Account*, *Transactions*, 1916, *loc. cit.* 5 *Transactions*, 1927, *loc. cit.*, repr. with label visible. 6 Hand, *Transactions*, 1927, repr. fp. 95. 7 Hand, *Transactions*, 1916, frontispiece, and 1927, repr. fp. 94. 8 *Ibid*, repr. fp. 96. 9 *Liverpool Mercury*, 4 June 1841, notice of sale.

BRITISH SCHOOL, 19th Century

2557 John Naylor Wright, Mayor of Liverpool

Oil on canvas, 91·5 × 71 cm. (36 × 28 in.)

John Naylor Wright (1788–1850), merchant, in robes as Mayor of Liverpool, to which he was elected in 1816 and 1833. The portrait must date from the latter period but the artist has not been identified.

Born Liverpool 23 March 1788,[1] the son of William Naylor Wright (d. 1809), one of the chief shipbuilders of Liverpool.[2] The sitter appears to have succeeded his father as merchant in St. Anne Street, later moved to Everton and finally to Princes Park, where he died 9 February 1850.[3] A stained glass window to his memory was erected in St. Nicholas' Church in 1853 by his widow Frances Wright.[4] He was an honorary member of Liverpool Academy 1810–1814.

The influence of Lawrence is apparent in the vigorous handling, and with the assured characterisation suggests William Bradley (*q.v.*) as a possible but not quite convincing candidate.

PROV: Presented to Liverpool by C. Rawson, 1866.[5]

REF: 1 St. Nicholas' Church Baptismal Register (Liverpool Record Office). 2 R. Stewart-Brown, *Liverpool Ships in the 18th Century*, 1932, pp. 127–129. 3 St. Nicholas' Church Register of Burials. He was re-buried in St. James's Cemetary, 1855 (*Liverpool Epitaphs*). 4 Henry Peet, *Liverpool in the Reign of Queen Ann*, 1908, p. 135, where it is described. 5 Library, Museum and Art Gallery Committee, 15 November, 1866 (Liverpool Record Office).

9194 Member of the Brancker Family

Oil on canvas, 76 × 63·5 cm. (30 × 25 in.)

Traditionally a portrait of John Brancker (1795–1871), fifth son of Peter Whitfield Brancker (see Allen 9055).

The sitter is a very much older man than appears in the miniature by Turmeau of 1838 (family ownership and now Walker Art Gallery), but the portrait can hardly be later than mid-19th century and is not particularly like.

John Brancker began his business career in Hamburg and married Marianne Grien in 1817. He later returned to Liverpool as a produce broker, principally in the West Indian Trade. He was a Town Councillor 1852–58. J.P. A promoter of the Liverpool Philharmonic Society and laid the foundation stone of the Hall in 1846. His only son, John Barnes Brancker of Greenbank was a chairman of the Dock Board and an important Liverpool public figure.[1]

PROV: By descent to the great-grandson of the sitter, H. M. Cubitt; presented by the Trustees of Mrs. Cubitt, 1976.

REF: 1 *Liverpool Courier*, 3 June 1903, *The Branckers of Liverpool* (by W. A. Stibbard), in obituary notice on John Barnes Brancker (Liverpool Record Office); H. Shimmin, *Portraits of Liverpool Town Councillors*, 1857; MS material on Brancker family (photocopies Liverpool Record Office).

2550 Old Plough Inn, Walton

Oil on canvas, 59·8×77·8 cm. (23½×30⅝ in.)

INSCRIBED, verso: *Old Plough Walton/taken down A D 1846*

The site was in the present Rice Lane on the road to Aintree, in what was then a rural community.

PROV: Bequeathed through Mrs. Benson, Anfield, Liverpool, 1948.

BRITISH SCHOOL, late 19th Century

7198 Sir Andrew Barcley Walker, Bart.

Oil on canvas, 139·7×99 cm. (55×39 in.)

Probably dating from the late 1860's. For biography see the portrait after Orchardson (3016).

PROV: Presented by Walker Cain Ltd., Liverpool from their head office, Duke Street, Liverpool, 1970.

L141 S.S. 'Truthful'

Oil on canvas, 60·5×91·3 cm. (23¾×35¹⁵⁄₁₆ in.)

Iron steamship of 1212 tons, built 1877 at Newcastle by Palmers & Co. for F. H. Powell and Company for their Liverpool-London passenger and cargo service.[1] Their pennant appears at the masthead.

PROV: Coast Lines Ltd., who presented it to Liverpool City Libraries, 1956; thence lent to the Gallery, 1973.

REF: 1 Information from Keeper of Shipping, Liverpool Museum.

7484 Rev. Alexander Whishaw

Oil on canvas, 71·1×91·4 cm. (28×36 in.)

The Rev. Alexander Whishaw (1823–1882), Chaplain to the School for the Blind in Liverpool. Born St. Petersburg, the son of an English merchant of Cheshire stock. Educated at Glasgow University and Trinity College, Oxford. Vicar of Chipping Norton, 1850–66, where his pupils included Charles Parnell; a Minor Canon at Gloucester and finally Chaplain at Liverpool, where he was a popular preacher, and a broad churchman in his sympathies. He was a good musician, an amateur painter (he exhibited at the L.A.E., 1873) a linguist, and a cultivated and witty raconteur; a friend of Wilberforce, Bishop of Oxford. He married three times.[1]

PROV: Presented to (?) the Blind School 6 February, 1883 by a group of personal friends (John Aikin, G. R. Cox, James Lister, A. G. Kurtz, Fred Massey, Edward Rayner, Alf Culshaw).[2] Transferred from Liverpool City Library to the Gallery, 1971.

REF: 1 M. S. Leigh, *A History of the Whishaw Family*, 1935, pp. 167–9. 2 From an inscription on the frame.

7134 John Weightman

Oil on canvas, 142·5×112 cm. (56⅛×44⅛ in.)

Alderman John Weightman (1798–1883), Chairman of the Finance and Estate Committee 1872–1881. Born London, he entered the Liverpool Borough Surveyor's Office under John Foster in 1824, was for a period in private practice and then from 1848–1864 was Corporation Surveyor. Elected Alderman 1868. He made a great reputation as a manager and administrator of the Corporation estate during a great period of expansion.[1]

PROV: Transferred from the City Estates Committee, 1968.

REF: 1 Liverpool Obituary Notices (Liverpool Record Office).

7780 William Henry Watts, Lord Mayor of Liverpool

Oil on canvas, 126×100·5 cm. (49⅝×39½ in.)

William Henry Watts, J.P. (1825–1924), in robes of office as Lord Mayor of Liverpool, 1894–5.

PROV: Transferred from the Municipal Offices, 1968.

BROCKBANK, Albert Ernest 1862 - 1958

Portrait and landscape painter. Born Liverpool 20 February 1862. Studied at Liverpool School of Art evening classes and the Liverpool Academy while working in an office. Then studied in London and at the Académie Julian, Paris. Lived at Formby. Exhibited at the Liverpool Autumn Exhibitions from 1881 and at the Royal Academy from 1886; also with the R.B.A., of which Member for a period from 1892. Member of Liver Sketching Club (President 1898) and Liverpool Academy (President 1914). Living near Kendal during part of 1939–45 War. Died Liverpool.

7142 Captain Cecil Heywood-Brunner
Oil on canvas, 92×71 cm. (36¼×28 in.)
SIGNED AND DATED: *A. E. Brockbank, 1920*
Captain Cecil Heywood-Brunner, J.P., of the 23rd West Lancashire Brigade R.F.A., died of wounds in Belgium 1914–18 war.
PROV: Transferred from City Estates Committee, 1969.
EXH: Walker Art Gallery, 1920, *Liverpool Autumn Exhibition* (731) repr.

6108 Back Goree
Oil on canvas, 71×91·4 cm. (28×36 in.)
SIGNED: *A. E. Brockbank.*
View of the overhead-railway and the Liver Buildings.
PROV: In artist's studio 1940; presented by the Rev. R. Denton, nephew of the artist, 1961.
EXH: Walker Art Gallery, 1929, *Liverpool Autumn Exhibition* (216) repr.

BROWN, Mather 1761 - 1831

Portrait painter. Born Boston, Mass. Followed Copley and West to London in search of a fashionable career and settled there after initial period in Paris. Exhibited Royal Academy 1782–1831. In spite of West's patronage and appointment as portrait and subsequently historical painter to the Duke of York, achieved only limited success and moved to the provinces. Was living in Liverpool 1810–13 and was elected a Member of the Liverpool Academy with whom exhibited 1810–22. Whilst here he wrote to his family: 'I sometimes sit down in despair and scarcely know where to go next. Some persons think I had better go to New York.' Moved afterwards to Manchester and returned to London 1824, continuing to paint portraits and historical subjects in an already outdated style until his death there, 1 June 1831.

7041 John Bridge Aspinall
Oil on canvas, 76×64·2 cm. (30×25¼ in.)
SIGNED: *Mather Brown/pinxt*
For the sitter see British School 7026.
PROV: By descent in the family of the sitter.[1] Presented to Liverpool Corporation by Captain O. Addison William Williamson, (?) post 1922; transferred to the Walker Art Gallery from City Estates Committee, 1967.
EXH: Probably Liverpool Academy, 1810 (52); Walker Art Gallery, 1970, *Taste of Yesterday* (6) repr., and 1976–7, *American Artists in Europe, 1810–1900* (22) repr.
REF: 1 Partially obscured label.

BROWN, BARNES and BELL

A firm of Photographers in Liverpool and Manchester, founded about 1865.

2560 Edward Sunners
Oil on canvas, 76·2×61 cm. (30×24 in.)
INSCRIBED AND DATED: *Brown Barnes &
Bell 1887*
Edward Sunners (about 1812–1886), missionary
worker. Started life as a foundry striker, and a
noted pugilist. At about twenty-one was
converted and became a Wesleyan, and
shortly afterwards was attached to the Liverpool
Town Mission and worked amongst the very
poor and particularly the Liverpool cabmen.
He was called 'Happy Ned' and later the
Cabmen's Bishop.[1]
PROV: Presented by the Cabmen of Liverpool,
1887.
REF: **1** Press cuttings (Liverpool Record
Office).

BUKOVIC, Vlaho 1855 - 1923

1779 Mrs. Richard Le Doux
Oil on canvas, 200×111·5 cm. (78¾×44 in.)
SIGNED, DATED AND INSCRIBED:
V. BUKOVAC L'pool 1892
The artist, a Serbo-Croat, came to England
from Paris at the invitation of the dealers,
Vicars Brothers, who introduced him to
wealthy merchants as possible clients. Richard
Le Doux of Liverpool (d. 1914), who was of
Westphalian extraction and settled here in
1868,[1] bought his *La Grand Iza* in 1882. In
1891 and again in 1892 the artist visited him
at his house, Marfield, West Derby. On the
second occasion he stayed for a month and
painted both his host and his wife.[2] Richard
Le Doux owned several of his works, which
included another portrait of Mrs. Le Doux.[3]

In this portrait she wears a pink gown and
holds a straw hat and a posy of flowers.

In a letter dated 11 February 1893 Mrs. Le
Doux wrote to the artist to tell him that many
of her friends were going to Paris to see this
portrait exhibited at the Salon,[4] where it was
extensively reviewed.[5]

A crayon portrait of Mrs. Le Doux by
John Lederer was at the Liverpool Autumn
Exhibition, 1889 (1468).

PROV: Entered the Collection between 1927
and 1958 from unknown source.

EXH: Walker Art Gallery, 1892, *Liverpool
Autumn Exhibition* (1255); Paris, 1893, *Société
des Artistes Francais* (290).

REF: **1** Liverpool *Porcupine*, 18 February 1905;
Liverpool Courier, 31 June 1914; *Post and
Mercury*, 24 June 1914. **2** Vlaho Bukovac
Moj Zivot, Zagreb 1918, pp. 132–3. **3** Bukovac
family papers, Cavtat, near Zagreb. **4** Bukovac
family papers. **5** *Revue des Beaux Arts,* Paris,
4 April 1893; *Daily Chronicle,* London,
29 April 1893; *Le Public,* Paris, 30 April 1893;
Evenement, Paris, 6 May 1893; *Souverenité,*
Paris, 9 May 1893; *Revue Internationale,* Rome,
14 July 1893; Louis Cardou, *Salon de 1893,*
1893; P. de Kelou, *Salon,* 1893. The com-
pilers are indebted to G. A. Newby and more
particularly to Dr. Vera Kruzic Uchytil for all
these references.

BURKE, Thomas 1906 - 1945

Born Liverpool June 1906. Trained at Liverpool College of Art and the Royal College of Art, London, and worked in Chelsea, Paris and Ireland. A radio officer in the Merchant Navy and Prisoner of War from 1941–5, when designed many posters in Prisoner of War camp. Died Liverpool July 1945.

1103 The Student
Oil on canvas, 101·3 × 76·2 cm. (39⅞ × 30 in.)
SIGNED: *Thomas Burke*
PROV: Presented by Miss L. Burke, 1946.
EXH: Walker Art Gallery, 1938, *Liverpool Autumn Exhibition* (47); Royal Hibernian Academy, 1939.

BUTLER, Anthony, living artist

3154 Web
Oil on canvas, 77 × 61 cm. (30⅜ × 24 in.)
PROV: Purchased from the artist, 1953.
EXH: Conway, Royal College of Art, 1952; Walker Art Gallery, 1953, *Liverpool Academy* (17); Agnew, 1955, *Acquisitions of the Walker Art Gallery 1945–1955* (40).

1814 Landscape
Oil on board, 54·2 × 76 cm. (21⅝ × 29⅞ in.)
SIGNED: *–BUTLER–*
PROV: Purchased from the artist, 1958.
EXH: Walker Art Gallery, 1958, *Liverpool Academy* (87).

3170 Fish on the Shore
Oil on board, 61·2 × 76·2 cm. (24⅛ × 30 in.)
SIGNED: *BUTLER*
PROV: Purchased from the artist and presented by John Moores, 1959.
EXH: Walker Art Gallery, 1959, *Liverpool Academy* (161).

CADDICK FAMILY
William Caddick 1719/20 - 1794, Richard Caddick 1748 - 1831, William Caddick, Junior 1756 - 1784

Portrait painters in Liverpool whose names and careers have been confused and whose work has not yet been satisfactorily disentangled; some new facts are now known from church registers, etc.

William Caddick, according to Dibdin and Falkner, was born Liverpool 1719 the son of William Caddick (*sic*) mercer (a sub-bailiff, churchwarden etc., who died 15 December 1756). Alternatively he may have been the son of William Chadock, shoemaker, born 9 April 1719 (St. Peter's Church Register; this is the only applicable entry either here or at St. Nicholas' around these years). His name is given as William Caddock (*sic*), limner, Old Hall Street, in the St. Nicholas' baptismal registers from 1748; in 1758 he becomes *Painter*. In the first street directory, 1766, this spelling is repeated and he is designated portrait painter; from 1774 he appears as Caddick, and his name alone continues until 1787, while from 1790 Richard alone appears. At his death, 29 December 1794 (at 74) he is registered as portrait painter and limner (i.e. he was presumably also a miniature painter).

In August 1746 he visited London with William Clarke, also apparently an artist, who kept an account. They visited the studios of Joseph Van Aken, Hudson, Ramsay, Rysbrack and (William) Rice, and besides these also met Alex. Van Aken and Henry Pickering at the Queen's Head Tavern; they saw the Bluecoat Hospital and Thornhill's decorations at Greenwich. They were working at Chester for a time from the September following.

Falkner states that the artist married Eliza Wood (1724–95), of the Burslem family of potters, and he records his and Richard's portraits of members of her family (Private Family Collections). The Holt and Gregson Papers which appear to be the source for later publications state that in youth 'Mr. Caddick' was a comrade of George Stubbs and that they studied together. Mayer states that William Caddick (but assumes the younger) was elected President of the second Society of Artists in Liverpool, 1773; he did not exhibit in the various early Liverpool exhibitions. Gore's *Liverpool Advertiser* recording his death described him as 'an eminent portrait painter' (the phrase employed later by Smithers and Underhill in reference to Richard).

Two children, Richard and William (see below) are recorded as portrait painters. Other children traced are: Ellen, buried 27 April 1752 (St. Peter's); another William, born 8 October 1753, probably buried 18 November 1755; Ann, born 3 April 1758, probably buried 18 November 1758 (the last two's births are registered at St. Nicholas, deaths at St. Peter's under Thomas Chaddock and Thomas Chadwick, limner); John, born 9 February 1762 and another Ann, born 3 April 1764, deaths untraced.

Richard was born 7 June 1748. In August 1770 he wrote desiring to study at the Academy

of the Society of Artists in London, when he already stated that he was a portrait painter by profession and well known to Mr. Stubbs and Mr. Wright. Mayer states that he was a member of the first Society of Artists in Liverpool, 1769; he did not exhibit in 1774, but was a Visitor and an exhibitor in the subsequent Society of 1784; he was not represented in that of 1787 (was he perhaps living away from Liverpool for a period?). He and his brother William were giving lessons in perspective, anatomy etc., to their cousin Enoch Wood (1759–1840), c.1770. He is recorded as a portrait painter in Old Hall Street between 1790 and 1800; his name is missing in 1803 and 1804, but appears 1805–07 and 1813–29 at addresses in Lord Street (1807 only) and Gerard Street, as *gentleman,* which suggests that he had retired from his profession. His wife Martha (date of marriage untraced), died 1829, aged 65, and he died about 22 May 1831 (buried the 27th), leaving one daughter, Martha, a spinster (born 13 April 1797) as his only child and sole heir, with an estate valued at under £4,000. According to Falkner and the Entwistle MS (evidently confusing him with his father) he had three sons, one called William, and his daughter Martha, they state married Thomas Smith, an engraver of Liverpool (this name is listed in 1834 and 1835 in Gloucester Place with a shop in North John Street). The Underhill MS (1831) states that Richard was a contemporary of Stubbs and Richard Wright, but here the father who is otherwise ignored, must again be indicated, and the probable source in the Holt and Gregson papers misunderstood.

William Caddick, junior, was born 16 June 1756. He exhibited a portrait in the character of Circe at the Royal Academy, 1780, from an address in North Walk (presumably his father's house). His death, on 12 March 1784, and exact age, are recorded in St. Nicholas' Church register, where he is described as portrait painter.

A family business or factory is a likely possibility, with Richard the son taking over in his father's old age, and perhaps marrying and becoming independent only after both parents' death. Some differences of style are evident in the following paintings consistent with different hands.

Ref: St. Nicholas' Church Registers of Births, 1748, 1753, 1756, 1758, 1762, 1764, 1797; Register of Deaths, 1756, 1784, 1795. St. Peter's Register of Births, 1719; Register of Deaths, 1755, 1758. William Clarke, *Account of a Journey to London, August–September 1764,* MS. 920 ROS 612 (all Liverpool Record Office). Letter of Richard Caddick to Society of Arts, 21 August 1770 (Royal Academy Library, SA/38/19). Will of Richard Caddick, 26 July 1816 and letters of Administration, 20 July 1831 (Lancashire Record Office, Preston). Holt and Gregson Papers (Gregson died 1824). J. G. Underhill, MS, *The Liver,* 1831, Vol. 2, p. 143; Vol. 3, pp. 86, 88, 92. P. Entwistle, MS on Liverpool Potteries, post 1900, pp. 82, 83, notes probably from Miss Alice Sudlow, an indirect descendant (all Liverpool Record Office). Gore's *Liverpool Advertiser,* 8 January 1795. Henry Smithers *Liverpool, its Commerce, Statutes, and Institutions,* 1825, p. 404. Joseph Mayer, *Early Exhibitions of Art in Liverpool,* 1876, pp. 4, 5, 36, 47. Frank Falkner, *The Woods of Burslem,* 1912. E. R. Dibdin, *Liverpool Art in the Eighteenth Century,* in *Walpole Society Journal, 1917–18,* 1918, pp. 69–71, 76–77.

1135 Joseph Brooks

Oil on canvas, 223·5 × 152·4 cm. (88 × 60 in.)

Joseph Brooks (1706–1788), Liverpool merchant and philanthropist was, with his brother Jonathan, the chief builder in the town. He was timber merchant, lime-burner and ropemaker, etc., concerned with building work on the Town Hall; and St. Nicholas's church was rebuilt, in the Gothic style, 1774–5, under his direction. He was President of the Infirmary, 1771, and took a keen interest in the welfare of the poor, being Treasurer of the Parish, 1769–1788.[1] A non-conformist, the tablet set up to his memory in Key Street Chapel reads:

'Sacred to the Memory of Joseph Brooks, Esq, who died 12 Feby 1788 in the 82nd Year of his age. Endowed by nature with an excellent understanding and favoured by Providence with an ample fortune, he declined the gratification of luxury, and the pursuits of Ambition, and employed his time and talents in active exertions for the welfare of the Town of Liverpool, particularly for the relief and comfort of the poor. His sorrowing relatives placed this monument here as a Testimony of their respect for his character. The gratitude of those who experienced his Charities will give him more honourable praise.'[2]

In the Vestry Minutes for 5 April 1774 is recorded: 'The thanks of this Vestry are returned to Mr. Joseph Brooks, Treasurer of this Parish, for his diligent, active, and just discharge of his said office, and in order to preserve a grateful remembrance of his services, it is ordered that his Picture at full length be executed by one of the most masterly hands in the Kingdom, and that the same be for ever hereafter hung up in the Committee Room of the Parish Poor House.'[3]

1135 would appear to be the only certain documented work by a member of the Caddick family for according to the Holt and Gregson Papers:[4] 'the execution of this work, at the request and recommendation of Mr. Brooks, was given to his Townsman Mr. Caddick, a work which does the artist much credit – the Sum paid for the Piece was 40 guineas.' The entry goes on to refer to the early association with Stubbs, and William Caddick must therefore be meant. This part of the manuscript appears to refer to data before 1792 so the source, which is not given and cannot be traced in the Vestry Minutes, may have been the artist. William Caddick was a tenant of Brooks in Old Hall Street[5] which might explain the choice of artist. It was considered an excellent likeness.[6]

However, Smithers' Liverpool Guide,[7] published 1825 while Richard was still living, gives Richard (while again referring to his contemporaries Stubbs and Wright) and 'Richard' apparently appeared on the frame label. This is followed by the Underhill MS, 1831. However, both the composition, echoing initially Hogarth's *Captain Coram*, 1740, and Ramsey's *Dr. Read* in the Foundling Hospital, and the dry decisive handling, suggest a mature rather than a comparatively young artist and William was evidently always meant.

In a fine carved gilt frame; the gold label perhaps added at a later date and its inscription now obscured.

PROV: Commissioned by the Liverpool Parish Vestry, 1774; hung in the Governor's Room of the Work House;[8] transferred from the Parish Offices to the Walker Art Gallery, 1928.

EXH: Walker Art Gallery, 1908, *Historical Exhibition of Liverpool Art* (12); and 1960, *Liverpool Academy 150th Anniversary Exhibition* (7).

REF: 1 J. A. Picton, *Memorials of Liverpool*, 1873, II, pp.66, 151–2; H.M. Colvin, *Biographical Dictionary of British Architects*, 1954, p. 99. 2 He lived in Old Hall Street and later in Hanover Street. The tablet was subsequently removed to Paradise Street and then to Hope Street Unitarian Chapel: see *Liverpool Epitaphs*, MS., 1895, V, p. 897, (Liverpool Record Office). 3 *Liverpool Vestry Books*, MS, (Liverpool Record Office), and publ. Henry Peet, edit., *Liverpool Vestry Books, 1681-1834*, 1912, I, p. 237. 4 MS, I, p. 27, (Liverpool Record Office); John Holt died 1801, Gregson in 1824. 5 Rate Books 1778, (Liverpool Record Office). 6 Henry Smithers, *Liverpool, its Commerce, Statistics and Institutions*, 1825, pp. 400–401, 404. This appears to be the earliest published reference to the portrait. 7 Smithers, *loc. cit.* The Underhill MS., *The Liver*, 1831, Vol. 3, also refers to it under Richard, but William is ignored. 8 Smithers, *loc. cit.*

3108 The Caddick Family

Oil on canvas, 74 × 100 cm. (29⅛ × 39⅜ in.)

The elderly man seated at table fingers a volume of coloured (?) prints, and other small volumes are piled up. Two vases are prominently displayed on pedestals. The youngish woman

wears a green ribbon in her straw hat and her silk purse with matching ribbons lies on the table (the perspective of which has been altered).

Accessioned as by Richard Caddick and believed by the last owner, Miss Alice Sudlow, a distant connection of the Caddick family, to represent Richard Caddick with three sons and daughter Martha; one son, standing right centre, identified as William.[1]

However, William and Richard appear here to be confused. Richard's first and only child Martha, was born in 1797.[2] The costume has been dated by Miss Buck and the Cunninghams on the strength of the woman's hat, to around 1787–88.[3] In 1788 Richard was forty, his wife, also called Martha, twenty-four,[4] his father William, sixty-nine; the younger William had been dead four years. Supposing a provincial backlog, a prematurely old Richard might be represented with friends and relations, but more probably his father is represented as the old man, with perhaps Richard standing beside him (and resembling a supposed self-portrait once belonging to Miss Sudlow,[5] though looking rather young for over-forty). The other three figures are more difficult to account for. The woman is too young for William's wife Eliza (née Wood, 1724–1795), but could be wife or sister to one of the younger men.

The prominence given to the vases is perhaps the key to the sitters and may therefore involve the Wood family[6] (Enoch Wood was 29 in 1788 and had married in 1780). The vases follow the type of black basalts Wedgwood was producing in the 1770's. Josiah Wedgwood had had his family painted by Stubbs in 1780; this might well have been painted also by a Liverpool artist, somewhat later, in emulation.

PROV: (?)Martha Caddick (?Mrs. Thomas Smith), at whose death passed to the nephew of Thomas Smith, Mr. Sudlow, and thence to his daughter, Miss Alice Sudlow, from whom purchased, 1908.

EXH: Harrogate, 1924, *Liverpool School of Painters* (23); Walker Art Gallery, 1970, *The Taste of Yesterday* (14) repr.

REF: **1** Peter Entwistle, MS Notes on Liverpool Pottery, pp. 82, 83, notes probably from Miss Sudlow, dated Feb. 4 1912 (Liverpool Record Office); see also Dibdin, *Walpole Society Journal*, 1918, pp. 69–70, pl. XXIX (c), and Falkner, *The Woods of Burslem*, 1912, repr. fp. 32. **2** St. Nicholas's Church Register of

Baptisms: baptised 25 April 1797. **3** Letters o[f] October and 24 November 1956. **4** S[t.] Nicholas's Church Register of Deaths: burie[d] 4 February 1829, aged 65 years. **5** Falkne[r] *op. cit.*, No. 100; Dibdin, *op. cit.*, pl. XXV (a[).] **6** Falkner, *op. cit.*, see for example No. 9.

3110 Head of a Young Man facing left

Oil on canvas, 39×31·7 cm. (15⅜×12½ in.)

Supposed to be a portrait of George Stubb[s] (1724–1806), but it does not noticeably resembl[e] known portraits of him. Richard Caddick, t[o] whom it has been ascribed, would have bee[n] too young to paint him; nor does it resemble i[n] style 3109. It may be the portrait of 'Stubbs' by Caddick which Mayer owned[1] and in th[e] Mayer sale, 1887 (see provenance), and thu[s] possibly be the picture ascribed by Gilbey[2] t[o] Thomas Chubbard *(q.v.)*.[3]

In the opinion of the compiler it more nearl[y] resembles portraits of Roscoe and the questio[n] arises whether it and 3109 may not at a[n] early date (?the Mayer sale) have bee[n] transposed.

PROV: Possibly Joseph Mayer, sold Branc[h] and Leete, Liverpool, 16.12.1887 (234). Pos[-] sibly Studley Martin,[4] executors' sale, Branc[h] and Leete, 29.1.1889 (430). Bequeathed by th[e] Rev. S. A. Thompson Yates, 1904.

REF: **1** Joseph Mayer, *Early Exhibitions of Ar[t] in Liverpool*, 1876, p. 36. **2** Walter Gilbey[,] *Life of George Stubbs*, 1898, p. 33. **3** Se[e] Dibdin, *op. cit.*, pp. 66–68. **4** He acquire[d] works from the Mayer collection.

3109 Portrait of a Young Man looking a[t] spectator

Oil on canvas, 50×42·2 cm. (19¾×16⅝ in.)

Supposed to be of William Roscoe[1] (for whom see Shee 3130 for biography), but the likenes[s] seems far fetched (and see 3110). A copyist product, almost identical in pose, is in Wood family ownership,[2] which suggests, although the sitter is unidentified, a family connection[.] The fluent and almost pastel-like style, while differing from any other picture grouped here under Caddick, closely resembles the portrait of John Wood of Brownhills (Wood family ownership).[3]

It may be the picture given to Richard Caddick in the Mayer sale, 1887 (see provenance).

PROV: Possibly Joseph Mayer, sold Branch

and Leete, Liverpool, 16.12.1887 (232). Purchased from John Hargreaves, Rock Ferry, 1893.

EXH: Harrogate, 1924, *Liverpool School of Painters* (49); Manchester, 1933; Liverpool City Library, 1931, *Roscoe Centenary* (1).

REF: **1** When purchased, and repeated in *The Connoisseur*, 1913, Vol. 36, p. 152 repr., and Dibdin, *op. cit.*, pl. XXIX (a). **2** Photo gallery files. **3** See Falkner, *op. cit.*, one version repr., No. 9: attributed in the family to either William or Richard.

L139 John Gore

Oil on canvas, 67·3 × 58·3 cm. (26½ × 23 in.)
Ascribed heretofore to William Caddick. Much retouched, particularly in the face. The thin underpainting bears comparison with 3108.

John Gore (1739–1803), Liverpool bookseller and publisher. The son of William Gore, saddler, and baptised at Key Street Presbyterian Chapel, Liverpool, 11 April 1739. He was at first, apparently, in a merchant's office.[1] By 1763, when his daughter Elizabeth was baptised, he was described as bookseller in Dale Street.[2] Later his shop was listed as 1 and, later again, 66 Castle Street.[3]

He published a weekly journal, *The Liverpool General Advertiser* or *The Commercial Journal*, from 27 December 1765, and in 1766 published Liverpool's first directory, called from 1767 *Gore's Liverpool Directory*. This appeared at increasingly frequent intervals until 1833 when it was taken over by Mawdsley and subsequently by Kelly. His editorial in 1773 stated that with it he was 'anxious of contributing his mite to the service of the community.' He died 14 November 1803 after a long illness.[4]

It was at his bookshop that Roscoe tried a month's work in 1768.[5]

A miniature by H. Hone was formerly in Liverpool City Library (destroyed 1939–45 war).

PROV: Probably the portrait ascribed to William Caddick recorded, 1871, in Messrs. Gore's establishment.[6] This or another portrait belonged to J. Wedderburn Wilson, Ascot, 1928.[7] Lent by Liverpool City Library, 1973.

REF: **1** J. Boardman, *Liverpool Table Talk a Hundred Years Ago*, 1871 edition, p. 2. **2** Key Street Chapel Registers (Liverpool Record Office). **3** J. A. Picton in *Memorials of Liverpool*, 1873, II, p. 17, mentions the changed position of the shop after demolition work in Castle Street, *c.* 1786, in his description of a contemporary watercolour, of which a variant copy is in Liverpool Record Office. **4** G. Shaw, *History of Liverpool Directories*, in *Transactions of the Historic Society of Lancashire and Cheshire*, 1906, repr. fp. 132 (owner not given); Arthur G. Wardle, *John Gore: Publisher*, in *Transactions, op. cit.*, 1946, pp.223–4. **5** Henry Roscoe, *The Life of William Roscoe*, 1833, I, p. 13. **6** Boardman, *loc. cit.* **7** Liverpool Record Office card file.

CALVERT, Frederick, active 1827 - 1844

1493 Shipping in the Mersey

Oil on canvas, 45·5 × 60·2 cm. (17⅞ × 23¾ in.)
SIGNED AND DATED: *F Calvert/1830*
The Liverpool waterfront with the Town Hall dome seen in the centre background. The shipping includes a pilot cutter (left), gig boats (foreground) and Mersey flats (distance), with a steam packet or ferry, centre.[1] Two further views on the Mersey are in Wallasey Public Library, and a view towards Birkenhead is in the Williamson Art Gallery, Birkenhead.

Ackermann's published two of the artist's views on the Mersey in March 1832.[2]

PROV: Purchased from F. T. Sabin, 1944.

EXH: Bluecoat Chambers, 1945, *Pictures of Old Liverpool* (12).

REF: **1** Information from Department of Shipping, Merseyside Museums. **2** Lithographs by L. Haghe: copies Liverpool Record Office (Binns 9, p. 88).

CAMPBELL, James 1828 - 1893

Genre and landscape painter. Born Liverpool (?17 February) and baptised at St. Peter's 30 March 1828, son of a book-keeper. During greater part of career known as James Campbell Junior to distinguish him from his father of the same name. Entered as probationer at Liverpool Academy Schools February 1851 and entered Royal Academy Schools in same year. Exhibited at Liverpool Academy, 1852–65; Associate, 1854; Member, 1856. Showed twice at the Royal Academy, and also at The Royal Scottish Academy and Suffolk Street. His work for a time showed the influence of the Pre-Raphaelites. Member of the Hogarth Club in London with this circle. Started broadening his style in 1862 and at the end of that year moved to London, where unsuccessfully tried to pursue his career until mid-1870's. His later work showed a considerable falling off and late in life he became blind. Died at Birkenhead 25 December 1893. John Miller of Liverpool and James Leathart of Newcastle were considerable patrons. After a period of eclipse his paintings are reappearing on the art market. His *Wife's Remonstrance*, 1858 (Birmingham City Art Gallery) was formerly attributed to Millais.

3062 The Old Fiddler
Oil on canvas,[1] 28·5 × 19·7 cm. (11¼ × 7¾ in.)
PROV: Bequeathed by John Bate, 1885.
EXH: Walker Art Gallery, 1908, *Historical Exhibition of Liverpool Art* (564).
REF: 1 Canvas stamp of John Reeves, Tottenham Court Road.

6365 Girl with Jug of Ale and Pipes
Oil on board,[1] 38·7 × 30·5 cm. (15¼ × 12 in.)
INSCRIBED in pencil verso (partially lost):
J[ohn] Miller / 10 / [James] Campbell / Liverpool 1856 and *J Campbell / Liverpool / J Miller*
The view is probably in the Everton or Walton area looking south across part of Liverpool with a church tower, probably of St. Luke's, in the background.
PROV: John Miller, sold Christie's (920D) 21.3.1858 (144). Purchased from Messrs. Leonard's, Liverpool, 1966.
REF: 1 Label of Winsor and Newton Prepared Board; frame label of David T. Blackburn, framemaker, 18 Wood Street, Liverpool.

1293 Waiting for Legal Advice
Oil on board, 77·5 × 63·5 cm. (30½ × 25 in.)
SIGNED AND DATED: *J. Campbell Junior / 1857*
At the time of acquisition called variously the *Heir at Law* and *The Disputed Bill of Costs.* Showing the interior of a solicitor's office with a sale notice hanging on the desk of *Mr. Wylie, 23 February 1857, Clarendon Buildings, South John Street,* and over the fireplace *Holden's Liverpool Almanack and Tide Table.*

It was exhibited in 1857 and was reviewed in the National Magazine:[1] 'We shall end by introducing to the reader two pictures by J. Campbell, Jun., whose admirable work "The Askings", was here last year. "Waiting for legal advice", No. 379, shows the interior of a country lawyer's office, wherein is seated before the rail of the clerk's sanctum an impatient litigant, whose private affairs are under discussion by two vulgar clerks, behind. Their audible whisperings are no alleviation to his impatience, as his sits with a bitter hardness on his face that speaks highly for the artist's power of rendering character. The blemish in the picture is the figure of a boy, who vainly endeavours to call the attention of the suitor to a teetotum, he has set spinning on the floor. This figure is out of drawing, distorted, and coarse. Mr. Campbell ought to repaint this figure, and turn a blemish into a beauty. The artist is young. He comes from the north of England, which has recently produced such notable painters as Messrs. Windus and Sterling.'

PROV: Presented by Bancroft Cooke, 1893.

REPR: *Apollo,* December 1962, p. 752, fig. 5; Walker Art Gallery, *Liverpool Bulletin,* 12, 1967, fig. 16.

EXH: Suffolk Street, 1857 (379) £110; Walker Art Gallery, 1908, *Historical Exhibition of Liverpool Art* (553); Harrogate, 1924, *Liverpool School of Painters* (7); Walker Art Gallery, 1960, *Liverpool Academy 150th Anniversary Exhibition* (67).

REF: **1** *National Magazine,* 1857, p. 54.

6246 News from My Lad

Oil on canvas,[1] ±51·7×47 cm. (±20⅜×18½ in.)

SIGNED AND DATED: *J. Campbell 1859 (sic)* Inscribed on letter: *Lucknow March 1858//My dear old Daddy, I dare say you will read this in the old shop and here am I under the burning sun of India*

The picture received a favourable review from the *Mercury* critic[2] when shown at the Liverpool Academy of 1858: 'We do not know whether this is a portrait, but it would almost seem so. An old locksmith is in his shop reading a letter, the cover of which, thrown upon the floor, bears the address, "Enoch Smith, locksmith, Kirkdale, England." The letter is from Lucknow, [as inscription above] – a trifle hotter, he supposes, than the "old shop." The grey haired son of toil is perusing the letter with great interest, and in his expressive brow and manly face there is an expression of inward satisfaction at the bravery and affectionate remembrance of his son. . . ' This picture and the artist's *Tidy Job* in the same exhibition, the critic considered, 'clever, and show the power of the artist to extract interest out of subjects of humble life.'

Neither floor nor envelope are now in the picture and the artist may have re-considered his composition in the following year, when he signed it and sent it to London. There, at the Suffolk Street exhibition, the *Art Journal* reviewer admired his 'independence of feeling well supported by the power of asserting it'; but considered that technically, 'painters only will praise the work, but they will not imitate it.'[3] The *Athenaeum* critic in a long notice admiring his *Labourer's Rest,* added, 'Yet, in point of finish, that is nothing to *News from my lad,* which though looking painfully like pleated paper, is a miracle of patient art; – the artist delights in humble life, and watches it

with no common eyes. There is such a quiet, serene, cosy delight in the face of the old smith . . . The detail of blue-filing dust, of rusted pincers, etc., is marvellously elaborate, and not without a quiet poetry. A little more central solidity would have much increased the infinitude of this workshop-world.'[4]

PROV: George Rae by 1876[5] and thence by descent to Mrs. Sonia Rae, from whom purchased 1964.

REPR: (As now), H. C. Marillier, *The Liverpool School of Painters,* 1904, fp. 84.

EXH: Liverpool Academy, 1858 (48), 35 gns.; Suffolk Street, 1859 (113) 42 gns.; Manchester Royal Institution, 1860 (844), £26.5.0.; Wrexham, 1876 (525); Whitechapel, 1905, *British Art 50 years ago* (286); Walker Art Gallery, 1908, *Historical Exhibition of Liverpool Art* (1095).

REF: **1** Cut down on all four sides and mounted on slightly larger stretcher, 21⅜×19½ in. **2** *Liverpool Mercury,* 23 September 1858, p.4. **3** *The Art Journal,* 1859, p. 142. **4** *The Athenaeum,* 2 April 1859, p. 458. **5** Also listed in *Catalogue of Mr. George Rae's Pictures,* p.p., about 1900, No. 54 (copy Birmingham Art Gallery; photocopy Walker Art Gallery).

3111 The King's Shilling

Oil on canvas, 92×71·5 cm. (36¼×28¼ in.)

Details of the composition reflect Hogarth's engraving *Canvassing for Votes,* 1757.

PROV: Bequeathed by John Bate, 1885.

EXH: *Liverpool Autumn Exhibition,* 1871 (378) 25 gns; Walker Art Gallery, 1908, *Historical Exhibition of Liverpool Art* (537).

3112 Village Politicians

Oil on canvas, 92·7×72 cm. (36½×28⅜ in.)

A passage in "The Democrat" newspaper is being discussed. Dating probably from the 1870's. A small oil of this subject (7½×9½) belonged to a Mrs. Procter, Liverpool in 1908.[1]

PROV: Bequeathed by John Bate, 1885.

EXH: Walker Art Gallery, 1908, *Historical Exhibition of Liverpool Art* (493); Glasgow, 1911, *Scottish Exhibition* (237); Arts Council, Kidderminster, 1955.

REF: **1** Information in Gallery files.

423 **The Homeward Trudge**
Oil on board,[1] 40×26·1 cm. (15¾×10 5/16 in.)
SIGNED AND DATED: *J. Campbell/86*

PROV: Bequeathed by C. E. Ashworth, 1932.
REF: **1** Label of Winsor and Newton, prepared Academy board.

CHUBBARD, Thomas 1737/8 - 1809

Portrait and landscape painter and successful teacher. Said to have been born Liverpool, the son of a mariner, Captain John Chubbard. He is first listed as a 'painter' in 1767; then as a 'limner' from 1774, and from 1790–1807 as a 'portrait painter'. Exhibited at the Society of Artists and Free Society, London, 1771–73 (and possibly 1763), and at the Liverpool Exhibitions of 1774, 1784 and 1787 when he was a Visitor. According to Mayer his success as a teacher won him the title of Magister. He is said to have assisted Dr. Matthew Turner in painting the east window of St. Anne's Church, Liverpool (demolished): Smithers *Liverpool, its Commerce,* etc., 1825 states that he invented a mode af engraving on glass. Perhaps, however, there may be confusion here with his brother Samuel (1740/1–1807), a carver and gilder and looking glass manufacturer, who invented with P. P. Burdett a new method of aquatint engraving. Died Liverpool 30 May and buried at St. George's Church, 5 June 1809. A watercolour is in the Collection and engravings after some local views are in Britton, *Topographical and historical description of . . . Lancashire,* 1807, and in Gregson's *Fragments,* 1817. Daniel Daulby was a considerable patron. Little is yet known about his portrait style.

An obituary appeared in the Liverpool *Courier,* 7 June 1809:
'On the 30th ult. at his house in King-street, Soho, without a struggle or a sigh, aged 71, Thomas Chubbard, Esq, much lamented and esteemed by those who had the pleasure of his acquaintance. He was an artist of considerable celebrity in his day, and well known as one of the institutors and active supporters of a *Society for promoting the Fine Arts,* and also the *Print Club* formerly established in this (his native) town.—To a well cultivated taste and considerable judgment in his profession he added a pleasing mildness and unassuming affability of behaviour, united to honest integrity and benevolence of heart. The annals of this great and opulent town will long have to record his name as a son of Science and of Taste.—His remains were deposited on Monday in the family vault at St. George's by the Rev. F. Hodson, B.D., Senior Bursar of Brazen-nose College, Oxon.'

8623 **Bridge over Rapids by a Mill in Mountainous Landscape**
Oil on card laid on canvas, 22×27·2 cm. (8 11/16 × 10 11/16 in.)

8624 **A Landscape with a Bridge and Cottages**
Oil on card laid on canvas, 21·4×27 cm. (8 7/16 × 10 5/8 in.)

INSCRIBED, VERSO: *Thos. Chubbard/delt. 1775* These are the first oil landscapes by Chubbard which have appeared. He evidently knew Dutch 17th century landscape and the work of J. C. Ibbetson, who was certainly connected with Liverpool art matters at this period (q.v.). 8623 might be a view in or near the Lake District.

PROV: Purchased from the Godolphin Gallery, Dublin, 1974.

COCKRILL, Maurice, living artist

8574 Two Windows/Two People
Acrylic on canvas (three sections), 213·3 × 428 cm. (83$\frac{15}{16}$ × 168$\frac{5}{8}$ in.)
Portraits of the artist and Caroline Slinger, another Liverpool Academy artist. The setting was the flat of Sam Walsh (q.v.) at Aigburth, Liverpool.[1] Preliminary sketches and photographs are in the Collection.
PROV: Purchased from the artist and presented by Liverpool Daily Post and Echo Limited, 1973.
EXH: Walker Art Gallery, 1973, *Liverpool Academy – Communications;* Sunderland Arts Centre, 1974, *Five Realist Painters and One Sculptor.*
REF: **1** Letter from the artist, 26.7.1977.

8828 The Walker Art Gallery
Oil on canvas, 126·8 × 101·3 cm. (49$\frac{7}{8}$ × 39$\frac{7}{8}$ in.)
SIGNED AND DATED: *Maurice Cockrill 1974/5*
Studies and photographs are in the Collection.
PROV: As 8722 above.

8722 Sudley
Oil on canvas, 126·9 × 101·5 cm. (49$\frac{15}{16}$ × 39$\frac{15}{16}$ in.)
SIGNED AND DATED, verso: *Maurice Cockrill 1974*
The garden front of the house bequeathed to Liverpool by Miss Emma Holt in 1945 together with the collection of paintings formed by her father, George Holt (see Bigland 8700 and Morrison 275). Studies and photographs are in the collection.
PROV: Commissioned from the artist for presentation by the Friends of Merseyside County Museums and Art Galleries, 1974.
EXH: Bluecoat Gallery, 1974, *Maurice Cockrill and Jim Weston* (2).

COLLINGWOOD, William 1819 - 1903

Painted landscapes and interiors. Born Greenwich 3 April 1819, son af an architect and grandson of Samuel Collingwood, printer to Oxford University. After period at the University, was instructed in art by his cousin, William Collingwood Smith, and by J. B. Harding and Samuel Prout. About 1837–38 living in Hastings and there knew Samuel Prout and William Hunt. Exhibited at Suffolk Street from 1838 and the Royal Academy 1839–60. Settled in Liverpool in 1839 as a drawing master and developed an extensive practice; exhibited with the Liverpool Academy from 1839; Member, 1843–45. Associate of the New Watercolour Society, 1845 and Member, 1852. Joined Old Watercolour Society as Associate in 1855 and Member, 1885. Published his lectures on *The Value and Influence of Art as a Branch of General Education,* in 1862. Left Liverpool in 1884, when many works were sold at auction, and after living at Hastings 1886–89, settled at Bristol, 1890 where he joined the Bristol Academy, and died there 25 June 1903. His son, W. G. Collingwood (1854–1932), was also an artist and the biographer of John Ruskin.

1465 An Antique Interior at West Hill House, Hastings

Oil on canvas, 62·8×48·2 cm. (23¾×19 in.)
SIGNED AND DATED: *W COLLINGWOOD/ 1842*

John Hornby Maw, a collector and amateur painter, at his retirement moved to a late Georgian house, West Hill House, Hastings. There he fitted up a room or studio with antique woodwork. He collected Turner watercolours and corresponded with the artists, and artists such as Prout and W. Hunt (both of whom resided at Hastings for a period) visited him. The interior formed the background for several of Maw's own pictures (Royal Academy 1841, 1843 and 1844) and other historical works.[1]

The house still exists but Maw's interior was later dismantled and much altered and only the ceiling, visible in this painting, remains.[2] It incorporates motifs with a crown over a medallion bearing the motto HONI. SOIT. QUI. MAL Y. PENSE. between E.R.[3]

A Liverpool Academy reviewer[4] wrote of the picture: 'It appears gaudy at first sight, from the apparently ostentatious glow which it exhibits; but when the eye has become a little accustomed to it, the glow disappears, and the picture is found to be not less distinguished for delicacy and harmony of tone than it is for brilliancy of effect. The blue oriental jar in one corner seems a very commonplace object to be brought so prominently forward, but we presume it has its utility in throwing back the warmer tints, and giving distance to the view, a matter not easy of attainment with such a uniform blaze of colour. On the opposite side of the canvas a serious want is observable in this respect.'

PROV: Presented by Miss A. M. Thompson, 1907.

EXH: Liverpool Academy, 1842 (196); Royal Academy, 1844 (114).

REF: 1 J. Manwaring Baines, *Historic Hastings,* 1972, p. 34. 2 *Ibid,* and information from Colin Bailey. 3 Letter from Miss P. Astley-Cooper, 27.11.1975 (Gallery files), who kindly visited it. 4 *Liverpool Courier,* 26 October 1842.

COOKE, Isaac 1846 - 1922

Landscape painter. Born Warrington 21 April 1846; lived at Liscard 1856–1910, and subsequently at Wallasey. Chiefly self-taught and attended Antique and Life classes at Liverpool Academy, where admitted student, 1877; Associate, 1881; Member, 1884. Member Liverpool Watercolour Society, 1882–94; Hon. Treasurer, 1884–90; Trustee, 1890–94. Exhibited at Liverpool Autumn Exhibitions from 1876, Royal Academy occasionally from 1879, R.I. from 1881, and Royal Society of British Artists from 1896; also in provincial exhibitions and abroad. Specialised in storm and light effects. Died Wallasey, 22 April 1922.

1796 Golden Moments

Oil on canvas, 76·2×122 cm. (30×48 in.)
Badly damaged along bottom edge, due to damp.

PROV: Purchased from the artist at the Autumn Exhibition, 1884.

EXH: Walker Art Gallery, 1884, *Liverpool Autumn Exhibition* (786); and 1908, *Historical Exhibition of Liverpool Art* (529).

COOKSEY, May Louise Greville 1878 - 1943

Painter of religious subjects. Born Birmingham 7 November 1878. Trained at Leamington and Liverpool Schools of Art and gained Liverpool City Travelling Scholarship to Italy, c. 1901–2. Designed murals for R.C. Church near her home, Newsham Park, Liverpool, 1900 and subsequently many series of Stations of the Cross for Liverpool R.C. Churches. Exhibited at the Royal Academy and provincial exhibitions. Member Liverpool Academy. Died at her home at Freshfield, near Liverpool, 18 December 1943.

1798 The Marriage of St. Catherine
Oil on canvas, with gilding, 100·3×60·3 cm. (39½×23¾ in.)
SIGNED AND DATED: *MAY L. GREVILLE COOKSEY/1902*
INSCRIBED ON THRONE: *SPONSABO . TE . MIHI . IN . FIDE*

PROV: Bequeathed by Sir William Bowring, 1925.
REPR: *The Studio*, XXVIII, 1903, p. 208.
EXH: Walker Art Gallery, 1902, *Liverpool Autumn Exhibition* (985).

COPEMAN, Constance Gertrude 1864 - 1953

Landscape and portrait painter and engraver. Born in Liverpool, the daughter of a solicitor. A favourite pupil of John Finnie (*q.v.*), and owned a collection of his work. She exhibited at the Liverpool Autumn Exhibition from 1885–1938 and the Royal Academy from 1894. Member, Liver Sketching Club. Associate of the Royal Society of Painters, Engravers and Etchers. After about 1914 she took up toy making with a friend, Miss Palethorpe. Etchings by her are in the Collection and in Liverpool City Libraries, where there is also a group of sketching albums of c. 1896–1934.

1800 John Finnie
Oil on canvas, 92×102·2 cm. (36¼×40¼ in.)
SIGNED AND DATED: *C. G. Copeman 1903*
John Finnie (1829–1907), Liverpool artist, *q.v.* A sketch of Finnie was exhibited by Constance Copeman at the Liverpool Autumn Exhibition, 1895,[1] and was presumably the other portrait by her at the 1907 memorial exhibition. Two further portraits appeared at the latter: by R. E. Morrison from Liverpool School of Art, and a sketch by F. T. Copnall from Liverpool Artists' Club.[2] A self-portrait was exhibited at the Royal Academy, 1862.

PROV: Presented by Miss Copeman, 1937.
EXH: Walker Art Gallery, 1903, *Liverpool Autumn Exhibition* (854); and 1907, *The Art of John Finnie* (80 or 437).
REF: **1** Constance Copeman's Note Book (Liverpool Record Office): the portrait was given to Dr. (Ellison) Finnie, who sold it. **2** Repr. in *The Studio*, XXVIII, 1903, p. 207.

COPNALL, Frank Thomas 1870 - 1949

Portrait painter, resident in Liverpool. Born Ryde, Isle of Man. Began business career in Liverpool 1885, painting in spare time. Took up portrait painting as career 1897, as result of a commission. Exhibited at the Liverpool Autumn Exhibition from 1894, the Royal Academy from 1902, and at various London and provincial societies. A Member of the Liverpool Academy and the Liver Sketching Club. Married Theresa Butchart, also an artist (*q.v.* Copnall, Teresa). Died 13 March 1949.

1801 Sir Roger de Poitou, first Norman Lord of the Honour of Lancaster.
Oil on canvas, 164×123·2 cm. (64⅝×48½ in.)
SIGNED AND DATED: *F. T. Copnall '07*
G. H. Hewitt J.P. (1838/9–1926), prominent public figure in Liverpool, in costume for the Liverpool Pageant, 1907.
PROV: Presented by Subscribers, 1910.
EXH: Walker Art Gallery, 1907, *Liverpool Autumn Exhibition* (107).

3020 Sir William Bowring, Bart.
Oil on canvas, 122×151·5 cm. (48×59⅝ in.)
SIGNED AND DATED: *Frank T. Copnall 1909*
Sir William Benjamin Bowring, Bart., J.P. (1837–1916), Liverpool merchant and shipowner. Born St. John's, Newfoundland; followed mercantile career in family firm in Liverpool, Newfoundland and New York. Member, Mersey Docks and Harbour Board from 1884; Liberal Councillor from 1884; Member of the Unitarian Church; Alderman, 1892; J.P., 1892; Lord Mayor, 1893–4. Gave Bowring Park (Roby Hall Estate) to the City, 1907. Created baronet, 1907.[1]
PROV: Transferred from the Town Hall, 1956.
EXH: Walker Art Gallery, 1910, *Liverpool Autumn Exhibition* (998).
REF: 1 Press cuttings (Liverpool Record Office); A. C. Wardle, *Benjamin Bowring and his Descendants,* 1940, pp. 171–2.

3021 E. Rimbault Dibdin
Oil on canvas, 124·5×84·5 cm. (49×33¼ in.)
SIGNED: *F. T. Copnall*
Edward Rimbault Dibdin (1853–1941), second curator of the Walker Art Gallery; for his biography see his portrait by Boadle.
PROV: Entered collection at unspecified date.
EXH: Walker Art Gallery, 1911, *Liverpool Autumn Exhibition* (1018) repr.

1507 My wife with Michael
Oil on canvas, 61×50·7 cm. (24×20 in.)
SIGNED: *F. T. Copnall*
The artist showed a full-length portrait of his wife at the Autumn Exhibition of 1915.
PROV: Purchased from the artist at the Liverpool Autumn Exhibition, 1922.
EXH: Walker Art Gallery, 1922, *Liverpool Autumn Exhibition* (623).

3011 Frederick C. Bowring, Lord Mayor of Liverpool
Oil on canvas, 136·5×122 cm. (53¾×48 in,)
SIGNED: *F.T. Copnall.*
Sir Frederick Bowring, J.P. (1857–1936), in robes of office as Lord Mayor of Liverpool, 1925–27. Born Newfoundland, a cousin of Sir William Bowring, Bart.; shipowner and merchant in Liverpool. Liberal Councillor, 1909–1934 (retired); on the Libraries, Museums and Arts Committee, 1928–1934, and Chairman of Art Sub-Committee; after 1934 a co-opted member. Gave a large donation towards the Gallery Extension, 1925–6; Knighted, 1928; Honorary Freeman, 1934.[1]
PROV: Bequeathed by the sitter, 1936.
EXH: Walker Art Gallery, 1926, *Liverpool Autumn Exhibition* (1008); Royal Academy, 1927 (448).
REF: 1 Press cuttings, (Liverpool Record Office); A. C. Wardle, *op. cit.,* pp. 174–7.

953 Henry A. Cole
Oil on canvas, 124·5×98·5 cm. (49×38¾ in.)
SIGNED: *F. T. Copnall*
Alderman Henry A. Cole, J.P. (1862/3–1939), Liverpool merchant. Conservative Councillor from 1912; Chairman of the Libraries, Museums and Arts Committee, 1921–1939.

Instrumental in organising the extension to the Gallery opened in 1933.

PROV: Presented by the sitter, 1929.

EXH: Walker Art Gallery, 1929, *Liverpool Autumn Exhibition* (130) repr.

7482 William Denton, Lord Mayor of Liverpool

Oil on canvas, 71·1 × 57·2 cm. (28 × 22½ in.)

SIGNED: *F. T. Copnall*

Alderman William Denton, T.D., D.L., J.P. (1865–1946). Lord Mayor of Liverpool, 1936–7, wearing his chain of office. A Chartered Accountant in Liverpool. Liberal Councillor 1896–1910 and from 1924; Alderman, 1934.

PROV: Transferred from Liverpool City Library, 1971.

EXH: Walker Art Gallery, 1937, *Liverpool Autumn Exhibition* (46).

COPNALL, Teresa 1882 - 1972

Portrait and flower painter. Née Butchart. Born Haughton-le-Skern, near Darlington, 24 August 1882. Trained at Brussels, the Slade School and Herkomer's School. Married Frank Copnall (*q.v.*). Exhibited at the Royal Academy, Liverpool Autumn Exhibitions, and other provincial exhibitions and Paris Salon. Member Deeside Art Group. Lived at Hoylake.

1451 A Mixed Bunch

Oil on canvas, 63·8 × 63·4 cm. (25⅛ × 25 in.)

SIGNED in monogram: *T N C*

PROV: Purchased from the artist at the Lancashire and Cheshire Artists Exhibition, 1932.

EXH: Walker Art Gallery, *Lancashire and Cheshire Artists Exhibition* (431).

COTES, Francis 1725 - 1770

1515 Sir Robert Cunliffe, Bart.

Oil on canvas,[1] 127·7 × 101·6 cm. (50¼ × 40 in.)

SIGNED AND DATED: *F. Cotes pixit. 1768*

1514 Lady Cunliffe

Oil on canvas, 126·7 × 101·6 cm. (49⅞ × 40 in.)

INSCRIBED: *Mary wife of/Sir Robt. Cunliffe Bart 1765* (sic)

Robert Cunliffe (1719–1778), Liverpool merchant and later of Saighton Tower, Cheshire and Pickhill, Denbighshire, and his wife Mary (1721–1791), daughter of Ichabod Wright, a banker of Nottingham.

He was born at Liverpool 17 May 1719, the younger son of Foster Cunliffe (1682–1758), an important merchant and M.P. for Liverpool.[2] His name appears with those of his father and elder brother Ellis, in the company of merchants

trading with Africa, 1750.[3] He married in 1752. St. Peter's baptismal registers give his address in Water Street and describe him progressively as Merchant, Alderman, and Esquire. His brother Ellis Cunliffe, was also an M.P. for Liverpool; he or his father bought Saighton Tower in 1755; he was created a baronet shortly after their father's death, 1759, with remainder in default of heirs, to Robert, who succeeded him in 1767. Robert died at Chester 9 October 1778.[4]

The inscription on Lady Cunliffe's portrait perhaps post-dates its painting which may well also be 1768 and commemorate their succession to the title.[5] She wears a shot pink and grey silk sack gown trimmed with green silk ruching and bows; he is in a reddish-brown coat and breeches with green silk waistcoat edged with gold braid.

These portraits formed part of the collection of family portraits and old masters at Acton Hall, Wrexham from 1789 until dispersed in 1950.[6] Cotes also painted the sitter's niece *Miss Cunliffe*.[7] A medallion portrait by Nollekins, 1778, is incorporated in a monument to Sir Robert in Bruera Church.

PROV: By descent to Sir Foster Cunliffe, Bart., Acton Hall, near Wrexham, Denbighshire, sold Sotheby's 1.2.1950: (108) bt. Agnew and thence to Mr. Cunliffe Fraser, from whom purchased 1953 after damage by fire, and (109), bt. Walker Art Gallery, 1950.

EXH: On loan to the Gallery, with Cunliffe Collection, 1918-1928; Agnew, 1955, *Walker Art Gallery Acquisitions, 1945-1955* (26).

REF: **1** Damaged by fire, 1953. **2** See E. F. Cunliffe, *Pages from the Life of John Sparling*

of Petton, 1904 (privately printed), pp. 162–3 and pedigrees of Cunliffe family; A. N. Palmer, *History of the Town of Wrexham*, 1893, V pp. 173–4. **3** MS Minutes, 1750–1820 (Liverpool Record Office). **4** *Gore's Advertiser* 16 October 1778, p. 3. Col. 4 (Liverpool Record Office). **5** Edward Mead Johnson, Stanford University of California, considered the later date more consistent with costume and style, in letter 11 October 1970; see also his *Francis Cotes*, 1976, Cat. No. 176 (and Cat. No. 258 for 1515). **6** Other family portraits, including Foster Cunliffe and his wife by (?) Hudson, were in another branch of the Cunliffe family (repr. E. F. Cunliffe, *loc. cit.*). **7** Johnson, *op. cit.*, Cat. No. 196.

COX, Reg, living artist

6305 Portrait of a Typo Man

Photo-montage on paper, 152·3 × 122 cm. (60 × 48 in.)

INSCRIBED in mirror-writing: *Ed Skyner Typographer*

PROV: Purchased from the artist, 1965.

EXH: Walker Art Gallery, 1965, *Liverpool Academy* (121).

CROSTHWAITE, Samuel, active 1832 - 1841,
Ascribed to

Portrait painter. Recorded in Liverpool 1832–1841 and exhibiting at the Liverpool Academy 1832–37.

2570 G. P. Day, Liverpool Newsman

Oil on canvas, 91·8 × 74 cm. (36⅛ × 29⅛ in.)

The Town Hall appears in the background and St. George's Church (demolished) on the left. The sitter holds a horn and carries a satchel and a bundle of newspapers of which the Liverpool Times is visible. This newspaper com-

menced 6 January 1829 and ceased 1 March 1856. George Porter Day (?1760-1843)[1] was a vendor of London and Liverpool newspapers. His name appears in Gore's Street Directories from 1810/11 to 1851 (*sic*), initially as a straw hat and bandbox manufacturer and deliverer of the London and Liverpool Papers, Dale Street (1823), subsequently newsman and (1848)

tobacconist and newsagent, Great Charlotte Street. At least one silhouette portrait of him, of post 1811, is in Liverpool Record Office; he there shows a similar profile to 2570 but is apparently a much older man and 2570 seems too young (in his forties or fifties) for the supposed dates of G. P. Day.

An attribution to Alexander Mosses, made perhaps in the early 1900's cannot be accepted. 2570 is stylistically similar to the portrait of the Rev. Iliffe and may therefore be by S. Crosthwaite who exhibited *The Old Newsman* at the Liverpool Academy of 1834.

PROV: Presented by Thomas Branch, 1857.[2]

EXH: (?)Liverpool Academy, 1834 (49); Walker Art Gallery, 1907, *700th Anniversary of Liverpool* (18) and 1908, *Historical Exhibition of Liverpool Art* (194); Bluecoat Chambers, January 1940.

REF: **1** Dates given in *Liverpool Daily Post,* 20 January 1940 (Press cuttings, Liverpool Record Office). **2** Library, Museum and Art Gallery Committee Minutes, 9 and 19 February 1857.

9262 Rev. F. Iliff

Oil on canvas, 61 × 50·8 cm. (24 × 20 in.)

Cut down from a three-quarter length portrait.[1]

Rev. Frederick Iliff (1799-1869), Head Master of the Royal Institution School, Liverpool, January 1834 – Midsummer 1846. He was born at Nottingham, educated at St. Paul's School, London and Trinity College, Cambridge; B.A. 1823, M.A. 1826, DD. 1838. Assistant and subsequently 2nd Master at Shrewsbury School before coming to Liverpool. He subsequently became Head Master of the Grange School Sunderland and Vicar of Gateforth, near Selby. Died at Sunderland, 9 March 1869. He was said to have an upright character and compelling personality and the school increased considerably under his mastership.[2]

PROV: Liverpool Royal Institution; presented by Liverpool University from the L.R.I., 1977.

EXH: Liverpool Academy, 1837 (3299).

REF: **1** A. T. Brown, *Some Account of the Royal Institution School,* 2nd edition, 1927, pp. 24, 25, 113; repr. fp. 160. **2** *Ibid,* pp. 24, 113.

DAHL, Michael 1656 - 1743

2359 Henrietta Maria, Lady Ashburnham

Oil on canvas, 231·8 × 136 cm. (91¼ × 53½ in.)

SIGNED AND DATED: *M Dahl : 1717*

Henrietta Maria, elder daughter and co-heiress (from 1714 sole heiress) of William, 9th Earl of Derby (d. 1702). She married first in 1706, John, 4th Earl of Anglesey (d. 1708), and secondly in 1714, John, 3rd Baron Ashburnham, as his second wife (he was created Earl of Ashburnham, 1730). Her only brother, Lord Strange, had died in 1698 and after the death of her sister Elizabeth in 1714, she became Baroness Strange in her own right. This title passed after the death of her own daughter to the Duke of Atholl.[1]

She wears a blue taffeta robe and gestures towards an orange tree bearing both flowers and fruit. This may refer to her family's connection with the House of Orange,[2] though it may bear on her two marriages.

A portrait of her husband by Dahl, probably dating from 1714, was also at Ashburnham House, near Battle, Sussex;[3] and a further smaller full length portrait of herself was in the same sale.[4] Her portrait by Kneller was at Knowsley with companions of her brother and sister.[5]

PROV: By descent to the Trustees of the Ashburnham Settled Estates, etc., sold Sotheby's, 15.7.1953 (108), bt. Agnew; presented by Major Philip R. England, 1954.

EXH: Agnew, 1955, *Acquisitions of the Walker Art Gallery, 1945-55* (22).

REF: **1** *The Complete Peerage,* 1910, I pp. 135, 272; 1916, IV, pp. 215-5; see also Foreign Schools Catalogue. **2** For the orange tree as symbolic of the protestant succession see John Ingermells in *The Burlington Magazine,* July 1976, pp. 511ff. **3** In Coronation robes; sale lot 104. **4** Lot 109, 43 × 30 in.; also with orange tree. **5** George Scharf, *Catalogue of the Pictures at Knowsley,* 1875, Nos. 158, 162, 165.

DALBY, David, active 1820 - 1840

8636 Car and Tandem outside Croxteth

Oil on canvas, 54·4×90·7 cm. (21⁷⁄₁₆×35¾ in.)
SIGNED AND DATED: *D. Dalby York 1833*
The main West front of the hall is shown.

Several other paintings by Dalby, all of 1833, were also at Croxteth. Four were of horses, one of Lt. Col. G. M. Molyneux with his troops, and a set of four of dogs.[1]

PROV: Purchased from the Executors of the Estate of the 7th Earl of Sefton, 1973.
REF: **1** Christie's Sale, Croxteth Hall, 19.9.1973 (1027–1031); Croxteth Inventory, 1946, Nos. 50, 52, 54–5, 75–8; this was No. 60.

DALBY, John, active 1840 - 1853

2326 Racing at Hoylake

Oil on canvas, 35·5×78·2 cm. (14×30¾ in.)
SIGNED AND DATED: *Dalby/1851*
This would appear, on the strength of an inscribed photograph of it,[1] to represent *The Shorts Handicap* at Hoylake on 11 September 1850. This was the second race at the autumn meeting of the Liverpool Hunt Club which was described in the *Liverpool Mercury* later the same week:[2]

'The weather was all that could be desired and the admirers of the Turf assembled in large numbers to witness the sports of the day. The Grand Stand was well attended and there was a tolerably good betting ring. There were a number of tents well supplied with the "creature comforts", and various amusements on the ground. The turf, which is good, was in excellent condition; and the course, with its recent alterations and improvements, is second to none in this part of the country. Mr. W. E. Topham as clerk of the course, handicapper, and starter, gave great satisfaction, the whole of the races taking place promptly at the appointed time; Mr. Horsley, as judge, discharged his duty well, and the best order prevailed throughout the day. The running was excellent THE SHORTS HANDICAP, sweepstakes of 5 sov. each, 3 sovs. forfeit, with a handsome piece of plate added, for horses of all ages. Half a mile. The last horse to pay the stakes of the second horse. 11 subs.

10. 9 br. c	Stepping-stone, 3 yrs Mr. Jones	1
12. 4 b g	Pizarro, aged..Mr. Watson	2
9. 10 b g	Daddy Longlegs, late Eunuch 3 yrs....... Mr. Gaman	3
12. 4 b g	Primrose, 5 yrs Mr. Duncan	0
11. 4 b f by	Touchstone, 4 yrs Mr. Clarke	0
10. 0 b c	Tol-lol-de-rol, late Standard Bearer, 3 yrs Mr. Mann	0

5 to 2 against Stepping-stone, 7 to 4 against Daddy Longlegs, 5 to 1 against Primrose, and 10 to 1 against Tol-lol-de-rol. The pace was very severe. About half way up the two-year-old course, Daddy Longlegs was leading, but was unable to maintain the pace, when Stepping-stone showed in front, and won by two lengths.'

The horses are identified[3] from the right, near the winning post as Stepping-stone (Mr. H. Longueville Jones), Pizarro, Daddy Longlegs, Primrose, Touchstone, Tol-lol-de-rol.

PROV: Walter Stone Collection; bequeathed by Miss Mary Stone, 1944.
EXH: National Gallery, 1945 (96); Bluecoat Gallery, Liverpool, 1953, *Walter Stone Collection* (6); Arts Council, 1974–75, *British Sporting Paintings, 1650–1850* (214).
REF: **1** In the Royal Liverpool Golf Clubhouse, Hoylake. **2** *Liverpool Mercury*, 13 September 1850, p. 8. **3** Photograph *loc. cit.*

DANIELS, William 1813 - 1880

Also called himself Daniel. Portrait and genre painter; born Liverpool 9 May 1813, the son of a brickmaker and victualler, late soldier, whom he assisted as a child. Taken up by Alexander Mosses (*q.v.*), who is said to have admired his clay models and drawings on sand at the brick works, and was his pupil at the Liverpool Academy Schools 21 February 1827 to about 1831; apprenticed to him as a wood engraver for seven years until about 1833; received no instruction in painting and taught himself at night by candlelight. Turned to portrait painting and quickly became successful. Exhibited at the Liverpool Academy, 1829–41 and 1862, but was never a member; Liverpool Society of Fine Arts, 1861–2; Royal Academy, 1840–1 and 1846; Manchester Royal Institution; Liverpool Autumn Exhibition, 1871–77. Married 1839, Mary Owen of Liverpool. An early patron was Sir Joshua Walmsley, who consistently helped him and recommended him. He painted portraits at the country houses of some sitters, and was planning a tour to include London and Paris in the summer of 1846. He is said to have made an unsuccessful attempt to establish himself in London for a short period. He had a prolific output but his intemperate life resulted in little advancement in his career and small financial gain. His style, realistic in conception, shows a bias towards the strong effects of light and shade; he often used himself or his family as models. Some of his portraits are in the Victoria and Albert Museum. Died Liverpool 13 October 1880.

4539 Self Portrait

Oil on board, 41·3 × 34·3 cm. (16¼ × 13½ in.)
A label on the back reads: *Portrait of Wm Daniels painted/by himself at the age of 20/ when a pupil of Mosses.* This is evidently a student's work and of poor quality.

PROV: Entered the Collection at unknown date before 1960.

7409 Portrait of a Young Man

Oil on canvas, arched top, fragment, 25·5 × 30·5 cm. (10 × 12 in.)
Perhaps a self portrait. Probably the same sitter in a similar pose, but in reverse, appears in *The Brigand* of 1837 (650).

PROV: George Milman, who presented it, 1970.

650 The Brigand

Oil on panel, 28·8 × 22·8 cm. (11⅜ × 9 in.)
SIGNED AND DATED: *W. DANIELS/1837*
See 7409 for study of the same model. A sketchier version with poorly painted head

belonged to Herbert Tyson Smith.[1] A further picture of this title but differing in composition and size dates from 1864.[2]

PROV: Purchased from W. J. Bishop, 1882.

REF: 1 Photo Gallery files. An inscription on the back stated that it was a self-portrait. 2 Sale, Node, Deighton and Son, Ludlow, 11.9.1973 (184) repr.

6367 Henry Morris

Oil on canvas, 90·5 × 70·2 cm. (35⅝ × 27⅝ in.)
SIGNED AND DATED: *W. DANIELS/1839*
The sitter was Trustee of the Licensed Victuallers' Association and a member of the West Derby Board of Guardians.[1] He is listed as Victualler, 129 London Road in 1839. He was later at the Pheasant Inn, Queen Square, Liverpool,[2] and subsequently lived at Linacre Marsh. He died 7 January 1860, aged 57, so was about 37 when Daniels painted him.

PROV: Thomas J. Morris, nephew of the sitter, in 1908; presented by Miss M. O. Morris, 1966.

EXH: Walker Art Gallery, 1908, *Historical Exhibition of Liverpool Art* (184).
REF: **1** Gallery files, 1908. **2** The copper plate of his visiting card was also presented by Miss Morris.

7625 (?) Self Portrait as a Young Man

Oil on canvas, 41×32 cm. (16⅛×12⅝ in.)

PROV: The Joseph Mayer Trust, Bebington,[1] presented by the Corporation of Bebington, 1971.
REF: **1** The Mayer Trust, *Handlist of Drawings, Prints, Sculpture*, etc., n.d., No. 39.

1724 Self Portrait

Oil on canvas, 91·5×71·7 cm. (36×28¼ in.)

The artist appears to be in his late twenties or early thirties, and perhaps the portrait which Marillier states was at the age of twenty-eight.[1]

PROV: Lewis Hughes, who presented it, 1883.
REPR: *Apollo*, LIV, September 1951, p. 79.
EXH: Walker Art Gallery, 1908, *Historical Exhibition of Liverpool Art* (554); Harrogate, 1924, *Liverpool School of Painters* (10).
REF: **1** H. C. Marillier, *Liverpool School of Painters*, 1904, p. 96.

7355 Joseph Mayer

Oil on canvas, 97×85 cm. (38¼×33½ in.)

SIGNED AND DATED: *W. DANIELS 1843* (on foot of table)

Joseph Mayer (1803–1886), antiquary and collector, a successful silversmith and jeweller in Liverpool *(q.v.)*. His collecting activities span the period between Roscoe and the opening of the public collections in Liverpool.

The sixth child of Samuel Mayer of Newcastle-under-Lyme (see 7623), he settled in Liverpool at twenty years of age and was apprenticed to his brother-in-law, Joseph Wordley, whose partner he subsequently became before finally setting up on his own at 68 Lord Street, about 1844–5. His taste for antiquities began early whilst still in Staffordshire and his collection eventually embraced a wide field from Egyptian antiquities to Wedgwood pottery and English paintings, and included an immense accumulation of MSS and other material to do with art and art history including a section on Liverpool. He sold his collection of Greek coins to the French

Government in 1844. In 1852 he opened his Egyptian Museum to the public in a house at 8 Colquitt Street. In 1867 he presented his collection to Liverpool Museum, which was subsequently called the Derby and Mayer Museums. He afterwards joined the Library, Museum and Art Gallery Committee. In 1860 he settled at Bebington and established a Free Library there in 1866. Remaining sections of his collection were dispersed in sales at Sotheby's in the 1870's and after his death and in a local sale of Liverpool material; much has been lost sight of.[1]

Fellow of the Society of Antiquaries and a member of many antiquarian societies; he was a founder member of the Historic Society of Lancashire and Cheshire, 1848, of which he was twice President. Amongst numerous writings he published works on Liverpool Pottery, 1854–5, etc., and *Early Art in Liverpool, with a Memoir of George Stubbs*, 1876. He was a patron of both Daniels and Ansdell and commissioned a series of busts of his friends from Giovanni Fontana of Bebington (some now in the Collection).

The portrait shows the sitter in the midst of his collection in his library at Clarence Terrace, Everton.[2] He is listed at that address in 1839 and 1841, while his business address, until 1843, was 56 Lord Street. He is seated in a gothic chair which was described on its exhibition in 1840,[3] as 'A Chair made from the house in which Roscoe was born [demolished 1823]. The two figures represent Lorenzo de Medici, the reviver of Literature in Europe and Leo X, the munificent patron of the Fine Arts – of whom Roscoe wrote the life. It is intended to introduce a medal of the Poet, with his autograph, arms, etc.' On the centre back is visible the carved initials of William Roscoe. It was to have a needlework cushion with a view of Roscoe's birthplace.[4] Both are now lost. Stanzas on the chair were published by J. Stonehouse for the Roscoe Centenary in 1853. The sitter holds a Wedgwood jasper vase and visible about the room are,[5] on the table: an Etruscan bronze candelabrum,* a North Peruvian pottery vessel representing llama,* a Wedgwood copy in red-stoneware of a classical oil lamp,* and a large jasperware relief medallion;* at the left on a cabinet with painted door and a plaque inscribed *WEDGWOOD* is a further Wedgwood vase,* a miniature bust of Roscoe by Spence, and a Sevres biscuit group of *Les Adieux de Paris*

*et Hélène;** behind this is the marble statue of Psyche by Gibson which formerly belonged to Roscoe,[6] a torso after the (?) Genius of the Vatican and a colossal head of Neptune, and to the right a bust of Napoleon and one of Lorenzo de Medici. One of his spaniels lies beneath his chair (see Ansdell 7777). The female portrait at the left may be that of his mother by Daniels and that on the rear wall is probably of his father, Samuel Mayer.[7] In the engraving (see below) Samuel Mayer is seated at the table with his son and a later anecdote[8] states that Daniels painted him out in a fit of pique when the likeness was criticised.

'Original sketches for the portrait of Joseph Mayer', presumably this picture, were in the Liverpool sale, 1887,[9] which also included designs for the Roscoe chair. A study for the portrait was at Bebington.[10]

Mayer was also painted by Harris at full length (see Harris biography: Bebington), by J. P. Knight (R.A. 1871, for Bebington), and in miniature by (?) H. Pelham.[11] (? John Ewart) Robertson was commissioned by Liverpool learned societies for a portrait in 1867/9.[12] A bust and relief by Fontana are now in the Collection (7599, 7613) and a life-size statue, also by Fontana is in St. George's Hall (7822 in the Collection).

ENGR: R. W. Buss (7¾ × 7 in.) inscribed: *THE LIBRARY OF JOSEPH MAYER/LORD STREET/LIVERPOOL.* Differing in some details from the painting above: Samuel Mayer is seated at left behind table on which is a cold collation in place of the numerous vases, etc; the female portrait is moved to the back wall. the colossal head at rear left is replaced by a classical vase. A proof before letters, 8285 in the Collection, is inscribed by Mayer: *Proof/Interior of my library at Clarence Terrace/Everton/Joseph Mayer.*

PROV: Painted for Joseph Mayer, who presented it to Liverpool City Museum to form part of the Mayer Collection, 1879,[13] transferred to the Gallery, 1969.

EXH: Mechanics Institution, Third Exhibition, 1844 (11), *Portrait of Joseph Mayer with Interior of his Library;* Walker Art Gallery, 1908, *Historical Exhibition of Liverpool Art* (96); and 1970, *The Taste of Yesterday* (47) repr.

REF: **1** Press cuttings and Mayer Papers (Liverpool Record Office); D.N.B.; sales at Sotheby's 12–13 Feb. 1875 (Ceramics); 21–24 June 1878 (Ceramics, antiquities); 23–26 May, 21–25 July,

1887 (Medals, miniatures, watercolours etc.). The local portion of the Mayer Collection sold Branch and Leete, Liverpool, 15–16 Dec. 1887. **2** See *Engraving,* and MS (copy) list, n.d., (Liverpool Record Office); also identified in letter of John Harding to J. A. Picton, 24 Nov. 1879, cited in newspaper report of gift (Gallery files). **3** Liverpool Mechanics Institute, First Exhibition, 1840 (240). **4** *Ibid,* No. 241 (design). A lithograph by T. Physicke after a drawing by W. G. Herdman is in the Mayer Papers (Liverpool Record Office). **5** Identified by Merseyside County Museums. Those marked with an asterisk are in the Museums' collection. **6** Visible in the watercolour *William Roscoe's Study:* see *Catalogue of Early English Drawings and Watercolours in the Walker Art Gallery,* 1968, No. 8. **7** Portraits of both were formerly in the Bebington collection (and see 7623). **8** Newspaper cutting, 16.10.1930 (Gallery files). **9** *Loc. cit:* lot No. 74, with other material to do with Daniels; and lot No. 13, J. Mayer original designs. **10** The Mayer Trust, *Handlist of Drawings, Prints, Sculpture, etc. . . Bebington,* n.d., No. 41; confirmed in newspaper cutting, 16.10.1930 (Gallery files). **11** MS (copy) list of bequest to Bebington (Liverpool Record Office). **12** Joseph Boult to Mayer, 13.6.1867 or 1869 (Mayer Papers). **13** Library, Museum and Art Gallery Committee, November 1879; Annual Report, 1880, p. 20.

7623 Samuel Mayer

Oil on canvas, 47 × 39 cm. (18½ × 15⅜ in.)

Samuel Mayer, J.P. (1767–1838), father of Joseph Mayer the antiquary and collector of Liverpool. The family originated in Newcastle-under-Lyme, where the sitter apparently both carried on the business of saddler and carrier, and developed a pottery industry associated with Josiah Wedgwood's Pottery. He there entered the Town Council, 1823 and was Mayor in 1833 under the charter granted by William IV.

He married 1792 his cousin Margaret Pepper, daughter of a neighbour and friend of Wedgwood. Joseph was the sixth of eleven children.[1] His family tomb, designed by William Spence for Joseph Mayer, is at St. Giles Parish Church, Newcastle-under-Lyme.[2]

A portrait of him also appears in the background of the portrait of Joseph Mayer (7355). A further portrait is recorded in the Mayer Papers.

F

PROV: The Joseph Mayer Bequest, Bebington;[3] presented by the Corporation of Bebington, 1971.

REF: 1 M. Byers, *Notes on the Family of Mayer* (about 1954), Mayer Papers (Liverpool Record Office). 2 Bill dated to August 1840 for £100, Mayer Papers (Liverpool Record Office) 3 The Mayer Trust, *Handlist of Drawings, Prints, Sculpture, etc.* n.d., No. 45.

1752 Master Edmund Kirby

Oil on canvas,[1] 127·5 × 101·5 cm. (50⅛ × 40 in.)

INSCRIBED on back of relining canvas: *PAINTED by Wm. Daniels/1844*

The little boy, posed with his rocking horse, has long golden ringlets and wears a tartan dress and blue velvet jacket trimmed with fur.

He was born in 1840 and died in 1922, and founded the family firm of Edmund Kirby and Sons, architects and surveyors in Liverpool; F.R.I.B.A.; F.S.I.[2]

PROV: By descent to the son of the sitter, Edmund Bertram Kirby, who presented it, 1949.

REPR: *Apollo*, LIV, September 1951, p. 82.

REF: 1 Relined. 2 Information from E. B. Kirby, letter, 24.6.1949.

1711 Portrait of a Young Girl standing by a Pedestal

Oil on canvas, 68·3 × 47·8 cm. (26⅞ × 18⅞ in.)

She wears a short white tucked lawn dress over long lace-trimmed pantalettes and blue embroidered apron; pink ribbons trim her dress and straw hat.

PROV: Mrs. B. E. Redfern, who presented it, 1948.

REPR: *Apollo*, LIV, September 1951, p. 82.

2562 A Young Man with a Squint

Oil on canvas, 60·6 × 50·5 cm. (23⅞ × 19⅞ in.)

SIGNED AND DATED: *W. Daniels/1848*

PROV: Dr. John Hay, who presented it, 1952.

3113 Chess Players

Oil on canvas, 62·2 × 81·3 cm. (24½ × 32 in.)

SIGNED: *W. Daniels*

Also called *Checkmated*.[1] Traditionally thought to be portraits of a Mr. Breeze, a warehouseman of Liverpool and friend and patron of Daniels, and his brother-in-law and his wife.[2] Probably dating from the 1840s.

PROV: (?) Artist's sale, Walker, Ackerley, Liverpool, 6.12.1880 (181).[3] Unidentified sale, lot 120.[4] T. T. Crane, who presented it, 1906.

EXH: Walker Art Gallery, 1908, *Historical Exhibition of Liverpool Art* (563).

REF: 1 Unidentified sale label, verso. 2 Ralph Fastnedge, *William Daniels*, in *Apollo*, LIV September 1951, p. 81; confirmed by Mr. K. A. Brooks, great-grandson of Mr. Breeze, July 1970. 3 Fastnedge, *loc. cit.* 4 Label.

2561 William Parkinson

Oil on canvas, 91·4 × 71 cm. (36 × 28 in.)

SIGNED AND DATED: *W. Daniels/1851*

INSCRIBED on back of canvas: *Wm. Parkinson Aged 46 1851/ Painted by Wm. Daniels*

The sitter holds a paper in his right hand inscribed *Parkinson Esq/L'pool*. He has not been identified amongst the various people of this name living in Liverpool at the time.

PROV: Mrs. Hancox, who presented it, 1951.

1618 A Gleaner

Oil on canvas, painted circle, 43·8 × 43·5 cm. (17¼ × 17⅛ in.)

Believed to be a portrait of the artist's eldest daughter, Mary.[1]

PROV: Richard Eastham, from whom purchased, 1909.

EXH: Walker Art Gallery, 1908, *Historical Exhibition of Liverpool Art* (129).

REF: 1 Oral information from descendants of the artist, January, 1952.

435 Joan of Arc

Oil on canvas, 47·7 × 41·1 cm. (18¾ × 16 3/16 in.)

Believed to be a portrait of the artist's maid-servant, Helen.[1]

PROV: Richard Eastham, from whom purchased, 1909.

EXH: Walker Art Gallery, 1908, *Historical Exhibition of Liverpool Art* (782).

REF: 1 Oral information from a descendant of the artist, January 1952.

2380 The Argument

Oil on board, 32·4 × 41 cm. (12¾ × 16⅛ in.)

On a label on the back is inscribed: *THE ARGUMENT/BY WILLIAM DANIELS,*

Painted in 1858/Each of the figures represents/ Liverpool worthies. £25/From Mr. Fred Doyens [?] collection of the artist's/work.
The quality is poor and the attribution doubtful.
PROV: Fred Doyens (?). Dr. T. Glynne-Morris. In the collection before 1958.

1710 The Card Players
Oil on canvas, 60·7×50·8 cm. (23⅞×20 in.)
PROV: (?) Edward Byrford in 1860. Purchased from H. E. Kidson (dealer), 1908.
EXH: ? Liverpool Society of Fine Arts, 1860 (supplementary), *Loans* (82).

1760 The Prisoner of Chillon
Oil on canvas, 84·5×114·5 cm. (33¼×45⅛ in.)
SIGNED AND DATED: *Wm. Daniels/1862*
Illustrating Byron's *Childe Harold*, Canto X:

A light broke in upon my brain -
 It was the carol of a bird;
It ceased, and then it came again,
 The sweetest song ear ever heard.[1]

The model is stated to be a Mr. Stephen of Liverpool (about 1815–1895).[2] An oil study (25×19½ in.), belonged in 1916 to Dr. Philip Nelson.[3]
PROV: (?) W. Somerville, 1882.[4] Purchased from John King (Liverpool dealer), 1892.
REPR: H. C. Marillier, *The Liverpool School of Painters*, 1904, fp. 96.
EXH: Walker Art Gallery, 1908, *Historical Exhibition of Liverpool Art* (552); Harrogate, 1924, *Liverpool School of Painters* (11).
REF: 1 Indistinct MS label, and see William Tirebuck, *William Daniels, Artist*, 1879, p. 40. 2 Letter from D. Jewsbury, 8.10.1957, a connection of the sitter. 3 Then deposited on loan. 4 Repr. *The Magazine of Art*, 1882, p. 341, where the rat by the vase has its tail to the right instead of to the left.

L137 John Stuart Dalton
Oil on canvas, 63·5×53·2 cm. (25×21 in.)
John Stuart Dalton (about 1796–1868), the first Chief Librarian of Liverpool, 1851–1867. His ability and zeal largely contributed to the success of the new public library. He established the local history section; branch libraries,

supplied books to prisons and hospitals and provided books for the blind.[1]
PROV: Miss Jane Calderwood, by 1908, who bequeathed it to Liverpool City Library, 1939; lent to the Gallery, 1973.
EXH: Walker Art Gallery, 1908, *Historical Exhibition of Liverpool Art* (959).
REF: 1 Peter Cowell, *Liverpool Public Libraries, a History of Fifty Years*, 1903, pp. 38, 112; *Liverpool Public Libraries Centenary, 1850–1950, Handbook*, 1950 p. 35 repr. (detail).

3114 An Italian Image Seller
Oil on canvas, 80×64·5 cm. (31½×25⅜ in.)
SIGNED AND DATED: *Wm. Daniels. 1870*
The title is of the time of acquisition and may be wrong: a tramp or down-at-heel man (whose face resembles portraits of the artist) sits on the wall of a country lane. By him on the ground is a statuette of a classical figure, perhaps Mercury or Cupid Disguised, and a bust of Clytie, which might be a cheap version of Copeland's Parian-ware bust.[1]
PROV: (?) J. Paris, Liverpool dealer, 1914;[2] John Elliot, who presented it, 1914.
REF: 1 C. and D. Shinn, *Victorian Parian China*, 1971, pp. 17, 31, repr. 2 Letter from John Elliot, 6 June 1914 (letter file).

7479 Joseph Hubback
Oil on canvas, 60×50·8 cm. (23⅝×20 in.)
Attributed to Daniels on grounds of style. Joseph Hubback (1813/14–1883), corn merchant of Liverpool. Elected Alderman 1862, and Mayor 1869–70. His portrait by John Ewart Robertson was at the Liverpool Academy, 1855.
PROV: Transferred from Liverpool City Library, 1971.

1606 Portrait of an Elderly Man
Oil on canvas, 55·8×43·1 cm. (22×17 in.)

1607 Portrait of an Elderly Woman
Oil on canvas, 45×38 cm. (17¾×15 in.)
Companion portraits.
PROV: By descent from the artist, through his daughter Penelope, Mrs. Priest, to W. D. Priest, who presented them, 1958.

436 A Nun
Oil on canvas, 47·! × 38·3 cm. ($18\frac{11}{16} \times 15\frac{1}{8}$ in.)
SIGNED AND DATED: *Wm. Daniels/1879*
PROV: Henry S. Eastham, and by descent to
Mrs. Lucie Trenbath, from whom purchased,
1927.

2974 The Critics
Purchased 1891; damaged beyond repair
1939–45 war and destroyed, 1961.

DAVIES, Austin Howard, living artist

1105 The Forest Fungus
Oil on board, 71·7 × 102·3 cm. ($28\frac{1}{4} \times 40\frac{1}{4}$ in.)
PROV: Purchased from the artist, 1955.
EXH: Walker Art Gallery, 1955, *Liverpool
Academy* (25).

1815 Under the Brown Hill
Oil on board, 60·7 × 86 cm. ($23\frac{7}{8} \times 33\frac{7}{8}$ in.)
PROV: Purchased from the artist, 1958.
EXH: Walker Art Gallery, 1958, *Liverpool
Academy* (141).

DAVIS, William 1812 - 1873

Landscape painter. Born Dublin, son of an attorney. Began to train for the law but quickly
turned to art and studied at The Dublin Society's School; practised in Dublin as a portrait
painter and exhibited portraits at the Royal Hiberian Academy 1833–35. Moved to England
and was living in Sheffield in 1837, where he is said to have painted portraits; at least one
landscape view of that neighbourhood is recorded. Exhibited at the Liverpool Academy from
1842/3 and settled in Liverpool probably at about the same date. Entered Liverpool Academy
Schools as probationer, February 1846, and Student, January 1848; Associate of Liverpool
Academy, 1851; Member, 1853; Professor of Drawing, 1856–59. Exhibited at the Royal
Academy, 1851–72, and at the Liverpool Autumn Exhibition, 1871–73. His early work
exhibited in Liverpool was still-life and figure subjects but he turned to landscape about 1853,
possibly under the persuasion of Robert Tonge (*q.v.*). The small-scale perfection and delicate
visual quality of his work was greeted with enthusiasm by Ford Madox Brown, and by Rossetti
who tried unsuccessfully to get the approval of Ruskin who preferred more important subject
matter. In the late 1850's Davis was a member of the Hogarth Club in London and on personal
terms with the fellow members of the Pre-Raphaelite circle. His style became more minute
and precise under the influence of their work. He worked chiefly for a few local patrons and
their connections, in particular John Miller, George Rae and James Leathart (of Newcastle).
But otherwise met with little success. Moved to London about 1870 and died there 22 April
1873. A memorial exhibition was held in Liverpool in 1873. Of his large family his sons
Val (born 1854) and Lucien (born 1860) were also artists.

8699 Gifts

Oil on canvas, 112·4×99·6 cm. (44¼×39¼ in.)

SIGNED: *W. DAVIS*

This is the first large-scale figure subject by Davis which has come to light. The similarity of style of the still life details of dead game with other paintings of the type suggests a date around 1850 and before the artist turned almost exclusively to landscape. The painting and characterisation of the girl's head and pose in particular, reveals a perceptive portrait style.

PROV: Purchased in the early 1930's, from an unidentified collection in the Conway area, by Alexander Laing as a present for his wife, from whom acquired by his niece, Mrs. Lydia Oldham; purchased from her, 1974.

700 Game

Oil on canvas, 58·3×50·5 cm. (23×19⅞ in.)

SIGNED: *W. Davis*

INSCRIBED on the back: *This picture is the exact representation of/ a Brace of Grouse shot in the Woodlands Denbighshire/by Charles Andrew November 1851*

PROV: John Elliot, who presented it in memory of Charles H. Lear, 1905.

EXH: Walker Art Gallery, 1908, *Historical Exhibition of Liverpool Art* (516); Whitechapel, 1909 (53).

2381 Pheasant and Drake

Oil on canvas, 44·8×64·5 cm. (17⅝×25⅜ in.)

From the same period as 700. The artist exhibited dead game subjects at the Liverpool Academy, 1850–1852.

PROV: Mrs. Pelham, from whom purchased 1908.

EXH: Walker Art Gallery, 1908, *Historical Exhibition of Liverpool Art* (517); Harrogate, 1924, *Liverpool School of Painters* (5).

L38 On the Alt near Formby and Ainsdale

Oil on board, 30·3×45·1 cm. (11⅞×17¾ in.)

INSCRIBED, verso, by (?) J. Miller: *W Davis/ Liverpool 1853 | Near Formby and Ainsdale/ J Miller || Mrs. Munn.*

PROV: John Miller, and by descent through his daughter, to Miss Margaret Anne Munn, who bequeathed it to Wallasey Corporation, 1946; lent by Wallasey Corporation, 1971.

L39 On the Liffey

Oil on canvas, 38·5×62·5 cm. (15¼×24⅝ in.)

INSCRIBED, verso: *W Davis | of Liverpool | on the Liffey |. . .|*

Davis revisited Ireland in 1853[1] and again in May 1857.[2] See also 6247 and 6248 which formerly belonged to Miller.

PROV: (?) John Miller; M. E. Miller, who gave it to Daisy Munn, 1902;[3] thence by descent to Miss Margaret Anne Munn, who bequeathed it to Wallasey Corporation, 1946; lent by Wallasey Corporation, 1971.

REF: 1 H. C. Marillier, *The Liverpool School of Painters,* 1904, p. 100. 2 J. Miller, letter to F. Madox Brown, 17 May and 21 June 1857 (Madox Brown Family Collection). 3 Inscription, verso.

1494 Bidston Marsh

Oil on board, 30·1×45·4 cm. (11⅞×17⅞ in.)

SIGNED: *W. DAVIS*

INSCRIBED on the back, in pencil: *Wm Davis Liverpool 1855*

The Flintshire hills appear in the background. Allen Staley suggests[1] a debt to Linnell in Davis's earlier work and here that Mark Anthony's landscapes may have been an influence on him.

PROV: Presented by John King (dealer, Liverpool), 1911.

REF: 1 Allen Staley, *The Pre-Raphaelite Landscape,* 1973, p. 139, pl. 74b.

6247 Near Leixlip, on the Liffey

Oil on board, 20·3×30·2 cm. (8×11⅞ in.)

INSCRIBED on the back in pencil: *Near Leixlip/on the Liffey/Wm Davis/Liverpool 1857* and *John Miller.*

The view is looking down-stream from the right bank of the Liffey towards the village of Leixlip with the boat-house in the grounds of Leixlip Castle visible at centre left.

John Miller, the Liverpool patron, also owned a further view at Leixlip, *Salmon Leap on the Liffey* (16½×24 in.) which is now in Birkenhead Art Gallery. Some of these pictures he mentions in writing to Ford Madox Brown in June 1857 giving him news of the Liverpool artist: 'Davis,' he wrote, 'has been in Ireland, and painted three very beautiful little things, all of which as a matter of course I suppose

have become mine.'[1] Davis was over in Ireland during May.[2]

Miller lent *Leixlip* and *On the Liffey* to the Memorial Exhibition in 1873.

PROV: John Miller: this or 6248 may have been in his sale Christie's, 21.5.1858 (122) – as *View on the Liffey, near Leixlip;* William Coltart;[3] (?) George Rae;[4] by descent to Mrs. Sonia Rae, from whom purchased 1964.

REF: **1** John Miller, letter to Ford Madox Brown, 21 June 1857 (Madox Brown family). **2** The same to the same 17 May 1857 *(loc. cit.)*. **3** Further inscription on the back panel. **4** The *Catalogue of Mr. George Rae's Pictures* (*c.* 1900), No. 55 is *Near Oxlip* (probably a misprint for Leixlip). It might refer to either 6247 or 6248.

6248 Junction of the Liffey and Rye near Leixlip

Oil on board, 20·3 × 30·5 cm. (8 × 12 in.)

INSCRIBED on the back in pencil: *Junction of the Liffey and Rye/near Leixlip/Wm. Davis Liverpool/1857/John Miller*

The view is from the right bank of the Liffey across to the Rye with the boat-house in the grounds of Leixlip Castle at the left and the Church tower of Leixlip on the right.

PROV: John Miller (and see 6247 above), possibly a gift from him to a Miss M. Arthur[1]; (?) George Rae; by descent to Mrs. Sonia Rae, from whom purchased, 1964.

REF: **1** A pencil inscription on the back suggests this.

L37 Bute from the High Ground

Oil on board, 20·3 × 49·5 cm. (8 × 19½ in.)

INSCRIBED, verso: *Bute from the high ground above the* [?] *Mill house bridge. . ./W. Davis //* [?] *In Autumn/*[?] *1857//J Miller*

John Miller, the Liverpool patron, had a house in Bute. Marillier[1] relates an incident which occurred during one of Davis's visits to him there, which may refer to this picture. He was painting a view of the Cumbraes from Bute and asked a farmer for the loan of a horse to paint in the foreground; the farmer refused in alarm to allow his horse to be 'painted', but it appeared in the picture nevertheless.

PROV: John Miller, and by descent to S. K. Munn, 1907;[2] Miss Margaret Anne Munn, who bequeathed it to Wallasey Corporation,

1946; lent by Wallasey Corporation, 1971.

REF: **1** H. C. Marillier, *Liverpool School of Painters*, 1904, pp. 108–9. **2** Inscriptions on verso.

8724 The Rainbow

Oil on canvas, 45·5 × 65·5 cm. (17$\frac{15}{16}$ × 25$\frac{13}{16}$ in.)

Evidently the picture of this title exhibited at the Liverpool Academy in 1858 when it was adversely criticised. The *Mercury* reviewer in contrasting it to another picture by Davis called it 'an offensive daub, in a scene which it is difficult to realise as taken from or approximating to nature.'[1] The *Courier* considered that it 'can only excite a smile of pity; it is the same unnatural iris which figures in last year's prize picture [Millais's *Blind Girl*], with an additional coat of paint added. A blind man could have painted better.'[2]

Prior to 1972 the canvas was folded back at the right concealing the rainbow, on a stretcher 55·3 cm. long probably removed from another picture by the artist,[3] suggesting that the artist himself concealed it, perhaps having taken the criticisms to heart.

PROV: William Sproston Caine; thence to his daughter, Hannah, Lady Clwyd, who bequeathed it to the Hon. Mervyn Roberts, who in turn gave it to W. S. Caine's granddaughter, Mrs. A. C. M. Jones,[4] who presented it, 1974.

EXH: Liverpool Academy, 1858 (49) *N.F.S.*

REF: **1** *Liverpool Mercury,* 23 September 1858. **2** *Liverpool Courier,* 29 September 1858. **3** An MS label inscribed: *No. 1 Near St. Helens, Lancashire/Wm. Davis/35 Plumpton Street/ N Liverpool.* Davis is recorded at this address between 1857 and 1859. Also on it is a framemaker's label of Sanderson, 10 Mount Pleasant, Liverpool. **4** Information from Mrs. A. C. M. Jones, in letter, 12.11.1974 (Gallery files).

424 Summertime

Oil on canvas, 43·7 × 67·2 cm. (17¼ × 26½ in.)

SIGNED AND DATED: *W. DAVIS 18* [? 61 or 2] the date indistinct and partly destroyed.

Evidently the picture at the Liverpool Academy of 1862 criticised in a local newspaper as follows: 'What shall we say of Mr. Davis? Ruskin has patted him on the back, and Palgrave, the much abused, has caressed him in his quashed pamphlet. We shall pass by his "Haystack"

with the remark that it is the best he exhibits, and speak of No. 153 as being the larger work and more open to criticism. The best feature in the picture is the vista seen through the trees in the centre, and the second best, certainly, the truthful rendering of the two calves to the right of the foreground. The former is a piece of honest, tender painting, having all the softened charm lent by distance, which is effected by a strict and careful attention to atmospheric effect. The second bit contains a vast amount of talent for animal deliniation, together with bright and, at the same time, simple colouring. The drawing of the foremost boy is bad in the extreme: his body is preposterously broad and the arm is stiff, while the dragon-fly to which he is pointing is a giant among insects. The sky has a smutched appearance, which is a fault Mr. Davis is rarely guilty of, and the trees have a painful similitude of form. If his rival, Mr. Newton, paints a tree, one can speak with certainty as to its denomination; but here we have several that are only distinguishable from each other by the colour. There is as much required from an artist in portraying foliage as any other part of his painting: and we should advise Mr. Davis to pay special attention to this branch of the art so essential to a landscape painter.'[1]

PROV: Bequeathed by John Elliot, 1917.

EXH: Liverpool Academy, 1862 (153), as *Landscape*.

REF: 1 *The Porcupine*, 25 October 1862, p. 234.

1115 Hale, Lancashire

Oil on canvas, 33 × 50 cm. (13 × 19¾ in.)

SIGNED: *W.D.*

INSCRIBED on the back: *Hale/Lancashire/ W. Davis*

Probably a view from the Liverpool end of the village where a cottage with construction similar to that shown here, still stands.

Probably dating from into the 1860's. This and 1121, 1495 and 1146 below have a more meticulous detail and brighter colour, showing Pre-Raphaelite influence.

John Miller noted in a letter of December 1861 that Ford Madox Brown was 'rightly informed in Davis's pictures being very fine of late – he is attending more to compose them than he did and introducing figures which you know he can do so well . . .'.

PROV: (?) William Coltart executors' sale,

Christie's, 11.4.1904 (110), bt. Mitchell. Purchased from John King (dealer, Liverpool), 1904.

EXH: Walker Art Gallery, 1908, *Historical Exhibition of Liverpool Art* (540); and 1960, *Liverpool Academy 150th Anniversary Exhibition* (73).

REPR: Allen Staley, *The Pre-Raphaelite Landscape*, 1973, pl. 76a.

REF: 1 John Miller to F. Madox Brown, 19 December 1861 (Madox Brown family).

1121 Old Mill and Pool at Ditton

Oil on canvas, 53 × 35·8 cm. (20⅞ × 14⅛ in.)

SIGNED: *W. DAVIS*

INSCRIBED on the back: *Old Mill/at Ditton/ Lancashire/W. DAVIS*

Ditton Windmill and a nearby pool are marked on the 1845–49 Ordnance Survey a little to the east of Ditton station, between the railway line and Ditton Bridge Road.

Allen Staley[1] assigns a date around 1856–60, but to the compiler the tight style suggests the early or mid-1860's. A *Ditton Mill* (15½ × 12 in.) was in John Miller's sale in 1881[2] and was perhaps the picture of the same size later in Ralph Brocklebank's collection;[3] a picture of the same title also belonged to William Newall.[4]

PROV: Bequeathed by John Bate, 1885.

EXH: (?) Liverpool Academy, 1864 (101), *Old Mill at Ditton*; Walker Art Gallery, 1908, *Historical Exhibition of Liverpool Art* (498); Harrogate, 1924, *Liverpool School of Painters* (43); Detroit and Philadelphia, 1968, *Romantic Art in Britain* (195); Cork, 1971, *Irish Art in the 19th Century* (34) repr.

REF: 1 In Philadelphia catalogue *loc. cit.*, and, Allen Staley, *The Pre-Raphaelite Landscape*, 1973, p. 141, pl. 75. 2 Branch and Leete, Liverpool, 6.5.1881 (279). 3 Walker Art Gallery, 1908 exhibition, and Brocklebank sale, Christie's 7.7.1922 (62) bt. Miss Foa. 4 His sale Christie's, 30.6.1922 (80, part), bt. Permain.

1495 View from Bidston Hill

Oil on canvas, 30·5 × 40·5 cm. (12 × 16 in.)

SIGNED: *W. DAVIS*

A view toward the South-west from the Wirral with the Clwydian Range in Denbighshire in

the background. A huntsman with hounds comes up through the trees on the far right and waves his arm as a hare hesitates in flight in the foreground. An almost identical view ($9\frac{1}{4} \times 12\frac{5}{8}$ in.) but with very minute differences belonged to Joseph Beausire of Liverpool (Christie's, 22.11.1969 and thence to Colnaghi). It may be a reduced version of 1495, but both pictures are exceptionally hard in finish.

Both the *Liverpool Daily Post* and *Porcupine* reviewers of the 1865 Liverpool Academy exhibition thought this and Davis's other exhibited pictures attractive but the introduction of a large hare eccentric. The latter wrote: 'It is a very charming little drawing of a stretch of flat landscape, but marred by the introduction of an immense and decidedly unnatural hare, which is running across the immediate foreground. The animal is simply an absurdity. It is grotesque in size, and its attitude is most untrue. Supposed to be running, it appears, with its ears cocked up, not thrown back level with the neck as we should have supposed, while its legs lead one to doubt whether it is moving at all. We should have forgiven Mr. Davis this last error if he had not already proved himself to be so proficient as an animal painter – he has therefore no right to give us such a comic animal production.'[1]

Another *Bidston Hill* ($12\frac{1}{2} \times 19\frac{1}{2}$ in.), belonged to A. T. Squarey of Liverpool.[2]

PROV: John Elliot before 1908; and bequeathed, 1917.

EXH: Probably this version at Liverpool Academy, 1865 (266), *At Bidston Hill;* Walker Art Gallery, 1908, *Historical Exhibition of Liverpool Art* (739); Cork, 1971, *Irish Art in the 19th Century* (35).

REF: 1 *Porcupine,* 14 October 1865; *Liverpool Daily Post,* 28 September 1865, Supplement. 2 His sale Christie's, 5.2.1912 (50), bt. King.

1146 Ploughing, Valley of the Conway

Oil on canvas, 91.8×147.5 cm. ($36\frac{1}{8} \times 58\frac{1}{8}$ in.)

SIGNED AND DATED: *W. DAVIS 1869*

INSCRIBED on the back: *Ploughing, Valley of the Conway 1869 William Davis*

A watercolour connected with this composition is also in the Collection (6249). The artist seems to have produced several variations on this subject; another example ($33\frac{1}{2} \times 57\frac{1}{4}$ in.),

perhaps R.A. 1870, is in the Williamson Art Gallery, Birkenhead.

PROV: John Elliot by 1873; and bequeathed 1917.

EXH: ? Liverpool Art Club, 1873, *William Davis Loan Exhibition,* as *Ploughing* (41); (?) Whitechapel, 1907 (103) and Walker Art Gallery, 1908, *Historical Exhibition of Liverpool Art* (721), as *Ploughing, Vale of Clwyd.*

1116 Corner of a Cornfield

Oil on panel,[1] 35.5×45.7 cm. (14×18 in.)

A letter dated from Haverstock Hill, London, 4 May, 1871 and addressed to Humphrey Roberts, Esq., is attached to the back of the panel and reads: 'The [or this] small cornfield / a study for a commission / which I have had in hand / and [? but] the study is better / than the picture / I am greatly obliged / for the help which you / have given me and think / you will find that I am / sensible of it / yours truly / Wm. Davis / Humphrey Roberts, Esq. / . . .'

Perhaps a study connected with the *Cornfield After Rain* exhibited posthumously at Liverpool Autumn Exhibition, 1873. Similar subjects were exhibited at the Liverpool Academy during the 1860's.

The crop appears to be maize.

PROV: (?) Humphrey Roberts, 1871; Col. W. Hall Walker (Lord Wavertree), who presented it, 1906.

EXH: Walker Art Gallery, 1908, *Historical Exhibition of Liverpool Art* (549); Harrogate, 1924, *Liverpool School of Painters* (20); Walker Art Gallery, 1960, *Liverpool Academy 150th Anniversary Exhibition* (74).

REF: 1 Label of Charles Roberson, artists' colourman, London.

1508 Tree Study

Oil on canvas, 30.5×45.7 cm. (12×18 in.)

SIGNED: *W. DAVIS*

A very broadly treated sketch.

PROV: Presented by Harold S. Rathbone, 1912.

DAVIS, William, ascribed to
8486 The Courtyard at Speke Hall

Oil on canvas, 50·2×43·5 cm. (19¾×17⅛ in.)

SIGNED AND DATED: *IC/1854* (initials in monogram, the I inside the C)

Repaired in an area in the right-hand tree.

A view from the door in the south front back between the great yew trees towards the entrance corridor on the north front. Apparently painted just before the restorations undertaken by the owner Richard Watt on coming into the property in 1855;[1] it shows a slightly different fenestration from today and the door visible at the left of the entrance may be an imaginary introduction.

Speke Hall, dating initially from the 16th century and owned by the Norres (Norreys etc.) family and their heirs the Beauclerks was sold in 1795–6 to Richard Watt, a merchant of Liverpool. It was then said to be in a ruinous state and Watt undertook some repairs, but did not live there after 1812. It was subsequently allowed to deteriorate. Joseph Brereton, timber merchant, was leasee from the late 1830's until *c.* 1855 when the owner's great-nephew and heir, also a Richard Watt, came of age. He took up his residence there and died 1865. From 1866–77 it was let by the Watt family to Frederick Leyland, the great Liverpool shipowner and art patron (who entertained Whistler there). In 1942 it was given to the National Trust and is now administered by Merseyside County Museums.[2]

The house, with its picturesque appearance and romantic Catholic associations, was a favourite subject for artists. In 1854, the date on this picture, G. D. Callow and Harry Williams of Liverpool each exhibited a *Speke Hall, Lancashire,* at respectively the Royal Scottish Academy and Manchester Royal Institution (a watercolour); William Collingwood exhibited *The Young Heir, Speke Hall,* at the R.A. of 1856 and *The Goldfish, a corner of Speke Hall* at the Liverpool Academy, 1856; James Drummond exhibited *Ancient Doorway, Speke Hall* at the R.S.A., 1856.

8486 is ascribed to William Davis on grounds of style and the cut remains of an MS label on the stretcher which appears to read *224 Speke Hall.* This can be equated with lot 224 in the sale of John Miller's collection at Liverpool (Branch and Leete), 6 May 1881, which was a picture of this title by William Davis, size 20½×17 in. (though in this sale width generally preceded height). An *Interior, Speke Hall* by Davis belonged in 1886 to A. J. Squarey of Liverpool, and was in his sale Christie's, 5 February 1912 (part of 51, no size given), and thence passed to Harold Brocklebank, also of Liverpool, and now untraced. The attribution does not explain the monogram which would have to be read as a D with a long tail and certainly uncharacteristic of Davis's usual, later, block-letter signatures. This remains a puzzle.

The attribution by the former owners was to James Collinson (1825–1881).[3] He was a genre painter and founder member of the Pre-Raphaelite circle of 1848 and the least original of the circle. From January 1853 to March 1855 he was a novice in the Society of Jesus and was at Stoneyhurst College, Lancashire until September 1854. It is, however, extremely unlikely that he would have been allowed to visit Liverpool or to paint there.[4] This painting, while akin to Pre-Raphaelite approach to nature and showing delicate observation in its light and shade, is uncharacteristic of Collinson, notably in its complete lack of subject. The only comparable landscape by him is the much more brilliant one in his *Woman and Child by a stile in the Isle of Wight* (Paul Mellon Collection) where the figures, as is usual with him, take up most of the canvas. His signatures are usually in full.

A watercolour by James Drummond dated 1855 and several interiors by Nash, etc., are also in the Collection. See also Huggins (44).

PROV: (?) John Miller, sold Branch and Leete, Liverpool, 6 May 1881 (224). Purchased from Jeremy Maas, Clifford Street, London, from the gift of F. W. Powell and with the aid of the Victoria and Albert Museum Grant-in-aid, 1973.

REF: **1** Information from Paul Lawson, Merseyside Museums, Speke. **2** *Ibid.* **3** Information from Jeremy Maas. **4** Information from Father F. G. Turner, Stoneyhurst College, and Francis Edwards, S.J., English Province of the Society of Jesus, London, January 1974.

DAWBARN, Joseph Yelverton 1856 - 1943

Landscape painter. Born Liverpool 24 October 1856, son of a Liverpool merchant to whom apprenticed until 18; then read mathematics at Queens' College, Cambridge, 1874–77; then law; called to the bar, 1881, but did not enjoy profession and practised little. His mother, an amateur artist, encouraged him and he studied art under John Finnie at Liverpool Institute School of Art and joined with brother in sketching tours in Flanders, Normandy, etc.; then in Paris under Bouguereau and Fleury, 1890–94. Exhibited at Liverpool Autumn Exhibitions from 1887, Royal Academy from 1897, and elsewhere. Member Liverpool Academy, 1898; Hon. Treasurer, 1899–1907, and President, 1908–12. Member Liver Sketching Club and Artists' Club. Died 17 September 1943.

437 Oppidi Opulentia
Oil on canvas, 61 × 51 cm. (24$\frac{1}{16}$ × 20$\frac{1}{16}$ in.)
SIGNED AND DATED: *J. Y. DAWBARN. 09.*
Liverpool Town Hall from Castle Street, in snow.

PROV: Purchased from the artist at the Autumn Exhibition, 1909.

EXH: Walker Art Gallery, 1909, *Liverpool Autumn Exhibition* (160); White City, London, 1911.

DAWSON, Henry 1811 - 1878

Landscape, marine, and occasionally portrait painter. Resident in Liverpool 1844–49. Born Hull and lived at Nottingham until thirty-five years, working in lace industry but early began painting. Set up as an artist 1835; had several lessons from W. H. Pyne, 1838, London, otherwise self-taught. Moved to Liverpool October 1844 in hopes of improved career. Sold some works through Joseph Richardson, artist and colourman of 5 Post Office Place; met John Barton, auctioneer of Liverpool and Preston and through him John Miller, art patron, and Philip Westcott, Richard Ansdell and thus Liverpool Academy artists. Made various sketching tours and revisited Nottingham while at Liverpool. Attended Liverpool Academy Life Class from 1845; elected Associate, 1846; Member, 1847; non-resident Member, 1850, and resigned March 1852. Exhibited at the Royal Academy from 1838, the British Institution from 1841, Liverpool Academy, 1845–52; Manchester and elsewhere. In last few years in London gained some increasing success. Father of Henry Thomas Dawson, marine painter and Alfred Dawson, engraver. Died London 11 December 1878.

725 Pont Faen, near Chirk, Denbighshire

Oil on panel, 76·2 × 63·5 cm. (30 × 25 in.)

While at Liverpool Dawson apparently visited North Wales with Philip Westcott *(q.v.)* and, according to information supplied to his biographer by John Barton the auctioneer, stayed at Chirk Castle and sketched around Llangollen.[1] A picture of Chirk Castle 24 × 36 in., is listed under 1845 in the biography,[2] which gives a probable date for the present painting.

PROV: Presumably Liverpool Academy Diploma picture; presented with nine others for Permanent Gallery of Art in Liverpool by the Liverpool Academy, 1851;[3] Liverpool Royal Institution;[4] deposited at the Gallery by the L.R.I., 1893,[5] and transferred by deed of gift, 1948.

REF: 1 Alfred Dawson, *Life of Henry Dawson,* 1891, pp. 36, 41. 2 *Ibid,* p. 47. 3 Liverpool Academy *Minutes* 10 March, 14 April 1851, 23 December 1853 (Liverpool Record Office). 4 1859 Catalogue, No. 173. 5 1893 Catalogue, No. 127.

406 The Harbour, Evening

Oil on canvas, 36·1 × 66·6 cm. (14¼ × 26¼ in.)

SIGNED: *H. Dawson*

PROV: Mr. Crossfield sale at Brown and Rose, purchased by H. R. Rathbone. Purchased 1908.

DICKINSON, H. J. B.

2666 Colonel William Hall Walker on Flirt

Oil on canvas, 41·3 × 51·5 cm. (16¼ × 20¼ in.)

SIGNED: *H. J. B. /Dickinson*

For biography see Morrison, 2569. A further portrait of Colonel Walker's polo pony, 'Flirt' by Frank Paton dates from 1880 (Inv. No. 2675).

PROV: Bequeathed by Lord Wavertree, 1933.

DOUGLAS, Sheila, living artist

1487 Pennine Landscape

Oil on canvas, 71 × 91·5 cm. (28 × 36 in.)

PROV: Purchased by John Moores from the artist at Liverpool Academy Exhibition 1955, and presented, 1958.

EXH: Walker Art Gallery, 1955, *Liverpool Academy Open Exhibition* (256).

DRURY or DURY, Tony, late 19th century

Artist working in Liverpool 1879–85/6, when exhibited at the Liverpool Autumn Exhibition from various local addresses. The name varies in the street directories and in 1886 appears as T. Drury alongside *Antonia Drury,* at the same general studio address. Presumably to be equated with Antoine Dury, born Lyon 1819; studied at the Ecole des Beaux Arts, Lyon and Paris, and exhibited in Paris 1844–78; established at Warwick, 1878, and apparently remained in England.

2590 Andrew Commins

Oil on canvas, 61·5 × 51 cm. (24¼ × 20⅛ in.)

Andrew Commins (1829/32–1916), LL.D., M.P., barrister practising in Liverpool. Born Ballybeg, Co. Carlow. A Liverpool Town Councillor from 1876 and Alderman 1892; member of the Libraries, Museums and Arts Committee. He was concerned with the cause of Irish Home Rule (President of the Home Rule Confederation of Great Britain, 1874). M.P. for Roscommon, 1880–92, and for Mid-Cork, 1893–1900. He was an omnivorous reader and book collector and also published poetry in the Irish papers.[1]

PROV: Presented by Mrs. Commins, 1917.

EXH: Walker Art Gallery, 1879, *Liverpool Autumn Exhibition* (591).

REF: 1 *Liberal Review,* 6 August 1881, pp. 10–11, and 10 September 1887, p. 7; B. G. Orchard, *Liverpool's Legion of Honour.* 1893, pp. 246–7; Obituary Notices (Liverpool Record Office).

DUNCAN, Edward 1803 - 1882

31 Laying the Foundation Stone of Birkenhead Docks

Oil on canvas, 35·7 × 84 cm. (14⅛ × 33 1/16 in.)

SIGNED AND DATED: *E. Duncan/1845*

The scene on the shore of the Mersey, a little north of Wallasey slip[1] on the afternoon of Wednesday 23 October 1844, when Sir Philip Egerton, M.P. for South Cheshire, laid the foundation stone of Birkenhead Docks. Liverpool is seen in the distance.

This event, marking an important development in the expansion of Birkenhead, was celebrated by public festivities for which over £2,000 was subscribed. On a fine clear morning a great procession of over 30,000 people marched to the site where the ceremony took place at 2 o'clock. In the evening a banquet, ball and firework display took place. The site was Wallasey Pool with over 150 acres and 8000 yards frontage. The new dock system, viewed initially as a rival to Liverpool docks, was amalgamated with the latter in 1857.

Other paintings of the subject include a pair by Henry Melling, in Wallasey Public Library, two by H. Oakes, in Birkenhead Art Gallery and with the Dock Board, and a view by J. W. Oakes, formerly in Liverpool Racquets Club. See also Andrew Hunt, *Wallasey Pool* (866).

PROV: Purchased from F. J. Sabin, 1943.

REF: 1 *Liverpool Mercury,* 25 October 1844, p. 354, describing the scene, and see P. Sulley, *History of Ancient and Modern Birkenhead,* 1907, pp. 176, and *passim.*

EDKINS, John 1931 - 1966

Born Bromley, Kent, 5 May 1931. Trained at Ealing School of Art, 1945–50. Painting, gardening and part-time teaching until 1954 when he went to Royal College of Art for three years. Awarded first class diploma and travelling scholarship, with which went to Greece. Subsequently taught at Bideford School of Art. Settled Liverpool 1961 where taught painting at Liverpool College of Art. Exhibited with Liverpool Academy, at the Axiom Gallery, and at the Walker. Gained a £100 prize at the John Moores Exhibition, 1965. One man show at the Bluecoat Gallery, 1966. Died 20 August 1966 after third heart operation. A memorial exhibition was held at the Walker and the Royal College of Art, 1967.

6306 Seven Answers

Plastic emulsion on canvas, 195·5 × 195·5 cm. (77 × 77 in.)

PROV: Purchased from the artist at the Liverpool Academy Exhibition, 1965.

EXH: Walker Art Gallery, *Liverpool Academy*, 1965 (114); and 1967, *John Edkins 1931–1966* (28)

6180 Nomex

Oil on canvas, 152·3 × 101·6 cm. (60 × 40 in.)

PROV: Purchased from the artist at Liverpool Academy Exhibition, 1963.

EXH: Walker Art Gallery, *Liverpool Academy*, 1963 (108); and 1967, *John Edkins 1931–1966* (24).

EGLINGTON, James Taylor, active 1829 - 1868

Genre and topographical painter. Son of Samuel Eglington. The 1861 census gives his place of birth as Middlesex, London and age 38, but this with other ages stated there must be incorrect. Exhibited at Liverpool Academy from 1829; elected Associate 25 August 1835, Member 5 September 1837; Secretary 1842–45, when resigned together with his father. Rejoined as Associate 5 April 1861, and Secretary 1861 to 13 June 1863, when resigned to join the Liverpool Institute of Fine Arts as Secretary, 1863–68. Exhibited at the Royal Academy 1847 and 1856, and at Birmingham. Died 23 May 1868, age given as 55 in registration of death.

940 Richard II and Bolingbroke, Duke of Lancaster

Oil on panel, 44·9 × 61 cm. (17¹¹⁄₁₆ × 24 in.)

SIGNED AND DATED: *J. T. EGLINGTON/ 1839*[1]

The entry into London of Richard II and Bolingbroke, 1399. Exhibited at Liverpool 1839 with a quotation from Shakespeare's *Richard II* (Act. V, Scene II) in the Catalogue:

'The Duke, great Bolingbroke, mounted on a hot and fiery steed, which his aspiring rider seemed to know, with slow but stately step kept on his course, while all tongues cried "God save thee, Bolingbroke." * * * * Men's eyes did scowl on Richard; no man cried God save him, no joyful tongue gave him his welcome home.'

PROV: Bought from J. Leger, Haymarket, London, 1904.

EXH: Liverpool Academy, 1839 (300), price £20.

REF: 1 Title, quotation, signature and date are also inscribed on the back.

2813 Lime Street in 1818

Oil on canvas, 28×44·5 cm. (11×17½ in.)

INSCRIBED on label, verso: *Lime S. in 1818/ the site of St. George's Hall/from a sketch on the [spot]/by the late S. Eglington/James T. Eglington, 1862*

PROV: Robert Gladstone;[1] presented by Mrs. Rae, Malpas, 1950.

EXH: Liverpool Academy, 1862 (137).

REF: 1 MS label, *loc. cit.*

2814 Old Cottage in Islington, 1822

Oil on board, 31·7×38·7 cm. (12½×15¼ in.)

INSCRIBED, verso: *Old Cottage/in Islington 1822/now the centre of/Islington Sqr./ J. T Eglington/From a sketch by S. Eglington 1822*

PROV: Alderman J. C. Cross, who presented it 1948.

EGLINGTON, Samuel 1786/7 - 1860

Genre, still-life, portrait and landscape painter. Age given as 64 at the 1851 census, described as portrait painter, born Aston, Warwickshire. He may have been the student (?) Sam Eglinton, entered at the Royal Academy, about 1809, aged 24. Probably lived for a period in London as his son James (*q.v.*) was born there; came to Liverpool perhaps about 1818 and listed in Islington from 1821. Exhibited at the Liverpool Academy from 1829 (perhaps from 1824); elected Associate, 1830; Member, 2 August 1832; Secretary and acting Treasurer 1834–41 and visited London each summer to solicit contributions to the exhibitions Treasurer, 1841–42, and President, 1842–45. Resigned, along with his son, in July 1845 Exhibited at the Royal Academy 1837 and 1853, at the British Institution, 1841–55, and a Birmingham. Died Liverpool, 20 April 1860, age given as 70 in registration of death.

407 Trout Fishing, North Wales

Oil on board,[1] 40·5×50·7 cm. (16×20 in.)

SIGNED AND DATED: *Sam Eglington/1855*

PROV: Thomas Oxton, Liverpool, who presented it, 1916.

EXH: Liverpool Academy, 1855 (135); Harro-gate, 1924, *Liverpool School of Painters* (42) Walker Art Gallery, 1960, *Liverpool Academ 150th Anniversary* (65).

REF: 1 Winsor and Newton prepared mill board label.

FINNIE, John 1829 - 1907

Landscape painter, etcher and mezzotinter. Born Aberdeen, son of a brassfounder, baptise 4 May 1829. After some drawing classes at local Mechanics Institute was apprenticed at 13 t an Edinburgh decorator, D. R. Hay, and subsequently to a japanner at Wolverhampton. At 1 back in Scotland working as housepainter, japanner and painter of clock faces. Then five year at Newcastle-upon-Tyne as a glass painter and attended the School of Design under Willian Bell Scott, who influenced his early paintings; also decorated a Newcastle theatre. 1853–5

studied and taught at Central School of Design, Marlborough House. In 1855 appointed Master of the Art School at the Mechanics Institute, Liverpool and Head Master at subsequent School of Art until retirement in 1896. Became a dominating personality in Liverpool art and a much loved teacher. Exhibited at Liverpool Academy from 1856; Associate, 1861; Member and Trustee, 1865; President, 1887–8. Exhibited Liverpool Autumn Exhibition, 1871–1907, and a consulting artist 1871–77. Exhibited at the Royal Academy from 1861, the British Institution, and the Paris Salon, and provincial exhibitions. A.R.E., 1887; R.E. 1895. Founded the Artists' Club, Liverpool, 1877 and a President; also, 1897–8, of the later club. Member Liver Sketching Club and President 1894. R.C.A., 1894 and Treasurer 1897. Continued painting and mezzotinting (which he had taken up seriously about 1886) in retirement near Llandudno; returned to Liverpool 1905 and died at Bootle, 27 February 1907. His mature style owed much to later Corot. A memorial exhibition held at the Gallery, 1907. Watercolours and a large group of mezzotints are also in the Collection. See Copeman (1800) for portrait.

1516 Snowdon from Capel Curig

Oil on canvas, 91·5 × 152·5 cm. (36 × 60 in.)
SIGNED: *J. Finnie* (initials in monogram)
An outdoor sketch for the picture, *Snowdon from Bryn Tyrch* was lent to the 1907 Finnie exhibition by H. E. Kidson.
PROV: Purchased from the artist at the Liverpool Autumn Exhibition, 1871.
EXH: Royal Academy, 1870 (911);[1] *Liverpool Autumn Exhibition,* 1871 (235); Walker Art Gallery, 1908, *Historical Exhibition of Liverpool Arts* (543).
REF: 1 *Diary* of Paintings, 1862–91 (Liverpool Record Office).

2818 Sunshine and Cloud: View near Capel Curig

Oil on canvas, 88·3 × 137·8 cm. (34¾ × 54¼ in.)
SIGNED AND DATED: *J. Finnie 1875–6* (initials in monogram)
A finished sketch was also sold to Wheddon, January 1875.[1]
PROV: Sold September 1876 to W. J. Wheddon, of Birmingham, £100.[2] William Geddes by 1886; thence to his son Arthur Geddes,[3] who presented it, 1911.
EXH: Liverpool Autumn Exhibition, 1874 (60) as *Clouds and Sunshine,* N.F.S.; Glasgow, 1874; Birmingham, 1875; Walker Art Gallery, 1886, *Grand Loan Exhibition* (73); and 1907, *John Finnie* (40).

REF: 1 Artist's Account Book of *Pictures Sold,* 1869–94 and *Diary* of Paintings 1862–91 with sketch (Liverpool Record Office). 2 *Loc. cit.* 3 Arthur Geddes in letter to E. R. Dibdin February 1911 (Gallery files).

2913 Close of a Stormy Day – Vale of Clwyd

Oil on canvas,[1] 122 × 183 cm. (48 × 72 in.)
SIGNED: *John Finnie*
In his review of the 1894 Royal Academy Claude Phillips considered this 'One of the most interesting things here . . . – less because it is the work of an artist who possesses the secrets of his craft, than because it is the outcome of a power to evoke in the spectator the emotion naturally corresponding to that mood.'[2]
PROV: Artist's sale, Branch and Leete, Liverpool, 7–8.12.1897 (207). John Latham, who presented it, 1910.
EXH: Walker Art Gallery, 1893, *Liverpool Autumn Exhibition* (886); repr.;[3] Royal Academy, 1894 (285); Paris Salon, 1896 (Hon. mention); Walker Art Gallery, 1907, *John Finnie* (55).
REF: 1 Framemaker's label of Poitier Fils. 2 *The Academy,* 2 June 1894, p. 46. 3 Account Book of *Pictures Sold,* 1869–94 (Liverpool Record Office).

2817 The Heart of Nature
Oil on canvas, 184·2 × 123·2 cm. (72½ × 48½ in.)
SIGNED AND DATED: *J. Finnie 1893–9*
(initials in monogram)
Exhibited with the following quotation in the catalogue:
 'Folly and falsehood and babble stay in the ground smoke far away' – Allingham.
PROV: Walter Stone, who presented it, 1916.
EXH: Walker Art Gallery, 1898, *Liverpool Autumn Exhibition* (1005) repr.; Royal Academy, 1899 (643); Walker Art Gallery, 1907, *John Finnie* (89) repr.; Harrogate, 1924, *Liverpool School of Painters* (19).

2403 The River
Oil on canvas, 76·5 × 107·7 cm. (30⅛ × 42⅜ in.)
SIGNED: *J. Finnie* (initials in monogram)
The following quotation appears on a label:
 'How pleasant, as the sun declines, to view, the spacious landscape change in form and line'—Wordsworth.
PROV: Alderman Sir William Forwood, Bart., who bequeathed it, 1928.

910 The Mere
Oil on canvas, 91·6 × 127·3 cm. (36⅛ × 50⅛ in.)
SIGNED: *J. Finnie* (initials in monogram)
In a review of the Liverpool Autumn Exhibition of 1893, the *Magazine of Art* noted: 'Among the most important canvases of local interest are Mr. John Finnie's "Close of a Stormy Day" [2913 above] and "The Mere", two of the finest works he has produced.'[1]
PROV: Purchased from the artist at the Liverpool Autumn Exhibition, 1893.[2]
EXH: Walker Art Gallery, 1893, *Liverpool Autumn Exhibition* (961) and 1908, *Historical Exhibition of Liverpool Art* (546); Harrogate, 1924, *Liverpool School of Painters* (3); Wembley, 1924, *Liverpool Civic Week*.
REF: 1 *Magazine of Art*, October 1893, p. iii. 2 Account Book of *Pictures Sold,* 1869–94 (Liverpool Record Office).

3097 The Margin of Rydal
Bequeathed by G. H. Ball, 1917; destroyed 1939–45 war.

FOWLER, Robert 1850/1 - 1926

Subject and landscape painter. Born Anstruther, Fife. His family settled in Liverpool and he was educated at the Liverpool Collegiate School, Shaw Street. After a period in an office and with an architect trained as an artist at Royal Academy Schools and at Heatherley's. Worked in Liverpool until 1902, then settled in London. Exhibited at the Liverpool Autumn Exhibition from 1875, the Royal Academy from 1876, and other London and provincial exhibitions and frequently on the continent. Elected R.I., 1891. Gained a considerable reputation in Germany. Died 28 October 1926 in his 76th year.

2823 Women of Phoenicia
Oil on canvas, 127·7 × 92·7 cm. (50¼ × 36½ in.)
PROV: William Geddes by 1886; presented by Arthur Geddes, 1911.

EXH: Walker Art Gallery, 1879, *Liverpool Autumn Exhibition* (3), 1886, *Grand Loan Exhibition* (72), and 1926, *Fowler Memorial Exhibition* (17).

2821 Ariel
Oil on canvas, 123·2×61 cm. (48½×24 in.)
SIGNED: *R. FOWLER* and in monogram: *RF*
A wash drawing is also in the Collection (7217).
PROV: Purchased from the artist at the Liverpool Autumn Exhibition, 1890.
REPR: Max Nonnenbruch, *Moderne Kunst und Robert Fowler*, in *Die Kunstunserer Zeit*, Munich 1896, 4, p. 71.
EXH: Walker Art Gallery, 1890, *Liverpool Autumn Exhibition* (775); Guildhall, 1892; Munich International, 1895; Bootle, 1912; Walker Art Gallery, 1926, *Fowler Memorial Exhibition* (49).

2915 Eve: the Voices
Oil on canvas, 76·3×179 cm. (30×70½ in.)
SIGNED: *Robert Fowler*
PROV: Purchased from the artist at the Liverpool Autumn Exhibition, 1894.
EXH: Walker Art Gallery, 1894, *Liverpool Autumn Exhibition* (1141); Munich International, 1895; Earls Court, 1897, *Victorian Art*.

2819 The Annunciation
Oil on canvas, 127×78 cm. (50×30¾ in.)
SIGNED: *Robert Fowler*
PROV: Sold by the artist to George Jones, 8 Nov. 1898, £100 with copyright;[1] thence to his daughter Miss Frederica Jones, who presented it in memory of her father, 1919.
EXH: Walker Art Gallery, 1926, *Fowler Memorial Exhibition* (29).
REF: 1 Account in Gallery files.

2822 Sleeping Nymphs discovered by a Shepherd
Oil on canvas, 111·8×137·2 cm. (44×55 in.)
SIGNED: *Robert Fowler*
PROV: Presented by Alderman J. R. Grant, 1903.
EXH: Royal Academy, 1902 (193); Walker Art Gallery, 1902, *Liverpool Autumn Exhibition* (138); Glasgow, 1911, *Scottish/Glasgow National History* (409); Walker Art Gallery, 1926, *Fowler Memorial Exhibition* (73).

FURSE, Charles Wellington 1868 - 1904

2824 Unloading a Ship: Study for a Spandrel in Liverpool Town Hall
Oil on canvas, triangular, in feigned gilt frame, squared up on 4 in. module, 118×179 cm. overall (46½×70½ in.)
The four spandrels under the dome of Liverpool Town Hall illustrate the theme of dock labour at Liverpool.[1] The dome, staircase, and reception rooms were redecorated in 1898–9 to the designs of F. M. Simpson, Professor of Architecture at University College, Liverpool.[2] In June 1898 he recommended that Charles Furse be asked to carry out the decorations under the dome for the £600 earmarked for the purpose. Simpson knew Furse and thought this his chance, but his inexperience in mural decoration caused initial difficulties with the Committee. Furse discussed his ideas with Sargent.[3] He agreed to provide a design for one of the panels for the Finance (Special) Committee's approval.[4] 2824 appears to be this first

design, although another of smaller size for *Cotton Trollies* is also recorded.[5] The remaining two subjects were *Dock Making* and a *Corn Warehouse*.

Furse wrote in June 1899 stating that he had completed one panel[6] and 2824 was exhibited the following winter at the New English Art Club. There the *Athenaeum* critic[7] thought it the best thing in the gallery, 'vigorous and artistic, an ingeniously packed composition of emblematic figures,' while D. S. McColl in *The Saturday Review*[8] in a long notice described it as an indirect result of the influence of the new School of Architecture and design at Liverpool University. He noted that 'the theory of flatness as the beginning and end of decoration has been marking time recently' and that Furse had returned to the Venetian idea, which included 'vigorous modelling and the use of light and shade as a decorative element.' He considered him in advance of

G

Frank Brangwyn but with the same difficulty in handling colour: 'He sees everything naturally in a kind of blue-blackish bath. From that no struggle perhaps will ever wholly free him, but in place of violent assertions in a vermilion pigment that remains obstinately black he may arrive at an agreeable silvery grisaille within his natural envelope. The present example promises such a result. Its great merits are the design and vigorous handling of the forms. These dock porters are more like a man's account of men than we are accustomed to meet in the galleries. The adaption of the subject to the triangular space moreover is ingenious. The ship's boom that swings across in variation of the upper line and the boy perched upon it in one corner are particularly happy. The relief in light of the distance against the chequered foreground of figures is well managed, and the scale and quality of these figures well judged for the space. The most doubtful point is the central space of shadow leaving the figures in light too much attached to the sides of the spandrel.'

Furse's health (due to tuberculosis) was already causing delays and the series was not completed until the end of 1901.[9] The four unstretched canvases were exhibited at the Walker Art Gallery early in 1902 before being put up.[10]

The full scale version of 2824 shows some differences: in particular the left foreground figure is turned at right-angles to face his bending companion and the head of the man bearing a sack behind them at the right turns his head in towards the centre. These changes together echo the movement inwards towards the centre, where, in the other three designs a single large figure, centre or just off-centre, dominates the composition. The artist may have realised, as had D. S. McColl, that in a composition of this shape, where the three corners fade off into obscurity, it was necessary to bring the chief interest into the middle.

The colour scheme is predominantly brown and beigish flesh tints with yellow and blue highlights. This picks up the cream, gold, and blue of the decoration and was designed to compliment Simpson's colours.

A story of the artist's own, quoted at a later date,[11] refers to his drawing on Sargent's experience: it states that at one period when he was stuck he sent off a diagram to Sargent and asked for advice; the latter dropped everything and appeared on the scaffolding the following day; the implication is that the location was Liverpool. There is no perceptible difference between the reproductions of the unstretched canvases and their present appearance under the dome, so either this incident refers to problems to do with attaching the canvases to the wall spaces or took place at the artist's studio at Chobham, where he was certainly working at them on scaffolding.[12]

The vigorous three-dimensional composition was a deliberate avoidance of the then fashionable decorative style. Furse's intentions and style of work were quoted in the *Architectural Review* notice:[13]

'All through I have borne in mind the fact that the building is bright in light and gay in decoration, for there is a quantity of colour and gilt in the architect's scheme. Also the architectural space into which the work fits is enclosed by a heavy moulding. I have therefore gone for great masses of light and shade relieved against one another, the only bright local colour being the blue of the workmens' coats and trousers. I have intentionally avoided the whole business of "flat decoration" by making the things part of the walls, as one is told is so important. On the contrary, I have treated them as pictures and have tried to make holes in the wall – that is as far as relief of strong light and shade goes; in the figures I have struggled to keep a certain quality of bas relief, that is, I have avoided distant groups and have woven my compositions as lightly as I can in the very foreground of the pictures, as without this I felt they would lose their weight, and dignity, which does seem to me the essential business in a mural decoration, and which makes Puvis de Chavannes a great decorator far more than his flat mimicry of frescoe does.

Everywhere I have tried to emphasise the big quality by making two or three figures give one silhouette, and by repeating action with slight modifications. Tintoretto in S. Rocco is my idea of the big way to decorate a building, great clustered groups sculptured in light and shade, filling with amazing ingenuity of design the architectural spaces at his disposal. A far richer and more satisfying result to me than the flat and unprofitable stuff which of late years has been called "decoration." I don't mean to say that there is only one sort of stuff, or that I am uninterested in Puvis, though I admit to being no enthusiast. I do see great qualities in his work, but do not count

mong them that particular *Côte extérieur* which enables the casual sightseer to detect is Puvis without a catalogue. Above all, I horoughly disbelieve in the cant of mural decorations preserving the flatness of a wall. I ee no merit in it whatever. Let them be nassive as sculpture, but let every quality of alue and colour lend them depth and vitality, nd I am sure the hall or room will be the icher and nobler as a result.'

This study received particular praise at the Burlington Fine Arts exhibition of the deceased rtist's work in 1906. The *Athenaeum* critic wrote: '. . . among a number of the sketch designs (all rather poor with this exception) the *Spandril for the Liverpool Town Hall: Ships Unloading*, stands out as a finely ordered eticent work of the highest power – possibly the most entirely satisfactory piece of painting n the show. . . its direction at once more erious and more quaint than was usual with im, it gives us some clue to what Furse night have attained with a happier destiny.'[14]

PROV: Presented by Dame Katherine Furse, widow of the artist, 1932.

EXH: New English Art Club, Nov.–Dec. 1899 (97); Burlington Fine Arts Club, 1906, *Charles Wellington Furse* (3).

REF: **1** *The Architectural Review*, XI, 1902, p. 76. **2** Finance Committee Minutes, 15 February–27 March 1898 (Liverpool Record Office). **3** *Op. cit.*, 24 June 1898; B.F.A.C., *Illustrated Memoir*, 1908, pp. 12–22, 35. **4** *Op. cit.*, 22 July 1898. **5** Lent by Mrs. Furse to Burlington Fine Art Club Exhibition, 1906 (31), *Horses hauling bales of cotton, painted 1900 (?)*, 50×44×46 in. **6** Finance Committee Minutes, 30 June, 7 July 1899. **7** *The Athenaeum*, 18 November 1899, p. 694. **8** *The Saturday Review*, 18 November 1899. **9** Finance Committee Minutes, 3 January 1902. **10** Reproduced unstretched, *The Architectural Review, loc. cit.* **11** Katherine Furse, *Hearts and Pomegranates*, 1946, p. 253, quoting *The Observer*, 19 April 1925; see also E. Charteris, *John Sargent*, 1927, p. 228. **12** Furse, *op. cit.*, p. 213. **13** *Ibid.*, and repeated in B.F.A.C. Catalogue, 1906. **14** *The Athenaeum*, 24 March 1906, p. 369. SEE APPENDIX

GAINSBOROUGH, Thomas 1727 - 1788

3780 Isabella, Viscountess Molyneux, later Countess of Sefton

Oil on canvas, 236×155 cm. (93×61 in.)

Isabella Stanhope (1748–1819), second daughter of the 2nd Earl of Harrington, married 27 November 1768, Charles William, Viscount Molyneux, afterwards 1st Earl of Sefton (see British School 8637). She wears a white satin gown striped in blue and black, and holds a black lace shawl.

When shown at the first Royal Academy Exhibition of 1769, the *St. James's Chronicle*, according to Whitley,[1] praised the portrait and considered it 'one of the few to which connoisseurs might profitably direct their attention.' Walpole identified the sitter and commented: 'ungraceful.'[2] Gainsborough was still at Bath at this time.[3]

Lady Sefton sat to various artists: she was painted by Reynolds, 1769–70 (Coll. Lord Leconfield, Petworth; engraved J. Watson, 1770); Tilly Kettle (engraved Watson, 1769: see 8648 in the Collection); Richard Cosway,

a pencil drawing (Coll. Countess of Sefton; engraved W. Dickinson, 1783); a portrait said to be of her was also at Croxteth,[4] and a portrait sketch belonged to the Earl of Wemyss.[5] A sketch of the present portrait was also at Croxteth. An engraved portrait appeared in *The London Magazine*, March 1774, 'Court Beauties.'[6]

Her character and that of her husband, was summed up by Georgiana, Duchess of Devonshire in 1779, in a letter to her mother, The Countess Spencer:[7] 'Ld & Ly Sefton arrived just before supper Ld Sefton is the most disagreeable & noisy of fools, as for her she is a compound of vanity nonsense folly & good-nature – for tho' many people deny her the last qualification I am sure she possesses it only she always contrives to put her faults in the clearest light – of all women I ever knew she is the soonest affronted & the soonest appeas'd – & if she really likes any person she'll fight thro' thick & thin for them.'

ENGR: G. H. Every, 1887.

PROV: By descent to the 7th Earl of Sefton; accepted in lieu of death duties by H. M. Government, 1973, and presented to the Gallery, 1975.
EXH: Royal Academy, 1769 (35), as *Portrait of a Lady, whole length;* Liverpool, 1840, *Mechanics Institution* (1245); British Institution, 1848 (177); Agnew, 1928 (14); Royal Academy, 1934, *British Art* (345); Amsterdam, 1936, *Engelsche Kunst* (45).
REF: **1** W. T. Whitley, *Thomas Gainsborough,* 1915, p. 66. **2** W. T. Whitley, *Artists and their Friends in England,* 1928, II p. 378. **3** See E. K. Waterhouse, *Gainsborough,* 1958, p. 89, No. 606, and pl. III. **4** Christie's sale, Croxteth, 19 September 1973 (1059). **5** R.A. 1934 Catalogue entry, *loc. cit.* **6** A doll dressed to represent her, which originally belonged to a god-daughter, was in Sotheby sale, 19 December 1974 (166) repr. **7** Letter of 21 August 1777, part of No. 181, 5th Duke's Group of Correspondence, Chatsworth: quoted in *Anglo-Saxon Review,* I, June 1899, p. 240, and G. H. White, *Complete Peerage,* XI, 1949, p. 593 n (information from Peter Day, Assistant Librarian, Chatsworth).

GAMBARDELLA, Spiridione active 1842 - 1868

Portrait and historical painter. Born Naples. A political refugee, escaped to America. Was in Boston, 1834–40, and had a period in France. Came to England in 1841 with an introduction from Emerson to Thomas Carlyle. Lived first in London, and then in Liverpool, 1844 and 1845, recorded at an address in Chatham Street under the name Samuel Gamberdelli; was afterwards again in London until at least 1852. Exhibited at the Royal Academy, 1842–52, and at Liverpool Academy, 1842–50. He held an exhibition in Old Post Office – place, Liverpool, in February 1848. Eventually returned to Italy, where he died. His daughter Julia Gambardella was also an artist.

2165 James Pownall

Oil on canvas,[1] 92×71 cm. (36¼×28 in.)
INSCRIBED, verso: *JAMES POWNALL ESQre/ETAT 52/GAMBERDELLA* (sic) / *PINXt.*

James Pownall (?1792–1855), merchant, the last Bailiff of Liverpool before the passing of the Municipal Reform Act. Descendant or relation of William Pownall, Mayor of Liverpool.[2] He purchased Pownall Hall, Morley, Cheshire and rebuilt the house.[3] His hand rests on a volume marked *CHESHIRE,* which may be an early edition of Ormerod's history. He died at Chester 19 June 1855.
PROV: Presented by James Tabley Pownall, the son of the sitter, 1882.
REF: **1** Canvas stamp of Charles Roberson, Long Acre. **2** Information in the sitter's will, Cheshire County Record Office. **3** Ormerod, *History of Cheshire,* 1882 edition, III p. 592.

7140 Edward Rushton

Oil on canvas, 127×101·5 cm. (50×40 in.)

Edward Rushton (1795–1851), when Stipendiary Magistrate of Liverpool. Born Liverpool, 22 September 1795, the son of Edward Rushton (1756–1814) the blind poet. He was active in the political field in the Reform interest and a noted orator in the elections of the period – he was called 'Roaring Rushton' by Cobbett. He spoke in opposition to Canning and Huskisson in the Liverpool elections: the latter recommended his studying for the Bar. Called to the Bar 18 November, 1831 and practised in London. Appointed Stipendary Magistrate of Liverpool, 17 May 1839. Died in Liverpool 4 April 1851.

He had cultivated taste for literature and the arts, admired Chantrey and Thorwaldson (whose studios he visited) and was a friend and admirer of Gambardella, (he presented his

portrait of Panizzi to the British Museum). He visited his studio in the summer of 1845 to see his wife's portrait in progress and to sit for his own – seemingly a further portrait subsequent to 7140, since the latter was exhibited in 1844.[1]

At the Liverpool Academy of that year the reviewer in the Liverpool *Albion*[2] commented:

'This painting, though undoubtedly like Mr. Rushton, is certainly not one of Mr. Gambardella's most felicitous efforts. The artist seems to have paid more attention to the costume than to the man; and that costume not very tastefully chosen. Never was satin better painted or velvet more beautifully imitated, both as regards shade and texture; but the face, though correctly limned, is not well coloured. The shadowings are not pure, and the flesh tints are muddy, so that the fine face has the appearance of being dirty.'

See also the portrait by Edward Smith (2575). A bust by Ormerod Smith is in the Town Hall (8242 in the Collection). A portrait by Mosses was at the Liverpool Academy, 1827, and one by J. Z. Bell at the Royal Academy and Liverpool Academy, 1849.

ENGR: T. H. Maguire, lithograph ($15\frac{1}{2} \times 12\frac{1}{2}$ in.), published by M. & T. Hanhart.

PROV: Painted at the request of the Bench of Magistrates of the Borough of Liverpool for presentation to St. George's Hall.[3] Hung in the Magistrates Court. Transferred to the Gallery by the City Estates Committee, 1969.

EXH: Liverpool Academy, 1844 (104); (?) Gambardella's exhibition, Old Post Office-place, February 1848,[4] or another portrait.

REF: **1** W. Lowes Rushton, edit., *Letters of a Templar 1820–1850*, 1903, *passim*. **2** *Albion*, 4 November 1844. **3** Liverpool Academy Catalogue entry, *loc. cit.* **4** *Albion*, 14 February 1848: 'a very bold transcript of the features of Mr. Rushton. . .'

GARRAWAY, George Hervey 1846 - 1935

Subject painter and copyist, resident in Liverpool about 1871–91. Born island of Dominica, West Indies 2 or 9 October 1846, son of a merchant. Trained at Heatherley's School, London and Ecole des Beaux Arts, Paris. Exhibited at the Liverpool Autumn Exhibition, 1871–95; intermittently at the Royal Academy, 1872–91. Member Liverpool Academy; Master, Liverpool Art Workers Guild, 1888. Member Society of Mural Painters. Visited Italy September 1877 – September 1879 and finally settled in Florence, February 1892, where he copied Old Masters. Revisited Liverpool about July – September 1895. Died Florence 7 October 1935. His diaries and art papers from 1894, chiefly containing introspections, are in Liverpool Record Office. Watercolours are also in the Collection.

2949 The Florentine Poet

Oil on canvas, 92·7 × 128·6 cm. ($36\frac{1}{2} \times 50\frac{5}{8}$ in.)

SIGNED AND DATED: *G H Garraway/1890*

Exhibited with the quotation:

'Florence, exult because thou art so great. That over land and sea thy wings thou beatest.' – Dante's *Inferno*

Showing a poet declaiming to a group of figures in quasi mediaeval dress, in an interior with a classical statue, perhaps of Apollo, and late sixteenth-century fresco or tapestry of the Adoration of the Magi.

In January 1895 the artist spent four days working on a platinotype of it.[1] He mentioned seeing his picture again at the Gallery in August 1895 when he noted that he 'was much struck by the intensity of its dramatic expression but the light and shade are handled with too superficial a breadth and neither is the study of the detail sufficiently accurate or comprehensive. Since I have been in Italy I have striven

hard to remedy these defects.' Later the same month he commented that there 'is too much regard shown for the unity of the composition.'[2]

PROV: Presented by Subscribers, 1890.

EXH: Walker Art Gallery, 1890, *Liverpool Autumn Exhibition* (958); and 1908, *Historical Exhibition of Liverpool Art* (562).

REF: 1 MS Diary, II, 23 January, 1895 (Liverpool Record Office). 2 *Op. cit.*, 5 and 24 August 1895.

2958 The Madonna di San Antonio, after Titian

Oil on canvas, 69·5 × 97·2 cm. (27⅜ × 38¼ in.)
After Titian's painting in the Uffizi, Florence.

An indistinct MS label on the back gives details of the technique and the date of completion, 19 September 1893. In his diary for 17 June 1895 the artist noted: 'I have at la completely mastered the theory of the mod in which the Old Masters painted – it has bee one of the great efforts of my life to maste this theory, and it needs to be mastere entirely from beginning to end before th light dawns.' Elsewhere he mentions using photograph for squaring up a copy, a metho which appears to have been generally practised.

PROV: Presented by George Holt, 1895.

EXH: Grindley's Gallery, Church Stree Liverpool, September 1895, Old Master copie and watercolours of Lake Maggiore b Garraway.[2]

REF: 1 MS Diary, II (Liverpool Recor Office). 2 *Op. cit.*, 23 September 1895 an *Liverpool Mercury,* 25 September 1895, p. 5.

GEDDES, Andrew 1783 - 1844

2944 John Gibson

Oil on canvas, 127 × 100·3 cm. (50 × 39½ in.)

SIGNED, DATED AND INSCRIBED: *A. Geddes* (initials in monogram) *Rome/1830.*

John Gibson (1790–1866), sculptor. Born near Conway and brought up in Liverpool from about nine years of age. He worked for Messrs. Franceys, marble masons, and learnt carving from their assistant, Frederick Legé. Through the assistance of several Liverpool patrons, in particular the d'Aguilar/Lawrence/Robinson families and William Roscoe, he was able to go to Rome in 1817, where he settled. Receiving assistance at first from Canova and Thorwaldson, he rapidly achieved fame. He was a member of Liverpool Academy for a period and Liverpool families were amongst his patrons. He left the greater part of his fortune and the contents of his studio to the Royal Academy, of which he was elected Member in 1836.

He is shown holding a modelling tool; the Torso Belvedere, in the Vatican, is seen through an archway at the rear; by his side is the monument he designed 1829–30 to the memory of Mrs. Emily Robinson (d. 1829) who had been an early Liverpool friend, and which was placed in St. James the Less (the Mortuar Chapel), Liverpool.[1]

Geddes was in Italy 1827–31. This portrai was purchased by William Earle (1760–1839) an important Liverpool merchant who usuall spent his winters in Rome for health reason during the years before his death there.[2] H had a considerable collection of Old Maste paintings, which included the Panini (2794 and the Tognolli (3040) in the Collection. Gibson executed memorial reliefs to both him and his wife for St. James the Less and St Nicholas's, Liverpool.[4]

A version of 2944, a half length seated to lef with his hand on a classical head, was bough by Sir Robert Peel for Drayton Park, Tamwort (engraved S. Bellin):[5] this or another portrai was exhibited at the Royal Academy, 1838.

The *Courier* reviewer of the 1835 Liverpoo Academy called Gibson's portrait 'the bes portrait in the room. The reposing countenanc of the artist, with the glow of genius bursting forth in every lineament, may be contraste with the assumption of greatness portrayed i the same subject by another artist, viz No. 11 [Portrait of John Gibson, Artist, by T. Ellerby] Portrait painters might learn something to from the rich sober tone of Geddes' colouring.'

Various portraits of Gibson are recorded including the following oils and sculptures: miniature by Thomas Griffiths (Walker Art Gallery, 6138); bust by Mrs. Vose of Liverpool, Royal Academy 1819; two paintings by Penry Williams, 1844 (Academy of St. Luke, Rome; and, formerly, Urbino: watercolour copy by F. Hargreaves, Walker Art Gallery 1055); oil by Partridge, 1847 (Walker Art Gallery, q.v.); oil by J. Graham Gilbert, 1847 (National Gallery of Scotland); oil by Landseer, c. 1850 (Royal Academy; Walker Art Gallery replica, q.v.); oil by William Boxall, 1851 and 1864 (Royal Academy); oil by Margaret Carpenter, 1857 (National Portrait Gallery); busts by William Theed, 1852 (Parish Church, Conway), 1868 (Royal Academy; replica, National Portrait Gallery); bust by J. Adams Acton, 1866 (Walker Art Gallery 4145, and Cardiff); medallion J. B. Crouchley (Walker Art Gallery 6137); medallion by Harriet Hosmer (version: Watertown, Mass.); tomb relief by B. E. Spence (Rome).

PROV: William Earle (d. 1839); presented by his son Charles Earle to the Liverpool Royal Institution, October 1843;[7] deposited at the Gallery, 1942 and presented in 1948.

EXH: Presumably Royal Academy, 1832 (171); Liverpool Academy, 1835 (179); Walker Art Gallery, 1960, *Liverpool Academy 150th Anniversary Exhibition* (42).

REF: 1 Lady Eastlake, *John Gibson, R.A.*, 1870, p. 36; T. Matthews, *The Biography of John Gibson, R.A., Sculptor, Rome*, 1911, pp. 23 ff, 72. 2 Matthews, *op. cit.*, p. 12; T. A. Earle, *Earle of Allerton Tower* in *Transactions of the Historic Society of Lancashire and Cheshire*, 1890, N.S. Vol. 6, pp. 48–50. 3 Sale Winstanley, Liverpool, 17–18 April 1839. 4 Transactions, *loc. cit.*, p. 49; 5 Matthews, *op. cit.*, p. 12. 6 *Liverpool Courier*, 18 September 1835, p. 318. 7 L.R.I. *Presents Book*, from 11 February 1832, (Liverpool University Library).

GHENT, Peter 1857 - 1911

Landscape painter. Born Birkenhead. Worked as a hairdresser and studied painting at Birkenhead Art School. Exhibited at Liverpool Autumn Exhibition from 1876 and the Royal Academy from 1879–96. After living in Liverpool gave up hairdressing about 1880 and moved to Tal-y-Bont, in the Conway Valley. Original member of Royal Cambrian Academy, 1882. Had a period of great success. After living in North Wales returned to Liverpool 1905 and died there 19 February 1911.

2645 Nature's Mirror

Oil on canvas, 123 × 182·3 cm. (48½ × 71¾ in.)

SIGNED: *P Ghent* (initials in monogram)

A view looking eastward across the Conway Valley near Tal-y-Bont towards what became known locally as Ghent's Crag.

PROV: Purchased from the artist by Malcolm Guthrie and Alderman T. W. Oakshott, and presented 1882.

EXH: Walker Art Gallery, 1882, *Liverpool Autumn Exhibition* (574); Saltaire, 1887; Birkenhead, 1912; Harrogate, 1924, *Liverpool School of Painters* (15); Bury, 1931; Rochdale, 1932.

911 Quiet Evening – Vyrnwy Valley

Oil on canvas, 101·3 × 152·5 cm. (39⅞ × 60 in.)

SIGNED: *P Ghent* (initials in monogram)

This oil and the six later watercolours in the Collection commissioned about 1885, commemorate the Welsh Valley taken over by Liverpool Corporation for a water supply under an act of 1880.

PROV: Bequeathed by William King, 1918.

EXH: Walker Art Gallery, 1881, *Liverpool Autumn Exhibition* (277).

GILL, Eric Peter, living artist

3162 Prenton Claypits
Oil on panel, 50×61·5 cm. (19¾×24¼ in.)
PROV: Purchased from the artist at Bluecoat Chambers Exhibition, 1940.

EXH: Bluecoat Chambers, Liverpool, 1940, *2nd Liverpool Artists Exhibition* (14).

GORDON, Sir John Watson 1788 - 1864

1138 William Brown
Oil on canvas, 239·4×146·7 cm. (94½×57¾ in.)
SIGNED, INSCRIBED AND DATED: *Sir John Watson Gordon R.A. & P.R.S.A. Pinxit 1857*
Sir William Brown, Bart (1784–1864), Anglo-American merchant banker of Liverpool, and donor of Liverpool City Library which was called after him.

Born Ballymena in Ireland, the eldest son of Alexander Brown, a merchant in the linen trade who emigrated with his family to Baltimore in 1798 and there built up one of the great merchant banks of America. William settled in Liverpool in 1810 to run a branch of the business and, as Brown, Shipley & Co., rapidly expanded the concern and acquired immense wealth in the American trade. Hon. Freeman, 1824; member of the Dock Committee; first Chairman of the Bank of Liverpool, 1831; Alderman, 1831–38; magistrate, 1833–45; M.P. for South-west Lancashire, 1846–59; Deputy Lieutenant for Lancashire, 1852; and High Sheriff, 1863; created baronet, 1863.[1]

Between 1853 and 1856 he gave £40,000 for a new building for the Free Public Library and Museum (founded 1852 in Duke Street). He laid the foundation stone on 15 April 1857 and at the banquet following, in one of the many flattering speeches, Nathaniel Hawthorne, then American Consul in Liverpool, commented: 'In considering the means by which he should best promote human happiness, he found no means so powerful as by diffusing knowledge among men.'[2]

He formally presented the building to the Mayor on 18 October 1860 at a magnificent opening ceremony before large crowds. His portrait was commissioned by the Corporation to commemorate the gift, exhibited in 1857, and placed in the Library at the time of the opening. A life-size statue by Patrick Macdowall was placed in St. George's Hall and unveiled at the opening banquet (7812 in the Collection).[3]

A bust by Isaac Jackson is now in the Collection (7806), and a pencil study by Thomas Hargreaves presumably for a miniature, is in Liverpool Record Office. Brown was also painted by Agar (engraved J. Stephenson).[4] An equestrian portrait with his sons,[5] in the uniform of Colonel of the Liverpool Brigade of Lancashire Volunteers, a battalion of which he raised and equipped, and a group portrait with his three brothers,[6] are also recorded.

PROV: Commissioned by Liverpool Corporation, 1856, for the free Public Library; later transferred to the Gallery. Hung in the Town Hall, 1972.

EXH: Liverpool Academy, 1857 (13).

REF: **1** J. C. Brown, *A Hundred Years of Merchant Banking*, 1909 pp. 58ff, 126–36; press cuttings (Liverpool Record Office). **2** *Liverpool Mercury*, Supplement, 17 April 1857; and see Nathaniel Hawthorne, *The English Notebooks*, 1941, pp. 457, 460, 588. **3** P. Cowell, *Liverpool Public Libraries, a History of Fifty Years*, 1903, pp. 56ff. **4** Copy Liverpool Record Office. **5** Repr. J. C. Brown, *op. cit.*, fp. 130. **6** *Ibid*, frontispiece.

GRAHAM, Henry, living artist

1816 Welsh Landscape
Oil on board, 76×101·7 cm. (30×40 in.)
PROV: Purchased from the artist, 1958.

EXH: Walker Art Gallery, 1958, *Liverpool Academy* (134).

GRANT, Sir Francis 1803 - 1878

6582 John Naylor
Oil on canvas, 225·6×132·7 cm. (88¾×52¼ in.)

6583 Georgina Naylor
Oil on canvas, 223·7×132·7 cm. (88×52¼ in.)
John Naylor (1813–1889) of Liverpool, the great-nephew of Thomas Leyland the Liverpool banker, and a partner in Leyland and Bullins Bank, and his wife Georgina, daughter of John Edwards of Ness Strange, Salop, whom he married in 1846. They at first lived at Liscard Manor, Wallasey. They had ten children. He was given the estate at Leighton near Welshpool for a wedding present by his uncle Christopher Leyland (Bullin)[1] and had William Henry Gee of Liverpool[2] rebuild the house in the Gothic style, 1850–56.[3] He undertook many improvements on the estate. He was a notable collector, owning several Turners, including *Pas de Calais* (Manchester), and Wilkie's *Bathsheba*, Collin's *Returning from the Haunts of the Sea Fowl,* and Scheffer's *Satan Tempting Christ,* in the Gallery; he patronised B. E. Spence, the Liverpool sculptor (two groups of his wife and children are in the Gallery), and Richard Ansdell

(q.v.), who painted him and his bride witnessing the grallocking of a stag (coll: H. P. McIlhenny, Philadelphia).[4]

These portraits are listed in Grant's sitters' book under 1857, with the price of £315 each.[5]

PROV: Presented to the sitters by their tenants and tradesmen; at £300 each;[6] Leighton Hall sale (N. R. Lloyd), 21–22.9.1950 (229, 230); by descent to J. M. Naylor, who presented them, 1967. Hung in the Town Hall.
ENGR: G. Sanders (private plate), 1859, mezzotint, each 76·1×48 cm.
REF: 1 T. N. Naylor, *The Family of Naylor from 1589,* 1967, pp. 37. 2 Edward Hubbard, verbally 1968. 3 Mrs. Cleaver, letter 19.6.1968. 4 Private sales, and Christie's, 19.1.1923, and at the house. (Copies of several Turners by a daughter, were still at the house, 1968); see E. Morris, *Catalogue of paintings. . . . owned by John Naylor,* in Walker Art Gallery, *Annual Report and Bulletin,* V, 1974–5, pp. 80ff, 5 Copy in National Portrait Gallery; information from Richard Ormond, 27.7.1970. 6 MS Inventory of John Naylor's collection, begun 1856 (family ownership): see Morris, *loc. cit.*

GRANT, James Ardern 1885 - 1973

Portrait painter and engraver, pastellist and lithographer. Born Liverpool. Trained Liverpool School of Art, where he subsequently taught, and at the Académie Julian in Paris. Exhibited at Liverpool Autumn Exhibition, 1908–21 and had a studio in South John Street, 1912 and 1913. Member of Sandon Studios Society around 1912. Moved permanently to London after marriage in 1913. Subsequently Member Royal Society of Portrait Painters, Royal Society of Painter Etchers and Engravers, a President af the Pastel Society and was Vice-Principal of the L.C.C. Central School of Arts and Crafts, London.

1631 George Harris

Oil on canvas, 76·8×55·8 cm. (30¼×22 in.)
SIGNED AND DATED: *Jas. A. Grant/1912*
George Harris (1878–1929), theatrical designer,
born Warwick. His father was manager of the
Shakespeare Theatre, Liverpool, and the
sitter began his career as a designer there about
1893, under Thomas Holmes. He was a student
under Augustus John etc. at the University
School of Art, 1898–1904 while working as a
scene painter etc., and from 1909–15 was
associated with the theatrical firm of Thomas
Robinson of The Ark, Liverpool. In 1907 he
designed the tableaux for the Liverpool Pageant.
In 1911 he joined Basil Dean, first controller of
the new Repertory Theatre in Liverpool (The
Playhouse), as scenic designer as the first step
in a long association in the Liverpool, London
and international theatre with Dean in his
Reandean Company, 1918–1929. He evolved
a free and exuberant style and his special
contribution was to develop the use of lighting
and colour effects. A dedicated craftsman,
his personality was retiring and he shunned
any publicity, so was little known outside
theatrical circles.[1]
In Liverpool he had a studio at the Bluecoat
Chambers which he occupied until his death,
always considering Liverpool his home. He
was an active member of the Sandon Studio
Society. Amongst his many friends in Liver-
pool was Grant whose studio in South John
Street he shared and where this portrait was
painted in 1912.[2]
A self-portrait drawing and a self-caricature
as a character, *The Bilious Dream*, for the
production of the pantomine *Fifinella* at
Liverpool Repertory Theatre, 1912, formerly
belonged to Herbert Tyson Smith, Liverpool.[3]
A caricature by Albert Lipczinsky is in the
Collection (8803).
PROV: Given by the artist to Mrs. Macleay,
wife of John Macleay, editor of Liverpool
Daily Post; presented by her daughter, Mrs.
Lance Buchanan, following the artist's wishes,
1958.
EXH: Walker Art Gallery, 1912, *Liverpool
Autumn Exhibition* (97) as *G.W.H. (a portrait
sketch)*; Sandon Studios Society, Bluecoat
Chambers, Liverpool, 1951, *Fifty Years of
Merseyside Art* (103); Walker Art Gallery,
1958, *George Harris* (144).
REF: 1 *George W. Harris*, memorial volume,
1930, passim; Basil Dean, in Walker Art
Gallery 1958 catalogue, *op. cit.*, and *Seven
Ages*, 1970. 2 R. F. Bisson, *The Sandon Studios
Society and the Arts*, 1965, pp. 30. 3 Walker
Art Gallery, Harris Catalogue, Nos. 122, 14.

GRIFFITH, Edward Hales, living artist

3155 Saturday Night

Oil on board, 40·7×51 cm. (16×20 1/16 in.)
SIGNED: *Griffith*

PROV: Purchased from the artist, 1954.
EXH: Walker Art Gallery, 1954, *Liverpool
Academy* (87).

GRIMSHAW, Atkinson 1836 - 1893

L138 The Docks, Liverpool, at night

Oil on canvas,[1] 60·8×91 cm. (23 15/16×35 3/4 in.)
SIGNED AND DATED: *Atkinson Grimshaw 1886*
and verso: *Liverpool/Atkinson Grimshaw/ 1886*
INSCRIBED on stretcher: *371/1886*
The shops include the *Cigar Stores* (39) and
Thompson, but these do not match any entries
in the street directory of 1886. The church
tower of St. Nicholas appears at the right.
PROV: B. Hackett, Newcastle-upon-Tyne,
who bequeathed it to Liverpool City Library,
1954; lent to the Gallery, 1973.
REF: 1 Canvas stamp of Lechertier Barbe &
Co., Regent Street.

L23 The Custom House, Liverpool, looking North

Oil on canvas, 61×91.5 cm. (24×36 in.)

The Corinthian columns on the large building are incorrect for Foster's Custom House (see Loan 24). Several similar views are known of which one is identified as Glasgow and the others as Liverpool: (a) 'Glasgow Docks by Moonlight' with slight variations in the details, $11\frac{1}{2} \times 17\frac{1}{2}$ in., art market 1973;[1] (b) identified as Liverpool, with slight variations in the details, $11\frac{3}{4} \times 17\frac{1}{2}$ in., signed and inscribed on the back, art market 1972;[2] (c) 'Liverpool from Wapping', from further south than Loan 23 and again with some variations, 24×36 in., signed and inscribed on the back, art market 1974;[3] (d) 'The Custom House, Liverpool', $11\frac{1}{2} \times 19\frac{1}{2}$ in., poor quality variation, art market, late 1960's.[4] (e) 'Canning Dock, Liverpool, by Night,' $23\frac{1}{4} \times 35\frac{1}{2}$ in.[5]

Besides these, a comparable view to the present painting but without the public building, and again with some variations, 24×36 in., signed and inscribed *Liverpool 1887*, is in the Tate Gallery.

PROV: Lent anonymously, 1965.

REF: **1** Sotheby's (Belgravia), 10.7.1973 (169) repr. **2** Sotheby's (Belgravia), 22.2.1972 (29) repr. **3** Christie's, 26.7.1974 (240) repr. **4** Photo Gallery files. **5** Christie's, 28.1.1977 (44) repr.

L24 The Custom House, Liverpool looking South

Oil on canvas, 60.7×91.2 cm. ($23\frac{7}{8} \times 35\frac{7}{8}$ in.)

A view of Strand Street and Wapping at evening, with the classical portico of the Custom House built by John Foster, Senior, 1828 (damaged by enemy action 1941 and demolished 1948). On the right ships are moored in the Canning and Salthouse docks.

The building of the wine and spirit merchant on the corner of Canning Place, at the left, survived until the early 1970's.

PROV: Lent anonymously, 1965.

HALLIDAY, Edward Irvine, living artist

8466 R. R. Bailey, Lord Mayor of Liverpool

Oil on canvas, 102×76.5 cm. ($40\frac{1}{8} \times 30\frac{1}{8}$ in.)

SIGNED AND DATED: *Edward I. Halliday 1956*

Alderman Reginald Richard Bailey (d. 1973) in robes of office as Lord Mayor of Liverpool, 1955–6. A native of Liverpool; City Councillor since 1931; J.P. 1944. Senior partner in Bailey, Page and Co.

PROV: Bequeathed by the sitter, 1973.

2406 Dr. William Brogdon Paterson

Oil on panel, 64×76.5 cm. ($25\frac{1}{4} \times 30\frac{1}{8}$ in.)

SIGNED AND DATED: *Edward I. Halliday 1933*

Dr. William Brogdon Paterson (1864/5–1934), G.P. in Liverpool.

PROV: Bequeathed by Miss Barbara Jean Paterson, 1935.

EXH: Walker Art Gallery, 1934, *Liverpool Autumn Exhibition* (1093).

HARGREAVES, Thomas 1774 - 1847

Portrait and miniature painter. Born Liverpool 16 March 1774, the son af Henry Hargreaves, Woollen Draper. Entered Royal Academy Schools March 1790; on 10 May 1793 was apprenticed for two years to Lawrence, whose influence is apparent in all his work. An advertisement in *Gore's Liverpool General Advertiser,* 6 August 1795, announced his return to Liverpool as a portrait painter in oils and miniature. His delicate health is said to have been the reason for him concentrating on miniature painting of which he made a successful career with many clients from the best Liverpool and county families.

He planned to return to London, October 1797 and is first listed in the street directories as portrait painter in 1803 at 25 Brunswick Street, but may also have assisted in his father's business in this street for between 1810 and 1816 he appears as 'woollen draper and portrait painter', living with his father in Vauxhall Road with a carpet warehouse in Brunswick Street and later 52 Church Street. From 1818 he is independant, listed only as portrait painter, artist, and finally, from 1845, miniature painter (though the baptisimal registers give miniature painter from 1810).

Original member of Liverpool Academy, 1810, where exhibited intermittently, 1810–35; exhibited at the Royal Academy, 1798, 1808–9 and ?1813; original member of the Society of British Artists, 1824. He and his wife Sarah (née Shaw) had several children of whom three sons were certainly artists, and a family business Hargreaves and Company, comprising miniature painting, teaching, framemaking and restoring, and later photography, was carried on in Bold Street from around 1834. Little of his children's work has yet satisfactorily been distinguished from his. His children, baptised at St. Peter's and two, Francis and Robert, at St. Nicholas's were: George, 14 January 1797 – ? 18 December 1869; Francis, 24 August 1804 – 1877, q.v. 3121 below; Robert, 24 July 1806 – post 1860, who entered as probationer at Liverpool Academy 11 December 1824, and exhibited landscapes there 1824–53, and at Manchester Royal Institution from 1827 (as 'Richard'): he is listed in the street directories as artist from 1837 and professor of drawing (at the brothers' establishment in Bold Street) from 1845–60; Charles, 11 December 1807 –?: a C. Hargreaves exhibited at Liverpool Academy in 1828; Lawrence, 21 April 1810–?; Emma, 29 May 1812–?; Augustus, baptised 11 September 1814–?: an A. Hargreaves exhibited at the Liverpool Academy in 1849.

Miniatures by Thomas and his sons George and Francis are in the Gallery Collection. A large collection of his (and possibly his sons'?) drawings for miniatures and some other studies are in Liverpool Record Office, others are in the Athenaeum Library, Liverpool.

According to a reviewer of 1827, who preferred his male portraits, he employed an unusual system: 'In Mr. Hargreaves method of taking likenesses there is a peculiarity which is not, in our opinion favourable to the accurate delineation of feminine loveliness. His *chief sittings* are short, and in them he contents himself with *pencil sketches,* from which he works up, at his leisure, those beautiful heads which have long been the admiration of the public. This method

is a vast relief to the person painted; but is more calculated to allow strong features or great peculiarities to be seized on, than to afford a faithful transcript of the numberless and ever-varying graces of the female countenance. We may be mistaken; but it appears to us that in *some* of his later pictures the shadows occasionally seem cold, from the preponderance of blue in their composition, and from his wish to preserve the predominance of pearly tints.'

He died Tuesday 5 January 1847 (not 23 December 1846 as is sometimes stated). A subsequent sale (Winstanley, Liverpool, 14/15.4.1847) contained many Old Masters and some 18th century English paintings. A local obituary (by Joseph Mayer?) noted: 'his likenesses were remarkably striking, and he was probably more celebrated for the faithful and yet strictly natural manner in which he depicted female beauty and loveliness than for any other of his miniature representations.'

Ref: Joseph Mayer Papers; St. Nicholas' Church Register of Births; St. Peter's Church Register of Births; *A descriptive and Critical Catalogue of the Works of Art now exhibiting in the Liverpool Exhibition, . . . from the Liverpool Mercury*, 1827. *Gore's Advertiser*, 6 August 1795; 7 January 1847; 23 December 1869; Indenture in Keightly Papers (LAW/1/15/p. 25), Royal Academy.

2683 Mrs. Johnson

Oil on canvas, 76·2 × 63 cm. (30 × 24¾ in.)
SIGNED AND DATED: *T. Hargreaves/1795*

2682 Miss Freckleton

Oil on canvas, 76·5 × 63 cm. (30⅛ × 24¾ in.)
It has not been established whether these are local sitters.

PROV: Anon. sale Christie's, 5.11.1954 (291), as John Opie, bt. Dent, £23.3.0. Passed to Sidney F. Sabin, from whom purchased, 1956.

3121 Francis Hargreaves

Oil on canvas, 72·4 × 63·8 cm. (28½ × 25⅛ in.)
The identity and artist is from the last owner. Francis Hargreaves was the second son of the artist; he became a miniature painter like his father. Born in Liverpool 24 August 1804[1] he was admitted probationer at the Liverpool Academy School 11 December, 1824 (with his brother Robert) and attended classes until November 1828.[2] He exhibited at the Liverpool Academy 1828–61, Associate 1835, Member 1853; he also exhibited at the Liverpool Autumn Exhibition 1873. He appears independently in the street directories in the early 1830's and was part of the family firm of carvers, gilders, miniature painters and teachers in Bold Street. From 1857 to 1864 he is listed as miniature painter and photographer. Died 1877. Four of his miniatures were lent by Miss M. Bond Bragg, a relative of the artist, to the Historical Exhibition 1908. His water-colour copy of a portrait of John Gibson by Penry Williams and an inscribed miniature are in the Collection, and a miniature is in Merseyside County Museums.

PROV: Miss M. Bond Bragg, Miss J. F. Bragg, from whom purchased, 1914.

EXH: Walker Art Gallery, 1908, *Historical Exhibition of Liverpool Art* (159); Harrogate, 1924, *Liverpool School of Painters* (17).

REF: **1** St. Nicholas' Church Register of Births (baptised 12 October), (Liverpool Record Office) and letter from him to W. G. Herdman (1876), Mayer Papers (Liverpool Record Office). Neither his name nor Robert Hargreaves' appears in the St. Peter's Baptismal Register where other children are recorded. **2** Liverpool Academy Council Minute Books (Liverpool Record Office).

HARRIS, John, active mid-19th Century

Portrait painter. Joseph Mayer notes (MS annotated letters, Liverpool Record Office), that he painted a picture of *The Outcast* with extraordinary detail, and a full-length of Mayer in his museum with his Egyptian statues, around 1856 (Bebington). He wrote to Mayer from Upper Norwood, London, in 1857, and appears to have moved for a time between London and Liverpool; he is recorded at Liverpool addresses in 1860 and 1861. He was writing from Lupus Street, Pimlico in 1866 and Old Cavendish Street in 1868 (or 60?), when he was offering or asking Mayer for work. He appears to have shown work at the Crystal Palace exhibitions during the 1860's.

7632 Joseph Clarke

Oil on canvas, 76·5 × 63 cm. (30⅛ × 24¾ in.)

Joseph Clarke F.S.A. (1802–1895),; antiquarian and collector of Saffron Walden, Essex. Friend and correspondent of Joseph Mayer and honorary member of the Historic Society of Lancashire and Cheshire. He assisted Mayer in arranging his collection of antiquities. At Saffron Walden he was closely associated with the Museum of which he was a trustee. He also established a Cadet Corps there to which Mayer (as Captain Commandant of Liverpool Borough Guards), presented a drum.[1]

Early in life he was associated with Charles Roache Smith, the antiquary, whom he assisted with the drawings for his *Collectanea Antiqua*. Writing to him in June 1857 he commented on Mayer: '. . . *Our* friend is destined to be fleeced [?] he has a painter at work for him who is doing it by wholesale, he was introduced to him by Dr. Hume – he first was to paint him a portrait of himself for a hundred guineas, he had already advanced him a hundred and eighty and the picture is not half finished, and does not seem likely to be – then he painted Mr. Harrison's little boy & dog £50 – then he pretended he would have to leave for debt, unless he could sell a picture which our friend was induced to give him £300 for, then he was ill and sent for our friend to say he had not a farthing to help himself – and got £10 – besides which he has helped him to above a thousand pounds worth of work.'[2] A portrait sketch of 1850, a portrait showing him at the back of Roos Farm, the family house, and a photograph in old age, were at Saffron Walden.[3] His bust by Fontana was included in Mayer's

collection at Bebington[4] (a copy at Saffron Walden) and is now in the Collection (7600).

PROV: Joseph Mayer; the Mayer Trust, Bebington Corporation,[5] and presented by them, 1971.

REF: 1 Obituary, and information from L. M. Pole, Curator, Saffron Walden Museum, 18 Dec. 1975. 2 Letter dated 1 June 1857, Mayer Papers (Liverpool Record Office). 3 Information from L. M. Pole, *loc. cit.* 4 Photograph in *Joseph Mayer and his Friends* (album, Liverpool Record Office). 5 The Mayer Trust, *Handlist of Drawings, Prints, Sculpture, etc.*, n.d., No. 55.

7629 Thomas Reay

Oil on canvas, 76·2 × 63 cm. (30 × 24¾ in.)

Thomas Reay was a friend of Joseph Mayer and a founder member of the Historic Society of Lancashire and Cheshire. He was a cutler and surgical instrument manufacturer at 8 Church Street, Liverpool; in 1864 he was described in the directory as Gentleman of 213 Canning Street. A bust by Fontana, which belonged to Joseph Mayer is also in the Collection (7609).

PROV: Joseph Mayer; The Mayer Trust, Bebington Corporation[1] and presented by them, 1971.

REF: 1 The Mayer Trust, *Handlist*, op. cit., No. 58.

7626 'Mug won't Beg'

Oil on canvas, 76·5 × 64 cm. (30⅛ × 25 3/16 in.)

Portrait of a boy living with Joseph Mayer,[1]

apparently a son of Mr. Harrison,[2] holding one of Mayer's dogs in his arms.

PROV: Joseph Mayer; The Mayer Trust, Bebington Corporation[3] and presented by them, 1971.

REF: 1 MS annotation by Mayer to Harris letter (Liverpool Record Office). 2 See 7632 text. 3 The Mayer Trust, *Handlist of Drawings, Prints, Sculpture*, etc., n.d., No. 23.

HARTLAND, Albert 1840 - 1893

Landscape painter, chiefly in watercolour. Born at Mallow, County Cork. Self-taught and worked for a time as a scene painter. Settled in Liverpool and Egremont 1872–81, when moved to Arthog, near Barmouth; then moved to London; returned to Liverpool 1890. Exhibited at the Royal Academy from 1869, Liverpool Autumn Exhibition from 1872, and various London and provincial exhibitions. Member Liverpool Academy and Liverpool Society of Painters in Watercolours. Died at Waterloo near Liverpool, 28 November 1893. Several watercolours are in the Collection and with Sefton District Council.

2930 Moorland, near Barmouth
Oil on canvas, 92·4 × 152·4 cm. (36⅜ × 60 in.)
SIGNED AND DATED: *Albert Hartland 79*
PROV: Purchased from the artist at the Autumn Exhibition, 1880.

EXH: Royal Academy, 1880 (452); Walker Art Gallery, 1880, *Liverpool Autumn Exhibition* (160).

HAY, James Hamilton 1874 - 1916

Landscape painter and printmaker. Born Birkenhead 6 December 1874, son of an architect. After several months in father's office spent four or five years at Birkenhead and Liverpool Art Schools, where found the South Kensington System of training unsatisfactory. Afterwards in classes of Julius Olsson at St. Ives, Cornwall; then in Liverpool under David Muirhead, Augustus John and others. Continued to visit St. Ives and Algernon Talmage there was sympathetic. Whistler's work was an early influence. Around 1901, with Clinton Balmer, met Gordon Bottomley at Cartmel who acquired many of his paintings. Exhibited at Liverpool Autumn Exhibition 1895–1915, intermittently at Royal Academy from 1900 and subsequently at other exhibitions including International Society of Painters, Sculptors and Engravers, Allied Artists, Friday Club, Royal Scottish Academy, Glasgow, etc. By 1900 had studio at 10 South Castle Street; in mixed studio exhibitions from 1901–2 and in 1904 organised exhibition including Hornel, Whistler, John and (?) Manet. Was in favourably reviewed exhibition at Liverpool Royal Institution, 1906. Member of Liverpool Academy. 1907

published watercolour views of Liverpool with text by Dixon Scott (1881–1916) who was enthusiastic reviewer of his work in *Liverpool Courier*. By 1908 had joined the Sandon Studios Society with avant garde artists in Liverpool.

In 1907 married Enid Rutherford, also an artist, and moved to Audlem, Cheshire until her death in 1911. One-man exhibition at Baillie Gallery, London, 1910. Early 1912 moved to London where gained increased reputation; style changed dramatically under impact of English Post-Impressionists. Met Paul Nash, through Bottomley, 1912. Painted direct from nature and travels in England included Dorset and the Lake District. Took up printmaking again in 1913 (after producing a few 1895–1900), including drypoint portraits under influence of Francis Dodd, and others showing influence of Japanese prints, and published fifty drypoints which are perhaps his most considerable original contribution. A memorial exhibition at the Goupil Gallery, London, 1917 succeeded his death at his family home in Hoylake, Cheshire 7 October 1916. Watercolours and prints are also in the Collection.

2511 The Lady in the Japanese Gown – Portrait of Miss Enid Rutherford

Oil on canvas, 198·8 × 122 cm. (78¼ × 48 in.)

A portrait of Enid Rutherford, daughter of Sir W. W. Rutherford, M.P. and Lord Mayor of Liverpool, 1902–3. She was a niece of Mrs. Maude Hall Neale *(q.v.)* and herself trained at Liverpool School of Art. According to an obituary, 'in her art she betrayed distinct leaning towards the more modern school.'[1] She exhibited at major exhibitions and with Liverpool Academy and the Sandon Studios Society. She married Hay in 1907 and died in 1911.

The influence of Whistler is evident in the portrait. The sitter wears over her white chiffon dress a black, white lined, embroidered satin kimono and stands in a neutral greyish room with dark skirting-board and japanese woodcut and fan asymetrically placed against the wall and a fine leaf spray hanging off-centre. The shallow carved gilt frame is engraved with a leaf motif and a series of medallions. By the early 1900's Whistler's reputation was high in England and an increasing series of books on him culminated in the large memorial exhibition at the New Gallery in February 1905, which Hay may possibly have visited.

Hay also painted a half-length seated portrait of his wife (Coll: P. F. Thomas), and she also appears in two interior paintings (Coll: Prof. J. D. Hay, and Mrs. E. R. Grant).

PROV: Presented by Lady Rutherford, mother of the sitter, 1943.

EXH: Walker Art Gallery, 1905, *Liverpool Autumn Exhibition* (1368) N.F.S.; and Walker Art Gallery, 1908, *Historical Exhibition of Liverpool Art* (661); Baillie Gallery, London, 1910, *James Hamilton Hay* (20), 100 gns.; Walker Art Gallery, 1973, *James Hamilton Hay* (1) repr.

REF: 1 *Liverpool Courier*, 14 June 1911.

2407 Cornish Seascape

Oil on canvas, 78 × 97·8 cm. (30¾ × 38½ in.)

SIGNED AND DATED: *Hamilton Hay 1907*

Similar to another seascape of 1897[1] when the artist was working in Julius Olsson's classes at St. Ives, Cornwall and was inspired by his seascapes. Other seascapes and St. Ives views date from later years.[2]

PROV: Presented by Lady Rutherford, mother-in-law of the artist, 1943.

EXH: Probably Walker Art Gallery, 1907, *Liverpool Autumn Exhibition* (1188), *Seapiece*; and 1973, *James Hamilton Hay* (4) repr.

REF: 1 1973 Catalogue, *op. cit.*, No. 94. 2 *Ibid*, Nos. 100, 205, etc. 3 Liverpool 1907 label.

714 The Lovers

Oil on canvas, 35·5 × 45·7 cm. (14 × 18 in.)

SIGNED AND DATED: *J. Hamilton Hay/ 1906* (or *8*)

The date is unclear. It may have been painted at Audlem[1] which would make 1908 certain.

A reviewer of the Liverpool Autumn

Exhibition, 1908 commented: '*The Lovers* gives a title and two specks to a picture distinguished for bold rural foreground and fine height of lovely sky.'[2]

The offer by the Gallery to purchase it in January 1909 at the usual twenty per cent discount provoked correspondence with the artist who expressed his distaste at the offer, which he ultimately accepted, and asserted his opinion that it was the duty of the Gallery to buy the best works by local artists (not at a discount) as well as works by leading national figures.[3]

PROV: Purchased from the artist at the Autumn Exhibition, 1909.

EXH: Walker Art Gallery, 1908, *Liverpool Autumn Exhibition* (129); Liverpool Academy, 1920 (24); Harrogate, 1924, *Liverpool School of Painters* (1); Walker Art Gallery, 1973, *James Hamilton Hay* (3) repr.

REF: **1** MS note by the artist on biographical form in Gallery files. **2** *Liverpool Daily Post*, 17 September 1908. **3** Letters, Gallery files, and see Introduction to 1973 Catalogue, *op. cit.*

2408 The Falling Star

Oil on canvas, 64 × 76·8 cm. (25¼ × 30¼ in.)

SIGNED AND DATED: *J Hamilton Hay – 1909*
Suggested by landscape around Audlem, where the artist lived and worked from 1907.[1] On its exhibition in Liverpool, autumn 1910, it was reviewed enthusiastically by Dixon Scott (1881–1916),[2] friend of the artist and reviewer for the *Liverpool Courier* and later *Manchester Guardian*, in the former newspaper: 'one of two quiet masterworks unsuspected at first sight like Mr. Hamilton Hay's magical *Falling Star*, a real secret exit this – a corridor leading one, as the great glimmering Cameron did,

clean out into the wide outer world of darkness and brooding Powers.' In a later review he added: 'it is one of the muted masterworks, not even the proximity of the great sunlit Lavery can dim or destroy its appeal. So strongly do I feel about this man's work, indeed, that I hesitate to speak of it; I will only say that the more I study it the more do I become convinced that he possesses one of the most exquisite pictorial talents of our time. And it is certain at least that the three pictures he has sent us – that night piece not a monochrome but simply a harmony of muted colours, colours enmeshed in the tissue of the moonstuff and shining purely in that frail prison. . . '[3] The reviewer in the *Liverpool Daily Post* was also favourable: 'And this brings us at last to what is perhaps the most powerfully suggestive and significant picture in the collection, Mr. Hamilton Hay's *The Falling Star*, the work of a man in whom the poetic outlook is so intensely strong that at times one has feared it might even cramp the expression of his genius.'[4]

PROV: Purchased from the artist at the Autumn Exhibition, 1910.

EXH: International Society of Painters, Sculptors and Engravers, 1910 (281); Baillie Gallery, 1910, *James Hamilton Hay* (21); Walker Art Gallery, 1910, *Liverpool Autumn Exhibition* (329); Bury, 1911; Liverpool Academy, 1920 (35); Harrogate, 1924, *Liverpool School of Painters* (4); Walker Art Gallery, 1973, *James Hamilton Hay* (5) repr.

REF: **1** MS note by the artist on biographical form in Gallery files, which may refer to 714 above also. **2** See Introduction to *Hay* catalogue, 1973. **3** *Liverpool Courier*, 17 and 24 September 1910. **4** *Liverpool Daily Post*, 5 October 1910.

HAYES, Frederick William 1848 - 1918

Landscape painter. Born Rock Ferry, Cheshire, 13 July 1848, son of a stained glass manufacturer; his mother was an artist. Trained as an architect at Ipswich, then studied painting at Liverpool and 1871–72 in London under Henry Dawson. Exhibited at the Royal Academy intermittently from 1872, at Suffolk Street, New Gallery, the Liverpool Autumn Exhibitions, and elsewhere. A founder of the Liverpool Society of Painters in Watercolours,

1872–3, and Secretary until 1877. A member Royal Cambrian Academy. Settled in London by 1880. Turned to commercial illustration in the 1890's. Was also an author and social reformer. Died London 7 September 1918.

4114 Boulders near Aberglaslyn
Oil on cardboard, 44·5 × 55·5 cm. (17½ × 21⅞ in.)
SIGNED: *F. W. Hayes*

596 On the Colwyn, Beddgelert
Oil on cardboard, 44·6 × 55·5 cm. (17⁹⁄₁₆ × 21⅞ in.)
SIGNED: *F. W. Hayes*

1452 On the Colwyn
Oil on cardboard, 45 × 56 cm. (17¾ × 22 in.)
SIGNED: *F. W. Hayes*

All three dating from 1881 and 1882 and they were each done at one sitting in a technique developed by the artist, of painting in thin oil on prepared white paper.[1]

PROV: Presented by the artist's widow, 1919.

EXH: Harrogate, 1924, *Liverpool School of Painters* (53, 50).

REF: 1 Letter from G. R. Hayes, the artist's son, 22.3.1919, and press cuttings, Gallery files.

HENDERSON, Cornelius 1799 - 1852

Portrait painter and copyist, working in Liverpool. Born Lancaster, 9 October 1799, son of John Henderson (1770/71 – 1853), shoemaker and amateur painter of local views. The son is said to have 'had the advantage of a training in art which was denied to the father' (Cross Fleury, *Time Honoured Lancaster*, 1891, pp. 275–6). He painted some local sitters and views around Lancaster are recorded, some apparently post-dating his appearance in Liverpool in about 1826. He appears in Liverpool street directories from 1827; after living at Brownlow Hill and Smithdown Road he moved, about 1834, to Mason Street, Edge Hill, to a house built for him by his patron Joseph Williamson (see British School 7481), who also left him an annuity. His wife died at Edge Hill in 1836, aged 36. His local sitters included William Roscoe (1826, after Lonsdale), Dr. William Shepherd (*q.v.*), Joseph Williamson, 1828, and Henry Byrom, which last was his only contribution to the Liverpool Academy, in 1834 (his father exhibited there at intervals from 1822–37). He copied Phillips' *Duke of York* and Lawrence's *George III* in the Town Hall, 1840, which he presented to Lancaster; and Hayden's *Christ healing the Blind*, (then in the School for the Blind), he was at some date working on a large copy of Rubens' *Descent from the Cross* when Williamson altered his house or painting room to fit it (J. Stonehouse, *The Streets of Liverpool*, 1870, p. 143: but perhaps Stonehouse is confusing this with Hilton's *Crucifixion*, now in the Collection, which Henderson copied 1835–36). Stonehouse, who knew him, stated (*loc. cit*, p. 131) that 'he was an artist of

considerable merit. His portraits were extremely faithful; and in other branches of his profession he attained some fame'. Henderson threatened Stonehouse with litigation, about 1846, if he read his proposed paper on Joseph Williamson's excavations at Edge Hill, and Stonehouse, knowing 'something of Henderson's litigious character,' desisted. Died at Edge Hill, 20 December 1852.

7020 Thomas Molyneux

Oil on canvas, 127×101·5 cm. (50×40 in.)

Thomas Molyneux, J.P. (1758–1835), merchant, of Newsham House, West Derby, Liverpool. Grandson of Anthony Molyneux of Wall Hill, West Derby (c. 1682–1743). Thomas married Ann, daughter of Thomas Watson of Ormskirk; they had two sons and four daughters.[1] He was Mayor of Liverpool, 1806.

The property of Newsham appears to have come into their family at its sale by the government after its forfeit by the Chorley Family due to their participation in the Rebellion of 1715.[2] Family information, however, suggests[3] its inheritance through Anthony Molyneux's marriage in 1710 with Mary, daughter and heiress of John Bolton of Newsham, whose ancestor is said to have bought the property from Birkenhead Priory, 26 June 1557. The estate was sold to the Corporation in 1846 and ultimately in part laid out as a public park. The house, built by the sitter towards the end of the 18th Century, was made the Judge's Lodgings, 1868.

The sitter is shown seated with his right hand resting on an open page with the arms of George IV. A plaque with the picture states:

> This portrait of THOS MOLYNEUX ESQ of Newsham House,/painted & placed here at the request of the Rate Payers, of the Township of West Derby, in testimony of their respect for his private worth/as an individual, for his uprightness of character as a Magistrate & for his constant and unwearied attention to the interests & welfare of/the Township
> An:Dom: 1829.

GEO: CLARE
INO: SMITH Overseers
INO: TAYLOR Govr of the Workhouse.
 CORNELIUS HENDERSON, Lpool Pinxit.

A portrait probably of this sitter, by Alexander Mosses, was exhibited at the Liverpool Academy, 1827 (121).

PROV: Painted for the ratepayers of the township of West Derby near Liverpool, 1829, and hung, presumably, in the Workhouse.

Newsham House before 1905;[4] transferred from the City Estates Committee to the Gallery, 1968. Hung at Newsham House.

REF: 1 Typescript with the picture; a photograph of a portrait of Mrs. Molyneux is also at Newsham House. 2 J. Picton, *Memorials of Liverpool*, 1873, II p. 501. 3 Typescript, *loc. cit.* and date from Mrs. T. Brocklebank (née Royds), a descendant. 4 Typescript.

9140 Rev. William Shepherd

Oil on canvas,[1] 122·8×97·8 cm. (48⅜×38½ in.)

The Rev. William Shepherd (1768–1847), eminent Unitarian minister in Liverpool and political reformer. For biography see Illidge 3013.

A portrait by Henderson belonged to the sitter's great political friend Lord Brougham.[2] The present portrait was given to the Liverpool Royal Institution by the artist, who borrowed it in 1847 to have it engraved.[3]

PROV: Presented by the artist to Liverpool Royal Institution, 1844;[4] presented to the Gallery by Liverpool University from the L.R.I., 1976.

EXH: (?) Mechanics Institute, 1842 (387) and 1844 (15).

REF: 1 Relined. 2 D.N.B. 3 L.R.I. Minutes of Committees 29.9.1847 (R.I.Arch.11: Liverpool University Library). 4 L.R.I. *Annual Report*, 1843–44; Index to Minutes, 1844, and Minutes of Committees, 31.5.1843 (R.I.Arch. 12 and 11: Liverpool University Library).

HENRI, Adrian, living artist

6575 Salad painting VI
Acrylic on canvas, 101·6 × 76·2 cm. (40 × 30 in.)
INSCRIBED, verso: *Adrian Henri. Salad paint-
ing VI./IX. 65.*
PROV: Purchased from the artist, 1967.

EXH: Walker Art Gallery, 1965, *John Moor*
Liverpool Exhibition V (42); Birmingham
Midlands Institute, 1967, *Adrian Henri* (8
Wolverhampton, 1976, *Adrian Henri, Paintin*
Drawings, 1960–76 (22) repr.

HENRY, George 1859 - 1943

241 Mrs. George Holt
Oil on canvas, 92·1 × 71·5 cm. (36¼ × 28 3/16 in.)
SIGNED AND DATED: *GEORGE HENRY/*
1913.
Elizabeth (1833–1920) daughter of Samuel
Bright of Liverpool, and wife of George Holt
(1825–1896), shipowner and collector. Their
daughter Emma bequeathed their collection
of paintings and their house, Sudley, Mossley

Hill, to the City in 1945. (See Morrison 27
and Bigland 8700).
PROV: Presented to the sitter on her eightiet
birthday by her great-nephews and niece
Miss Emma Holt, who bequeathed it
Liverpool, 1945. At Sudley.
EXH: Walker Art Gallery, 1914, *Liverpo*
Autumn Exhibition (1005) repr.

HERDMAN, William Gawin 1805 - 1882

Landscape and topographical artist and teacher. Born Liverpool 13 March 1805, son of a cor
merchant. Self-taught and at about thirteen began sketching the fast-changing local scene
Published many of his drawings in *Pictorial relics of Ancient Liverpool*, 1843, 1857 and 187:
Also exhibited views in France and Switzerland from mid 1830. His theories on curvilinea
perspective published in *The Art Journal*, 1849 and in volume form 1851 and 1853; othe
publications included poetry. Alderman William Bennett and Joseph Mayer were chi
amongst his patrons, and large collections of his and his sons' views are in Liverpool Cit
Library (some formerly Walker Art Gallery) and with the Mersey Docks and Harbour Boar
His oil paintings are more rare. A student of Liverpool Academy, January 1827; Associat
1836; Member, 1838; Secretary, 1845–47; exhibited also at the Royal Academy occasional
1834–61 and at Suffolk Street. He was a founder of the shilling Art Union. His sons W
Patrick, John Innes, Stanley, and in particular William, were also topographical artists. F
was in opposition to the Pre-Raphaelite faction in the Liverpool Academy and set up the riv
Institute of Fine Arts, 1858–62 which was shortlived but contributed to the downfall of th
Academy. Died Liverpool 29 March 1882. See Kidson for portrait.

L140 Lime Street, Liverpool

Oil on canvas, 70·5×91 cm. (27¾×35⅞ in.)

INSCRIBED AND DATED: *W. G. Herdman/
1858.*

Version of a drawing by Herdman reproduced in his *Pictorial Relics of Ancient Liverpool*, 1878, (II, pl. XLII fp. 10) with differently placed figures and building material added in the right corner. Watercolours of a similar view dating from 1857 and 1858 are in the Mersey Docks and Harbour Board,[1] and in Liverpool Record Office (Binns Collection 602).

His text described the subject as follows: 'The drawing exhibits the principal buildings in the Street, and commences with the first facade of the Old Railway Station designed by John Foster [replaced 1868]; next is shown the carriage works of Varty [Jonathan Varty, the first to introduce gas into Liverpool, 1816] and Wilson and Garner's Livery Stables (now the Grapes Hotel and Alexandra Theatre); the Three Legs of Man inn; and beyond London Road and Commutation Row, much in the same state as at the present day; and in the distance Islington Flags, over which the spire of Christ Church, Hunter Street, is seen. To the left is shown a portion of St. George's Hall. At this date the lions were placed as shown; as also were the two red granite columns (facetiously styled "candlesticks"), which were really surplus pillars not required in the interior of the Hall. The amount of ridicule they met with on the part of the towns-people induced the authorities eventually to remove them. . .'

PROV: Lent by Liverpool City Library, 1973.

REF: **1** Repr. Ramsay Muir, *Bygone Liverpool*, 1913, pl. LXIII.

HERITAGE, John, living artist

3028 Landscape No. 2

Oil on board, 90·2×131·5 cm. (35½×51¾ in.)

PROV: Purchased from the artist, 1959.

EXH: Walker Art Gallery, 1959, *Liverpool Academy* (166).

8279 Pope in a car

Oil on board, 118·2×89·5 cm. (46½×35¼ in.)

PROV: Presented by the artist, 1972.

EXH: Walker Art Gallery, 1970, *Liverpool Academy* (24).

HERKOMER, Hubert von 1849 - 1914

3057 Charles MacIver

Oil on canvas, 129×102·2 cm. (50¾×40¼ in.)

SIGNED AND DATED: *H. H. 82*

Charles MacIver (1812–1885), prominent Liverpool shipowner as D. and C. MacIver. Born Greenock. In 1839/40 with his brother David, George Burns of Glasgow, and Samuel Cunard of Halifax, N.S., established the Mail Steamship Service from Liverpool to Canada and the U.S., from which sprang the Cunard Line. He made a major contribution to its success and retained his interest as Manager and Liverpool Agent until it became a public company in 1880.[1] His house, Calderstones, was later bought by the Corporation for use as a public park.[2]

PROV: Presented to the City by Subscribers, 1882.[3]

EXH: Walker Art Gallery, 1883, *Liverpool Autumn Exhibition* (581); Wembley, 1924, *Liverpool Civic Week*.

REF: **1** B. G. Orchard, *Liverpool Exchange Portrait Gallery*, 2nd series, 1884, pp. 104 ff.; C. W. Jones, *Pioneer Shipowners*, 1935, pp. 47 ff., repr.; H. MacIver, *Clan Iver*, 1912, pp. 50ff. **2** R. Millington, *The House in the Park*, 1957, pp. 25 ff. **3** See MacIver, *op. cit.*, pp. 66 ff.

HINCHLIFFE, Richard George 1868 - 1942

Portrait painter in Liverpool. Born Manchester. Trained at Liverpool School of Art, the Slade School, the Académie Julian, Paris, and the Royal Academy, Munich, where gained gold medal, 1900. Exhibited at Liverpool Autumn Exhibition from 1901 and the Royal Academy from 1902. A president of the Liverpool Academy, Royal Cambrian Academy and the Liver Sketching Club. Died Liverpool, 7 January 1942.

7139 John Morris
Oil on canvas, 168×109 cm. (66⅛×43 in.)
SIGNED: *R. G. Hinchliffe.*
John Morris (1850–1951), in robes as High Sheriff of his native Merionethshire, 1914–15. A builder and contractor in Liverpool: he built some of the first houses in Princes Avenue and Ullet Road. City Councillor 1899–1910, as a Liberal; J.P. 1906–1938 (retired). Lived until a hundred and one.
PROV: Transferred from City Estates Committee, 1968.

EXH: Walker Art Gallery, 1920, *Liverpool Autumn Exhibition* (38).
REF: Press cuttings (Liverpool Record Office)

600 A Water Nymph
Oil on canvas, 91·5×71·2 cm. (36×28 1/16 in.)
SIGNED: *R. G. Hinchliffe.*
PROV: Purchased from the artist, 1935.
EXH: Walker Art Gallery, 1934, *Liverpool Autumn Exhibition (1101).*

HOLDEN, Lily, living artist

3029 The Pawnshop, Scotland Road
Oil on canvas, 45·7×61 cm. (18×24 in.)
SIGNED: *Lily Holden*
PROV: Purchased from the artist at Liverpool Academy, 1959.

EXH: Walker Art Gallery, 1959, *Liverpool Academy Open Exhibition* (38).

HOLT, Herbert, living artist

2411 Sam's Wife
Oil on canvas, 76·8×63·5 cm. (30¼×25 in.)
SIGNED: *HOLT*
The artist had moved from Liverpool to London by 1937. The sitter was the wife of another artist in the same block of studios as Herbert Holt.[1]

PROV: Purchased from the artist at the Liverpool Autumn Exhibition, 1938.
EXH: Walker Art Gallery, 1938, *Liverpool Autumn Exhibition* (838).
REF: 1 Information from the artist, February 1977

HOODLESS, Harry Taylor, living artist

3030 The Old Port, Amlwch, Anglesey
Oil on board, 65·4×99 cm. (25¾×39 in.)
SIGNED AND DATED: *HOODLESS '57*
PROV: Purchased from the artist, 1959.
EXH: Walker Art Gallery, 1959, *Liverpool Academy* (164).

1488 Winter Evening on the Solway
Oil on millboard, 71×91·5 cm. (28×36 in.)
SIGNED AND DATED: *HOODLESS. 52*
PROV: Presented by John Moores, 1958.
EXH: Royal Academy, 1953 (363).

HORSFIELD, Nicholas, living artist

1817 Liverpool Street
Oil on canvas, 76×63·5 cm. (30×25 in.)
Mount Street by Liverpool College of Art.
PROV: Presented by John Moores, 1958.
EXH: Walker Art Gallery, 1958, *Liverpool Academy* (122).

2621 Le Pollet Cliffs
Oil on canvas, 51×61·3 cm. (20⅛×24⅛ in.)
PROV: Purchased from the artist, 1955.
EXH: Walker Art Gallery, 1955, *Liverpool Academy* (19).

HUGGINS, William 1820 - 1884

Animal, portrait, architectural, historical and still-life painter. Born Liverpool 13 May 1820, younger brother of Samuel, architect and local historian. Studied at Mechanics Institute, where he won prize at 15 for ambitious biblical design; studied avidly at the Liverpool Zoological Gardens, and entered Liverpool Academy Schools 19 October 1835 (with Richard Ansdell), the year he first exhibited there. Associate 1847; Member, 1850; resigned 1856, during the split over the Pre-Raphaelite controversy but exhibited there in the sixties and with the rival Society of Fine Arts. Exhibited at the Royal Academy 1842–75; at Suffolk Street, and at the Liverpool Autumn Exhibitions, 1871–78.

Early works included many chalk portraits but he was ambitious to be an historical painter; his few attempts usually included animals. It was as a painter of farm, domestic and wild animals that he made his mark. The latter he studied at the Liverpool Zoological Gardens, at Chester and at the travelling menageries. His small-scale early portraits show an understanding and grasp of character, which he transferred to his animal studies. His earlier romantic glossy style changed dramatically during the fifties to a bright palette of translucent colours, painted over a white ground. He is said occasionally to have collaborated with other artists, e.g. Robert Beattie, who provided backgrounds for some of his animal subjects.

In 1861 he moved to Chester, living with his brother Samuel for a time. In 1876 he was

living at Bettws-y-Coed to paint landscape, and in 1878 at Llanbedr in the Vale of Clwyd, where his wife died. He moved back to Christleton, near Chester, in the early 1880's, where he died, 25 February 1884. His gravestone there describes him as 'a just and compassionate man, who would neither tread on a worm nor cringe to an emperor.'

1729 The Water Mill

Oil on canvas, 63·3 × 76·5 cm. (24⅞ × 30⅛ in.)

Evidently an early work.[1]

PROV: John Elliot, who bequeathed it, 1917.

EXH: Walker Art Gallery, 1908, *Historical Exhibition of Liverpool Art* (232).

REF: **1** H. C. Marillier, *The Liverpool School of Painters*, 1904, p. 152.

1715 Self Portrait as a Young Man

Oil on panel, 53·7 × 37·8 cm. (21⅛ × 14⅞ in.)

SIGNED AND DATED, indistinctly: . . . *Huggins /184. .*

Compare the small bust in 1716. A self-portrait of 1841 belonged to Henry Thompson, Jnr. in 1886.[1]

A bust of him by John Blackburn of Liverpool was exhibited at the Liverpool Academy, 1845 (798).

PROV: Presented by John King (dealer, Liverpool), 1899.

EXH: (?) Liverpool Academy, 1840 (430); Walker Art Gallery, 1908, *Historical Exhibition of Liverpool Art* (536); Harrogate, 1924, *Liverpool School of Painters* (46); Lowndes Lodge Gallery, 1966, *William Huggins* (30).

REF: **1** Lent Walker Art Gallery 1886, *Grand Loan Exhibition* (24).

1716 The Sculptor's Studio

Oil on panel, 62·9 × 52 cm. (24¾ × 20½ in.)

SIGNED AND DATED: *W. Huggins 1841*

A portrait of William Spence (1793–1849) the Liverpool sculptor and father of Benjamin Spence. The miniature head he is working on appears undoubtedly to be that of Huggins himself (compare 1715). Part of a life-size sculpture is also visible. A chalk portrait by Huggins of 1845 is also recorded.[1]

Spence was an apprentice with John Gibson at Messrs. S. & A. Francey's the marble masons in Liverpool, and succeeded to the business, which became Francey and Spence in 1830. His large family may have prevented his own travel abroad but he sent his son to Gibson at Rome. He was Master of the Drawing Academy, 1837–43, while Huggins was a student, and died at Liverpool 6 July 1849. Monuments by him are in several Lancashire, Cheshire and North Wales churches and sculptures by him are in the Collection.

Picton wrote of him;[2] 'For unflagging, untiring, patient industry and thorough devotion to his profession there have been few men equal to him. Although necessarily absorbed in the mere manufacture of marble as a trade, he snatched every leisure moment he could steal for a loving devotion to art as such. For quickness in modelling and readiness in catching the expressive lines of a countenance he was surpassed by few. . . Modest and gentle in his outward demeanour, he was in character and conduct one of the kindest and most unselfish beings it has ever been my lot to meet. He was never so happy as in his workshop, surrounded by his assistants, the sharp click of the chisel in his ears, the modelling tools in his hand, clad in a long grey duffel coat, his curling grey hair flowing over his shoulders. Here he would chat merrily with his friends, working assiduously all the time, his eye lighting up with pleasure as tidings came from time to time of his son's progress at Rome. . . .'

The original owner also had (1876) a portrait 'Mr. Spence Snr.' by Alexander Mosses.[3]

PROV: J. A. Atkinson in 1876; presented by Miss W. E. Atkinson, 1946.

EXH: Liverpool Academy, 1841 (397); *Liverpool Art Club Exhibition*, 1876 (21); Walker Art Gallery, 1960, *Liverpool Academy 150th Anniversary Exhibition* (49).

REF: **1** J. Cooper Morley, *Biographical Notes on Some Liverpool Artists (reprinted from Liverpool Weekly Mercury)*, 1890, p. 17. **2** J. A. Picton, *Memorials of Liverpool*, 1873, II pp. 245–6. **3** Liverpool Art Club, 1876 (25) and/or (102).

3119 Portrait of a Gentleman

Oil on canvas, 62·2 × 51·5 cm. (24½ × 20¼ in.)

SIGNED AND DATED: *W. Huggins 1842*

PROV: Purchased from E. Pryor and Son, 1945.

EXH: Walker Art Gallery, 1960, *Liverpool Academy 150th Anniversary Exhibition* (51).

3118 The Artist's Wife

Oil on canvas,[1] 91·5 × 70·5 cm. (36 × 27¾ in.)

SIGNED AND DATED: *W. Huggins/1843*

The sitter is not unlike the undoubted portrait of the artist's wife of about twenty years later (3116) though the hair is of a different colour. In 1843 she would have been about 19. The identification, however, is uncertain.

PROV: Presented by Captain A. Crosland Graham, 1948.

REF: 1 Relined.

2563 Mrs. Coupland

Oil on canvas, 91·5 × 71 cm. (36 × 28 in.)

SIGNED: *W. Huggins*

Probably a relative of the donors.[1]

PROV: Presented by the Misses L. and E. Holt, 1951.

REF: 1 Information from A. Neville Holt, June 1972.

2565 William Taylor (Banker) of Oxford

Oil on canvas,[1] 92 × 71·7 cm. (36¼ × 28¾ in.)

INSCRIBED on back of canvas: *W. Huggins No. 3*

The sitter, who died 7 July 1847, had two sons in business in Liverpool.[2] A pencil portrait of the same sitter (8 × 6 in.) was lent to the 1908 exhibition by James Smith.

PROV: Painted for a son of the sitter, who bequeathed it to James Smith (of Blundell-sands),[3] who presented it, 1900.

EXH: Walker Art Gallery, 1908, *Historical Exhibition of Liverpool Art* (541).

REF: 1 Canvas stamp of J. Richardson, Liverpool, artists' colourman. 2 Letter from James Smith, 20.11.1900 (Gallery files). 3 *Ibid.*

2564 William Peck

Oil on canvas, 91·5 × 71 cm. (36 × 28 in.)

PROV: Presented by Mrs. E. Boadle, 1934.

5132 Study of an Ox

Oil on board,[1] 21·3 × 14·5 cm. (8⅜ × 5¹¹⁄₁₆ in.)

An old inscription on the frame gives the date 1845.

An almost identical animal appears in *The Millenium* of 1844 (55 × 37 in.)[2] which illustrated *Isaiah* xi. 6. On the back is a sketch of a (?) Cottage scene.

PROV: Presented by Mrs. A. R. Kennedy, 1960.

REF: 1 Top left corner cut away. 2 Mrs. A. M. Matthews' sale, Christie's 20.11.1970 (77) repr. and anon. Sotheby's 20.11.1973 (80) repr.

777 Waiting

Oil on canvas, 31·7 × 46·3 cm. (12½ × 18¼ in.)

SIGNED AND DATED: *1845/W. Huggins*

Study of a horse.

PROV: Bequeathed by John Elliot, 1917.

7803 The Angels Ithuriel and Zephon finding Satan at the ear of Eve

Oil on panel, 30 × 37·6 cm. (11¹³⁄₁₆ × 14¹³⁄₁₆ in.)

Sketch for the painting exhibited at the Liverpool Academy, 1845 (166),[1] with the following quotation from Milton's *Paradise Lost*, book 4 line 800ff, in the catalogue:

'Him there they found
Squat like a toad, close at the ear of Eve,
Assaying by his devilish art to reach
The organs of her fancy.

* * *

Him thus intent, Ithuriel, with his spear,
Touch'd lightly; for no falsehood can endure
Touch of celestial temper, but returns
Of force to its own likeness: up he starts
Discover'd and surpris'd. As when a spark
Lights on a heap of nitrous powder, laid
Fit for the tun some magazine to store
Against a rumour'd war, the smutty grain
With sudden blaze diffused, inflames the air;
So started up in his own shape the fiend,
Back stept those two fair angels half amazed
So sudden to behold the grisly king.'

PROV: Boydell Galleries, Liverpool 1970; anon. sale Christie's, 21.4.1972 (71), bt. Colnaghi for the Gallery.

EXH: Boydell Galleries, 1970, *19th Century Liverpool School* (59).

REF: 1 54 × 36 in.; Coll: C. F. Garner, lent Walker Art Gallery, 1908, *Historical Exhibition of Liverpool Art* (215).

3117 Christian and the Lions

Oil on board, 31·7×23·5 cm. (12½×9¼ in.)
Sketch for 1753 with slight differences in the composition.

Another sketch (18×14 in.), corresponding to the finished painting, was on the art market.[1]

PROV: Bequeathed by John Elliot, Esq. 1917.

REF: 1 Bonham, sale 3.11.1977 (279) (photo Gallery files).

1753 Christian about to turn back for fear of the lions in his approach to the Palace Beautiful

Oil on canvas, 133×99·5 cm. (52⅜×39¼ in.)
SIGNED AND DATED: *W. Huggins/1848*
Exhibited at the Liverpool Academy, 1848, with the following quotation in the catalogue from Bunyan's *Pilgrim's Progress*:

'Now, before he had gone far, he entered into a very narrow passage, which was about a furlong off the porter's lodge; and looking very narrowly before him as he went, he espied two lions on the way. . Then he was afraid, and thought to go back, for that nothing but death was before him. But the porter at the lodge, whose name was "Watchful," perceiving that Christian made a halt, as if he would go back, cried unto him, saying, "Is thy strength so small?" (Mark iv, 40), "Fear not the lions, for they are chained." '

PROV: Bequeathed by Herbert Grundy of Manchester, 1897.

EXH: Liverpool Academy, 1848 (193); Walker Art Gallery, 1908, *Historical Exhibition of Liverpool Art* (545); Harrogate, 1924, *Liverpool School of Painters* (35).

3120 John Deane Case J.P. and a favourite Hunter (Tried Friends)

Oil on board,[1] 71·7×91·5 cm. (28¼×36 in.)
SIGNED AND DATED: *W. Huggins 1852*
Called 'Tried Friends' in the collection but the identity of the portrait was pointed out by Albert Wood in 1891.[2] Case was Treasurer to Liverpool Corporation about 1818–1834 and afterwards settled on the Wirral, where he was connected with the development scheme for Birkenhead. A subscription portrait for Birkenhead Town Hall by Illidge was at the Liverpool Academy of 1845. At the 1852 Liverpool Academy the likeness in Huggins' portrait was said by the *Mercury* critic to be admirable and the style was discussed as antagonistic to Pre-Raphaelitism which was much in evidence that year.[3]

PROV: Purchased from Alker & Co., 1884.

EXH: Liverpool Academy, 1852 (106); Grosvenor Gallery, 1890, *Arts and Sports* (198) as *Mr. Case*; Whitechapel, 1907; Walker Art Gallery, 1908, *Historical Exhibition of Liverpool Art* (538); Harrogate, 1924, *Liverpool School of Painters* (45); Wembley, 1924; Stoke-on-Trent, 1928; Walker Art Gallery, 1960, *Liverpool Academy 150th Anniversary Exhibition* (62).

REF: 1 Winsor and Newton prepared millboard. 2 In a letter, 8 January 1891 (Gallery files). 3 *Liverpool Mercury*, 8 October 1852, p. 807.

6260 William Banister of Liverpool

Oil on canvas,[1] 90·5×70·5 cm. (35⅝×27¾ in.)
The attribution to Huggins is traditional but the style is uncharacteristic. The sitter was believed to be an ancestor of Mrs. Davis (see provenance), possibly connected with law and at one period living in Chester.[2]

PROV: Mrs. Mona Wycliffe Davis née Banister, thence to her husband, who bequeathed it to his sister, Mrs. B. M. Smith; presented by Mrs. Smith in the name of Mrs. Davis, 1964.

REF: 1 Laid down on board at time of restoration prior to acquisition. 2 Information from Mrs. Nichol (née Banister) in a letter, 21.10.1964.

340 On Guard

Oil on board, 30·3×38·1 cm. (11¹⁵⁄₁₆×15¹⁄₁₆ in.)
SIGNED AND DATED: *W. Huggins/1853*
PROV: John Elliot, who bequeathed it, 1917.

EXH: Walker Art Gallery, 1908, *Historical Exhibition of Liverpool Art* (259), as *Poultry*; Harrogate, 1924, *Liverpool School of Painters* (48).

3116 The Artist's Wife

Oil on board, 38×28 cm. (15×11 in.)
Elizabeth Huggins, who died near Ruthin 18 March 1879, aged fifty-four.[1]

PROV: Samuel Huggins, brother, of the artist, prior to 1884; H. E. Kidson, who presented it 1899.

EXH: Chester, 1884, *William Huggins* (8);[2] Walker Art Gallery, 1908, *Historical Exhibition of Liverpool Art* (532); Harrogate, 1924 *Liverpool School of Artists Painters* (6).

REF: **1** Information from Adrian Bristow, Chester, 14 December 1970. **2** MS label on back.

44 Speke Hall

Oil on board, 36·9×46·4 cm. (14$\frac{9}{16}$×18$\frac{5}{16}$ in.)
SIGNED AND DATED: *W. Huggins 1860*
View of the south corner of the west front, showing the window of the Great Chamber. Dating from the period of Richard Watt V's residence there, 1855–65, when he had the house put into good repair and considerably restored.[1] For the history of the house see Davis 8486.

PROV: John Elliot before 1908, and bequeathed by him, 1917.

EXH: Liverpool Society of Fine Arts, 1860 (93), £20;[2] Walker Art Gallery, 1908, *Historical Exhibition of Liverpool Art* (301).

REF: **1** Information from Paul Lawson, Merseyside County Museum. **2** MS label on back confirms this.

1713 Chester Cathedral

Oil on board, 61×46·5 cm. (24×18$\frac{5}{16}$ in.)
The North transept from the cloister green; perhaps after restoration.

PROV: John Elliot, by 1878 and bequeathed 1917.

EXH: (?) Liverpool Academy, 1862 (16) as *A Nook in the Cloisters*[1]; (?) Wrexham, 1878 (541); Walker Art Gallery, 1908, *Historical Exhibition of Liverpool Art* (252).

REF: **1** A partially torn MS label on the back gives an incomplete title *Chester Cath[edral] from the [– – – –]/ N[o. –] by W [Huggins]/ The Grove/Chester.*

1739 Chester Cathedral

Oil on canvas, 87×115 cm. (34$\frac{1}{4}$×45$\frac{1}{4}$ in.)
SIGNED AND DATED: *1862/W. Huggins*
The East end and South transept with the graveyard from the City Walls, before the restoration undertaken by George Gilbert Scott in the late 1860's.[1]

PROV: John Elliot, who bequeathed it, 1917.

EXH: (?) Liverpool Academy, 1862 (45) *Chester Cathedral from the City Walls;* (?) Wrexham, 1878 (540); Walker Art Gallery, 1908, *Historical Exhibition of Liverpool Art* (262).

REF: **1** Compare the photograph from similar angle in Pevsner and Hubbard, *Chester* (Buildings of England) 1971, fig. 12.

449 Siesta – Sleeping Lions

Oil on board, 31×45·7 cm. (12$\frac{1}{4}$×18 in.)
SIGNED AND DATED: *W. Huggins/1863*
A drawing of the lion is in a private collection.[1]

PROV: John Elliot, who bequeathed it, 1917.

EXH: Walker Art Gallery, 1908, *Historical Exhibition of Liverpool Art* (234).

REF: **1** Photograph Gallery files.

1517 Old Mill and Salmon Trap on the Dee, Chester

Oil on board, 36·7×46·3 cm. (14$\frac{1}{2}$×18$\frac{1}{4}$ in.)
SIGNED: *W. Huggins*
The mills and the salmon fishing of Chester were of great historical importance.[1]

PROV: John Elliot, who bequeathed it, 1917.

EXH: (?) British Institution 1863 (459) and Manchester Royal Institution, 1865 (180) £15.15.0; (?) Wrexham, 1878 (542); Walker Art Gallery, 1908, *Historical Exhibition of Liverpool Art* (1086).

REF: **1** See Canon R. Morris, *Chester in the Plantagenet and Tudor Reigns*, 1893, pp. 101 ff; Thomas Hughes, *A Stranger's Guide to Chester*, 1856, pp. 37–39.

446 A Disagreement

Oil on canvas, 63·8×77·1 cm. (25$\frac{1}{8}$×30$\frac{3}{8}$ in.)
SIGNED AND DATED: *1866/W. Huggins*
Lion surprised by an African python.

PROV: Bequeathed by John Elliot, 1917.

425 The Raider

Oil on board, 47×54·5 cm. (18$\frac{1}{2}$×21$\frac{1}{2}$ in.)
SIGNED AND DATED: *1866/W. Huggins*
A cat disturbing a hen with her chicks. The same or a similar tabby cat was painted by the artist in 1867.[1]

PROV: Presented by Col. W. Hall Walker (Lord Wavertree), 1913.

REF: **1** Lowndes Lodge Gallery, 1966, *William Huggins* (21) repr.

447　Near Helsby
Oil on canvas, 51·5×76·5 cm. (20$\frac{5}{16}$×30$\frac{1}{8}$ in.)
SIGNED AND DATED: *W. Huggins/1867*
PROV: John Elliot, who bequeathed it, 1917.
EXH: (?) Walker Art Gallery, *Historical Exhibition of Liverpool Art* (233); Harrogate, 1924, *Liverpool School of Painters* (31).

1738　Cattle in a Landscape
Oil on board, 70·5×92 cm. (27$\frac{3}{4}$×36$\frac{1}{4}$ in.)
SIGNED AND DATED: *1867/W. Huggins*
PROV: Bequeathed by John Elliot, 1917.

448　A Mixed Family
Oil on board, mounted on cardboard, 31×48 cm. (12$\frac{1}{4}$×18$\frac{5}{16}$ in.)
SIGNED AND DATED: *W. Huggins/1867*
A donkey, cow and sheep resting together.
PROV: Presented by Col. W. Hall Walker (Lord Wavertree), 1913.

1714　Cheshire Meadows
Oil on board, 46·7×62 cm. (18$\frac{3}{8}$×24$\frac{3}{8}$ in.)
SIGNED AND DATED: *1868/W. Huggins*
Helsby appears in the background. The view is similar to that in 447.
PROV: Presented by Col. W. Hall Walker (Lord Wavertree), 1913.

43　The Drinking Pool
Oil on board, 46·8×33·9 cm. (18$\frac{7}{16}$×13$\frac{3}{8}$ in.)
SIGNED AND DATED: *W. Huggins/1868*
PROV: John Elliot before 1908, and bequeathed by him, 1917.
EXH: Walker Art Gallery, 1908, *Historical Exhibition of Liverpool Art* (236) as *Cattle in a Stream*.

339　By the Stream
Oil on board, 46·7×62·2 cm. (18$\frac{3}{8}$×24$\frac{1}{2}$ in.)
SIGNED AND DATED: *1868/W. Huggins*
PROV: Presented by Col. W. Hall Walker (Lord Wavertree), 1913.

1510　Near Moreton
Oil on board, 47×62·2 cm. (18$\frac{1}{2}$×24$\frac{1}{2}$ in.)
SIGNED AND DATED: *W. Huggins/1868*
PROV: John Elliot before 1908, and bequeathed by him, 1917.
EXH: Walker Art Gallery, 1908, *Historical Exhibition of Liverpool Art* (1098).

1712　Bebington Church
Oil on board, 47×63 cm. (18$\frac{1}{2}$×24$\frac{3}{4}$ in.)
SIGNED AND DATED: *1869/W. Huggins*
St. Andrew's Church, Bebington, a mediaeval church restored in 1846 and subsequently during the 19th century. Nathaniel Hawthorne, writing in 1853, commented that he had 'seen nothing in England that so completely answered my idea of what such a thing was as this old village-church of Bebington.'[1]
PROV: John Elliot before 1908, and bequeathed by him, 1917.
EXH: Walker Art Gallery, 1908, *Historical Exhibition of Liverpool Art* (248).
REF: 1 Nathaniel Hawthorne, *The English Notebooks*, 1941, p. 19; see also Raymond Richards, *Old Cheshire Churches*, 1947, pp. 47 ff.

652　Interior of Bebington Church
Oil on board, 47×62·1 cm. (18$\frac{1}{2}$×24$\frac{1}{2}$ in.)
SIGNED AND DATED: *W. Huggins 1869*
PROV: John Elliot in 1878, and bequeathed by him, 1917.
EXH: Wrexham, 1878 (539); Walker Art Gallery, 1908, *Historical Exhibition of Liverpool Art* (228).

1754　A Lion's Head
Oil on board, 24·5 cm. diam. (9$\frac{5}{8}$ in. diam.)
DATED: *1872*
PROV: John Elliot, who bequeathed it, 1917.
EXH: Walker Art Gallery, 1908, *Historical Exhibition of Liverpool Art* (216).

HUGGINS, William 1820-1884 and BOND, W.J.J.C. 1833-1926

1621　Donkey and Foal
Oil on canvas, 82×63·7 cm. (32$\frac{1}{4}$×25$\frac{1}{8}$ in.)
SIGNED AND DATED: *1867/W. Huggins/and W J J C Bond 1884*
The landscape, which is in a thicker technique than Huggins' normal practice, was presumably added by Bond after Huggins' death.
PROV: Samuel Huggins, sold Branch and Leete, Liverpool, 1891, bought by the Gallery.
EXH: Whitechapel, 1907; Walker Art Gallery, 1908, *Historical Exhibition of Liverpool Art* (502).

HUGHES, Margaret, living artist

2365 Old Man
Oil on canvas, 61 × 40·6 cm. (24 × 16 in.)
PROV: Purchased from the artist, 1955.
EXH: Walker Art Gallery, 1955, *Liverpool Academy* (254).

6181 Garden, January, 1963
Oil on board, 63·5 × 76·2 cm. (25 × 30 in.)
PROV: Purchased from the artist, 1963.
EXH: Walker Art Gallery, 1963, *Liverpool Academy* (80).

HULME, Frederick William 1816 - 1884

1472 Rivington Valley
Oil on canvas, 44·4 × 67·2 cm. (17½ × 26½ in.)
View looking south down the Rivington reservoirs from the high ground on the east side, north of the crossing to Heath Charnock; the crossing at Rivington embankment is visible in the centre distance and the moors rise in the left background.

The subject was published as a chromolithograph the same size as 1472, by J. Isaac, Liverpool, in 1857, drawn by Vincent Brooks after Hulme.[1] A larger oil version (41 × 60 in.), commissioned in 1872, is in Bolton Art Gallery.[2]

The Rivington Waterworks scheme to obtain water for Liverpool dated initially from 1847.
PROV: Purchased through Edward Samuelson, Mayor, 1873.[3]
REF: 1 17 × 25¾ in.; prints in Liverpool Record Office destroyed 1939–45 War. 2 Photograph and letter from H. R. Rigg, Bolton, 26.11.1970. 3 Library, Museum and Art Gallery Committee, 10 April 1873; it was ordered to be sent for cleaning to Grindley's (Liverpool printseller, etc.).

HUNT, Alfred William 1830 - 1896

Landscape painter. Born Liverpool 15 November 1830, only surviving son of Andrew Hunt (*q.v.*). Educated at Liverpool Collegiate School and Corpus Christi, Oxford, where won the Newdigate prize and elected a Fellow, 1853, but finally decided to become an artist. Studied at Liverpool Academy Life Class and first exhibited at Liverpool Academy, 1847; Associate, 1854; Member, 1856; a non-resident Member, 1865. Exhibited at the Royal Academy from 1854. His early work followed the pattern of his father and the latter's friend, David Cox. In the late 1850's he came under Pre-Raphaelite influence and joined the Hogarth Club as a non-resident member, 1858. Married 1861 and moved to wife's home at Durham and about 1865 to London. He turned chiefly to watercolour in the early 1860's due to unsympathetic reception by the R.A. and achieved considerable success with a highly finished and detailed style in which atmospheric effects predominate. He made summer sketching holidays and worked up finished paintings in his studio in the winter. Associate of the Old Watercolour Society, 1862; Member, 1864. Also exhibited at Suffolk Street, the Grosvenor Gallery, the Liverpool Autumn Exhibition, and elsewhere. Died London 3 September 1896.

718 Stybarrow Crag, Ullswater

Oil on canvas, 38×60·3 cm. (15×23¾ in.)

SIGNED AND DATED: *Alfred W. Hunt 1847* and inscribed with title.

PROV: Presented by Col. W. Hall Walker (Lord Wavertree), 1917.

EXH: Liverpool Academy, 1847 (716); Walker Art Gallery, 1960, *Liverpool Academy 150th Anniversary Exhibition* (54).

944 Brignall Banks

Oil on canvas, 28·6×46 cm. (11¼×18⅛ in.)

Two views on the River Greta which Brignall overlooks were exhibited at the Royal Academy in 1859.[1] These were probably watercolours.[2] A further picture was exhibited the following year at Suffolk Street but from the review[3] appears again to have been a different picture. It would be interesting to know whether this highly finished and very atmospheric summer landscape was painted on the spot in the Pre-Raphaelite manner, or as a studio composition from studies.

PROV: Purchased from Miss Violet Hunt, daughter of the artist, 1910.

REF: **1** See Allen Staley, *The Pre-Raphaelite Landscape*, 1973, p. 145 (repr. pl. 79a). **2** Water-colours of the same title were in the Hunt Exhibition, Burlington Fine Arts Club, 1897 (18) *On the Greta*, 7¼×10 in. lent C. W. Mitchell of Newcastle, and (75) *Junction of the Tees and Greta*, 12⅜×18¾ in., 1858, lent Rev. Canon Greenwell of Durham; and subsequently at the Liverpool Memorial Exhibition. **3** *The Saturday Review*, 28 April 1860, p. 531.

HUNT, Andrew 1790 - 1861

Landscape painter. BORN Erdington, near Birmingham; a pupil of the successful Birmingham drawing master and landscape artist, Samuel Lines (1778–1863). Moved to Liverpool and is listed as a print-seller, framemaker and artists' repository from 1818 to 1843 in Bold Street. He opened a successful drawing academy, listed from 1834 in Bold Street and 1848 in Oldham Street. Exhibited at the Liverpool Academy from 1822; Associate, 1842; Member, 1850. Must have made numerous sketching trips to Wales, Ireland and the Lake District. Most of his exhibited pictures would appear to have been in oil rather than watercolour; a large group of the latter are also in the Collection. His son was Alfred William Hunt (*q.v.*) and his daughters also exhibited at the Liverpool Academy. Died Liverpool 22 July 1861.

4315 Sefton Church

Oil on paper, 22·2×29·5 cm. (8¾×11⅝ in.)

Seen across the mill-stream and with the Mill in full view to the right. Perhaps worked up from the larger watercolour 1442 in the Collection, of the same view, which has less foliage on the trees and thus shows also the building to the left of the church.

PROV: Presented by Miss Violet Hunt, grand-daughter of the artist, 1910.

5665 A Sketch of a Cornfield with Figures

Oil on composition board,[1] 25·4×36 cm. (10×14⅛ in.)

PROV: Uncertain: possibly presented by Mrs. Benson and Mrs. Fogg Elliot, grand-daughters of the artist, 1919.

REF: **1** Label of Charles Roberson, 99 Long Acre.

2937 The Estuary of the Mersey
Oil on canvas, 105·7×174·6 cm. (41⅝×68¾ in.)
Showing a windmill and fishermen and shrimpers on the shore of the Mersey, with Wallasey shore in view opposite. What appears to be one of the Bootle landmarks (erected 1829) is visible at the far left.

Presented as by Andrew Hunt; its stilted quality suggests it may be an early attempt in oil, or by another hand.
PROV: Presented by Thomas Harding, 1878.
EXH: Walker Art Gallery, 1908, *Historical Exhibition of Liverpool Art* (519).

866 A Sketch of Wallasey Pool from Seacombe Shore
Oil on composition board, 34·2×47·7 cm. (13 7/16 × 18¾ in.) (painted surface: 28×47·7 cm.: 11×18¾ in.)
Indecipherable inscription top left.
PROV: Presented by Miss Violet Hunt, grand-daughter of the artist, 1910.

HUNT, William Holman 1827 - 1910

1636 Harold Rathbone
Oil on panel, 23·1×17·8 cm. (9⅛×7 in.)
SIGNED AND DATED in monogram, on a shield: 9 *W h h 3*
Harold Steward Rathbone (1858–1929), Liverpool artist, poet and pottery designer *(q.v.)*. His connection with William Holman Hunt probably came about through his organisation of the public subscription for the purchase of Hunt's *Triumph of the Innocents* for the Gallery in 1891.
PROV: The artist until after 1911. Alderman John Lea, who bequeathed it, 1927.

REPR: *Country Life Annual,* 1968, p. 70; *Cheshire Life,* May 1973, p. 55.
EXH: Walker Art Gallery, 1894, *Liverpool Autumn Exhibition* (1190): Manchester, 1906, *William Holman Hunt* (38); Walker Art Gallery, 1907, *William Holman Hunt* (40); Glasgow, 1907, *William Holman Hunt* (23); Manchester, 1911, *Ford Madox Brown and the Pre-Raphaelite Brotherhood* (218); Cummer Art Gallery, Jacksonville, Florida 1965, *Artists of Victoria's England* (31); Walker Art Gallery and Victoria and Albert Museum, 1969, *William Holman Hunt* (61) repr.

HUSON, Thomas 1844 - 1920

Landscape painter and etcher. Born Liverpool 18 January 1844. Worked from seventeen as an analytical chemist. Self-taught as an artist. Exhibited at the Royal Academy 1871–89, at the Autumn Exhibitions from 1871. R.I., R.E., R.C.A. Retired to Pen-y-Carth, Bala, North Wales about 1906, where he died 2 February 1920.

2838 A Sunny October Morning
Oil on canvas, 100×153·7 cm. (39⅜×60½ in.)
PROV: Presented by Arthur Geddes, 1911.
EXH: *Liverpool Autumn Exhibition,* 1875 (144) price £100.

2986 Burning of Liverpool Landing Stage, 1874
Presented by Rev. John Miles Moss, 1885; Destroyed 1939–45 War.

914 When Seas are Fair and Winds are still

Oil on canvas, 99·6 × 153·7 cm. (39¼ × 60½ in.)
SIGNED: *Thos Huson R.I.*
PROV: Presented by James Barrow, 1889.
EXH: Royal Academy, 1889 (1179); Walker Art Gallery, 1889, *Liverpool Autumn Exhibition* (1176), price £157.10.0.
REPR: *Pall Mall Gazette Extra,* No. 48, 6 May 1889, p. 57 (a sketch).

2975 A Midsummer Day

Oil on canvas, 99 × 153 cm. (39 × 60¼ in.)
SIGNED: *Thos Huson R.I.*
PROV: Purchased from the artist at Liverpool Autumn Exhibition, 1902.
REPR: *The Studio,* XXVIII, 1903, p. 207.
EXH: Walker Art Gallery, 1902, *Liverpool Autumn Exhibition* (135).

HUYSMANS, Jacob 1633 - 1696

8640 Lady Mary Molyneux

Oil on canvas, 128·3 × 103·1 cm. (50½ × 40 9⁄16 in.)
In the character of a shepherdess.[1] The sitter is presumably Mary, daughter of the 3rd Viscount and sister of Richard and William: she married Sir Thomas Preston of Furness (see also British School 8630).[2]
PROV: Purchased from the Executors of the Estate of the 7th Earl of Sefton, 1974.
REF: 1 Croxteth Inventory, 1946, No. 2, as School of Kneller; No. 111 was a portrait of a young man as a Shepherd in a landscape (School of Kneller), 50 × 40 in., which might well have been a companion. The present ascription confirmed by Sir Oliver Millar, letter of 3 February 1976. 2 Her sister-in-law wife of Richard, also called Mary, and daughter of the 1st Marquess of Powys, who later married Viscount Montagu, appears in a portrait attributed to Largillière at Coughton Court and cannot be the same sitter.

IBBETSON, Julius Caesar 1759 - 1817

Landscape and genre painter. Born Farnley Moor, Yorkshire. Having met difficult times in his career in London he was in Liverpool around 1798/99 working under contract for Thomas Vernon, a dealer set up in Liverpool 1794–1802, who became insolvent about 1801, causing the artist considerable financial loss. At Liverpool he knew William Roscoe, with whom he afterwards corresponded; a paper read before the *Society for Promoting the Arts in Liverpool,* published by Mayer in *Early Exhibitions of Art in Liverpool,* must be his. He afterwards moved to Scotland, the Lake District, and finally to Masham in Yorkshire where he died.

1819 Lower Rydal Waterfall

Oil on canvas, 91·5 × 66·7 cm. (36 × 26¼ in.)
INSCRIBED on back of original canvas (which is now protected by glass): 'Correct View of the Lower/RYDAL waterfall/in Sr Michael le Flemings Garden/Drawn from Nature October and finished/in December 1798 by JULIUS IBBETSON/for Mr. T. Vernon of Liverpool/who pays more liberally than [drawing of a Ducal crown] or [a Marquis' coronet] or [an Earl's coronet] or [a Baron's coronet] or [a Bishop's mitre].'

1798 was the year of Ibbetson's contract with Thomas Vernon of Liverpool, initially for six months, and his first visit to the Lake District.[1]

The picturesqueness of the view had already been noted by 18th century devotees: William Gilpin described it in his Tour of 1772,[2] shortly before Sir Michael le Fleming (1748–1806) acquired the property: 'It is seen from a summer-house; before which its rocky cheeks circling on each side form a little area; appearing through the window like a picture in a frame. The water falls within a few yards of the eye, which being rather above its level, has a long perspective view of the stream, as it hurries from the higher grounds; tumbling, in various, little breaks, through its rocky channel, darkened with thicket, till it arrives at the edge of the precipice, before the window; from whence it rushes into the basin, which is formed by nature in the native rock.[2]' The summer-house from which Ibbetson probably drew the fall, is described in a 19th century tour: 'a little thatched summer-house, standing on the banks of the Rothay, and which, from the date upon one of the window-shutters, would seem to have been erected in the year 1617.'[3]

The last owners, the Darbishires, appear to have been more closely associated with Manchester and Cheshire than with Liverpool: a painting by Ibbetson of the *Waterfall (Rydal)* was in an anonymous Winstanley sale at Manchester in 1828.[4]

PROV: Family of James Mather Darbishire,[5] in Liverpool; purchased from his grandson's wife, 1958.

EXH: Royal Academy, 1799 (257).

REF: 1 Rotha Mary Clay, *Julius Caesar Ibbetson*, 1948, p. 61. 2 William Gilpin, *Observations relative chiefly to Picturesque Beauty, made in the year 1772, on several parts of England.* Vol. II. 3 Gage D'Amitié, *The Northern Tourist*, 1834; illustrated with an engraving after a view of the Lower Rydal Fall by G. Pickering; see also Harriet Martineau, *Guide to Windermere and the other English Lakes*, 1855, p. 55. 4 Winstanley, Manchester, 29.2.1828 (114). 5 Listed in Liverpool street directories from 1890's; died *c.* 1916.

2529 Hugh Mulligan

Oil on panel, feigned oval, 20·6×15·7 cm. (8⅛×6³⁄₁₆ in.)
A long inscription and 'Message to Posterity'

in Ibbetson's hand on a sheet pasted to the back (quoted below).

Hugh Mulligan (1746/7–1802) was known to William Roscoe, when a boy, as an engraver on copper plates and painter at William Reid's China Manufactory (1756–61) on Brownlow Hill near his home. He was a member of the same congregation in Benn's Gardens and their acquaintance appears to have continued through life.[1] In 1777 and 1781 Mulligan is listed in the street directories as an engraver (Charles Street); in 1790 as engraver and potter, and in 1796 and 1800 as engraver and bookseller, Whitechapel. He died, at Toxteth Park, Liverpool 9 December 1802, at 55 years.[2] At least one engraving by him *The Sailor's Return* is known.[3]

He was the author of a volume of *Poems, chiefly on Slavery and Oppression, with notes and illustrations* (London), 1788. He seems to have been a man of benevolent and philanthropic character. His death was lamented in a poem by Edward Rushton, the blind Liverpool poet:

'A Bard from the Mersey has gone
 Whose carols with energy flow'd;
Whose harp had a wildness of tone,
 And a sweetness but rarely bestow'd.
Then say – ye dispensers of fame,
 Of wreathes that for ages will bloom,
Ah! say, shall poor Mulligan's name,
 Go silently down to the tomb?' etc.[4]

He was associated with Ibbetson in work for the Liverpool dealer Thomas Vernon (the 'overbearing cruel tyrant' noted below), whose doubtful financial activities caused Ibbetson at least much anxiety and financial loss. The sketch on which 2529 is based would appear to date from about 1800 when Ibbetson, after revisiting Kingston-upon-Hull, sailed for Leith on his way to meet Vernon at Edinburgh.[5] The painting was in existence by 1803 when Ibbetson wrote, on 17 September, to William Roscoe in connection with the publication of his *Painting in Oil,* and offered this portrait:

'I must beg your acceptance or rather Mrs. Roscoe's of a sketch which I made at sea of a little kindhearted worthy man, now no more, whose sincere and excessive attachment to You and your family if You did but know it as I do, would entitle His portrait which is but small, to a place in Your best apartments, we were fellow sufferers in Vernon's Scotch campaign. I made a sketch of it & nothing could be more like. I was dancing Bear, Mully

& my son, Monkeys, V. Show man, beating a double drum & blowing a cracked trumpet – Mrs. V. taking the money – I shall never forget our misery, the poor little man's heart was almost broke – I painted Him from a small black lead sketch & it is like, but the disguise of a fur cap, a nightcap & silk handkerchief, will prevent His being so easily recognised. I did it for myself but without that, Hugh Mulligan will always be present to my mind – I had many times mentioned His great love and attachment to You, to Mrs. Ibb. & also the very friendly attentions I & my son had received from you, when she suggested that it might be an acceptable little present to Mrs. Roscoe, which if it happens so, will give great pleasure. It was only thursday last we thought of it – a Gentleman on a visit to us was mentioning Your Son whom he knows at Cambridge & speaking highly of His talents, brought it forward.'[6]

Ibbetson has represented the sitter in a feigned oval with the corners painted in grisaille with symbols representative of the Arts: a torch and scroll, a palette and maulsticks, a lyre with serpent, sun, mirror and mask, a cherub with two doves. A drawing for this border (ink and wash, $7\frac{5}{8} \times 5\frac{3}{4}$ in.,) belonged, 1954, to Mrs. E. L. Godfrey of Dorset.[7] It is partly duplicated, with variations, in a portrait of an unidentified child.[8] In technique use is made of a limited palette and transparent medium over a watercolour underpainting, bearing out the artist's treatise on *Painting in oil*, published 1803.[9]

The inscription on the back gives the picture's history; the 'Message to Posterity' is reminiscent of the inscription noted as occurring on a self-portrait of 1804:[10]

'Hugo Mulliganus N.O.B.A.
This sketch of Hugh Mulligan of Liverpool, the only one in being at the time, was taken unknown to Him by his Friend Julius Ibbetson on a coasting voyage between Hull and Leith while they were following the fortunes of an overbearing, cruel Tyrant – whose treatment of Him was by no means calculated to lengthen His Days –. Poor Hugh! "tread lightly on his ashes ye men of goodness for He was your friend" – poor little Mully! the kindest hearted of all mor[tal]s – the most Philanthropic, benevolent & sensible creature that ever groped his way through the world in chill penury's blind alleys, or the garrets & iron terrains of gaunt poverty – Like a sensitive plant among thistles, or St. Fond berit by bagpipers, did'st thou pass through this purgatory without any real solace but an excellent heart. Thy Sarah Granger, possessing every imaginary perfection of that dulcinea adored by the [?]onetime

Fable Knight of La Mancha, and thy beloved pipe of tobacco. These were thy domestic enjoyments – and abroad the kind notice of William Roscoe and his amiable Family consoled thy kind soul for every hardship, for every insult to which thou wert for ever liable from those beasts in breeches who too often, god knows, came athwart thy hawse – sometimes indeed.

"in oblivious grateful cup thou'dst drown the galling sneer, the supercilious frown, the strange reserve, the proud affected state of upstart knaves grown rich and fools grown great" but where is the wonder, it is only that it happened so very seldom that the painter of Hugo never witnessed it but once and then through the mistaken hospitality of a very worthy scotsman – & then! Curtis Hampden or Sidney were errant cowards to thee! "Kings may be blest but thou wert glorious oer all the ills of Life victorious" My much lamented Hughey! thy memory is dear to me but, Thou art gone for ever – Thy place is vacant – Thy pipe is out – may that immaterial spark concerning the fate of which all Mortals are so anxious to know so little May thy soul when it arrives in the Land of Spirits, meet with souls congenial – Vale – Farewell – I follow.

To Posterity. greeting.
This bequest of the portrait of poor Hugh my dear fellows is without any view whatever except purely to gratify your curiosity in wishing to know whether you ever had any ancestors – I do declare that to the best of my knowledge I never was a gainer by it in any one instance neither do I ever expect the smallest favour or indulgence, except in taking care of this likeness – but you must be strange creatures indeed if you do not feel most grateful for the innumerable blessings we have handed down to you from this present AD. 1803 – and which you will have enjoyed at least 200 years before I intend any of you to see a word of this – You cannot properly have improved in anything, everything is at the acme of perfection – You will never be able to contrive more ingenious taxes which are everything that is dear to us. You will never more be able to borrow such sums as exceed in value ten times the whole of the gold and silver on the face of the earth – Your Priests cannot possibly be better shots or take greater care of their own interests and your tithes. – I defy you to have better forms of prayer by law established or which answers my purpose better – among all your lawyers I defy you to produce me one more impudent and [?]noisy than Sergeant [?]Soakil, or among your Priests one more unfeeling, greed and grim than fe! fo! fum! Llandaff – better Balm of Gilea you need never expect – happy posterity! You will have no trouble or disputes about the division of the soil, every inch of that was divided in the fairest and most equal manner long before I was born. – You will not behold those [?]disgraceful scenes of which our ancestors were witness once in seven years, when they imagined they had some share in choosing their legislators. You will have the happiness of being governed by humane, tender hearted & learned Soldiers whose gau[dy] trappings will make you forget those solemn courts which dispensed Law so cheap and sometimes justice interesting and valuable as poppies in a cornfield or as the harmless bugs in a bedstead. You will have nothing to do but admire their reviews and manoevres – oh how I envy you,

& were it not for particular reasons I would most certainly come and live among you – poor Hugh Mulligan! how will you laugh at this ridiculous notion. He imagined that nations might be happy without going to war and that Reason and Philosophy might perhaps succeed the tyranny of Priests and some others – but you are happily better informed than poor Hugh.'

A copy, same size, with a copy of the entire inscription pasted on the back which is inscribed in a different ink 'copied by [?] S. McCreery', belonged 1972 to Mr. Paul Rich, Farnham. This was perhaps Phoebe McCreery, daughter of Roscoe's printer and friend.

PROV: Given by the artist to William Roscoe, 1803; Mrs. W. S. Roscoe in 1845; bequeathed by Mrs. Agnes Muriel Roscoe, widow of William Mallin Roscoe, great-grandson of William Roscoe, 1950.

EXH: Presumably Liverpool Mechanics Institute, 3rd Exhibition, 1845, Catalogue p.17, case 4 (artist not stated); Walker Art Gallery, 1955, *Cleaned Pictures* (39); Iveagh Bequest, Kenwood, 1957, *Julius Caesar Ibbetson* (29) repr.

REF: **1** Henry Roscoe, *Life of William Roscoe*, 1833, I p. 10; Knowles Boney, *Liverpool Porcelain*, 1957, pp. 57, 127; Benn's Gardens Registers, 1773 ff. (microfilm, Liverpool Record Office). **2** *Gore's Advertiser*, 23.12.1802, p. 3, described as an author. **3** Inserted in *The Mayer Papers*, II, *Art in Liverpool*, p. 59: ? after Ibbetson. **4** Edward Rushton, *On the death of Hugh Mulligan*, in *Poems and other Works*, 1824, pp. 30–32. **5** Rotha Mary Clay, *Julius Caesar Ibbetson*, 1948, pp. 64–65. **6** Roscoe Papers 2197 (Liverpool Record Office); quoted in full in Ralph Fastnedge, *A Rediscovered Portrait by J. C. Ibbetson*, in *Liverpool Bulletin*, Vol. 4, Nos. 1 & 2, October 1954. **7** Photograph in Gallery files. **8** Clay, *op. cit.*, pl. 108. **9** See Fastnedge, *op. cit.*, p. 52. **10** Clay, *op. cit.*, pp. xix, 122, pl. 103.

ILLIDGE, Thomas Henry 1799 - 1851

Portrait painter. Born Birmingham 26 September 1799. Trained under Mather Brown and William Bradley of Manchester. Was living in Manchester 1827–31; was in Yorkshire 1833, Blackburn and London 1836 and 1837, Liverpool 1838–41, and finally London from 1842. Exhibited at Manchester Royal Institution 1827–37, Liverpool Academy 1827–50, and the Royal Academy, 1842–51. Died London 13 May 1851.

7030 Sir Joshua Walmsley, Mayor of Liverpool

SIGNED: *T. H. Illidge/pinxit*

Oil on canvas,[1] 258·9 × 168·5 cm. (102 × 66½ in.) Sir Joshua Walmsley (1794–1871), Mayor of Liverpool 1839–1840, in robes of office and with the mace on a table at the right. A corn merchant in Liverpool he was President of the Mechanics Institute, 1826, and from 1835 he was active in Municipal affairs on the liberal side; knighted 1840 on the occasion of the Queen's marriage. He was the friend and supporter of George Stephenson in his railway and mining enterprises, and patronised William Daniels, the artist.

He was unsuccessful in his parliamentary candidature at Liverpool, 1841 and in 1843 moved to Ranton Abbey, Staffordshire. Entered Parliament as M.P. for Bolton, 1849–52 and Leicester 1852–57. He supported the repeal of the corn laws and was President of the National Reform Association; actively supported Cobden, Bright, and Hume. As President of the National Sunday League, 1856–1869, he advocated the Sunday opening of Museums. Retired to Wolverton Hall, Hants, 1857.[2]

PROV: Presented to Lady Walmsley by subscription, 1840.[3] It was in the Town Hall before 1869 when temporarily deposited in the Museum.[4] Transferred from the City Estates Committee to the Gallery, 1968. Hung in the Town Hall.

EXH: Liverpool Mechanics Institute, 1840,

First Exhibition of Objects Illustrative of the Fine Arts etc. (Picture Gallery, 1); Liverpool Academy, 1840 (178).

REF: **1** Relined. **2** H. M. Walmsley, *Life of Sir Joshua Walmsley*, 1879, *passim*. **3** *Ibid*, p. 121, and Mechanics Institute Catalogue, *loc. cit.* **4** Annual Report for 1869.

3012 Rev. William Shepherd

Oil on canvas,[1] 185·5 × 139·7 cm. (73 × 55 in.)
INSCRIBED, verso: *Revd. William Shepherd LLD/Author of the Life of Poggio Bracciolini/ by T H Illidge 33 Bruton Street/London* and a large *3* twice.

The Rev. William Shepherd, LL.D. (1768–1847), eminent Unitarian minister in Liverpool and political and educational reformer. Born 11 October, 1768, the son of a master shoe-maker and freeman of the borough, and his wife Elizabeth, daughter of the Rev. Benjamin Mather. After his father's early death his education was supervised by his uncle the Rev. Tatlock Mather, non-conformist minister; after his death, 1795 Shepherd went to Daventry Academy 1785–88 and New College, Hackney, 1788–90. In 1790 he became tutor in the family of the Rev. John Yates of Toxteth Park and Paradise Street Chapel, and there first met William Roscoe, who with Dr. Currie and Dr. Percival was to influence his later life. In 1791 he was appointed minister at Gateacre Chapel, near Liverpool, where he was to remain. He married Frances Nicholson and conducted a flourishing boys' school at his house, The Nook, Gateacre.

He was early interested in radical reform and actively supported civil and religious liberty, and was one of the 'Liverpool Jacobins' with Roscoe and others in the early 1790s. He took up his Freedom of Liverpool in 1796 and took a leading part in municipal affairs in the liberal interest to which his ability as an after dinner speaker and raconteur contributed. He had an extensive circle of friends in public affairs covering a broad field of interest; chief amongst his political friendships was that with the first Lord Brougham. He produced many political pamphlets and public letters, while his main literary work was the *Life of Poggio Bracciolini*, 1802. Honorary L.L.D. Edinburgh, 1834.[2]

He is shown seated in his library looking at a bust of William Roscoe, his lifelong friend.[3] His library was sold in Liverpool, December 1848;[4] many of his papers are now at Manchester College, Oxford.

The following portraits are recorded: by John Bishop, Liverpool Academy, 1843 (243) by Cornelius Henderson (9140 in the Collection from the Liverpool Royal Institution);[5] by Moses Haughton;[6] a miniature by Thomas Hargreaves, 1816, is at Manchester College Oxford;[7] a portrait was published by J. Dickson 1841.

Isaac Jackson exhibited a bust at the Liverpool Academy, 1834 (438); a bust by him dated (?) 1850 was in St. George's Hall (now in the Gallery, 7805) and a further bust by him is incorporated in the monument to Shepherd in Gateacre Chapel (1851). The inscription on this, by Lord Brougham, reads:

SACRED TO THE MEMORY OF WILLIAM SHEPHERD, L.L.D./FOR FIFTY SIX YEARS MINISTER OF THIS CHAPEL/A MAN OF UNDEVIATING INTEGRITY IN ALL THE RELATIONS OF LIFE/AN ACCOMPLISHED SCHOLAR AND CLASSICAL WRITER CONVERSANT WITH ANCIENT AND MODERN LANGUAGES/WELL VERSED IN THE LITERATURE OF BOTH/EMINENT FOR HIS WIT WHICH WAS ORIGINAL AND RACY/OF MEMORABLE SAGACITY IN JUDGING OF MEN AND THINGS/A STAUNCH SUPPORTER OF CONSTITUTIONAL FREEDOM/THE UNDAUNTED ENEMY OF OPPRESSION AND ABUSE/A FORMIDABLE ADVERSARY WHEN HIS PRINCIPLES WERE ASSAILED/A WARM AND STEADFAST FRIEND AT ALL TIMES TOWARDS DESERVING OBJECTS GENEROUS BEYOND HIS MEANS/DEVOTING HIS LIFE TO THE USEFUL AND HONOURABLE OFFICE OF TEACHING/AND THE SACRED DUTIES OF HIS PASTORAL CALLING/REVERED BY HIS FLOCK/BELOVED BY HIS FRIENDS/RESPECTED BY ALL/BORN OCTOBER 11th 1768 DIED JULY 21st 1847.

PROV: Presented by Sir Joshua Walmsley 1862.[8]

EXH: Liverpool Academy, 1843 (8).

REF: **1** Canvas stamp (2) of Winsor and Newton, type B (Alec Cobbe, *Artist Colourmens' Canvas Stamps. . . in Studies in Conservation*, Vol. 21, No. 2, May 1976, p. 88, fig. 6) The condition is poor due to faulty technique recorded as poor by W. J. J. C. Bond in his report to the Committee, 2 July 1874. **2** *Selection from the early Letters of the late William Shepherd, L.L.D.*, 1855, Introduction, pp. 5 ff. F. Nicholson and E. Axon, *The Manuscripts of William Shepherd at Manchester College, Oxford*

in *Transactions of the Unitarian Historical Society,* Vol. II, No. 4, 1921, pp. 119 ff.; E. Axon, edit., *Memorials of the Family of Nicholson, Liverpool,* 1928; Ian Sellers, *William Roscoe, the Roscoe Circle and Radical Politics in Liverpool, 1787–1807,* in *Transactions of the Historic Society of Lancashire and Cheshire,* Vol. 120, 1968, p. 48; Albert Nicholson in D.N.B.; information from Caroline Kerkham. 3 Probably by William Spence: a smaller scale plaster bust of the same type is in Liverpool University Department of Education, from the L.R.I. 4 Winstanley, 18–23.12.1848; advertised in *Liverpool Mercury,* 15.12.1848. 5 A portrait by Henderson was lent by Lord Brougham to the Liverpool Mechanics Institute Exhibition, 1842 (367). 6 D.N.B. 7 Letter from H. L. Short, Principal, Manchester College, Oxford, 14 February 1972. 8 Library, Museum and Art Gallery Committee Minutes, 13 November 1862.

JARDINE, George Wallace, living artist

7764 Full fathom five
Acrylic, sea shells, blue stone and feathers on hardboard, 56 × 55 cm. (22 × 21⅝ in.)
SIGNED: *G. W. Jardine* and *GWJ*
INSCRIBED: *FULL FATHOM FIVE*
REPR: John Willett, *Art in a City,* 1967, pl. 135.
PROV: Purchased from the artist, 1971.
EXH: Neptune Theatre Gallery, Liverpool, 1971, *G. W. Jardine* (1).

6368 Sea Change
Collage on hardboard, 121·9 × 121·9 cm. (48 × 48 in.)
SIGNED: *G W Jardine*
INSCRIBED: *DAY & NIGHT/MERMAN*
PROV: Purchased from the artist, 1966.

JENKINS, David Charles 1867 - 1916

Landscape painter. Born London, son of a picture dealer, and afterwards lived in Nottingham. Trained under Jackman in London; exhibited occasionally at the Royal Academy from 1885 and at the Society of British Artists, Liverpool Autumn Exhibition and elsewhere. From 1890 living in Liverpool with studio in Pool Buildings, Castle Street and joined successively the Liver Sketching Club, the Liverpool Academy and the Sandon Studios Society. Died as a result of overstrain while working in munitions during the Great War, 10 March 1916.

2939 The Sands, New Brighton
Oil on canvas, 103·2 × 128 cm. (40⅝ × 50¾ in.)
PROV: Presented by Miss C. G. Copeman for the Artist's Executors, 1922.
EXH: Walker Art Gallery, 1911, *Liverpool Autumn Exhibition* (1028); and 1922 (524).

KAUFMANN, Wilhelm born 1895

1110 William Armstrong
Canvas, 76·2×63·5 cm. (30×25 in.)
SIGNED in monogram and dated: *WK 1929*
William Armstrong (1882–1952) actor, producer
and director at the Liverpool Playhouse from
1914 to 1944; from 1945 to 1947 he was
assistant director at the Birmingham Repertory
Theatre.

A charming and witty man, a local obituary
noted that 'as a producer he brought fame and
fortune to the Playhouse and set on the road
to stardom many now famous on stage and
screen.'[1]

PROV: Presented by the sitter, 1949.

REF: 1 Obituary in the *Liverpool Echo*
6 October 1952; see also the *News Chronicle*
7 October 1952.

KEATES, John Gareth, living artist

423 Derelict Station
Oil on board, 88·5×122 cm. (34¾×48 in.)
PROV: Purchased from the artist, 1956.
EXH: Walker Art Gallery, 1956, *Liverpool
Academy* (118).

KELLY, Robert Talbot 1861 - 1935

Specialist in Eastern subjects. Born Birkenhead 18 January 1861. Educated at Birkenhead
School. Trained under father, R. G. Kelly. From 1882 resided chiefly in Spain, Morocco,
Algiers and Egypt, with home in Birkenhead and studio in Liverpool until 1902, when
removed to London. Member of Liverpool Academy; R.B.A., 1892–1908; R.I., R.B.C.,
F.R.G.S., F.Z.S. Exhibited at Liverpool Autumn Exhibition from 1882, Royal Academy
occasionally from 1888; R.B.A., etc; and on the continent and in Japan. Published books on
Egypt and Burmah, and received the Order of the Medjidish from the Kedive of Egypt. Died
London 1 January 1935.

**2512 The Flight of the Khalifa after his
defeat at the Battle of Omdurman,
1898**
Oil on canvas, 133·5×199·5 cm. (52½×78½ in.)
SIGNED AND DATED: *R. Talbot. Kelly/1899*
The Battle of Omdurman on 2 September 1898
at which Kitchener's forces routed the Khalifa,
broke the Mahdist stand in the Sudan and
avenged the death of General Gordon at
Khartoum, was the conclusion of the Anglo-
Egyptian conquest of the Sudan which gave
Britain control over the whole Nile valley.
The victory was received with jubilation in
England and several publications followed the
initial despatches.

The artist had, in 1895–96, provided the

illustrations to Slatin's famous account of his captivity with the Mahdi and the defeat of General Gordon, in *Fire and Sword in the Sudan,* and the present picture was published as a print the year of its painting. The artist's impression shows the Khalifa on a donkey fleeing with his attendants accompanied by camel riders bearing his black flag and the green flag of (?) Osman Sheikh Ed Din,[1] with the dome of the Mahdi's tomb in the centre of Omdurman visible in the background through the surrounding dusk. The Khalifa's flag was taken in the battle and Winston Churchill's more accurate description from contemporary material, published in 1899, described the flight:[2] 'at four o'clock the Khalifa, hearing that the Sirdar [Kitchener] was already entering the city. . . mounted a small donkey, and accompanied by his principal wife, a Greek nun as a hostage, and a few attendants, rode leisurely off towards the south. Eight miles from Omdurman a score of swift camels awaited him. . . the surviving Emirs hurried to his side. . . And so all hurried on through the gathering darkness, a confused and miserable multitude – dejected warriors still preserving their trashy rifles, and wounded men hobbling pitiably along; camels and donkeys laden with household goods; all in thousands. . .'

Paintings of the battle included two by Caton Woodville, *Charge of the 21st Lancers,* 1898 (presented to the Gallery, 1901), and *Gordon's Memorial Service. . at Khartoum,* Royal Academy, 1899; and also Adrian Jones' *21st Lancers – 'Charge',* Liverpool Autumn Exhibition, 1899.

ENGR: Photogravure published by Messrs. Fishburn and Jenkin, London, 1899–1900.

PROV: Presented by Alderman T. W. Oakshott, 1903.

EXH: Walker Art Gallery, 1900, *Liverpool Autumn Exhibition* (211), price £500; Whitechapel Art Gallery, 1908; Walker Art Gallery, 1908, *Historical Exhibition of Liverpool Art* (561).

REF: 1 See Winston Spencer Churchill, *The River War,* II, p. 98. 2 *Ibid,* p. 181.

KENNERLEY, George, living artist

3156 Liverpool Landscape
Oil on canvas, 40·6 × 50·8 cm. (16 × 20 in.)
PROV: Presented by the artist, 1952.
EXH: Royal Academy, 1952 (447); Arts Council, London, 1952, *Merseyside Artists from the Sandon Studios Society* (22).

7400 Iris (Hommage to Van Gogh)
Oil on canvas, 101·5 × 88·9 cm. (40 × 35 in.)
PROV: Purchased from the artist, 1970.
EXH: Crane Kalman Gallery, 1970, *Recent Paintings & Collages by G. Kennerley* (1).

KERR-LAWSON, James 1865 - 1939

2592 Mrs. Thomas Brocklebank
Oil on canvas, 76·2 × 63·5 cm. (30 × 25 in.)
Petrena, daughter of Henry Royds of Liverpool and Heswall, married 1867, Thomas Brocklebank (d. 1919) of the Liverpool shipping firm. Lived in London and Florence. They formed a collection of Italian masters and Pre-Raphaelites. She was a Fellow of the Royal Historical Society and Hon. Corresponding Member of the Institut Historique et Heraldique de France. She made an important collection of photographs of Reigning and Allied families which she left to the British Museum.[1]

PROV: Presented by Mrs. Kerr-Lawson, 1950.
REF: 1 *The Times,* 20 May 1937, p. 9.

KIDSON, Henry Edwin 1832 - 1910

Landscape painter. Born Leeds 6 September 1832. Settled in Liverpool after period in Leeds, York and Windsor. A picture dealer and pawnbroker; member of Liver Sketching Club; exhibited at Liverpool Autumn Exhibition, Manchester, and Leeds. Died Liverpool 24 March 1910.

2591 W. G. Herdman
Oil on canvas, 40·7×31 cm. (16×12¼ in.)
INSCRIBED, verso: *W. G. Herdman/H. E. Kidson/Pinxt/1895* (or 6)
William Gawin Herdman (1805–1882), Liverpool topographical artist *(q.v.)*.

PROV: Purchased from the artist, 1905.
EXH: Walker Art Gallery, 1896, *Liverpool Autumn Exhibition* (235).

After LANDSEER, Sir Edwin 1802 - 1873

2122 John Gibson
Oil on canvas, 91·7×71 cm. (36⅛×28 in.)
John Gibson (1790–1866), sculptor, settled at Rome; for biography see under Geddes (2944). Replica of a portrait (35×27 in.) given to the Royal Academy by the artist's Executors.[1] Here he appears older than in the Partridge portrait of 1847 *(q.v.)* and it therefore probably dates from one of his later return visits to England.

PROV: Anon. sale Christie's, 22.6.1901 (65), as 'after Landseer', bt. S. J. Smith, 4 gns.; anon. sale Christie's, 21.11.1908 (97) bt. Paris, 3 gns.; presented by Alderman J. G. Paris, 1908.
REF: 1 See John Woodward, Catalague, *Paintings and Drawings by Sir Edwin Landseer R.A.,* Royal Academy 1961 (78 repr.)

Studio of LAWRENCE, Sir Thomas 1769 - 1830

3078 Rt. Hon. George Canning
Oil on canvas, 240×147·3 cm. (94½×58 in.)
George Canning (1770–1827), Statesman. Foreign Secretary 1807–8 and 1822–27; Prime Minister the year of his death. He was elected M.P. for Liverpool in 1812, 1816, 1818 and 1820 and was very popular in the constituency, which he represented until 1823. A Canning Club was founded in 1812 by his political supporters which entertained him from time to time, in particular in August 1822 when he had been appointed Governor General of India. He revisited Liverpool for the last time in 1823.[1] Canning Street was named after him.

The history of this portrait is uncertain. It is a 'studio variant' after the prototype which was painted for Canning himself and which now belongs to the Earl of Harewood (93½× 56½ in.); several variants are recorded.[2] It is listed as presented to Liverpool in 1852,[3] and was certainly in the Corporation collection by 1865,[4] but records of its acquisition and source have not yet been traced.

The full length statue by Chantrey is in the Town Hall (8228 in the Collection); a bust by W. Spence is in the Collection (3996) and a

medallion portrait by the same sculptor is in the Athenaeum Library, Liverpool.

PROV: Presented to Liverpool Corporation (?) 1852, and later transferred to the Gallery.
EXH: South Kensington Museum, 1868, *Third Exhibition of National Portraits* (237).
REF: **1** See Barbara Whittingham-Jones, *Liverpool's Political Clubs, 1812–1830*, in *Transactions of the Historic Society of Lancashire* *Cheshire*, III, 1959, pp. 117 ff. **2** Kenneth Garlick, *Sir Thomas Lawrence*, 1954, p. 50. **3** Charles Dyall, *First Decade of the Walker Art Gallery: a Report of its Operations from 1877–1887*, 1888, p. 7. **4** Library, Museum and Art Gallery Committee Minutes, 19 October, 1865: Mr. Alker's estimate for regilding, cleaning and varnishing, £6.12.0.

LEDERER, John A. F.　1830 - 1910

Born Frankfurt-on-Main 1830. Trained at Frankfurt, Antwerp and Brussels; lived in Paris for some years. Came to London, 1859 and before 1864 to Liverpool, where he settled. Died Liverpool 1 June 1910.

2412　Portrait of an Old Man with white Beard
Oil on panel, 63×51·5 cm. (24¾×20¼ in.)
SIGNED: *J. Lederer*
PROV: Presented by Mrs. H. E. Roberts, 1951.

2413　Portrait of Elderly Man
Oil on panel, 60·3×47 cm. (23¾×18½ in.)
PROV: Presented by Mrs. H. E. Roberts, 1951.

LEE, John J., active 1860 - 1867

Genre painter, influenced by the Pre-Raphaelite style. Member of a Liverpool merchant family. He exhibited at the Liverpool Academy 1859–67, at the Royal Academy 1863–67, and at Suffolk Street 1860 and 1861. He lived at Rock Ferry, Cheshire, with a (?) studio in Church Street and Lord Street in 1859 and 1861/2; by 1866 he had moved to Haverstock Hill, London. He is said to have died there comparatively young. Thirteen pictures are recorded in exhibition catalogues but the location of only two, beside the present examples, are at present known, in the Williamson Art Gallery and in a private collection.

450　Bird Nesting
Oil on canvas, 21·8×26·9 cm. (8⅝×10⅝ in.)
The attribution is that of the last owner; presumably an early immature work.
PROV: Bequeathed by John Elliot, 1917.

501　Going to Market
Oil on canvas, 46·2×37 cm. (18¼×14⅝ in.)
SIGNED AND DATED: *JIL* (monogram) *June/ 1860*

PROV: John Elliot by 1908, and bequeathed by him, 1917.
REPR: *Apollo*, December 1962, p. 752, fig. 6.
EXH: Probably Suffolk Street, 1860 (217), and Liverpool Academy, 1860 (160) as *The Young Carriers* (price at both £20); Walker Art Gallery, 1908, *Historical Exhibition of Liverpool Art* (725); Harrogate 1924, *Liverpool School of Painters* (22).

LIGHTFOOT, Maxwell Gordon 1886 - 1911

Landscape, still-life and subject painter. Born Liverpool 19 July 1886. Later lived at Helsk and trained at Chester School of Art. In 1905 his family returned to Liverpool; apprentice to chromolithographer and attended art classes at Sandon Terrace Studios which began th autumn under the direction of Gerard Chowne (1875– 1911),who influenced his early wor and Herbert McNair (1868–1955). First exhibited at Liverpool Autumn Exhibition, 190; and afterwards with the Sandon Studios Society. 1907–9 at the Slade School under Henr Tonks, where he won various prizes and made friends with advanced students like Nevinso Wadsworth, Stanley Spencer, Mark Gertler etc. Besides lyrical landscapes also produce near-macabre pen drawings at this time. He lived in Primrose Hill and used the children c his landlord as models and found others in the gallery of the Bedford Theatre of Varietie including Katie, wife of a working man, who appears to have sat for him often. Probabl through Spencer Gore joined the Camden Town Group at whose first show, June 1911, h exhibited and which brought him critical recognition; but while, like them he responded t French Post-Impressionism, he remained more traditional in outlook and sombre in colourin The considerable promise of his career was cut short by suicide due to personal problem 27 September 1911. He is said to have destroyed much of his work. Drawings are also in th Collection.

1124 Flowers in a Blue and White Vase
Oil on canvas, 39·3×31·7 cm. (15½×12½ in.)
SIGNED in monogram and dated: *MGL 07*
White stock, blue aster and knapweed. One of a group of flower-pieces dating from 1907 at a period when the artist was attending the Sandon Studios where the flower painter Gerard Chowne was teaching. A debt to Chowne is evident and also to Fantin Latour, whom Lightfoot's contemporary, Herbert Tyson Smith, recalled they all imitated after his death as he was selling so well.[1]
PROV: Presented by Herbert Lightfoot, brother of the artist, 1954.
EXH: The Minories, Colchester, 1961, *Camden Town Group* (49); Walker Art Gallery, 1972, *Maxwell Gordon Lightfoot* (8) repr.
REF: 1 See 1971 Catalogue, *loc. cit.*

7256 Knapweed, Thistles and other Flowers in a Vase
Oil on canvas, 31·8×39·3 cm. (12½×15½ in.)
SIGNED in monogram and dated: *MGL 1907*

See 1124 above. White and blue cornflower purple knapweed, thistles and an unidentifie yellow flower in a shiny vase.
PROV: Given by the artist to E. Carter Prestor who later gave it to the Sandon Studic Society; purchased from them, 1970.
EXH: Walker Art Gallery, 1972, *Maxwe Gordon Lightfoot* (9).

2366 Landscape Abergavenny
Oil on canvas, 51×61·7 cm. (20⅛×24¼ in.)
The subject has been identified by Stanle Reed.[1] Probably dating from the artist's vis to Monmouthshire in 1910, and similar i treatment to other landscapes of this dat including watercolours also in the Collectio Similarities to Spencer Gore's *Blackdou Hills, Somerset* have been suggested.[2]
PROV: Presented by Herbert Lightfoot, brothe of the artist, 1954.
EXH: Sandon Studios Society, Liverpool, 195 *Fifty Years of Merseyside Art* (13); Agnew 1955, *Selected Acquisitions of the Walker A Gallery, 1945–1955* (not in catalogue); Walke

Art Gallery, 1972, *Maxwell Gordon Lightfoot* (39).

REF: **1** Letter 14.10.1971. **2** See 1972 Catalogue, *loc. cit.*

1720 View of Conway from above Gyffin, looking towards Deganwy and the Great Orme

Oil on canvas, 57·4 × 76·2 cm. (22⅝ × 30 in.)

One of three known studies of this subject of about 1910–11 from slightly differing vantage points: an oil (46 × 61·4 cm.) belonged to Miss G. M. Lightfoot, and a watercolour (20·7 × 22·9 cm.) is in the Collection. The decorative quality and organised composition of 1720 suggests that it may be a studio interpretation, rather than painted on the spot.[1]

PROV: Presented by Herbert Lightfoot, brother of the artist, 1954.

EXH: The Minories, Colchester, 1961, *The Camden Town Group* (48); Walker Art Gallery, 1972, *Maxwell Gordon Lightfoot* (41) repr.

REF: **1** See 1972 Catalogue, *loc. cit.*

1719 Study of Two Sheep

Oil on canvas, 50·8 × 63·7 cm. (20 × 25⅛ in.)

SIGNED AND DATED: *M G LIGHTFOOT 1911*

The restrained composition, monochromatic ochre colouring in almost flat tonal areas and firm outline, is characteristic of the artist's move towards simplification around 1910–11 and may owe something to his study of Puvis de Chavannes.[1]

PROV: Presented by Herbert Lightfoot, brother of the artist, 1954.

EXH: Sandon Studios Society, Bluecoat Chambers, Liverpool, 1951, *Fifty Years of Merseyside Art* (93); Walker Art Gallery, 1972, *Maxwell Gordon Lightfoot* (42) repr.

REF: **1** See 1972 Catalogue, *loc. cit.*

LOCKHART, William Ewart 1846 - 1900

3058 Samuel Smith, M.P.

Oil on canvas, 128·2 × 102·2 cm. (50½ × 40¼ in.)

SIGNED AND DATED: *W. E. Lockhart R.S.A./ 1899*

The Rt. Hon. Samuel Smith, M.P. (1836–1906), politician and philanthropist, shown reading a blue-book. Born Kirkcudbright; settled in Liverpool 1853 and apprenticed to a cotton broker; wrote on statistics and the cotton market as *Mercator* in *Liverpool Daily Post* from 1857. Visited America and later London to study the cotton markets and founded successful cotton brokerage business, 1864. President, Liverpool Chamber of Commerce, 1876–77.

Particularly concerned with child welfare and social reform; closely associated with the Y.M.C.A.; founded Gordon Smith Institute for Seamen in memory of his son (d. 1898). Town Councillor for a period from 1878; J.P.; Liberal M.P. for Liverpool, 1882–85, and for Flintshire, 1886–1905, and specialised in moral, social, religious, currency, and India questions. Privy Councillor, 1905. Died on a visit to India.[1]

PROV: Presented by Alderman James Smith, brother of the sitter, 1907.

EXH: Walker Art Gallery, 1898, *Liverpool Autumn Exhibition* (83); Wembley, 1924, *Liverpool Civic Week.*

REF: **1** S. Smith, *My Life Work*, 1902, *passim;* press cuttings (Liverpool Record Office).

LOGSDAIL, William 1859 - 1944

2566 Thomas Hampson Jones

Oil on canvas, 36·5 × 25·7 cm. (14⅝ × 10⅛ in.)

Thomas Hampson Jones (1845/6 or 1854–1916),[1] Liverpool landscape painter, trained at Cork, under John Finnie at Liverpool, and at Venice. Exhibited at the Royal Academy from 1876, the Liverpool Autumn Exhibition, etc.; a President of the Liverpool Society of painters in Watercolour and member of the Liverpool Academy.

PROV: Presented by the Executors of the sitter, 1917.

REF: **1** According to the obituary notices he was in his 70th year in 1917, but the biographical form completed for the Gallery by the artist gives 1854 as year of birth.

LONSDALE, James 1777 - 1839

Portrait painter, London. Born (?)Lancaster 16 May 1777, and went to London at an early age. His prolific practice included numerous Liverpool sitters and he exhibited at the Liverpool Academy, 1813, 1829–31, and 1834–38. He was in Liverpool some time in 1832 and may have made other visits.

3004 William Roscoe

Oil on canvas, 142·2 × 112·4 cm. (56 × 44¼ in.)

See Shee 3130 for biography. Of this portrait Henry Roscoe wrote: 'At the solicitation. . . of several of his friends at Liverpool, he was painted by Lonsdale, in the year 1825; and the picture was presented to the Liverpool Royal Institution. From this painting an engraving has been published.'[1] The date given here is incorrect: 3004 was in fact the portrait exhibited at the R.A. in 1823, the year in which it entered the collection of the Institution.[2] The surviving annual reports do not record it and it is first mentioned in print, and in passing, in the L.R.I. Catalogue of 1836. Roscoe was appointed Chairman of the General Committee of the L.R.I. in 1814 and became its first President in 1822.

The medallion on a ribbon which hangs over the edge of the table, bears a portrait of Lorenzo de'Medici and is inscribed *LAURENTIUS/MEDICES*. (It is attributed by Hill[3] to Bertoldo di Giovanni, *c.* 1420–1491).

For copies see 3013 below.

ENGR: S. Freeman, stipple (detail), 1832 published in W. Jerdan, *National Portrait Gallery*, 1833, Vol. 4, and in W. C. Taylor, *The National Portrait Gallery of Illustrious and Eminent Personages*, 1846, Vol. 2, p. 35.

PROV: Presented to the Liverpool Royal Institution, 1823; deposited at the Walker Art Gallery, 1942; presented by the L.R.I., 1948.

EXH: Royal Academy, 1823 (198).

REF: **1** Henry Roscoe, *The Life of William Roscoe*, 1833, I, p. 475. **2** T/S copy of Thomas Winstanley's valuation of the L.R.I. Collection 17 January 1824 (Gallery files): 3004 is assessed at £73.10.0d. **3** G. F. Hill, *A Corpus of Italian Medals of the Renaissance before Cellini*, 1930, I p. 241; repr. II pl. 148.

2284 General Isaac Gascoyne

Oil on canvas,[1] 91·8 × 71·3 cm. (36⅛ × 28⅛ in.)

Isaac Gascoyne (1770–1841), younger son of Bamber Gascoyne of Childwall Hall. He entered the army as an ensign in 1779 and rose

o the rank of general in 1819. He first entered parliament in 1796 as Tory M.P. for Liverpool, succeeding his brother Bamber Gascoyne and won each succeeding election until he was finally defeated in 1831, when he retired from politics.

A 'common-place' politician, he was according to Aspinall[2] nicknamed 'The Old General' and 'Cunning Isaac'.

Joseph Williamson (see British School 7480) had a three-quarter length portrait of him, possibly by Cornelius Henderson.[3]

PROV· ? Robert H. Grundy (Liverpool dealer), sold Christie's, at 44 Church Street, Liverpool, 20–29.11.1865 (1048), bt. Isaac, 10/6. Purchased from A. Bowker & Son, Liverpool, 1883.

EXH: Royal Academy, 1829 (26); Liverpool Academy, 1829 (84); Walker Art Gallery, 1960, *Liverpool Academy 150th Anniversary* (31).

REF: 1 Canvas stamp of T. Brown, High Holborn; relined 1960. 2 J. Aspinall, *Liverpool a Few Years Since*, 1852, pp. 157–9. 3 *Liverpool Mercury*, 4 June 1841, p. 97, referring to his executor's sale.

L251 Henry Hollinshead Blundell

Oil on canvas, 127 × 101·5 cm. (50 × 40 in.)
Henry Hollinshead Blundell (1755–1832), colliery owner. Grandson of Bryan Blundell, a founder of the Blue Coat Hospital, and son of Jonathan[1] who commenced the colliery business. Owner of Orrell, Blackrod and Pemberton Collieries; took the additional name of Hollinshead in 1802 to comply with an inheritance.[2] Mayor of Liverpool, 1791, 1793 and 1807.

He was Treasurer of the Blue Coat Hospital 1815 and 1816. This portrait appears on the wall in the background of Ansdell's group of the Blue Coat Governors together with L247. Hughes[3] gives it to Lonsdale and stylistically it agrees with his portrait of Gascoyne (*q.v.*) and the sitter appears in a similar chair. In June 1827 he was asked to sit for his portrait by the Governors and it was delivered in September 1828,[4] but this was presumably the portrait exhibited by Alexander Mosses at the 1828 Liverpool Academy where it was described as 'painted for the Blue Coat Hospital,' and is now untraced.

PROV: Presented, according to Hughes,[5] to the Blue Coat Hospital by the sitter's son, Richard B. B. Hollinshead Blundell, before 1842/6; lent by the Blue Coat School, 1975.

EXH: ? Liverpool Academy, 1830 (18).

REF: 1 The sitter gave the full length portrait of Jonathan Blundell to the Blue Coat in 1804 (Committee 26 June 1804). 2 D. Anderson, *Blundell's Collieries, the Progress of the Business,* in *Transactions of the Historic Society of Lancashire and Cheshire*, 116, 1965, pp. 69 ff., repr. 3 J. Hughes, *Sketch of the History of the Liverpool Blue Coat Hospital*, in *Transactions, op. cit.*, 16, 1864, p. 66. 4 MS Minutes of Governors' Meetings, 26 June 1827, 30 September 1838 (Liverpool Record Office). 5 Hughes, *loc. cit.*

L247 George Brown

Oil on canvas, 127 × 101·5 cm. (50 × 40 in.)
George Brown (about 1757–1836), merchant and ship owner of Liverpool, son of a sailor. Seated in an interior with the Blue coat Hospital visible in right background.

He was admitted to the Blue Coat 1 July 1765[1] without friends or supporters to assist his application. He went to sea and after initial misfortunes became in turn captain, ship owner and wealthy merchant. He was Treasurer of the Blue Coat Hospital 1809 and 1810 and continued to assist the Treasurer in subsequent years.[2] In 1835 the Trustees recorded their thanks for his long service to the school to which he had been the 'kind and constant friend.'[3] He left £500 to the foundation.[4]

This portrait appears in the right background of Ansdell's group of the Governors of the Blue Coat Hospital in their Board Room, 1842–46 (at the School), together with L251. It is certainly by the same hand and perhaps a companion; Hughes also gives it to Lonsdale. Like L251 another now lost portrait to do with the School is recorded whilst the source of this portrait is untraced: at the request of the Trustees a portrait with a Blue Coat boy was painted in 1827–28,[5] and, according to Hughes,[6] hung in the Boys' School Room; a man of retiring character, the sitter had been reluctant to sit.

PROV: ? In the Blue Coat Hospital before 1827[7] certainly there by 1842–6; lent by the Blue Coat School, 1975.

REF: 1 MS Minutes of Governors' Meetings, 1 July 1765 (Liverpool Record Office). 2 Minutes, 28 September 1809, etc.; J. Hughes, *Sketch of the History of the Liverpool Blue Coat Hospital*, in *Transactions of the Historic Society of Lancashire and Cheshire*, 13, 1861, pp. 101–2.

3 Minutes, 29 December 1835. **4** Hughes, *loc. cit.* **5** Minutes, 27 March 1827. **6** Hughes, *op. cit.,* 16, 1864, p. 70. **7** *Ibid;* untraced by the compiler in Minutes of Governors' Meetings.

7002 Thomas Colley Porter, Mayor of Liverpool

Oil on canvas, $36\frac{1}{4} \times 28\frac{1}{4}$ in. ($92 \cdot 2 \times 71 \cdot 8$ cm.)
Thomas Colley Porter (1780–1833) in his robes as Mayor of Liverpool, to which he was elected in 1827 in a six-day contest with Nicholas Robinson (see his portrait by Thompson, 6347). 'The reasons for the contest,' wrote Picton,[1] 'were of the most trivial and personal character. There was no political question at issue, nor any municipal point to be decided. . . The most probable origin of the struggle was the jealousy between the tradesmen and the mercantile interest. Mr. Porter was a thriving and prosperous plumber and painter, who had by industry raised himself to affluence, and by means of some family connections had obtained admission into the ruling municipal clique. Mr. Nicholas Robinson was a respectable merchant of standing and position. Previous to the election, the friends of each candidate held a meeting. . . but there was no salient point to take hold of. Every person could see that it was simply a question of money. The office of mayor was to be put up to auction and knocked down to the highest bidder.'

Robinson had the municipal interest while Porter was the popular candidate. Towards the end of the six-day contest of 18 to 24 October £30 was being paid for a burgess's vote by each candidate. Porter won by 1780 to 1765. Robinson was duly elected in the following year.

Porter was the son of William Porter (1732–1812), of Hindolveston, who had settled in Liverpool, and his third wife, Mrs. Mary Tudor (née Colley).[2] He was elected a Freeman in 1815. He had a lime kiln in Mill Lane and lived in the fashionable St. Anne Street in a house built by Samuel Sandbach, 1825. The house was subsequently the Judges Lodging until 1868.[3] A portrait of Mrs. Porter, by Mosses, belongs to a descendant.[4]

PROV: Mrs. Christian (whose husband's mother was the sister of William Goodman Porter, grandson of the sitter), who presented it to Liverpool, 1928; transferred from the City Estates Committee to the Gallery, 1967. Hung in the Town Hall.

EXH: Liverpool Academy, 1831 (2).

REF: **1** J. A. Picton, *Memorials of Liverpool,* 1873, I pp. 472–4; *Liverpool Mercury,* 19 October 1827. **2** Information from John Drummond, in letter 17.8.1967. **3** Picton, *op. cit.,* II p. 356. **4** Drummond, *loc. cit.*

9138 Thomas Stewart Traill

Oil on canvas, $141 \cdot 7 \times 111 \cdot 1$ cm. ($55\frac{3}{4} \times 43\frac{3}{4}$ in.)
SIGNED AND DATED: *J. Lonsdale 1832*
Thomas Stewart Traill, M.D., F.R.S.E; native of Orkney and medical practitioner and scholar in Liverpool, 1803–33: see Mosses L 263 for biography. He was a founder member of Liverpool Royal Institution, 1814, Professor of Chemistry, and President 1826–28. He gave many series of lectures on scientific and art topics at the L.R.I. and elsewhere; he was appointed Keeper of the Museum, 1822–26 and Curator from 1829, when the first catalogue of the Natural History Collection of its museum was published, compiled by him.[1] In 1833 he left Liverpool for Edinburgh on his appointment as Professor of Medical Jurisprudence Audubon, the American naturalist, during his stay in Liverpool in 1826 was impressed; at dinner at his house he recorded, 'Dr. Traill enlivened me much. Indeed a man of [such] extensive knowledge of all things cannot fail to be agreeable if only he will talk.'[2]

His portrait was commissioned by subscribers previous to his departure and he sat to Lonsdale during the latter's visit to Liverpool.[3] He is shown seated holding a portfolio and a porte-crayon (or possibly a steel pen) and looking towards a bird on a stand on the table at the left. This bird was a type specimen *Oriolus traillii traillii (Vigors),* in the L.R.I. Museum, unidentified in Traill's catalogue and published 1830–1831 by Vigors and named at the time *Pastor Traillii* in his honour (this the male type, is now in Merseyside County Museums).[4] One of the books beneath the table is inscribed ZACCHIAS, alluding to the celebrated 17th century Italian scholar of medical jurisprudence.

PROV: Commissioned by thirty-two subscribers and presented to Liverpool Royal Institution, January 1833;[5] presented to the Gallery by the L.R.I., 1976.

EXH: Walker Art Gallery, 1960, *Liverpool Academy 150th Anniversary Exhibition* (37).

REF: **1** *Catalogue of the Mineralogical Collection*

the Museum of the Royal Institution, Liver-
pool, 1829, *Catalogue of Mammalia. . . ,
Catalogue of Birds*. . . . **2** Alice Ford, *The 1826
Journal of John James Audubon*, 1957, p. 178,
journal for 30 September 1826. **3** Letter of
James Gilfinnan to the President of the L.R.I.,
9 January 1833 (R.I. Arch. 61.37, Liverpool
University Library). **4** Presumably Nos. 792,
93 in the 1829 catalogue; published Zoo-
gical Society, London, *Proceedings*, 1830–1,
. 175; John Gould, drawings of male and
male specimens, exhib. *loc. cit.*, 1832 and
epr. in his *A Century of birds from the Himalaya
ountains*, 1832; the female specimen is
ntraced since the dispersal of the L.R.I.
ollections (information from Peter Morgan,
Merseyside County Museums, 1976). **5** Gil-
nnan, *loc. cit.*, and L.R.I. Presents Book
R.I. Arch. 37, Liverpool University Library).

249 James Aspinall

Oil on canvas, 127 × 101·5 cm. (50 × 40 in.)

James Aspinall (about 1794–1847), merchant of
Liverpool. He was mayor of Liverpool 1834 and
835 and is seated in a chair whose arms are of
he type of Town Hall chair which also appears
n the artist's portrait of Porter (7002) and
Phillip's portrait of Case (7023). He was elected
Trustee of the Blue Coat Hospital, 1830 and
was Treasurer for three years, 1835–38.[1] He
ied at Vauxhall Gardens whilst on a visit
o London, 19 June 1847.[2] According to
tonehouse[3] he was 'a most remarkable man.
He was Mayor in 1834 and 1835. He did not go
ut of office until the new Municipal Reform
ill came into operation. . . He was of immense
ulk both in height and breadth, weighing,
 was said, twenty-four stones. His face was
ingularly handsome, while his manners were
xceedingly pleasant, kindly, and courteous to
ll who had intercourse with him. He was
lways remarkably well and fashionably dressed.
n fact in Liverpool he was the "observed of all
bservers." ' He was known as the double
andy.[4]
He was painted by Illidge (Liverpool
Academy, 1841 (83)) and also appears in four
aintings by Ansdell: *The Waterloo Cup* 1840
9021), *The Meeting of the Board of Governors
f the Blue Coat*, 1842–46 (Blue Coat School),
 small full length sketch,[5] engraved by Chant,[6]
nd a small seated portrait, probably a study
or the Blue Coat portrait.[7]

PROV: Lent by the Blue Coat School, 1975.

EXH: Liverpool Academy, 1835 (113).

REF: **1** MS Minutes of Governors' Meetings
(Liverpool Record Office); see also Thomas
Ellison, *Gleanings and Reminiscences*, 1905,
pp. 111–113. **2** *The Times*, 22 June 1847, p. 4;
Liverpool Mercury 22 and 25 June 1847;
Liverpool Times, 22 June 1847. **3** J. Stonehouse,
The Streets of Liverpool, 1870, p. 152. **4** W.
Lewin, *Clarke Aspinall, a biography*, 1893,
pp. 50–51. **5** Christie's sale, 5.3.1971 (91):
photo Gallery files. **6** Copy Liverpool Record
Office. **7** Christie's sale, 29.7.1977 (98): photo
Gallery files.

LONSDALE, James, After
3013 William Roscoe

Oil on canvas, 144·7 × 114·3 cm. (57 × 45 in.)
There is a family tradition that this copy of
3004 is by Cornelius Henderson (1799–1852),
q.v. A copy was painted after 1847.[1] However,
an undoubted copy by Henderson, signed and
dated 1826 (55 × 54 in.) and of higher quality
than 3013, passed through the sale rooms in
1969.[2]

PROV: Charlotte Alicia Roscoe[3] (second wife
of Richard Roscoe (1833–1892), a grandson of
the sitter); by descent to Mrs. Philip Roscoe,
who presented it, 1931.

EXH: Liverpool Public Library, 1931, *Roscoe
Centenary Exhibition* (3).

REF: **1** *Index to the Minute Book of the Liverpool
Institution, 1847–c. 1871* (Liverpool University
Library). **2** Anon. sale Phillips, London,
28 April 1969 (76); a photograph N.P.G.
3 F. W. Dunston, *Roscoeana* (1905), p. 7, note 1.

LYONS, Arthur J. active 1891 - 1912

3079 The Inaugural Banquet af the 41st Autumn Exhibition, 1911

Oil on canvas, 228·5 × 302 cm. (90 × 119 in.)

SIGNED AND DATED: *Arthur J. Lyons/1911*

Held at the Walker Art Gallery on 21 September, 1911. Speaking is Alderman John Lea, Chairman, Arts and Exhibition Sub-Committee. Seated to his right is the Lord Mayor of Manchester and the Lady Mayoress of Liverpool, and to his left the Lady Mayoress of Manchester and the Lord Mayor of Liverpool (S. M. Hutchinson). Further to the right are Sir W. B. Forwood, Sir W. B. Bowring and Sir W. H. Lever.[1]

PROV: Presented by subscribers, 1912.

EXH: Walker Art Gallery, 1911, *Liverpool Autumn Exhibition*.

REF: **1** *Annual Report for 1911*, 1912 pp. 77–78.

McCROSSAN, Mary, died 1934

Landscape painter. Born Liverpool, daughter of an iron founder. Trained at Liverpool School of Art under John Finnie and gained gold and silver medals and travelling scholarship; afterwards at L'Academie Délécluse, Paris and under Julius Olsson at St. Ives, Cornwall. Had studio at 10 South Castle Street about 1900–08. Afterwards moved to London and subsequently to St. Ives. Member Liverpool Academy while in Liverpool, Member Royal Society of British Artists, 1926. Exhibited at Liverpool Autumn Exhibitions from 1886, Royal Academy from 1898, also at International Society of Sculptors, Painters and Engravers, and New English Art Club, London. A friend of J. Hamilton Hay (*q.v.*). Travelled much on the Continent and in the Near East. Noted for her watercolours. Died November 1934 at about seventy years of age.

668 White Gigs, Moonlight

Oil on canvas, 76·5 × 63·5 cm. (30⅛ × 25 in.)

SIGNED AND DATED: *M. McCROSSAN/ 1907*

PROV: Purchased from the artist at the Autumn Exhibition, 1908.

EXH: International Society of Painters, Sculptors and Engravers, Winter or Spring, 1908;[1] Walker Art Gallery, 1908, *Liverpool Autumn Exhibition* (1038); Rochdale, 1932; Walker Art Gallery, 1935, *Memorial Exhibition* (3).

REF: **1** Letter from the artist, Gallery files.

617 Umbrellas and Barges, Venice

Oil on canvas, 60·5 × 85·4 cm. (23⅞ × 33⅝ in.)

SIGNED: *M. McCROSSAN*

PROV: Presented by Miss Jessie McCrossan. 1937.

EXH: Walker Art Gallery, 1935, *Memorial Exhibition* (1).

McEVOY, Ambrose 1878 - 1927

51 Mrs. John Rankin

Oil on canvas, 102·5 × 76·8 cm. (40⅜ × 30¼ in.)

SIGNED: *McEVOY*

Dating from 1922.[1] Helen Margaret, daughter of James Jack, J.P. of Liverpool, married John Rankin (1845–1929), Liverpool Shipowner and philanthropist, in 1875. She died in 1937 in her 88th year.[2] Her daughter, Mrs. William Rathbone was also painted by McEvoy (L33 below).

PROV: James Rankin, son of the sitter, who presented it, 1955.

REF: 1 'Wigs', *The Work of Ambrose McEvoy*, 1923, p. 78 (list). 2 Obituary, *Liverpool Daily Post*, 3 August 1937, and press cuttings (Liverpool Record Office).

L33 Mrs. William Rathbone

Oil on canvas, 123·2 × 92 cm. (48½ × 36¼ in.)

An unfinished portrait dating from 1923.[1] Agnes Dorothea, daughter of John Rankin, Liverpool Shipowner, and Helen Margaret (née Jack), married William Rathbone VIII.

PROV: The sitter, and thence to her son, William Rathbone IX; lent to the Gallery, 1937.

REF: 1 'Wigs', *The Work of Ambrose McEvoy*, 1923, p. 78 (list).

MACKENZIE, Charles Douglas 1875-post 1926

Portrait and landscape painter. Born Liverpool and trained at Liverpool School of Art under John Finnie, and at the Herkomer School. Exhibited at the Liverpool Autumn Exhibition, 1895–1926. Associate of Liverpool Academy until 1913, when gave London address; disappears from the street directories from 1914.

2567 Rt. Hon. Thomas Price

Oil on canvas, 84·2 × 66·3 cm. (33⅛ × 26⅛ in.)

SIGNED: *C. DOUGLAS MACKENZIE*

Thomas Price (1852–1909), premier of South Australia. Born Brymbo near Wrexham, 19 January 1852. He was brought up in Liverpool where he attended a penny school, became a stonecutter and took an interest in public affairs. Married Anne Elizabeth Lloyd, daughter of a timber merchant in 1881 and in 1883 was ordered to Australia for his health. There followed his trade in Adelaide; became Secretary of the Masons and Bricklayers Society of South Australia, 1891 and entered the House of Assembly in 1893. In July 1905 became the first Labour premier of an Australian state, and died in office, 31 May 1909.[1]

PROV: Presented by William Johnston, 1909.

EXH: Walker Art Gallery, 1908, *Liverpool Autumn Exhibition* (246) repr.

REF: 1 D.N.B.; *The Times*, 1 June 1909; T. H. Smeaton, *From Stone cutter to Premier... Tom Price...*, 1909.

MANN, James Scrimgeour 1883 - 1946

Marine artist. Born Dundee. Trained at Liverpool School of Art. Member of Royal Institute of Painters in Watercolours. Exhibited Royal Academy and elsewhere. Member and a President of Royal Cambrian Academy. Died Caldy, Wirral, 1 June 1946.

1530 Tide Time
Oil on canvas, 107·4 × 153·8 cm. (42¼ × 60½ in.)
SIGNED: *James S. Mann*
A Blue Funnel liner in the Mersey.

PROV: Presented by Miss Ruth Holt, 1951.
EXH: Walker Art Gallery, 1925, *Liverpool Autumn Exhibition* (75).

MARSHALL, Thomas Falcon 1818 - 1878

Historical and genre painter. Born Liverpool, December 1818. Little is known about his Liverpool years. Exhibited at Liverpool Academy from 1836; elected Associate 20 December 1842; Member Elect 12 June 1846, but no longer a Member the following year. He had moved to London by 1847 but continued to exhibit at Liverpool until 1877. Died London, 26 March 1878.

7543 The Woodcutter
Oil on panel, 23·8 × 40·4 cm. (9⅜ × 15⅞ in.)
SIGNED AND DATED: *T. F. Marshall 1854*
PROV: Dr. R. E. Gibbs; purchased from Waverley Antiques, 1972.
EXH: Bluecoat Chambers, 1972, *Antiques Fair.*

2979 John Howard visiting the Prisons in Italy in 1786
Oil on canvas, 104 × 145·5 cm. (41 × 57¼ in.)
SIGNED AND DATED: *T F M 59*[1]
Presumably the picture exhibited at the Royal Academy in 1859 with the following quotation in the catalogue:

> "He, touched with human woe, redressive searched
> Into the horrors of the gloomy jail,
> Unpitied and unheard, where misery moans,
> Where sickness pines, where thirst and hunger burn,
> And poor misfortune feels the lash of vice."
> *(Thomson)*

John Howard (1726–1790), philanthropist and prison reformer, made extensive tours of inspection in Great Britain and on the Continent. He visited Liverpool in 1787 and designed the jail in Great Howard Street which was named after him.
PROV: Purchased from G. W. Brown, London, 1912.
EXH: Presumably Royal Academy, 1859 (936), Liverpool Academy, 1860 (448), and Manchester Royal Institution, 1861 (687) £367.10.0; Leicester, 1961, *Victorian Vision of Italy* (23).
REF: **1** Not now visible due to damage by water causing paint loss.

MARTIN, William Alison 1878/9 - 1936

Landscape painter, Born Liverpool, 18 August 1878 (? or 9). Trained at Liverpool School of Art from 1897, and under Augustus John at the Liverpool University School. Won City travelling scholarship and worked in Paris and Italy. Member Liverpool Academy. Exhibited at Liverpool Autumn Exhibition, Allied Artists etc. Had studio at 10 South Castle Street by 1905. Early work included mural decorations (Toxteth Branch Library with Clifton Balmer, 1904), and was for a time influenced by Monticelli. Visited Spain to make studies for commission for Pacific Steam Navigation Company. Worked chiefly in North Wales.

21 A Breezy Day
Oil on canvas, wax medium, 80×106·7 cm.
(31½×42 in.)
SIGNED: *W. ALISON MARTIN*
PROV: Purchased from the artist at the Autumn
Exhibition, 1922.
EXH: Walker Art Gallery, 1922, *Liverpool
Autumn Exhibition* (668).

655 Evening Glaslyn Valley
Oil on canvas, wax medium, 70·8×92 cm.
(27⅞×36¼ in.)
PROV: Presented by Mrs. Alison Martin, 1936.

MAYER, Joseph 1803 - 1886

7620 and 7621 are by Joseph Mayer (1803–1886) or his sister Jane. For biography of Joseph see the portrait by Daniels 7355.

7620 White Tower of Seville
Oil on canvas, 35·5×30·5 cm. (14×12 in.)
PROV: Joseph Mayer Trust, Bebington;[1]
presented by Bebington Corporation, 1971.
REF: 1 Given to Joseph in MS copy list of articles bequeathed by Joseph Mayer to Bebington Museum and Free Library, n.d. Liverpool Record Office), and *Handlist of Drawings, Prints, etc., in the Mayer Hall,*

Bebington, n.d. (17). An MS label on the frame is, however, inscribed: *Jane Mayer April 19th 1860/20–33.* (She was a sister of Joseph).

7621 Cottage Scene with woman carrying buckets
Oil on canvas, 25·5×37·5 cm. (10×14¾ in.)
PROV: Joseph Mayer Trust, Bebington;[1] presented by Bebington Corporation, 1971.
REF: 1 As 7620; *Handlist* No. 51; Similar MS label.

MAYER-MARTON, George 1897 - 1960

Born Hungary and trained at Vienna and Munich and made a successful career. An intimate study of Chinese art for illustrations, 1932, was an important factor in his subsequent style. Settled in London 1938, worked as a lecturer and from 1943–52 for C.E.M.A., which

involved much travelling about. 1952 settled at Liverpool when appointed to Liverpool College of Art where he made a notable impact. Member of Liverpool Academy. Besides landscape practised mural painting and mosaic in several commissions in the north west. Died Liverpool 8 August 1960. See also Foreign Schools Catalogue.

3157 The Weir, Summerbridge

Oil on canvas, 61·3 × 81·5 cm. (24⅛ × 32⅛ in.)
A photograph of the same viewpoint exists.[1]
Dating from 1952.[2]
PROV: Purchased from the artist, 1953.
EXH: Walker Art Gallery, 1953, *Liverpool Academy* (62); Agnew, 1955, *Walker Art*

Gallery Acquisitions, 1945–55 (42); Walker Art Gallery and Derby, 1961, *Memorial Exhibition* (19).
REF: **1** Coll. Mrs. Braithwaite, niece of the artist. **2** Walker Art Gallery 1961 Memorial Catalogue.

MERCIER, Captain Charles 1834 - active 1879

Portrait and history painter. An Army officer. He had an address in Manchester in 1863 when he exhibited at the Royal Academy, at Pendleton 1865–66, and later in London. In 1859 'J. D. and C. Mercier, artists,' are listed in Church Street, Liverpool, afterwards from 1860–70 John David Mercier only is listed at various Liverpool addresses. Charles may have kept up a connection in Liverpool in this manner. Exhibited at the Manchester Royal Institution 1862–66 and at the Liverpool Autumn Exhibition in 1879. Portraits by him are in Salford Art Gallery. Nothing is known about John David Mercier.

8639 William Philip, 4th Earl of Sefton

Oil on canvas,[1] 236·3 × 140·1 cm. (93 × 55⅛ in.)
SIGNED: *Charles Mercier*
William Philip, 4th Earl of Sefton (1835–1897),[2] see under Pearce for biography. In uniform as Lord Lieutenant and wearing the star and riband of the Portugese Order of the Tower and the Sword, of which he was made Knight Grand Cross as a result of acting as Chief Commissioner with the Garter to King Luiz I of Portugal in May 1865. This portrait may commemorate that occasion or his marriage the following year, and might well be a presentation portrait.
PROV: Purchased from the Executors of the Estate of the 7th Earl of Sefton, 1973.
REF: **1** Framemaker's label of Charles Roberson, Long Acre. **2** Previous to acquisition identified as his eldest son Charles William Hylton, 5th Earl (1867–1901) (and in 1946 Inventory,

No. 17), but this is not possible: an incorrect *Who Was Who* may have been the cause.

7005 Oliver Holden

Oil on canvas,[1] 76·4 × 63·9 cm. (30⅛ × 25⅛ in.)
Alderman Oliver Holden, coal merchant of Liverpool. Town Councillor from 1850 and a member of the Health Committee for over twenty years. He died 22 December 1872, aged 67.[2]
PROV: Presented to the Health Committee by subscribers, through Alderman Thomas Rigby, 1875;[3] transferred to the Gallery, 1967.
REF: **1** Canvas stamp of George Rowney & Co., 2 Rathbone Place and 29 Oxford Street, London. **2** Gold label; press cuttings (Liverpool Record Office). **3** Health Committee Minutes, 25 February 1875, quoting letter from Alderman Rigby.

MILLINGTON, James Heath 1799 - 1872

7024 William Rathbone, Mayor of Liverpool

Oil on canvas, 238·5 × 154 cm. (94 × 60½ in.)
William Rathbone (1787–1868), the fifth of the name, member of the distinguished Liverpool Quaker family. He wears the robes of office of Mayor of Liverpool, 1837–8. Eminent educationalist and philanthropist, and a leading Liberal in local politics, he favoured electoral reform and was an early advocate of catholic emancipation. He entered the Town Council after the Municipal Reform Act, 1835. He married Elizabeth Greg, a member of a Unitarian family and himself finally withdrew from the Friends, 1829. He assisted in the foundation of the Liverpool Royal Institution, the Liverpool Mechanics Institute, and the Sailors' Home. His friends included William Roscoe, the friend of his father; he gave a final home to Joseph Blanco White, and he entertained J. J. Audubon on his visit to Liverpool, 1826. His collection of paintings included several of the Dutch School.[1]

This portrait was finally completed in 1843, but was then refused for the Town Hall by the Tories, then in power. It was therefore hung in the Liverpool (Mechanics) Institute until in 1865 the Tory Council applied for its transfer and it has since hung in the Town Hall.[2] The identity of the artist has long been confused and ascribed for some years to a W. Smith (see W. Smith 2572), but is described as by Mr. Millington when accepted on deposit from the subscribers by the Mechanics Institution in 1844,[3] and hung in their exhibition of that year. This was presumably James Heath Millington (1799–1872), an Irish portrait and miniature painter settled in London.

A portrait by J. Robertson, 1864, is in family ownership. A statue by Foley is in Sefton Park, and a bust by Edward Davis is in the Collection. A sculpture portrait by B. Smith was exhibited at the Royal Academy, 1847.

PROV: Commissioned by the sitter's friends and admirers; deposited in the Liverpool (Mechanics) Institute 1844 until 1865, when transferred to the Town Hall, Liverpool.

EXH: Liverpool Mechanics Institution, 3rd Exhibition, 1844 (19), as by *Millington*.

REF: 1 D.N.B.; E. A. Rathbone, *Records of the Rathbone Family*, 1913, pp. 166 ff; J. Picton, *Memorials of Liverpool*, 1873, II p. 306. 2 *Porcupine*, 6 May 1865; Picton, *loc. cit.*: Liverpool Common Council, Minutes, 4 and 14 October 1843; Liverpool Mechanics Institute, *Annual Report*. 1844, pp. 34–5, and 1866, p. 9. 3 Liverpool Mechanics Institute, *Annual Report*, 1844, pp. 34–5; *Liverpool Mercury*, 21 June 1844, Mayer Papers (Liverpool Record Office).

MOORE, George, living artist

6332 Life Machine
Plastic emulsion on board, 127 × 102 cm. (50 × 40⅛ in.)
PROV: Purchased from the artist, 1965.
EXH: Walker Art Gallery, 1965, *John Moores Liverpool Exhibition V* (3).

MORRISON, Robert Edward 1851/2 - 1924

Portrait painter, born Peel, Isle of Man. Came to Liverpool at 18 and employed as a house painter; at 21 became student at Liverpool School of Art where he gained the gold medal afterwards student at Heatherley's School, London, and the Académie Julian, Paris, under Bouguereau and Fleury. Settled in Liverpool and made successful career as painter of civic and other public figures. Also painted landscape as a recreation. Exhibited at Liverpool Autumn Exhibitions from 1881, Royal Academy, 1884–1911. President of the Liverpool Academy for ten years; member of the Liver Sketching Club, the Arts Club, London, and the University and Artists' Club, Liverpool. Died at Liverpool, 25 December 1924.

3005 Sir James Allanson Picton
Oil on canvas, 127 × 101·6 cm. (50 × 40 in.)
SIGNED AND DATED: *R. E. MORRISON/–89*
Sir James Allanson Picton, born 1805 and died on 15 July 1889. For biography see Boadle (3056). His *Memorials of Liverpool* (1873) lie on the table at his side with another volume.
PROV: Purchased from the artist, 30 October 1889.[1]
EXH: Walker Art Gallery, 1889, *Liverpool Autumn Exhibition* (not in cat.)
REF: 1 Old Register, p. 456.

7133 Sir David Radcliffe
Oil on canvas, 92 × 71 cm. (36¼ × 28 in.)
Sir David Radcliffe, J.P. (1834–1907), Mayor of Liverpool 1884–85 and 1885–1886. Born Yorkshire; railway engineer and business man in Liverpool. Conservative Councillor and Alderman; J.P., 1880; knighted by Queen Victoria on the occasion of the opening of the *Exhibition of Navigation*, etc., in Liverpool, 1886. Officer of the Legion of Honour, 1886. In the same year he presented the chain pendant for the use of future Lady Mayoresses in commemoration of Queen Victoria's visit to Liverpool in the 50th year of her reign.[1]
PROV: Transferred from City Estates Committee, 1968.
EXH: Walker Art Gallery, 1890, *Liverpool Autumn Exhibition* (986).
REF: 1 Press cuttings (Liverpool Record Office), and label.

7483 James Eckersley Reynolds
Oil on canvas, 127 × 106·8 cm. (50 × 42 in.)
SIGNED: *R. E. MORRISON*
James Eckersley Reynolds, J.P. (1831/2–1895) cottonbroker in the long established Liverpool firm of Reynolds, Gibson and Co.; a prominent Roman Catholic.[1] He was president of the Liverpool Club, 1889–91.
PROV: Acquired by Liverpool Record Office together with documents of his firm, 1963 transferred from Liverpool City Libraries, 1971
EXH: Walker Art Gallery, 1891, *Liverpool Autumn Exhibition* (229).
REF: 1 Press cuttings (Liverpool Record Office).

275 George Holt
Oil on canvas, 76·6 × 63·9 cm. (30 3/16 × 24 3/16 in.
SIGNED AND DATED: *R. E. MORRISON 1892*
George Holt (1825–1896), eminent Liverpool shipowner, collector and public benefactor. Eldest surviving son of George Holt (1790–1861), cotton broker and founder of the family fortunes in Liverpool, and Emma, daughter of William Durning of Liverpool (see Westcott 8710). A Unitarian family of Liberal views, the Holts made numerous benefactions to the city particularly in the field of education. The sitter served his apprenticeship with T. and J. Brocklebank, and in 1845 became a partner with W. J. Lamport with whom he founded the shipping firm of Lamport and Holt. Their

ships traded mainly with India, South Africa and the west coast of South America, and they were pioneers in the development of steamship services to Brazil in the 1850's. He was active in the shipping world, sat on the Dock Board, and was a Director of the Liverpool Globe Insurance. Married Elizabeth, daughter of Samuel Bright of Liverpool, 1862 (see Henry 241). J.P. 1864. He had wide interests mainly working in consort with his brothers, Philip, Robert (see Bigland 2584), and Alfred; he founded two Chairs at Liverpool University.

He formed a collection of English paintings, chiefly Victorian, but with a nucleus of important examples by Gainsborough, Turner and the Pre-Raphaelites, which was bequeathed to the City by his only child Emma, in 1945, with his residence, Sudley, Mossley Hill.

PROV: Commissioned from the artist (bill 26 February, 1892), and thence by descent; bequeathed to the City by Miss Emma Holt, 1945.
REF: 1 Press cuttings (Liverpool Record Office). 2 See the Gallery publication, *The Emma Holt Bequest, Sudley, Illustrated Catalogue and History of the House, 1971, passim.*

2166 J. G. Livingston

Oil on canvas, 127·5 × 102·5 cm. (50¼ × 40⅜ in.)
SIGNED AND DATED: *R. E. MORRISON 1893*
Alderman Joseph Gibbons Livingston, J.P. (1819–1901). Born Liverpool; a merchant in the China trade. Conservative Councillor from 1855; Alderman, 1868–93; J.P., 1866; Mayor of Liverpool, 1870–1.[1]

PROV: Presented to the sitter by subscribers 1893 and presented by him to the City.
EXH: Walker Art Gallery, 1893, *Liverpool Autumn Exhibition* (312).
REF: 1 Press cuttings (Liverpool Record Office).

753 Rev. Alexander Stewart

Oil on canvas, 223 × 153·7 cm. (87¾ × 60½ in.)
Alexander Stewart, M.A. (about 1826–1916), Rector 1870–1904, and Canon of Liverpool; Chairman of the Select Vestry.[1]

PROV: Presented to the sitter by the Select Vestry of Liverpool and by the sitter to the Vestry; transferred to the Gallery from the Parish Offices, 1928.

EXH: Walker Art Gallery, 1893, *Liverpool Autumn Exhibition* (110).
REF: 1 Press cuttings (Liverpool Record Office).

2569 Colonel William Hall Walker, afterwards Lord Wavertree

Oil on canvas, 71·8 × 56·2 cm. (28¼ × 22¼ in.)
SIGNED: *R. E. MORRISON*
William Hall Walker (1856–1933), Lord Wavertree; politician and sportsman. Third son of Sir Andrew Barclay Walker, the donor of the Gallery, he entered the family business of Peter Walker, Warrington, and Walker, Cain and Sons, Liverpool, brewers. City Councillor, 1900–1905; Conservative M.P. for Widnes, 1905–19; Deputy-Lieutenant for Lancashire; elevated to the peerage, 1919. He was a leading figure on the turf, won the Grand National with *The Soarer* in 1906, and gave his stud to the Government in 1916.[1]

He was active in the Volunteer movement and was Captain in the Royal Lancashire Militia Artillery, 1879 and Hon. Colonel 1897. He appears in the dress uniform of Hon. Colonel with the badge (inscribed R.L.M.A.) at the top left.[2] He was also Hon. Colonel of the 9th Battalion, the King's Regiment, of the 55th (West Lancs.) Divisional Royal Engineers, Liverpool, and of the Royal Field Artillery, Special Reserve, 1914–18.

He was Deputy-Chairman of the Arts and Exhibitions sub-committee for thirty-one years and always took a close interest in the Walker Art Gallery, to which he bequeathed his collection of sporting paintings and trophies, and other pictures, and a picture grant of £20,000.

See also H. C. Dickinson, 2666, Lynwood Palmer, 2629, and Sargent (after) 955.

PROV: Unknown, entered the Collection about 1933.
REF: 1 *Who's Who;* press cuttings (Liverpool Record Office). 2 Information from E. J. Priestley, Merseyside County Museums.

7006 Thomas Hughes, Lord Mayor of Liverpool

Oil on canvas, 127 × 101·8 cm. (50 × 40 in.)
SIGNED AND DATED: *R. E. MORRISON 1897*
Sir Thomas Hughes, J.P. (1838–1923), wearing

robes and chain of office as Lord Mayor of Liverpool. Born Liverpool; in business as a timber merchant. Elected to the Council as a Conservative, 1878; Mayor, 1889–90; Alderman, 1891; Lord Mayor, 1896–7. Freeman 1897 and knighted 1898. He was a pioneer in licensing reform.[1] A further portrait of the sitter by Morrison very similar in pose to 7006 was exhibited at the Liverpool Autumn Exhibition in 1890. See also 7138 below.

PROV: This or 7138 presented to the City by Miss Mounsey of Hoylake, 1961.[2] Transferred from City Estates Committee to the Gallery, 1967.

EXH: Walker Art Gallery, 1897, *Liverpool Autumn Exhibition* (1034); Royal Academy, 1898 (468).

REF: 1 Press cuttings (Liverpool Record Office). 2 Finance and General Purposes Committee Minutes, 27 September, 1961.

7138 Sir Thomas Hughes

Oil on canvas, 142 × 109 cm. (55⅞ × 42⅞ in.)
SIGNED AND DATED: *R. E. MORRISON 1907*
See 7006 for biography.

PROV: Painted at the request of the Justices of the City of Liverpool July 1907, and presented to the sitter. Transferred from City Estate Committee to the Gallery, 1967.

EXH: Walker Art Gallery, 1907, *Liverpool Autumn Exhibition* (103).

2681 Portrait of Elderly Man

Oil on canvas, 71 × 61 cm. (28 × 24 in.)
SIGNED: *R. E. Morrison*
PROV: Unknown.

1359 Sir William Bower Forwood

Oil on canvas, 92 × 71·8 cm. (36¾₆ × 28¼ in.)
Sir William Bower Forwood, K.B.E., D.L. J.P., (1840–1928), in the uniform of Deputy Lieutenant for Lancashire, and wearing the cross and star of the K.B.E.. For biography see the portrait by G. Hall Neale (3022).

An earlier portrait of the sitter by Morrison was exhibited at the Liverpool Autumn Exhibition, 1892.

PROV: Bequeathed by the sitter, 1928.

EXH: Walker Art Gallery, 1919, *Liverpool Autumn Exhibition* (166).

7011 Edward Russell-Taylor, Lord Mayor of Liverpool

Oil on canvas, 126·5 × 84 cm. (49¾ × 33 in.)
SIGNED AND DATED: *R. E. MORRISON 1921*
Alderman Edward Russell-Taylor, J.P. (1864–1939), in court dress and wearing the Jewel pendant, as Lord Mayor of Liverpool, 1920–21. Born Liverpool; architect and surveyor. Conservative Councillor from 1900; Alderman 1917.[1]

PROV: Presented to the sitter by members of the City Council, and presented by the sitter to the City, 1920. Transferred from Municipal Buildings to the Gallery, 1967.

EXH: Walker Art Gallery, 1921, *Liverpool Autumn Exhibition* (50).

REF: 1 Press cuttings (Liverpool Record Office).

MOSSES, Alexander 1793 - 1837

Portrait painter and engraver; son of George Mosses, a plasterer and stucco maker of Liverpool, who apprenticed him (from 1 October 1806; indenture dated 7 April 1807) to Henry Hole, the Liverpool engraver and pupil of Thomas Bewick. As Hole's apprentice, he appears to have been responsible for many of the engravings of local buildings in Troughton's *Liverpool*, 1810. According to a note by Joseph Mayer, he learnt colouring from (J.) Jenkinson, a Liverpool portrait, landscape and marine painter and his first exhibits at the Liverpool

Academy are landscape subjects. He exhibited there 1811–36, is listed as Member in 1822, Master of Drawing Academy, 1827, and Professor of Drawing, 1835. He introduced William Daniels (*q.v.*), whom he is said to have discovered, to the Drawing School. He painted many of the eminent local men of his day in small or full scale portraits and these and his genre subjects show his command of line and form and atmosphere, and his mature works echo the neo-classical tradition. He also painted some biblical subjects in the fashion of the day. His brother Thomas was also an engraver, resident in London. Several of his anatomical studies, sketches, studies for pictures, engravings and lithographs, and his indentures and some letters, acquired from his widow by Joseph Mayer, are in the Hornby Library, Liverpool City Library. He died Liverpool, 14 July 1837 aged forty-four, and the obituary notice in the *Liverpool Mercury* for the 21st reads: 'As an artist Mr. Mosses ranked high in his profession, and many of his portraits and sketches will long remind his friends of his premature loss.' A bust by his friend Edward Lyon, 1827, was with a descendant of the artist, 1939.

7634 Cottage Girl

Oil on panel, 9 × 7·5 cm. (3½ × 3 in.)
Presumably an early work.[1] A picture of this title was shown at the Liverpool Academy, 1813. The girl holds a basket of either faggots or possibly brimstone matches.

PROV: The Joseph Mayer Trust, Bebington; presented to the Gallery by Bebington Corporation, 1971.

EXH: Liverpool Arts Club, 1876 (35).

REF: 1 The Mayer Trust, *Handlist of Drawings, Prints, Sculpture,* etc., n.d. No. 21. However, it is just possible it might be No. 19, *Head of a girl* by (Joseph) Clover, whose style is not dissimilar, or No. 20, *Head of a girl* by (?Andrew) Hunt.

3063 Portrait of a Young Man

Oil on panel, 30·5 × 25 cm. (12 × 19¹³⁄₁₆ in.)
INSCRIBED on the back: *ALEXANDER MOSSES/A PORTRAIT.*

PROV: Purchased from R. Warner (dealer) London, 1926.

2980 Blind Howard and his Grandchildren

Oil on canvas, 147·3 × 122 cm. (58 × 48 in.); including 26·5 cm. (10 in.) strip at left side and narrow strips at top, right and lower edges as far as the join.

SIGNED AND DATED: *Alex. Mosses/1819*
Blind Howard was apparently an inmate of the Blind Asylum at Liverpool and the inventor of a method of weaving sash cords.[1] A new church for the Blind Asylum was consecrated in October 1819 and 2980 may be a topical allusion. The engraving (see below), illustrates a story by the author of 'Recollections of the Peninsula' which describes a perhaps imaginary encounter between him and the blind man.

ENGR: Edward Smith, for *The Winter's Wreath,* Liverpool and London, 1830; with slight variations in trees at left and more shading on the boy's face.

PROV: Painted for Thomas Kaye, Liverpool (d. 1865),[2] and thence to his niece, Miss Eleanor Cairns, who bequeathed it, 1903.

EXH: Walker Art Gallery, 1908, *Historical Exhibition of Liverpool Art,* (526).

REF: 1 A letter from Mosses to Joseph Mayer, giving this information was lent by the latter to the Mechanics Institute Exhibition, 1845 (cat. p. 21). 2 Founder and Proprietor of the *Liverpool Courier.* Information from Miss E. Cairns, niece of the donor, 1903.

3006 William Ewart

Oil on canvas, 143·5 × 111 cm. (56½ × 43¾ in.)
William Ewart (1763–1823), of lowland stock, settled in Liverpool and after working under Sir George Dunbar, merchant, set up his own firm of Ewart and Rutson, African, East Indian and general commission merchants. Married Margaret, daughter of Christopher Jacques of Bedale, near Northallerton. Father

153

of William Ewart, M.P. for Liverpool and later Dumfries, and Joseph Christopher Ewart, M.P. for Liverpool; a daughter Margaret married into the Gott family of Yorkshire. He was a close friend of John Gladstone who named his son William Ewart Gladstone after him. He died at Liverpool 8 October, 1823.[1]

A posthumous portrait, 3006 follows the pose of a print (head and shoulders only) published subsequent to the sitter's death.[2] The print reproduces in facsimile part of a letter from George Canning, 21 October, 1823: 'A more upright, honourable, right minded, and kind hearted man I do not know.'

An engraving exists by W. Holl after a half-length portrait (untraced).[3] A seated statue by Joseph Gott (1786–1860), 1832 is in the Mortuary Chapel, St. James's Cemetery, Liverpool. This was based on a bust also by Gott (possibly, that formerly in Leeds Institute), and on two prints, presumably those noted above.[4] The inscription describes Ewart as 'an intelligible, indefatigable and successful merchant, a virtuous and amiable man.'

PROV: W. E. Gladstone, who presented it to Liverpool, 1873.

EXH: Liverpool Academy, 1828 (107).

REF: 1 W. A. Munford, *William Ewart, M.P., 1789–1869*, 1960, p. 17; J. Morley, *The Life of William Ewart Gladstone*, 1903, I p. 7. 2 Anonymous: a copy in Liverpool Record Office. 3 Copy Liverpool Record Office. 4 M. R. D. Foot, edit., *The Gladstone Diaries*, 1968, I, pp. 510, 513, entries for 2 and 4 June 1832; T. Freeman and T. Stevens, *Joseph Gott*, Catalogue, 1972, pp. 24, 30.

7630 Expulsion of Adam and Eve

Oil on canvas,[1] 91·5 × 71·5 cm. (36 × 28⅛ in.)

One of the artist's rare biblical subjects, illustrating the lines from Milton's *Paradise Lost*, Book xii:

'In either hand the hastening angel caught
Our lingering parents, and to the eastern gate
Led them direct, from down the cliff as fast
To the subjected plain; then disappeared.
They, looking back, all the eastern side beheld
Of Paradise, so late their happy seat,
Wav'd over by the flaming brand.'

At the Liverpool Academy critics were not enthusiastic; one press review commented: 'Evidently hastily got up and not possessing all the qualities that might have been expected

had Mr. Mosses given the subject more attention. . . '. Another reviewer was damning: 'Behold an act of retributive justice, richly merited by such a pair as are here presented: the wonder is however they found their way into the garden of Eden at all, further, by what means, after being driven from thence, they gained access to their present snug domicile. Humanity would not suffer severely were they once more expelled – angel and all; – for a more effective burlesque on Mosses and Milton we have rarely gazed upon. Fallen, indeed, are these our first parents with a vengeance! Should Mr. M. again attempt to paint them, he would do wisely to study – as well as quote – the poet of Paradise a little, – and, in limning our common mother, remember that some trace should still be visible of those transcendent charms so profusely showered upon her by the Creator:–

Grace was in all her steps, heaven in her eye,
In every gesture dignity and love;

and the whole of these attributes Mr. Mosses has, with much laudable pains and success, expunged in this picture, to the utter astounding of unhappy Adam, who naturally enough, stands aghast at this incomprehensible metamorphosis. Face-making, however, and poetry are somewhat different things and your mere matter-of-fact Apollo is but a sorry companion for the Muses.'[2]

PROV: The Joseph Mayer Trust, Bebington,[3] presented to the Gallery by Bebington Corporation, 1971.

EXH: Liverpool Academy, 1829 (74) as *The Expulsion from Paradise*.

REF: 1 Canvas damaged and bituminous; restored 1973. 2 Press cuttings with catalogue (Liverpool Record Office). 3 Mayer Trust, *Handlist of Drawings, Prints, Sculpture*, etc. n.d., No. 16.

L263 Thomas Stewart Traill

Oil on canvas, 76·5 × 63·5 cm. (30⅛ × 25 in.)

Thomas Stewart Traill (1781–1862), M.D., F.R.S.E. Native of Kirkwall, Orkney; studied medicine in Edinburgh, where he returned in 1833 as Professor of Medical Jurisprudence.

He settled in Liverpool as a general practitioner, 1803. Appointed physician to the Ophthalmic Infirmary; published articles on medicine and on art (he was probably the reviewer of the 1827 Liverpool Academy in

the *Mercury*); lectured widely, and became an important figure in the cultural life of the town. He swam the Mersey in his youth; married a widow with five young sons, and appeared at a fancy dress ball in 1821 'in the classical garb and helm of Epaminondas.' Later he was the editor of the 8th edition of the *Encyclopaedia Britannica*. He died at Edinburgh 30 July 1862.

He was Professor of Anatomy to the new Liverpool Academy, 1810–14; a prime mover in the formation of the Literary and Philosophical Society, 1812 and its first Secretary 1812–32. He was intimately associated with the foundation of the Liverpool Royal Institution, 1814, of which he was a Vice-President in 1825 when he organised the preparatory meetings to found a Mechanics Institute (later Liverpool Institute School), and addressed the preliminary meeting in June 1825. For it he gave the initial course of lectures on Chemistry that year and was elected President in 1827.[1]

Mosses exhibited a portrait of Traill at the Liverpool Academy of 1822 (untraced), and a small three-quarter length with his books and instruments, in 1827 (Scottish National Portrait Gallery ($19\frac{3}{4} \times 16\frac{1}{4}$ in.); he also showed a portrait at the Manchester Royal Institution in 1830. The present portrait was recorded as painted for the Mechanics Institute at the time of its presentation:[2] the sitter looks rather older than the 1827 portrait, but younger than the portrait by Lonsdale of 1833 (9138 in the Collection), and it might be that shown at Manchester.

Two other portraits are recorded: by Jeremiah Steele, Liverpool Academy, 1811; and by John Turmeau, miniaturist, Liverpool Academy, 1811. Three sculptures are known: by Solomon Gibson, Liverpool Academy, 1824; by Edwin Lyon, modelled for the Mechanics School of Art, Liverpool Academy, 1828; and by Joseph Deare, Liverpool Academy, 1834. Plaster casts of two of these are in the Collection (6949, 6960). A further group portrait is recorded.[3]

PROV: (?) Painted for the Mechanics Institute; presented by Mrs. Mosses, widow of the artist, 1842; lent by the Liverpool Institute School, 1975.

EXH: Possibly Liverpool Mechanics Institute Exhibition, 1840 (205); the same 1844 (22).

REF: 1 DNB; *Gentleman's Magazine*, 1862, ii, p. 372; J. A. Picton, *Memorials of Liverpool*, 1873, I, p. 456, II, p. 292; T. Bickerton, *A Medical History of Liverpool . . .*, 1930, p. 72, 74–5; H. J. Tiffen, *History of Liverpool Institute Schools*, 1935, pp. 21–23, 135, 168, repr. p. 21; Literary and Philosophical Society, 1862, p. 3; Liverpool Institute, *38th Annual Report*, 1863, p. 8. 2 Liverpool Mechanics Institute, MS, *Minutes*, 3 October 1842 (Liverpool Record Office); Tiffen, *op. cit.*, p. 168. 3 Information from Miss S. Bruce Lockhart, Scottish National Portrait Gallery, January 1976.

7032 Thomas Brancker, Mayor of Liverpool

Oil on canvas, $238 \cdot 8 \times 147$ cm. ($94 \times 57\frac{7}{8}$ in.)

Sir Thomas Brancker (1783–1853), in his robes of office as Mayor of Liverpool, 1830–31. A sugar refiner, member of a merchant family of long standing in Liverpool and eldest son of Peter Whitfield Brancker (see Allen 9055). J.P. Elected to the Common Council 1823; bailiff 1824 and 1826; he was knighted by William IV on 13 September 1831 on the occasion of the presentation of an address on the coronation. He afterwards left the Council and was appointed Receiver of the Town Dues.[1]

Mosses received much praise at the opening dinner of the Liverpool Academy in 1831, at their new rooms in Church Street. This was reported in the Liverpool *Mercury* and the *Kaleidoscope*, the former commenting: 'We congratulate our townsman, Mr. Mosses on the prominent place which has been assigned to his excellent portrait of our present Mayor, which was very generally complimented, at the opening dinner of the Liverpool Academy, in the warmest terms of praise.' Both papers quoted the congratulatory speech of Mr. James Brancker (brother and business partner of the sitter): 'It was a proud distinction for Liverpool to be possessed of a man capable of painting such a picture. He had seen many capital works of the kind, but he never met with one fit to be compared with that. He trusted the successors to their worthy Chairman, the Mayor, would feel it a part of their office, and all their friends and relatives deem it their duty, to continue to afford the artists of this town the opportunities of celebrating themselves. So long as the town could produce such an artist, they had no occasion to go abroad to seek strangers. . .'[2]

PROV: Presented to Liverpool by James

Brancker, October 1834,[3] and hung in the Town Hall.

EXH: Liverpool Academy, 1831 (1).

REF: 1 J. Picton, *Memorials of Liverpool*, 1873, I, p. 510; *Liverpool Courier*, 3 June 1903 (press cuttings, Liverpool Record Office); J. Touzeau, *The Rise and Progress of Liverpool*, 1910, II, p. 869; MSS material on the Brancker family (photocopies Liverpool Record Office). 2 *The Kaleidoscope*, 23 August 1831, p. 477; *Liverpool Mercury*, 1831, p. 262. 3 Council Minutes, 1 October 1834, reprinted in Touzeau, *loc. cit.*; *Inventory of Furniture in the Town Hall*, 1835 (Liverpool Record Office).

3122 The Savoyard

Oil on panel,[1] 38 × 28 cm. (15 × 11 in.)

A picture called *The Hurdy Gurdy* was deposited in the 3rd Exhibition of the Mechanics Institute, 1844, by John Foster, which might be the present picture. A version of the boy and monkey was sold Sotheby's (Belgravia) 14 June 1974 (repr.).

PROV: John Elliot by 1908, and bequeathed by him, 1917.

EXH: (?) Liverpool Academy, 1832 (14); Walker Art Gallery, 1908, *Historical Exhibition of Liverpool Art* (789); Harrogate, 1924, *Liverpool School of Painters* (51); Walker Art Gallery, 1960, *Liverpool Academy 150th Anniversary Exhibition* (34).

REF: 1 Label of Rowney and Forster, Rathbone Place, London: Flemish Ground Panel Boards.

3124 The Shrimper

Oil on panel, 23 × 18.5 cm. (9⅛ × 7¼ in.), incorporating a wood strip 2 cm. (⅝ in.) on top edge.

SIGNED AND DATED: *Alexr. Mosses/1831*

In the background is the estuary of a river, perhaps the Dee, with fishing boats on the shore. A pencil sketch of similar fishing boats on a different stretch of shore, signed and dated 1823, is in the Hornby Library.

PROV: John Elliot by 1908, and bequeathed by him, 1917.

EXH: Liverpool Academy, 1832 (30), 15 gns.; Walker Art Gallery, 1908, *Historical Exhibition of Liverpool Art* (145); Harrogate 1924, *Liverpool School of Painters* (32); Walker Art Gallery, 1960, *Liverpool Academy 150th Anniversary Exhibition* (35).

3123 The Sculpture Boy

Oil on panel, 24.5 × 20.5 cm. (9⅝ × 8⅛ in.) incorporating 2 cm. (⅝ in.) strips on left right and lower edges.

The boy rests on an embankment on the outskirts of a town; he holds a large plaster statuette of Cupid between his knees and smaller statuette of putti stand on the bank his side. The picture may be identified with either *The Italian Boy*, Liverpool Academy 1834 (38), or *The Image Boy*, Liverpool Academy 1835 (90).

PROV: Presented by John Elliot in memory of Charles Lear, 1905.

EXH: Walker Art Gallery, 1908, *Historical Exhibition of Liverpool Art* (513); Harrogate 1924, *Liverpool School of Painters* (33).

MOSSES, Alexander

Change of Attribution, see CROSTHWAITE, S. 2570 G. P. Day, Liverpool Newsman.

NEALE, George Hall, active 1883 - 1940

Portrait and genre painter. Born Liverpool, son of a corn merchant. Studied at Liverpool School of Art and in Paris under Laurens and Constant. His earliest works were genre but he later concentrated on portrait painting. Exhibited at the Liverpool Autumn Exhibition from 1883 and the Royal Academy from 1891; also at the Royal Society of Portrait Painters. A President of Liverpool Academy. Married Maud Rutherford, also a portrait painter (q.v.): frequently she would paint the wife of his sitter. Moved to London about 1914 but retained a studio in Liverpool. Died London 27 April 1940, around seventy years of age.

6 First steps

Oil on canvas, 91·6 × 117·3 cm. (36$\frac{1}{16}$ × 46$\frac{3}{16}$ in.)

SIGNED: *G. H. NEALE*

The *Magazine of Art* commented that the artist 'has happily invented a strongly domestic subject.'[1]

PROV: Bequeathed by G. H. Ball, 1917.

EXH: Walker Art Gallery, 1888, *Liverpool Autumn Exhibition* (1194) repr.

REF: 1 *Magazine of Art,* 1888, p. iii.

195 Sir Edward Russell, afterwards Lord Russell

Oil on canvas, 143 × 101·5 cm. (56$\frac{1}{4}$ × 40 in.)

SIGNED AND DATED: *G. HALL NEALE 1908*

Edward Richard Russell (1834–1920), editor of the *Liverpool Daily Post*. Born London and largely self-educated; after a varied early career turned to writing and became editor of the *Islington Gazette*. In 1860 came to Liverpool as assistant editor to Michael Whitty (see Bishop 3002) on the *Liverpool Daily Post* where he rapidly proved himself of outstanding ability and in 1869, following a break as leader writer on the *Morning Star,* was appointed editor, which post he retained for forty-six years.

A noted public figure, Liberal in politics, and an M.P. for Glasgow 1885–87, he was knighted in 1893 and elevated to the peerage as Lord Russell of Liverpool, 1919. Life member of the Court of Liverpool University; Life Governor of University College, Aberystwyth; Treasurer of the Newspaper Press Fund; first President of the Liverpool Reform Club, 1879. His writings included various volumes of reminiscences, religious subjects, and theatrical criticisms, in which he showed an early appreciation of Henry Irving.[1] Various records and papers are in the Liverpool Record Office.

A portrait by G. A. Mackenzie was exhibited at the Liverpool Autumn Exhibition in 1893, repr., and another by Hall Neale in 1904 (1146) repr. A portrait of his second wife is 7196 below.

PROV: Presented to Lady Russell by the Liverpool Reform Club; thence by descent to the sitter's step-grand-daughter, Miss J. McFarlane, who presented it and 7196, 1970.

EXH: Walker Art Gallery, 1908, *Historical Exhibition of Liverpool Art* (598), and 1908, *Liverpool Autumn Exhibition* (52) repr.; Royal Academy, 1909 (671).

REF: 1 Press cuttings (Liverpool Record Office); B. Orchard, *Liverpool's Legion of Honour,* 1893, pp. 605–611.

3014 W. J. J. C. Bond

Oil on canvas, 118 × 91·8 cm. (46$\frac{1}{2}$ × 36$\frac{1}{8}$ in.)

SIGNED: *G. HALL NEALE*

INSCRIBED: *W. J. J. C. BOND*

The Liverpool Artist *(q.v.).* The portrait was accepted on behalf of the City by the Lord Mayor (Dr. Caton) at a ceremony at the Town Hall on 12 October, 1908; the artist was not present.[1]

PROV: Presented by Subscribers (Sir John Gray Hill, R. C. Beazley, Alfred Booth, John Elliot, T. Rowland Hughes, Mrs. George Rae, Miss Rae, Mrs. Edward Rae, G. Bentham Rae, Edward Rae & Sons), 1908.

EXH: Walker Art Gallery, 1908, *Liverpool Autumn Exhibition* (not in catalogue).

REF: 1 Commemorative booklet in Gallery files; *Liverpool Daily Post,* 13 October 1908, with repr.

7595 Edward Lewis Lloyd

Oil on canvas, 101·4×76·5 cm. (39⅞×30⅛ in.)
SIGNED AND DATED: *G. HALL NEALE/ 1909*

Alderman Edward Lewis Lloyd, J.P. (1858–1910); Liverpool solicitor; Councillor, 1895; Alderman, 1907; Chairman of the Liverpool Corporation Tramway Finance and Traffic Sub-Committee.[1]

PROV: Presented to the sitter by the Tramway employees of the Corporation on the occasion of his silver wedding, 1909; thence to Miss Doris Lloyd, daughter of the sitter, who left a life interest in it to Miss Olive Caldecott; passed from thence to the Corporation, 1971.

REF: 1 Press cuttings (Liverpool Record Office).

3022 Sir William Bower Forwood

Oil on canvas, 127·5×101 cm. (50¼×39¾ in.)
SIGNED: *G. HALL NEALE*

Sir William Bower Forwood, K.B.E., D.L., J.P. (1840–1928), in the uniform of Deputy Lieutenant for Lancashire. Born Liverpool; merchant, cotton broker and shipowner, active in public life. Conservative Councillor from 1868; Alderman, 1877; Mayor, 1880–81 and Lord Mayor January to February, 1903; appointed J.P. for Liverpool, 1875 and for Lancashire, 1883. Knighted, 1883. Chairman of the Library, Museum and Arts Committee, 1890–1908. Hon. Freeman of Liverpool, 1902. Appointed Deputy Lieutenant for Lancashire, 1902; High Sheriff for Lancashire, 1910; K.B.E., 1917. He was a pioneer in the scheme for the Mersey Tunnel and a Founder of Liverpool Cathedral.[1]

See also the portrait by Morrison. A bronze bust by E. Whitney Smith is also in the Collection.

PROV: Presented by the sitter, 1917.

EXH: Walker Art Gallery, 1907, *Liverpool Autumn Exhibition* (84) repr.

REF: 1 W. B. Forwood, *Recollections of a Busy Life*, 1910, passim, and *Incidents in My Public Life, 1840–1925*, 1926, passim; B. Orchard, *Liverpool's Legion of Honour*, 1893, pp. 307–9; press cuttings (Liverpool Record Office).

89 Self Portrait

Oil on canvas, 76×63·2 cm. (29⅞×24⅞ in.)
SIGNED: *G. HALL NEALE*

PROV: Bequeathed by Mrs. Hall Neale, 1956.

EXH: Paris Salon (Société des Archives Français), 1932 (1795) repr. (Silver Medal).

NEALE, Maud Hall, active 1889 - 1938

Portrait painter. Born Waterloo, near Liverpool, daughter of William Rutherford. Wife of George Hall Neale (*q.v.*). Studied under Délécluse, Paris. Exhibited London, Liverpool, etc.

7196 Lady Russell

Oil on canvas, oval, 123×98 cm. (48½×38½ in.)
Jean Stewart, Lady Russell (1853–1927), (née Macdonald), widow of Joseph McFarlane and second wife of Sir Edward, later Lord Russell, (see 7195 above), whom she married in 1902.

PROV: J. Alexander McFarlane, and by descent to Miss J. McFarlane, who presented it, with 7195, in 1970.

EXH: Walker Art Gallery, 1906, *Liverpool Autumn Exhibition* (872), and 1908, *Historical Exhibition of Liverpool Art* (579).

2571 James Maury

Oil on canvas, 91·4×71 cm. (36×28 in.)

James Maury, of Virginia (1746–1840) settled in Liverpool as a merchant in the Virginia trade about 1786. He was the first American Consul in Liverpool until 1829, and the first President of the American Chamber of Commerce in Liverpool, 1801–2.[1]

He wrote to his friend Thomas Jefferson from Liverpool on 17 September 1786: 'I am lately arrived here and settling in the Virginia Business... Almost ever since you left America have I been waiting for the Consular arrangement to take place, til at length I became quite tired of remaining in Suspense and came out. My friends in Congress, however, still assure me I am continued on the list of Candidates and that if the Business should come on the Tapis during their being in office, they will attend as much to my Interest as if present. If in the Course of your Correspondence it occur, you'll much oblige me by putting our friends in Mind of me. London is my first object, and if this cannot be had, it would be a secondary one to be appointed for this place in the Sub class. This is now become the second port in Britain for Trade in General or with America in particular. I beg the favor of you to inform me if Mr. Adams has power to make any temporary appointments in this Line...'[2] Jefferson added a rider to his letter from Paris of 20 December to John Adams (the British envoy, 1785–88): 'Should a Mr. Maury of Virginia, but now a merchant of Liverpool, present himself to you, I recommend him to your notice as my old schoolfellow, and a man of the most solid integrity'.[3]

Maury first appears in the Liverpool Directories as Consul, in 1796.[4] According to his grandson[5] he was appointed by George Washington (President of United States, 1789–96). In 1825 his portrait was presented to the American Chamber of Commerce; the artist was probably chosen because he was also an ex-patriot American. A testimonial signed by fifty-one subscribers accompanied the portrait: 'This portrait of James Maury, Esq., Consul from the United States of America for the Port of Liverpool and its Dependences, Painted by G. S. Newton, was presented to the American Chamber of Commerce, on the 1st January 1825 by several members of it whose names are here recorded in Testimony of their Esteem for the Integrity of Feeling, the impartial steadiness of Principle, the conciliating Manners and domestic Virtues, which have distinguished his public and endeared his private character, during a residence in Liverpool of over forty years.'[6]

He had three sons of whom William followed him in the American Chamber of Commerce.[7] On his retirement to America c. 1829, he was presented by the Chamber with a large service of plate.[8] A copy of 2571 painted for a son was, in 1908, in the possession of his grandson James F. Maury.[9]

ENGR: Richard Lane (lithograph), published Hullmandel.

PROV: Presented by subscribers to the American Chamber of Commerce in Liverpool, 1825; presented to the Gallery by Sir John Gray Hill on behalf of the Chamber, October 1908.

EXH: Walker Art Gallery, 1907, *700th Anniversary of Liverpool*; Walker Art Gallery, 1976–7, *American Artists in Europe* (44), repr. plate 16.

REF: 1 W. O. Henderson, *The American Chamber of Commerce in Liverpool*, in *Transactions of the Historic Society of Lancashire and Cheshire*, Vol. 85, 1933, pp. 2, 6, 56, repr. p. 2; G. J. Duncan, *Brief Sketch of the American Chamber of Commerce from its Foundation in 1801*, 1859; papers of the Chamber in Liverpool Record Office. 2 J. P. Boyd, etc., edit., *Papers of Thomas Jefferson*, 1950–55, Vol. 10, pp. 387–8. 3 *Op. cit.*, p. 619. 4 In 1790 he is still described as *Merchant*. 5 J. F. Maury to J. N. Stolterfoht, Jnr., letter 27 August 1908, copy in Chamber *Minutes* (Liverpool Record Office). 6 Sir John Gray Hill, letter to *Liverpool Courier*, 21 February 1908; then in his possession. 7 Henderson, *loc. cit.* 8 J. F. Maury, letter, *loc. cit*; tray with Anne Fontaine Maury Hirschfeld, Florida, 1974. 9 Repr., A. F. M. Hirschfeld, *Intimate Virginia*, 1941, frontispiece.

NEWTON, John Edward 1834/5 - 1891

Landscape and still life painter, using technique of photographic minuteness. Worked i Liverpool and exhibited at Liverpool Academy 1856–67; Associate, 1857; Member, 1859 Exhibited at the Royal Academy 1862–81 and at the Society of British Artists, Suffolk Street Member of the New Watercolour Society. Moved to London about 1866/7 and sought t improve his pictures by broadening his style. Settled at Kingston-on-Thames by 1874 an buried there 10 March 1891.

6250 Mill on the Alleyn, Denbighshire
Oil on canvas, 30·5 × 36·8 cm. (12 × 14½ in.)
SIGNED: *J. Newton*
This is not the mill at Gresford itself[1] and has not been identified.
PROV: Purchased from Liverpool Academy Exhibition, 1861 by George Rae, £21;[2] by descent to Mrs. Sonia Rae, from whom purchased, 1964.

EXH: Liverpool Academy, 1861 (198), 20 gns. Royal Academy, 1862 (625); Whitechapel, 1905 *British Art Fifty Years Ago* (291); Walker Ar Gallery, 1908, *Historical Exhibition of Liverpoo Art* (808).
REF: 1 As supposed in H. C. Marillier, *Th Liverpool School of Painters,* 1904, p. 180 2 Liverpool Academy Purchase Book (Liverpoo Record Office.).

NORBURY, Richard 1815 - 1886

Portrait, landscape and historical painter. Born Macclesfield, 24 July 1815, son of a silkman resident in Liverpool. Student at the Royal Academy Schools and exhibited there 1852–78 Exhibited at Liverpool Academy from 1843 and at the Liverpool Autumn Exhibition 1871–84. Member of Royal Cambrian Academy, and President of Liverpool Watercolou Society. Died 25 April 1886. Several of his children were artists.

2572 Hugh Shimmin
Oil on panel, painted oval, 40 × 27·3 cm. (15¾ × 10¾ in.)
Hugh Shimmin (1819–1879), journalist and philanthropist in Liverpool. Self-educated, took advantage of the evening classes of the Mechanics Institute, and a member of the Mental Improvement Society. Apprenticed to a bookbinder and became a master bookbinder, and at the same time wrote for local papers and

eventually became editor and proprietor o *The Porcupine.* He became an important publi figure noted for his iconoclastic and forthrigh opinions and criticisms, and his crusade fo social and sanitary reforms in Liverpool.[1]
PROV: Presented by Mrs. Shimmin, 1896.
EXH: (?) Liverpool Academy, 1862 (835).
REF: 1 Obituary notices (Liverpool Recor Office).

OAKES, John Wright 1820 - 1887

Landscape painter. Born Middlewich, Cheshire, 9 July 1820. His family settled in Liverpool and he was apprenticed to a house-painter. Received some lessons from W. J. Bishop, with whom always a close friend and sketching companion. First exhibited Liverpool Academy, 1839; admitted as Student to the Schools, 25 April 1845; elected Associate 1847, by which time he had given up house painting; Member, 1850; Secretary, 1853–4; retired 1859. Exhibited R.A. from 1847; moved to London 1855; elected Associate of the Society of Painters in Watercolours, 1874, resigned 1875; elected A.R.A., 1876. His subjects were usually Welsh or Scottish scenery with some Swiss views—the result of a foreign tour. Some early exhibited works were painted on glass, a technique he may have learnt from W. J. Bishop.

L46 Morecambe Bay
Oil on board, 23·5 × 46·5 cm. (9¼ × 18¼ in.)
PROV: Daisy Munn, and thence by descent to Miss Margaret Anne Munn, who bequeathed it to Wallasey, 1946; lent by Wallasey Corporation, 1971.

2704 A North Devon Glen – Autumn
Oil on canvas, 124 × 167 cm. (48¾ × 65¾ in.)
SIGNED AND DATED: *J Oakes/70* (initials in monogram).
Exhibited at Liverpool 1872 with the following quotation in the catalogue:
‘. laying here and there,
A fiery figure among the leaves.’
PROV: Purchased from the artist, *Liverpool Autumn Exhibition*, 1872.
EXH: *Liverpool Autumn Exhibition*, 1872 (31); Leeds, 1889; Harrogate, 1924, *Liverpool School of Painters* (39).

410 Morning at Augera, Lago Maggiore
Oil on canvas, 88·9 × 127·3 cm. (35 × 50⅛ in.)
SIGNED AND DATED: *J W Oakes/186(5 or 6)* (initials in monogram)
The line attached to the fishing net, centre, has been formed into the artist's initials, *J W O*.
PROV: John Elliot, who bequeathed it, 1917.
EXH: Royal Academy, 1866 (515); Harrogate, 1924, *Liverpool School of Painters* (9); Wembley, 1924, *Liverpool Civic Week*.

8188 The Tivey at Newcastle Emlyn, Cardiganshire
Oil on canvas, 90 × 128 cm. (35⅝ × 50¾ in.)
SIGNED AND DATED: *J W Oakes 78* (initials in monogram)
PROV: W. A. Musgrove, who presented it to Hale Urban District Council; presented by them, 1972.

OLIVER, Charles William, living artist

1489 In a Kitchen
Oil on board, 60·8 × 75·8 cm. (24 × 29⅞ in.)
SIGNED AND DATED: *C. W. OLIVER 1955*
PROV: Presented by John Moores, 1958.
EXH: Walker Art Gallery, 1955, *Liverpool Academy Open Exhibition* (61).

149 Frederick Arthur, 16th Earl of Derby, as Lord Mayor of Liverpool

Oil on canvas, 168 × 232·8 cm. (66⅛ × 91⅝ in.)

SIGNED AND DATED: *W.Q.O. /97*

The Right Hon. Frederick Arthur Stanley (1841–1908), 16th Earl of Derby, K.G., P.C., G.C.B., G.C.V.O., J.P., LL.D. Second son of the 14th Earl; raised to the peerage 1886, as Lord Stanley of Preston; succeeded his brother the 15th Earl, 1893. In robes as Lord Mayor of Liverpool, 1895–96 (the first Lord Mayor of Greater Liverpool). First Chancellor of Liverpool University from 1903; Freeman of Liverpool, 1904; Lord Lieutenant for Lancashire from 1897; M.P. in turn for Preston, North Lancashire and Blackpool, 1865–86; held many political offices and was Governor General of Canada, 1888–93. Revived the family interest in horse racing.

His portrait was also painted by Herkomer, 1897; a monument by Pomeroy of 1911 is in St. George's Hall, the statuette of which is in the Gallery (Nos. 7821 and 4124 in the Collection); a bust by Goscombe John is at Preston.

PROV: Presented by Subscribers to the sitter, who presented it to the City of Liverpool, 1897.

EXH: Walker Art Gallery, 1897, *Liverpool Autumn Exhibition* (1044); Society of Portrait Painters, 1908–9.

ORCHARDSON, William Quiller, After

3016 Sir Andrew Barclay Walker, Bart.

Oil on canvas, 133·3 × 193 cm. (52½ × 76 in.)

Sir Andrew Barclay Walker, Bart. (1824–1893), brewer and donor of the Gallery. Copy after the portrait exhibited at the Royal Academy, 1891, which gained favourable reviews in the press[1] (Coll: Sir Ian Walker Oakeover).[2]

The sitter was of Scottish descent, son of Peter Walker of Ayr who founded the family firm, moved to Liverpool, and erected a brewery at Warrington, 1846. The sitter became sole proprietor and enormously expanded the business, having eventually over two hundred houses in Liverpool and district with breweries at Warrington and Burton on-Trent.

He also had colliery property in South Wale and Ayr.

Entered the Town Council as a Conservative 1867; Alderman, 1872–1889 (retired); Mayo 1873–4 and 1876–7. A High Sheriff of Lanca shire. He announced his intention of buildin and presenting an art gallery to the tow during his first term of office as Mayor and was opened during his second, when th occasion was made a public holiday, wit trades processions, fireworks and a grea banquet. In recognition he received a knight hood. In 1882 he paid for the extension to th gallery. Created baronet, 1886. Freeman, 189 His other public benefactions included a Engineering School for the University. H residences were at Gateacre Grange, nea Liverpool, and Osmaston Manor, Derbyshire

Also in the collection is an over-life-si statue by John Warrington Wood, and further portrait (see British School 7198 A group portrait by John Davies, a full lengt portrait, and a bust by Warrington Woo belong to Allied Breweries Ltd. See als Sargent (after), *Colonel Hall Walker (Lor Wavertree)*.

PROV: Presented by Lord Wavertree, son of th sitter, 1927.

EXH: Walker Art Gallery, 1927, *Liverpoo Autumn Exhibition* (243).

REF: **1** *The Magazine of Art*, 1891, p. 254, an p. iii. **2** Repr. *Country Life*, 12 March 1964 p. 570, fig. 5. **3** Press cuttings (Liverpoo Record Office).

After ORPEN, William 1878 - 1931

017 Edward, 17th Earl of Derby, as Lord Mayor of Liverpool

Oil on canvas, 117·5×94·5 cm. (46¼×37¼ in.)

The Right Hon. Edward George Villiers Stanley (1865–1948), 17th Earl of Derby, K.G., P.C., G.C.B., G.C.V.O., C.B., J.P. succeeded 1908. Wearing the chain of office as Lord Mayor of Liverpool, 1911–12. Copy of the portrait presented to him by Liverpool citizens and exhibited at the *Liverpool Autumn Exhibition*, 1912. He was M.P. for West Houghton, 1892–1908, and held various political posts including Postmaster-General, 1903–; finally retired from politics, 1924. Succeeded his father as Chancellor of Liverpool University; Freeman of Liverpool 1912. His local interests included chairmanship of the Liverpool Chamber of Commerce, 1910–43; chairmanship of the Cotton Growing Association, and the Cathedral Building Committee. Lord Lieutenant for Lancashire from 1928. A keen racehorse owner.

His portrait was also painted by Copnall, Gunn, Halliday, Lavery and Llewellyn.

PROV: Presented to the City by the sitter. Transferred from the City Estates Committee to the Gallery, 1968. Hung in the Town Hall.

OULESS, Walter William 1848 - 1933

573 Andrew George Kurtz

Oil on canvas, 61·3×51 cm. (24⅛×20⅛ in.)

SIGNED AND DATED: *WWO/1877*

Andrew George Kurtz (1825–1890), prominent in the chemical industry at St. Helens and art and autograph collector. The son of Andrew Kurtz (d. 1846), native of Reutlingen in Wurtenburg, chemist and founder of their company in the alkali trade. The sitter was sent to complete his training in chemistry in Paris and succeeded to the business at 21 years of age, and built up a great undertaking. His philanthropic activities included the provision of the first public baths at St. Helens and the Cottage Hospital. His collection of contemporary works of art by Leighton, Millais, Linnell, Bonheur, etc., was often open to the public at his home, Grove House (later Dovedale Towers), Wavertree, where he also held musical soirees. He presented Dicksee's *Ideal Portrait of Lady Macbeth*, and Leighton's *Elijah* to the Gallery in 1878 and 79, and Millais's *Martyr of the Solway* was also from his collection. He bequeathed his collection of autograph letters to the British Museum.[1]

PROV: J. A. E. Rayner (United Alkali Co. Ltd.), son of Susannah Kurtz, sister of the sitter,[2] who bequeathed it, 1925.

REF: 1 D. W. F. Hardie, *A History of the Chemical Industry in Widnes*, 1950, pp. 24, 218–9, 231; T. C. Barker and J. R. Harris, *A Mersey subtown of the Industrial Revolution: St. Helen's 1750–1900*, 1954, pp. 233, 320, 382, 464; *Athenaeum*, 12 September 1885; A. N. L. Mundy, *Cult of the Autograph letter in England*, 1962, p. 71; his executors' sale took place at Christie's, 9–11 May 1891, 2 Hardie, *loc. cit.*, p. 231.

PAICE, Philip Stuart 1884 - 1940

Landscape painter and teacher. Settled in Merseyside from Canada and U.S.A., about 192c
Art master at the Birkenhead Institute. Member and a President of the Liver Sketching Clul
Exhibited London and Liverpool. Lived at Rock Park, Birkenhead.

411 Rock Ferry, Cheshire
Oil on canvas, $51 \times 60 \cdot 8$ cm. ($20\frac{1}{16} \times 24$ in.)
SIGNED: *Philip S. Paice*
H.M.S. Conway is lying off-shore. (Launched
as a battleship as H.M.S. Nile in 1839, in 1876
she became the third Merchant Navy training-
ship Conway in the Mersey. John Masefield
published a biography on *The Conway* in 1933
and in July 1937 she was due for repair and
refitting after a long interval. She moved to th
Menai Straits in 1941 and grounded an
broke-up there in her move back to the Merse
for another refit in 1959).
PROV: Purchased from the artist, 1937.
EXH: Royal Academy, 1937 (482); Walker A
Gallery, 1937, *Liverpool Autumn Exhibitic*
(73).

PALMER, Lynwood 1866/7 - 1941

**2629 Colonel William Hall Walker, M.P.,
on Buttercup**
Oil on canvas, $152 \cdot 5 \times 189$ cm. ($60 \times 74\frac{1}{2}$ in.)
SIGNED AND DATED: *Lynwood Palmer 1913*
For biography see Morrison 2569. Colonel
Walker rode Buttercup (by The Baron) in
1910 to win the House of Commons Light-
weight Point-to-Point Steeplechase at Epping.
In that year he undertook the management of
the Cheshire Hounds. In 1915 he was elected
a Member of the Tarporley Hunt Club and the
green collar of the club has been added to the
painting.[1] A coloured mezzotint by Richard
Smythe, dating from before the alteration,
also in the collection.[2]
 Colonel Walker (later Lord Wavertree) al
bequeathed eleven other paintings of h
horses by Lynwood Palmer to the Gallery.
PROV: Bequeathed by Lord Wavertree, 1933
EXH: Walker Art Gallery, 1913, *Liverpo
Autumn Exhibition* (46); Arley Hall, 196
Bicentenary ball of the Tarporley Hunt Club
REF: 1 J. G. Ferguson, in letter 29.11.196
2 See also George A. Fothergill, *Given to t*
Nation: The Tully Stud, 1916, frontispiece.

PARTRIDGE, John 1790 - 1872

2981 John Gibson
Oil on canvas, $142 \cdot 2 \times 111 \cdot 7$ cm. (56×44 in.)
Bituminous in large areas of the figure and
background.
 John Gibson (1790–1866), sculptor, settled
at Rome. For biography see Geddes 2944.
 Dated 1847 in Partridge's manuscript lists.[1]
He had made a pencil portrait of Gibson as a
much younger man presumably during h
visit to Italy in the 1820's,[2] and the prese
portrait may have arisen out of a renewal
their acquaintance in London. Partridge w
Portrait Painter Extraordinary to Quee
Victoria and the Prince Consort.
 The sculptor is shown standing with h
modelling tools by a terracotta model for th

fe-size statue of Queen Victoria, commissioned
y the Queen and the cause of his first return
isit to England in the summer of 1844[3]
Buckingham Palace; replica at Osborne). She
nd the Prince Consort wished to have it like
Greek statue with classical draperies and
ie gave the sculptor sittings at Windsor at
aat time. He mentions that he had completed
ie full-scale model at Rome by mid-1845
nd it was the normal practice amongst
culptors first to make a smaller model. The
atue itself was shown at the Royal Academy
f 1847, which would make the theme of this
ortrait topical, in particular because the partial
nting of the marble, a new departure of
ibson's in which he reverted to the Greek,
roused much criticism, though the royal
ouple were perfectly satisfied. The artist
resented a replica of the head to Liverpool
234 in the Collection).

PROV: John Partridge, Executors' sale Christie's,
15.6.1874 (67), bt. Agnew, £27.6.0; presented
by Messrs. Thomas Agnew, 1877.
EXH: ? Liverpool Academy, 1852 (304);
National Portrait Exhibition, 1868 (589),
photographed; Liverpool, 1902, *Welsh
Industries*.
REF: 1 *Pictures in my House and Gallery in 1863*,
No. 68, and *Pictures in my Gallery, 1870*, added
after No. 97 (National Portrait Gallery Arch-
ives). 2 Partridge Sketch Book (National
Portrait Gallery). 3 Lady Eastlake, *Life of
John Gibson, R.A.*, 1870, pp. 123-9.

PATTEN, George 1801 - 1865

ortrait, miniature and history painter resident in London. He painted many Liverpool
tters and exhibited at the Liverpool Academy from 1834; gained the £50 prize for *Maternal
ffection* (1131 in the collection); elected non-resident Member, 1841.

264 William Fawcett

il on canvas,[1] 122×91·2 cm. (48×35⅞ in.)
Villiam Fawcett (1760/61–1844), engineer
nd ironfounder of Liverpool. In 1784 after
erving his apprenticeship, he joined the
aanagement of what was originally the
hoenix Foundry, a branch of Coalbrookdale
ronworks; in 1790 he became manager in
aaccession to his uncle, Joseph Rathbone, and
a 1794 bought the business for £2,300. Under
im the foundry expanded from producing
agar engines for the West Indies to the
roduction of cannon and to marine engineer-
ag. As a result of his changing activities he
ft the Society of Friends in 1797. He always
ad financial problems and became bankrupt in
810 and sold the business but was retained
manager and bought back a third share in
817. Under many changes the foundry was
ways known as *Fossets'*.[2]

He was one of the founders of the Mechanics'
Institute and its President in 1843. His
'unostentatious and long-continued efforts'
to help the Institution, were noted in the 1845
annual report.[3]

James Nasmyth, the engineer, provides a
graphic description of him:[4] 'His peculiar
courteous manner, both in speech and action,
reminded me of the "grand old style"... there
was also a dignified kindness about him which
was peculiar to him... His neat old-fashioned
style of dress quite harmonised with his
advanced age, and the kindly yet dignified grace
of his manner left a lasting impression on me
as a most interesting specimen of "the fine old
English gentleman, quite of the olden times." '

A bust by Jackson was exhibited at the
Mechanics Institute exhibitions of 1842 and
1844.

ENGR: T. Lupton, mezzotint (24×15 in.).

PROV: Painted by subscription for the Mechanics Institute, 1840; lent by Liverpool Institute School, 1975.

EXH: Royal Academy, 1840 (392); Liverpool Academy, 1841 (91); Liverpool Mechanics Institute Exhibition, 1844 (21).

REF: 1 Reduced from a full-length seated portrait at uncertain date; mounted on hardboard. 2 *The Liverpool Courier,* 1 Feb. 1854, p. 39, *The Phoenix Foundry;* J. A. Picton, *Memorials of Liverpool,* 1873, II pp. 324–328; H. White, *Fosset's,* 1958, *passim.* 3 *Annual Report,* 1845, p. 13. 4 R. Dickinson, *James Nasmyth and the Liverpool Iron Trade,* in *Transactions of the Historic Society of Lancashire and Cheshire,* 108, 1956, p. 86, quoting Nasmyth's *Autobiography,* 1883.

6326 Thomas Sands, Mayor of Liverpool

Oil on canvas, 127 × 101·5 cm. (50 × 40 in.)

Thomas Sands (1790–1867) merchant and shipowner, Mayor of Liverpool 1843–4, in robes of office with the mace on a table at his left.

Born Leeds, the son of James and Jane Sands. After his marriage in 1814 he settled for a period in New York and ran a merchandising and shipping firm with one of his brothers. In 1835 he returned and settled in Liverpool and established the shipping firm of Sands and Turner and built a family mansion, *Elmswood,* at Mossley Hill. One of his ships was the *Sarah Sands,* a steamship, which caught fire on the passage to India carrying troops to help quell the Indian Mutiny (described by Rudyard Kipling in 'The Burning of the Sarah Sands' in *Land and Sea Tales for Scouts and Guides, 1923)* Sands and his wife spent the latter part of their lives in Glasgow, where he died, 1867.[1]

PROV: By descent to the Venerable Archdeacon H. H. A. Sands, great-grandson of the sitter, who presented it, 1965.

EXH: Royal Academy, 1847 (225).

REF: 1 Information provided by Thomas Blakemore Sands, great-grandson of the sitter, in a letter 22 November, 1971.

2167 Thomas Berry Horsfall

Oil on canvas,[1] 128·3 × 102·2 cm. (50½ × 40¼ in.)

Thomas Berry Horsfall (1805–1878), merchant, Mayor of Liverpool, 1847–8, and Conservative M.P. for Liverpool 1853–1868. His family erected several churches in Liverpool, including

Christ Church, Great Homer Street on part o their own property.[2]

A lithographic portrait by C. Baugnier wa published 1860.

PROV: Commissioned by John Campbell, wh presented it, 1878. (Hung in the Town Ha until 1955 when transferred to the Gallery).

EXH: Liverpool Academy, 1853 (28); Roya Academy, 1854 (49).

REF: 1 Relined. 2 J. A. Picton, *Memorials o Liverpool,* 1873, II p. 419.

7025 Samuel Holme, Mayor of Liverpoo

Oil on canvas,[1] 239 × 148 cm. (94 × 58¾ in.)

Samuel Holme (about 1800–1872), J.P., Mayo of Liverpool 1852–3, in his robes of office witl the sword of state and mace on a table at hi left. He was, with his brother James, an exten sive builder and contractor for railway an(other public works, including St. George' Hall. A Conservative Town Councillor, he wa a strenuous advocate in the provision of wate from Rivington, and in matters of publi health and improvements in the town.[2]

PROV: Transferred from the Estates Com mittee to the Gallery, 1968. Hung in the Tow Hall.

EXH: Liverpool Academy, 1853 (98); Roya Academy, 1854 (259).

REF: 1 Relined. 2 (H. Shimmin), *Pen and in sketches of Liverpool Town Councillors,* 186(pp. 29 ff; J. A. Picton, *Memorials of Liverpoo* 1873, II p. 422.

PEARCE, Stephen 1819 - 1904

3634 William Philip, 4th Earl of Sefton

Oil on canvas, 43·2 × 53·3 cm. (17 × 21 in.)

INSCRIBED, verso: *Ashdown Park 1864/Roan horse Bought of Willis the barber 1853/died 1868*
The sitter (1835–1897), born at Croxteth Hall 14 October 1835, eldest son of the 3rd Earl (see Ansdell 8655); succeeded to the title 1855. Captain in the Grenadier Guards and served in the Crimea; retired 1858 and Lord Lieutenant of Lancashire, 1858 until his death. Knight Grand Cross of the Portuguese Order of the Tower and the Sword, 1865; Knight of the Garter, 1885. Married 1866, Cecil Emily, daughter of the 1st Baron Hylton. Built the extensive additions to Croxteth on the East and South sides, 1874–77.

He was painted by Ansdell as a child, 1843 and 1846;[1] by Sir Francis Grant (engraving published 1865);[2] for another portrait see Mercier 8639.

PROV: Purchased from the Executors of the Estate of the 7th Earl of Sefton, 1973.

EXH: ? Royal Academy, 1867 (221).

REF: 1 Croxteth Inventory 1946, Nos. 16 and 53; Coll: Countess of Sefton. This was No. 41. 2 Countess of Sefton.

PEDDER, John 1850 - 1929

Landscape painter. Born Liverpool and trained at Liverpool School of Art and Liverpool Academy. Exhibited at Liverpool Autumn Exhibition from 1871, and the Royal Academy from 1875; Member of Liverpool Academy, 1874; Member and Hon. Secretary of Liverpool Society of Painters in Watercolours, 1877–82. In 1883 on his marriage moved to London and finally settled near Maidenhead. R.I. 1898; R.B.C., 1910. A friend of George Clausen who influenced his style.

8601 Sheep in a Field

Oil on canvas, 66 × 106·7 cm. (26 × 42 in.)

SIGNED: *J. PEDDER*

PROV: Presented by Mrs. A. C. M. Jones, 1973.

PELHAM, James, senior 1800 - 1874

Miniature and portrait painter. Born London 16 September 1800, son of a miniature painter of the same name with whom his earlier career and work may well be confused. Said to have set up as a portrait painter in London and to have toured provincial towns from Norwich and Bath to Edinburgh. Married 1838 and settled in Liverpool by 1847. Elected Associate of the Liverpool Academy, 11 March 1848; Member, 1851; Secretary, 1854–61; Treasurer, 1869–71; President of Liverpool Sketching Club. Apparently turned in later life to genre as photography overtook portraiture. Died Liverpool 17 April 1874. His daughter

Emily was also an artist. His eldest son of the same name (1840–1906) was a landscape and genre painter who turned chiefly to teaching around the 1860's: Associate of the Liverpool Academy 1862; Member, 1865; Secretary from 1863 and helped to reorganise the Academy during the 1870's; Member of Liverpool Sketching Club and helped to form Liverpool Artists' Club. Watercolours by father and son are in the Collection.

2598 Study of an Old Man
Oil on canvas, 53·5×43·2 cm. (21×17 in.)
In the costume of the first quarter of the 19th Century.

PROV: Mrs. Pelham in 1908; presented by Miss Pelham, 1923.
EXH: Walker Art Gallery, 1908, *Historical Exhibition of Liverpool Art* (743).

PENN, William Charles 1877 - 1968

Portrait, genre and still life painter. Born South London 31 December 1877; trained at Lambeth and the City and Guilds Schools of Art from 1895, where he won medals and scholarship to the Royal Academy Schools, 1900–05, and there gained various awards; studied in Paris at Académie Julian under Jean Paul Laurens, 1908, and in Holland and Belgium, 1909. Master at Liverpool School of Art, 1911–40. Exhibited at the Royal Academy 1905–35; Liverpool Autumn Exhibitions from 1904; had various one-man shows. Member Liverpool Academy and Sandon Studios Society. Member Royal Institute of Oil Painters, 1908; Royal Society of Portrait Painters, 1952. Military Cross, 1918. Died Brampton, Cumberland, 27 May 1968.

7130 Bruton W. Eills, Lord Mayor of Liverpool
Oil on canvas, 142·5×102 cm. (56⅛×40⅛ in.)
SIGNED AND DATED: *Will. C. Penn 1920*
Alderman Bruton W. Eills, J.P. (1856/7–1936), in robes and chain of office as Lord Mayor of Liverpool, 1919–20. Liverpool merchant and ship's chandler; City Councillor from 1901; J.P., 1908; Alderman, 1927. A leader of the Liberal party in Liverpool.
PROV: Presented to the sitter, 1920; presented to the City by the sitter's family, 1964;[1] transferred from the City Estates Committee to the Gallery, 1968.
EXH: Walker Art Gallery, 1920, *Liverpool Autumn Exhibition* (85).
REF: 1 Finance and General Purposes Committee, 22 July 1964.

8485 Eileen and Harry Chrimes
Oil on canvas, 136×85·2 cm. (52½×33½ in.)
SIGNED AND DATED: *W. C. Penn. 1922*
PROV: Presented by the sitters, 1973.
EXH: Walker Art Gallery, 1922, *Liverpool Autumn Exhibition* (412) repr.

2707 The Happy Infant
Oil on canvas, 102·2×76·5 cm. (40¼×30⅜ in.)
PROV: Purchased from the artist at the Liverpool Autumn Exhibition, 1923.
EXH: Walker Art Gallery, 1923, *Liverpool Autumn Exhibition* (816); Walker's Galleries, London, 1925.

77 Cynicht

Oil on panel, 40·8 × 50·7 cm. ($16\frac{1}{16} \times 9\frac{15}{16}$ in.)

SIGNED: *Will C. Penn*

PROV: Purchased from Restoration Fund Exhibition, Bluecoat Chambers, 1942.

EXH: Bluecoat Chambers, 1942.

1035 Sir Sydney Jones, Lord Mayor of Liverpool

Oil on canvas, 110·5 × 85 cm. ($43\frac{1}{2} \times 33\frac{1}{2}$ in.)

SIGNED AND DATED: *Will C. Penn/1943*

Sir (Charles) Sydney Jones, J.P. (1872–1947), wearing chain of office as Lord Mayor of Liverpool, 1938–42. Shipowner and eminent public figure, particularly in the field of education; benefactor to Liverpool University; Liberal and Unitarian; born Liverpool; joined Alfred Holt and Company, 1912. City Councillor from 1912; J.P., 1914; M.P. (Liberal), 1923–24; High Sheriff of Lancashire, 1929; Alderman, 1936; knighted, 1937. From 1908 a member of the University Council, and subsequently Treasurer, and Pro-Chancellor from 1930. Endowed the chair of Classical Archaeology, 1916; gave the Department of Education and other property; contributed largely to the School of Education and University Libraries, and made a large bequest to the University. This included his collection of English watercolours. The University commemorates his interest in art and education by the Sydney Jones Lectures, and a Chair of Education. The new general Arts Library is named after him.[1]

His portrait by E. I. Halliday (*Liverpool Autumn Exhibition,* 1930), is in the University Department of Education.

PROV: Presented to the sitter, 3rd May, 1943,[2] and presented by him to the City; transferred from the City Estates Committee, 1968.

EXH: Sandon Studios Society, Bluecoat Chambers, 1945, *Will C. Penn* (17).

REF: **1** Press cuttings (Liverpool Record Office); *Who was Who;* information from John Vaughan, Department of Education. **2** *Liverpool Echo,* 4 May 1943.

PENNINGTON, John (?) 1773 - 1841

There was a family of potters and china decorators in Liverpool, the brothers James, John and Seth Pennington, each of whom apparently had a son called John (see Knowles Boney, *Liverpool Porcelain,* 1957, pp. 132, 134–135, 142–143). The son of James was probably the 'Student' who exhibited at the *Society for Promoting Painting and Design in Liverpool,* 1784, worked for a time for Josiah Wedgwood and subsequently worked for fifty years at Worcester Porcelain Works (born about 1765 – died about 1842). The son of John is also called a china painter and artist by Boney, working as a pottery decorator with his uncle James for a time and giving it up for painting about 1792; he would appear to have died after 1830.

There may be some confusion between him and the son of Seth, who was born 27 June 1773 (St. Nicholas' Church register), and was undoubtedly the Liverpool artist and member of the Liverpool Academy described as 68 at his death in April 1841 at his residence in Everton Terrace (Gore's Advertiser, 29 April). The Academy gave him a small pension, 1840, and paid his funeral expenses (Liverpool Academy Minutes, 25 February 1840, 16 October 1841).

The name first appears as 'artist' in the street directory for 1807 (12 Everton Town); next in 1813 and 1814 as 'painter, 28 Duncan Street East', if this is the same person. J.

Pinnington (sic) of Stockport exhibited landscapes at the Liverpool Academy, 1811; the alternative spelling and Liverpool, is given in 1812. The 1822 catalogue (first of the new series), lists John Pinnington (sic) as Member, of Ranelagh Street, which agrees with the street directories of 1816 and 1818; from 1824 he appears as Pennington, Everton Terrace (His name is missing from the street directories of 1821, 1823 and 1825, but reappears in 1827 when it replaces Seth Pennington at 5 Everton Terrace). In the Poll Books a Potter of the name is listed in 1802 in Islington; 1806 in Everton; 1812 in Bridport Street; 1818 in Ranelagh Street; 1830 in Everton.

Further, to confuse the matter, four children were registered at St. Nicholas' Church to John Pennington, artist, and his wife Mary Davies[1]: a daughter Alice in April 1807 when the address is given as Church Street, which does not agree with the street directory entry noted above; a son Thomas in 1807; a daughter Jemina Alice and a son John in November 1819 when the address is given as Ranelagh Street, which does match.

Nor do W. G. Herdman's recollections agree: he described the Liverpool Academy artist in his *Pictorial Relics of Ancient Liverpool, 1878*, from personal recollection, when discussing the potteries of Liverpool: 'We may notice that the works which show most recent date in Shaw's Brow, kept by Mr. Pennington, and called 'Pennington's Bank', were established by the father of the artist, John Pennington, who was one of the earliest members of the Liverpool Academy, being a contemporary of Mosses, Thomas Hargreaves . . . the two Williamsons . . . and others. He was a bachelor and lived with his two sisters in a small house in Everton Terrace . . . He usually painted frost and snow scenes, and thereby obtained the sobriquet of John Frost. We remember well visiting him in his little back painting room, from which at that time there was a magnificent prospect of the river, Cheshire, and the Welsh mountains . . .'.

While dying within a year of Charles Towne (*q.v.*) the Liverpool Academy artist rated no eulogistic obituary and remains an obscure figure leaning towards topography in subject matter. It is not entirely certain whether in the early years of the 19th century there were not two artists of the name working at the same time in Liverpool. Certainly a common style exists between the signed views in Troughton's *History of Liverpool*, 1810, and 142 below.

Ref: 1 Information from R. C. Stones, 10.5.1977.

L142 Walton-on-the-Hill
Oil on canvas,[1] 47×81·5 cm. (18½×32⅛ in.)
SIGNED in abbreviated form: (?) *J Pegtn*
INSCRIBED verso, on relining canvas: *John Pennington 1802/Walton on the Hill 1802*
Showing the old parish church of St. Mary's, Walton. The body of the church was rebuilt 1742, the chancel 1810 and the tower 1831.

PROV: Paget Collection, Kingston;[2] purchased from William Rivett Ltd., London, by Liverpool City Library, 1961; lent to the Gallery 1973.
REF: 1 Relined. 2 Label.

PERCIVAL, Robert Murdoch, living artist

1111 Flower Boxes
Oil on canvas, 50·7×61 cm. (20×24 in.)
SIGNED AND DATED: *Robt. PERCIVAL 54*
PROV: Purchased from the artist, 1954.
EXH: Walker Art Gallery, 1954, *Liverpool Academy* (92).

3158 Mother and Child
Oil on canvas, 129·8×53·3 cm. (51⅛×21 in.)
SIGNED AND DATED: *Robt PERCIVAL/55*
PROV: Purchased from the artist, 1955.
EXH: Walker Art Gallery, 1955, *Liverpool Academy* (51).

PHILLIP, John 1817 - 1867

Portrait and subject painter, born Aberdeen. Made successful career in London. R.A. 1859. Exhibited at the Liverpool Academy 1842, when the Academy bought his *Barefoot Friar* (2713 in the Collection), and at intervals until 1861. Friend of Richard Ansdell, who visited Spain with him in 1856–7, and who painted the animals in some of his pictures.

7506 Sir John Bent
Oil on canvas, 127×101·5 cm. (50×40 in.)
SIGNED AND DATED, in monogram: *18 J P 55*

7507 Lady Bent
Oil on canvas, 127×101·5 cm. (50×40 in.)
SIGNED AND DATED, in monogram: *18 J P 56*
John Bent (1793–1857), brewer of Liverpool (for biography see Westcott 3083), and his wife who was the daughter of J. Davenport Esq., M.P., of Westwood Hall near Leek. They married in 1822 and had one daughter who married Robert Frank of Aigburth, near Liverpool.

Bent was a considerable collector. Phillip painted another portrait of him signed and dated 1855 (42×27½), which was on the art market 1931–2;[1] and a pair of portraits of the couple, smaller in scale to the present works, belonged to Mrs. Frank.[2] He also owned Phillip's *Scotch Washing*, 1850 and *The Gypsy Queen*, 1852.[3]

Mrs. Bent wears a black taffeta dress with green floral pattern and green trimmings, and pink ribbons to her cap; a gold, (?) enamel and diamond brooch is pinned to her lace collar with a black velvet ribbon; she holds half-glasses in her lap; a Bible lies on the table at her side with a posy of flowers and a tall vase.

PROV: Mrs. Lucy Frank, who deposited them at the Gallery, 1926; purchased from R. D. Frank, great-grandson of the sitters, 1971.
EXH: 7506: Royal Academy, 1855 (570).[4]
REF: **1** 1971 correspondence in Gallery files. **2** *Ibid.* **3** Mrs. Frank, sold Christie's 11.3.1899 (81) and (82). **4** This is supported by a label, verso, signed by the artist with his London address and marked *No. 1*.

PHILLIPS, Sir Thomas 1770 - 1845

Portrait painter, resident in London. Royal Academician 1808 and Professor of Painting 1825–32. He was initially commissioned by the Corporation of Liverpool to paint the portrait of H.R.H. the Duke of York (on the latter's choice) for the Town Hall, which may have led to other local commissions.

7023 George Case, Mayor of Liverpool

Oil on canvas, 240·5 × 148·5 cm. (94¾ × 58½ in.)
Alderman George Case (1747–1836), in the robes of Mayor of Liverpool to which he was elected in 1781; he stands before a chair of the type still in the Town Hall. The painting was commissioned in 1829 by the Corporation, when at their meeting of 5 August the Council resolved: 'that upon the present occasion of the Opening of the New Council Chamber Room, Mr. Ald. George Case be requested to sit for his portrait, to be hung up in the Council Room, in testimony of the sense entertained by the Council of Mr. Case's highly valuable services for the long period of fifty-four years, during which he has been a member of the Body; and that Mr. Case be requested to select his own artist for the Painting.'[1] It appears in Phillips' sitters' book under *16 December 1829, No. 620.*[2]

The sitter was a native of Prescot and lived at Walton Priory.[3] He was the leader of the Tory party in the town council and in Aspinall's opinion,[4] 'without exception, the best chairman of a public meeting whom we ever met with.' His son John Deane Case was Treasurer to the Corporation (see Huggins, *Tried Friends*).

PROV: Commissioned by the Corporation for the Town Hall, Liverpool, 1829;[5] transferred from the City Estates Committee to the Gallery 1968 .Hung in the Town Hall.

EXH: Royal Academy, 1830 (36); Liverpool Academy, 1832 (164).

REF: 1 Council Minutes, reprinted in J. A. Picton (edit.) *Liverpool Municipal Archives and Records, 1700–1835,* 1886, p. 314, and in J. Touzeau, *The Rise and Progress of Liverpool,* 1910, II, p. 848. 2 From the copy of Phillips' sitters' book, 1899, National Portrait Gallery. 3 F. G. Paterson, *The History of Prescot,* 1908, p. 64. 4 (James Aspinall), *Liverpool a few years since,* 1869, p. 30. 5 Recorded in the *Inventory of Furniture etc. in the Town Hall,* 1835, Liverpool Record Office.

7031 William Wallace Currie, Mayor of Liverpool

Oil on canvas, 240·5 × 149·4 cm. (94¾ × 58¾ in.)
William Wallace Currie (1784–1840), the first Mayor of Liverpool under the Reform Act, 1836, in robes of office and standing by the mayoral chair. He was the eldest son of Dr. James Currie, the friend and associate of William Roscoe in liberal politics and the first editor of Burns, who had settled in Liverpool in 1780 after an adventurous youth, and in 1783 had married the daughter of William Wallace, an Irish merchant in Liverpool.

The sitter was educated at Edinburgh University and was a man of cultivation. He took a prominent part in Liverpool public life and had the reputation for honesty in politics.[1] In 1831 he published a *Memoir of the Life of James Currie,* which he dedicated to William Roscoe who had been unable to undertake it.

This portrait appears in Phillips' sitters' book under *12 August 1837, No. 752, W.L.*[2]

A pencil drawing by Hargreaves, presumably for a miniature, is in Liverpool City Library.[3] For another portrait see under Thompson.

ENGR: T. Lupton, mezzotint (27 × 16⅞ in.)

PROV: Commissioned by the Corporation for the Town Hall, Liverpool, and hung in the Council Chamber, December 1837;[4] transferred from the City Estates Committee to the Gallery, 1968. Hung in the Town Hall.

EXH: Royal Academy, 1837 (12); Liverpool Mechanics Institution, 1840, *1st Exhibition of Objects Illustrative of the Fine Arts, etc.* (85)

REF: 1 (James Aspinall), *Liverpool a Few Years Since,* 1869, p. 97. 2 MS copy, dated 1899, in the National Portrait Gallery. 3 J. A. Picton, *Memorials of Liverpool,* extra illustrated, III fp. 505. 4 *Liverpool Mercury,* 5 January 1838, report of Council Proceedings.

PICKERING, Henry, active 1740 - 1770/1

Portrait painter about whom little is known; his style is a stiffer rendering of Hudson. His earliest dated picture known is of 1740, several others are signed and dated up to 1769. Vertue states that in 1745 he had latterly returned from an Italian trip and that he made use of Van Aken, the drapery painter; Caddick (*q.v.*) saw him in London in mid-1746. His will (dated 1759) requested that his pictures 'may be finish'd by the Best Drapery Painter and then delivered to the Gentrey [*sic*] who have favoured me with their commands . . .' He must have moved about between Yorkshire, Lancashire, Cheshire and North Wales, all of which districts provided him with sitters. In 1759 he was living in Manchester, possibly in Deansgate, and he appears to have been there at his death. His will refers to properties in Kirkby (under Lord Molyneux), Westminster, and elsewhere, unspecified; but he seems to have been in debt at the time of his death, his will being proved by a creditor. He had a brother Thomas living at Thelwell, Cheshire, and a sister Charlotte at Warrington. His wife, Mary, and four children under age are mentioned in his will and of these his son Henry might be that cited by Dibdin (Walpole Society Journal, 1917, p. 89) as listed in Liverpool street directories in 1781, 1790, and possibly 1796. The artist did not exhibit with the Liverpool Art Society of 1769 and it is not clear whether he was ever resident in Liverpool. His will was proved 18 February 1771, when letters of administration were granted to his sister and to Thomas Kirk, merchant of Manchester (one of his creditors).

7016 Thomas Johnson
Oil on canvas, 127×101 cm. (50×39¾ in.)

7015 Mrs. Thomas Johnson and her Daughter
Oil on canvas, 126×100 cm. (49½×39¼ in.)
SIGNED AND DATED: *H. Pickering Pinxt. 1759*
Thomas Johnson (d. 1771) in the uniform of a Volunteer regiment raised to repel a threatened invasion during the Seven Years War; he gestures towards a battery overlooking British ships at sea.

In 1759 the Mayor and merchants of Liverpool met to consider the defence of the town against the French and various batteries were set up to protect the sea approaches.[1] In March 1760, the newly equipped Volunteer regiments were reviewed. *Williamson's Advertiser* for 14 March noted; 'On Tuesday last Colonel Spencer's, Captain William Ingram's and Captain John Tarleton's independent companies, of this town, were reviewed by the Right Hon. the Earl of Scarborough, in Princes Square, . . . the companies were all clothed in their new uniform, at their own private expense. The Colonel's company in blue, lapelled and faced with buff; Captain Ingram's in scarlet coats, gold laced hats, and cue wigs; and Capt. Tarleton's in blue, with gold vellum button holes; Capt. Thomas Johnson's company of the train of artillery, wear the uniform of the navy, blue and buff, with gold laced hats.' The sitter was Mayor of Liverpool in 1766–67. He died 24 February 1771.[3] His wife and child appear in 'Van Dyck' Costume.

PROV: Purchased by the Corporation for the Town Hall, from an unrecorded source, 1912 (£50).[4]

REF: **1** *Williamson's Advertiser*, 9 November 1759, quoted in J. A. Picton, *Memorials of Liverpool*, 1873, I p. 218–19. **2** Quoted Picton, *op. cit.*, I p. 220. **3** *Gore's Advertiser*, 1 March 1771. **4** *Accounts of the Treasurer of the Corporation of Liverpool for 1912, 1913*, p. 39; Epitome of Proceedings of Finance Committee for 30 August, 1912.

PRESCOTT, Charles Trevor, active 1890 - 1942

Chiefly a commercial artist. In Liverpool until about 1899, when moved to London.

2720 St. John's Market, Liverpool – Saturday Morning

Oil on canvas, 76·8 × 102·2 cm. (30¼ × 40¼ in.)

SIGNED AND DATED: *TREVOR/PRESCOTT 1892*

Interior of the 1822 market. In the foreground appears Alderman Grindley, the picture dealer, with white hair and beard.[1]

PROV: Purchased from the artist, 1942.

EXH: Walker Art Gallery, 1892, *Liverpool Autumn Exhibition* (300) price £35; Bluecoat Chambers, 1945, *Pictures of Old Liverpool* (21).

REF: 1 Liverpool Daily Post, 20 January 1943 (press cuttings, Liverpool Record Office). A watercolour interior by R. I. Barrow of about 1828 is also in the Collection.

2157 Water Street

Oil on canvas, 61 × 45·8 cm. (24 × 18 in.)

SIGNED AND DATED: *TREVOR/PRESCOTT 1892*

Looking up the street to the Town Hall.

PROV: Purchased from the artist, 1942.

EXH: Bluecoat Chambers, 1945, *Pictures of Old Liverpool* (20).

1512 Bold Street from Waterloo Place

Oil on canvas, 103 × 76·8 cm. (40½ × 30¼ in.)

SIGNED AND DATED: *C. TREVOR / PRESCOTT 1893*

Horse-drawn vehicles include the Garston bus, hansom-cabs and the Mayor's coach.[1]

PROV: Purchased from the artist, 1942.

EXH: Walker Art Gallery, 1894, *Spring Exhibition* (109) price £40; Bluecoat Chambers 1945, *Pictures of Old Liverpool* (22).

REF: 1 *Liverpool Daily Post*, 20 January 1943.

2721 Underground Railway, Liverpool

Oil on canvas, 61·5 × 92·7 cm. (24¼ × 36½ in.)

SIGNED AND DATED: *C. TREVOR PRESCOTT. 1894*

Work began on the underground railway in 1880 and sections were opened between 1886 and 1892.[1]

PROV: (?) Presented by the artist, 1942.

REF: 1 G. W. Parkin, *The Mersey Railway* n.d., p. 11.

2719 Steble Fountain, William Brown Street

Oil on canvas, 82·5 × 122 cm. (32½ × 48 in.)

A poor woman and child cross the flags by the Wellington Monument where workmen are seated on the plinth. The skyline of Dale Street is seen beyond the fountain and the pillars of the Picton and William Brown Libraries and the Museum. Probably the picture called 'Poverty and Wealth' presented by the artist.

PROV: (?) Presented by the artist, 1942.

PRESTON, Edward Carter 1884 - 1965

Sculptor, painter and medallist. Born Liverpool 7 July 1884. Apprenticed to firm of glass decorators and studied in the School of Applied Art at Liverpool University. On its amalgamation with Liverpool School of Art, 1905, joined the rival Sandon Terrace Studios, where Gerard Chowne was his chief mentor; began friendship with Herbert Tyson Smith, later his brother-in-law. Shared studio in Bluecoat Chambers (Liberty Buildings) with G. T. Capstick

for a time and then on his own; later had studio in his house in Bedford Street. Began as a painter but turned to sculpture after the Great War and gained national repute as a medallist, designing various war medals, etc. Commissioned, 1926, for the statues for Liverpool Cathedral. Died Liverpool, 2 March 1965.

1072 Daphnis and Chloe
Wax and spirit medium on panel, 47·6×
47·6 cm. (18¾×18¾ in.)
SIGNED: *E Carter Preston*
Painted in the early 1920's.[1]

PROV: Presented by Mrs. Frank Hornby, 1940.
REF: **1** Letter from the artist, June 1940 (copy Gallery files).

RAE, Robin, living artist

6574 Caradoc
Mixed media, 170·8×123·2 cm. (67¼×48½ in.)
Studies are in the Collection.
PROV: Purchased from the artist, 1967.

EXH: Walker Art Gallery, 1967, *Liverpool Academy* (15).

RATHBONE, Harold Steward 1858 - 1929

Landscape, portrait and subject painter, pottery manufacturer and poet. Born Liverpool 10 May 1858, son of Philip Rathbone of the merchant family (Chairman of the Arts and Exhibitions Sub-Committee, 1886–95). Trained at Heatherley's School, the Slade School under Legros, and a pupil of Ford Madox Brown for three years from 1882/3, when Madox Brown was painting his Manchester Town Hall wall decorations; he seems to have remained under Madox Brown's wing until the late 1880's. He was also at Julian's in Paris under Bouguereau and Fleury, and later in Italy and Florence. He used to accompany his father around the artists' studios in London when pictures were being chosen for the Liverpool Autumn Exhibitions, where he himself exhibited, 1882–1920; member Liverpool Academy; exhibited also at the Royal Cambrian Academy and at the Grosvenor, Dudley and other London galleries and at the Paris Salon. He organised the subscription to acquire William

Holman Hunt's *Triumph of the Innocents* for the Collection, 1892 (see Holman Hunt f[...] portrait).

He is best known as founder of the Della Robbia Pottery Company, Birkenhead, establish[...] at 2 Pine Street in 1894, of which he was Art Director until 1906, when it had to close [...] a result of financial failure. (sale 5-7 December, 1906). He then moved to Llandudno a[...] during 1915-16 to semi-retirement at Port St. Mary, Isle of Man, where he died 12 Decemb[...] 1929.

Madox Brown was an early influence, while the early Rennaissance formed the basis f[...] his work as a pottery designer. He was in the Arts and Crafts circle of the end of the centur[...] with Mackmurdo, Anning Bell (*q.v.*) Conrad Dressler etc. He built up a collection of wor[...] of art, including works by Madox Brown. Most was dispersed (?) privately and at sal[...] (Christie's, 26 April 1909). He appears to have been of a shy and retiring personality a[...] had no head for business.

He published an illustrated volume of poems, *Dunvegan Castle*, 1900; a watercolour is [...] Birkenhead, where is a large collection of pottery, which is also well represented in Merse[...] side County Museums.

2686 Jeanne d'Arc
Oil on canvas, 126·5×99 cm. (49¾×39 in.)
SIGNED AND DATED, in monogram: *H S R '86*
Exhibited with the quotation:

 'At earliest morn, when little children kneel,
 Into some wayward chapel she would steal,
 And lingering there, in her bright arms
 arrayed,
 Thro' whelming tears to her dear Lord she
 prayed,
 That aye she might their guiding voices hear,
 Then onward march without one touch of
 fear.'

PROV: Presented by the artist, 1889.

EXH: Grosvenor Gallery, 1886 (140);[1] Walk[...] Art Gallery, 1886, *Liverpool Autumn Exhibiti[...]* (881), sale price £140; Hogarth Club, 189[...] Cork International Exhibition, 1902; Nu[...] eaton, 1931.
REF: 1 Repr. *Pall Mall Gazette Extra*, No. 2[...] 1886, p. 140.

2984 The Banqueting Hall, Conway Cast[...]
Oil on canvas, 92·4×71 cm. (36⅜×28 in.)
SIGNED AND DATED: *H.R. 1888*
PROV: Presented by the artist, 1916.
EXH: Possibly Royal Cambrian Academy, 19[...] (47), £52.10.0.

REED, Stanley, living artist

2370 Danae
Oil on canvas, 76×63·5 cm. (30×25 in.)
SIGNED AND DATED: *Stanley Reed 3.1935*
Portrait of the second daughter of Herbert Tyson Smith, the Liverpool sculptor.

PROV: Purchased from the artist, 1935.
EXH: Royal Academy, 1935 (688); Walker A[...] Gallery, 1935, *Liverpool Autumn Exhibiti[...]* (136) repr.

REID, Sir George 1841 - 1913

599 Rev. John Watson, D.D.
Oil on canvas, 62×46·7 cm. (24½×18⅜ in.)
SIGNED: *R*
The Rev. John Watson, D.D. (1850–1907), minister of Sefton Park Presbyterian Church 1880–1905; theological author, and under pseudonym of Ian MacLaren, author of popular sketches of Scottish life and character. Intimate friend of Alderman John Lea.[1]

PROV: Bequeathed by Alderman John Lea, 1927.
EXH: Walker Art Gallery, 1914, *Liverpool Autumn Exhibition* (1087); Bury, 1931; Rochdale, 1932.
REF: **1** Press cuttings (Liverpool Record Office); *Who was Who;* Frank Elias, *John Lea, Citizen and Art Lover,* 1927, *passim.*

After REYNOLDS, Sir Joshua 1723 - 1792

504 Colonel Banastre Tarleton
Oil on canvas, 76·5×63·8 cm. (30⅛×25⅛ in.)
The sitter, later General Sir Banastre Tarleton, Bart. (1754–1833), was born Liverpool 1 August 1754 the third son of John Tarleton, merchant and formerly mayor, and member of an influential Liverpool family. He was intended for the law but a cornetcy was purchased for him in the King's dragoon guards in April 1775. He went as a volunteer with Lord Cornwallis to North America in that year and quickly won distinction and promotion on the British side in the American War of Independence. In 1781 he was appointed Lieutenant Colonel commanding the British Legion (mixed cavalry and light infantry), which acquired the title of 'Tarleton's Green Horse' from the colour of their facings: he appears thus in this portrait. He was hated by the republicans as 'Bloody Tarleton' and designated a butcher and barbarian.[1] After the British capitulation in 1781 he returned to England early in 1782 and was appointed Lt. Colonel of light dragoons in December of that year. His final promotion was to General in 1812. Created a baronet, 1818; G.C.B., 1820. He unsuccessfully contested Liverpool in the parliamentary elections of 1784 but was returned as a Whig, 1790–1806, when defeated by Roscoe, and sat as a Tory 1807–1812, when he gave place to Canning. He was an advocate of the slave trade in support of major Liverpool interests. He published *A History of the Campaigns of 1780 and 1781 in the Southern States of North America,* in 1787. He was a protector of Mary 'Perdita' Robinson; in 1798 he married Susan Priscilla Bertie, natural daughter of the last Duke of Ancaster.[2]

Copy of the full-length portrait by Reynolds (97×57½ in.), for which he began sitting 28 January 1782. He is shown astride a cannon with flags behind, one of which appears to be that of the British Legion. The loss of two fingers of his right hand in the campaign is just apparent in the portrait. The picture was exhibited at the Royal Academy, 1782 along with an equestrian portrait by Gainsborough (lost), and sent to his mother at Liverpool in July; it appeared at the Liverpool exhibition of 1784; it is now in the National Gallery.[3] It was engraved by J. R. Smith, 1782, and by S. W. Reynolds. Various small copies are recorded. The present copy was thought by the last owner to have been painted by the artist's sister Frances Reynolds, who is known to have copied his work, but this cannot be substantiated.[4]

PROV: Messrs. Grindley and Palmer, Liverpool, who owned it at least from 1919;[5] purchased from them, 1933.
REF: **1** See Robert D. Ross, *The Green Dragoon, the Lives of Banastre Tarleton and Mary Robinson,* 1958. **2** Obituary, *The Gentleman's Magazine,* 1833, CIII, part I, p. 273; J. A. Picton, *Memorials of Liverpool,* 1873, II pp. 95 ff. **3** A. Graves and W. V. Cronin, *Sir Joshua Reynolds,* 1899, III, pp. 952–3; Martin Davies, National Gallery Catalogue, *British School,* 1959, p. 88. **4** Letters in Gallery files. **5** *Ibid.*

REYNOLDS, Samuel William, Junior 1794 - 1872

8702 Richard Potter

Oil on canvas, 90·2 × 70 cm. (35½ × 27½ in.)

INSCRIBED on a paper held by the sitter: *NOTICE OF PROCEED[INGS]/of the/ HOUSE of Commons/. . . of June 1836*

Richard Potter (1778–1843), Manchester merchant; M.P. for Wigan 1832; grandfather of Lawrencina who married Richard Durning Holt of Liverpool (see Bigland 2584).[1] He spoke twice in the debates in the House of Commons on 22 and 30 June 1836,[2] which presumably accounts for the inscription on this portrait.

ENGR: S. W. Reynolds, junior.

PROV: By descent to Miss Anne Holt, granddaughter of Robert Durning Holt, who presented it, 1974.

REF: **1** Georgina Meinertzhagen, *From Ploughshare to Parliament, A Short Memoir of the Potter Family*, 1908, repr. frontispiece. **2** *Proceedings of Parliament*, XXXIV, June 1836, columns 753, 1051.

8720 Thomas Potter

Oil on canvas, 90·2 × 70 cm. (35½ × 27½ in.)

Sir Thomas Potter (1774–1845), brother Richard. Settled Manchester 1803. First May◗ of Manchester, 1838. Knighted 1840. portrait by William Bradley, 1842, is Manchester Town Hall.

PROV: By descent to Miss Anne Holt, gran◗ daughter of Robert Durning Holt, w◗ presented it, 1974.

RICHARDS, Albert 1919 - 1945

War artist. Born Liverpool 19 December 1919. When six years of age his family moved ◗ Wallasey, Cheshire. At fifteen gained scholarship to Wallasey School of Art and again fro◗ there to the Royal College of Art. At R.C.A. January to April 1940, when called up for w◗ service. Posted as private in the Royal Engineers. Painted in every spare moment and pictur◗ bought by the War Artists Advisory Committee. Transferred Spring 1943 to a parachu◗ squadron. Finally confirmed as an Official War Artist March 1944 with rank of Captai◗ Parachuted into Europe on D Day with his old regiment and served with distinctio◗ killed whilst preparing to paint a night attack near the river Maas, 5 March 1945. His sty◗ showed a synthesis of current British painting of the 1930's and much future promise.

8728 The Seven Legends: Self Portrait

Tempera on board, 73·5 × 55·6 cm. (29 × 21⅞ in.)

SIGNED in monogram and dated: *A R/1939*

INSCRIBED, top left: *ALBERT RICHARDS* and verso: *SEVEN LEGENDS*.

The artist appears standing on the edge of bay against a mountainous landscape, su◗ rounded by a series of legendary inciden◗ He wears a grey suit and white shirt witho◗ a tie, blue-tinted glasses, and no shoes. I◗ holds a black rat by the tail with his left ha◗

/hile his right hand is clenched; a white
abbit looks out of his right pocket.

The incidents surrounding him are from
op left:

A figure parachuting head-first into a barrage
alloon, his parachute not having opened.

Three demons stepping out of the sea, one
vith very oriental features; he and one of the
thers draped with seaweed and with red eyes.
The centre demon with one red and one real
ye; flames rise from a crater behind him.

A devil standing in or emerging from a red
ole from which flames come. Near him a man
ides under a large leaf and points with the
ndex finger of his left hand towards the devil.

From top right:

A demon in grey draperies, holding a red
asin containing black matter which he appears
o sprinkle about as he descends towards the
ext incident.

A rolling-stock truck attached to the tails of
pair of white oxen which are dragged upwards
y two naked women with wings; a third
voman stands on the back of the truck which is
lled with red drops or tears on which a large
y rests; the tears spill over and fall downwards.

A persian-like Perseus figure on a white
orse and holding a long cloth with a woman's
ead in it, rides along the shore-line between
wo incidents. To the right of him is a black
avern full of flames beneath a hill on which
; a crucifixion, and to the right of the cavern
a black draped figure on the edge of a cliff
bove the artist's monogram and next to the
ther scene where (?) Andromeda in a blue
obe stands on a small island looking out to
ea; a sea serpent swims towards her from near
erseus.

Below her rocks, a black man and a white
1an play at dice on a sea shore with a black
nd a white dice; an open fire is lit near
hem.

Probably stemming most immediately out of
he artist's experience of Surrealist art seen at
he Liverpool Autumn Exhibition in 1938 with
George Jardine and from the Persian manu-
cripts at the Victoria and Albert Museum seen
vith George Jardine on visits to London.[1] The
rtist might also have been reading such
hilosophers as Nietzsche.[2]

Another self-portrait was in *Rebellion at the
'oo*, also formerly in the artist's mother's
wnership.

ROV: Purchased from Mrs. George Richards,
1other of the artist, 1974.

EXH: Bluecoat Chambers, 1948, *Albert Richards
1919–1945, Memorial Exhibition* (25); (?) Wal-
lasey Festival of Arts, 1966 (5), *Captain Albert
Richards*.

REF: **1** Information supplied by George Jardine
to Mr. A. Frere, Manchester, and to the
compiler 10 May 1977. **2** See his *Thus spoke
Zarathustra*, chapter The Way of the Creator
(suggestion of Marco Livingstone).

2371 Sappers erecting Pickets in Snow

Oil on panel, $51 \cdot 4 \times 82 \cdot 5$ cm. ($20\frac{1}{4} \times 32\frac{1}{2}$ in.)

The artist was stationed at Mickley in North-
umberland during the very cold winter of 1940
to 1941.[1] This was one of several paintings he
sent to the Artists' Advisory Committee and he
described the subject in a letter to the Secretary
in May 1941: 'The picture of sappers working
alongside A.A. guns. This painting was painted
while attached to an A.A. battery in Co.
Durham. The work we were engaged upon as
far as I know was purely experimental. The
painting represents the building of a huge
aerial designed to give better gun-laying. The
work was carried out in the midst of this year's
snow storms. Part of the work entailed the
driving in of steel pickets, concreting their base
and threading masses of wire through the holes
in the top of the pickets to form a net. This
work is very simple in summer, but in winter
the handling of the steel pickets itself is a trial
upon the hands.'[2]

PROV: Purchased by the War Artists' Advisory
Committee, 1941 (15 gns.), and presented 1946
(LD. 1125).

EXH: Royal Academy, 1945, *National War
Pictures* (53); Bluecoat Chambers, 1948, *Albert
Richards Memorial* (1); Wallasey Festival of
Arts, 1966 (17); Bluecoat Gallery, 1974,
Images of War; Imperial War Museum, and
Arts Council touring, 1978, *The Rose of Death:
Paintings and Drawings by Albert Richards* (27).

REF: **1** Information from A. Frere, Manchester.
2 Letter 13.5.1941 (Imperial War Museum
archives), quoted in 1978 exhibition catalogue.

8727 Seacombe Ferry in Wartime

Oil on board, $52 \cdot 1 \times 74 \cdot 9$ cm. ($20\frac{1}{2} \times 29\frac{1}{2}$ in.)

SIGNED: *Albert Richards*

Showing the mast and stripped upper deck
of the Mersey ferry, Royal Daffodil II, sunk
off Seacombe ferry on the night of 8 May 1941

by a direct hit to the starboard side of her engine room. She was raised thirteen months later and re-entered the service 2 June 1943. (Built 1934 by Cammell Laird for £45,000, to hold 2,000 passengers; renamed St. Hilary, 1947, and sold for breaking up, 1962).[1]

A dredger stands off beyond her and a ferry crosses the Mersey.

It was rejected by the War Artists' Advisory Committee,[2] possibly as too civilian in subject.

PROV: Purchased from Mrs. George Richards, mother of the artist, 1974.

EXH: Wallasey, 1966 (14) as *Royal Daffodil II, sunk at Seacombe Landing Stage*; Imperial War Museum, and Arts Council touring, 1978, *The Rose of Death* (38).

REF: 1 C. L. D. Duckworth and G. E. Langmuir, *West Coast Steamers*, 1966 edition, pp. 56–7; *Liverpool Daily Post*, 3 June 1943 (Liverpool Record Office press cuttings). 2 A. Richards, letter 25.4.1942 (Imperial War Museum archives), quoted in 1978 exhibition catalogue.

2600 Holland: The Flooded Maas

Oil on hardboard,[1] 58·4 × 77·5 cm. (23 × 30½ in.) A typewritten label reads: 'Holland. *The Flooded Maas*. British Transport crossing this great natural obstacle. The constant widening of the river has meant constant watch by the maintenance engineers.'

PROV: Presented by the War Artists' Advisory Committee, 1946 (LD. 4827).

EXH: Royal Academy, 1945, *National War Pictures* (843); Bluecoat Chambers, 1948, *Albert Richards Memorial* (3); Wallasey Festival of Arts, 1966 (54); Bluecoat Gallery, 1974 *Images of War*.

REF: 1 Framemaker's label of *A.S. & S.*

2601 Holland: Cold Holland

Oil on hardboard,[1] 58·4 × 77·5 cm. (23 × 30½ in.) A typewritten label reads: 'Holland, Cold Holland. The Approach of Winter. Holland the land of Central Heating, with a ration of 1 lb. of coal per person per week.'

PROV: Presented by the War Artists' Advisory Committee 1946 (LD. 4826).

EXH: Royal Academy, 1945, *National War Pictures* (858); Bluecoat Chambers, 1948, *Albert Richards Memorial* (2); Wallasey Festival of Arts, 1966 (53); Imperial War Museum, and Arts Council touring, 1978, *The Rose of Death*.

REF: 1 Framemaker's label of *A. S. & S.*

RICHARDS, Richard Peter 1839 - 1877

Landscape painter in oil and watercolour. Born Liverpool. Self-taught as a painter, having initially been a tailor. Exhibited at the Liverpool Academy from 1854 and elected Associate 1867; at the Liverpool Society of Fine Arts 1860 and 1861 and elected an Associate; at the Royal Scottish Academy from 1865; at Liverpool Autumn Exhibition, the Royal Academy from 1871 and elsewhere. Member Liver Sketching Club. Went abroad for his health in 1876 and died at Pisa, 3 or 4 April 1877.

2697 The Diamond Fields; View on the River Wharfe, near Bolton Abbey

Oil on canvas, 112·5 × 169·2 cm. (44¼ × 66⅝ in.)
SIGNED AND DATED: *R. P. RICHARDS/ 1874*

PROV: Presented by A. Von Sobbe, 1922.

EXH: *Liverpool Autumn Exhibition*, 1874 (230); Harrogate, 1924, *Liverpool School of Painters* (41).

698 The Silver Cloud

Oil on canvas, 100×173·7 cm. (39⅜×68⅜ in.)

SIGNED AND DATED: *R. P. RICHARDS/*
875

PROV: Presented by Miss Agnes S. Steele,
1903.

EXH: *Liverpool Autumn Exhibition,* 1875 (183)

Price £425.

426 'Twixt night and day'

Oil on canvas, 44·2×63·7 cm. (17$\frac{7}{16}$×25$\frac{1}{16}$ in.)

SIGNED: *R. P. RICHARDS*

PROV: Presented by Sir Cuthbert C. Grundy,
1909.

RIPPINGILLE, Alexander Villiers, active 1815 - 1842

139 Rev. Thomas Raffles

Oil on canvas, 142·2×111·8 cm. (56×44 in.)

The Rev. Thomas Raffles (1788–1863), emin-
ent independent minister of St. George's
(Congregational) Chapel, Liverpool, 1812–1862.

Born Spitalfields 17 May 1788, the son of a
solicitor. After a brief pastorate at Hammer-
smith, 1809–1812, he became the first minister
of Great St. George's Street Chapel, which
had been newly completed for the immense
congregation attracted to the ministry of the
Rev. Thomas Spencer at Newington Chapel
(Spencer's short ministry having been termin-
ated by his untimely death by drowning in
1811). Raffles proved extremely popular and
became a noted preacher throughout the
country. LL.D. Aberdeen, 1820; D.D. Union
College, Connecticut, 1822. He was active in
the institution of the Blackburn Academy
which ultimately became the Congregational
College, Whalley Range, Manchester, and
was Chairman from 1839.[1]

He married Mary Catherine Hargreaves of
Liverpool, and their son Thomas Stamford
Raffles (see Boadle 7136) was stipendiary
magistrate in Liverpool. He published a life
of Thomas Spencer, 1813; he made an immense
autograph collection,[2] and owned a valuable
MSS collection bearing on dissenting history.
Some of his sermons are at the Congregational
College, Manchester, where is a portrait of
him (by ? B. R. Faulkner).[3]

A portrait by Mosses was published in
1822;[4] one by H. Wyatt was exhibited at the
Liverpool Academy in 1822 (157), one by
T. H. Illidge in 1838 (1), and one by W. Scott
published 1835; a bust by Joseph Deare
appeared at the Liverpool Academy in 1832

(376); a bust by Isaac Jackson is in the Col-
lection, and one by McBride is on loan from
Great St. George's (Liverpool Academy 1865,
where was also exhibited a model plaster bust
by E. Stirling, from photographs).

First catalogued at the Walker Art Gallery
as by Edward Rippingille but the 1842 exhibi-
tion (see below), supports Alexander's can-
didature.

PROV: Presented to the Corporation by
Thomas Burley, 1863.[5]

EXH: (?) Liverpool Mechanics Institute, 1842
(362), lent by the artist, 'A. V. Rippingille.'

REF: **1** T. Stamford Raffles, *Memoir of the Life
and Ministry of the Rev. Thomas Raffles,* 1863,
passim; Rev. B. Nightingale, *Lancashire Non-
conformity,* 1893, pp. 155 ff; Joseph Thompson,
Lancashire Independent College, 1893, pp. 151 ff.
2 A. N. L. Mundy, *Cult of the Autograph
Letter in England,* 1962, pp. 64–66. **3** Repr.
Nightingale, *op. cit.,* fp. 156, and Thompson,
op. cit., fp. 153. **4** *Biographical memoir of the
Rev. Thomas Raffles,* in the *Imperial Magazine,*
Vol. 4, 1822, p. 596. **5** Library, Museum and
Art Gallery Committee Minutes, 8 October
1863, and 7 January 1864.

ROBERTS, Henry Benjamin 1831 - 1915

Genre painter and watercolourist, specialising in rustic humour. Born London Road
Liverpool, 5 February 1831, the son of a house painter, Benjamin Roberts, who also painted
and taught his son and exhibited still-life and genre subjects at the Liverpool Academy 1850–6
and the Liverpool Autumn Exhibition in 1872. Henry was apparently first trained to his
father's calling but turned to painting and entered Liverpool Academy Schools as a probationer
21 November 1850; exhibited there, 1852–65; elected Associate, 1855; Member, 1859
According to his daughter Mrs. Riston, he visited Edinburgh in 1855 and studied under
William Fettes Douglas (1822–91). He moved to London 1859/61, having adresses in both
places during this time and again having a Liverpool address 1864/5 and visiting the town
later. He was 'corresponding artist in London' for the Liverpool Autumn Exhibition, 1871–76
and exhibited there 1871–1904. He exhibited with the Royal Institute of Painters in Water
colours and elected Associate, 1867, and Member, 1870; he resigned in 1884. Member
Society of British Artists, 1878. He also exhibited at the Royal Academy, 1859–75 and th
British Institution, 1859–66. He married Ann Barton of Liverpool. He moved to Leyton
Essex in the 1880's and died there 23 January 1915.

1340 Creating a Sensation
Oil on canvas, 82×64 cm. (32¼×25¼ in.)
SIGNED AND DATED: *H. B. Roberts 1861*
(initials in monogram).
PROV: Richard Eastham in 1908; purchased,
1910.
EXH: Liverpool Academy, 1861 (213), £73.10.0;
Walker Art Gallery, 1908, *Historical Exhibition
of Liverpool Art* (154), and 1970, *The Taste of
Yesterday* (31) repr.

2696 The Rehearsal
Oil on canvas, 92×138·5 cm. (36¼×54½ in.)
SIGNED AND DATED: *H. B. Roberts 1866*
(initials in monogram)
A study perhaps connected with this picture,
called *The Acrobat's Rehearsal,* was exhibited
at the Institute of Painters in Watercolours
1868 (Sketches), No. 424.
PROV: Presented by Colonel W. Hall Walker,
1910.
EXH: Harrogate, 1924, *Liverpool School of
Painters* (28).

1118 Oliver Twist's First Introduction t
Fagin
Oil on composition board, 35·5×45·7 cm
(14×18 in.)
SIGNED AND DATED: *H. B. Roberts/ 68*
Illustrating Chapter VIII, where Oliver i
taken by his newly found companion, th
Artful Dodger, to meet Fagin. Dickens' nove
was first published in 1837–8. A watercolou
version (7⅝×10¼ in.) was in a private collectior
1970.
PROV: Ald. Edward Samuelson in 188(
Purchased from H. E. Kitson, 1908.
EXH: *Liverpool Autumn Exhibition,* 1871 (280)
Walker Art Gallery, 1886, *Grand Loan Exhibi
tion* (1456); Harrogate, 1924, *Liverpool Schoc
of Painters* (18).

ROBERTSON, John Ewart 1820 - 1879

Portrait painter. Born Kelso, trained at Edinburgh and exhibited at Royal Scottish Academy, 1838–63. He had moved to Liverpool by 1847 when first exhibited at Liverpool Academy and admitted student in the Life School, 20 November; Associate, 1848; Member, 1850; Treasurer, 1854–67. He had a London studio address in the late 1860's. Exhibited at the Royal Academy, 1844–65, the British Institution, and the Liverpool Autumn Exhibition 1871–76. He worked in chalks as well as oils and sometimes introduced landscapes into the background of his portraits. His style was influenced by the detailed technique of the Pre-Raphaelite circle in the 1850's and he supported their faction in the Academy. John Miller was an early patron. Died in a mental asylum. (His portrait miniature by Pelham is in the Collection, 2197).

8657 Joseph Robinson
Oil on canvas, arched top, 126·8 × 101·8 cm. (49 15/16 × 40 1/16 in.)
INSCRIBED on label on stretcher: *John Robertson/9 Slater Street Liverpool*

8658 Mrs. Robinson
Oil on canvas, arched top, 126·8 × 101·4 cm. (49 15/16 × 39 15/16 in.)

Joseph Robinson, who changed the spelling of his name from Robieson (?), was a Scotsman who settled in Liverpool as a merchant. He is first listed in 1837 with Cannon, Miller and Company, and was then living in Falkner Terrace, Upper Parliament Street. In 1853 he appears as Gentleman, 30 Falkner Square and later appears as a shipowner. By 1870 he had retired to Lindsay House, Magazine Brow, New Brighton and his son William Lindsay appears at his old address. The family firm still continues.

A neighbouring merchant in the same office buildings at 20 Crosshall Street was John Miller, also a Scotsman, the patron of various Liverpool artists like Davis, Windus and Robertson, who might well have recommended Robertson to him as a portrait painter.[1]

The portrait was reviewed in *The Art Journal*[2] when exhibited at the R.S.A. in 1854: 'a good example of unmannered style and forceful pencilling. The accessory of the Egyptian arum plant contrasts happily in its tinting and tone with the warm local colour against which it is played off: the pose of the figure is easy, and the solidity and breadth of the whole are quite admirable.'

Mrs. Robinson wears a black satin dress trimmed with broad fringe, a gold brooch on her lace collar and white feathers on either side of her lace and ribbon cap.

PROV: By descent to Mrs. K. G. Robinson, wife of the sitter's grandson, and presented by her, 1974.
EXH: 8657: Liverpool Academy, 1853 (19); Royal Scottish Academy, 1854 (1); Royal Academy, 1859 (176).
REF: 1 At the same address was also Tennant and Co., another Scottish firm, one of whose partners was Clow (or Clough), another Liverpool collector. 2 *The Art Journal*, 1854, p. 108.

7033 John Stewart, Mayor of Liverpool
Oil on canvas, 203·4 × 139·6 cm. (80 × 55 in.)
SIGNED AND DATED: *J. Robertson 1857*

John Stewart (1791–1871), in robes of office as Mayor of Liverpool, 1855–6. Born Liverpool, the son of a Scottish builder and surveyor, in which business he followed. He was Chairman of the Finance Committee and an active member of the Committee for building St. George's Hall.[1]

PROV: Commissioned by friends of the sitter and presented to him. Transferred to the Gallery from the City Estates Committee, 1968. Hung in the Town Hall.

EXH: Royal Academy, 1857 (396); Liverpool Academy, 1857 (396); Royal Scottish Academy, 1859 (128).
REF: 1 *The Porcupine*, Vol. 7, 1865, pp. 174–5; (Hugh Shimmin), *Pen and Ink Sketches of Liverpool Councillors*, 1866, pp. 6–10; *In Memoriam*, 1876, pp. 218–9.

7137 James Aikin

Oil on canvas,[1] 143×113 cm. (56¼×44½ in.)
SIGNED AND DATED: *J. Robertson/1873*
James Aikin, J.P. (1792–1878), Liverpool merchant and shipowner. Born Dumfries, the son of a writer to the Signet and friend of Robert Burns, he was sent to a relative in Liverpool as an apprentice merchant, 1806, and subsequently built up his own flourishing firm. He was active in the Liberal interest and a Town Councillor, 1840–49. He was Chairman of the School for the Blind, a founder of the Sailors' Home, the School of Design in Dumfries, etc., the Liverpool Philomathic Society, and the Liverpool Royal Institution, and took a cultivated interest in the theatre.

A Liverpool obituary noted that: 'Mr. Aikin was one of the towers of strength which sustained the early struggles of Liberalism in this town. . . and there was no man at the meetings of olden time in Liverpool who could so effectually silence an opponent by the readiness and vigour of his repartee than James Aikin. In latter years the retrospect which his simple presence recalled of an honourable commercial career and of useful public labour, added to the reputation for scholarly tastes which was associated with his life, made the attendance of the venerable, but always intellectually vigorous, Mr. Aikin a genial and graceful presence upon every platform upon which he sat, and an influence which it needed no word from him to mak felt. Some few years ago his brother magis trates, without distinction of politics, desire to pay him some compliment, and it wa intimated to him that it was generally wishe that he should give sittings for his portrai The unostentatious tone of his characte forbade his compliance with this request, bu he said that he would have his portrait painted and after his death leave it at the disposal of hi friends. An admirable painting by Robertson was subsequently painted, and attracted much attention at one of the Autumn exhibitions. The painting was hung in the magistrate room.[2]

A portrait by Robertson was exhibited at the Royal Academy, 1865 (319), and a portrait i reproduced in the *Union Marine Insuranc Company*, 1863–1913, fp. 38.

PROV: Liverpool Magistrates Court. Trans ferred from the City Estate Committee to the Gallery, 1969.
EXH: *Liverpool Autumn Exhibition*, 1873 (150) Walker Art Gallery, 1908, *Historical Exhibitio of Liverpool Art* (165).
REF: 1 Frame label of W. M. Walters, Artists Colourman, 118 Bold Street. 2 *Liverpool Daily Post*, 8 July 1878; *Porcupine*, Vol. 20, 1878 pp. 227–8, 259; *Proceedings of the Liverpoo Philomathic Society*, 1878–9, pp. i – v.

3010 James Allinson Picton

Presented by subscribers, 1860; destroyed 1939–45 war.

ROYLE, Herbert F. 1870 - 1958

Landscape painter. Born Patricroft, Lancashire, 13 June 1870. Trained at Harris Institute Preston and the School of Art, Southport; also studied under J. Buxton Knight. Lived a' Birkdale and Ainsdale, near Southport and subsequently moved to Nessfield, near Ilkley Yorkshire. Member of Manchester Academy of Fine Arts, the Liverpool Academy of Art

nd Sandon Studios Society. Exhibited in London and at the Liverpool Autumn Exhibition rom 1893. Died at Ilkley, 17 October 1958.

330 Haymaking Weather, Tawd Vale
Oil on canvas, 71·3 × 90·5 cm. (28⅛ × 35⅝ in.)
SIGNED: *H. Royle*

PROV: Purchased from the artist, 1906.
EXH: Walker Art Gallery, 1906, *Liverpool Autumn Exhibition* (923).

SALISBURY, Frank Owen 1874 - 1962

354 John Lea
Oil on canvas, 112·7 × 87 cm. (44⅜ × 34¼ in.)
SIGNED: *Frank O. Salisbury*

Alderman John Lea J.P. (1850–1927), Chairman of the Arts and Exhibitions Sub-Committee, 896–1927. Liverpool merchant; City Councillor from 1890; Lord Mayor, 1904–5; Alderman, 1912. Officer of the Legion of Honour.

His bequests to the Gallery included his bust by Goscombe John and the portrait of Harold Rathbone by William Holman Hunt *(q.v.)*. A presentation volume of sketches by members of the Liverpool Academy is also in the Collection.

PROV: Presented to the sitter by members of the Arts and Exhibitions Sub-Committee to commemorate his twenty-five years as Chairman, 1922; bequeathed by the sitter, 1927.
EXH: Walker Art Gallery, 1922, *Liverpool Autumn Exhibition* (888); Royal Academy, 1923, (601); Grafton Galleries, 1929, *Recent Works of Frank Salisbury* (88); Bury 1931; Rochdale 932.
REF: 1 Press cuttings (Liverpool Record Office); Frank Elias, *John Lea, Citizen and Art Lover*, 1927, *passim*.

7129 Frank Campbell Wilson, Lord Mayor of Liverpool
Oil on canvas, 241 × 147·5 cm. (95 × 58 in.)
SIGNED AND DATED: *Frank O. Salisbury/1923*

7128 Mrs. Wilson, Lady Mayoress of Liverpool
Oil on canvas, 241 × 147·5 cm. (95 × 58 in.)
SIGNED AND DATED: *Frank O. Salisbury/1923*

Frank Campbell Wilson (1868–1939) in Court dress when Lord Mayor of Liverpool (1922–3) and the Lady Mayoress. He wears the Jewel dating from 1877 and she the chain and badge of 1886.[1] The mace of 1667 lies on the table at his side.

He was a miller and corn merchant in Liverpool. Entered the City Council as a Liberal, 1910 and joined the Conservative Party, 1925; Chairman of the Electricity Committee; Alderman, 1927–30 and from 1931. Mrs. Wilson was an active public servant in War Relief organisations, on the Board of Guardians and as a City Councillor from 1923, following her husband into the Conservative Party, 1925.[2] The couple celebrated their silver wedding during their term of office.

He took a prominent part in commissioning Salisbury to execute the lunettes commemorating the dead of the Great War in the Memorial Hall of Liverpool Town Hall.[3]

PROV: Bequeathed to the City of Liverpool by the sitter, 1939; transferred from the City Estates Committee, 1968.
EXH: Walker Art Gallery, 1923, *Liverpool Autumn Exhibition* (88 and 75) repr.
REF: 1 Presented respectively by Sir A. B. Walker, 1877 and Sir D. Radcliffe, 1884. 2 Press cuttings (Liverpool Record Office). 3 Frank O. Salisbury, *Portrait and Pageant*, 1944, pp. 66 ff; *Liverpool Town Hall, collection of illustrations* (Liverpool Record Office).

SALOMON, Robert 1775–post 1842

Marine painter who travelled the ports of Great Britain, living or based for some time at Liverpool; after 1828 in Boston, U.S.A. Also known as Salamon, Saloman and in America as Salmon. Born Whitehaven and baptised there 5 November 1775, son of Francis Salomon, jeweller; other members of his family were mariners. The little known about his career before he left for America is chiefly derived from the transcript of his catalogue of paintings in Boston, and from dated works. He probably left Whitehaven for London in the late 1790's, moved to Liverpool 10 June 1806, when he began to list and number his works: No. 1, a *Battle of Trafalgar* sold for £8.8.0, suggests a connection between the artist and the Parorama exhibiting in Liverpool October–November 1806 (after five months in London) of the same subject, and a likely beginning of his career in this field and in scene painting. He is next noted at Greenock 13 April 1811, until 1822; arrived Liverpool 11 October 1822 and here until 1825, living in Warwick Street, Toxteth; Greenock 1825–26; London 1826–27; then in Southampton and North Shields; left North Shields 28 May and Liverpool 16 June 1828 for New York and Boston, where he settled; his catalogue list continues until 1840. Works are recorded for many ports on the English and Scottish coasts. He records at Liverpool Nos. 1–113 during 1806–11 and Nos. 374–452 for 1822–24, and he sold Nos. 593 and 594 here in 1828. Numbers are sometimes to be found on the backs of his pictures. He records imitating (Samuel) Williamson, and J. M. W. Turner in some works. His earliest known dated painting is of 1800, a ship off Whitehaven, and of Liverpool, 1802 (Greenwich). Exhibited at the Royal Academy, 1802 from a London address; Greenock 1813; Glasgow 1821; the Liverpool Academy 1824, and the British Institution 1828. After a successful career at Boston he returned to Europe about June 1842, and was certainly dead by 1851. Wilmerding (*loc. cit.*) publishes two Italian views, signed and dated 1845 which might possibly be by him. He may have died in his native Cumberland. Paintings are also in Merseyside County Museums.

Ref: John Wilmerding, *Robert Salmon, Painter of Ship and Shore*, 1971, citing other sources; D. R. Periman, Carlisle Art Gallery; *Liverpool Mercury*, October–November 1806.

597 Liverpool Town Hall, 1806

Oil on canvas,[1] 38 × 59·2 cm. (15 × 23¾ in.)

SIGNED AND DATED: *R.S. 1807.*

During a tour of England in 1806 the Prince of Wales and the Duke of Clarence stayed at Knowsley and made an official visit to Liverpool at the invitation of the Mayor and Council. A general illumination of buildings to mark the occasion was recommended by the Council.[2]

The local press, noting details of the itiner-ary, mentioned that: 'The Town Hall is to be most splendidly illuminated under the direction of Mr. Alderson, of Lord Street, and there can be no doubt that the inhabitants at large will follow the example.'[3] The visit, on Thursday, 18 September embodied a drive through the town, a tour of the docks and dinner with the Mayor at Lillyman's Hotel in Castle Street (the new rooms in the gutted Town Hall not being finished), and an evening tour of the illuminations which were carried out under the

superintendence of John Foster, Corporation Architect and Surveyor.[4]

In describing the illuminations, the Chronicle gave pride of place to the Town Hall:

'It seems to be generally admitted, and the Prince himself, we understand, is decidedly of the same opinion, that this superb edifice exhibited on Thursday evening the finest spectacle of the kind ever seen in the United Kingdom. Indeed the building itself, from its form and situation, is remarkably adapted to the purposes of an illumination. From every point of view, particularly from the heights which command the town, the dome had a most sublime and magnificent effect. It presented the appearance of an enchanted temple, and recalled to the mind of the spectator the fabulous tales of the Arabian Nights – and when taken altogether from Castle Street, formed an object of grandeur and splendour almost beyond conception.

'All the great outlines of the front, and the prominent parts of the building from the top of the dome to the lower windows, including the pediment, and the pilastres [sic] at each extremity, and the architecture of the dome were marked by lamps; the centre was superbly enriched, the columns being wreathed, and other parts ornamented with lamps formed into arches, festoons and stars, judiciously placed in the intervals. In the three centre large windows were three fine transparencies of Britannia, Commerce and the Prince's Crest; – upon the right and left of the centre were large initials of G P W; along the plinth of the centre in capitals, LONG LIVE THE PRINCE. The top of the pediment was crowned by a large and superb crown; and the hand of the figure of Britannia, placed on the top of the dome, held a very large flambeau. The extent of the building thus brilliantly illuminated, with 7383 chrystal lamps, is 106 feet front, and 132 feet in height, and was lighted, and all the scaffolding and apparatus completely removed, by 30 men, in 63 minutes.'[5]

Salomon shows the scene at three minutes to nine just before the Princes were due to appear. He also painted the Princes' visit to the docks where the American East Indiaman *Orozimbo* and other ships in the Queen's Dock were dressed overall.[6]

A print of the Town Hall illuminated was published probably post 1813[7] with slight differences from this painting.

PROV: Purchased from Nicholson Gallery, 1944.

REPR: Wilmerding, *op. cit.,* p. 6 fig. 2.

EXH: ? Greenock, 1813 (36); National Gallery, 1945, *Walker Art Gallery Acquisitions, 1935–1945* (98); Bluecoat Chambers, 1945, *Pictures of Old Liverpool* (5).

REF: 1 Relined. 2 MS *Visit to Liverpool of the Prince of Wales in 1806,* Proceedings of Council, Committees, etc., p. 4, and Proceedings of the Town Council, 8 September 1806 (Liverpool Record Office); and see J. Touzeau, *The Rise and Progress of Liverpool,* 1910, II pp. 734–741. 3 *Liverpool Chronicle,* 3 September 1806; John Alderson had an oil and lamp manufactory. 4 *Liverpool Chronicle,* 24 September. 5 *Ibid.* 6 John Wilmerding, *Robert Salmon, Painter of Ship and Shore,* 1971, col. pl. II (private collection), $15 \times 23\frac{1}{4}$ in., signed and dated *RS 1807;* Wilmerding also records a second version (letter to compiler, 4 Dec. 1975). 7 There is a companion print of illuminations in 1813 (Liverpool Record Office).

598 View in the Mersey

Oil on canvas,[1] 50.5 × 78 cm. ($19\frac{7}{8} \times 30\frac{3}{4}$ in.)

SIGNED AND DATED: *R.S. 1807*

Starboard view of a 22 gun merchant sailing ship in the Mersey with Liverpool waterfront behind and stern view of what may be the same ship at right. The panorama shows the windmills at the north end, the cupola of St. Paul's Church, the old spire of St. Nicholas (collapsed 1810), the cupola of the Town Hall, the spires of St. George and St. Thomas (far right), and in the foreground a line of what may be fortifications on the timber yards immediately behind the Parade on the edge of George's Dock.

There is no indication of the ship's identity but it may be the picture identified as the *Liverpool Ship Arctic* (see below).

PROV: Early 20th Century records identify this with *A Marine View* ascribed to R. Serres when bought in 1880 from Mr. Howard, Oxford Street East.[2] It may, however, be confused with 599 below and thus have been presented in 1915 by T. R. Davies, as the *Liverpool Ship Arctic.*

REF: 1 Damaged by fire in May 1941 Blitz; relined. 2 Library, Museum and Art Gallery Committee, 3 and 10 June 1880.

599 American ships in the Mersey off Liverpool

Oil on composition board, 41·9×60·5 cm. (16½×23⅞ in.)

SIGNED: *R.S.*

Two ships flying the stars and stripes and with signals at their mastheads, passing each other in the river, one firing a salute. The Perch, or Black Rock Lighthouse off New Brighton, seen at the left, was built in 1827, completed June 1829 and opened March 1830.[1]

PROV: Early 20th Century records identify this as *The Liverpool Ship Arctic,* presented by Thomas Rowe Davies, 1915. It may however be confused with 598 and thus have been acquired in 1880.

EXH: Bluecoat Chambers, 1945, Pictures of Old Liverpool (10).

REF: 1 *Annals of Liverpool.*

479 A Sailing Ship in the Mersey

Oil on canvas, 41·9×64·4 cm. (16½×25¾ in.)

SIGNED AND DATED: *R.S. 1811*

Starboard view of an 18 gun merchant ship with a stern view of what may be the same ship on the right. The panoramic view of Liverpool in the background is from slightly higher upstream and from further out than 598. The cupolas of St. Paul's Church and the Town Hall are visible and to the right the reach of the estuary towards the south with many ships.

PROV: Purchased from F. T. Sabin, London, 1945.

EXH: Bluecoat Chambers, 1945, *Pictures of Old Liverpool* (6).

After SARGENT, John Singer 1856 - 1925

955 Lord Wavertree

Oil on canvas, 91·5×71 cm. (36×28 in.)

Col. the Rt. Hon. Lord Wavertree, in peers parliamentary robes. For biography see the portrait by Morrison, 2569. Sargent made portrait drawings of Lord and Lady Wavertree in 1919 after the sitter had been raised to the peerage.[1] The head in 955 is based on this drawing but the drapery etc. is unlikely to relate to Sargent.[2] A water colour after the same drawing, by G. di Fenile, 1919 is also in the Collection.

PROV: Presented by Lord Wavertree, 1927.

EXH: Walker Art Gallery, 1927, *Liverpool Autumn Exhibition* (898) repr.

REF: 1 Formerly collection of Lady Wavertree, later the Hon. Mrs. Fisher; exhibited Liverpool Autumn Exhibition, 1925 (repr. pl. 29). 2 Letter from C. M. Mount, U.S.A., 4 December 1974.

SAVAGE, Deirdre, living artist

6906 Marsh Landscape, I

Oil on canvas, 30·5×40·7 cm. (12×16 in.)

PROV: Purchased from the artist, 1969.

EXH: Neptune Theatre, Liverpool, 1968–9, *Deirdre Savage* (1).

6907 Marsh Landscape, II

Oil on canvas, 60·7×91·4 cm. (24×36 in.)

PROV: Purchased from the artist, 1969.

EXH: Neptune Theatre, Liverpool, 1968–9, *Deirdre Savage* (9).

579 Lady with a Cyclamen: Hon. Mrs. H. Chaloner Dowdall

Oil on canvas, 76·2 × 85 cm. (30 × 33½ in.)

SIGNED AND DATED: *C. H. SHANNON. 99*

The Hon. Mary Francis Harriet (1876–1939), daughter of the 16th Lord Borthwick; author and contributor to various journals. She married Harold Chaloner Dowdall in 1897: he was Lord Mayor of Liverpool, 1908–9.

'I never knew anyone more eminently paintable', wrote Professor C. H. Reilly of her, and more often painted by great people, like Shannon and Augustus John. Her house was full of portraits of herself, my wife being one of those who put her on canvas.'[1] Portraits and drawings of her exist by Francis Dodd, Percy Gelting, and others.[2] She was a great friend of Augustus John who also painted the famous portrait of her husband as Lord Mayor. They were painted in a family group by Gerard Chowne,[3] and Shannon's portrait of Chaloner Dowdall was also exhibited with the present portraits in 1900.[4]

PROV: H. Chaloner Dowdall, and thence by descent; presented by Mrs. R. B. B. Tollinton, 1967.

EXH: Grafton Galleries, 1900, *Society of Portrait Painters* (67); Glasgow, 1901; Wolverhampton, 1902; Walker Art Gallery, 1909, *Liverpool Autumn Exhibition* (1040) repr., and 1933 (160).

REPR: *Charles Shannon, A.R.A.* (Masters of Modern Art), 1924, pl. 4.

REF: 1 *Liverpool Daily Post*, 22.5.1939 (press cuttings, Liverpool Record Office). 2 Private collections. 3 Sandon Studios Exhibition, 1908 (41), private collection. 4 Grafton Galleries, 1900 (1); a small portrait is in family ownership.

6578 Mrs. Elizabeth Dowdall

Oil on canvas, 78·8 × 85 cm. (31 × 33½ in.)

SIGNED AND DATED: *C. H. SHANNON. 99*

Elizabeth Grace Dowdall, née Chaloner (1825–1903), mother of Judge H. Chaloner Dowdall, Lord Mayor of Liverpool, 1908–9.

J. Hamilton Hay, who borrowed it for an *Independent* exhibition in Liverpool in 1904 admired 'its vague aesthetic atmosphere and delicate charm,' in his review of the exhibition in *The Sphinx*.[1] *The Courier* reviewer considered it 'a painting of accomplished scholarship, delicate intuition, and masterly composition; the colour may seem at first sight low in tone, but its richness and range will not be lost on a sensitive eye. . .'[2]

PROV: H. Chaloner Dowdall, and thence by descent; presented by Mrs. Jessie Petrie and Mrs. Joanna Tewiah, 1967.

EXH: Grafton Galleries, 1900, *Society of Portrait Painters* (81); Bradford, 1904; The Studios, 10 Castle Street, Liverpool, 1904, *The Independent Exhibition*.

REF: 1 *The Sphinx,* Liverpool, 1904, p. 126. 2 *Liverpool Courier,* 14 March 1904.

007 Monsignor Nugent

Oil on canvas, 153 × 123·8 cm. (60¼ × 48¾ in.)

SIGNED AND DATED: *J. J. Shannon/1897*

Rt. Rev. Monsignor Nugent (1822–1905). Born Liverpool of Irish parents. His ecclesiastical training was at Ushaw and the English College, Rome. After working at Blackburn and Wigan he was appointed to Liverpool, 1849. First Prison Minister at Walton, 1863–82. Appointed domestic prelate by the Pope, 1892. Renowned for his life's work amongst the poor and destitute, promoting the betterment of the young by education, recreation and emigration.[1]

A monument by Pomeroy is in St. John's Gardens; a bust by him, 1904 is in the Collection; a bust by A. McGreeham was in the *Liverpool Autumn Exhibition,* 1902 (repr.)

PROV: Presented by Subscribers to the sitter, on the Jubilee of his Ordination 5 May 1897, and given by him to the city.

REF: 1 Press cuttings (Liverpool Record Office); Canon Bennett, *Father Nugent of Liverpool,* 1949, repr. frontispiece.

SHARPE, Charles William 1881 - 1955

Landscape painter. Born Liverpool, 29 March 1881, grandson of an engraver. Trained a Liverpool School of Art. Held various teaching posts and from 1930 was Principal of the Laird School of Art, Birkenhead. A draughtsman during 1914–18 War. Member and Hon Secretary of Royal Cambrian Academy; Member Ulster Academy of Arts, Liverpool Academy and Sandon Studios Society. Exhibited London, Liverpool and internationally. Died Deganw 27 July 1955.

1453 Hilbre
Oil on canvas, 61 × 71 cm. (24 × 28½ in.)
SIGNED: *Chas. W. Sharpe*
PROV: Purchased from the artist at the Autumn Exhibition, 1935.

EXH: Walker Art Gallery, 1935, *Liverpoo Autumn Exhibition* (137).

SHEE, Sir Martin Archer 1769 - 1850

3130 William Roscoe
Oil on canvas, 233 × 166·5 cm. (91¾ × 65½ in.)
An inner canvas round the figure 139·5 × 108 cm. (55 × 42½ in.) has been enlarged on all four sides.
INSCRIBED: *William Roscoe* and *Sir M. A. Shee Px./1822*
William Roscoe (1753–1831), one of Liverpool's greatest and most versatile citizens. An attorney by profession, he was historian, poet, collector, politician, philanthropist, agriculturalist and botanist.

Born Mount Pleasant, Liverpool 8 March 1753, the son of a market gardener and publican, baptised at Benn's Gardens Chapel. He was largely self-educated; he taught himself ancient and modern languages and developed an early enthusiasm for Italian history and literature which resulted in his publishing *The Life of Lorenzo de' Medici*, 1796 and *The Life and Pontificate of Leo X*, 1805. Translated into several languages they gave him an assured position as an historian. He was articled to an attorney in 1769 and admitted attorney of the Court of the King's bench in 1774. He married Jane Griffies in 1781 and they had seven sons and three daughters (see under John Williamson).

Successful as a lawyer, he was able to sell his Liverpool partnership in 1796 to devote all his time to literary and agricultural pursuits. In 1799 he moved to Allerton Hall but was obliged soon after to become a partner in William Clarke's Bank. He represented Liverpool in the Parliament of 1806–7, in the Whig interest when he gave whole-hearted support to the Bill for abolishing the Slave Trade. His humanitarian and liberal ideas were those of the most enlightened of his day. Made Honorary Freeman of Liverpool, 24 June 1815. A member of the Unitarian Church.

Inspired by what he believed to be the example of the great Renaissance princes Roscoe early played his part in the cultural development of Liverpool in the midst of her commercial expansion. He was active in the organisation of the early art exhibitions, the foundations of the Athenaeum Library, the Liverpool Royal Institution, and the Botanic Garden. He was a notable early collector of 'primitive' Old Master paintings and drawings as well as a friend and patron of modern artists in particular Fuseli; and the nucleus of the Walker Art Gallery Collection was originally his. As the result of a run on his bank in 1816 he sold his fine library and his pictures drawings and engravings, and Allerton Hall but was nevertheless declared bankrupt in 1820. His many friends helped him to settle to a reduced way of life and acquired many of his pictures for the Liverpool Royal Institution

The remainder of his life was chiefly devoted to literary activities; much time was spent in preparing a catalogue of the Manuscript Library at Holkham, while his later publications included an edition of Pope, 1824, various pamphlets on penal jurisprudence and the important 'Monandrian Plants.' He died at Lodge Lane, Liverpool, 30 June 1831.[1]

Thomas Creevy, his fellow townsman, in a graphic letter to his niece Miss Ord, summed up Roscoe's impact on his contemporaries:

'. I am in the second volume of poor Roscoe's *Lorenzo de Medici*. I read his *Leo* three or four years ago with great pleasure, and the present book with increased delight. I can scarcely conceive a greater miracle than Roscoe's history – that a man whose dialect was that of a barbarian, and from whom, in years of familiar intercourse, I never heard above an average observation, whose parents were servants (whom I well remember keeping a public house), whose profession was that of an attorney, who had never been out of Liverpool – that such a man should undertake to write the history of the 14th and 15th centuries, the revival of Greek and Roman learning and the formation of the Italian (illegible) – that such a history should be to the full as polished in style as that of Gibbon, and much more simple and perspicuous – that the facts of this history should be all substantiated by references to authorities in other languages, with frequent and beautiful translations from them by himself – is really *too!* Then the subject is to my mind the most captivating possible: one's only regret is that poor Roscoe, after writing this beautiful history of his brother bankers the Medici, should not have imitated their prudence, and by such means have escaped appearing in that profane literary work, the *Gazette!* Oh dear! what a winding up for his fame at last!"[2]

This portrait was painted for Roscoe's new acquaintance Thomas Coke of Holkham, Norfolk, later 1st Earl of Leicester. Roscoe visited Holkham late in 1814 chiefly to examine the important but then virtually unexplored Manuscript Library. He promised to superintend its re-ordering and binding at Liverpool and to prepare a simple catalogue.[3] Coke returned his visit in October 1815 and asked for a portrait, presumably in compliment to Roscoe's undertaking: it was hung in the Ante-Room to the Manuscript Library, later called the Classical Library.[4] Roscoe is shown seated writing, surrounded by books and manuscripts, and with a bust of Charles James Fox, his great political hero, placed in front of him next to volumes of his *Leo X*. Roscoe's catalogue, much extended by Frederic Madden and completed in 1828, was never published on grounds of expense.[5]

Roscoe sat to Shee at least four times in November and early December 1815,[6] and wrote from London to inform Coke on 6 December 'You will see how ready I am to comply with the request you did me the honour of making to me at Allerton, when I inform you that I have been with Mr. Shee and had several sittings for a portrait, which will be so far finished before I leave Town as to prevent any occasion for a journey into Lancashire on so unimportant an occasion. . .'[7] At this stage the portrait was a three-quarter length, probably standing, to meet with Roscoe's own wish (see 4555 below), but Coke wrote in February 1816: 'I have seen Mr. Shee's picture, and highly approve the likeness, but I must have a full length of you sitting in my library, of which I shall be prouder than of any room in the House.'[8] In June Coke wrote again that he was 'so anxious about the proper arrangement of this MSS Library that I have prevailed upon Mr. Shee to accompany Mr. Sequier to Holkham in August [?] so that no mistake may arise in the finishing and fixing of your Portrait.'[9] Shee went down in August or September;[10] the portrait was nearly finished by February 1817[11] and on its way down to Holkham during July.[12] Roscoe does not appear to have sat again for it. Seams of the added canvas around the initial 50×40 in. format are just visible and the alterations must explain the delay in finishing.

It has been pointed out by Derek Shrub[13] that the chair in which Roscoe sits is probably based on Sir Joshua Reynolds' sitters' chair, which passed by tradition to succeeding Presidents of the Royal Academy (now Royal Academy collection). Though glamourised by gilding and a different form of arm, the same doric-style decoration is in evidence around the seat. It should be noted, however, that Shee did not succeed Lawrence as President until 1830 and the inscription on this portrait, which was found on cleaning in 1953 to lay on top of the final varnish, must post-date that year (and very probably Roscoe's death in 1831).

On its exhibition at the Royal Academy of

1817 this portrait was noted by *The Literary Gazette* as 'certainly the finest likeness ever painted of this celebrated man; and altogether, in colouring, disposition, and character, does honor to the artist's pencil. We are prevented by our restricted limits only, from a detailed notice of this important picture.'[14] Contemporaries of Roscoe considered it a good likeness but thought the body too large, in relation to the head.[15]

An oil sketch (*c.* 18×9 in.) by Shee formerly belonged to Mrs. A. M. Roscoe (d. 1949).[16] For other portraits see under Caddick, Lonsdale and J. Williamson. Miniatures by Hargreaves and Haughton (2184, 2192, 3997), and examples of the plaster medallion by Gibson and the miniature bronze by W. Spence are also in the Collection (2536, 2527, 4157). Chantrey's seated statue is in St. George's Hall (7811 in the Collection).

The bust presented by Gibson to the Liverpool Royal Institution is still there. A Centenary medal designed by Allen and Moore for Joseph Mayer, 1853 and a Wedgwood blue and white jasper medallion, 1852, is in Liverpool City Library, where are various engravings, which include the following not noted under any of the above: J. Thomson, drawn and engraved, published *European Magazine*, August 1822; the line version of head by W. Read, 1822; Hopwood after unidentified portrait three-quarters to r., published W. H. Payne, 1 July 1815; engraving after drawing by Daniel Maclise (Alfred Croquis), 1832.[17]

PROV: Painted 1815–17 for T. W. Coke, later 1st Earl of Leicester, whose son, the 2nd Earl, presented it to the Corporation of Liverpool 1860.

REPR: Walker Art Gallery Catalogue, 1928, frontispiece; George Chandler, William Roscoe of Liverpool, 1953, frontispiece (in colour).

EXH: Royal Academy, 1817 (149); South Kensington Museum, 1868, Third Exhibition of National Portraits (160); Walker Art Gallery, 1955; *Cleaned Pictures* (40).

REF: **1** Henry Roscoe, *Life of William Roscoe,* 1833, *passim;* for various aspects of his activities see Liverpool Bulletins, 1952 *et seq.* **2** *The Creevy Papers,* edit. by The Rt. Hon. Sir Herbert Maxwell, Bt., 1912, p. 598. **3** Henry Roscoe, *op. cit.,* II pp. 84 ff, 98. **4** J. Dawson *The Stranger's Guide to Holkham, containing a description of the Paintings, Statues, etc., of Holkham House, in the County of Norfolk,* 1817,

p. 80, No. 119. **5** See J. E. Graham, *T Cataloguing of the Holkham Manuscripts, Transactions of the Cambridge Bibliographic Society,* IV, 2, 1965. **6** Roscoe to his son W. Roscoe, 30 Nov., and 6 Dec., 1815 (Rosc Papers 4148, 4151, 4152, Liverpool Reco Office). **7** Holkham MS 768 (microfil Liverpool City Library). **8** Coke to Rosc 15 Feb. 1816 (Roscoe Papers 900). **9** Coke Roscoe 18 June 1816 (Roscoe Papers 905 **10** Dawson Turner to Roscoe, Sept. 181 Coke to Roscoe, 18 Oct., 1816 (Roscoe Pape 4887, 915). **11** William Carey to Rosco 25 Feb., 1817 (Roscoe Papers 739). **12** Coke Roscoe, 31 July 1817 (Roscoe Papers 934 **13** Derek Shrub, Victoria and Albert Museur in letter 6 June 1966 (Gallery files). **14** *T Literary Gazette,* 1817, p. 299. **15** W. S. Rosc to W. Roscoe, 6 June 1818 (Roscoe Pape 4178). **16** Exhibited Walker Art Gallery 190 *Historical Exhibition of Liverpool Antiquiti* (100a). **17** See also list in G. Chandler, *Willia Roscoe of Liverpool,* 1953, pp. 158–9.

4555 William Roscoe

Oil on canvas, 141×110·5 cm. (55½×43½ in.)

This shows the original format of 3130 abov In a letter to Roscoe of 4 April 1819, Sh wrote 'You are aware that Mr. Coke require a portrait of you much larger, & of a charact different from that for which you sat, as mo: appropriate to the situation in which he wishe to place it. I took care however, to make a exact duplicate, the size of the first, & in tl standing position for which you may rememb to have stood when I had the pleasure of seeir you here. This I have now finished & I a: given to understand with such success, tha I am induced to include it in my selection fc our approaching Exhibition. . .'[1] From h reply[2] we learn that Roscoe would have pr ferred a half-length standing, for the portra at Holkham, and would prefer that this ne portrait were neither exhibited nor engrave but did not wish to stand in the artist's wa over this, and offered to sit again if necessar Both modesty and his impending bankrupto may have prompted his reserve. It was exhibite but not engraved. The space beyond the lo wall and column, more largely obscured by curtain than in 3130, here reveals a colonnade building in place of the stacked book-case c the other.

W. C. Edwards made a drawing after it fc

n engraving to preface the Manuscript
Catalogue but as Roscoe did not want it
engraved the engraving after Hargreaves'
miniature was used instead.[3]

ROV: Painted 1819. (?) John Barratt in 1857.[4]
(?) Eliza, widow of Henry Roscoe (1833–1899).[5]
F. W. Dunston; Dr. Martin, of Salisbury,
thence by purchase to Charles Roscoe, OBE.,
who presented it, 1960.[6]

EXH: Royal Academy, 1819 (174); (?) Man-
chester, 1857, Art Treasures (British Portraits
Gallery, 320).

REF: 1 Roscoe Papers 4354, (Liverpool Record
Office). 2 Draft letter Roscoe to Shee, 17 April
1819 (Roscoe Papers 4355). 3 Coke to Roscoe,
8 November 1824; W. C. Edwards to Roscoe,
N.D.; Dawson Turner to Roscoe, 9 April
1825 (Roscoe Papers 963, 1434, 4939); and
see Hargreaves 2184. 4 Scharf Sketch Book,
Vol. 49, p. 20, shows same format as 4555
(National Portrait Gallery Library). 5 F. W.
Dunstan, Roscoeana, (1905), p. 7 note 1.
6 Recent history in letter 28 April 1959 (Gal-
lery files).

SMITH, Edward 1779/80 - 1849

A native of Liverpool who was living in Camden Town, London in 1840, when 2575 was
exhibited in Liverpool. According to Gallery records he was a remote cousin of the Caddick
family of artists and great-uncle to Miss Alice Sudlow, one of their descendants. (see Caddick).
This may equate him with the Liverpool engraver recorded at local addresses 1816–29 and a
member of the Liverpool Academy in 1822. He exhibited engravings after portraits there in
1822, and in 1832 from London; he is probably the engraver for The Winter's Wreath (see Mosses
1980) and of various recorded portraits of Liverpool sitters including Roscoe. He died at
Camden Town, 18 April 1849 aged 69, and Gore's Advertiser noted that he was 'an artist of
considerable ability.'

2575 Edward Rushton
Oil on canvas,[1] 92×71 cm. (36¼×28 in.)
Edward Rushton (1795–1851), for biography
see the portrait by S. Gambardella (7140).
ROV: Presented by Thomas Smith, 1861.[2]

EXH: Liverpool Academy, 1840 (160).
REF: 1 Relined. 2 MS label; Library, Museum
and Art Gallery Committee, 31 January 1861.

SMITH, George Grainger 1892 - 1961

Painter and engraver. Born Hull and moved to Liverpool 1895. Trained at Liverpool School
of Art. Art Master at Liverpool College. Exhibited London, Liverpool, etc. Member of
Liverpool Academy and member and a President of the Royal Cambrian Academy. Retired
to Wales. Died 15 May 1961.

2684 Snowdon from Capel Curig
Oil on hardboard, 64·2 × 76·8 cm. (25¼ × 30¼ in.)
SIGNED: *Grainger Smith*
The names of peaks from left to right are: Y-Lliwedd (2,947 ft.), Y-Wyddfa (Snowdon: 3,560 ft.), (G)Crib-Goch (3,024 ft.), Crib y Ddysgyl (3,493 ft.). The former Royal Hotel, subsequently a Y.H.A. property, is seen at centre.[1]
PROV: Presented by the artist in memory of his wife, 1956.
EXH: Bluecoat Chambers, Liverpool, Dec. 1939–Jan. 1940, *Liverpool Artists Exhibition* (56); Southport, 1950, *Wirral Society of Arts*.[2]
REF: **1** Information from James Farquharson. **2** Label.

1089 The Enemy Raid, May 3rd 1941[1]
Tempera on board, 29·8 × 39·8 cm. (11¾ × 15¾ in.)
SIGNED AND DATED: *GRAINGER SMITH MAY 1941*
Liverpool at night during the May blitz of 194 seen from the artist's Wallasey home. The Liver Building and the dome of the Dock Board are silhouetted against the flames.
A pastel of the subject by P. F. Shepheard is also in the Collection (1085).
PROV: Purchased from the artist, 1942.
REF: **1** Artist's label, verso.

SMITH, William, later 19th Century

Artist recorded at addresses in Bedford Street and Stanhope Street, Liverpool, between 1864/5 and 1883.

2576 William Rathbone
Oil on canvas, 91·4 × 71·4 cm. (36 × 28⅛ in.)
SIGNED AND DATED: *W. Smith 1864*
William Rathbone (1787–1868); for biography see the portrait by Millington. This is probably from a photograph of the sitter in a similar pose.[1]
PROV: Presumably the picture received (from Mr. Herdman) by the Library, Museum and Art Gallery Committee, 8 March 1866, and acknowledged to the donor, Horatio N Hughes, 15 March 1866.[2]
REF: **1** A print is with the Rathbone family repr. in S. Marriner, *Rathbones of Liverpool 1845–73*, fp. 10. **2** Minutes of meetings.

STEVENSON, William Lennie, living artist

1818 Milan
Tempera on board, 91 × 121·5 cm. (35⅞ × 47⅞ in.)
PROV: Presented by John Moores, 1958.
EXH: Walker Art Gallery, 1958, *Liverpool Academy* (102) repr.

STUBBS, George 1724 - 1806

Eminent animal painter who started as a portrait painter, native of Liverpool where his career began. Born 25 August 1724, the son of John Stubbs, currier Dale Street, and baptised at St. Nicholas's Church. The source for his early years is the manuscript *Account* by Ozias Humphrey dating from the 1790's (with some interpolations by Stubbs' companion Mary Spencer), in which dates and times are far from precise. At about eight years his family living in Ormond Street; he began anatomical drawings with materials from a neighbour, Dr. Holt; he was associated with Caddick and 'Dick' Wright (*qq.v.*) in drawing etc. His father did not prevent his chosen career and advised him, when dying, to study painting with a professional; soon after father's death (buried St. Peter's, 16 August 1741), he went to Hamlet Winstanley (*q.v.*). He assisted Winstanley, then copying pictures at Knowsley, but a quarrel soon terminated his only formal training and he resolved to study Nature only; intending to qualify himself for painting portrait, pastoral and familiar subjects in history.

When nearly 20 left Liverpool for Wigan, then Leeds, practising portrait painting, and finally York, 1744, where he had commissions and began his serious study of anatomy, dissecting human and animal subjects, which qualified him to lecture to the hospital students; he drew and etched the plates to John Burton's book on midwifery, published 1751, having specially learnt the process from a Leeds housepainter. About 1752 he went to Hull, where under patronage of Nelthorpe family. About beginning of 1754, apparently after a return visit to Liverpool, embarked for Rome, but returned after only a few months. After a week in London, he returned to his mother's house at Liverpool, and here 'Pictures in abundance were proposed to him'; he painted portraits, animals and continued dissecting various animals. Following his mother's death he remained some time settling her estate; her death date untraced but he appears to have been here until some time in 1756. His pictures of his own grey mare gained acclaim and the advice of a London dealer, Mr. Parsons, to remove to London.

This or other reasons, probably to find privacy for further anatomical studies, caused his removal initially to Lincolnshire where old commissions awaited him and he began the work for his great publication of the *Anatomy of the Horse,* published London 1766, which put the seal on his success in the capital. He may have revisited Liverpool for a Mary, described as daughter of George Stubbs limner, was buried at St. Georges Church 18 September 1759.

He settled in London about 1760. Associate and exhibitor of the Incorporated Society of Arts, 1761–74, and President 1773; exhibited at the Royal Academy, 1775–1803; A.R.A. 1780; R.A. elect, 1781. He sent two paintings, *Harvest Scene, Reapers* and *Ditto, Haymakers* to the second exhibition of the Society for promoting Painting and Design in Liverpool, 1787, which were apparently copied by Charles Towne, it is said to his annoyance, and Caddick acted as an agent for prints of these subjects in 1789, otherwise his connection with Liverpool ends. Several of his later paintings are in the Collection.

8294 James Stanley

Oil on canvas, feigned oval, $75 \times 62 \cdot 5$ cm. $(29\frac{1}{2} \times 24\frac{5}{8}$ in.)

INSCRIBED, verso, on relining canvas (evidently copied from an original inscription): *James Stanley/An: AE tat 33. Christ. 1755/Geo: Stubbs pinx:*

One of the earliest portraits by Stubbs that has yet appeared,[1] it must date from his final stay in Liverpool. It shows a developed grasp of form and ability to portray personality, which was to be characteristic of his later work. The sitter, a substantial well-turned out figure in buff coloured coat and scarlet and gold waist coat, has not been identified amongst the variou Lancashire families of the name. A Jame Stanley is recorded in Ormond Street, Liver pool, where Stubbs had once lived, in 1758.[2]

PROV: Mrs. Y. N. China, sold Sotheby' 23.6.1971 (91), repr., bt. Spink; thence pu chased by the Gallery.

EXH: Spink, 1971, *English Painting*.

REF: 1 Portraits of the Nelthorpe family Lincolnshire may precede it. 2 Poor Ra Register, 1758, Plumbe-Tempest Papers (Live pool Record Office).

SULLIVAN, William Holmes 1836 - 1908

Born Liverpool 16 November 1836. Studied at Liverpool Academy Schools and later Member; a President of the Liverpool Society of Watercolour Painters and of the Roy Cambrian Academy. Exhibited at the Royal Academy in 1875, at the Liverpool Autum Exhibition, 1871-1884. Died 1908.

2417 Harvest Moon

Oil on canvas, $61 \cdot 5 \times 108$ cm. ($24\frac{1}{4} \times 42\frac{1}{2}$ in.)

SIGNED: *W. Holmes Sullivan*

PROV: Presented by A. M. Jones, 1876.

SUTCLIFFE, Stuart 1940 - 1962

Born Edinburgh 23 June 1940, son of a Merchant Navy Engineer. Educated Prescot Gramma School and thence to Liverpool College of Art, where he took a diploma in painting. Le autumn 1960 to play bass guitar with the Beatles in Hamburg night club. April 1961 – Marc 1962, pupil under Eduardo Paolozzi at Hamburg State High School (Art School) whi playing with Beatles every night. Most of his work was concentrated into these months. Die of a brain tumour, 10 April 1962. Exhibitions have been held at the Gallery in 1964, th Neptune Theatre, Liverpool 1970 and the South London Art Gallery, 1976.

6253 Hamburg Painting No. 2

Oil on canvas, $124 \cdot 5 \times 100$ cm. ($49 \times 39\frac{3}{8}$ in.)

PROV: Presented by Mrs. M. Sutcliffe, mother of the artist, 1964.

EXH: Walker Art Gallery, 1964, *Stuart Su cliffe* (14).

TATE, William, active 1770 - 1806

Portrait painter. Brother of Richard Tate (d. 1787), Liverpool merchant living here by 1766. According to a reference in the Roscoe Papers, he went to school at Woolton near Liverpool and at the same time studied art with a fellow pupil Richard Hurlestone the painter. He was a pupil of the latter's great friend Joseph Wright of Derby (who lodged with Richard Tate at Liverpool, 1769), whose work he copied and with whom he corresponded. He also painted genre and subject pictures. Fellow of Society of Artists, 1774, where he exhibited 1771–91 (from 1778–82 using Wright's address, Craven Street, Strand); exhibited Royal Academy at intervals, 1776–1804; and at the three Liverpool exhibitions (where other members of the Tate family also exhibited). He is recorded in London 1771/72, Manchester 1773, Liverpool 1774/76, London 1777/82; Liverpool 1784, Manchester 1787/1803. In 1787 Wright referred to him as 'now advantageously placed at Manchester' and planning again to exhibit at the Royal Academy after a long interval due to unsatisfactory treatment there. Again, in 1795, Wright expressed pleasure that he was painting again (in oil) seemingly after a period of watercolour painting only.

He settled in Bath, January 1804 and died there 2 July 1806.

541 Daniel Daulby

Oil on canvas,[1] 76·5 × 63·5 cm. (30⅛ × 25 in.)

Daniel Daulby (1745/6–1798), member of a well known family of Liverpool brewers and an important collector; brother-in-law of William Roscoe (see 2543 below). He was also an enthusiastic farmer and fruit grower. In 1781 he lived at Sir Thomas's Buildings, Liverpool and moved to Birchfield, Folly Lane about 1788. In 1796 he retired to Rydall Mount, Westmorland, where he died in March 1798. His collection embraced old master paintings, contemporaries like Wright of Derby and Chubbard of Liverpool but most particularly Rembrandt etchings;[2] he is best remembered as the author of *A Descriptive Catalogue of the Works of Rembrandt* (Liverpool, 1796), to which William Roscoe contributed an introduction. He is seen here with an unidentified landscape print or drawing in his left hand.

Probably painted as a companion to 2542 and therefore dating from about 1774. This was also the year of Liverpool's first art exhibition with which Daulby was closely associated. A miniature portrait of him by Patrick McMorland also belonged to the sitter.[3]
The paint surface is very worn.

PROV: Daniel Daulby,[4] by descent to his youngest daughter, Catherine Daulby (d. 1873); James Thornely 'of Woolton' whose wife was a grand-daughter of William Roscoe; Mrs. Laura Thornely; Miss Beatrice Thornely[5] (d. 1950); thence to her nephew Colonel L. M, Synge whose sister Mrs. E. J. Macnaughton. presented it with 2542 and 2543 below, 1952.
EXH: Walker Art Gallery, 1908, *Historical Exhibition of Liverpool Art* (312).
REF: 1 Relined: *W. Tate F.S.A.* is inscribed on the back. 2 Sales Liverpool (T. Vernon) 27.8.1798 and 12.2.1799, and Christie's, 14–17.5.1800. 3 *Catalogue of the Books, Prints Pictures & Drawings, of Daniel Daulby. Liverpool 1793.* (MS), p. 48, No. 70 (Liverpool Record Office). 4 *Ibid*, No. 65, as by Tate. 5 Provenance in Letter 19.2.1961.

2542 Elizabeth Knowles, Mrs. Daulby

Oil on canvas, 76·2 × 63·5 cm. (30 × 25 in.)

Elizabeth (1751–1775), daughter of Thomas and Mary Knowles, and first wife of Daniel Daulby (2541). The date of her marriage is not known but it is recorded in the Register of St. George's Church, Liverpool, that 'John, son of Daniel Daulby Jnr. Brewer' was born 12 August, 1775 and christened 1 October of

the same year.[1] As it was customary for the eldest son in the Daulby family to be called John,[2] it may be conjectured that Daniel and Elizabeth Daulby were married around 1774; she died 29 September 1775 aged 24.[3] Tate is known to have been living in Liverpool during this period and 2542 may have been a wedding portrait.

PROV: As 2541.[4]

EXH: Walker Art Gallery, 1908, *Historical Exhibition of Liverpool Art,* (290).

REF: 1 *(Peet transcript) Register of St. George's Church, Liverpool, 1734–1897,* p. 50, (Liverpool Record Office). 2 J. Paul Richter, *A Descriptive Catalogue of a Selection of Old Masters from the Maryon-Daulby Collection* (privately printed), n.d., p. 4, note. 3 Label. 4 Daulby MS Catalogue, *loc. cit.,* No. 66, as by Tate.

2543 Margaret Roscoe, Mrs. Daulby

Oil on canvas, 76·2 × 63·5 cm. (30 × 25 in.)

Margaret (1754–1819), the only sister of William Roscoe, was the second wife of Daniel Daulby (2541). Their eldest child was born on 3 December 1783.[1] This portrait may date from about 1784 when it is known that Tate was back in Liverpool, but could be earlier as inscribed on the page of the pamphlet which the sitter turns towards the spectator are the words *MOUNT PLEASANT* – the title of Roscoe's descriptive poem, written in 1771 and published anonymously in 1777. These verses were inspired by the view of Liverpool from Mount Pleasant (Roscoe's Birthplace); they are, however, interesting only because they contain proof of the writer's early loathing for the slave trade.

PROV: As 2541.[2]

REF: 1 *(Peet transcript) Register of St. George's Church, Liverpool. 1734–1897,* p. 56 (Liverpool Record Office). 2 Daulby MS Catalogue, *loc. cit.,* No. 67, as by Tate.

9067 Mr. Tate of Toxteth Park

Oil on canvas, 127 × 100·6 cm. (50 × 39⅝ in.)

The sitter holds a landscape sketch in his left hand and a porte-crayon or pencil in his right; in the left distance is a lake in a mountain setting. He wears a dark blue or black coat with brass buttons over a biscuit coloured waistcoat and beige breeches; his hair is powdered or grey. The costume suggests a date

around 1800, the sitter might be in his late 20's or 30's.

He is evidently Thomas Moss Tate (d. 1825), a son of Richard Tate (d. 1787), merchant of Liverpool, and nephew of William Tate the artist. He is listed as a merchant with a tobacco and snuff manufactory from 1790, having probably joined or taken over from his father in 1787. He was a member of the company of merchants trading with Africa, succeeding his father in 1789.[2] From 1803 he became a gentleman, having sold the business to Joseph Williamson, who married his sister Elizabeth (see British School 7480), and from 1821 he is listed at Toxteth Park. He died 7 March 1825.[3]

All his family seem to have practised painting or drawing, exhibiting as honorary members in the Liverpool exhibitions of 1774 or 1784.[4] He himself showed four pictures (three certainly drawings) at the 1784 exhibition, one of which was after Joseph Wright of Derby who taught his uncle and with whom he was himself intimate. He accompanied Wright on a sketching trip to the Lake District in 1793 and 1794, which might perhaps be commemorated in this portrait. He owned a group of Wright's works including *The Lady In Comus,*[6] which must be 2500 in the Collection, and *Matlock High Tor* bequeathed him by his uncle William and a copy of which subject he exhibited at the 1784 exhibition.

The dog also appears in a horse portrait by J. Boultbee dated 1801,[8] which was in the same collection, as was a portrait of Miss Tate, which probably dates from the early 1790's and is in a style closer to earlier Tate portraits in the Collection than is 9067. SEE APPENDIX.

PROV: By descent from a member of the Tate family through the female line, to Major G. H. Hunter; his sale (Bruton, Knowles) the Old Rectory, Madresfield, Great Malvern 17.2.1976 (304) as *Wright of Derby,* bt. by the Walker Art Gallery.

REF: 1 Richard, son of Richard Tate was born 1773 (St. George's Church Register (Peet Transcript)), stated age 56 at death in 1820 (if the same); so the present sitter may have been a little older. 2 Company Committee Minutes, 1750–1820 (Liverpool Record Office 352 MDL); see B. Nicholson, *Joseph Wright of Derby,* 1968, I p. 139. 3 *Gore's Advertiser* 10 March 1825. 4 Confirmed by references in sitters' will (Preston Record Office). 5 Nicholson, *op. cit.,* I pp. 19, 139. 6 Cited in the

codicil of 1822 to his will of 1816. A group of paintings purporting to be from his collection, but few agreeing with those cited in his very detailed will, were in a sale of the 'Executors of a gentleman recently deceased' at Winstanley's, Liverpool (advert, *Liverpool Mercury*, 6 & 13 April 1849): this included *The Convent of Cosimato*, now 2139 in the Collection. **7** Will, 1806 (Public Record Office). **8** Same sale, 17.2.1976 (305). **9** Same sale, 17.2.1976 (303).

THOMPSON, Thomas Clement, about 1778 - 1857

Irish portrait painter settled in London. He exhibited at the Liverpool Academy 1828–46 giving Liverpool addresses in Bold Street and Rodney Street as well as his London address during some years.

6347 Nicholas Robinson, Mayor of Liverpool

Oil on canvas,[1] 129.6 × 103.5 cm. (51$\frac{1}{16}$ × 40$\frac{13}{16}$ in.)

SIGNED: *T C THOMPSON R.H.*

Nicholas Robinson (1769–1854), in the robes of Mayor of Liverpool, 1828–9. His six day contest with Thomas Colley Porter for the mayoralty of 1827–8, which Porter won, is described under the latter's portrait by Lonsdale.

A corn merchant of Liverpool, he built Sudley, Mossley Hill in the mid-1820's on ground bought from the Tarleton Estate at Aigburth in 1809.[2] This was bought from his heirs by George Holt in 1883 and now houses the Holt Collection.[3] His son, Charles Backhouse Robinson, was a sculptor, who lived in later years at Frankton Grange, Loppington, where this picture was housed together with other pictures, furniture and property of his father.[4]

Robinson presided at the opening of the Liverpool Academy Exhibition, 1829 at which this portrait was exhibited.

The reviewer in the local press commented on the likeness:

'Forced as we are to confess that our Hiberian artist has not rendered justice either in attitude or expression to the firmness and decision of character in his subject, we gladly welcome the appearance of our Chief Magistrate in this collection; and we trust that his successors will do as Nicholas Robinson has done – preside at the annual dinner of the Academy, and send their portraits to the exhibition. No charge of vanity can touch this course of action, for it is true legitimate patronage of the Arts, and consequently will reflect honour and nothing else on every one of the Council, whose affection for them and the good old town shall lead him to follow as serviceable and good an example.'[5]

Pencil sketches of Robinson and his wife by Thomas Hargreaves are in the Liverpool Record Office; a bust by his son is in the Gallery collection (6348).

PROV: Family descent; presented by the Robinson family from the Frankton Grange estate, 1966. Hung at Sudley.

EXH: Liverpool Academy, 1829 (52).

REF: **1** Not relined. **2** Matthew Gregson, *Fragments*, 1824, p. 199. **3** See *Sudley* Catalogue, Walker Art Gallery, 1971. **4** Sales: Hall, Wateridge, Owen, at Frankton Grange, 26–27.5.1966; Sotheby's, 21.1.1966, 9.2.1966, 18 and 23.3.1966, 4.5.1966. Merseyside County Museums have some items. **5** Press cuttings with catalogue (Liverpool Record Office).

3018 Rt. Hon. Dudley Ryder, Viscount Sandon

Oil on canvas, 129.5 × 102.2 cm. (51 × 40$\frac{1}{4}$ in.)

Noted by earlier catalogues as signed and dated: *T. C. Thompson July 1834*; but not now visible.

Dudley Ryder (1798–1882), when Viscount Sandon; succeeded his father as second Earl of Harrowby, 1847. Conservative politician. After representing the family constituency of

Tiverton until 1830, he subsequently sat as M.P. for Liverpool, 1831–1847. Presented with the Freedom of the Borough of Liverpool, 2 November 1831. He supported the Reform Bill 'as a means of peace' *(Address to Liverpool Electors, 1834)*. He was later Chancellor of the Duchy of Lancaster and Lord Privy Seal; F.R.S., 1853; Order of the Garter, 1869. Died at Sandon, Staffordshire.[1]

He is seated by a writing table embellished with a large satyr's head. This table of the Louis Phillipe period in the Boulle style is still at Sandon.[2]

His portrait was also painted by F. Massot, 1825 (Sandon), Sir George Hayter, 1832 (Sandon), T. H. Illidge (R.A. 1845), William Bradley, George Richmond (R.A. 1861), and he appears in the House of Commons Group Portrait, 1833 (the first Reformed Parliament), by George Hayter (National Portrait Gallery).

ENGR: T. Hodgetts: published by Welch and Gwynne, 15 November 1837 (19¾ × 16⅛ in.)
PROV: Purchased March 1864 (with No. 3015 for £5).[3]

EXH: Liverpool Academy, 1834 (199); Royal Academy, 1835 (162).
REF: 1 D.N.B., and information from Miss R. E. Campbell, Harrowby MSS Trust 2 Miss R. E. Campbell, letter 8 June 1972 3 Library, Museum and Art Gallery Committee Minutes, 10 March 1864.

3015 William Wallace Currie, Mayor of Liverpool

Oil on canvas, 127 × 101·5 cm. (50 × 40 in.)
SIGNED AND DATED: *T. C. Thompson/1836*

William Wallace Currie (1784–1840), Mayor of Liverpool, 1836; dressed in mayoral robes the Town Hall appears in the background. For biography see his portrait by Thomas Phillips.

PROV: Purchased from unspecified source March 1864 (with No. 3018 for £5).[1]
EXH: Liverpool Academy, 1837 (309).
REF: 1 Library, Museum and Art Gallery Committee Minutes, 10 March 1864.

TIMMIS, Robert 1886 - 1960

Portrait, landscape and decorative painter. Born Leek, Staffordshire, 12 July 1886. Educated at Leek and at Allan Fraser Art College, Arbroath. Art Master at Liverpool College of Art. Exhibited in London, the provinces and abroad. Died Liverpool 18 May 1960.

1113 The Two Jugs
Oil on canvas,[1] 50·7 × 61 cm. (20 × 24 in.)
SIGNED: *R. TIMMIS*

PROV: Purchased from the artist, 1954.
REF: 1 Canvas stamp of Reeves.

TONGE, Robert 1823 - 1856

Landscape painter. Born Longton, near Preston, son of the Rev. Robert Tongue (*sic*), vicar of Longton and later of Walton-le-Dale. His father declining to buy him an army commission, he took up painting and took lessons from R. Beattie, the Preston and Liverpool portrait painter. He exhibited at the Liverpool Academy from 1843, when he was living in Liverpool; entered as a student, 25 April 1845; Associate, 1850. He exhibited R.A. in 1853 only. He was

friend of William Davis, with whom he visited Ireland in 1853, and W. L. Windus, who married his sister. They both apparently sometimes put the figures into his landscapes. He died too soon for his essentially fluid and undefined style to be influenced in any way by Pre-Raphaelitism as their work was. He took his subjects chiefly from the locality and from Welsh borders. He went to Egypt in 1855 in an attempt to recover from tuberculosis, but died there, in a tent erected for him in the temple of Luxor, 14 January 1856. An inscription to his memory is amongst family monuments at Walton-le-Dale.

372 Landscape, Sefton, Lancashire
Oil on canvas, 52·6 × 115·8 cm. (20¾ × 45⅝ in.)
SIGNED AND DATED: *R.T. 1848*
PROV: Purchased from J. King, Liverpool dealer, 1899.
EXH: Walker Art Gallery, 1908, *Historical Exhibition of Liverpool Art* (556).

163 Landscape
Oil on canvas, 71·1 × 91·8 cm. (28 × 36⅛ in.)
SIGNED: *Robt. Tongue (sic)*
PROV: John Elliot, who bequeathed it, 1917.
EXH: Harrogate, 1924, *Liverpool School of Painters* (12); Wembley, 1924, *Liverpool Civic Week*.

545 Landscape with distant Town
Oil on canvas,[1] 25·7 × 56·2 cm. (10⅛ × 22⅛ in.)
SIGNED AND DATED: *R T 1848*
PROV: Mrs. D. Chambers, Prestbury, Gloucestershire, who presented it, 1953.
REF: **1** Label on stretcher of G. J. Keet, Artist's Colourman, Renshaw Street, Liverpool.

08 Cheshire Landscape – View from Bidston Hill, looking to the South West
Oil on mill-board,[1] 20·3 × 45·7 cm. (8 × 18 in.)
SIGNED AND DATED: *Robt Tonge/May 1850*
INSCRIBED, verso; on label: *From Bidston Hill, looking towards the SW by Robt. Tonge* and *John Miller,*
John Miller patronised many local artists like Tonge and the greater part of his collection was sold after his death in 1886.
PROV: John Miller, who sold it to George Holt, 1872 (receipt dated 28 November)[2], £40; thence by descent to Miss Emma Holt, who bequeathed it to Liverpool, 1945.

EXH: Walker Art Gallery, 1908, *Historical Exhibition of Liverpool Art* (284).
REF: **1** Label of G. Keet, Stationer, Renshaw St., Liverpool. **2** Holt Papers, Walker Art Gallery, and see catalogue of Emma Holt Bequest, *Sudley,* 1971, p. 72.

307 Cheshire Landscape
Oil on canvas, 50·7 × 86·7 cm. (20 × 34⅛ in.)
SIGNED AND DATED: *Robt. Tonge, 1853*
PROV: George Holt, who listed it as bought from Polak (no bill extant);[1] thence by descent to Miss Emma Holt, who bequeathed it to Liverpool, 1945.
EXH: Walker Art Gallery, 1908, *Historical Exhibition of Liverpool Art* (186), and 1960, *Liverpool Academy 150th Anniversary Exhibition* (64).
REF: **1** Holt Papers, Walker Art Gallery, and see catalogue of the Emma Holt Bequest, *Sudley,* 1971, p. 72, pl. 32.

TOWNE, Charles 1763 - 1840

Sporting, animal and landscape painter, who worked for a considerable part of his life in Liverpool. Two artists of this name have been identified by W. Shaw Sparrow (*The Connoisseur,* May – August, 1930), working over a similar period and with similar styles, but this is uncertain and the other Charles Towne (sic) of London, may have been a landscape painter only. The present artist was the son of Robert and Mary Town of Wigan and was baptised there 7 July 1763. At about 12/13 he walked to Leeds where he helped John Rathbone, the landscape artist, in some project; he was then in Liverpool where he worked as a coach painter for the coach builder (Robert) Lothian. About September 1779 he was at Lancaster; then at Manchester, and at 17 again in Liverpool, where he may have set up as japanner and ornamental painter, possibly with Robert Town (father or brother). His name is not in the Liverpool Directory for 1783, but he married Margaret Harrison, widow, of Liverpool on 8 May 1785, when he was registered as a 'Coach Painter' (St. Peter's Register of Marriages). The baptismal registers of his children at St. Nicholas' (3) and St. Peter's (1) give him as a painter in 1786 and 1787, horse painter in 1789 and painter in 1792. In 1786 he was living in Hale's Street and by 1792 in Byrom Street. He exhibited a landscape at the second Liverpool Exhibition of the Society for Promoting Painting and Design, in 1787, and is said to have copied Stubb's *Reapers* and *Haymakers* at that exhibition. In 1790 and 1796 he appears as a 'painter' living at Hale's Street and Byrom Street, Liverpool. In the late 1790's he was at Manchester. In 1796 he must have visited London for Farrington mentions him being employed by Blundell (of Ince) to copy a Wilson landscape (now again at Platt Hall, Manchester; versions by Towne at Easton Neston), and in 1797 notes 'Towne is much employed at Manchester, has six months work bespoke – improved much from seeing last Exhibition – never was in London before – was with Loutherburgh and saw him paint – surprised at his exhibition picture – was originally with a coach painter. Towne is a man of coarse debased manners and conversation – paints cows.' He exhibited his first picture at the Royal Academy in 1799, with an *e* to his name from a London address. While in London he apparently associated with George Morland. He appears also to have lived in Essex and Oxfordshire before returning to Liverpool.

He is missing from the Liverpool street directories from 1800–10, in 1811 reappears and in 1813 the *e* is added to his name. He was a founder member of the Liverpool Academy in 1810, Vice-President, 1812 and 1813. In January 1813 he advertised 'to the Nobility and Gentry of this and the neighbouring Counties' as a restorer of old pictures while 'he still continues to paint portraits of Horses, Dogs and Cattle in general, at various prices from Six to Sixty Guineas, according to the size of the picture, style of finishing, etc. – Views of Parks and other scenery, painted in a superior style.' He must have travelled about much while centred in Liverpool; he rated notices in the sporting journals of the 1820's and 30's and a mezzotint and a colour print were published after his works. He declined exhibiting at the

Liverpool Academy after 1825. He developed an increasingly delicate and lyrical style. He was living at Rock Ferry, Cheshire, in 1839 and died in Norton Street, Liverpool, 6 January 1840. He left his effects (valued at under £300) to his (?2nd) wife Catherine (née King).

His death (which coincided with the rising success of Richard Ansdell) was fittingly recorded in the local newspapers:

'On the 6th instant, at his house, Norton Street, Charles Towne Esq; in his 80th year. Mr. Towne's talents as an animal painter were of a high order, and were duly appreciated, not only by his townsmen, but by connoisseurs in all parts of the kingdom; his ability in portraying the horse – his favourite subject – has rarely been equalled, certainly not surpassed, and the foundation of his excellence was laid in deep knowledge of the anatomical structure of the animal. In early life he associated intimately with the celebrated George Morland, mastering his principles of composition, and exhibiting much of his feelings for colour, which he retained in his practice for many years; latterly his style became more peculiarly his own, and he laboured to form what might with propriety be termed an 'eclectic style'. Mr. T. was one of the founder members of the Liverpool Academy, but for several years had declined sending any of his productions to the annual exhibitions. Of the works he has left behind him many collectors will doubtless be eager to possess themselves; but he has left even a still more valuable legacy to his brethren in the art especially to the younger ones – the example of a patiently laborious and temperate life. He knew that an honest fame was not to be had on other terms, and he willingly paid the price.'

1240 Landscape with Cattle, Sheep and Drover by a Stream and a Woman and Child crossing a Rustic Bridge

Oil on canvas, 64×85 cm. (25¼×33½ in.)

The artist's landscapes of this type are difficult to date stylistically. Between the late 1790's and the mid-1820's he exhibited many landscapes with cattle, which, from dated examples are seen to owe something to the Dutch 17th century school, something to the nostalgic romanticism of Loutherburg and Morland. The romantic overtones of many of his scenes of rural life were sometimes reflected in his choice of title – *Morning* and *Evening* (1801, 1811 and 1812) or quotations from Gray or Thomson; while a closer imitation of the Dutch School is illustrated by the title of a picture exhibited in 1824 as 'in the style of Berghem'.

The fairly fluid handling, together with the costume of the woman, suggest a date around 1800 for the present work. See also 1241, 2313, and 2345 below.

PROV: Purchased from J. King (dealer), Liverpool, 1885.

REPR: E. R. Dibdin, in *Walpole Society Journal*, 1917, pl. XXVI (a).

EXH: Walker Art Gallery, 1908, *Historical Exhibition of Liverpool Art* (510); Harrogate, 1924, *Liverpool School of Painters* (30); Walker Art Gallery, 1971, *Charles Towne of Liverpool* (1).

1241 Landscape with Cattle and Sheep crossing Rustic Bridge near a Ruined Castle with a Drover on Horseback

Oil on canvas, 72·3×91·5 cm. (28½×36 in.) Probably dating around 1800.

PROV: Presented by Professor R. C. Bosanquet, 1920.

EXH: Harrogate, 1924, *Liverpool School of Painters* (29); Wembley, 1924, Liverpool Civic Week; Walker Art Gallery, 1970, *The Taste of Yesterday* (15) repr.; and 1971, *Charles Towne of Liverpool* (2).

40 Landscape with Herdsman driving Cattle on the banks of a Pond

Oil on canvas, 35·9 × 43·8 cm. (14⅛ × 17¼ in.)

SIGNED: *C. Towne*

This and 2313 come closest to deliberate pastiches of the Dutch 17th century school, which Towne is recorded to have made in the 1820's but they might date from the decade before this. The Stone catalogue dates this to about 1800.

PROV: Walter Stone Collection (No. 49); bequeathed by Miss Mary Stone, 1944.

EXH: Walker Art Gallery, 1971, *Charles Towne of Liverpool* (3).

2313 Farm labourer driving Cattle and Sheep by a ford near a Farm

Oil on canvas, 46 × 61·5 cm. (18⅛ × 24⅛ in.)

See 40 above. The Stone catalogue dates this to about 1820.

PROV: Walter Stone Collection (No. 48); bequeathed by Miss Mary Stone, 1944.

EXH: Bluecoat Chambers, Liverpool, 1953, *Walter Stone Collection* (32); Walker Art Gallery, 1971, *Charles Towne of Liverpool* (4).

7642–7646 Scenes in the Life of a Race-horse:

Mare and Foal (1); The Racehorse (3); Fallen in Shafts of Hucksters Cart (6); Lying Dead in a Field (7); Carted off (8)

Oil on canvas, each ± 33 × 42·3 cm. (13 × 16⅝ in.) Five scenes from a set of eight which formerly belonged to Joseph Mayer. Three of another set (formerly with Messrs. Spink) are reproduced by Shaw Sparrow,[1] and are dated to the artist's early period around 1790. The present set would appear to be variants of poorer quality; they are considerably damaged.

A complete set, showing slight variations was with a London dealer in 1972[2] (each 33 × 40·6 cm. : 13 × 16 in., signed with initials *CT*): their subjects are *Mare and Foal; Exercising* (the horse cloth has the initial P and the Prince of Wales Feathers); *The Racehorse; The Hunter setting out; Carriage Horse* (the initials PR on the carriage); *Huckster's Carthorse; Dead in a Field; Carted off.*

The subjects vary slightly from *The life of a racehorse in a series of six different stages,* from the foal to the death, which R. Gooch exhibited at the Royal Academy in 1783.

PROV: Joseph Mayer, who bequeathed them to the Mayer Trust, Bebington, Cheshire; presented to the Gallery by Bebington Corporation, 1971.

EXH: Walker Art Gallery, 1971, *Charles Towne of Liverpool* (not in cat.).

REF: **1** Walter Shaw Sparrow, *A Book of Sporting Painters,* 1931, fp. 135, 138 (3). **2** Richard Green, *Annual Exhibition of Sporting Paintings,* 1972 (44) repr. **3** The Mayer Trust, *Handlist of Drawings, Prints, Sculpture, etc* n.d. Nos. 4–11.

2340 Gentleman on horseback shooting Partridges

Oil on panel, 30·5 × 38·3 cm. (12 × 15⅛ in.)

SIGNED: *C. Town/pinxit.*

2341 Gentleman returning from Shooting

Oil on panel, 30·5 × 38·3 cm. (12 × 15⅛ in.)

SIGNED: *C.T.*

A pair of shooting subjects, dateable by the costume to the 1790's.

PROV: Walter Stone Collection (38a and b); bequeathed by Miss Mary Stone, 1944.

EXH: Bluecoat Chambers, Liverpool, 1946, *Walter Stone Collection* (30), and 1953 (23 and 21); Delft, 1949–50, *Merry Old England* (68 and 69); Whitechapel, 1950, *English Sporting Pictures* (82 and 83); Walker Art Gallery, 1971, *Charles Towne of Liverpool* (5 and 6); 2341-Arts Council, 1974–5, *British Sporting Paintings 1650–1850* (115) repr.

2160 Gentleman on black shooting Pony talking to an Attendant, in mountainous Landscape

Oil on canvas, 61·4 × 77·5 cm. (24⅛ × 30½ in.)

SIGNED in monogram: *C T*

The monogram is that used by Towne at least as early as 1796.

PROV: Walter Stone Collection (No. 41); bequeathed by Miss Mary Stone, 1944.

EXH: National Gallery, 1945, *Walker Art Gallery Acquisitions, 1935–1945* (83); Bluecoat Chambers, Liverpool, 1946 *Walter Stone Collection* (32); Walker Art Gallery, 1971, *Charles Towne of Liverpool* (8); Arts Council 1974–75, *British Sporting Paintings, 1650–1850* (118).

2551 Gentleman on a Grey Mare

Oil on panel, 50·5×66 cm. (19⅞×26 in.)

SIGNED AND DATED (partially illegible): *Chas. Tow[ne]/1799*

Possibly the picture exhibited by Towne at the Royal Academy of 1799, from a London address, called *Portrait of a Gentleman and trotting mare.*

PROV: Purchased from Baron Nettelbladt, Glassenbury Park, Cranbrook, Kent, 1934.

REPR: *The Connoisseur*, March 1935, p. 151.

EXH: Walker Art Gallery, 1971, *Charles Towne of Liverpool* (7); Arts Council, 1974–75, *British Sporting Paintings, 1650–1850* (117).

2312 Two Bull-Terriers attacking a Fox

Oil on panel, 24·3×30·4 cm. (9½×12 in.)

SIGNED AND DATED: *C T 1809*

PROV: Walter Stone Collection (No. 51); bequeathed by Miss Mary Stone, 1944.

EXH: Walker Art Gallery, 1908, *Historical Exhibition of Liverpool Art* (201); and 1971, *Charles Towne of Liverpool* (9); Bluecoat Chambers, Liverpool, 1946, *Walter Stone Collection* (38).

2346 Mischief in a Park.

Oil on canvas, 49·5×67·3 cm. (19½×26½ in.)

SIGNED in monogram: *C T*

The artist must have been aware of Stubbs' *Stag and Greyhound* (27½×40½ in.) at Ince Blundell Hall.[1]

PROV: Walter Stone Collection (No. 50); bequeathed by Miss Mary Stone, 1944.

EXH: (?) Liverpool Academy, 1812 (48) as *Fallow Deer and Dogs, 'But alas he flies in vain.'*; Bluecoat Chambers, Liverpool, 1953, *Walter Stone Collection* (33); Walker Art Gallery, 1971, *Charles Towne of Liverpool* (10); Arts Council, 1974–75, *British Sporting Paintings, 1650–1850* (120) repr.

REF: 1 See Walker Art Gallery Exhibition, *George Stubbs*, 1951 (16).

2342 Shooters Resting

Oil on canvas, 58·5×71 cm. (23×28 in.)

PROV: Walter Stone Collection (No. 40); bequeathed by Miss Mary Stone, 1944.

EXH: Bluecoat Chambers, Liverpool, 1946, *Walter Stone Collection* (31), and 1953 (27); Walker Art Gallery, 1971, *Charles Towne of Liverpool* (11).

2345 Landscape with Cattle and Sheep and a Rider in conversation with a Herdsman

Oil on canvas, 97·8×132·7 cm. (38½×52½ in.)

SIGNED AND DATED: *C Towne – 1812*

PROV: Walter Stone Collection (No. 47); bequeathed by Miss Mary Stone, 1944.

EXH: Bluecoat Chambers, Liverpool, 1953, *Walter Stone Collection* (31); Walker Art Gallery, 1960, *Liverpool Academy 150th Anniversary* (22); and 1971, *Charles Towne of Liverpool* (12).

2348 A saddled Bay Hunter tethered outside a Stable

Oil on panel, 47·8×59 cm. (18¾×23¼ in.)

SIGNED AND DATED: *C Towne – 1812*

The initials W W appear on the water bucket.

PROV: Walter Stone Collection (No. 53); bequeathed by Miss Mary Stone, 1944.

EXH: Walker Art Gallery, 1908, *Historical Exhibition of Liverpool Art* (180); Bluecoat Chambers, Liverpool, 1953, *Walter Stone Collection* (25); Walker Art Gallery, 1971, *Charles Towne of Liverpool* (13).

6107 Four horses in a Landscape

Oil on canvas, 120×150·5 cm. (47¼×59¼ in.)

SIGNED AND DATED: *Chas. Towne/Pinxit/1814.*

A typed label on the back of the frame reads: 'This picture of four horses and two dogs which were the property of my grandfather Harrison at Urmston, Cheshire, belongs to my son Stewart Sandbach Harrison (Signed) Wm. Stewart Harrison.' See also 1164 below.

PROV: By descent in the Harrison family to Mrs. Maxwell-Heron (née Harrison), who bequeathed it to Mrs. H. Bollam, Chirk, who presented it, 1961.

EXH: Walker Art Gallery, 1971, *Charles Towne of Liverpool* (14).

2314 A Groom holding an unsaddled Chestnut Hunter outside a Stable

Oil on canvas, 50·8×64·5 cm. (20×25⅜ in.)

SIGNED AND DATED (indistinct and possibly retouched): *– C Towne – 1817.*

The fore ground and the right-hand side of the

picture appear to be much rubbed; the signature may be altered. Stone mistakenly identified the cathedral in the background as York.

PROV: Walter Stone Collection (No. 46); bequeathed by Miss Mary Stone, 1944.

EXH: Walker Art Gallery, 1908, *Historical Exhibition of Liverpool Art* (171); and 1971, *Charles Towne of Liverpool* (15).

8635 A Grey Cob outside Croxteth Hall

Oil on canvas,[1] 30·6×41·1 cm. (12$\frac{1}{16}$× 16$\frac{3}{16}$ in.)

SIGNED AND DATED: *C.T.P./1820*

The south end of the principal west front of Croxteth Hall appears at the left and the spire of (?) Knowsley Church in the distance.

Two other paintings by Towne were at Croxteth: a chestnut horse with a poodle, 1810, and three horses in a paddock, 1818.[2] All these were presumably commissioned by the 2nd Earl of Sefton (1772–1838; succeeded to the title 1795), a keen sportsman, caricatured as 'Lord Dashalong'. From his period probably also date the sporting paintings by J. Boultbee of 1801 (2), F. C. Boult of 1822 (2), E. Bristow of 1824 (2) and 1828 (1) and J. Dalby *(q.v.)*.[3]

PROV: Purchased from the Executors of the Estate of the 7th Earl of Sefton, 1973.

REF: 1 Relined. 2 Inventory, Croxteth, 1946 Nos. 47, 44: Coll. Lady Sefton. This was No. 26. 3 1946 Inventory; Christie's Sale, Croxteth Hall, 19.9.1973 (1040–1045).

2344 'Maghull Racecourse with a match between three horses'

Oil on canvas, 66·3×91·5 cm. (26$\frac{1}{8}$×36 in.)

SIGNED AND DATED: *Chas. Towne/Pinxit/ 1822.*

Racing scenes appear to be exceptional in the artist's work, but a similar composition of horses appears in *A match between Sir Joshua and Philo da Puta* (two horses only) of 1819 (Rutland Gallery 1970 – given to Charles Towne of London, 1781–1854),[1] and in the engraving after Towne, of *Newton Races in 1831* (three horses). In them the artist follows the standard 18th century mode of representing galloping horses in distinction to his otherwise more naturalistic approach.

The first Liverpool race meeting at Maghull on a newly constructed course with grandstand was organised by John Formby, a local landowner, in 1827,[2] five years after this picture;

the race meeting subsequently moved t Aintree. Liverpool meetings on Crosby marshe date from the 18th century.

PROV: By 1908 Walter Stone Collection (N 42); bequeathed by Miss Mary Stone, 1944.

EXH: Walker Art Gallery, 1908, *Historic Exhibition of Liverpool Art* (100); Nation: Gallery, 1945, *Walker Art Gallery Acquisition. 1935–1945* (29); Bluecoat Chambers, Liverpoo 1953, *Walter Stone Collection* (29); Walke Art Gallery, 1960, *Liverpool Academy 150t Anniversary* (25), 1970, *Taste of Yesterday* (25 repr., and 1971, *Charles Towne of Liverpool* (16

REF: 1 Rutland Gallery, *This England* exhibi tion, 1970, No. 45 repr., where the two horse and riders are very close in pose to the tw right-hand horses in 2344. 2 John Formby *An Account of the Liverpool Races Establishe in the Year 1827 with observations on th conduct of the committee formed in Februar 1828*, 1828; information from the *Racin Information Bureau*, 16 December 1970.

2338 Fox hunting, Full-cry

Oil on canvas, 50·8×68·4 cm. (20×26$\frac{7}{8}$ in.)

SIGNED AND DATED: *C Towne 1825*

Compositionally reminiscent in the setting c Philip Reinagle's *Breaking Cover*, published a a line-engraving, 1811.[1]

PROV: (?) Anon. sale Christie's, 28.4.1913 (53 bt. King; Walter Stone Collection (No. 37) bequeathed by Miss Mary Stone, 1944.

EXH: Bluecoat Chambers, Liverpool, 194€ *Walter Stone Collection* (28), and 1953 (26) Walker Art Gallery, 1971, *Charles Towne o Liverpool* (17).

REF: 1 Arts Council, 1974, *British Sportin Painting, 1650–1850* (246) repr. A paintin; dated 1815 in the Danson Collection is ver much closer to the Reinagle (photo Galler files).

2319 A Chestnut Hunter with Groom in : Landscape

Oil on canvas, 81·3×107·3 cm. (32×42$\frac{1}{4}$ in.)

SIGNED, DATED AND INSCRIBED (partiall illegible in a paint loss): *C. Towne/Di. . . ir[?] 18[?2]*

The date has been given in the Stone Catalogu as about 1830, though its harder finish make a slightly earlier date possible. Sportin; costume of the early 19th century does no

llow a sufficiently precise development to elp in dating.[1]

ᴘʀᴏᴠ: Walter Stone Collection (No. 45); equeathed by Miss Mary Stone, 1944.

ᴇxʜ: Bluecoat Chambers, Liverpool, 1946, *Walter Stone Collection* (35), and 1953 (22); *Walker Art Gallery*, 1971, *Charles Towne of Liverpool* (19).

ᴇF: 1 Letter from Miss Anne Buck, December, 1970.

1839 The Second Horse

il on canvas, 51×65·2 cm. (20×25⅝ in.)

ᴳᴺᴇᴅ ᴀᴺᴅ ᴅᴀᴛᴇᴅ: *C Towne/1828*
meet of lap-dog beagles.[1]

ᴘʀᴏᴠ: Walter Stone Collection (No. 38); equeathed by Miss Mary Stone, 1944.

ᴇᴘʀ: W. Shaw Sparrow, *A Book of Sporting Painters*, 1931.

ᴇxʜ: Bluecoat Chambers, Liverpool, 1946, *Walter Stone Collection* (29), and 1953 (24); *Walker Art Gallery*, 1971, *Charles Towne of Liverpool* (18).

ᴇF: 1 W. Shaw Sparrow, *Charles Towne* in *the Connoisseur*, August 1930, p. 90, pl. II.

1847 A Chestnut Hunter standing in a Landscape

il on canvas, 39·5×47·5 cm. (15½×18¾ on.)

ᴳᴺᴇᴅ ᴀᴺᴅ ᴅᴀᴛᴇᴅ: *C. Towne/1828*

ᴘʀᴏᴠ: Walter Stone Collection (No. 52); equeathed by Miss Mary Stone, 1944.

ᴇxʜ: Bluecoat Chambers, Liverpool, 1946, *Walter Stone Collection* (39), and 1953 (28); *Walker Art Gallery*, 1970, *The Taste of Yesteray* (17) repr., and 1971, *Charles Towne of Liverpool* (20).

1864 The Intruder

il on canvas, 61·2×72·5 cm. (24⅛×28¼ in.)

ᴳᴺᴇᴅ ᴀᴺᴅ ᴅᴀᴛᴇᴅ: *C. Towne 1829*

he original owner, Henry Harrison, a merch-it of Liverpool, is listed in the directories etween the 1820's and 1871; his wife was a andbach.[1] See also 6107 above.

ᴘʀᴏᴠ: Painted for Henry Harrison of Mostyn, igburth; passed to his son Sandbach Percy arrison (of Canta Fiero, Uruguay and ffwell House, Honiton, Devon), who be-ueathed it after the death of his last surviving ster, 1929.[2]

ᴇxʜ: Walker Art Gallery, 1971, *Charles Towne of Liverpool* (21); Arts Council, 1974–75, *British Sporting Paintings, 1650–1850* (123).

ᴇF: 1 A drawing for her portrait, by Thomas Hargreaves, is in Liverpool Record Office. 2 Label on back.

TOWNE, Charles, Imitator of

2315 A Grey Racehorse and Brown Foal standing outside a Stable

Oil on canvas, 51·3×67·4 cm. (20 3/16×26½ in.)

The racehorse is identified as Mr. W. Garford's *Pyramus* in the Stone Catalogue, having previously been thought to be *Chanticleer* whose dates were wrong. *Pyramus*, a grey colt by *Black Sir Charles* out of *Vesta*, was born in 1816 and raced on the flat in 1819 and 1820. He came second at Pontefract, a third at Newmarket, and both third and second at Northallerton in 1819, and fourth at York in 1820.[1]

ᴘʀᴏᴠ: Walter Stone Collection (No. 44); bequeathed by Miss Mary Stone, 1944.

ᴇxʜ: Walker Art Gallery, 1971, *Charles Towne of Liverpool* (22).

ᴇF: 1 Information from the *Racing Information Bureau*, 16 December, 1970.

2343 A Grey Racehorse with Jockey up, on a Racecourse

Oil on canvas, 58·5×77·2 cm. (23×30⅜ in.)

This would appear to be the same horse as that in 2315.

ᴘʀᴏᴠ: By 1908 Walter Stone Collection (No. 43); bequeathed by Miss Mary Stone, 1944.

ᴇxʜ: Walker Art Gallery, 1908, *Historical Exhibition of Liverpool Art* (250); National Gallery, 1945, *Walker Art Gallery Acquisitions, 1935–1945* (86); Bluecoat Chambers, Liverpool, 1946, *Walter Stone Collection* (34), and 1953 (30); Walker Art Gallery, 1971, *Charles Towne of Liverpool* (23).

TOWNE, Charles
Change of attribution
See
BRITISH SCHOOL

949 **Everton Village**
2662 **Landscape with Cattle** (not in this catalogue)

Ascribed to TWEEDIE, William Menzies
1826/28 - 1878

7012 Samuel Robert Graves
Oil on canvas,[1] 143·5 × 113·7 cm. (56½ × 44¾ in.)
Samuel Robert Graves (1818–1873), a native of Ireland, settled in Liverpool and became an eminent merchant and shipowner; Mayor, 1860–61; a chairman of the Dock Board, the Shipowners Association and the Local Marine Board; Commodore of the Mersey Yacht Club; J.P.; Conservative M.P. for Liverpool, 1865–1873. He was noted for his charm of manner and general popularity; a commercial authority in Parliament. His sudden death, 18 January 1873, cut off a promising public career.[2]

A statue by Fontana is in St. George's Hall and a bust by G. Adams is in the Collection (7817 and 4165). A portrait formerly belonged to the Mersey Docks and Harbour Board. See under Walters 760 for one of his ships.

PROV: Presented to the Conservative Club, Liverpool at an unknown date;[4] thence to Liverpool Corporation who acquired the building, subsequently the Municipal Annexe, about 1931; transferred to the Gallery, 1967.

EXH: (?) Royal Academy, 1858 (357), and Walker Art Gallery, 1880, *Liverpool Autumn Exhibition* (1035).

REF: 1 Artists' colourman label of Keet, Renshaw St., Liverpool. 2 Orchard, *Liverpool Legion of Honour*, 1893, pp. 337–340; J. Picton, *Memorials of Liverpool*, 1873, I pp. 626–7. 3 Lent 700th *Anniversary Exhibition*, 1907 (56). 4 Label on frame.

WALKER, Frederick 1841 - 1874

Landscape painter. Born Liverpool 12 April 1841. Worked at first as a clerk; was at Birkenhead School of Art and joined the circle of artists meeting at John Miller's house. Exhibited at the Liverpool Academy 1856 and 1862. Due to ill-health he moved to Chester, then to Tanlan near Llanrwst and finally to Denbigh; died 17 May 1874.

351 A Road Through a Cutting
Oil on panel, 28·2 × 22·7 cm. (11⅛ × 8¹⁵⁄₁₆ in.)
SIGNED with monogram: *F C* (?)
The monogram is unexplained. Probably an early work and not, according to the artist's brother, a good example.[1]

PROV: Presented by Henry Walker, brother of the artist, 1895.
EXH: Walker Art Gallery, 1970, *The Taste of Yesterday* (57) repr.
REF: 1 Letter in Gallery files.

WALSH, Sam, living artist

6194 Pin up 1963 – For Francis Bacon
Oil on board, 122 × 122 cm. (48 × 48 in.)
PROV: Purchased from the artist, 1963.

EXH: Walker Art Gallery, 1963, *John Moores Liverpool Exhibition IV* (100).

311 Three Figures in a Warm Climate

il and plastic emulsion on board, 143×122 cm.
6¼×48 in.)

ᴏᴠ: Purchased from the artist, 1965.

ᴇxʜ: Walker Art Gallery, 1965, *Liverpool
cademy* (16); Everyman Theatre, 1976, *Sam
'alsh* (16).

6310 Emmett Dalton in Hollywood

Oil and plastic emulsion on board, 40·6×
43·5 cm. (16×17⅛ in.)

ᴘʀᴏᴠ: Purchased from the artist, 1965.

ᴇxʜ: Walker Art Gallery, 1965, *Liverpool
Academy* (11).

WALTERS, George Stanfield 1837 - 1924

andscape and marine painter. Born Liverpool 1837, son of Samuel Walters (*q.v.*). Helped
is father and exhibited at the Liverpool Academy from 1853 at fifteen years of age;
robationer, 1855; Student in the Life School, 1856; elected Associate, 1861. Moved to
ondon about 1865. Exhibited at the Royal Academy, 1860–88; also at the British
nstitution, the Royal Institute of Painters in Watercolour and the Royal Institute of Painters,
tc.; Member, Royal Society of British Artists, 1867. Died London, 12 July 1924.

**80 View on the Mersey with Victoria
Tower**

il on panel, 30·8×42·8 cm. (12⅛×16⅞ in.)

ɪɴSCRIBED AND DATED: . . . *S WALTERS
8(?5)2* (what might be an erasure is visible
efore the first initial and the 5 is conjectural).
he immature style suggests that this is
robably by George Stanfield Walters, son of
amuel (*q.v.*).[2] A sailing ship is being towed to
ea, Victoria Tower seen at the right at the

entrance to Salisbury Dock, was completed
in 1848. The Perch Rock Lighthouse is visible
at the far left.

ᴘʀᴏᴠ: Presented by Robert Gladstone, 1938.

ᴇxʜ: Bootle, 1959, *Samuel Walters* (20).

ʀᴇꜰ: **1** The numbers 77.4.22.3 are inscribed
over the varnish. **2** An MS label gives a title
and the artist as "by Samuel Walters, R.B.A./
Exhibition £35.0.0."

WALTERS, Miles 1774 - 1849

larine painter and carver and gilder. Born at Ilfracombe and baptised there 22 May 1774,
ne son of John Walters, who was possibly a carpenter and ship builder. Apprenticed as a
nipwright at Bideford. By 1810 was in London probably as carver and gilder. Settled
iverpool before 1830 as an artist, and established in business as a carver and gilder with his
on William Miles Walters, by 1834. Some paintings were produced in combination with
is son Samuel (*q.v.*); very few signed by him are known. Exhibited at Liverpool Academy
831 and 1832. Died 1849.

143 The Pleasure yacht 'Zephyr'

il on canvas, 75·5×102 cm. (28½×40 in.)

ɪGNED AND DATED: *Walters/1832*

he yacht heads a race off the Black Rock
ort and Lighthouse with the sailing ship
ictory to starboard.

ᴘʀᴏᴠ: Purchased by Liverpool City Library
from Frank Sabin, London, 1959; lent to the
Gallery, 1973.

ᴇxʜ: (?) Liverpool Academy, 1832 (324).

WALTERS, Samuel 1811 - 1882

Marine painter. Born 1 November 1811 on passage from Bideford to London, the son of
Miles Walters (q.v.). His family must have settled in Liverpool by 1830 when Samuel first
exhibited at the Liverpool Academy and entered the Academy Schools in December; admitted
student November 1831. The father carried on a business as carver and gilder from about
1834 with his son William Miles, who took it over at his death. Samuel first painted portraits
and helped his father with his painting and some works from 1829 are signed Walters and
Son. Exhibited at Liverpool Academy, 1830–65; Associate, November 1837; Member, 1840
but resigned August 1845 on moving to London, where his address in Leadenhall Street was
that of W. J. Huggins the marine painter. He was back in Liverpool by 1847. Exhibited at
the Royal Academy, 1842–61; Liverpool Society of Fine Arts, 1859–60; Liverpool Autumn
Exhibition, 1871–80. During the period of great expansion in the shipping industry he painted
many of the celebrated vessels trading from the Mersey belonging to the Cunard, Inman,
White Star and other lines. He also painted other port and harbour scenes and views in Holland.
A number of his works were published, some lithographed by himself; in later life he
published many photographs of his pictures as 'Walters and Sons, Marine Photographers.'
Died Bootle, 5 March 1882. Paintings by him are in Merseyside County Museums. His son
G. S. Walters (q.v.). His obituary was recorded in the *Liverpool Mercury* 8 March and the
Illustrated London News 23 March 1882:

> 'THE LATE MR. SAMUEL WALTERS. – Our obituary to-day contains an announce-
> ment of the death of Mr. Samuel Walters, the well-known marine painter. He was born in
> London in the year 1811, but when quite young came to Liverpool, where he commenced
> as a portrait painter, and in that line promised to be very successful, but was drawn into
> marine work through his father being engaged in that line of art in a very modest way. His
> success as a marine painter is well known both in Liverpool and the United States, where
> many of his pictures went, and of late years his works have been reproduced by photograph
> and distributed largely abroad. He was a student, and also at one time a member, of the
> Liverpool Academy. Eminently a worker, he loved his art, and never was so happy as when
> at work; and although for the last two years of his life he was afflicted with a most painful
> disease, yet whenever a little free from pain he resumed his brush, and was really at work
> a few hours before his death. He was of a kindly and genial disposition, and had the happy
> faculty of making himself beloved by those he came into contact with. This was especially
> so in his large family circle. Among the works left behind in his studio, which in course
> of time will come before the public is "A View of the Port of Liverpool from the River,"
> one of his most important works, which it is hoped by some means may be secured by
> the town for the permanent gallery, it being a picture of great interest for future generations
> in Liverpool as a thoroughly correct representation of the port in the year when painted.
> He died of cancer and heart disease.'

732 Returning to Ireland, Scene off St. George's Pier, Liverpool

Oil on canvas, 51 × 71 cm. (20⅛ × 28 in.)

SIGNED AND DATED: *S. WALTERS/1836*

Identified with the picture of the above title exhibited at the Liverpool Academy in 1836. Boats are ferrying off passengers to the paddle-steamer standing off the pier. (The first floating landing stage was not built until 1847). The building by the pier is George's Pierhead Baths.

PROV: Purchased from B. B. Hands, Liscard, 1912.

EXH: Liverpool Academy, 1836 (197); Bluecoat Chambers, 1945, *Pictures of Old Liverpool* (17); Walker Art Gallery, 1960, *Liverpool Academy 150th Anniversary* (43).

3000 The Steamship 'British Queen' in a heavy sea

Oil on canvas, 89 × 152·5 cm. (33 × 60 in.)

SIGNED AND DATED: *S. WALTERS/1838*

Wooden paddle steamer built by Curling and Young for the British and American Navigation Company of Liverpool, floated at Limehouse 23 June 1838 and her engines fitted at Glasgow and finally completed 1839. Length 275 feet, 1862 tons, 700 hp., the longest ship of her day. Not registered at Lloyds, in common with several other steam pioneers. She visited Liverpool on her way from Glasgow, July 1839, and set out on her maiden voyage from London to New York on 11 July 1839. She was intended to be the first steamer to cross the Atlantic but the delay in her completion prevented this. Walters evidently anticipated an earlier maiden voyage in this painting. She was sister ship to the ill-fated *President* which disappeared in a storm in March 1841, possibly due to the additional top weight of a third deck, on her third voyage (also painted by Walters). This disaster virtually ruined the company which had been a notable innovator in building large steamers, and the *British Queen* was sold to the Belgian government in August 1841.[1]

Walters exhibited *The British Queen Steamship's visit to Liverpool, July 1839*, at the Liverpool Academy of that year. A painting by J. Pringle of *The British Queen in New York Harbour*, is in New York Public Library.[2] Ten prints of the ship in various views are listed by Parker and Bowen.[3] A coloured lithograph,

The British Queen leaving Spithead for New York, 1839, (Parker and Bowen, *loc. cit.*, (h)), is in Merseyside County Museums; a view of the saloons and plan of the cabins, lithograph by J. Isaac, and a port view at sea, (Parker and Bowen, *loc. cit.*, (f)), published by J. Coventry, are in Liverpool City Library (Record Office).

PROV: Jamieson family since 1849; and by descent to Colonel Lachlan Jamieson in 1899;[4] thence to his daughter, Mrs. Hector McKenzie, who presented it, 1907.

EXH: Probably Liverpool Academy, 1838 (265) as *The British Queen Steam-ship on her passage to New York – strong breeze*.

REF: **1** R. P. Bonsor, *North Atlantic Seaway*, 1955, pp. 5–7; information from Keeper of Shipping, Merseyside County Museums. **2** Repr. J. Pringle, *Steam Conquers the Atlantic*, 1939, fp. 104. **3** C. Parker and F. C. Bowen, *Mail and Passenger Steamships of the Nineteenth Century*, 1928, pp. 41–43. **4** Label.

2999 The Great Gale of January 1839

Oil on canvas, 56·5 × 78 cm. (22¼ × 30¾ in.)

The Liverpool Steam-tug No. 1 going to the assistance of a steam-boat at the entrance of the Mersey on the night of 6 January 1839, when a gale of unprecedented force struck the town causing widespread damage to property and much loss of ships and lives at sea. The Liverpool newspapers recorded the disaster: 'A terrific and most destructive hurricane visited Liverpool on the evening of Sunday, the 6 January, and continued with little intermission till the following afternoon. . . The loss of life among the shipping of the port was awful. The N.W. Lightship was driven from her moorings and brought into port. The New York packets, outward bound (the Pennsylvania and St. Andrew), with valuable cargoes, and the Lockwoods, an emigrant ship, with 108 souls on board, were lost on the North Bank. The Brighton, from Bombay, was wrecked near the Middle-patch Buoy, and 14 of [the] crew were drowned in attempting to reach the shore on a raft; also the Harvest Home, for St. Thomas, on Mad Wharf, some of the hands being in the rigging for 40 hours; together with many others, whose crew and passengers became a prey to the contending elements. The Victoria steam-tug assisted by the Magazines, life-boat, succeeded in saving 55 persons from the Lockwoods, 23 from the St. Andrew, and 26 from the Pennsylvania –

in all 104 souls. The Humane Society awarded the Steam-tug Company £400 for the use of their boat, £100 to the captain, £10 to the mate, and £5 to each of the crew; the Pilots' Committee also awarded £5 to each of the pilots who had volunteered their services on this distressing occasion.'[1]

PROV: Presented by H. Noel French (liquidator) on behalf of the Shareholders of the Liverpool Steam Tug Co., 1911.

EXH: Bootle, 1959, Samuel Walters (8).

REF: 1 Annals of Liverpool in Street Directories.

420 The 'Frankfield'

Oil on canvas,[1] 109·2 × 166 cm. (43 × 65⅜ in.)

SIGNED AND DATED: S. WALTERS/1841

Full rigged ship of 750 tons, built at New Brunswick in 1840 for Wilson and Company of Liverpool for their Liverpool-Sydney Service. Built of softwood (birch, spruce and pine), and metal clad. Length 145 feet, beam 29·5 feet. She was wrecked in Cemeas Bay on 7 December 1847.[2] Her name appears on the blue and red flag at her main mast and on the prow; the Blue Peter is at her foremast. The town in the background might be Whitehaven.

PROV: George Wilson, shipowner, Liverpool; by descent to his grandson and granddaughter, Ernest Heys-Jones and Miss C. W. Heys-Jones, who presented it, 1943.

EXH: Bootle, 1959, Samuel Walters (17).

REF: 1 Framemakers' label of W. M. Walters (the artist's brother), Liverpool. 2 Information from Keeper of Shipping, Merseyside County Museums; Lloyds Register of Shipping.

2988 The Liverpool Ship 'Bland'

Oil on canvas, 82 × 125 cm. (32¼ × 49¼ in.)

Damaged by fire, 1939-45 war.

Port view of a three-masted sailing ship with fourteen guns, and a male figurehead, flying a blue and white pennant from her main mast and signal flags from her foremast, which have not been identified in Marryat.[1] She closely resembles the sailing ship 'Bland' in a starboard view, by Walters and son, reproduced in Cushing.[2]

The ship was built by Bland and Chaloner, Liverpool, 1829. Her initial subscribing owners were William Field Porter, Merchant, Francis Ashley, Merchant, and Peter Chaloner, Master Shipwright; Thomas Bland, Master Shipwright had eight of the sixty-four shares. The

shares subsequently passed through vario[us] members of the same families and othe[r] Porter, the first chief shareholder, traded wi[th] South America. The Bland was lost aft[er] sailing from Callao for Cork, 5 Septemb[er] 1854.[3]

In the background appears shipping off t[he] Cape and Table Mountain with the port [of] Cape Town. Walters is certainly not believ[ed] to have visited there but Stephen Riley h[as] pointed out that whilst in London in 1845 Walters was at the same address in Leadenh[all] Street (public house with lodgings over) [as] William J. Huggins (1781–1845), the mari[ne] painter who certainly painted views off t[he] Cape; or alternatively that sketches made [by] the artist's uncle, Samuel Walters, R.N., abo[ut] 1806, and including views of Table Bay, m[ay] have been available to him before 1833 wh[en] the uncle emigrated to Canada.[5] What appea[rs] to be another view of the same ship is at t[he] left.

PROV: Bequeathed by Thomas Rowe Davi[es] 1915.

REF: 1 Captain Marryat, List of Signals, 18[] 2 James S. Cushing, Genealogical Record of [the] descendants of John Walters and Mary Vessaille, 1944 (2nd edit. 1952, p. 6A): possib[ly] the picture with a London dealer Novemb[er] 1928, 27½ × 46 in., signed and dated Walters a[nd] Son, June 1831, in the river Mersey (MS lett[er] copy Merseyside Museums). 3 Informati[on] from Stephen Riley, Department of Shippi[ng] Merseyside County Museums, May 197[] Lloyds Register of Shipping. 4 Ibid. 5 See Northcote Parkinson, Samuel Walters, Lie[u]tenant R.N., 1949: his diary and sketches [are] again in family ownership after reappear[ing] at New Orleans about 1914.

418 S.S. City of Brussels

Oil on canvas, 93·5 × 160 cm. (36¾ × 63 in.)

S.S. City of Brussels, built at Glasgow 18[] length 405 feet; beam 40½ feet; register[ed] tonnage 2660; owner the Inman Steam S[hip] Company of Liverpool. A passenger steamer [on] the Atlantic run, she made the passage Liv[er]pool to New York in under eleven days. S[he] was sunk in a collision at the mouth of t[he] Mersey in dense fog on Sunday 7 Janu[ary] 1882, when ten people lost their lives.[1]

This appears to be a 'specification' view [of] the ship set in an imaginatively handled s[ea] This is borne out by a 'carte de visite' pho[to]

aph of the picture with a plan of the cabins
 the back, included in a series of Walters'
otographs of his paintings of ships in Liver-
ol Record Office.[2] A larger photographic
int, over-painted in oil and inscribed, verso:
man Co/S Walters/LIVERPOOL PXT/
.4.0 1873, is in a private collection.[3]
ROV: Unknown; entered the Collection before
48, when the artist was unidentified.
EF: 1 Lloyds Register of Shipping; informa-
n from Keeper of Shipping, Merseyside
ounty Museums; press cutting attached to
rge print noted in text. 2 Some of these are
scribed: S. Walters, publisher of Marine
hotographs, 3 Falkner Street, Bootle. (He is
corded at this address until 1871). 3 Photo-
aph (1973) Gallery files.

o The Port of Liverpool

il on canvas, 70·8 × 130 cm. (27⅞ × 51⅛ in.)
GNED AND DATED: S.W./1873

 view of Liverpool waterfront from the
ersey; the pennant of Samuel Graves
818–1873), merchant, shipowner and M.P.
r Liverpool, appears at the masthead of
ntral ship. Apparently the picture referred
 in the artist's obituary as in the artist's
udio at the time of his death, 'well known
 the photographs taken from it and widely
stributed.'[1] A family tradition identifies
ople in the rowing boat in the left fore-
ound as relatives of the artist.[2]
 The public and business buildings visible
ong the waterfront include, from the left:
e great chimney of Muspratt's chemical
orks, Vauxhall Road (demolished 1922);
e cupola of St. Paul's Church (demolished
)31); St. Nicholas' Church; Tower Buildings
emolished about 1907), with George's Pier-
ad Baths (demolished 1907) in front and the
ipola of the Exchange Buildings (of 1863/7)
hind; the dome of the Town Hall; the
ire of the Municipal Buildings in Dale Street;
e spire of St. George's Church (demolished
)99), partially hidden by the ship, off-centre;
e dome of Foster's Custom House (bombed,
emolished 1948), behind the Albert Dock
arehouses; the spires of perhaps St. Thomas's,
rk Lane and St. Michael's, Upper Pitt
treet, with, in the far distance at right, a
indmill on the site of Liverpool Cathedral.
NGR: A lithograph of the same subject with
ight variations was executed by T. Picken,
d published by Samuel Walters in 1877.

PROV: Thomas Davies, who presented it, 1882.
EXH: Harrogate, 1924, *Liverpool School of Painters* (440); Wembley, 1924, Liverpool Civic Week; Amsterdam, 1929; Bootle, 1959, *Samuel Walters* (19); Bluecoat Chambers, 1945, *Pictures of Old Liverpool* (18); Walker Art Gallery, 1970, *The Taste of Yesterday* (50), repr.
REF: 1 *Liverpool Mercury*, 8 March 1882, p. 6; *Illustrated London News*, 25 March 1882, quoted in C. Northcote Parkinson, *Samuel Walters, Lieutenant R.N.*, 1949, p. 123. 2 Mr. and Mrs. O. A. Walters (grand-children of the artist), Otley, Yorks, visit 30 August 1973.

WALTERS, Samuel, Attributed to

1820 The Sailing Ship 'Emma'

Oil on canvas, 64 × 91·5 cm. (25⅛ × 36 in.)
A barque built in 1845 by Richard Wilkinson at Sunderland. Length 105·3 feet; beam 25·1 feet; depth 19 feet; 449 gross tons. George Holt senior had shares in her and she was presumably named after his wife, née Emma Durning. She was engaged on the Liverpool-China run. In February 1847 George Holt transferred his shares to his son George and the latter's part-ner William James Lamport, who traded together as Lamport and Holt. In 1850 *Emma* was changed to ships' rig as she appears here. She was sold on 18 June 1852 to a Mr. Schiltze.[1]
 She is shown with the Lamport and Holt house-flag at her foremast, off Liverpool, with St. Nicholas' Church, George's Pierhead Baths and the Custom House visible in the back-ground.

PROV: Presented by Alfred Holt and Company, 1958.
REF: 1 Information from Keeper of Shipping, Merseyside County Museums and *Blue Funnel and Glen Lines Bulletin*, January 1959, p. 67 (repr.).

WANE, Richard 1852 - 1904

Landscape and marine painter. Born Manchester 3 April 1852. Lived at Egremont, Cheshir 1896 until death. After beginning as photographer under brother in Isle of Man turned t painting and studied under Frederick Shields at Manchester. Settled at Deganwy, Nort Wales, 1883, where met Liverpool artists; moved to London 1890; and thence to Cheshir due to ill-health. Exhibited at Royal Academy, Liverpool Autumn Exhibitions, Grosveno Gallery and elsewhere from 1885. Died Egremont 8 January 1904.

1373 The Lonely Watch
Oil on canvas, 66·6 × 127 cm. (26¼ × 50 in.)
SIGNED: *R. WANE*
PROV: Purchased from the artist at the Liverpool Autumn Exhibition, 1904.
EXH: Royal Academy, 1902 (774); Walker Art Gallery, 1904, Liverpool Autumn Exhibition (147); and 1908, *Historical Exhibition of Liverpool Art* (533).

2959 Little Gardeners
Oil on canvas, 108 × 184 cm. (42½ × 72½ in.)
SIGNED: *R. WANE*
Probably dating from the artist's residence i Wales.[1]
PROV: Presented by Herbert Robinson, 190;
REF: 1 MS label gives Welsh address.

WARRINGTON, Richard William 1868 - 1953

Artist and stained glass designer. Taught stained glass design at Liverpool University Department of Design, 1900–05 under McNair, and drew in the evening classes; transferre to the Liverpool School of Art. He is listed in the Street directories 1902–15 as artist, an 1916–52 (with a break 1917–21) as stained glass designer. Designed a window for Hop Street Unitarian Church. Many drawings by him are in the Collection.

6890 Still Life with Lamp
Oil on canvas, 46·5 × 33 cm. (18¼ × 13 in.)
DATED, verso: *Dec. 1888* and illegible inscription.
Pencil drawings are on the back.

6891 Still Life
Oil on canvas, 61 × 51 cm. (24 × 20 in.)
SIGNED AND DATED, on stretcher: *R. W. Warrington 1886*

6889 Still Life
Oil on canvas, 51 × 61 cm. (20 × 24 in.)

PROV: 6889–6891 Presented to Liverpool Cit Museums by Miss Porter, sister of the arti with other material by the artist, 1953; tran ferred from Merseyside County Museum 1968.

WATSON, William, Junior, active 1866 - 1921

Painter of highland cattle subjects. Son of William Watson, miniature painter. Pupil of Landseer and Rosa Bonheur. He was living in Seacombe and Birkenhead from 1872–1914. Exhibited at the Royal Academy 1872 and elsewhere, and at the Liverpool Autumn Exhibition a few times from 1874. Died London, 1921.

1332 Morning, near Oban
Oil on canvas, 61×91·5 cm. (24×36 in.)
SIGNED AND DATED: *W. Watson 1897*
PROV: Bequeathed by James Munro Walker, 1921.

1343 On the Goil, Glen Goil, Argyllshire
Oil on canvas, 61·5×91·5 cm. (24¼×36 in.)
SIGNED AND DATED: *W. Watson 1897*
PROV: Bequeathed by Joseph Munro Walker, 1921.

WESTCOTT, Philip 1815 - 1878

Portrait painter of Devon stock; apprenticed to Thomas Griffiths, miniature painter and picture restorer in Liverpool. Exhibited at Liverpool Academy 1837–53; Associate, 1842; Member, 1844; Treasurer, 1847–53; resigned December 1854 and Non-Resident Member until 1865. He and his brother Thomas restored pictures for Liverpool Royal Institution. Removed to London 1854/5 after a successful career in Liverpool but appears not to have achieved success in London and after 1862 moved to Manchester. He exhibited at the Royal Academy, 1848–61, Liverpool Autumn Exhibition and at Manchester and elsewhere. He also painted landscapes and some historical subjects. Died Manchester 10 January 1878.

2577 Charles William Molyneux, 3rd Earl of Sefton
Oil on canvas, feigned oval, 76·2×63·5 cm. (30×25 in.)
The head is in the same pose as the Westcott/Ansdell portrait 8655 below.
PROV: Presumably the picture presented by W. Weaver, Liverpool, 1869.[1]
REF: 1 Library, Museum and Art Gallery Committee Minutes, 21 October, 1869.

139 Joseph Brooks Yates
Oil on canvas, 141·1×110·8 cm. (55 9/16 × 43 5/8 in.)
SIGNED AND DATED: *Philip Westcott. 1850*
Joseph Brooks Yates (1780–1855), F.S.A., F.R.G.S., Liverpool merchant in the West Indian trade, philanthropist and collector specialising in manuscripts, early books and old masters; eldest son of the Rev. John Yates of Toxteth. He was 'an ardent advocate of the promotion of education, science and literature'.[1] A founder member of the Literary and Philosophical Society of Liverpool, 1812 and President for many years. He contributed many papers to their deliberations. He is shown holding a manuscript with a seal and a portfolio rests beside his chair marked with the coat of arms of the Literary and Philosphical Society and its motto VIRES ACQUIRIT EUNDO.

To mark his tenth year as President a subscription was opened in March 1851 (*sic*),[2] and this portrait was presented to him at the meeting of the Society on 26 January 1852 with the intention of placing it in a public collection. It passed immediately to the Liverpool Royal Institution, in whose headquarters in Colquitt Street the society held its meetings.[3]

Yates had been President of the L.R.I. in 1842.

Yates was a subscriber to the presentation of the Preti pictures to the L.R.I. 1829, gave a painting by Cranach 1842, and several of his paintings subsequently passed to the L.R.I. and thence to the Gallery.[4]

ENGR: (?) Photo-reproduction, by Emery Walker, frontispiece to *Descriptive Catalogue of Fourteen Illuminated Manuscripts in the Collection of Henry Yates Thompson*, 1912 Vol. IV.

PROV: Painted for the Literary and Philosophical Society of Liverpool, who deposited it in the Liverpool Royal Institution 1852; presented by the University of Liverpool to the Gallery from the L.R.I., 1976.

EXH: Liverpool Academy, 1850 (41).

REF: **1** Obituary, *Liverpool Courier,* 19 December 1855; *Liverpool Mercury,* 15 December 1855, reprinted in Rev. John Yates, *Memorials of the Yates Family,* 1890; *Gentleman's Magazine,* January, 1856. **2** Subscription notice dated 12 March 1851 (Mayer Papers, Liverpool Record Office). **3** Literary and Philosophical Society, *Proceedings,* 26 January 1852; letters of their Hon. Sec. to the L.R.I., 27 and 30 January 1852 (R.I. Arch. 17–17, Liverpool University Library). **4** Preti, and Cranach, 2779, 2887–9, 1222 in the Collection. Lots 37–40 in his executors' sale, Winstanley's Liverpool 14.5.1857, are now 2788, 1177, 6942, 1192, 2786 in the Collection, presented by Liverpool University and the L.R.I. (see Foreign Schools Catalogue).

8710 George Holt, senior

Oil on canvas, framed as oval, 109·2 × 84·5 cm. (43 × 33¼ in.)

George Holt (1790–1861), Liverpool cotton broker and founder of the family fortunes in Liverpool.

Eldest son of Oliver Holt of Rochdale (see Arrowsmith 8704) by his first wife; born Rochdale 24 June 1790; apprenticed 7 October 1807 to Samuel Hope, cotton broker in Liverpool; taken into partnership 1812 and added banking to their joint activities; partnership terminated 30 June 1823 with Holt continuing as cotton broker and Hope as banker. Helped to found the Bank of Liverpool, 1831, and the Liverpool Fire and Life Assurance Company, 1836; built India Buildings for offices 1834 which proved a sound speculation; member of the Dock Committee until 1851; J.P.. First entered the Town Council 1835; Chairman of

Water Committee 1849–1856 and a keen advocate of the Rivington Pike Scheme. Retired from the Council 1856. Closely concerned with the Mechanics Institute and bought Blackburne House nearby for a Girls Public School, 1844 (given to the city by his children).[1]

Married 1 September 1820 Emma, daughter of William Durning of Edge Hill, Liverpool Unitarians (see Arrowsmith 8703, 8705). Their four sons, George, Alfred, Philip and Robert were successful merchants and shipowners and active in public life (see Morrison 275, and Bigland 2584). Died at Edge Hill 16 February 1861.

A smaller version of 8710 belonged to Liverpool and London Globe Insurance, and another is at Blackburne House (Westcott was finishing a replica at the time of his death). A portrait as a young man is in Martins Bank Buildings, Liverpool.[4] A portrait by J. Robertson was painted for the Liverpool Institute School (R.A. and L.A. 1861). A portrait drawing is also in the Collection (8714).

PROV: By descent to Miss Anne Holt who presented it, 1975.

EXH: Liverpool Academy, 1851 (198).

REF: **1** *A Brief Memoir of George Holt, Esq. of Liverpool,* (1861), photograph of 8710 as frontispiece, dated 1860 altered to 1850; (Hugh Shimmin), *Pen and Ink Sketches of Liverpool Town Councillors* (1857), 1866, pp. 22–26. J. Hughes, *Liverpool Banks and Banking,* 1906, pp. 206–8; F. E. Hyde and J. R. Harris, *Blue Funnel Line,* 1956, pp. 1–9; H. J. Tiffen, *A History of the Liverpool Institute School 1825–1935,* 1935, p. 106, pl. 18. Information from George Holt, January 1975. **2** Repr. *Blue Funnel Line;* now with Ocean Steam Ship Co. **3** H. C. Marillier, *Liverpool School of Painters,* 1904, p. 229. **4** Repr. G. Chandler, *Four Centuries of Banking,* 1964, I p. 24 (colour).

8711 George Holt, senior

Oil on canvas, 110·5 × 85 cm. (43½ × 33½ in.)

Copy of 8710 above.

PROV: As 8710.

1140 Venerable Archdeacon Brooks

Oil on canvas, 218·5 × 147·3 cm. (86 × 58 in.)

The Venerable Archdeacon Jonathan Brooks

M.A., J.P. (1775–1856). Rector of Liverpool 1829–55, Archdeacon 1848–1855. He was concerned extensively in promoting measures for public usefulness and social improvement: the Bluecoat School, the National Schools and School for the Blind, Infirmaries, prisons, savings banks, etc., etc. His funeral drew an immense gathering.[1]

A life-size statue by B. E. Spence, 1858, commissioned by public subscription, is in St. George's Hall, a bust by S. Joseph, 1831, is in the Town Hall (7818 and 8238 in the Collection); a portrait by Lonsdale, 1830, was engraved and two portraits by Lonsdale were in R. H. Grundy's sale, Liverpool, 1865.[2] A full length portrait was (1965) in the Lyceum, Liverpool. A portrait by S. Crosthwaite of Liverpool was at the Liverpool Academy, 1834.

ENGR: T. O. Barlow, mezzotint, 66·8×44·8 cm. 26$\frac{5}{16}$×17$\frac{11}{16}$ in.)

PROV: Painted for the Select Vestry, Liverpool, 'as a public testimony of esteem,'[3] and placed in their Board Room, Brownlow Hill; transferred from the Parish Offices, 1928.

EXH: Royal Academy, 1851 (394); Liverpool Academy, 1851 (112); Manchester, 1857, Art Treasures (505).

REF: 1 J. A. Picton, Memorials of Liverpool, 1873, II pp. 402–3; In Memoriam, 1876, pp. 26 f., 43; A. L. Schuster, Brief Account of the Origin and Growth of the Liverpool Savings Bank, 1810–1920, p. 4 repr. 2 Christie's at 44 Church Street, Liverpool, 20–29.11.1865 (1047 and 1049). 3 Entry in L.A. Catalogue, 1851.

757 Rev. Augustus Campbell

Oil on canvas,[1] 219·7×147·5 cm. (86$\frac{1}{2}$×58 in.)
The Reverend Augustus Campbell, M.A. 1786–1870). He was Rector of Wallasey until 1824, when he became Vicar of Childwall. In 1829 he was instituted to the Rectory of Liverpool (in succession to the Rev. Samuel Renshaw), which he held conjointly as junior Rector with the Rev. Jonathan Brooks (see above), until the latter's death in 1854 when he entered upon sole charge.[2]

The Athenaeum reviewer of the Royal Academy of 1852 commented on the portrait:– 'We cannot congratulate the Liverpool congregation on the high Art exhibited in the portrait of their rector (551) by Mr. Westcott. However striking the likeness may be, – every "mote and beam" and unpicturesque speciality,

which should have been tenderly toned down, has been made prominent. The red nose glows all the hotter near the cool grey hair, – and were the subject other than it is would convey a doubt whether to habitual brandy and water or to accidental alarm the scared wild look is to be attributed. The pumps, we admit, hold out models to the rugged school.'[3]

A portrait drawing by Thomas Hargreaves is in the Athenaeum Library, Liverpool.

PROV: Transferred from the Parish Offices to the Gallery, 1928.

EXH: Royal Academy, 1852 (551) and Liverpool Academy, 1852 (46).

REF: 1 Not relined. 2 In Memoriam, 1876, pp. 43–47, 101; J. Murphy, Religious problem in English education: the crucial experiment, 1959, pp. 43 ff. 3 The Athenaeum, 12 June, 1852, p. 656.

3083 Sir John Bent, Mayor of Liverpool, on the occasion of Her Majesty's visit, 1851

Oil on canvas, 238·5×147·5 cm. (94×58 in.)
SIGNED AND DATED: Philip Westcott, 1853
John Bent (1793–1857), in his robes of office as Mayor of Liverpool, 1850–51. Eldest son of William Bent of Stoneyfield, near Newcastle-under-Lyme, where he was born and educated. He became a successful brewer in Liverpool. In 1822 he married the daughter of J. Davenport of Westwood Hall near Leek. On Queen Victoria's visit to Liverpool during his term of office as Mayor he was knighted by her 9 October 1851.[1] According to an obituary notice:[2] 'No man stood higher in the estimation of all classes'. He was a collector and patron of the arts: see the portraits of him and his wife by John Phillip (7506).

The Art Journal reviewer considered this portrait 'a production of very great excellence.'[3]

PROV: Painted by subscription and presented to Lady Bent;[4] by descent to the sitter's grandson, R. John Frank, who presented it, 1898.

EXH: Royal Academy, 1853 (447); Liverpool Academy, 1853 (48).

REF: 1 (H. Shimmin), Pen and ink sketches of Liverpool Town Councillors, 1866, pp. 147–9; In Memoriam, 1876, p. 8. 2 In Memoriam, or Funeral Records of Liverpool Celebrities, loc. cit. 3 The Art Journal, 1853, p. 148, review of the Royal Academy. 4 Entry in L.A. Catalogue, 1853.

8709 Emma, wife of George Holt, senior, with her daughter Anne

Oil on canvas, 109·2×85 cm. (43×33½ in.)

Dating from about 1856.[1] Emma (1802–1871), daughter of William Durning of Edge Hill, Liverpool, and wife of George Holt (see 8710), with their daughter Anne (1821–1885), in an interior of their family house in Lodge Lane. Mrs. Holt wears a lavender watered silk dress with black lace shawl, her cap is ornamented with red and blue ribbons, and she holds a cream parasol. Anne wears a white muslin and satin dress with a peacock blue shawl with gold/yellow pattern. The room is papered in green with a blue-bordered red carpet. The Sèvres casket and ornamental gilt table on which it rests with ivory chessmen and another box, are still in family ownership,[2] as was the chair which was destroyed in the 1939–45 War.

PROV: By descent to Miss Anne Holt, who presented it, 1974.

REF: 1 Bill from the artist to George Holt, 16 September 1856 for making three drawings in chalk of sons and painting picture of Mrs. and Miss Holt, all framed inclusive, £210 (R. D. Holt Papers, deposited Liverpool Record Office). 2 Information from Miss Anne Holt, 1974.

404 On the Marshes

Oil on canvas, 75×106 cm. (29½×41¾ in.)

SIGNED AND DATED: *Philip Westcott 1872.3*

PROV: C. E. Ashworth, who bequeathed it, 1932.

WESTCOTT, Philip 1815-1878 and ANSDELL, Richard 1815-1885

8655 Charles William, 3rd Earl of Sefton

Oil on canvas,[1] 289·5×213·5 cm. (114×84 in.)

Charles William Molyneux (1796–1854), eldest son of the 2nd Earl and his wife Margaret, daughter of the 6th Earl Craven; succeeded to the title 1838. Married 1834, Mary Augusta, daughter of Robert Gregge Hopwood of Hopwood Hall, Lancashire. M.P. for South Lancashire, 1832–35 as a Liberal (Whig); Lord Lieutenant and custos rotulorum of Lancashire. Lived chiefly at Croxteth Hall and a keen follower of field sports.[2]

He was a considerable patron of Richard Ansdell *(q.v.)* and Westcott is said to have advised him on art matters.[3] He was also painted by William Bradley,[4] and in an equestrian portrait by Richard Dighton, 1844–5. He appears in the *Waterloo Cup* and family sporting group by Ansdell (9021 and 877 above), and in Sir Francis Grant's, *A Shooting Party at Ranton Abbey*, 1840 (Shrugborough).

This portrait was exhibited in Liverpool towards the end of April 1849 with Ansdell's *The Wounded Deer*. It was reviewed in the *Liverpool Chronicle*[6] with enthusiasm: 'There are two beautiful pictures now on view at the Lyceum, in Bold Street, which every lover of the fine arts ought to make a point of seeing. The first is a portrait of a nobleman well known and deservedly popular in this district, the Earl of Sefton. As a likeness it is excellent, as a work of art inimitable. It is the joint production of Messrs. Westcott and Ansdell and has been painted for the gentlemen of the hunt.'

A copy, 30×21 in. was on the Art Market 1974, and see also Westcott 2577 above.

ENGR: S. Bellin (31⅝×21⅝ in.), published by Thomas Agnew, Manchester, 1 March 1851.

PROV: Probably presented to the sitter by gentlemen of the hunt, 1849; by descent to the 7th Earl of Sefton, and purchased from the Executors of his Estate, 1974.

EXH: Royal Academy, 1848 (283); Lyceum, Liverpool, week of 21 April 1849.

REF: 1 Croxteth Inventory, 1946, No. 68, as by Sir Francis Grant and Richard Ansdell. 2 D. Ross, *Sketch of the History of the House of Stanley and the House of Sefton*, 1848, pp. 10–11. 3 Letter from H. C. Pidgeon to Joseph Mayer, n.d., Mayer Papers, *Letters on Art*, I p. 76 (Liverpool Record Office). 4 Christie's Sale, Croxteth Hall, 17–20.9.1973 (1016). 5 Croxteth Inventory, 1946, No. 106. 6 *Liverpool Chronicle*, 21 April 1849, p. 5 and advertisement p. 1.

WIFFEN, Alfred K. 1896 - 1968

Born Eastwood, Nottinghamshire, 18 March 1896. After serving in the Great War and a period farming in Nottinghamshire, went to Nottingham Art School. Moved to Liverpool 1928 to teach Graphic Arts at Liverpool School of Art, where many noted Liverpool artists trained under him; retired 1961. Subsequently President of Deeside Art Group. Member Royal Cambrian Academy. Exhibited in London and Liverpool. Died November 1968.

7004 Jet of Iada
Oil on canvas, 51×60·8 cm. (20×24 in.)
SIGNED AND DATED: *Alfred K. Wiffen 1949*
An Alsatian belonging to the donor of the portrait, which worked in the Civil Defence rescue operations after enemy raids in London, shown with his handler searching through wreckage for signs of life. He saved over fifty lives and was awarded the Dickin medal.

He is buried in Calderstones Park Rose Garden.[1]
A bronze head by Edna Rose is also in the Collection.
PROV: Presented by Mrs. H. M. Cleaver for Calderstones Park House, 1967.
REF: 1 *The Liverpolitan*, June 1946, p. 8 (photo).

WILLIAMS, Anne, living artist

7583 Windows
Acrylic on canvas, stuck on shaped hardboard and wood, 40·5×151 cm. overall (16×59½ in.)
INSCRIBED, verso: *A. Williams, Liverpool. 119*

PROV: Purchased from the artist, 1971.
EXH: Walker Art Gallery, 1971, *Liverpool Polytechnic Art College Exhibition.*

WILLIAMS, John Henry or Harry, active 1845 - 1877

Landscape painter. Said to be son of a Liverpool tradesman and possibly connected with William and Henry Williams, furniture brokers. He exhibited at the Liverpool Academy 1845–58, his subjects including local, Cheshire and Welsh views. He is listed in the street directories 1851, 1853 and 1855, in the latter year adding John to his name. By 1856 he had moved to London, and subsequently about 1873 to Penzance. He also exhibited at the Royal Academy, 1856, the Society of British Artists, 1854–77, and the Liverpool Autumn Exhibition, 1874–76.

721 Near Altcar
Oil on canvas, 33×57·7 cm. (13×22¾ in.)
SIGNED AND DATED: *J Harry Williams 1856* (?) (first two initials in monogram)
View looking south-west amongst the sand-dunes at the mouth of the river Alt on the estuary of the Mersey, with Formby lighthouse

in the centre background and the Wirral and Welsh hills in the distance across the Mersey.
PROV: Presented by Alfred Kind, 1908.
EXH: (?) Suffolk Street, 1858 (544), *Evening near mouth of the Alt, Lancashire, £21*; Walker Art Gallery, 1908, *Historical Exhibition of Liverpool Art* (1314A).

WILLIAMSON, Daniel Alexander 1823 - 1903

Born Liverpool, 24 September 1823, one of a family of artists; his father Daniel was a landscape painter; his grandfather was John Williamson (*q.v.*) and his uncle Samuel Williamson (*q.v.*). Apprenticed to a Liverpool cabinet maker as a draughtsman but preferred painting, and attended life class in Newman Street, London, where he lived 1849–60 (at Peckham and Clapham). Started as a portrait painter and turned to landscape in the mid-1850's. Settled in North Lancashire at Warton-in-Carnforth (1861) and Broughton-in-Furness (1864). Not therefore strictly of the Liverpool school. Exhibited at the Liverpool Academy 1848–67, the Royal Academy 1853–58, and Liverpool Autumn Exhibitions occasionally 1871–79 and 1892–95. A close friend of W. L. Windus. His work showed the influence of the Pre-Raphaelites for a period in the 1860's and has an intense and brilliant colour and minute though impasto technique. His style in the 1870's became increasingly free and more impressionistic and he turned almost entirely to watercolour for a period of about twenty years before attempting some oil painting again. A large group of his watercolours are in the collection. He was incapacitated for some years in middle life by a serious illness during which time he ceased to work out of doors but continued working indoors and studied cloud effects through his window. Again, during his last years he worked within doors. James Smith of Blundellsands was a considerable patron. Died at Broughton-in-Furness, 12 February 1903. A portrait drawing of him is by James Paterson (4953 in the Collection).

862 Sheep Resting

Oil on board, 25·3 × 31·5 cm. (10 × 12½ in.)
SIGNED, in monogram: *DAW*
Stylistically difficult to date; probably painted at Peckham in the late 1850's when he was exhibiting various pictures with this type of subject. However, comparison with a watercolour in the collection of *Sheep Changing Pastures,* dated 1869 (357), makes a later date possible.
PROV: James Smith (of Blundellsands), before 1912, and bequeathed by him, 1923.
EXH: Manchester, 1912, *Works of James Charles, George Sheffield, William Stott and D. A. Williamson* (254).

781 Morecambe Bay from Warton Crag

Oil on board, 25·1 × 33·5 cm. (9$\frac{15}{16}$ × 13¼ in.)
INSCRIBED verso: *Morecambe Bay/from/Warton Crag/DAW* (monogram)/*1862*
Holman Hunt's *Strayed Sheep,* 1852 (Tate Gallery), is an evident source of influence.[1]
PROV: A. T. Squarey, who purchased it from

the artist 1862 and his in 1897;[2] James Smith (of Blundellsands) before 1912, and bequeathed by him, 1923.
REPR: *Apollo,* December 1962, p. 753, fig. 9; Allen Staley, *The Pre-Raphaelite Landscape,* 1973, pl. 81a.
EXH: Liverpool Academy, 1862, (182); Walker Art Gallery, 1960, *Liverpool Academy 150th Anniversary Exhibition* (77) repr.; Cummer Gallery, Jacksonville, Florida, 1965, *Artists of Victoria's England* (59) repr.
REF: 1 See Allen Staley, *loc. cit.,* p. 148. 2 MS label: 'Morcambe Bay from Warton Crag/Painted by Danl. A. Williamson 1862/Bought by me in the same year from the Artist/through Mr. John Miller of Liverpool./[signed] A. T. Squarey Feby, 28.1897.'

784 Spring, Warton Crag

Oil on canvas, mounted on panel, 27 × 40·6 cm. (10$\frac{5}{8}$ × 16 in.)
INSCRIBED on a label, verso: *Spring, Arnside Knot and Coniston range of hills from/Warton Crag. DAW* (monogram)

According to a note on the back, signed by Smith, 784 was painted in 1863.

PROV: Mr. Quaile, who purchased it from the artist;[1] James Smith (of Blundellsands), before 1904, and bequeathed by him, 1923.

REPR: H. C. Marillier, *The Liverpool School of Painters*, 1904, fp. 238; Allen Staley, *The Pre-Raphaelite Landscape*, 1973, pl. 7 (col) and 81b; Jeremy Maas, *Victorian Painting*, 1969, p. 227.

EXH: Manchester, 1912, *Works of James Charles, George Sheffield, William Stott and D. A. Williamson*, (255); Tate Gallery, 1913, *Pre-Raphaelite Painters from collections in Lancashire* (5); Ottawa, 1965, *An Exhibition of Paintings and Drawings by Victorian Artists in England* (169) repr.; Sheffield, 1968, *Victorian Paintings, 1837–1890* (173).

REF: 1 MS label.

27 Spring Flowers
Oil on paper, 19·3 × 20 cm. (7⅝ × 7⅞ in.)
SIGNED in monogram: *DAW*

VERSO: Part of watercolour landscape (varnished).

PROV: James Smith (of Blundellsands), who bequeathed it, 1923.

1344 Wensleydale
Oil on board, 57·7 × 82 cm. (22¾ × 32¼ in.)
SIGNED in monogram and dated: *DAW/1887*
PROV: Presented by Councillor Joseph Bibby, J.P., and Councillor F. C. Bowring, J.P., 1911.
EXH: Wembley, 1924, *Liverpool Civic Week;* Harrogate, 1924, *Liverpool School of Painters* (8).

925 Warkworth Castle
Oil on cardboard, 48·5 × 69 cm. (19⅛ × 27³⁄₁₆ in.)
SIGNED in monogram and dated: *DAW/1890*
PROV: James Smith (of Blundellsands), before 1912, and bequeathed by him, 1923.
EXH: Manchester, 1912, *Works of James Charles, George Sheffield, William Stott and D. A. Williamson* (55); Harrogate, 1924, *Liverpool School of Painters* (14).

924 Early Summer
Oil on canvas, 49·5 × 69·5 cm. (19½ × 27⅜ in.)
SIGNED in monogram and dated: *DAW/189 (?)*
PROV: James Smith (of Blundellsands) before 1908, and bequeathed by him, 1923.
EXH: Walker Art Gallery, 1908, *Historical Exhibition of Liverpool Art* (962); Manchester, 1912, *Works of James Charles, George Sheffield, William Stott and D. A. Williamson* (56); Walker Art Gallery, 1922, *Liverpool Autumn Exhibition* (511); Harrogate 1924, *Liverpool School of Painters* (24).

WILLIAMSON, John 1751 - 1818

Portrait painter. Born Ripon 1751. Was a decorator in a Birmingham japanning works before coming to Liverpool, about 1783, where he settled. Two visits to London are recorded in May 1792 and April 1813 (Mayer Papers). A landscape as well as portraits by him were included in the Liverpool exhibition of 1784, and he was also a Visitor and contributor to the exhibition of 1787. An original member of the Liverpool Academy 1810–11 and he exhibited there in 1810, 1811, 1813 and 1814. He married in 1781 and his two sons, Daniel and Samuel (*q.v.*), and a grandson, Daniel Alexander (*q.v.*), were artists. Died at Liverpool 27 May 1818.

The *Liverpool Mercury*, 5 June 1818 published a laudatory obituary by a friend of the artist: 'On Wednesday se'nnight, aged 67, Mr. John Williamson, for more than thirty years a distinguished portrait painter in this town. – In this individual was happily blended the urbanity of the gentleman, with the liberality of the christian, possessing a heart "open as day to melting charity;" and if the limits of a newspaper obituary did not forbid the detailed enumeration of virtues, which are at once the admiration of all liberal minds, the author of this paragraph could dwell with peculiar satisfaction upon the many possessed by him, whose friendship it was his happiness for many years to enjoy, and its deprivation now to lament. – As an artist, his productions were not, perhaps, always equally happy, yet the portraits of Wm. Roscoe, Esq., Sir Wm. Beechy, R.A., Mr. Fuseli, R.A., the Rev. J. Clowes, the late Mr. Litherland, the inventor of the lever watch, and many others, with his last production, the portrait of Joseph Birch, Esq., M.P., will ever hold a highly respectable rank in the Arts, standing second only to a Reynolds or a Lawrence, and in the estimation of some, equal to them.'

1542 Henry Fuseli

Oil on canvas, 61·5 × 52 cm. (24¼ × 20½ in.)

Henry Fuseli (Johann Heinrich Fussli: 1741–1825); painter of literary and historical subjects in a highly imaginative mannerist style. A native of Zurich, he came to England in 1764 and finally settled here in 1770; A.R.A. 1788; R.A. 1790, and afterwards Keeper and Professor of Painting. He apparently first visited Liverpool in 1767, and on a further visit about 1779 met William Roscoe,[1] who subsequently became a friend and patron and assisted him in selling his pictures locally.[2] Their common interests were literary as well as artistic. Fuseli sent pictures to the 1784 and 1787 Exhibitions and later to the Liverpool Academy. Four of his paintings are in the Collection.

Fuseli continued to visit Roscoe from time to time and according to Knowles, Fuseli's first biographer, this portrait was painted in 1789.[3] Supporting this are two letters from Knowles to Roscoe's eldest son. In 1825 he asked: 'Did you not tell me that he [Fuseli] sat for his Portrait at Liverpool, do you know in what year, and who the artist was?'; in the following year he wrote again: 'Did you not say that a Mr. Williamson painted a portrait of Fuseli now in your possession, if so, in what ye[ar]'[4] The replies have not survived but evidently confirmed all this. Fuseli would seem to have visited Liverpool with his wife a little before he wrote to Roscoe in November 1789 when he described the disagreeable journey by mail coach.[5] He had already met Williamson by 1786 when he promised a drawing or two for him.[6]

The portrait shows the artist with the white hair described by Knowles, which was apparently the result of a fever caught at Rome in 1774.[7]

PROV: Presented to William Roscoe;[8] W. S. Roscoe by 1826; thence by descent to William Malin Roscoe, whose widow, Mrs. A. M. Roscoe, bequeathed it, 1950.

REPR: George Chandler, *William Roscoe of Liverpool*, 1953, pl. 50; The *Liverpool Bulletin*, Vol. 8, 1959/60, fig. 2 (Walker Art Gallery Number).

REF: 1 John Knowles, *The Life and Writings of Henry Fuseli*, 1831, I pp. 66–7. 2 See Hugh Macandrew, *Henry Fuseli and William Roscoe*, in *Liverpool Bulletin*, Vol. 8. 1959–60, pp. 5 ff. fig. 2; and *Selected Letters from the Correspondence of Henri Fuseli and William Roscoe of Liverpool*, in *Gazette des Beaux Arts*, LXII, 1963, pp. 205 ff. 3 Knowles, *op. cit.*, I p. 352 4 J. Knowles to W. S. Roscoe, 29 Dec. 1825, 27 Nov. 1826 (Roscoe Papers 2280, 2281, Liverpool City Library). 5 Fuseli to Roscoe 25 Nov. 1789 (Roscoe Papers 1599). 6 Fuseli to Roscoe 24 Aug. 1786 (Roscoe Papers 1596). 7 Knowles, *op. cit.*, I p. 49. 8 MS *Inventory of Household Furniture, etc., belonging to William Roscoe*, 9 Feb. 1820, p. 6, as a present (Roscoe Papers 3906).

2547 William Roscoe

Oil on canvas, 38·5×30·3 cm. (15⅛×11⅞ in.)

See Shee, 3130, for biography. Shown seated to left, leaning his hands on a large marbled folio. Supposedly the portrait which Henry Roscoe chose to illustrate his biography of his father and of which he wrote: 'Painted about the year 1791, by Williamson, an artist of considerable ability at Liverpool, presents a very pleasing idea of him at this period of his life, and has been selected to illustrate this work from its not having been before engraved.'[1] Slight differences are evident in the drapery and hair.

A replica (15×12 in.) is in the possession of E. J. T. Roscoe; another (once William Rathbone's and in which the sitter holds a red bound folio) belongs to Mrs. Vere E. Cotton.

ENGR: W. C. Edwards, 1833 (4½×3½ in.); etat 38.

PROV: William Malin Roscoe (eldest grandson of William Stanley Roscoe), whose widow, Mrs. A. M. Roscoe, bequeathed it, 1950.

REPR: *Liverpool Bulletin*, Vol. 8, 1959–60, pg. 8, detail (Walker Art Gallery Number).

EXH: Walker Art Gallery, 1907, *Liverpool 700th Anniversary Exhibition* (97, p. 214).

REF: 1 Henry Roscoe, *The Life of William Roscoe*, 1833, II, p. 474, repr. I, frontispiece.

2589 Mrs. William Roscoe

Oil on canvas, 61×50·8 cm. (24×20 in.)

Jane Griffies (1757–1824), second daughter of William Griffies of Liverpool, married William Roscoe on 22 February 1781 at St. Anne's Church, Liverpool. The identity of the sitter is a family tradition. The attribution to Williamson is recent.

PROV: Charlotte Alicia Roscoe[1] (second wife of Richard Roscoe (1833–1892), a grandson of the sitter); by descent to Mrs. Philip Roscoe, who presented it, 1931.

EXH: Liverpool City Library, 1931, *Roscoe Centenary Exhibition* (4).

REF: 1 F. W. Dunston, *Roscoeana* (1905), p. 7, note 3.

167 Five Sons of William Roscoe

Oil on canvas, 74·3×91·5 cm. (29¼×36 in.)

Presumably representing Roscoe's first five sons (anticlockwise from the left): William Stanley (b. 1782); Edward (b. 1785); James

(b. 1787); Robert (b. 1789) and Thomas (b. 1791). Assuming that the eldest son is approximately ten years old and that the youngest cannot be more than two (the sixth son Richard was born 1793), the picture must date from about 1792. Of poor quality and possibly a copy of a lost original.

A replica of similar quality belongs to E. J. T. Roscoe.

PROV: William Roscoe; thence to Mary Ann Roscoe, and by descent to Miss H. W. Jevons, who presented it, 1950.[1]

REF: 1 Provenance in letter 6.10.1950.

2266 William Roscoe

Oil on canvas, 33×27·8 cm. (13×10¹⁵⁄₁₆ in.)

The date of this portrait is uncertain. It appears to represent a slightly older man than 2547 and may therefore date from the mid-1790's. The attribution is confirmed by a contemporary MS. label on the back of the canvas.

PROV: William Roscoe; by descent to William Malin Roscoe, whose widow Mrs. A. M. Roscoe, bequeathed it, 1950.

EXH: Walker Art Gallery, 1907, *Liverpool 700th Anniversary Exhibition* (96, p. 214).

2265 Peter Litherland

Oil on canvas, 75·8×62 cm. (29¾×24⅜ in.)

Peter Litherland (1756–1804), watch and watch movement maker, the inventor of the rack-lever escapement. He is shown holding an open watch and another is on the table at his side.

Born at Warrington and when living at Latchford near Warrington he took out his first patent in October 1791 (No. 1830), for the rack-lever. By 1792 he was living in Liverpool, first in Mount Pleasant and by 1800 in Commutation Row, and in the former year took out his second patent (No. 1889), for (1) a watch to beat once a second and (2) a compensation curb, and (3) a mechanism to wind watches by means of an external lever.[1] His inventions appear to have been used by Litherland, Whiteside and Co., about 1800–1813, and continued by Litherland, Davies and Co., 1818–1876.[2]

He died at Liverpool intestate and administration of his goods was granted to his son Peter B. Litherland gent., with bondsmen, Robert Bill of Stone, Staffordshire, and Daniel

Williamson, of Liverpool, artist.[3] Daniel, a son of John Williamson, apparently married a Litherland, possibly one of the sitter's four daughters.[4] The portrait is mentioned in the obituary cited above and a descendant of the sitter confirmed the attribution of 2265 to John Williamson in 1926.[5]

PROV: Presented to the Corporation prior to 1873,[6] and transferred from the City Library after 1908.

EXH: Walker Art Gallery, 1907, *Liverpool 700th Anniversary Exhibition* (14a, p. 199), and 1908, *Historical Exhibition of Liverpool Art* (153).

REF: **1** G. H. Baillie etc. edit., *Britten's Old Clocks and Watches and Their Makers*, 7th edition, 1956, p. 426. **2** See R. Vaudrey Mercer, *Peter Litherland & Co.*, in *Antiquarian Horology*, No. 11, Vol. 3, June 1962 pp. 316 ff. **3** Information from Lancashire Record Office, Preston, 21.7.1961. **4** Copy of notes by a Robert Williamson (1900–1910) Gallery Archives. **5** Note in Liverpool Record Office. **6** Charles Dyall, *First Decade of the Walker Art Gallery, A Report*, 1888, p. 7 (list).

2267　Mrs. Roscoe and Child

Oil on canvas, 38·3 × 30 cm. (15$\frac{1}{16}$ × 11$\frac{7}{8}$ in.)

Traditionally a portrait of William Roscoe's wife Jane with her eldest son, William Stanley (born 1782),[1] but the costume makes a date in the early 1800's certain. It might be of her with her youngest son Henry (born 1799) but even so the sitter appears rather too young for Mrs. Roscoe at this period.

PROV: William Malin Roscoe whose widow Mrs. A. M. Roscoe, bequeathed it 1950.

REPR: George Chandler, *William Roscoe of Liverpool*, 1953, pl. 34.

EXH: Walker Art Gallery, 1907, *Liverpool 700th Anniversary Exhibition* (93), p. 214.

REF: **1** F. W. Dunston, *Roscoeana* (1905), p. 7, note 3; letter from W. Roscoe to the Liverpool City Librarian 2 May 1932 in *Roscoe Memorials* (Mayer Papers), Pt. II, p. 131 (Liverpool Record Office).

8706　William Durning

Oil on canvas, 76·2 × 64·7 cm. (30 × 25$\frac{1}{2}$ in.)

8707　John Durning

Oil on canvas, 87·6 × 71·7 cm. (34$\frac{1}{2}$ × 28$\frac{1}{4}$ in.)

8708　Anne Durning

Oil on canvas, 72·4 × 61 cm. (28$\frac{1}{2}$ × 24 in.)

A feigned oval painted over the original square format, partially obliterating the arms of the sitter.

William Durning (*c.* 1714–1803), son of William Durning (1667–1727) of Edge Hill, Liverpool; his son John (1752–1802) and daughter Anne (1754–1831); a Unitarian family. John managed the Speke Estates; he predeceased his father and the family land at Edge Hill passed to Anne (Nancy), who in middle life married Robert Nuttall, who took the name of Durning. She left her property to the representatives of the younger branch of the Durnings, Emma Holt (see Westcott 8707), and Jemima, wife of J. B. Smith, M.P. for Norwich.[1] Streets in the area now commemorate the family.

The portrait of John is said to be posthumous.

PROV: With Anne Holt by 1885;[2] thence by descent to Miss Anne Holt, grand-daughter of Robert Durning Holt, who presented them 1975.

REF: **1** Anne Holt, *Memoir of the Durnings*, MS (1885), copy in Liverpool Record Office. J. Hughes, *Liverpool Banks and Banking*, 1906, p. 207 n.1. **2** Anne Holt, *op. cit.*, p. 7.

2585　John Shepherd

Oil on canvas,[1] 76·2 × 65·4 cm. (30 × 25$\frac{3}{4}$ in.)

This would appear on stylistic grounds to be by Williamson, who exhibited a portrait of the sitter at the Liverpool Academy of 1814 though the sitter here appears to be in his 30's or early 40's. John Shepherd (1764–1836) naturalist and first Curator of the Botanic Garden, Liverpool, 1802–1836. Born Gosforth, Cumberland, he lived in the Manchester area before settling in Liverpool. His appointment at Liverpool (at a salary of £105 a year) was due to William Roscoe and Dr. Rutter on the recommendation of J. L. Philips of Manchester. The gardens, opened 3 May 1802 (with an address delivered by Roscoe), were in Mosslake Fields on the site bounded by Myrtle Street, Olive Street and Laurel Street. Under Shepherd's guidance they became a model of international standing and his expert knowledge was widely recognised. He published a catalogue of the plants, 1808; with his friend Dr. Bostock he contributed to the 5th edition of the *Arrangement of British Plants* by Dr.

Withering, 1812, and thence to Hall's *Flora of Liverpool*, 1839; he assisted Roscoe in his work on Scitamineae for his *Monandrian Plants*, 1828; he sent plants to the Imperial Botanic Gardens at St. Petersburg; in 1818 his name was adopted by Nuttall for the genus *Shepherdia*. He died 27 September 1836, having seen the removal of the gardens to Edge Lane. They were taken over by Liverpool Corporation in 1841 and were subsequently at Harthill Estate and Calderstones Park.[2]

The obituary in the *Liverpool Mercury* described him as 'Endowed with a native love of gardening, and indefatigable in his exertions, he succeeded in raising the establishment over which he was placed, to a state of competition with the first gardens of Europe. . . Of social habits, and great cheerfulness of mind, his society was much courted by the cultivators of plants in his own immediate vicinity and the neighbouring counties, many gentlemen being anxious to avail themselves of his correct taste in the disposition of their gardens.'[3]

PROV: Liverpool Corporation, Parks and Gardens Department, at unknown date, and transferred to the Gallery.

EXH: Probably Liverpool Academy, 1814 (42).

REF: **1** Background largely destroyed by bitumin; restored 1971. **2** J. A. Picton, *Memorials of Liverpool*, 1873, II pp. 257–8; Anne Lee, *John Shepherd and John Bostock*, in *The Lancashire and Cheshire Naturalist*, XVII, 1924–5, pp. 126 ff, 157 ff, 200 ff; *Handbook to the Herbarium Collections in the Public Museums, Liverpool*, 1935, pp. 33–4, repr. (detail) fp. 32. **3** *Liverpool Mercury*, 30 September 1836, quoted in Lee, *op. cit.*, p. 200.

WILLIAMSON, John, After

6136 William Roscoe

Oil on canvas, (painted surface within an oval), 42·8×36 cm. (16⅞×14⅛ in.)

See Shee 3130 for biography. Though of inferior quality this is possibly autograph, and a smaller version of the picture formerly in the Roscoe family and now in the National Portrait Gallery (963: 30×24½ in.). The only essential difference is that in the latter the sitter reads a pamphlet instead of the document shown here. The original may have been the portrait exhibited at the Society for Promoting Painting and Design in Liverpool, 1784 (109), with which Mayer equates 6136.[1] A watercolour sketch of the head, supposedly by Williamson (? but perhaps by another hand), is in the Mayer Papers in Liverpool City Library and is inscribed in pencil 'John Williamson // the first sketch Roscoe ever sat to.' This description Mayer repeats in reference to 6136 as 'the first portrait he ever sat for. . .'[2] The sitter appears rather older than thirty-one.

PROV: Joseph Mayer, F.S.A.; bequeathed to the Bebington Borough Council who presented it, 1962.

REF: **1** Roscoe Memorials (Mayer Papers), 1926, part I, p. 2. **2** Joseph Mayer, *Early Exhibitions of Art in Liverpool*, 1876, p. 61; and MS. list of Oil Paintings in the Lecture Theatre, Bebington, September 1873, No. 31: 'the first painted portrait of him.'

WILLIAMSON, Samuel 1792 - 1840

Landscape and marine painter. Born Liverpool 1792, the younger son of John Williamson (*q.v.*) and father of Daniel Alexander Williamson (*q.v.*); his brother Daniel was also an artist and teacher. Associate of Liverpool Academy at foundation, 1810; Member, 1811; resigned 1831 but re-elected 1838 and continued to exhibit until 1839. Exhibited at Royal Academy, 1811; also at Manchester, Birmingham and Leeds. He is said to have travelled abroad and John Gibson was hoping to see him at Rome in 1818.

His early style, based on classical and Dutch prototypes, changed in the later 1820's to a looser realistic manner and hotter colouring, echoing to some extent Turner's later manner. Many examples of his sketches of figure groups and landscape on which he drew for his compositions, belonged to Joseph Mayer and are now in the Collection. Died Liverpool 7 June 1840. A memorial obelisk was erected to his memory in St. James's Cemetery in 1842.

2961 Mountainous Landscape with herdsman on a donkey driving cattle

Oil on canvas, 128·3 × 103·5 cm. (50½ × 40¾ in.)
A sketch similar to the figure on the donkey is among drawings by Williamson in the Collection (6385 verso).

PROV: Presented by Alderman J. G. Paris, 1906.

EXH: Walker Art Gallery, 1908, *Historical Exhibition of Liverpool Art* (491).

2285 North Shore, Liverpool

Oil on canvas, 64·2 × 94·6 cm. (25¼ × 37¼ in.)
This is evidently the picture exhibited at the Liverpool Academy in 1828 under the present title. The subject was apparently exceptional at the time and appears to have been chosen by the commissioner to record the scene before the building of the new range of Docks begun in 1826 obliterated the view. Visible on the horizon from the left are, the cupola of St. Paul's Church (since demolished) the remains of a windmill, the dome of the Town Hall, the spire of St. George's (on site of Liverpool Castle; demolished 1897), and the tower of St. Nicholas's Church (rebuilt in 1815) at the Pierhead, with shipping in George's Dock; the banks of the south side of the Mersey appear in the right background.

Williamson's exhibited work of the year, and particularly this picture, were the centre of a controversy in the local Press between a faction favouring N. G. Philips' more classical style and anti the Liverpool Academy, and Williamson and pro-Academy adherents.[1] Philips and Williamson were rivals for the Corporation £20 prize for the best oil painting, which Williamson won. The 'Amateur Critic' of the *Liverpool Chronicle* started an attack: 'Elements demanding and allowing the application of breadth even to the extent of grandeur, are here cut up into shreds and patches. It is utterly impossible for excellence to come out of so vicious a style. The river, the beach, and boats and sails, are broken by a thousand lines, and a tawdry colouring complete the mischief.

The figures however, are spirited, and the sky handled freely; but a picturesque scene is, after all, very indifferently treated.'

A correspondent in *The Albion* expressed regret at the alteration in the artist's style and printed a protest against 'a fashionable imitation of Turner's vagaries . .'

Among correspondents coming to the artist's rescue, one mentioned that his abandonment of the 'broad bold style with which he set out,' was due to the necessity to undertake 'that which sells,' and another that the subject, 'that most unpoetic spot', was not chosen by the artist but a commission.

A more favourable reviewer remarked that the artist 'enriches every subject to which he applies himself. The subject is one which combines much local interest, and will, from the nature of the operations now carrying on in the North Shore, become hereafter a work of much interest and value. . .', and from another hand came a eulogy: 'Nothing can be more spirited, in execution and in colour than his various groups of figures and boats with which he has enlivened his landscape. There is a crispness of handling in his small figures which reminds the spectator of the light period of Teniers, to which his groups generally bear a strong resemblance. He has failed, however, in giving air-tint to his more distant faces, which are almost as sharp and well defined as those near his foreground. But, worst of all, and totally unlike himself and itself also, is the *Good Old Town*. The drawing, both in regard to proportion and detail, of the singular steeple of St. Nicholas, is most defective, and the dome of the Town Hall is little better. In colour they, and the mutilated windmill are, as Swift says of an unfamiliar lady's hand – "dry and cold in hue". Nothing but extreme haste and carelessness can account for this departure from his usual excellence, and there is no doubt, that, when the exhibition closes, the picture will leave his easel what it should be.'

A picture by Williamson of *Old Liverpool* –

North Shore was in a Liverpool sale in 1863 under watercolours.[2]

PROV: Painted for Arthur Heywood (1753–1836), Liverpool banker, who sold it to his cousin Samuel Harry Thompson (Thingwall Hall, Liverpool), who died 1892;[3] thence to Miss Anna Thompson, who bequeathed it, 1942.

EXH: Liverpool Academy, 1828 (7); Walker Art Gallery, 1908, *Historical Exhibition of Liverpool Art* (260) as *Liverpool from Bootle Sands;* and 1960, *Liverpool Academy 150th Anniversary* (26); Antwerp, 1973, *Op de Rede* (p. 26).

REPR: *The Connoisseur*, June 1973, p. 125.

REF: 1 A series of press cuttings is inserted in a copy of the Liverpool Academy Catalogue in Liverpool Record Office. 2 Walter and Ackerley, Church Street, 5.11.1863 (49). 3 Letter from Beatrice I. Bush, 13 October 1942 (Gallery files).

2962 New Brighton Shore in 1835
Oil on canvas, 98·4 × 144·2 cm. (38¾ × 56¾ in.)

SIGNED AND DATED: *Samuel Williamson/1835*

Looking up the Mersey towards Liverpool on the opposite shore. The Lighthouse and the Perch Rock Battery appear in the middle distance, and the mass of grotesque rock, called the Red Noses, in right foreground.

A sketch of a woman on a horse, of similar type to the detail here, is amongst drawings by Williamson in the collection (6393).

PROV: Presented by John Elliot, 1914.

2421 Fishing boat in a heavy sea
Oil on canvas, 67·3 × 135·2 cm. (26½ × 53¼ in.)

PROV: Presented by George Comer, 1870.

EXH: Walker Art Gallery, 1908, *Historical Exhibition of Liverpool Art* (542).

7633 View of Wedgwood's Pottery at Etruria, Staffordshire
Oil on canvas, 61·1 × 83·7 cm. (24 × 33 in.)

SIGNED AND DATED: *S. Williamson 1838*

Identified[1] as a view from Basford Bank towards Mow Cop on the far horizon; Etruria Hall is seen in the centre with the factory to its left. Burslem or Hanley appears on the outcrop beyond and Wolstanton Church spire on the hill at centre left; the river runs through the valley. Newcastle-under-Lyme, the birthplace and home of Joseph Mayer,[2] the owner of the picture, would be back of the spectator.

PROV: Joseph Mayer Trust, Bebington; presented by Bebington Corporation, 1971.

REF: 1 By Bruce Tattersall, Wedgwood Museum, 1974. 2 MS *List of Oil Paintings . . . at Bebington*, 1873, (39), and Mayer Trust, *Hand List of Drawings, Prints, Sculpture, etc. . . . Mayer Hall, Bebington*, n.d. (25).

419 Fishing boats entering harbour in a rough sea
Oil on panel, 26·6 × 22·1 cm. (10½ × 8¾ in.)

A label gives the title *Morning Run.*

PROV: ? John H. Paris, dealer, Liverpool;[1] John Elliot, who bequeathed it, 1917.

REF: 1 Label.

4605 Landscape
Presented by George Comer, 1870; burnt beyond repair during 1939–45 war and destroyed, 1961.

— The Old Oak
Purchased, 1873; untraced and believed destroyed during 1939–45 war.

WINDUS, William Lindsay 1822 - 1907

Painter chiefly of romantic literary and historical subjects, with some portraits and landscape sketches. Born Liverpool, 8 July 1822. He had a few lessons from William Daniels (*q.v.*) and studied at the Liverpool Academy Schools, which he entered as probationer in February 1846, and a Life School run by a brother of J. R. Herbert, R.A. (?W. G. Herbert). Exhibited

at the Liverpool Academy, 1845–64; Associate, 1847; Member, 1848; exhibited at the Royal Academy 1856 and 1858 only. In the 1840's his work showed a marked concern with chiaroscuro but he was later influenced by the Pre-Raphaelite Brotherhood whose paintings he first saw at the Royal Academy in 1850 which he visited at the suggestion of the Liverpool collector John Miller. As a member of the Liverpool Academy Council he was instrumental in awarding their work the annual prize during the 1850's, which was the cause of the annihilation of the Academy itself. Their influence first became apparent in his painting *Burd Helen*, R.A. 1856 (*q.v.*), and he joined with them in exhibiting in London in 1857 and in the formation of the Hogarth Club. He was a friend of D. A. Williamson (*q.v.*) and married a sister of Robert Tonge (*q.v.*) in 1858. She died 2 August 1862, leaving a daughter; a son Robert had died 1860. The combined effects, on an abnormally sensitive temperament, of Ruskin's adverse criticism of *Too Late*, R.A. 1858 (Tate Gallery) and his wife's untimely death is said to have been the cause of his ceasing to paint any major finished works after the early 60's and his withdrawal into seclusion, though he apparently still produced sketches and landscape studies, many of which he destroyed. He moved to Walton-le-Dale, near Preston in the mid-1860's and later, about 1879, to London. Three of his sketches appeared at the New English Art Club in 1886 and a further two in 1899, when an article on him was published by E. R. Dibdin. Besides the present very representative collection, which also includes watercolours, some of his pictures are in the Tate Gallery, the Williamson Art Gallery, Birkenhead, and at Manchester City Art Gallery; a few sketches remain in family possession. He died at Denmark Hill, London, 9 October 1907.

1604 Self Portrait as a Young Man

Oil on canvas, 61·5 × 51 cm. (24¼ × 20⅛ in.)
PROV: James Hamilton of Liverpool by 1912;[1] purchased from Miss Betty Hamilton, 1939.
REPR: Walker Art Gallery, *Liverpool Bulletin* VII, 1958–9, p. 20.
EXH: National Gallery, 1945, *Walker Art Gallery Acquisitions, 1935–1945* (100).
REF: 1 Note by E. R. Dibdin in Gallery files.

1601 The Black Boy

Oil on canvas, 76·1 × 63·5 cm. (30 × 25 in.)
The figure has been cut down from a larger composition at about the time of acquisition.

The subject is said[1] to have been a stowaway who came to Liverpool and was discovered by the artist on the doorstep of the Monument Hotel; he engaged him as an errand boy. The picture was put in the window at the frame-maker's where it was seen by a sailor relative of the boy who searched him out and eventually took him back to his parents.

According to Dibdin[2] it was painted in 1844 for the godfather of William Windus of Clifton. The latter found it in a farm house in the late 1880's after it had been lost sight of for several years.

PROV: Acquired by William Windus (of Clifton), 1880's; passed to William Windus (of Waterloo) and presented by him, 1948.
REPR: Walker Art Gallery, *Liverpool Bulletin*, VII, 1958–9, p. 21.
EXH: Whitechapel, 1905, *British Art Fifty Years Ago,* (318); Walker Art Gallery, 1908, *Historical Exhibition of Liverpool Art* (187), 36 × 27 in.; Mappin Art Gallery, Sheffield, 1968, *Victorian Paintings 1837–1890* (20).
REF; 1 Whitworth Wallis, 1892, quoted in A. G. Temple, *Art of Painting in the Queen's Reign,* 1897, p. 330. 2 E. Rimbault Dibdin, *William Windus,* in *Magazine of Art,* December, 1899.

1594 Study of seated female nude

Oil on board, 58·3 × 43 cm. (23 × 16 15/16 in.)

This and the three studies below (1595, 1596 and 1599) may have been painted at the Liverpool Academy life class in the 1840's.

PROV: Presented by James Smith (of Blundellsands), 1922.

1595 Study of standing female nude

Oil on board, 58·3×43 cm. (23×16$\frac{15}{16}$ in.)

PROV: James Smith (of Blundellsands) by 1911, and presented by him 1922.

EXH: Manchester, 1911, *Ford Madox Brown and the Pre-Raphaelites* (316).

1596 Study of reclining female nude

SIGNED: *W. L. Windus*

Oil on board, 35·5×60·9 cm. (14×24 in.) See No. 1594 above.

PROV: Presented by James Smith (of Blundellsands), 1922.

EXH: Mappin Art Gallery, Sheffield, *Victorian Paintings, 1837–1890* (5),

1599 Study of female nude leaning over a well

Oil on board, 49×35·3 cm. (19$\frac{3}{8}$×13$\frac{7}{8}$ in.)

PROV: Bought from Messrs. Brown and Rose's Sale by James Loudon and given by him to J. Y. Dawbarn 14.12.1909;[1] presented by the latter, 1910.

REF: 1 MS label.

1598 Touchstone nominating the degrees of the lie

Oil on canvas, 123·2×101·6 cm. (48$\frac{1}{2}$×40 in.)

Illustrating Shakespeare's *As You Like It,* Act V, scene iv.

A local critic of the 1846 Liverpool Academy thought this and Davis's *Ejectment* 'worthy of attention.' Windus's picture, he considered, 'has also many points of excellence and appreciation of character, but we ask of both why select such a dark tone of picture? It is quite a mistaken idea; no degrees of positive daylight in the atmosphere will allow of such tones; and we are quite aware that young artists adopt this sombre treatment of their subjects, because some other masters have done so before them. Eschew this looking at others – think for yourselves – and nature will richly reward all who enquire personally at her bounteous gate. Pictures like these have been painted a thousand times.'[1]

PROV: Purchased from A. E. Lewis, 1910.

EXH: Liverpool Academy, 1846 (245), Birmingham Society of Artists, 1847 (178); Harrogate, 1924, *Liverpool School of Painters* (25); Walker Art Gallery, 1960, *Liverpool Academy 150th Anniversary* (53).

REF: 1 Liverpool Mercury, 20 November 1846.

1593 Morton before Claverhouse at Tillietudlem

Oil on board, 23×29 cm. (9$\frac{1}{16}$×11$\frac{7}{16}$ in.)

Illustrating Walter Scott's *Old Mortality,* Chapter XII. A sketch for the painting exhibited at the Liverpool Academy in 1847, No. 354 (43×55$\frac{1}{2}$ in.), and now in the Williamson Art Gallery, Birkenhead. It differs very slightly in the details from the finished painting where the models have evidently been taken from the life.

PROV: Perhaps John Miller of Liverpool.[1] Charles Hargitt, sold Branch & Leete, Liverpool, 15–19.3.1881 (733) bought by the Gallery.

REF: 1 Signature on label on back.

1602 Cranmer endeavouring to extort a confession of guilt from Catherine Howard

Oil on board, 25·4×17·8 cm. (10×7 in.)

A sketch for 1591, with very slight differences in the details.

PROV: Purchased from H. J. Kidson, Esq., 1907.

EXH: Walker Art Gallery, 1908, *Historical Exhibition of Liverpool Art* (511).

1591 Cranmer endeavouring to extort a Confession of Guilt from Queen Catherine

SIGNED AND DATED: *W. L. Windus 1849*

Oil on canvas, 122×86·4 cm. (48×34 in.)

Exhibited at the British Institution with a slightly shorter title and the following quotation:

"We have before us a letter from Cranmer to the King. He begins by describing Catherine's wretched condition. He then tells the King that he had delivered to her his grace's *promise of mercy;* upon which she held up her hands and gave most humble thanks, and for a time she recovered from the frenzy in which he had found her, and

began to be more temperate and quiet, saving that she still sobbed, and wept, etc."– *Macfarlane*.

In 1848 the artist also exhibited (at Liverpool) his painting of *Reginald Pole (afterwards Cardinal Pole) exhorting Henry the Eighth against the Divorce of Catherine of Arragon*.

PROV: F. D. Leyland, sold Christie's 28.5.1892 (29), bt. Hill; William Windus (of Clifton), a relative of the artist, by 1899;[1] passed to William Windus (of Waterloo), who presented it, 1948.

REPR: Walker Art Gallery, *Liverpool Bulletin*, VII, 1958–9, p. 22.

EXH: Royal Manchester Institution, 1848 *(sic)* (122); British Institution, 1849 (411); St. Helens, 1900 (36); Walker Art Gallery, 1908, *Historical Exhibition of Liverpool Art* (175).

REF: 1 E. Rimbault Dibdin, *William Windus* in *The Magazine of Art,* December 1899.

1603 The Interview of the Apostate Shaxton, Bishop of Salisbury with Anne Askew in Prison

Oil on canvas, 86·4 × 111·2 cm. (34 × 43¾ in.)

Anne Askew, the Protestant martyr, was burnt at the stake on 16 July 1546, at twenty-five years of age. On the previous 18 June she was arraigned for heresy at the Guildhall with Bishop Shaxton and two others. Shaxton and one of the others recanted the following day. He endeavoured to persuade her to do likewise but did not succeed. He was appointed to preach to the victims at their execution at Smithfield.

PROV: Presented by Alderman John Lea, J.P., 1913.

REPR: Walker Art Gallery, *Liverpool Bulletin*, VII, 1958–9, p. 23; Graham Reynolds, *Victorian Painting*, 1966, pl. 44.

EXH: Liverpool Academy, 1849 (96); Harrogate, 1924, *Liverpool School of Painters* (38), Wembley, 1924, *Liverpool Civic Week;* Detroit and Philadelphia, 1968, *Romantic Art in Britain* (214).

1592 Middlemas's Interview with his Parents – A Scene from the Surgeon's Daughter

Oil on panel, 45·7 × 35·2 cm. (18 × 13⅞ in.)

According to Smith[1] painted as the result of a commission made through John Miller the collector, to provide a frontispiece for a new edition of the Waverley Novels. It was exhibited at the Liverpool Academy of 1854 with the following quotation from Scott's novel (Chapter VIII) in the catalogue:

' "O my more than father," he said, "how much greater a debt do I owe to you, than to the unnatural parents who brought me into the world by their sin, and deserted me by their cruelty." Zilia, as she heard these cutting words, flung back her veil, raising it in both hands till it floated behind her like a mist, and then, giving a faint groan, sank down in a swoon.'

John Miller informed Ford Madox Brown when the Russell Place exhibition was being organised in 1857: 'But Windus absolutely interdicts exhibition of any of his sketches and only gave a most reluctant assent to that of the Surgeon's Daughter, requesting if you exhibit it you should insert on the card "painted in 1853".'[2]

An oil sketch for the composition (8 × 6 in.) is in the Williamson Art Gallery, Birkenhead.

PROV: John Miller, sold Branch & Leete, Liverpool, 6.5.1881 (149); John Bibby by 1891, sold Christie's, 3.6.1899 (108) bt. Lepper; purchased from Lawrie & Co., by James Smith (of Blundellsands), 1899,[3] and bequeathed by him, 1923.

REPR: H. C. Marillier, *The Liverpool School of Painters,* 1904, fp. 242.

EXH: Liverpool Academy, 1854 (81); Russell Place, 1857, *Pre-Raphaelite Exhibition,* (70), or the sketch; U.S.A., 1857–8, *American Exhibition of British Art,* New York (165), Philadelphia (105), Boston and Washington; Birmingham Society of Artists, 1858 (201); Liverpool Institute, 1861, *Loan Exhibition* (37); Liverpool Arts Club, 1876 (19); Birmingham, 1891 (166); Guildhall, 1894 (109); Whitechapel, 1905, *British Art Fifty Years Ago* (406); Walker Art Gallery, 1908, *Historical Exhibition of Liverpool Art* (293); Manchester, 1911, *Ford Madox Brown and the Pre-Raphaelites* (297); Walker Art Gallery, 1922, *Liverpool Autumn Exhibition* (461); Harrogate, 1924, *Liverpool School of Painters,* (47); Wembley, 1925, *British Empire* (W.1); Mappin Art Gallery, Sheffield, 1968, *Victorian Paintings, 1837–1890* (55).

REF: 1 (James Smith) *In Memoriam D. A. Williamson and W. L. Windus,* privately

printed n.d., p. 14. **2** John Miller to Ford Madox Brown, 17 May 1857 (MS Family papers); this date given in the Catalogue. **3** MS copy of note in J. Smith's Catalogue (Gallery files).

158 Burd Helen

SIGNED in monogram and dated: *W L W 1856*
Oil on canvas, 84·4 × 66·6 cm. (33¼ × 26¼ in.)

Exhibited at the Royal Academy in 1856 with the following lines in the catalogue, from the Scottish Ballad of Burd Helen (which is inscribed with variations on the frame):

> Lord John he rode, Burd Helen ran,
> A live-long simmer's day;
> Until they cam' to Clyde water,
> Was filled frae bank to brae.
>
> 'See'st thou yon water, Helen,' said he,
> 'That flows from bank to brim?'
> 'I trust to God, Lord John,' she said,
> 'You ne'er will see me swim.'[1]

It was the first picture by Windus painted under the influence of the Pre-Raphaelites, having an intense seriousness of subject and using, in a tentative manner, their technique. At the R.A. Exhibition of 1856 it attracted the attention of Rossetti,[2] who persuaded Ruskin to add a postscript to his *Academy Notes* in its favour, 'The work is thoughtful and intense in the highest degree. The pressure of the girl's hand on her side, her wild, firm, desolate look at the stream – she not raising her eyes as she makes her appeal, for fear of the greater mercilessness in the human look than in the glare of the gliding water – the just choice of the rider's cruel face, and the scene itself, so terrible in its haggardness of rattling stones and ragged heath, are all marks of the actions of the grandest imaginative power, shortened only of hold upon our feelings because dealing with a subject too fearful to be believed true.'[3]

A Mrs. Burns sat for the woman and a Mr. Wilfred Steele, a connection of the Miller family of Liverpool, for the lover. The background is supposed to have been painted in North Sannox Glen, Isle of Arran.[4]

John Miller, the purchaser, had it hung up by January 1857 opposite to where he wrote,[5] and in 1861, sometime after its sale at Christie's, informed Madox Brown: 'your friend Plint is now the proud possessor of Burd Helen at £400.'[6] It is stated in a biographical note by James Smith that it was not signed when later in the possession of Frederick Leyland and that at about the time of the later Miller sale (of 1881), he wished to get in touch with the artist to have this done.[7]

ENGR: National Magazine, 1857; *Poems inspired by certain pictures at the Art Treasurers Exhibition, Manchester,* by 'Tennyson Longfellow Smith,' illustrated by the 'Hon. Botibol Bareacres,' Manchester, 1857 (caricature).

PROV: John Miller, from the artist, sold Christie's 21.5.1858 (172), bt. Roberts, 250 gns.; apparently bought from a Mr. Harrison by Gambart for T. E. Plint;[8] T. E. Plint, sold Christie's 7.3.1862 (323), bt. in; Frederick Leyland by about 1881, sold Christie's 28.5.1892 (27), bt. Bibby; again in the Leyland family, before 1904;[9] by descent to the Hon. Mrs. Maurice Wingfield; purchased from Colnaghi's, 1956.

REPR: E. R. Dibdin in *Magazine of Art,* December 1899, p. 53; P. Bate, *The English Pre-Raphaelite Painters,* 1899, after p. 82; H. C. Marillier, *The Liverpool School of Painters,* 1904, fp. 248; Liverpool Bulletin, Vol. 7, 1958–9, p. 18; *Apollo,* December 1962, p. 751.

EXH: Royal Academy, 1856 (122); Manchester 1857, *Art Treasures* (403) Royal Scottish Academy, 1858 (141); Liverpool Academy, 1864 (87) Walker Art Gallery, 1886, *Grand Loan Exhibition* (1179); Birmingham, 1947, *The Pre-Raphaelite Brotherhood* (78); Walker Art Gallery, 1960, *Liverpool Academy 150th Anniversary* (79); Royal Academy, 1968–9, *Bicentenary* (403).

REF: **1** For another version see T. Percy, *Reliques of Ancient English Poetry,* 5th Edition 1812, III, pp. 95–103, *Childe Waters.* **2** G. B. Hill, *Letters of D. G. Rossetti to William Allingham, 1854–1870,* 1897, pp. 187–8. **3** Cook and Wedderburn, *Works of John Ruskin,* 1904–12, XIV, *Academy Notes,* pp. 85–87. **4** (James Smith), *In Memoriam W. L. Windus, D. A. Williamson,* privately printed pamphlet n.d., p. 16. Robert Tonge (d. 1856) painted *Foot of Sannox Burn, Arran* (Walker Art Gallery, 1908 (263)) and other Arran views: Windus perhaps accompanied him or alternatively made use of his views. **5** John Miller to Ford Madox Brown, 4 January 1857 (MS letter, artist's family). **6** The same, 20 (?) January 1861 *(loc. cit.).* **7** Smith, *loc. cit.* **8** According to H. C. Marillier in *The Liverpool School of Painters,* 1904, p. 248. **9** *Ibid.*

8297 Study from Nature – The Kingfisher's Haunt, Eastham Wood

Oil on board, 30·5 × 45·8 cm. (12 × 18 in.)

It must date from before or during 1859 when the artist moved house from the address given on a label.[1]

PROV: John Miller, sold Branch and Leete, Liverpool, 6.5.1881 (277).[2] Albert Wood of Conway by 1901; his sale Christie's, 20.10.1936 (3). Purchased 1973.

EXH: Glasgow, 1901 (407); Whitechapel, 1905 (394); Walker Art Gallery, 1908, *Historical Exhibition of Liverpool Art* (294); Manchester, 1911, *Ford Madox Brown and the Pre-Raphaelite Brotherhood* (295).[3]

REF: 1 109 London Road, Liverpool (No. 2). 2 Label, verso gives lot number. 3 Labels, verso.

863 The Baa Lamb: View on a Tributary of the River Duddon

Oil on board, 21·2 × 30·5 cm. (8 5/16 × 12 in.)

According to Smith[1] and Marillier[2] dating from 1864, the site near the home of Windus's fellow artist and friend, D. A. Williamson, with whom Windus spent his summers for several years. Smith changed the title to *The Stray Lamb*.

PROV: John Miller, sold Branch and Leete, Liverpool 6.5.1881 (248) as *The Baa Lamb*.[3] John Bibby, sold Christie's 3.6.1899 (111) with present title; bt. from Lawrie and Co. by James Smith (of Blundellsands) 1899[4] and bequeathed by him, 1923.

REPR: Walker Art Gallery, *Liverpool Bulletin,* Vol. 7, 1958–9, p. 25; Allen Staley, *Pre-Raphaelite Landscape*, 1973, pl. 82. b.

EXH: Great Horton, Bradford;[5] Glasgow, 1901 (409); Walker Art Gallery, 1908, *Historical Exhibition of Liverpool Art* (317); Manchester, 1911, *F. M. Brown and the Pre-Raphaelite Brotherhood* (300); Walker Art Gallery, 1922, *Liverpool Autumn Exhibition* (459).

REF: 1 James Smith, *In Memoriam D. A. Williamson and W. L. Windus,* privately printed pamphlet n.d., p. 18. 2 H. C. Marillier, *The Liverpool School of Painters,* 1904, p. 250. 3 An MS label on the back also gives this title. 4 MS copy of a note in James Smith's Catalogue (Gallery files). 5 MS label.

480 The Young Duke

Oil on board, 38·2 × 24·5 cm. (15 1/16 × 9 5/8 in.)

According to Marillier[1] this was Windus's last completed picture, but the technique is free and sketchy and it appears unfinished especially in the faces. It probably dates from the 1860's. An oil sketch (11 × 6 1/2 in.) with variations is in the Williamson Art Gallery, Birkenhead.

PROV: John Bibby by 1876,[2] sold Christie's 3.6.1899 (109), bt. Lepper; James Smith (of Blundellsands) 1899, who bequeathed it, 1923

REPR: Walker Art Gallery, *Liverpool Bulletin* Vol. 7, 1958–9, p. 30.

EXH: Wrexham, 1876, (435); Birmingham 1891 (167); Guildhall, 1894 (138); Grafton Gallery, 1897 (167); Glasgow, 1901 (412) Whitechapel, 1905 (371); Walker Art Gallery 1908, *Historical Exhibition of Liverpool Art* (302); Manchester, 1911, *F. M. Brown and the Pre-Raphaelite Brotherhood* (298); Tate Gallery 1913, *Pre-Raphaelite Painters from Collections in Lancashire* (12); Harrogate, 1924, *Liverpool School of Painters* (52); Wembley, 1925 *British Empire* (W. 9).

REF: 1 H. C. Marillier, *The Liverpool School of Painters,* 1904, p. 252. 2 According to Marillier *loc. cit.*, originally belonging to John Miller and after Bibby's sale to Squarey before passing to Smith, but he may have been confusing it with *The Young Knight* (now at Birkenhead).

1597 A Roman Patrician, A.D. 60

Oil on canvas, 41 × 64 cm. (16 1/8 × 25 1/4 in.)

Described in 1886 as an unfinished sketch for a picture. Its condition has been much affected by the use of an unsound medium.

PROV: Mrs. Isabella Teed, daughter of the artist, by 1899, who presented it, 1908.

REPR: *Magazine of Art* December, 1899, p. 52

EXH: New English Art Club, 1886 (87) Glasgow, 1901 (411); Walker Art Gallery 1908, *Historical Exhibition of Liverpool Art* (324); Leicester, 1968, *The Victorian Vision of Italy* (18).

WINSTANLEY, Hamlet 1694 - 1756

Portrait painter and engraver. Born Warrington, son of William Winstanley, a tradesman, and baptised there 6 October 1694. Attended the Free Grammar School; showed talent in drawing and made crayon portraits. Taken up by the Hon. and Rev. Dr. John Finch (brother of Earl of Nottingham), Rector of Winwick, who let him copy his pictures. About 1718 went to London and worked in Kneller's drawing academy, receiving some advice from Kneller himself. Returned to Warrington 1721, and painted the country gentry with success, and came under the patronage of Sir Edward Stanley of Bickerstaffe, Bart., at Preston (later 11th Earl of Derby), who introduced him to James, 10th Earl of Derby for whom he painted portraits and landscapes in the vicinity of Knowsley. On the Earl's advice went to Rome and Venice about 1723, where copied and purchased pictures for the Earl's collection. Returned 1725. Employed at Knowsley painting portraits and copying Old Masters; published his etchings after some of these, 1728. George Stubbs (q.v.) is said to have been his pupil and assistant there for a short period, 1740. His sitters elsewhere included George Patten of Warrington (Warrington Art Gallery), and the Blackburne family (formerly Hale Hall). Returned to Warrington where he died 16 May 1756, aged 61.

Vertue describes his method of painting portraits, the heads only on small canvases which he stuck on large blank canvases and sent to the drapery painter Joseph Van Aken (d. 1744) in London to be made up by him into portraits, the pose and drapery added, 'a method quite new and extraordinary.' A portrait of Patten (at Warrington Art Gallery) confirms this method.

Ref: J. Paul Rylands, in *Local Gleanings in Lancashire and Cheshire,* 1877, n. 637; W.Beamont, *Memoir of Hamlet Winstanley, formerly of Warrington,* in *Miscellaneous Works,* 1883, pp. 3–10; Richard Lawson of Urmston, *Hamlet Winstanley, a Local Artist,* in *Cheshire Notes and Queries, The Cheshire Sheaf,* N.S. V–VI, 1891, pp. 43–45.

139 Elizabeth, Countess of Derby and her son Edward

Oil on canvas, 127×101·6 cm. (50×40 in.)

INSCRIBED: *Elizh. Countess of Derby/wife to Edward Earl of /Derby & Edward their/Son 1740. – /Hal. Winstanly* (sic) *Pinxt*

Elizabeth, daughter and heiress of Robert Hesketh of Rufford, married in 1714 Sir Edward Stanley of Bickerstaffe, Bart. (1689–1776); who succeeded as 11th Earl of Derby in 1735. She only survived her husband two days, dying on 24 February 1776. Edward was their youngest son (c. 1732–1745).

A further portrait of her is amongst other family portraits by Winstanley still at Knowsley.[1] Formerly there was a large group portrait by the artist composed of the Countess with her husband and eight children.[2] The present portrait does not appear in Scharf nor the 1772 MS Catalogue at Knowsley.

PROV: Earl's of Derby, Knowsley, sold Christie's, 8.10.1954 (140), bt. Agnew for the Walker Art Gallery.

REF: 1 George Scharf, *Catalogue of the Collection of Pictures at Knowsley Hall,* 1875, No. 173. 2 MS *Catalogue of Pictures at Knowsley* 1772: (?) *The Family Piece; Lancashire and Cheshire, Local Gleanings* Nov. 1899, p. 139.

L148 View of Knowsley

Oil on canvas, 117×227·4 cm. (46×89½ in.)
Called 'View of Knowsley from Walton' in the
1860 MS Catalogue.[1] Knowsley Hall is a
tiny red speck in the centre background. The
church at the left might be identified as Walton
with (?) Walton Hall to its right.

Winstanley painted another landscape for
the Earls of Derby.[2] Views of the house and
estate by Molyneux, Tillemans and anon.
also exist.[3]

PROV: Earls of Derby at Knowsley; lent by
the Rt. Hon. the Earl of Derby.

REF: **1** Added on p. 23 in another hand (Know-
sley archives); George Scharf, *Catalogue of
Pictures at Knowsley Hall*, 1875, No. 259.
2 *Ibid*, No. 260. **3** *Ibid*, Nos. 1, 274, 326. 328,
454.

WITHEROP, Jack Coburn, living artist

2377 Fishing Nets, St. Ives

Egg tempera on board, 63·5×81·3 cm. (25×
32 in.)

SIGNED AND DATED: *J. COBURN
WITHEROP 1939*

PROV: Purchased from the artist, 1939.

EXH: Bluecoat Chambers, Liverpool, 1939,
Liverpool Artists Exhibition (61).

3159 Tin Mines, Cornwall

Tempera on board, 41·7×81·2 cm. (16⅜×
32 in.)

SIGNED, DATED AND INSCRIBED: *J Coburn
Witherop/Cornwall 1954*

PROV: Purchased from the artist, 1954.

EXH: Walker Art Gallery, 1954, *Liverpool
Academy* (4).

WOOD, Eleanor S. 1856–active 1912

Portrait painter. Native of Manchester and trained there and in Paris. Lived in Manchester
until 1901, then near Liverpool, retaining her Manchester studio until 1905 and living much
on the continent. Exhibited at the Paris Salon, at the Royal Academy from 1876, and at the
Liverpool Autumn Exhibition and at Manchester.

2603 William Edwards Tirebuck

Oil on canvas, 61×50·8 cm. (24×20 in.)

William Edwards Tirebuck (1853–1900), native
of Liverpool, journalist and novelist. Worked
for a period as sub-Editor on the Liverpool
Mail and on the Yorkshire Post and then
turned exclusively to writing. Was also a
composer. His novels usually dealt with Welsh
and local subjects; his other writings included
a pamphlet on *William Daniels, Artist*, 1879,
and *Dante Gabriel Rossetti, his art and influence*,
1882. Some of his poems were published in the
Graphic, Academy, and *Scotia*. He lived at
Coldingham, Berwickshire and afterwards in
Wales; died Liverpool 22 January 1900.[1]

PROV: Painted at the request of Charles Porter
and presented by him, 1901.

EXH: Walker Art Gallery, 1900, *Liverpool
Autumn Exhibition* (150).

REF: **1** W. E. Tirebuck, *Poems*, 1912, forward
by J. Hogben; press cuttings (Liverpool
Record Office); information from Arnold
Hyde, 22 May, 1970.

WOODLOCK, David 1842 - 1929

Landscape and genre painter. Born Ireland and came to Liverpool at age of twelve. Apprenticed to an outfitters; attended Liverpool Academy Schools and trained under John Finnie at Liverpool School of Art; became professional artist in 1880. Exhibited at Liverpool Autumn Exhibition from 1871, the Royal Academy from 1888, and the Royal Institute of Painters in Watercolours, and elsewhere. Founder member of Liver Sketching Club 1872, and President 1897. Studied at Ruskin Museum, Sheffield, 1889; visited Venice and North Africa 1894, and later Holland. Died Liverpool 4 December 1929.

423 Old Friends

Oil on canvas, 76·8×61·5 cm. (30¼×24¼ in.)
SIGNED with initials: *D.W.*

A study of Alderman Edward Samuelson with his favourite Amati violin.

Edward Samuelson (1823–1896), a Liverpool merchant in the tobacco trade. Elected to the Council as a Conservative 1864, later an Alderman and J.P.; Mayor 1872–3. Chairman of the Fine Arts Committee, which organised the Liverpool Autumn Exhibition, 1871–1885. Chairman of the Library, Museum and Art Gallery Committee, 1889–90. A keen musician and picture collector; his pictures were exhibited at the Gallery in the Loan Exhibition of 1886. Died Trefriw, North Wales, 19 December, 1896.[1]

A bust by T. Stirling Lee is also in the collection (4175).

PROV: Presented by Alderman Samuelson, 1896.

EXH: Walker Art Gallery, 1886, *Grand Loan Exhibition* (1494) as *An Old Acquaintance;* 1908, *Historical Exhibition of Liverpool Art* (550), and 1929, *David Woodlock* (168).

REF: **1** Press cuttings, (Liverpool Record Office).

2424 Feeding the Pigeons – St. Marks Square, Venice

Oil on canvas, 152·3×76·5 cm. (60×30⅛ in.)
SIGNED: *D. Woodlock*

Based on a drawing painted on the spot.[1] A watercolour of a similar view is also in the Collection (1210). One reviewer refered to his 'highly original treatment.'[2] Another called it 'a brave and bold picture, the sumptuous colour well atoning for some merely passing errors of draughtsmanship.'[3]

PROV: Presented by R. R. Douglas, 1932.

EXH: Walker Art Gallery, 1897, *Liverpool Autumn Exhibition* (339) repr.

REF: **1** *The Porcupine*, 24 July 1897, p. 12. **2** *The Magazine of Art*, 1897, pp. 342–3. **3** *The Artist*, November 1897, p. 563.

WRIGHT, John Dutton 1847 - 1924

Amateur artist. Born Liverpool. Career in family firm. Founder Member, and President 1923–24, of Liver Sketching Club. Exhibited at Liverpool Autumn Exhibitions. In later years lived at Rock Ferry, Birkenhead. Died 27 November 1924.

103 The Old St. George's Dock: Site of the present Royal Liver Building

Oil on canvas, 105·5×73·5 cm. (41½×29 in.)
SIGNED: *J. D. WRIGHT*

Based on sketches taken on the spot in the 1870's.[1]

PROV: Presented by the artist's son, L. H. Wright, 1925.

EXH: Walker Art Gallery, 1913, *Liverpool Autumn Exhibition* (21), £52.10.

REF: **1** *Sincerity in Art, a memoir of John Dutton Wright*, [1927], repr. fp. 14 and note.

WRIGHT, Richard, active 1741/6 - 1773

Marine painter. Probably born Liverpool around 1720 (Richard, son of Edward Wrigh[t] joiner, was born 23 March 1723 and baptised at St. Nicholas'), and not in 1735 as is general[ly] stated. One source states him to have been a son of Richard or William Wright, a boo[k] binder off Old Hall Street (Thomas Reay, claiming descent, in Mayer Papers, Liverpo[ol] Record Office). By 1746 he was living in Old Hall Street, described as painter, and in 1748 [a] limner when he baptised four children at St. Nicholas', 1746–51. He is still recorded the[re] in the Rate Book for 1758. He was thus a neighbour and probably near contemporary [of] William Caddick (q.v.), and of George Stubbs (q.v.). An engraving by Clements after his vie[w] of Liverpool from Mann's Island is variously dated to 1741 and 1760; nothing else is as y[et] known of his Liverpool work. His subsequent movements are suggested by his paintings [of] *Captain Elliott's Engagement off the Isle of Man*, 1760 and *Passage of Princess Charlotte to Englan[d]* 1761, sketched from life. By 1762 he was living in London at Craven Buildings, Crave[n] Street, Strand. Exhibited at the Society of Artists, 1762–73; the Free Society, 1764, and t[he] Incorporated Society of Artists, 1765–70, of which he was a member and much involved [in] its affairs. He gained the premium of the Royal Society of Arts for the best seapiece, 176[4,] 1766 and 1768. Several works were engraved. An unsuccessful exhibition at York in Ra[ce] Week is said (Edward Edwards, *Anecdotes of Painters*, 1808), along with the premature dea[th] of his son, to have hastened his death before 1775.

An Edward Wright (possibly a second son of the name, one such having been born [in] Liverpool 1746 and died there 1752), exhibited at the Society of Arts, 1769–73; Miss Wrig[ht] (?Nancy, born Liverpool, 29 May 1748), exhibited there 1770 and 1773; Elizabeth (bo[rn] Liverpool 21 March 1751) exhibited there 1773–76, in 1775 from Stubbs' house; and M[rs] Wright (?Louisa) exhibited 1770–77.

2164 The Fishery

Oil on canvas, 51 × 69 cm. (20 × 27⅛ in.)

A likely candidate for the original picture which gained the first premium of thirty guineas given by the Society of Arts for a sea-piece in 1764. Several versions of the subject are recorded (see below). Its free autograph quality is comparable to pictures by the artist at Greenwich and superior to those known to the compiler from reproductions and photographs. It is close to Woollett's engraving, but unlike the engraving or some other versions does not have the inscription on the cart of *Fish Machine*. This may have been an afterthought for the engraving as Edward Edwards, an early biographer, points out[1] that Wright 'paid a compliment to the Society of Arts by introducing an allusion to their encourageme[nt] of the scheme for supplying the metropo[lis] with fish, by the means of land carriag[e.] However, E. Hamilton writing in 183[1] commented, 'but it may be observed, that t[he] scenery is not English, that the man of w[ar] standing close in shore under a press of sail, [is] an improbable incident, which accuracy [of] delineation cannot counterbalance, and t[hat] its title of a Fishery is equally inappropria[te] as the only piscatorial association hitches on [an] odd-looking carriage, inscribed "Fi[sh] Machine", whose driver makes for the wat[er] actuated apparently with the intention [of] washing his horses within a cable's length [of] a seventy-four in full sail!'

In style and motif it closely reflects Jose[ph]

236

ernet (1714–1789), which explains the description of some prints after Woollett's engraving to the French artist.

ENGR: **1** William Woollett, 1768, 39·4 × 53 cm. (15½ × 20⅞ in.), inscribed: *Richd Wright pinxt./The Fishery/Wm. Woollett//To Sir John Hort/His Majesty's Consul General at Lisbon/This Plate is inscribed by his obliged Humble Servant Wm. Woollett Sc./The picture from which this Plate is engraved obtained the first Premium 1764 from the Soc. of Artists. Published as the Act directs 30 June 1768 and sold by W. Woollett Charlotte St. Rathbone Place and John Boydell etc.* A series of trial proofs was in Liverpool City Library (destroyed 1939–45 war).

In reverse, probably after Woollett print, 29·7 × 38 cm. (11¼ × 14¾ in.); inscribed: *Vernet pinx./La Peege/J. J. A. [vril] Sculp.// A Paris chepy rue St. Jacques pres la rue de la Parcheminerie.* Two prints of different sizes are said by Grant[3] to have been pirated and ascribed to Vernet.

Normand fils, in outline, probably after Woollett, 8·2 × 11·4 cm. (3¼ × 4½ in.), in E. Hamilton, *The English School,* London and Paris, 1832.

Versions recorded:
Rev. H. Scott Trimmer, sold Christie's, 17.3.1860 (65), as *Wright of Derby, The Fishery – the subject engraved by Woollett* bt. Radcliffe, £2.12.6. **2** 25 × 50 in. repr. Col. Grant, *Old English Landscape Painters,* 1958 edition, III, fig. 204 (pp. 212–3). **3** 13½ × 19 in.: Museum and Art Gallery, Scunthorpe (photo Walker Art Gallery). **4** 32 × 40 in.; a woman with a basket of fish on her head replaces the cart at right: Mrs. Sobinski, Vancouver, 1965 (photo Walker Art Gallery). **5** 21½ × 31½ in.: with Knoedler, 1941. **6** 22½ × 30½ in.: sold Sotheby's, 4.10.1967 (114). **7** 'Similar picture with variations': W. Shaw Adamson, Forfarshire, 1915. **8** 24 × 31 in.; said to be the same with artist in foreground: J. V. Webb,

1962. **9** 27 × 31 in., copy by O. Hodgson, 1830: H. C. H. Merewether, 1967. **10** Drawing in reverse, ? after 'Vernet' engraving: W. M. Hill, 1968, (photo Walker Art Gallery). **11** 15½ × 21¼ in., in reverse, ? after engraving: sold Sotheby's, 20.3.1974 (6). **12** 31 × 40½ in. with two additional figures in centre fishing boat and no flag on the sailing boat behind the man-of-war: sold Christie's 26.3.1976 (8) (photo Walker Art Gallery). **13** 24¾ × 30 in., the cart driver raises his right arm: Harriet Wynter 1976, from a Christie sale (photo Walker Art Gallery). **14** 30½ × 59½ in., Christie's sale, 18.3.1977 (86) repr.

PROV: Purchased from Colonel Fox, London, 1914.

EXH: (?) Free Society, 1764 (195) as *A seapiece with a squall of rain,* £30 premium; Harrogate, 1924, *Liverpool School of Painters* (36).

REF: **1** Edward Edwards, *Anecdotes of Painters,* 1808, p. 48. **2** E. Hamilton, *The English School,* London and Paris, 1832, p. 124. **3** Col. Grant, *Old English Landscape Painters,* 1958 edition, III pp. 212–3.

YEOMANS, Geoffrey, living artist

14 Outdoor Cafe Scene
Oil on canvas, 60·2 × 90·8 cm. (23¾ × 35¾ in.)
PROV: Purchased from the artist, 1956.

EXH: Walker Art Gallery, 1956, *Liverpool Academy* (270).

YOUNG, Richard, living artist

6966 Interior with Figure
Oil on canvas, 92·3 × 152·3 cm. (36⅜ × 60 in.)
INSCRIBED on back: *Richard Young/Interior with Figure/1967*
PROV: Purchased from the artist at the Liverpool Academy Exhibition, 1969.
EXH: Walker Art Gallery, 1969, *Liverpool Academy Open Exhibition* (105).

6364 Chandelier
Oil on board, 67 × 60·8 cm. (26⅜ × 23¹⁵⁄₁₆ in.)
PROV: Purchased from the artist, 1966.
EXH: Walker Art Gallery, 1966, *Liverpo Academy* (2).

APPENDIX

BRITISH SCHOOL, 18th Century

9283 John Earle
Oil on canvas, feigned oval, 76 × 63·5 cm. (30 × 25 in.)
INSCRIBED: *John Earle Mayor of/Liverpool 1703* (sic) *Married Mary/only daughter and Heiress of Ralph Finch Esquire/& Elizabeth De Anyers Coheiress with her sister Ellen/Willis of Colonel Willm De Anyers*

John Earle (1674–1749), merchant of Liverpool; Mayor in 1709. Eldest son of John Earle of Warrington. At 14 he was sent to the merchant house of William Clayton, M.P., of Liverpool with whom he sided in politics later; subsequently set up on his own account as merchant and shipowner and founded the family which continued in importance until the late 19th century. He married in 1700, Eleanor Tyrer (d. 1702) and took up his freedom in that year. In 1703 he was elected, without his consent, to the Council. In 1705 elected Bailiff and in 1709 Mayor. In 1709 married for the second time to Mary Finch, an heiress. He retired fro business after some reverses in fortune at and died at Prescott April 1749. Several of h descendants were important in public affair his grandson William was also a collector a patron of John Gibson (and see Gedde portrait of Gibson, 2944).[1] This portrait see to follow closely an elaborate drawing of t sitter published by Earle,[2] though there t sitter looks somewhat younger. The Ear family became heirs of the Willis estates 1788, and the inscription may post-date t occurrence.

PROV: Anon, sale Bonham's, 9.3.1978 (18 bt. Agnew for the Gallery.

REF: **1** T. Algernon Earle, *Earle of Allert Tower*, in *Transactions of the Historic Society Lancashire and Cheshire, 1890*, VI 1892, pp. ff. **2** *Loc. cit.*, repr. p.31.

238

FURSE, Charles Wellington 1868 - 1904

306 Cotton Trolleys

Oil on canvas, painted spandrel with paint trials on the unpainted canvas, 59·6 × 89 cm. (23½ × 35 in.)

Sketch for one of the spandrels in the dome of Liverpool Town Hall which illustrate the theme of dock labour in Liverpool. Commissioned 1898, finished at the end of 1901 (see 824, p. 97).

The drayman who takes up the centre of the composition is carried through, with variations, into the final canvas, while the horses and dray are much altered in the details and the ship's boom behind is moved over to the right.

Two drawings for the composition, together with seven for other spandrels were acquired by the Gallery from the same source. An oil sketch (50 × 38 in.) belongs to the artist's family,[1] and that or yet another was exhibited at the Memorial exhibition at the Burlington Fine Arts Club, 1908, No. 31.

PROV: Dame Katherine Furse, widow of the artist; Rear Admiral J. P. W. Furse, C.B., and Mrs. Furse, who presented it with other drawings for the series to the *Finish the Cathedral Auction,* sale (E. Owen and Son), at the Walker Art Gallery, 20.4.1978 (74a), purchased by the Gallery.

REF: **1** Letter from Mrs. J. P. W. Furse, 8 May 1978.

HALLIDAY, Edward Irvine, living artist

305 Hilary of Poitiers

Oil and tempera on panel, squared up on in. module, 32·5 × 50·9 cm. (12¾ × 20 in.)

Scale design for a painting commissioned by the Booth Line for their passenger and cargo ship S.S. Hilary.[1] The painting (30 × 60 in.) which was hung over the companion way[2] follows the study closely, and the subject is inscribed on its frame:

A.D. 353 HILARY, A PHILOSOPHER OF POICTIERS, WAS INVITED BY THE PRIESTS AND PEOPLE OF THE CITY TO BECOME THEIR BISHOP./ HE HERE CONSIDERS THEIR OFFER, WHILE HIS WIFE, DAUGHTER AND TWO FRIENDS/URGE CAUTION IN MAKING A DECISION WHICH WILL MEAN THE SURRENDER OF HIS INHERITANCE. THE MERCHANT FROM THE EAST ASKING / A SERVANT WHAT IS

HAPPENING, FORESHADOWS HILARY'S SUBSEQUENT BANISHMENT.

PROV: Presented by the artist to the *Finish the Cathedral Auction,* sale (E. Owen and Son), at the Walker Art Gallery, 20.4.1978 (44, part), purchased by the Gallery.

REF: **1** All the Booth Line Ships were called after Divines. Built during the Depression by Cammell Laird, 1931; 7400 gross; £219,000. Traded with Brazil, used in Combined Operations during the 1939–45 war and scrapped about 1960 (see A. H. John, *A Liverpool Merchant House . . . Alfred Booth and Company, 1863–1958,* 1959, pp. 139). **2** In oil and tempera, signed *EDWARD I. HALLIDAY 1931*; now (1978) in Booth Line Head Office, Albion House, Liverpool (information kindly supplied by Mr. E. Tozer of Liverpool Nautical Research Society, and Mr. Metze of the Booth Line).

9304 Athena and Arachne

Oil and tempera on panel,[1] 36·6×26 cm. (14¾×10¼ in.)

Design for one of the three panels commissioned for the Library of the new headquarters of the Athenaeum Club, Liverpool by Benjamin S. Johnson, one of the proprietors,[2] and executed by Halliday 1928–30. Initially trained in Liverpool, the artist had just completed three years study and travel in Italy, Greece, North Africa, etc., and set up in London.

The three subjects executed were: The Contest between Athena and Poseidon for the Patronage of Athena, The Story of Marsyas, and the present subject (90×62 in.)[3]. This represents the incidents of the Life of Arachne, the skilled weaver who defied Athena to a contest of skill and coming under her just wrath, hanged herself and was metamorphosised into a spider. As in the other panels, the various incidents in the story are introduced. Visible on Athena's loom her contest with Poseidon is repeated. The artist himself appears standing at the right of the picture and his wife modelled Athena; a pencil study for her as the centre figure in the foregroun[e] exists.[4] The architecture is based on th[e] Propylaeum on the Acropolis with a re[] construction of the method of fluting th[e] columns from scaffolding, and a view in Greec[e] is seen through the columns in the background.

The squared up study for Athena's contes[t] with Poseidon was acquired by Liverpoo[l] University from the same source as 9304, an[d] they previously acquired the study for Marsya[s] (which was originally presented by the artis[t] to C. Sydney Jones).[6]

PROV: Presented by the artist to the *Finis[h] the Cathedral Auction*, sale (E. Owen and Son[] at the Walker Art Gallery, 20.4.1978 (44, part[) purchased by the Gallery.

REF: 1 Stamp of Reeves and Sons, prepare[d] board. 2 See *Liverpool Daily Post*, 1 Septembe[r] 1954 (where the finished picture is reproduce[d] after restoration). 3 Edward I. Halliday an[d] Prof. C. H. Reilly, *The Athena Panels in th[e] Library of the Athenaeum Liverpool*, n.d[] 4 Oral information from the artist, 5 Ma[y] 1978. 5 *Ibid*. 6 From Sotheby Sale, 16.7.197[] (299).

TATE, William, active 1770 - 1806

9281 Miss Tate of Toxteth Park

Oil on canvas, 76·2×63·5 cm. (30×25 in.)

The sitter was probably Elizabeth, who appears to have been the only daughter[1] of Richard Tate, (d. 1787), merchant of Liverpool, and niece of the artist. Like her brother, Thomas Moss Tate (see Tate 9067), she appears to have been an amateur artist (a Miss Tate exhibited two landscape drawings at the 1787 exhibition in Liverpool).[2] In 1802 she married Joseph Williamson, (see British School 7480) who succeeded to her brother's business as tobacco merchant.

This portrait with that of her brothe[r] descended through her family to the last owne[r]

PROV: Major G. J. Hunter, sold, Bruto[n] Knowles, Madresfield, Great Malver[n] 17.2.1976 (303), as by George Romney; bt. i[n] purchased from Major Hunter, 1977.

REF: 1 She is the only sister mentioned i[n] Thomas Moss Tate's Will (Lancashire Recor[d] Office). 2 Thomas Moss Tate also mentio[ns] several drawings by her in his Will.

Indices

Titles, Sitters, Mayoral Portraits, Liverpool Views, Merseyside, Lancashire and Cheshire Views, Pictures missing, Donors.

TITLES

Abergavenny, Landscape	M. G. Lightfoot
Aberglaslyn, Boulders near	F. W. Hayes
Adam and Eve, Expulsion of	A. Mosses
Alleyn, Mill on the, Denbighshire	
	J. E. Newton
American Ships in the Mersey	R. Salomon
Amlwch, The Old Port, Anglesey	
	H. T. Hoodless
Angels Ithuriel and Zephon finding Satan at	
the ear of Eve (Paradise Lost)	W. Huggins
Anne Askew in Prison	W. L. Windus
Anglesey, Rhoscolyn	W. J. J. C. Bond
Annunciation, The	R. Fowler
Ariel	R. Fowler
'Arctic', The Ship See	R. Salomon
Argument, The	W. Daniels
Arles	M. Bell
Autumn, North Devon Glen	J. W. Oakes
Baa Lamb, The	W. L. Windus
Back Goree	A. E. Brockbank
Barmouth, Moorland near	A. Hartland
Bay Hunter outside Stable	C. Towne
Beach at Scheveningen, Arrival of the Fishing	
Fleet	W. J. J. C. Bond
Beddgelert, On the Colwyn (2)	F. W. Hayes
Bird Nesting	J. J. Lee
Black Boy, The	W. L. Windus
'Bland', The Ship	S. Walters
Blind Howard and his Grandchildren	A. Mosses
Blue Funnel Liner – Tide Time	J. S. Mann
Blundell, Jonathan, with his greyhounds	
	R. Ansdell
Bold Street from Waterloo Place	T. Prescott
Bombed Houses	M. Bell
Brace of Pheasants	R. Ansdell
Breezy Day, A	W. A. Martin
Brigand, The	W. Daniels
Brignall Banks	A. W. Hunt
'British Queen' in a heavy sea	S. Walters
'Brussels', The Ship	S. Walters
Bull-terriers attacking a Fox	C. Towne
Burd Helen	W. L. Windus
Bute, from the high ground	W. Davis
By the Stream	W. Huggins
Capel Curig, Snowdon from	G. G. Smith
Capel Curig, Sunshine and Shower	J. Finnie
Caradoc	R. Rae
Card Players	W. Daniels
Cattle in Landscape See :	W. Huggins
	C. Towne
Chandelier	R. Young
Chess Players	W. Daniels
Children Playing	A. Ballard
Chirk, Pont Faen near	H. Dawson
Christian and the Lions (2)	W. Huggins

Clock with decorative panels	R. A. Bell
Close of a Stormy Day, Vale of Clwyd	J. Finnie
Colwyn, On the, Beddgelert (2)	F. W. Hayes
Conway Castle	W. J. J. C. Bond
Conway Castle, Banqueting Hall	H. Rathbone
Conway from above Gyffin	M. G. Lightfoot
Conway Valley, Nature's Mirror	P. Ghent
Conway Valley, Ploughing in the	W. Davis
Corner of a Cornfield	W. Davis
Cornfield with figures	A. Hunt
Cornish Seascape	J. H. Hay
Cornwall, Tin Mines	J. C. Witherop
Cottage Girl	A. Mosses
Cottage Scene	J. Mayer
Cranmer and Catherine Howard (2)	
	W. L. Windus
Crazy Kate	W. J. Bishop
Creating a Sensation	H. B. Roberts
Cynicht	W. C. Penn
Danae	S. Reed
Daphnis and Chloe	E. C. Preston
Dead Hare	R. Ansdell
Death of the Stag	R. Ansdell
Dennison Street	British School
Derelict Station	J. G. Keats
Diamond Fields, The: View on the River	
Wharfe near Bolton Abbey	P. R. Richards
Dieppe, Le Pollet Cliffs	N. Horsfield
Disagreement, A	W. Huggins
Donkey and Foal W. Huggins & W. J. J. C. Bond	
Dovedale Derbyshire	C. Barber
Drinking Pool, The	W. Huggins
Early Summer	D. A. Williamson
'Emma', The Ship	S. Walters
Emmett Dalton in Hollywood	S. Walsh
Enemy Raid, May 3rd 1941	G. G. Smith
Entry into London of Richard II and Bolingbroke	
	J. T. Eglington
Etruria Staffordshire, Wedgwood's Factory	
	S. Williamson
Eve, Satan at the ear of	W. Huggins
Eve: the Voices	R. Fowler
Evening, Glaslyn Valley	W. A. Martin
Everton Village	British School
Expulsion of Adam and Eve	A. Mosses
Falling Star, The	J. H. Hay
Farm	A. Ballard
Feeding the Pigeons, St. Mark's Square, Venice	
	D. Woodlock
Figures bathing	M. Bell
Figures in a Warm Climate, Three	S. Walsh
First Steps	G. H. Neale
Fish on the Shore	A. Butler
Fishery, The	R. Wright
Fishing boat entering harbour	S. Williamson
Fishing boat in heavy sea	S. Williamson
Fishing Nets, St. Ives	J. C. Witherop

SITTERS

244

Tarleton, Bannastre	*J. Reynolds, after*
Tate, Mr.	*W. Tate*
Taylor, William	*W. Huggins*
Tirebuck, W. E.	*E. S. Wood*
Traill, Thomas Stewart	*J. Lonsdale*
	A. Mosses
Walker, Sir Andrew Barclay	*British School* 7198
	Orchardson, after
Walker, Col. W. Hall (Lord Wavertree)	
	H. Dickinson
	R. E. Morrison
	L. Palmer
	J. S. Sargent, after
Walmsley, Sir Joshua	*T. H. Illidge*
Watson, Rev. J.	*G. Reid*
Watts, W. H.	*British School* 7781
Weightman, J.	*British School* 7134
Whishaw, Rev. A.	*British School* 7484
Whitty, John	*J. Bishop*
Williamson, Joseph	*British School* 7480
Williamson, Robert	*British School* 3019
Wilson, F. C.	*F. O. Salisbury*
Wilson, Mrs. F. C.	*F. O. Salisbury*
Windus, W. L.	*W. L. Windus*
Wright, J. N.	*British School* 2557
Yates, Joseph Brooks	*P. Westcott*

MAYORAL PORTRAITS

1803	Aspinall, John Bridge	
		British School 7026, 2587
1827	Porter, Thomas Colley	*J. Lonsdale*
1828	Robinson, Nicholas	*T. C. Thompson*
1781	Case, George (painted 1830)	
		T. Phillips
1830	Brancker, Sir Thomas	*A. Mosses*
1833	Wright, John Naylor	*British School* 2557
1836	Currie, W. Wallace	*T. C. Thompson*
		T. Phillips
1837–8	Rathbone, William	*J. H. Millington*
1839–40	Walmsley, Sir Joshua	*T. H. Illidge*
1843–4	Sands, Thomas	*G. Patten*
1844–5	Lawrence, James	*R. Beattie*
1847–8	Horsfall, Thomas Berry	*G. Patten*
1850–1	Bent, Sir John	*P. Westcott*
1852–3	Holme, Samuel	*G. Patten*
1855–6	Stewart, John	*J. E. Robertson*
1881–2	Hughes, John	*J. Barrett*
1894–5	Watts, William Henry	
		British School 7781
1895–6	Derby, 16th Earl of	*W. Q. Orchardson*
1896–7	Hughes, Sir Thomas	*R. E. Morrison*
1911–12	Derby, 17th Earl of	*W. Orpen, after*
1919–20	Eills, B. W.	*W. C. Penn*
1920–21	Russell-Taylor, E.	*R. E. Morrison*
1922–3	Wilson, F. C. and Mrs. Wilson	
		F. O. Salisbury
1924–5	Dowd, Thomas and Mrs. Dowd	
		J. A. Berrie

1925–7	Bowring, Sir Frederick	*F. T. Copnal*
1927–8	Beavan, Miss Margaret	*J. A. Berri*
1936–7	Denton, William	*F. T. Copnal*
1938–42	Jones, Sir Sydney	*W. C. Pen*
1955–6	Bailey, R. H.	*E. I. Hallida*

LIVERPOOL VIEWS

Bathhouses, Pierhead *See* **Returning to Ireland**	
	S. Walter
Blue Coat School *See* **George Brown**	*J. Lonsda*
Bold Street from Waterloo Place	*T. Prescot*
Custom House	*A. Grimsha*
Dennison Street, brick works	*British School*
Docks *See* **Pierhead**	
Everton Village	*British School*
Everton *See* **Girl with Jug of Ale**	*J. Campbe*
Exchange *See* **Town Hall**	
Goree, Back	*A. E. Brockban*
Goree Piazzas *See*	*R. Salomo*
Islington, Old Cottage	*J. T. Eglingto*
Knowsley, View of	*H. Winstanle*
Lime Street	*W. G. Herdma*
Lime Street in 1818	*J. T. Eglingto*
Liver Buildings *See* **Enemy Raid**	
	G. Grainger Smit
Mount Street *See* **Liverpool Street**	*N. Horsfiel*
Mersey, Pierhead, Docks and Panoramas *See*	
Liverpool from Tranmere, c. 1769	
	British School
View in the Mersey, 1807	*R. Salomo*
Shipping in the Mersey	*R. Salomo*
American Ships in the Mersey	*R. Salomo*
The North Shore	*British School*
The North Shore, 1829	*S. Williamso*
Bootle Landmarks	*S. Aust*
Black Rock Fort and Lighthouse	*S. Aust*
Shipping in the Mersey, 1830	*E. Calve*
Pleasure Yacht Zephyr, 1832	*M. Walte*
New Brighton Shore, 1835	*S. Williamso*
Returning to Ireland, St. George's Pier,	
1836	*S. Walte*
Wallasey Pool from Seacombe Shore	*A. Hu*
Laying foundation stone of Birkenhead	
Docks, 1845	*E. Dunca*
Sailing Ship 'Emma	*S. Walte*
Victoria Tower	*G. S. Walte*
Port of Liverpool, 1873	*S. Walte*
Docks at Night, 1886	*A. Grimsha*
Old St. George's Dock, 1913	*J. D. Wrig*
Tide Time, 1925	*J. S. Man*
Enemy Raid, 1941	*G. G. Smi*
Seacombe Ferry in Wartime	*A. Richar*
Rock Ferry	*P. S. Pai*
Rows *See* **Liverpool Landscape**	*G. Kennerle*
St. George's Hall *See*	*W. G. Herdma*
St. John's Market	*T. Presco*
St. Nicholas' Church *See*	
The North Shore	*S. Williamso*
The Docks at Night	*A. Grimsha*
St. George's Dock	*J. D. Wrig*
Scotland Road, The Pawnshop	*L. Holde*
Sudley	*M. Cockri*

Town Hall, Burning of	*British School*
Town Hall, Illuminated	*R. Salomon*
Town Hall (Oppidi Opulentia)	*J. Y. Dawbarn*
Town Hall *See*	
J. B. Aspinall	*British School*
J. Naylor Wright	*British School*
W. W. Currie	*T. C. Thompson*
Water Street	*T. Prescott*
Underground Railway	*T. Prescott*
Victoria Tower	*G. S. Walters*
Walker Art Gallery	*M. Cockrill*
Walton-on-the-Hill	*J. Pennington*
Walton, Old Plough Inn	*British School*
Walton *See*	
Landscape, View of Knowsley	*H. Winstanley*
Water Street	*T. Prescott*
William Brown Street, Steble Fountain	*T. Prescott*
Windermere House	*J. Baum*

Morecambe Bay	*J. W. Oakes*
Morecambe Bay from Warton Crag	*D. A. Williamson*
Moreton	*W. Huggins*
New Brighton Shore	*S. Williamson*
New Brighton, The Sands	*D. Jenkins*
North Shore	*British School*
North Shore	*A. Hunt*
North Shore, Liverpool from the	*S. Williamson*
Oxton, Houses at	*W. J. J. C. Bond*
Perch Rock *See* Black Rock	
Prenton Claypits	*E. P. Gill*
Ravens Fall near Hurst Green	*W. J. J. C. Bond*
Rivington Valley	*F. W. Hulme*
Rock Ferry	*P. S. Paice*
Seacombe Ferry in Wartime	*A. Richards*
Sefton Church	*A. Hunt*
Sefton Landscape	*R. Tonge*
Speke Hall	*W. Huggins*
Speke Hall, Courtyard	*W. Davis*
Tranmere, Liverpool from	*British School*
Wallasey Pool from Seacombe Shore	*A. Hunt*
Walton *See* Liverpool	
Warton Crag, Arnside Knot and Coniston Old Man, from	*D. A. Williamson*

MERSEYSIDE, LANCASHIRE AND CHESHIRE VIEWS

Alt, on the, near Formby and Ainsdale	*W. Davis*
Altcar *See*	
Waterloo Cup	*R. Ansdell*
Altcar, near	*H. Williams*
Bebington Church (Interior and Exterior)	*W. Huggins*
Bidston Hill, view from	*W. Davis*
Bidston Hill, view from	*R. Tonge*
Bidston Marsh	*W. Davis*
Birkenhead Docks, Laying foundation stone	*E. Duncan*
Blackrock Fort and Lighthouse	*S. Austin*
and *See*	
Pleasure Yacht Zephyr	*S. Walters*
American Ships in Mersey	*R. Salomon*
New Brighton Shore	*S. Williamson*
Bootle Landmarks	*S. Austin*
Cheshire Landscape (2)	*R. Tonge*
Cheshire Meadows (Helsby)	*W. Huggins*
Chester Cathedral (Exterior) (2)	*W. Huggins*
Croxteth Hall *See*	
Grey Cob outside Croxteth	*C. Towne*
Car and Tandem outside Croxteth	*D. Dalby*
Dee, Old Mill and Salmon Trap on the	*W. Huggins*
Ditton, Old Mill at	*W. Davis*
Eastham Wood, Kingfisher's Haunt	*W. L. Windus*
Everton *See* Liverpool	
Hale	*W. Davis*
Helsby *See*	
Cheshire Meadows	*W. Huggins*
Hilbre	*C. W. Sharpe*
Hoylake Fishing Boat	*W. J. J. C. Bond*
Hoylake, Racing at	*J. Dalby*
Leasowe Shore	*W. J. J. C. Bond*
Maghull Race Course	*C. Towne*

PICTURES DESTROYED OR MISSING SINCE 1939-45 WAR

Portrait of Philip Rathbone	*W. B. Boadle*
The Critics	*W. Daniels*
The Margin of Rydal	*J. Finnie*
Burning of Liverpool Landing Stage	*T. Huson*
Portrait of James Allinson Picton	*J. E. Robertson*
Landscape	*S. Williamson*
The Old Oak	*S. Williamson*
Gerona, Spain	*J. C. Witherop*

DONORS AND LENDERS

Agnew, Thomas & Sons	
J. Partridge	2981
American Chamber of Commerce through Sir J. Gray Hill	
G. S. Newton	2571
Anonymous	
A. Grimshaw	L23, 24
Armstrong, W.	
W. Kaufmann	1110
Ashworth, C. E.	
J. Campbell	423
P. Westcott	404
Aspinall, Clarke	
British	7026
Aspinall, R. A.	
British	2587
Atkinson, Miss W. E.	
W. Huggins	1716

248

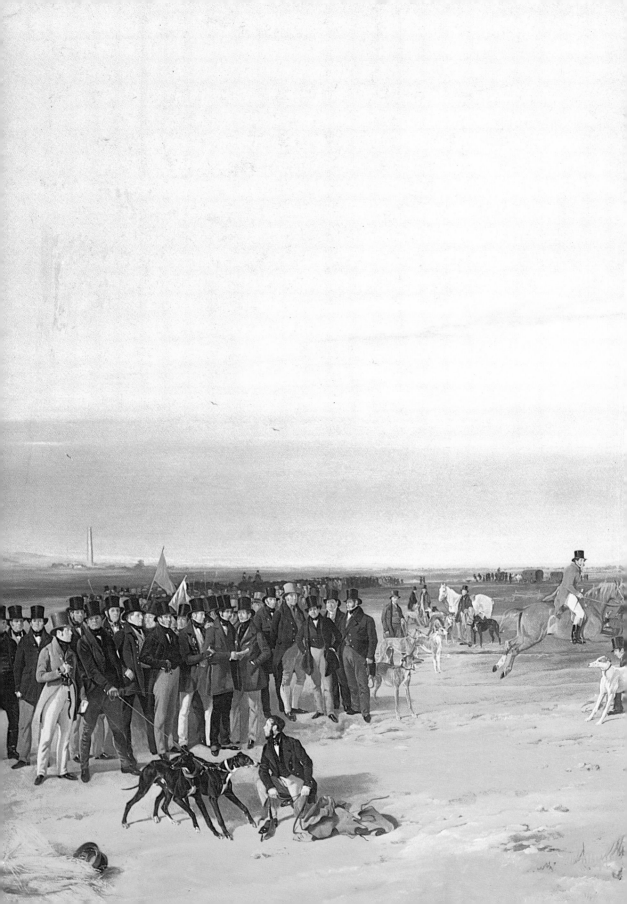